W9-DFB-782

Art of the Twentieth Century
Protagonists, Movements and Themes of Art
from 1900 to the Present Day

The book has been published
thanks to the collaboration
and the contribution of

 UniCredit Group

WARSAW PUBLIC LIBRARY
MAIN LIBRARY DIVISION
CENTRAL PLANS

Art of the Twentieth Century
1900–1919
The Avant-garde
Movements

CABRINI COLLEGE LIBRARY
10 KING OF PRUSSIA ROAD
RADNOR, PA 19087

SKIRA

N
6490
.A146
2006

X 775 18916

Cover Design
Pierluigi Cerri

Design
Marcello Francone

Translation
Antony Shugaar

Copy Editor
Timothy Stroud
Emanuela Di Lallo

Layout
Serena Parini

Iconographic Research
Massimo Zanella

Cover
Vasily Kandinsky, *White Zigzag*, 1922
Oil on canvas, 95 × 125 cm
Venice, Museo d'Arte Moderna
di Ca' Pesaro

First published in Italy in 2006 by
Skira Editore S.p.a.
Palazzo Casati Stampa
Via Torino, 61
20123 Milano
Italy
www.skira.net

© 2006 Skira editore, Milano
© Alexandr Archipenko, Giacomo Balla, Alexandre Benois, Constantin Brancusi, Georges Braque, Carlo Carrà, Felice Casorati, Marc Chagall, Giorgio de Chirico, Filippo De Pisis, Robert Delaunay, Sonia Delaunay, Fortunato Depero, André Derain, Maurice de Vlaminck, Otto Dix, Marcel Duchamp, Raoul Dufy, James Ensor, Max Ernst, Achille-Emile-Othon Friesz, Albert Gleizes, George Grosz, Raoul Hausmann, Erich Heckel, Vilmos Huszár, Vasily Kandinsky, Paul Klee, Oskar Kokoschka, Mikhail Larionov, Fernand Léger, Jean Metzinger, Joan Miró, Giorgio Morandi, Edvard Munch, Max Pechstein, Francis Picabia, Pablo Picasso, Gerrit Rietveld, Alexandr Rodchenko, Georges Rouault, Karl Schmidt-Rottluff, Kurt Schwitters, Chaïm Soutine, Gino Severini, Paul Signac, Mario Sironi, Succession H. Matisse, Vladimir Tatlin by SIAE 2006

All rights reserved under international copyright conventions.
No part of this book may be reproduced or utilized in any form or by any means, electronic or mechanical, including photocopying, recording, or any information storage and retrieval system, without permission in writing from the publisher.

Printed and bound in Italy.
First edition

ISBN-13: 978-88-7624-604-3
ISBN-10: 88-7624-604-5

Distributed in North America by
Rizzoli International Publications, Inc.,
300 Park Avenue South, New York,
NY 10010.
Distributed elsewhere in the world
by Thames and Hudson Ltd.,
108a High Holborn, London WC1V
7QX, United Kingdom.

The chapters in the current text were written by a group of scholars, each one dealing with a specific portion of the work, as indicated below:

The Eccentric Vision of Modernism/ Barcelona; From Scapigliatura to Futurism
(Pietro Bussio)

The Eccentric Vision of Modernism/ Russia; The Rigorous and Geometrical Line of Modernist Culture/Prague and *Vienna; Art Nouveau and the Parisian Crucible of the Avant-gardes/Brussels*
(Roberta D'Adda)

Aesthetic Experimentation and Transformation of Artistic Language at the Dawn of the Twentieth Century; The Rigorous and Geometrical Line of Modernist Culture/Munich
(Massimiliano De Serio)

From Secessions to Expressionism; The Fusion of the New Languages; The Experiences of Abstraction
(Fiorenzo Fisogni)

Art Nouveau and the Parisian Crucible of the Avant-gardes/Paris 1900–1910, The Meteor of Fauvism and *The Semantic Revolution of the Avant-gardes; The End of the Artistic Object*
(Domenico Quaranta)

Foreword

The idea of a major new systematic publication looking back over and revisiting world art throughout the 20th century has been the top priority in the plans of the Skira publishing house for many years.

In fact, in order to cater for the increasing interest shown by the public of museums and exhibitions in the protagonists and themes of the art of the last century, the need was felt for an updated work that could be at the same time a major database of information and images ready to be consulted and a critical guide for interpreting and analysing more deeply the key phenomena of 20th-century art from all over the world.

This effective need also inevitably encountered the equally objective complexity—in terms of methodology and dimensions—represented by such a highly structured, rich and problematic theme as the organisation of the artistic scene of the astonishing century that was the last.

The energies required in terms of design, organisation and finance were truly enormous.

In this regard, the coming together of Skira and UniCredit was decisive.

The activities of the major credit institutes to support cultural enterprises have a long tradition, particularly in Italy. But never before had a large banking group developed a project that was so organic, complex and cohesive as to support the 'system' of modern and contemporary art.

Not coincidentally, the meetings between UniCredit and Skira have become increasingly frequent in the most high-quality museums and on the occasion of major exhibitions: an enlightened sponsor and a specialist publisher travelling along the same path, yet without even admitting as much to each other.

It was almost natural that this liaison would result in a major common publishing project devoted to the overall interpretation of the art of the 20th century; it was equally natural that the work on this would be harmonious in order to make it an innovative and exhaustive instrument, destined to become a reference point for both art specialists and the countless enthusiasts among the public at large.

Control over the project was entrusted to a prestigious scientific committee, composed of personalities who have long combined their studies with the running of prestigious museum institutions and the curatorship of major international exhibitions.

The editorial 'head' of the work is therefore, by choice, Italian, albeit represented by scholars of international scope, but the contributions that make it so original come from every part of the world.

The narrative text, prepared by an editorial team specially formed for the work, is in fact combined with essays of in-depth analysis commissioned from international specialists selected, theme by theme, by the scientific committee.

The work as a whole deals with the complex panorama of the art of the 20th century, following a chronological path that relates together events, artists, cultural personalities, situations contemporary to each other, sometimes homogeneous in choices and in directions taken, more frequently contradictory, in a continuous clash between innovation and tradition, between avant-garde and academicism.

In other words, an attempt has been made to transcend the usual manual-type structure in terms of artistic movements and groups, instead seeking to highlight the evolution of the language, the innovative ideas, the choices that have proven successful, from the current historical perspective, but always in relation to a panorama and a cultural fabric impregnated with tradition and references to the past, stimulated by the proposals of renewal and at the same time reluctant to accept these.

From this point of view, the outstanding iconographic apparatus has given precedence to the publication of works less frequently seen in the exhibitions, while not neglecting the presence of the best-known masterpieces, those full-blown icons of modernity. It aims to be an independent visual path that, though accompanied by a rich and necessary historical and critical narration, presents readers with the innovations in language, the *volte-faces* in style, the boldness of themes that generations of artists have gradually forged during the course of little more than a century.

The supporting idea of the work is therefore that of proposing an approach to the protagonists and works of art of the 20th century that is global, up-to-date and multifaceted: a synthesis of historical-critical data and updates for the specialists and scholars, but also a very rich repertory of proposals and interpretations for the wider audience of students, art enthusiasts and all those who have always looked at modern and contemporary art—especially the latter—with diffidence or indifference, since they have lacked the historical and critical instruments necessary to understand the paths and choices of the artistic culture of the 20th century.

It will be up to our readers, now, to tell us whether we have succeeded in our aims.

The Publisher

Guide for Readers

The Art of the 20th Century is a book structured into five volumes that is distinguished by its innovative style and by its format, which offer readers various possible approaches and uses of its content.

The narrative text

Each volume has a narrative text that accompanies readers through the chapters in the reconstruction of the various historical events, the background cultural panorama and the individual artistic and intellectual personalities that have characterised and profoundly marked the artistic culture in various cities and countries, in a constant and complex comparison of links and contrasts. The text has been written with the collaboration of young scholars with the intention of going back over the various historical moments of artistic debate, forming a consistent thread running through that helps readers disentangle themselves amid situations, movements, groups, artists and works.

The subdivision into chapters follows a geo-historical format; that is, it identifies cities and/or nations that became centres of debate in specific years and the clashes—often bitter—between innovations and traditions. This focus is accompanied by an account conducted year by year—indeed, often month by month—highlighting pockets of works, events and comparisons that clarify the relations between the various components of the artistic culture examined.

Analysis boxes

In order to avoid excessive fragmentation, the narrative text is accompanied by a number of boxes for analysis, making it possible to highlight and focus clearly on a specific subject, an event, a situation, a personality, contributing to enriching the overall itinerary with details.

The illustrative apparatus

Images play a fundamental role in this work, not only as a medium and as the visualisation of the statements and analyses presented in the text, but above all as an independent path for reading. The works have been chosen with the intention to give particular precedence to examples that are little seen and/or known, yet that are important in the general discourse, this alternating with the presentation of works that have definitively become part of an ideal and shared gallery of the masterpieces of modernity. The matching and linking, the details and technical captions, all enable the reader to read in visual form the differences and similarities, the reciprocal influences, the extraordinary technological and expressive innovations, together with the sudden returns to tradition, the thematic innovations and the inexorable transformations of style.

The essays

A fundamental part of the structure of the work is its organisation into short essays; these are detailed and new in their interpretative style, inspired by a multidisciplinary approach that gives precedence to the cultural with respect to the purely historical and artistic aspect. Entrusted to scholars of international renown, these contributions are full-blown investigations that, due to the wealth of analyses and scope of the essays, are intentionally not illustrated precisely so as to become a third possible path of independent reading.

The synoptic tables

Each volume possesses a rich apparatus of synoptic tables distributed year by year in relation to the chronological segment identified, in which historical events are connected with the most significant events in science, literature, music and criticism and, obviously, with the world of art itself. The latter is divided into geographical areas, with particular attention to the centres of inspiration and action, and includes movements of artists, the execution of emblematic works and the formation and breaking up of groups and factions.

The thematic bibliography

Each volume offers readers a synthetic thematic bibliography structured into works of a general character and works dedicated to individual movements/groups and artistic personalities of particular significance. The thematic bibliography gives precedence to recent texts that can be found on the market and gives an account of newly published works on the themes discussed. The structure follows that of the chapters of each individual book.

The analytical index

There is an analytical index for each volume, with the names, artists and works cited and/or illustrated in the texts and essays. It is a useful instrument for consultation, but it is also a precious store of information: indeed, besides the personalities from history and culture, the index gives the titles of magazines, movements, associations, groups, and above all the names of the artists, with places and dates of birth and death, and the list in chronological order of the works cited in the volume, each with their current location.

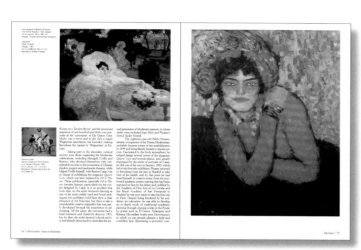

The narrative text

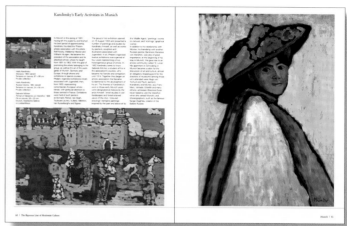

Analysis boxes

The essays

The synoptic tables

Scientific Committee

Gabriella Belli
Carlo Bertelli
Germano Celant
Ester Coen
Ida Gianelli
Valerio Terraroli, *editor of the work*

Contents

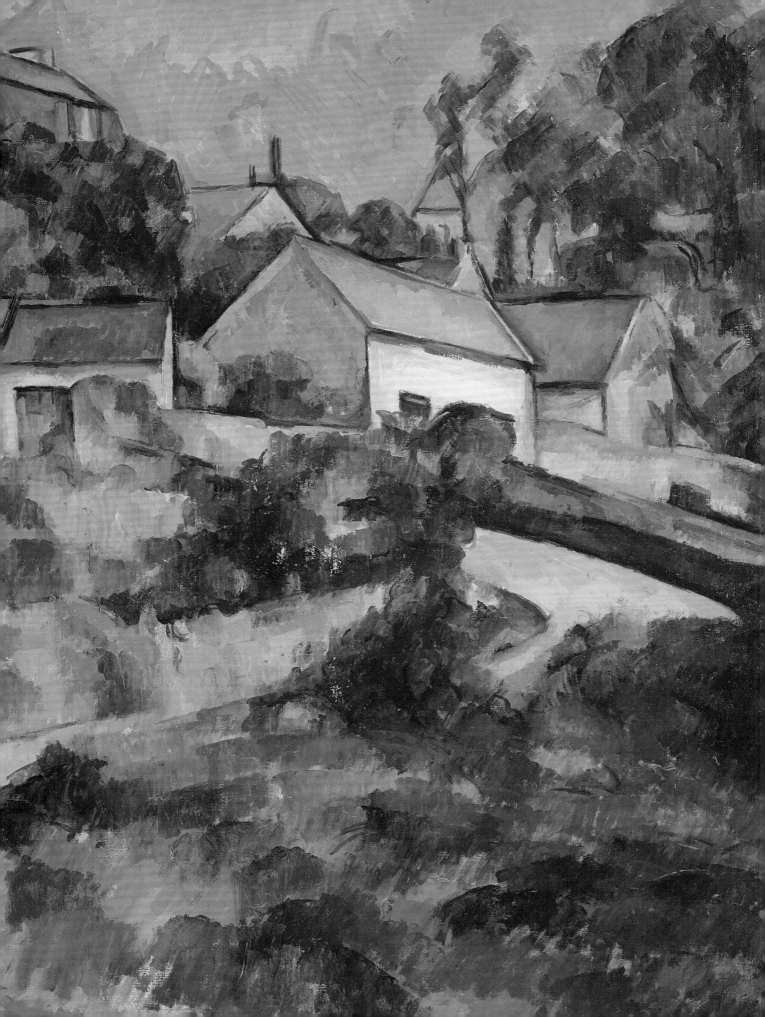

Aesthetic Experimentation and Transformation of Artistic Language at the Dawn of the Twentieth Century

The turn of the new century, charged with anticipation, hopes, and trust in the 'magnificent and progressive fate' of mankind, and at the same time riven with disquiet, conflict, and desires for reforms—possibly radical reforms of the systems of behaviour, right down to the very mechanisms of perception and the rules of taste—seemed to take form in a first, startling mass phenomenon: a worldwide event that brought to a single location hundreds of thousands of people, a uniform audience, apparently devoid of cultural and class distinctions, setting forth a synthesis of the contemporary world in a sort of colossal diorama. The Exposition Universelle Internationale opened its doors to the public in 1900, but its groundwork had been laid with an official decree as early as 1892, calling for the organisation of a simultaneous exhibition of artwork and an exposition of industrial products. The Expo's success did not actually measure up to the efforts expended; nor did the design and the temporary architectural structures show much consistency with the dictates of the new style—international modernism—which, in contrast, had typified the great Paris exposition marking the centennial (1889), with its cunning use of iron and glass.

In contrast with the high-flown French pavilions (Grand and Petit Palais), whose load-bearing structures were concealed beneath layers of plaster, carved wood, gilding and paint in a triumph of the theatrical style of the 'Belle Epoque', the pavilions of Germany and Austria, nations which had not taken part in the 1889 Expo, had a well-balanced and matching set of rooms—in effect, architectural spaces—that carefully harmonised with the furnishings. The Symbolist themes of the paintings were seamlessly linked with the *boiseries*, carved and painted with stylised plant motifs, and the furniture in bentwood to create an overall effect of practical utility and elegant aesthetic quality. On the other hand, Nordic countries as well, especially Finland, with the pavilion designed by Eliel Saarinen, and Norway and Denmark, but also Hungary and Romania, set forth an interesting hybrid of folk traditions, the ethnographic repertory of their own traditions, and the all-inclusive decorative sense of modernism.

Despite the efforts and the declarations of intent that enshrined the absolute and necessary alliance between the decorative arts and industry in the mythical goal of a fusion of Beauty and Utility, a sharp division was surreptitiously re-established between the 'fine arts' and the 'industrial arts', infusing renewed vigour in a problem that over the course of the first decade of the twentieth century was to prove insoluble. The continuous use of such terms as 'modern style', 'new art' and 'art industry' entailed the hope that these new modalities of expression and execution might take concrete form in the clear and unequivocal definition of a style. Regardless, the Expo succeeded in offering a glittering display of a modern and industrialised world that was attempting to update its own image and, above all, the space of its own social, intimate life.

The art world of all Europe flocked to the Exposition Universelle in Paris—from Picasso to Matisse to Previati to Balla to Munch—making the event the presage of a series of exchanges, both theoretic and visual, that took to a conclusion the contradictions inherent in naturalist verism and increased the pressure for change that had already made itself felt in Paris and other European capitals over the previous fifteen years or so. At the turn of the new century, the irreversible crisis in the themes and means of expression of the Impressionist school, which by that time had been codified and been accepted by French gallery-owners and collectors, does not seem to have affected the diffusion of naturalism throughout the rest of Europe, but it became caught up in the trends that were more correctly Post-Impressionist in character from the 1880s, particularly so in the last show of the Impressionist group in 1886 in the works of Claude Monet, Paul Gauguin, and the precursor of geometric-abstractionist painting, Paul Cézanne. The works of these artists—though also of the always modern Degas, the rather tired colourist Renoir, and the landscape artists who recognised the power of chromatic segments immersed in the atmosphere, Camille Pissarro and Alfred Sisley—were

Paul Cézanne
Street at Montgeroult, 1898 (detail)
Oil on canvas, 81.2 x 66 cm
New York, The Museum of Modern Art

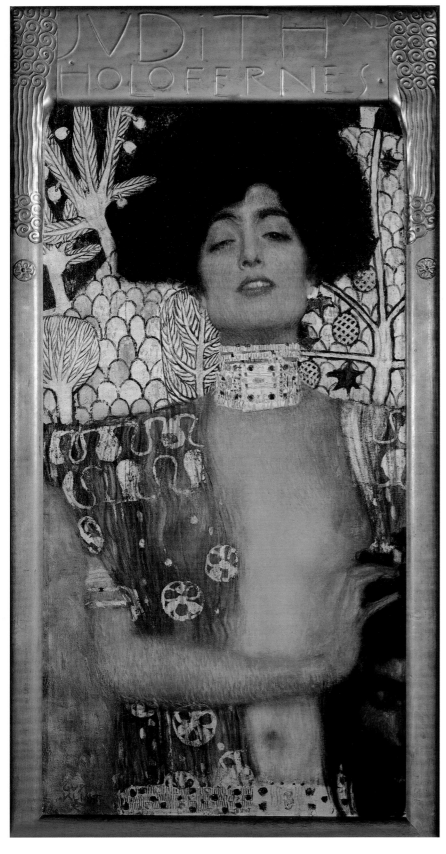

brought together with the strongly expressionist canvases of Vincent van Gogh during his Provencal phase and the scientific experiments of Georges Seurat and Paul Signac. They were exhibited across Europe, in such cities as Vienna, Berlin, Brussels, Dresden, Munich, Prague, Moscow and St Petersburg, thanks to the promotion work undertaken by artists' associations (in particular the Secessionists in Munich, Vienna and Berlin), and to the support of farsighted gallery-owners like Tannhauser in Berlin, and of collectors like the Russians Schukin and Morozov, and for the carefully selected acquisitions made by museums. The perfect example of museum activity was the figure of Hugo von Tschudi, who purchased paintings by Manet, the Impressionists and Van Gogh for the modern art museums of Munich and Berlin.

The rapid developments and transformations in taste and, in consequence, in style occurred within the broad setting of Symbolism, which began with the crisis in nineteenth-century naturalism—of which the Impressionists were the last representatives—and closed with the explosive and metaphorical launch of the historic avant-gardes of the early twentieth century. The Symbolist culture nourished and encouraged a series of options and models that were to become the prescriptive basis of many creative movements at the start of the century: the expression of existential and psychological anguish by means of a completely innovative use of colour, as in Van Gogh and Munch, the improbable combination of dreamlike and natural situations tinged with a degree of sarcasm and irony, as in Ensor and Rops, the characteristics of deformation and decorative fragmentation, the enervating exotic and barbaric elegance combined with a cogent, cynical contemporaneity, as in Khnopff, Klimt and Schiele, the formalist and structural experimentation that began with Cézanne and ran through to the abstraction of Kupka and also Klimt, and finally the allegorical, two-dimensional and anti-naturalistic interpretations of medieval and classical iconography, as seen in Puvis de Chavannes and the works of the Nabis, in particular Sérusier and Gauguin. This cultural and historic conjuncture occurred at the same time as the introduction of new technological and manufacturing systems in architecture and the mass production of everyday objects, thereby presenting the huge and extraordinary illusion of "art for all" that was to spawn the theory of total art at the end of the nineteenth century, which was considered to be the harmonious fusion

Gustav Klimt
Judith I, 1901
Oil on canvas, 84 x 42 cm
Vienna, Österreichische Galerie
Belvedere

Vincent van Gogh
*La Berceuse (Woman Rocking
a Cradle)*, 1889
Oil on canvas, 92 x 73 cm
Otterlo, Kröller-Müller Museum

Pages 16–17
Georges Seurat
Bathers at Asnières, 1883–84 (detail)
Oil on canvas, 200 x 300 cm
London, National Gallery

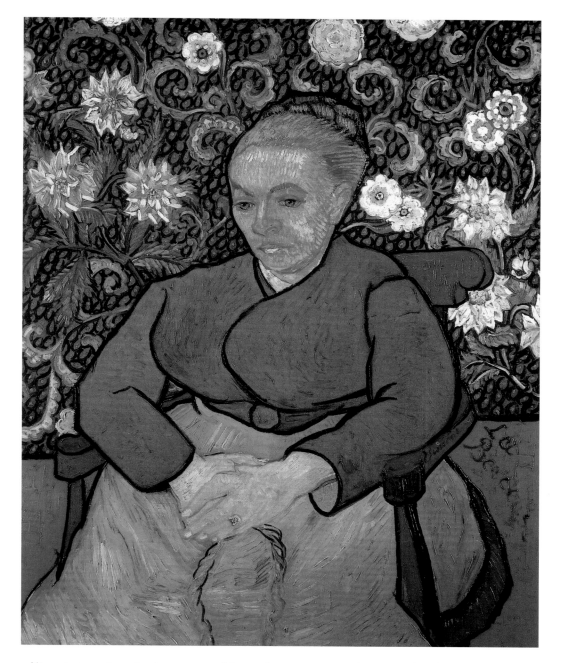

of linguistic and aesthetic systems addressed to the masses. During that period, figurative art, the architectural design of exteriors and interiors, graphics, and the decorative and industrial arts succeeded in codifying a system of communication that was aesthetic and ethical, useful and rational, anti-historicist but also linked to the transformations taking place in contemporary life: in other words, the fertile terrain for the development of the modern age.

In 1886 the painter Émile Bernard spent two months in Pont-Aven, a small village in Brittany, and was to return there in July 1888; Van Gogh worked with Bernard from the end of 1886 and formed a friendship from 1887 with Gauguin. And in Au-

gust 1886 the second Salon des Indépendants opened in Paris, which was to be the final joint exhibition of the Impressionists: Signac, Cross, Camille and Lucien Pissarro, Angrand, Dubois-Pillet and Seurat all displayed works in the same room. Seurat had already begun his experimentation into the visual effects of the fragmentation of colour in the canvas *Bathers at Asnières* (1883–34), and in this particular exhibition he presented *Sunday Afternoon on the Island of Grande Jatte*, which was a theoretical and practical manifesto for Pointillism. A development of what remained of the Impressionist movement, the original core of the new revolutionary direction in European painting—pointillism/divisionism—was fully repre-

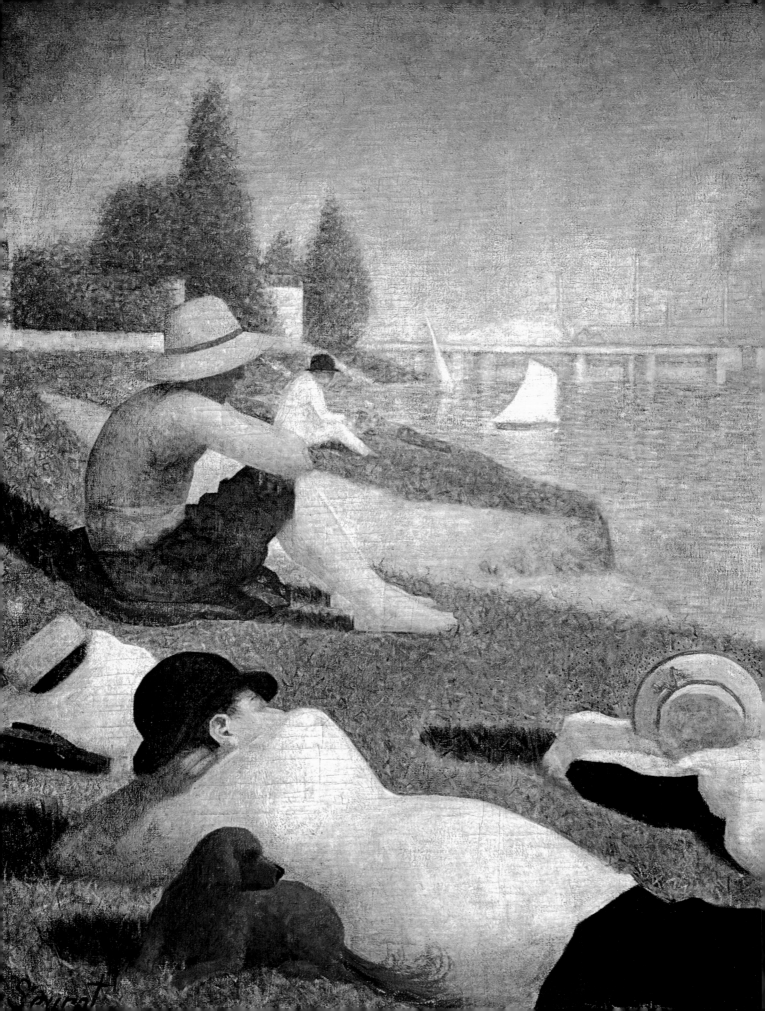

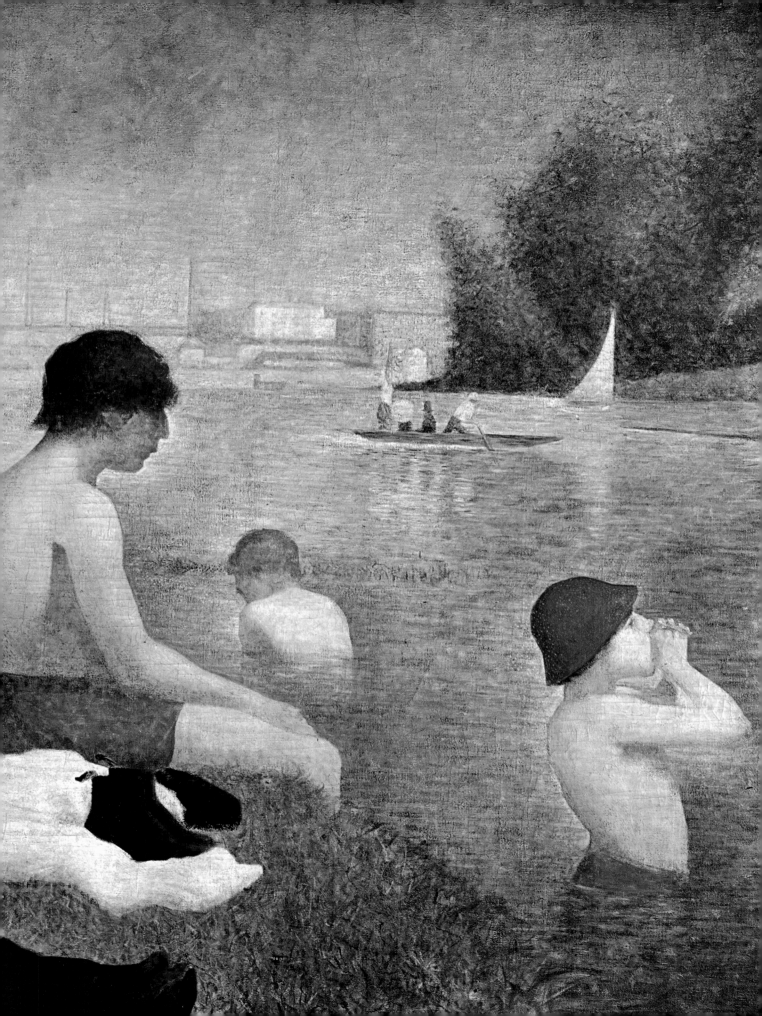

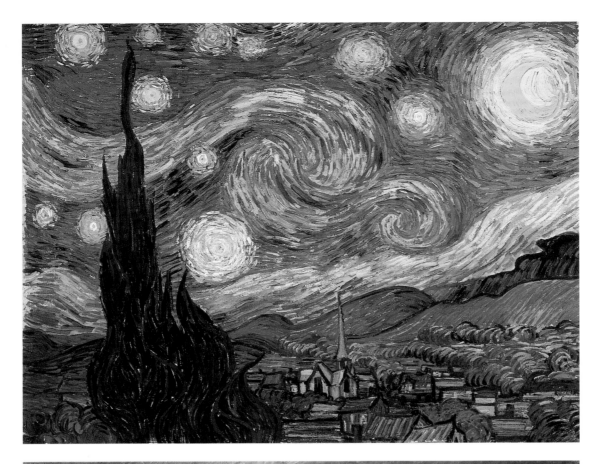

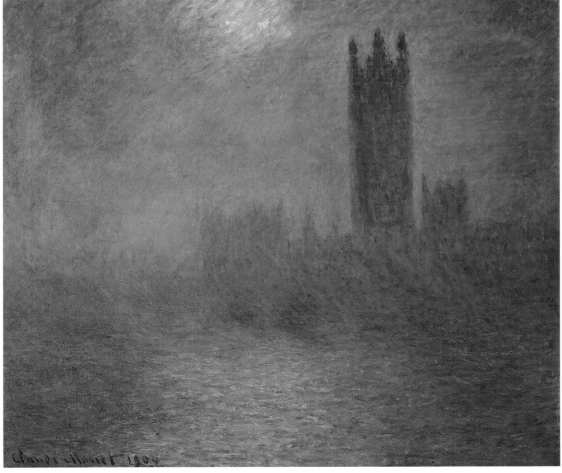

Claude Monet
The Rouen Cathedral at Noon, 1894
Oil on canvas, 100 x 65 cm
Moscow, Pushkin Museum
of Fine Arts

Opposite
Vincent van Gogh
Starry Night, 1889
Oil on canvas, 73 x 92 cm
New York, The Museum of Modern Art
Mrs Lillie P. Bliss Fund

Claude Monet
Houses of Parliament, London, 1904
Oil on canvas, 81 x 92 cm
Paris, Musée d'Orsay

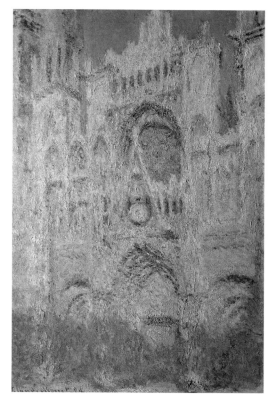

sented at the second Salon des Indépendants, despite the opposition of the exhibition's promoters to this sort of work. A compromise was reached in which the paintings of the Pointillists were hung together in one room, while in others there were pastels by Edgar Degas, landscapes by Paul Gauguin and drawings by Odilon Redon.

At this time the art critic Félix Fénéon published a short article in the magazine *La Vague* in which he gave an outline of the theory of the *mélange optique*, which was in turn based on the theories of light and colour devised by James Maxwell and Ogden Rood and seen in the works of Eugène Delacroix. The article was later reprinted in a booklet published at the end of the year with the title *Impressionistes en 1886*—which was a real Neo-Impressionist manifesto. Four years later, in 1890 in the publication *Hommes d'aujourd'hui* Fénéon discussed in detail his own colour theory, which was similar to that on which Seurat and the Divisionist group based their painting. Aspects considered included the modification of the local colour of an object, the quality of light, the phenomenon of tone contrast, and the notion of simultaneous contrast, i.e., when one colour modifies the observer's perception of another colour next to it. According to the law of *mélange optique* (the union of a colour reflected from an object with the different coloured lights that modify it), if a painter

juxtaposes the colours on the canvas in the form of small dots or separate patches of colour, these elements will be recomposed on the retina of the observer's eye to create a mixture of the colours and light. Seurat furthered his method with theories he took from the *Introduction à une esthétique scientifique* published in 1885 by the mathematician and philosopher Charles Henry, a friend of Fénéon. This book built on the intuitions of Humbert de Superville and Charles Blanc on the subject of the expressive value of the use of lines. However much he was involved in experimentation with colour, Seurat was also interested in the arguments regarding the expressivity of the directions of lines, shadows and lights, and colours and their synthesis. According to these theories, joyfulness, calm, sadness, etc., can be expressed by the use of colours, linear directions and different lights. Furthermore, Signac contributed to several of Henry's writings, for instance, in 1889 he produced a lithograph to illustrate Henry's *Cercle Chromatique*.

At the opposite extreme from Claude Monet and his *Water-lilies*, where a sort of immense fusion takes place between the painter, nature and the painting itself, Seurat offers a vast, inaccessible space in which one senses a chilly distance. In this sense, it is easy to understand his interest for the theme of the circus and spectacle in general, since in it convention establishes a sharp separation between two worlds: the world depicted and the world seen in the spectator's gaze. This may be referred to as the search for pure pictorial nature, in which the artist succeeds in achieving descriptive depth without relying on perspective, and a harmony of forms on the surface without slipping into abstraction: all within a profound sense of both space and light, where the quality of the void is the "trademark" of Seurat's painting.

Paul Signac followed in Seurat's footsteps, radicalising his assumptions and results: he no longer painted outdoors but in his own atelier; limiting his research and pictorial expression to the refinement of a precise and systematic technique through which sensations merge in a single virtual and anti-verist image.

In February 1892, on the occasion of the Salon des Vingt in Brussels, Signac showed five paintings with musical titles (*Scherzo, Larghetto, Allegro Maestoso, Adagio, Presto Finale*) in which the objects took the form of a musical score and became starting points for the gradation, measure and intensification of

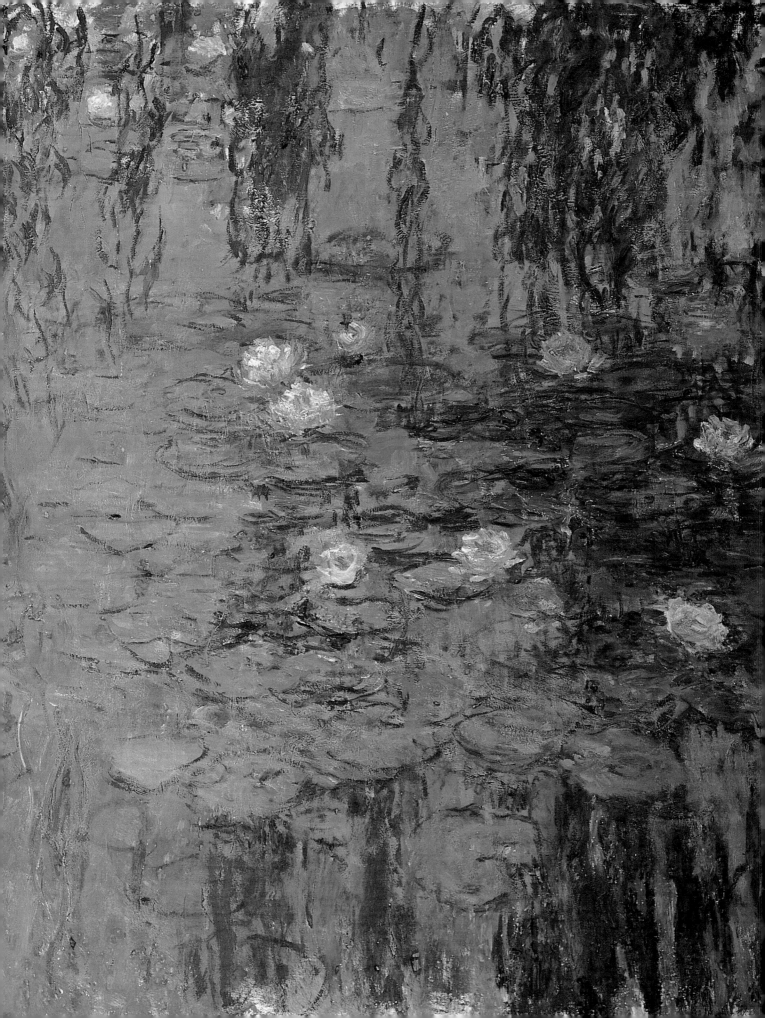

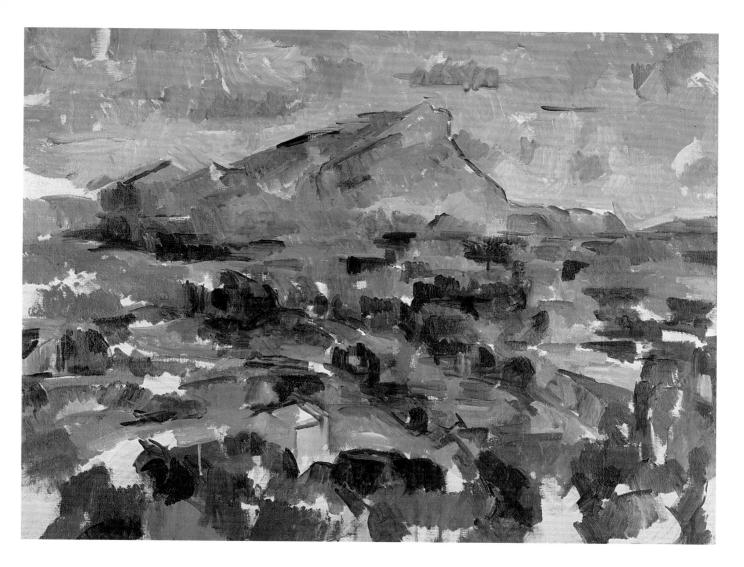

Paul Cézanne
Mont Sainte-Victorie, 1905
Oil on canvas, 63.5 x 83 cm
Zurich, Kunsthaus

Opposite
Claude Monet
Blue Water Lilies, 1916–19 (detail)
Oil on canvas, 200 x 200 cm
Paris, Musée d'Orsay

the chromatic accents. The colours and their arrangement on the canvas established the sonority of each painting. Colours were no longer used to depict objects, but the objects themselves became vehicles for the representation of colours, creating links and separations, while the differentiations in the formal language conformed to action.

From 1896, Signac worked on his book of theory, *D'Eugène Delacroix au nèo-impressionisme*, which appeared in the form of articles in 1898 in the *Revue Blanche*, where Fèlix Fénéon was managing editor, and then in book form in 1899. To mark the first Neo-Impressionist exhibition in Germany, which was held in the Keller and Reiner Gallery in Berlin from 22 October to 2 December 1898, the magazine *Pan* published a summary in German.

The Neo-Impressionist "school" immediately attracted a following in European art. Camille Pissarro, whose sensibility remained impressionist, enthusiastically took up Seurat's method as a means to perfect his

own style, though he abandoned it soon after. In the wake of Neo-Impressionism came several works by Henri Matisse (formerly a student of the Symbolist painter Gustave Moreau) which were partly influenced by the Divisionist painter Henri Edmond Cross. In the summer of 1904 Matisse paid frequent visits to Signac's Saint-Tropez studio, where Cross was also painting. Matisse's painting *Luxe, calme et volupté*—initially begun that summer, finished the following winter and later purchased by Signac himself in 1905—reveals the influence on Matisse of Divisionist theory and artworks, especially if we consider the manner with which Signac attempted to guide the observer's eye through unitary chromatic intensities. Moreover, the white underlying canvas constitutes a background in which the movement develops itself freely on the surface of the painting. The colour fields are arranged in a straightforward manner and almost impel the movements of the eye around the composition as a whole.

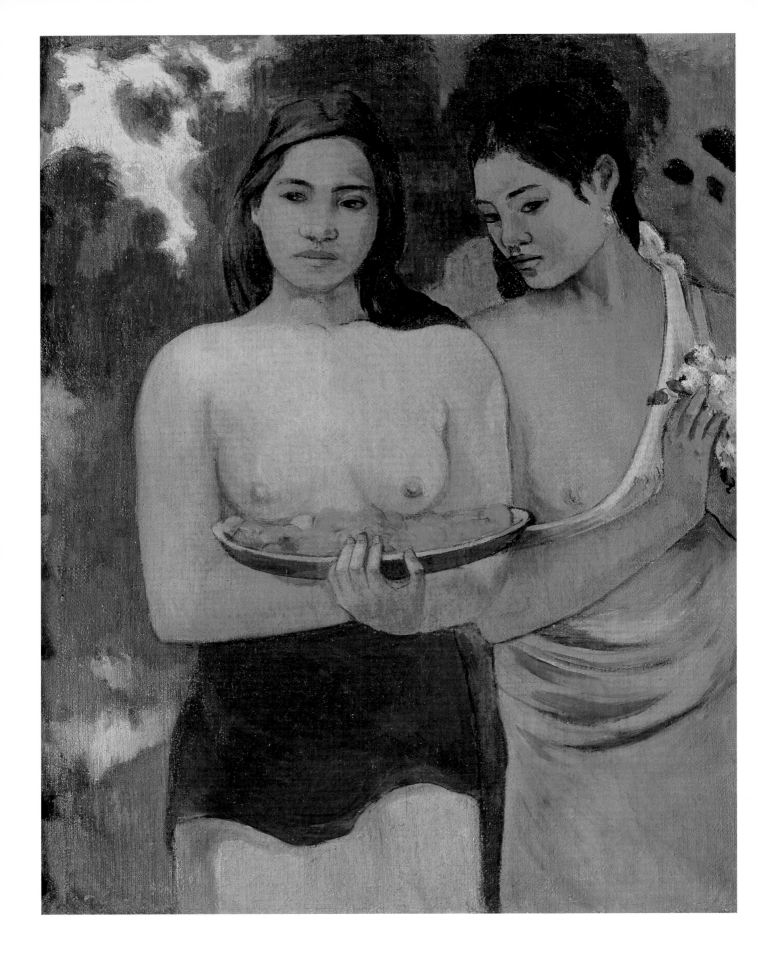

Paul Gauguin
Two Tahitian Women, 1899
Oil on canvas, 94 x 72.4 cm
New York, The Metropolitan Museum
of Art

Paul Cézanne
The Large Bathers, 1906
Oil on canvas, 208 x 251 cm
Philadelphia Museum of Art

The importance of the teachings of the Divisionists in the affirmation of a constructive autonomy for colour was evident in the work of artists like Robert Delaunay and Jean Metzinger as early as the three-year period 1905–08. The Druet Gallery actively supported the spread of Divisionism in those years by holding a solo exhibition of Signac's work in 1904 and one for Cross in 1905.

The first explicitly Post-Impressionist exhibition in Europe was only held between November 1910 and January 1911 at the Grafton Galleries in London, where it was curated by Roger Fry and Desmond Mac-Carthy. Titled 'Manet and the Post-Impressionists', the exhibition included works by—among others—Manet, Cézanne, Gauguin, Van Gogh, several Neo-Impressionists, Matisse, Denis and Picasso. In Fry's opinion,

Cézanne lay at the centre of post-impressionist research into space, light and colour, whom he considered the "prototype" artist of "post-impressionism". At the point of contact between Symbolism and Impressionism, the artists seemed to respond to a psychological and social need for sensorial introspection in reality through their art. The painting of artists like Van Gogh and Cézanne represented a resolute act of will that had no need of being "completed": nature bent and subjected itself to the will of the artist.

The communion between art, nature and personal consciousness reached a peak matched by a corresponding intensity in the use of colours and lines—a use that was both expressive and, at the same time, totally free of any convention, whether of an academic or scientific character.

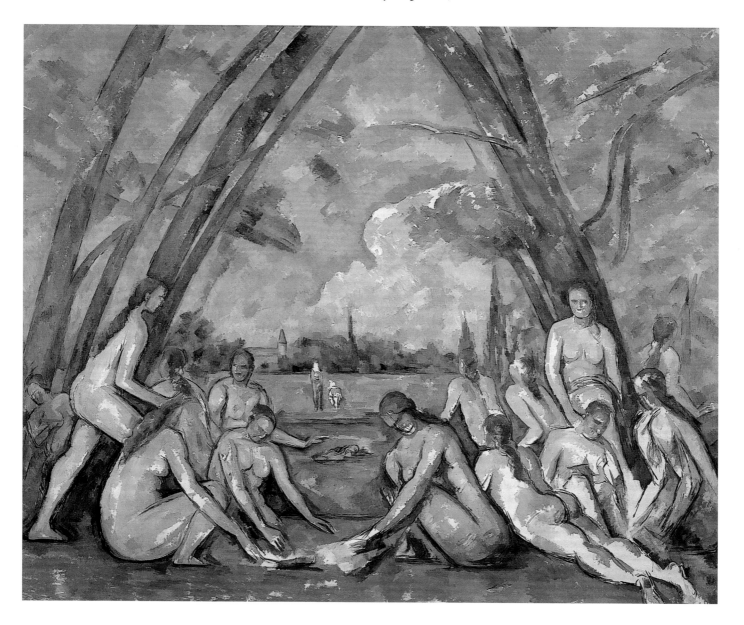

Heinz Althöfer

Protagonists of the Modern Techniques and Materials Used in New Art

The allure of the avant-garde often causes us to overlook the fact that this type of artistic expression was largely conceived in the first half of the twentieth century. Close analysis reveals the early precursors of Informalism to be Hofmann, Wols, Jackson Pollock with his dripping-technique, and the incorporation of found objects in the paintings of Carl Buchheister. In a similar manner, Expressionism, with its unvarnished, crudely structured works, also influenced the future of painting. Surrealism, with its concept of painting technique, along with collage and the ever-increasing importance of paper as a medium for paint and as a part of objects, were further preparations for the avant-garde. The use of plastic as an artistic material also has its conception in this period. Finally, degradation as an artistic intention—which simultaneously created a new problem for the task of restoration—is first referred to in Modernism. And throughout the first half of the twentieth century, certain Impressionistic art, with its reliance on painting technique, provides evidence of the continuation of traditional painting far into the avant-garde of the second half of the twentieth century and into the new millennium.

In the 1960s, we have the mixing of sand into the oil paintings by Tápies and Poliakoff, as well as kaolin on canvas by Manzoni, with his further mounting of painting paper and cardboard on wooden boards and subsequent plating. Among textiles comes the introduction of sailcloth projects (Edgar Hofschen) and the frequent use of muslin and velvet (Piero Manzoni).

On the other hand, these represent extensions corresponding to stylistic and thematic connections, as with Picasso's *Crucifixion* of 1930, a theme that was later taken up in a similar manner by the then 28-year-old Bacon.

Another example was Tom Wesselmann's inspiration by Jackson Pollock and Willem de Kooning to project figures onto metal plates with laser beams and later cut them out. This technique became increasingly popular until the end of the twentieth century. In part, there is also a return to the classical techniques and materials. After acrylic colours, considered dead and dull, there is a return to the structural and seemingly transparent classical materials and the traditional layered construction of paintings.

In some important aspects, however, material technique is first focused upon in the second half of the century, as with the use of the modern material, plastic and with the first examples of intentional degradation. Many examples, such as Surrealist paintings in particular, or, to an even greater extent, those by Mondrian, clearly show that the purist standards of the unaltered, perfect condition of artwork prevail.

Thus, the affinity, for example, to Dieter Roth, despite the relative temporal proximity, is unthinkable. At the same time, there is an increase in individualists of unique styles and 'personal' painting or material techniques. One could say that the continuation of old art, its emergence and materialisation persisted throughout 1945.

It almost seems as if the material paper is frequently associated with East Asian art and calligraphy, stimulating progressive stylistic developments. Hans Har-

tung arrived in 1921–22, already on his path towards physical abstraction. Similar relations with Pollock and Tobey can also be ascertained as early as 1922.

From 1919 Julius Bissier was tied to the Far East through the Sinologist Ernst Grosse, and André Masson's discovery of Automatism is unimaginable without calligraphy, which he learned of in his 1943–44 exile to Boston.[1] There are comparable affinities to Indian Ajanta painting and to South Sea Exoticism. Ernst Ludwig Kirchner comes to mind, along with Nolde and Pechstein. One example of this early awareness is Ernst Ludwig Kirchner's *Girl under a Japanese Parasol* of 1909, now in Düsseldorf in North-Rhine Westphalia. Last but not least, in his book published in 1912, *Concerning the Spiritual in Art*, Kandinsky also reflected upon the Japanese brushstroke and classic East Asian art. It is worth noting that Kandinsky also anticipated another area of Modernism: in his work *Crepuscule* of 1943, he presents 'cell-figures, emerging from blister-like forms'.[2]

Arnold Böcklin—who, with questionable materials such as copaiva and asphalt paint, significantly helped shape Colourism and the material experimentation of the early twentieth century, thereby influencing the Surrealists, such as Giorgio de Chirico and later Ernst Fuchs, with their comparable efforts in painting technique—was a prototype for the beginning of twentieth-century material art.[3] Faith in progress encouraged reliance on the simultaneous development of restoration and scientific research techniques: Max von Pettenkofer, with his new regeneration process, Wilhelm Conrad Röntgen, who shortly before the turn of the century conducted the first x-ray examination of paintings, Faber and Kögel, who in 1914 applied ultraviolet rays in the examination of paintings, and finally, between 1924 and 1932, Bayle's application of infrared rays, discovered in 1800, to the scientific examination of works of art.

In the first half of the twentieth century, the new and somewhat venturesome ideas in painting techniques challenged those from the end of the nineteenth century and were significantly extended. Increasingly, restorers were faced with new materials and fragile structures, for example, unvarnished paintings, to which cleaning methods had to be directly applied, effectively exposing them to a high risk of permanent damage. They were faced by the fundamental questions: What is allowed? What should and what can one do from a conservationist standpoint with these unframed, unvarnished, large format works of art, whose transient existence is based upon the concept of degradation as an artistic intention?

Next to the traditional painting techniques of the Impressionists, there were artists who embraced the future with their strange techniques and compositional schemes, such as those of Automatism, found-object elaboration and Surrealist collage. Schwitters' collages had a progressive material technique and greatly anticipated the material work of Robert Rauschenberg of the 1950s. Certainly, Rauschenberg was more brutal and chaotic, even in his choice of objects and their arrangement. In addition, painting, or rather the paint itself, carries more weight in Rauschenberg's work. It is frequently applied in crude, pasty structures, narrowing the apparent gap between painting and collage material.

Significant principles of successive collage art were conceived by Schwitters as early as 1919. Similarly, the scheme of fixing and mounting, as the case may be, was accompanied by their respective conservation risks. In some cases, it was advisable to remount rusted metal clips or nails as, above all, this is helpful in preventing the material from (further) pitting. Finally, the re-gluing or even the complete dismantling of a collage's parts became necessary, for example, the paper collages of Juan Gris, among others.

Inventiveness and diversity of materials are special requirements of the restorer (consider the collages of Gino Severini), who, in the context of the material art of the second half of the twentieth century, was faced with an entirely new field. This is true to the same measure for Sophie Taeuber-Arp, Magritte, and so forth. The protagonist, if one may use this term, of Trash Art was Vladimir Tatlin. With his *Blue Contour Relief*, he provided an early and exceptional example of the artistic elaboration of raw and used materials.

After 1910, Braques and then Picasso worked with wallpaper, newspaper clippings and paper scraps. In the 1920s, Josef Albers created paper webs with a knife and scissors.[4] In his *Gouachen* (1940), Kandinsky used black paper, which he made himself, and Miró used tissue paper as a base for his drawings.

Only somewhat later did the first new, until then unusual, paper techniques emerge, particularly in connection with photography: a photo-collage with pencil created by Georges Hugnet.

In the area of paper works, the automatic techniques, frottages and grattages of Max Ernst were inspiring. He developed unusual methods that went beyond painting in order 'to help [his] hallucinatory powers', as he wrotes in 1936. Similar to Pollock's drippings, the traceability of an individual style and perspective on painting technique is, if at all, only partially possible.

The autonomy of paint and other materials as well as Automatism and the techniques of ageing and patina, alienate insight into artistic structures, and the work of art is further distanced from the artist's direct technique and hand. But it must be reiterated that diversity and parallelism in style reflected the variations of painting techniques. Mondrian worked in perfect detail and did not tolerate ageing. Craquelées (tiny cracks) seemed to be tolerated by Oskar Schlemmer and Jean Arp, where the breaches in the paint have a less disturbing effect. Blocks of paint are separated by literally razor-sharp borders created with the use of adhesive tape, as in Barnett Newman's cadmium-red sections of the 1940s. During that same period, at the end of the 1940s, Marc Rothko put aside 'all connections between colour and form. I want to express the emotions'.

Other Modernists stirred similar emotions: like Franz Kline, they worked in a consciously strong and rather casual way. Normally, Kline nailed the unstretched canvas to his studio wall and painted it with fabric paint (these were the days before he could afford artist's paints).[5] Kline not only allowed the paint to explode, but he also projected his essentially small format paintings in De Kooning's atelier onto canvas in large formats: an impetus for Kline's later monumental paintings. Fur-

ther proposals from Willem de Kooning's studio provide ulterior evidence of his unencumbered orientation towards pure painting. In addition to using traditional canvas, he painted on sailcloth. Spontaneity and flurry of the painting process: the eye is sharp, the hand fresh. His new technique, drawings in layers, which were superimposed and torn up, or simply fragments of drawings became collages with great spontaneity and vitality.

This connivance, this Automatism was, in all its differentness, a characteristic trait of the New York school. Robert Motherwell—an Abstract Expressionist, influenced by French Surrealism and Automatism—became the informant and teacher of many American artists, whom he supported in the resolution of technical painting problems, especially those concerning the mastering of the work in automatic drawings.

Without question, the concentration on old techniques and materials in the first half of the twentieth century was a significant aspect. They then became more varied, pragmatic and free in their application. Varnish was largely omitted but, on the other hand, there were rich variations of the ground coat. Either it too was omitted, as with the Expressionists, or with virtuosity it was smoothed, scratched, structured, or lightly glazed on, as by Clyfford Still in his paintings from the '40s.

After a movement in the direction of relatively flat, painting-like, or even ephemeral collages, such as those by Rauschenberg, a shift took place towards three-dimensionality, as with Joseph Cornell's casts, which were filled with ready-made objects. This was undoubtedly a later influence of the French Dadaists, who were fascinated by the traditional reference to the mounting of Italian Renaissance paintings. Calder—who between 1936 and 1941 bent industrial-finished wire into three-dimensional forms in rooms—took another step forward in ambient art.

Industrial products gained the interest of, among others, the Constructivist sculptors, who used celluloid next to transparent glass to suggest non-existent surfaces, similar to Calder's concept of virtual volumes.

Celluloid and newer plastics expanded the artistic field in ways never before imagined. It was certainly a great challenge for art, but also for restoration. Plastics first appeared in the nineteenth century in just a few early forms but gained increasing significance in the first half of the twentieth century. Archipenko recognised transparent plastic as a new aesthetic element as early as the '40s.[6] More and more, plastics found their way into restoration. They allow possibilities for the impregnation and lining of paintings, they serve as a filler in cementing and are even used as a varnish coating. Acrylic gains special significance as an adhesive agent in retouching.

By the beginning of the nineteenth century, organic materials were already being produced artificially. Celluloid was discovered as early as 1870 and in 1908, Bakeland began manufacturing Bakelite. Shortly before this, polymethacrylic acid ester had been discovered, and this became the basis for 'various acrylic bonds, which are of particular importance in the painting and sculpting of Pevsner and Naum Gabo'.[7] With plastic, the new technical century made a decided entry into modern

art. From the 1930s, the easily malleable Plexiglas, whose properties make it a convenient artistic material, was employed by László Moholy-Nagy and Naum Gabo. It is important to recognise that these are industrial products—as were the first concrete plastics in 1935—which were considered 'counterfeit products' and 'cheap surrogates'.[8]

The use of material underwent radical changes in the twentieth century, in particular, it gained its own meaning and function in art. In many cases, it was the key to representation and gave a work of art its character. It is a document of its time and in its application a signal of its social functions. The type and the application of the material determine the durability of the artwork as well as the technique and methods of conservation.

In the twentieth century, the still dominant material, paint, became 'supercharged with programmatic significance'.[9] The matte application of paint with coarse strokes was intended by the Expressionists to convey primitivity, however, it also demonstrated a poor adhesion to jute and this results in pulverisation. At the same time, the problem of fixing the colour arises because of the unvarnished, matte surface.

The fire paintings of Yves Klein and Otto Piene from 1920 found their precursors in the burning processes photographed by Man Ray and the fumages by Wolfgang Paalen and Antonin Artaud in 1937. In this case, the restoration problems are already very similar to those of the Zero artists. One example is the sensitivity of fragile burn scars, resistant to all types of conservation techniques.

Marcel Duchamp, who was especially interested in materials, worked with glass, granite and largely with rubber or caoutchouc. In 1917 he experimented with the elasticity of this material by cutting bathing caps into strips and stretching them throughout a room. This same material was to become interesting to Bruce Naumann and Richard Serra in the avant-garde following 1945. And Salvador Dalí used milk, pubic hair and women's shoes in his objects.

With the Cubists, Surrealists and Dadaists came a multifaceted and widely varied use of wood. In the first decade of the twentieth century, Constantin Brancusi used marble. The surprising conclusion—from the perspective of Zero art—were the light-room modulators by Moholy-Nagy from 1910–20!

Even the seemingly traditional painting of the time was pervaded by the same zeal for experimentation. Strongly opaque and glazed parts were alternated; pasty structures appeared as additional dimensions; and individual areas could hardly be separated from the various techniques: oil painting stands starkly next to varnish paintings.

These new materials simultaneously show their own special sensitivities, as we know from classical painting: pastiness harbours the danger of collecting dirt. Masses of wet paint may run and drip, flowing over the painting, changing the concept and the composition, as in a painting by Picasso. Martin Kippenberger has traced this occurrence in his *Portrait of Paul Schreber* (oil on canvas with varnish and silicon, 1994).

As with Böcklin and the Surrealists (Fuchs), Klinger stimulated Max Ernst in his creation of Surrealist collages. Edvard Munch experimented with the dripping technique, Cézanne's paintings, with their ungrounded canvases, were precursors of Morris Louis and reached as far as Sigmar Polke. In addition to all these new experiments, the problems of conservation were carried into the future: just as we find Munch's scratching technique in the grattages of Max Ernst, the Expressionists' pulverisation recalls the material chalkiness in the paintings of the great Experimenters.

Fine variations within a fundamentally Classical construction of a painting suggested the new possibilities of Impressionistic techniques, as seen early in the twentieth century in the dry, aspirated tones of Edgar Degas' later works. Techniques of painting and pastel merge to ascertain the attractiveness of early Impressionistic works (*Danseuse à mis-corps se coiffant*, 1900–12). Somewhat more sharply contoured, in what is perhaps a more pointillistic tonality, is Picasso in his view of Paris. In a dryer method, Claude Monet—like the Expressionists—allowed the painting's base to determine the surface: shimmering, the paint allows both the subject and the material structure to be recognised.

Overall, these paintings of a traditionally oriented structure demonstrate a great distancing from nineteenth century painting. Derain, Dufy, Bonnard, Renoir, Vuillard, Fantin-Latour, as well as, a few years later, Utrillo, Corinth and Liebermann all work in this [formally] traditional manner But these artists are all innovators with regard to painting technique—only now their decisive presentation of colour follows this new style. From the precursors of the late nineteenth century, such as Corot and Vuillard, to the Impressionists shortly thereafter, not excluding the Constructivists of Kliun and his circle, traditional painting construction remained basically unchanged. And it remained the case, except for subtle variations, such as the use of tempera instead of oil-resins, or Moholy-Nagy's oil on Bakelite, or Picasso's use of sand in oil paints as early as 1907.

Also André Masson, the father of Informalism and exponent of early Automatism since 1923, used traditional painting techniques in his *Landscape with Injured Bird* from 1927: oil on canvas, layers of paint, varnish. Automatism and spontaneity now characterised the painting process. As for restoration, this allowed at best only an approximate reproduction of the work.

André Masson's final discovery of Automatism can be understood in consideration of these very premises. Shortly after his return from America, he completed his sand paintings and introduced painting techniques to Informalism. Hoffmann, Pollock's teacher and artist of the European school, was instrumental in broadening the already rich colour palate, which then allowed Informalism to become the radiant art that it was in the second half of the twentieth century.

To this group belong the early works of Willem de Kooning, Richard Pouselte-Dart, David Smith and Franz Kline. In Germany, the early, energetic paintings from the years after 1938 of the Informalist, Fritz Winter, should be mentioned, as well as the still underestimated Wols, with his dream scenes of 1932, placing him very

close to Klee and once again illustrating his Surrealist heritage. Wols created paintings that, as with Liebermann and Renoir, allow the merging of objective landscape forms and informal abstractions. His French-influenced artistic heritage calls attention to the informal tendencies of other French artists, such as Monet, who stand as great examples of this art.

In addition to paint as a material, found objects became collaged into artworks. The process of creating a work of art now carried a special meaning. Carl Buchheister painted with oil in 1923 but he already mixed 'since his beginnings in paper work, watercolours, lead and coloured pencils, charcoal, sand and marble dust'. In 1930 he experimented with Plexiglas, cords, mirrors, sheet metal, iron rods, wood plates, logs, and so on.[10] And Gerhard Hoehme emerged as the great perfecter of plastic art.

Thus, the Informalists linked the art of the second half of the twentieth century with the forerunners of Modernism from 1900 to 1945.

[1] Marguerite Müller-Yao, *Informalist Painting and Chinese Calligraphy*, in Heinz Althöfer (ed.), *Informal. Encounter and Change* (Dortmund/Düsseldorf: Forschungsinstitut Museum am Ostwall, 2002) pp. 322 ff.

[2] Claudia Bulk, *Egg Cells and Mold*, in Heinz Althöfer (ed.), *Informal. Encounter and Change* (Dortmund/Düsseldorf: Forschungsinstitut Museum am Ostwall, 2002) pp. 175 ff.

[3] Heinz Althöfer, Arnold Böcklin, "Painting Technician and Colorist" in *Painting Technique/Restoration*, 4/1974, pp. 197 ff.

[4] Monika Wagner (ed.), *Encyclopædia of Artistic Materials* (Munich: 2002).

[5] Jack Burnham, *Kunst und Strukturalismus* (*Art and Structuralism*) (Cologne: DuMont Schauberg, 1973).

[6] Heinz Althöfer, "On the Restoration of Modern Art Objects", in *Journal for Aesthetics and General Science of Art*, XVII, 2, 1972, pp. 195–213; see also Wagner, *Encyclopædia of Artistic Materials*.

[7] Josef Riederer, *Plastics in the 19th Century*, in Heinz Althöfer (ed.), *The 19th Century and Restoration. Contributions to Painting, Painting Technique and Conservation* (Munich: 1987), p. 134.

[8] See Wagner, *Encyclopædia of Artistic Materials*, p. 38.

[9] See Wagner, *Encyclopædia of Artistic Materials*, p. 81.

[10] Willi Kemp, *Carl Buchheister and His Material*, in Althöfer, *Informal. Encounter and Change*, pp. 75 ff.

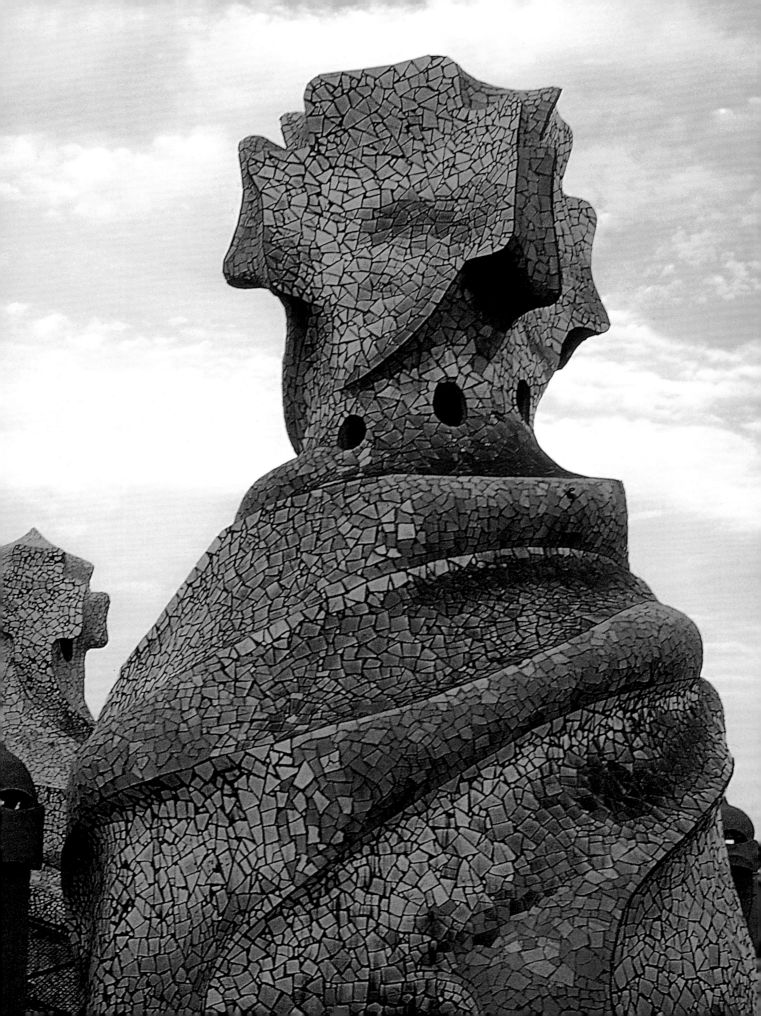

The Eccentric Vision of Modernism

Barcelona

Catalonia and Barcelona in particular played a decisive role in the transformation of the artistic languages of the early twentieth century in Europe: as a heavily industrialised region and very active mercantile centre, Barcelona was already one of the most modern cities in Europe at the end of the nineteenth century. It was among the first to adopt a far-reaching city development plan and gave a significant stimulus to the modernist architecture of which Anton Gaudí was a renowned exponent. Gaudí was an architect, decorator and inventor of original building designs in line with the Modernist system, but designs that were continually influenced by and amalgamated with an eclectic set of details from the past: from the Arab culture of *azulejos* (polychrome majolica tiles), Gothic architecture, and abstract touches from the legacies of oriental classical cultures. For example, in Parco Güell, which he laid out between 1900 and 1914, on the one hand the glowing lizard-dragon in the fountain has affinities with Art Nouveau and modern decorative arts, but on the other it brings to mind the Python of Greek mythology that guarded the underground waters from its position on the steps of the temple of Apollo at Delphi. And the Casa Milá (1905–10), called La Pedrera, is more like a gigantic abstract sculpture than a building, in which nature and Art Nouveau lines merge in a new and eccentric artistic language. Another of the architects working in that period in line with the technological and formal developments of international modernism was Puig y Cadafalch. The first building designed by Cadafalch in Barcelona was the Martí House (1896), where the Cerveceria (beer-bar) Els Quatre Gats was located on the ground floor. The cerveceria was one of the popular gathering places of the artists, writers and actors in Modernist Barcelona, but the idea pursued by the four founders—Luis Rusiñol, Ramon Casas, Miguel Utrillo and Pere Romeu—of founding an establishment based on the literary café Le Chat Noir in Paris was prompted by earlier contacts and interactions with the French capital that were reinforced on their return to Barcelona.

Luis met Ramon in Paris in the 1880s, where they lived in the same apartment at the Moulin de la Galette with Miguel Utrillo, and often showed their work together at the same exhibitions. Whereas Rusiñol was more interested in the evolution of the painting of the Symbolists, the Pre-Raphaelites and the work of Puvis de Chavannes, Casas, who had been in Paris longer and who was already working in Carolus Duran's atelier, was attracted by the painting of Sargent, De Nittis and especially Manet, Toulouse-Lautrec and Degas. These influences were translated for both of them into an 'Impressionistic' painting abounding in desolate foregrounds or with a few figures, generally depicting shadowy interiors; whereas after 1900 painting for Ramon mostly focused on human subjects, Luis developed in parallel a style, especially in lithographs, that was more Symbolist, underscored by luminous and colourful atmospheres while continuing to focus on landscapes as subjects. These stylistic characteristics are a point of reference for all modernist painting and spread among the Catalonian artists thanks to the pair's intense cultural activity following their return to Spain. Following Rusiñol's return from Paris, with the help of Casas and the enthusiastic participation of the writer Joan Maragall, he organised the 'Fiestas Modernistas' in his residence-museum at the Cau Ferra in Sitges from 1892 to 1899, which soon became crucial episodes in the promotion and diffusion of the movement's ideas. These 'Festivals' were a sort of celebration—artistic, expositional, theatrical and musical—in which the dramatic works of the Belgian Maurice Maeterlinck enjoyed immense success, especially the *Intruse*, which was staged in its entirety. Works by El Greco were exhibited and sold, then carried in procession like religious relics through the streets of the city.

The success and the importance of the Fiestas Modernistas led Ramon Casas, Pere Romeu, and later Luis Rusiñol and Miguel Utrillo to open the Cerveceria Els Quatre Gats in Barcelona in 1897. From the very beginning the establishment became a hangout for artists, writers, musicians, poets and actors of the whole city, and drew them from all over Europe. It was also a space for exhibitions and theatre events, and the walls of the cerveceria were hung works by Casas, including the ironic oil painting *Ramon Casas and Pere*

Antoni Gaudí
Detail of the fireplaces of the Milá House (*La Pedrera*), 1905–10
Barcelona

Hermenegild Anglada-Camarasa
The White Peacock, 1904 (detail)
Oil on canvas, 78.5 x 99.5 cm
Madrid, Thyssen-Bornemisza Museum

Opposite
Pablo Picasso
Margot, 1901
Oil on cardboard, 69 x 57 cm
Barcelona, Museu Picasso

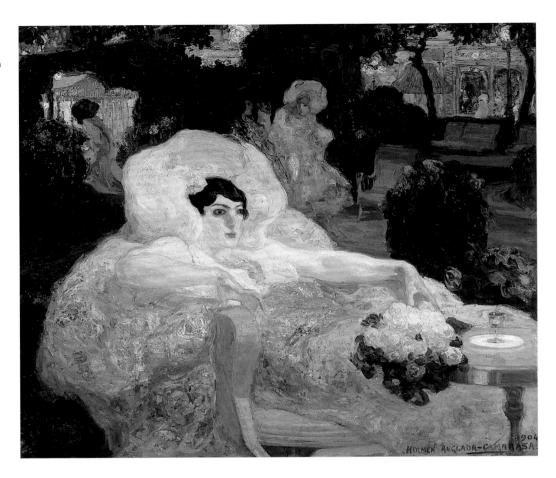

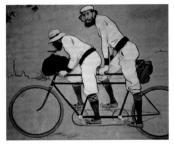

Ramon Casas
*Ramon Casas and Pere Romeu
on a Tandem Bicycle*, 1897
Oil on canvas, 191 x 215 cm
Barcelona, Museu Nacional d'Art
de Catalunya

Romeu on a Tandem Bicycle and the renowned sequence of one hundred and thirty-two portraits of the 'customers' of Els Quatre Gats. Music was a focus and in the club a major Wagnerian association was founded, making Barcelona the capital of 'Wagnerism' in Europe.

Taking part in the abundant cultural activity were those organising the Modernist celebrations, including Maragall, Utrillo and Romeu, who devoted themselves with considerable success to the promotion of Chinese shadow-puppet and marionette theatres, while Miguel Utrillo himself, with Ramon Casas, was in charge of publishing the magazine *Quatre Gats*, which was later replaced by *Pél & Ploma*. These publications, especially *Pél & Ploma*, became famous, particularly for the covers designed by Casas. It is no accident that from then on the artist favoured drawing as one of his most widely used and loved techniques; his confident, bold lines show a clear influence of Art Nouveau, but there is also a considerable creative originality that was partly developed through his experience in advertising. All the same, the cerveceria had a brief existence and closed its doors in 1903; but by then the multi-faceted cultural activity had already done much to stimulate the sec-

ond generation of Modernist painters, in whose ranks were included Joan Miró and Picasso's friend, Isidre Nonell.

The eighteen-year-old Pablo Picasso, already a frequenter of the Fiestas Modernistas, probably became aware of the establishment in 1899 and immediately became a regular patron. Fascinated by the lively atmosphere, he helped design several covers of the magazine *Quatre Gats* and several menus, and, greatly impressed by the series of portraits of Casas, he did one of his own in January 1900, which led to his first solo exhibition. Picasso returned to Barcelona from his stay in Madrid to take care of his health, and by this point he had freed himself, in creative terms, from the iron-bound academic artistic training that had been imposed on him by his father and codified by the Academy of Fine Arts of La Coruña and the Royal Academy of San Fernando in Madrid; he was now ready to take his first trip to Paris. Despite being hindered by his academic art education, he was able to develop an in-depth study of traditional academic painting through copying works in the Prado by artists such as El Greco, Velázquez and Rubens. His earliest works were *Tauromaquias* in which we can already glimpse a bold and confident line, illustrating a powerful 'cari-

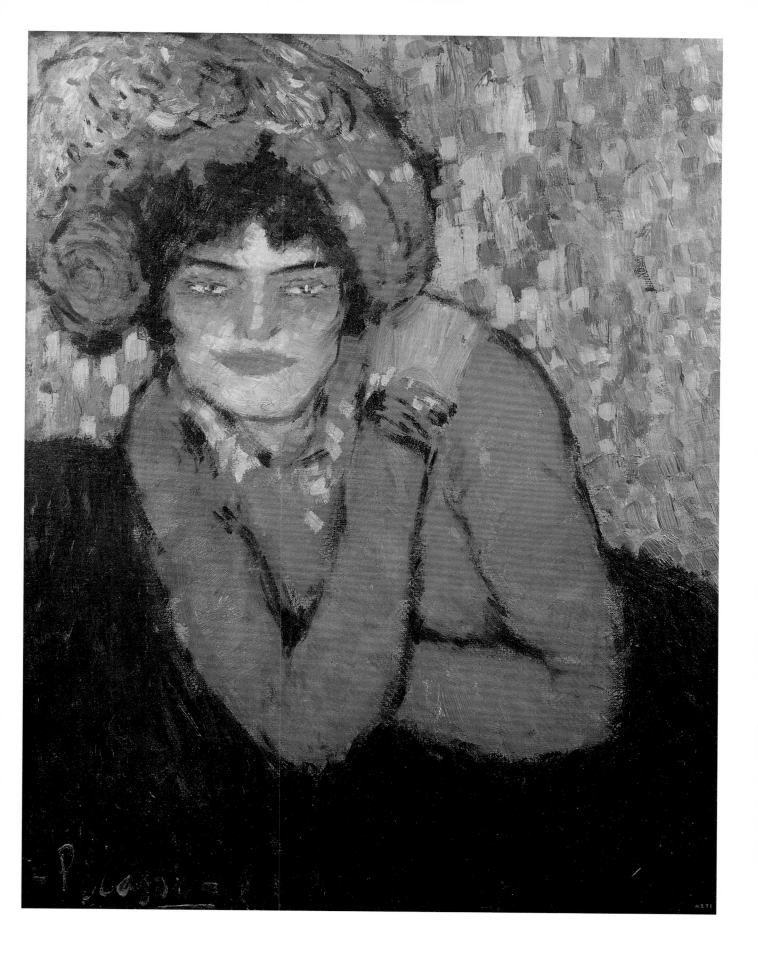

catural' style. The desire to pursue an increasingly immediate artistic autonomy, distant from all academic formalisms, and to become familiar with the artistic milieus of Munich and Paris, which were renowned at the time throughout the art world for their cultural richness, led the artist to abandon the Academy of Madrid, seizing on the occurrence of sickness to justify moving to the more exciting city of Barcelona. In all likelihood, his interest in the new pictorial ideas of the French, indicated by the drawing of his sister Lola, was developed by Picasso thanks to his innate capacity to assimilate in an original manner any new idea that attracted or struck him, as well as from the time he spent in the openly pro-French environment of Els Quatre Gats. The logical consequence was his trip to Paris in October 1900 when one of his paintings that had hung in the cerveceria was accepted for exhibition at the Exposition Universelle. As a guest of the Modernist painter Isidre Nonell, he arrived in the city with his friend Casagemas. These were feverish months for the Spanish artist, and many new ideas in the field of painting came to him in the French capital, in particular from the canvases of the Impressionists and the Post-Impressionists. Among them, Toulouse-Lautrec, with his synthetic line and his expressive power, was the painter who most intrigued him: as a sort of homage, he painted the *Moulin de la Galette*. There are countless references and citations visible in this canvas to the Parisian painting of the preceding years, but he still managed to keep from slipping into the trap of imitation and developed his own style: he mutes and mingles the figures with light, so that they become silhouettes of colour. The brushstroke is in part hasty and rapid, and there is a greater attention to the volumes, which are rather like chromatic spots standing out against the dark background. *La Pierreuse* or the *Entratenida* are in the same style but they focus on the lay-

Ramon Casas
Idleness, 1898–1901
Oil on canvas, 64.5 x 54 cm
Barcelona, Museu Nacional d'Art de Catalunya

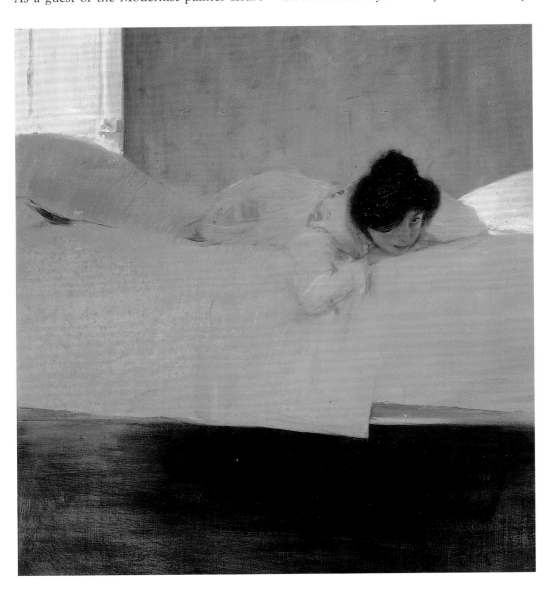

Antoni Gaudí
Detail of the Fountain
in the Parc Guell, 1903
Barcelona

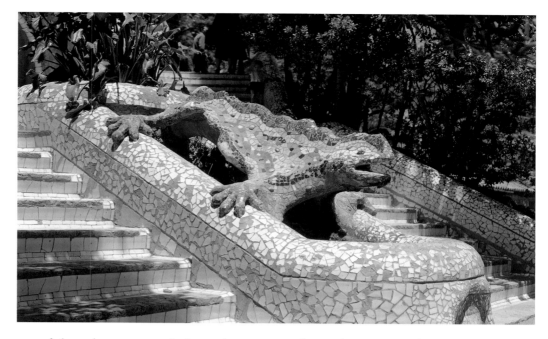

out of the volumes, engendering a determination to engage in spatial experimentation and leading the artist towards a new plastic deformation of the figures. His return to Spain (1900) led him to collaborate in Madrid with the writer Francisco de Asis de Soler on the magazine *Arte Joven*, promoting the works of young artists and writers and diffusing his own ideas about art in the Spanish milieu. The suicide of Casagemas in February 1901, due to a disappointment in love, led him to return to Paris in May of that year and take up residence in the studio his painter friend had occupied. Casagemas's violent death seems to have shaken him profoundly, and the months that followed were difficult for the artist. They were made even worse by his poverty, despite the interest of the collector Berthe Weill and the art dealer Ambroise Vollard, who in June of that year organised Picasso's first Parisian solo exhibition and who, over the nine years that followed, committed himself to the purchase of many of the artist's works. It was from that moment that the series of works known as the Blue Period began, but they were mainly painted in Barcelona, where he spent all of 1902 and 1903, with the exception of a short stay in Paris with the poet Max Jacob. This crucial phase in Picasso's long and varied production was marked by the gradual domination in his paintings of a blue monochromy in various hues and nuances, in clear contrast with the powerful polychromy of his previous style. The subjects too became uniform, representing the tragedy of human misery—prostitutes, beggars, cripples—which was also present in his previous period, but on this occasion he stripped it of its Impressionist links to

reality and nature in order to investigate solitude and human misery. These, of course, have a precedent in realistic painting, but for Picasso they became a subjective path that led to powerful pictorial innovations and the creation of his own interior symbolic dimension. Certainly, Casagemas's violent death helps to explain in part this state of mind, but the milieu of Barcelona—where the anarchistic theories of Bakunin, the existential ideas of Nietzsche and the introspective literature of Dostoevsky were present—played a decisive role. The choice of the colour blue and of a style of painting with strong chiaroscuro, verging on the nocturnal, was suggested by Picasso's acquaintance with Isidre Nonell. Nonell's art was socio-critical, but since childhood Picasso had been attracted by an interior solitude, individual isolation, and a silent, contained, everyday grief. The *Self-Portrait* (1901) clearly exemplifies this creative transition: the echoes of Gauguin and Van Gogh are mediated and tempered by the monumentality of the 'smooth' and detailed figure, and a sense of drama is conferred by the use of various shades of blue. The works of this period have continual variations, but they always tend towards a chromatic purification and a compositional stylisation, alternating with the use of brushstrokes that are at times ample and volumetric, at other times nervous, destructured, and episodic. *Evocation (The Burial of Casagemas)* and *La Vida* (Life) represent the culmination of this phase: both were highly complex works in their symbolic 'deciphering' and certainly works that were still intentionally 'open' in terms of comprehension and interpretation. Certainly, if on the one hand they represent the

Pablo Picasso
Woman in Blue, 1901
Oil on canvas, 133 x 101 cm
Madrid, Museo Nacional Centro
de Arte Reina Sofía

two stylistic tendencies adopted by Picasso in this period—with the more indefinite and episodic brushstroke of *Evocation*, and the clearer and more homogeneous brushstroke of *Life*—they also share many elements in common. Most important are the theme of his friend's suicide, complex symbolism, and the theme of sacred and profane love expressed by the characters portrayed, in particular by the female adamitic nudes that are present in both canvases. But what is often not emphasised in these works is the powerful link that they show with his artistic education in Spain as a youth; the composition of the *Evocation* borrows from the works of El Greco: the posture of Casagemas, a sort of saint indicating the mother in *Life*, reveals Picasso's studies of old painting in his years at the Academy and his visits to museums, the tomb of the *Evocation* is reminiscent of classical ruins, and the nude crouching figures depicted in the background of *Life* are evocative of a sort of archaic bas-relief. But though it is all brought up to date in stylistic terms and it all refers to present-day events in the life of the artist, the symbolism is eternal, that of life and death. In their individuality, the two works, and others of this productive period, represent the artist's tendency to transcend the individual autonomy of the work, making an effort to establish a general and shared line of development for all his artistic creation.

One of the last works of the Blue Period was *Celestina*, a further reference to the Spanish cultural context, and in particular, to the cunning and malevolent character in the Renaissance tragicomedy of that name by Fernando de Rojas. Picasso's allusion to this character was a pretext for updating a portrait of a Spanish *maîtresse*, who, despite being partly blind, had a profoundly greedy gaze. This is once again a reference to the desolation of the human characters in the Blue Period and reminiscent of the picaresque culture of the literary figures Miguel de Cervantes and Francisco de Quevedo, a legitimate citation for the artist of a world that he had certainly observed in French cafés or at the Moulin de la Galette, but which had already made a profound impression upon him during the time of Els Quatre Gats. In spring 1904, Pablo Picasso set off once again for Paris and rented an apartment in the studio-building of the Bateau-Lavoir. It was the end of the Blue Period, and in the summer he completed his final projects, but the artist already felt the need to express himself in a new creative phase, stimulated by the fruitful encounters in his new environment.

Picasso's departure for Paris marked the advent of a new historic and artistic phase for Barcelona; gradually Modernist ideas made way for the nationalistic-cultural ideology of the Noucentisme: under the pseudonym of Xènius, in 1906 Eugeni d'Ors published his *Gloses*, a sort of philosophical essay in which he set out the foundations of a new movement. The publication called for the foundation of an art based on a cultural background that found its models in the recovery of the Greco-Latin style. The return to the classics was an intentional reference to the legitimisation of the political autonomy of Catalonia, which thus found in the arts an expression of its distinct identity and a voice in the European landscape. The movement had a clear connection with the political activity of the Lliga Regionalista Catalana. D'Ors was a fervent supporter of the Lliga, and in the *Gloses* he outlined a series of terms that became the foundation of the movement: *Imperialisme, Arbitrarietat, Voluntat, Civilitat,* and especially *Mediterraneisme*. All of these definitions, in D'Ors's view, could be summarised in the word *Noucentisme*. Although the first three terms had openly political connotations, it was the last one that was fiercely debated, precisely because of its theorising of a cultural paradigm, which, upon the foundation of its 'classical' roots, proposed an urban model of a Greco-Roman state and a strongly idealised rural archetype. Quite soon differences arose on this point, and in 1911 Josep Maria Junoy took his distance from this conception and, in close conjunction with the poet Joan Maragall, supported the idea of a 'pan-Latinism' that linked all Mediterranean culture in virtue of an international spirit and the aspiration for a dialogue and confrontation with European culture, in particular with the French avant-garde. In this lively debate, many artists abandoned their Modernist beliefs and converted to the different nuances of *Noucentisme*, among them the young Joan Miró.

Closely tied to the rural tradition since he was a child, one with which he came into regular contact in his long childhood stays in his grandparents' houses in Cornudella and Mallorca, Joan could not help but be attracted to the concept of *Mediterraneisme*, but his vision, distant from the political views of D'Ors, was closer to the lyrical approach of Junoy. For Miró, as for Junoy, *Mediterraneisme* was a shared cultural heritage of the Latin nations, it was an aesthetic and linguistic model, but it was also a very strong tie that linked the Catalonian peasant to his land, a subject that he did not fail to depict repeatedly, distant from any Arcadian idealism and rich in

Pablo Picasso
Evocation (The Funeral of Casagemas),
1901
Oil on canvas, 150 x 90 cm
Paris, Musée d'Art Moderne
de la Ville de Paris

Opposite
Pablo Picasso
La Vida (Life), 1903
Oil on canvas, 197 x 127 cm
The Cleveland Museum of Art

poetic lyricism. In contrast with the wishes of his father, who wanted him to become a merchant, the nineteen-year-old Miró succeeded in persuading his family to accept his artistic vocation and enrolled in 1912 in Francisco Galí's 'progressive' School of Art. This marked a decisive turning point in his education, following the disappointing experiences of the Academy of Llotja. The school offered an innovative curriculum with a considerable degree of interdisciplinary linkage that pushed the students to consider new foreign artistic movements, and sent them on field trips to other cities and to see important exhibitions. While attending it, Joan met Enric Cristófol Ricart, with whom he enjoyed an important friendship and professional alliance, and his acquaintanceship with many other young Catalonian artists led to the foundation in 1918 of the Agrupació Courbet. That same year, Miró visited the exhibition of Cubist art at the Dalmau gallery, where works were exhibited by Agero, Gleizes, Metzinger, Gris, Le Fauconnier, Léger, and—for the first time—the famous *Nude Descending a Staircase* by Duchamp. For the young Catalonian painter, the meeting with the gallery-owner and art dealer Josep Dalmau proved very important, since they drew him into the Parisian avant-gardist debate. The gallery's exhibitions, which opened in 1907, brought together, along with other exhibition spaces that opened in

Barcelona in the same years, the weight of the cultural heritage of Els Quatre Gats in the promotion and introduction of new European and local artistic developments. In particular, the Dalmau gallery played a fundamental role in connecting Barcelona with Paris, and during World War I, thanks to Spanish neutrality, it became a refuge for various Parisian artists, including Picabia and the Gleizes. The works exhibited by Josep Dalmau, who introduced to Catalonia the new ideas of the Cubists, helped to launch a heated debate that was exacerbated in 1917 by the Exposition d'Art Français. With the exception of a work by Matisse the show featured relatively new paintings, but was striking for the total absence of the Cubists; this indicated a certain indifference towards avant-garde groups on the part of cultural clubs and the 'Noucentistes', and in particular of D'Ors. What were accepted and preferred, instead, were the 'proto-Cubist' pieces by Cézanne, whose landscapes were the model for the leading Noucentiste painter, Joaquim Sunyer, or for the classical-style painting of Joaquín Torres-García. Miró, on the other hand, was strongly attracted to Cubism, the Fauves, the Expressionists, as well of course as Cézanne. The painting *Red Flower Vase* translated these powerful influences which led him to mediate his first decidedly more Expressionistic paintings and to restrict his powerful colourism into more rigid and composed structures. This work, with *Prades: the Village* and, especially, *The Portrait of V. Nubiola* and the *Self-Portrait*, betray the influences of the Cubo-Futurists, which he certainly assimilated during the time he spent with the painter Rafael Baradas, a proponent of *Vibracionismo*, but even more so from his friend Ricart, who had spent time in Italy and had enthusiastically frequented the Futurists, especially the Florentine circle of *Lacerba*. But in Barcelona during the war years there was no shortage of further stimuli, and many magazines emerged, offering forums for artistic debate and exchange: propaganda in favour of the avant-gardes published in the now-famous *Revista Nova*, the pro-French, anti-German debate represented by the magazine *Norte-Sur*, the new Cubo-Dadaist innovations publicised by *391*, a new publication by Picabia who was living in Barcelona in this period, and finally the brief but significant presence of Picasso in 1917 for the execution of *Parade* and the drawings for Diaghilev's Ballets Russes. In February 1918 Miró held his first solo exhibition at the Dalmau gallery, but this was received with discouragingly negative reviews and suffered

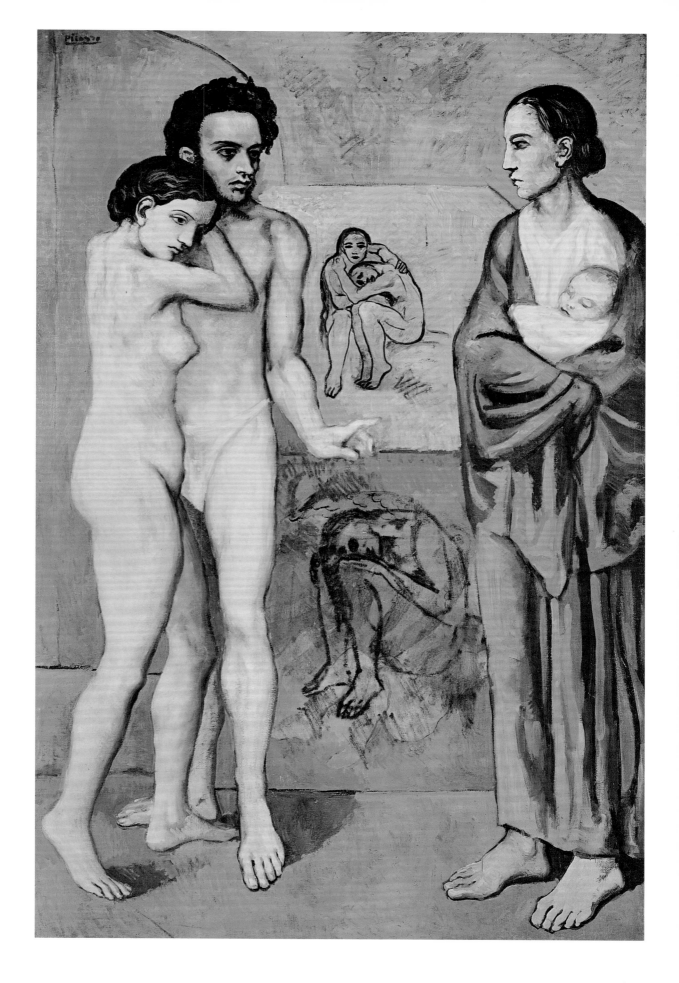

Pablo Picasso
Acrobat on a Ball, 1905 (detail)
Oil on canvas, 147 x 95 cm
Moscow, Pushkin Museum of Fine
Arts

Opposite
Pablo Picasso
Celestina, 1904
Oil on canvas, 81 x 60 cm
Paris, Musée National Picasso

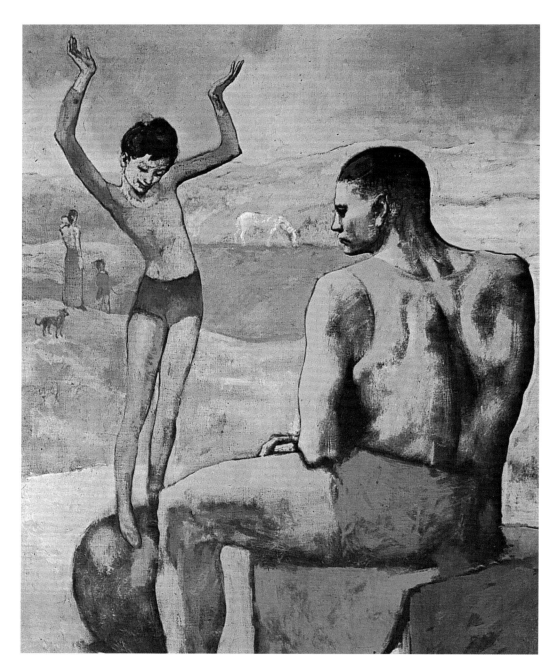

bad sales. Meanwhile the 'Cubist-Futurist-Expressionist' synthesis of the artist's work found no room within the context of the pro-French debate, which was increasingly riven between 'Mediterraneist' purism and 'Cubo-Futurist' tendencies. But that same year Miró executed two fundamentally important works: *The Garden with Donkey* (1918) and *The Palm House,* showing a considerable stylistic transition. Though the rural theme of his homeland remained a point of reference, his painting had evolved: it became simpler and stylised, and the line took on greater importance, reordering the colours and becoming functional to the draughtsmanship. He depicted Nature through details and stylised—almost calligraphic—lines, turning subjects into symbols and representing the landscape by means of pictorial archetypes: for Miró, these developments were the evident characteristics of a transition from a pictorial to a poetic approach. The attainment of this turning point, with its astonishing results, came with the canvas *Montroig: Village & Church* in which the depiction of the country setting reveals a scientific attention, bordering on the maniacal, a sort of poetic universe and a unique evocation of the demiurgic conceptions of Gaudí, whom the young Miró had greatly admired. With the exception of the occasional joint exhibition with the Agrupació Courbet, the Catalonian artist felt increasingly remote from the political platforms of Noucentisme, and in March 1920 he prepared to leave for Paris with Ricart.

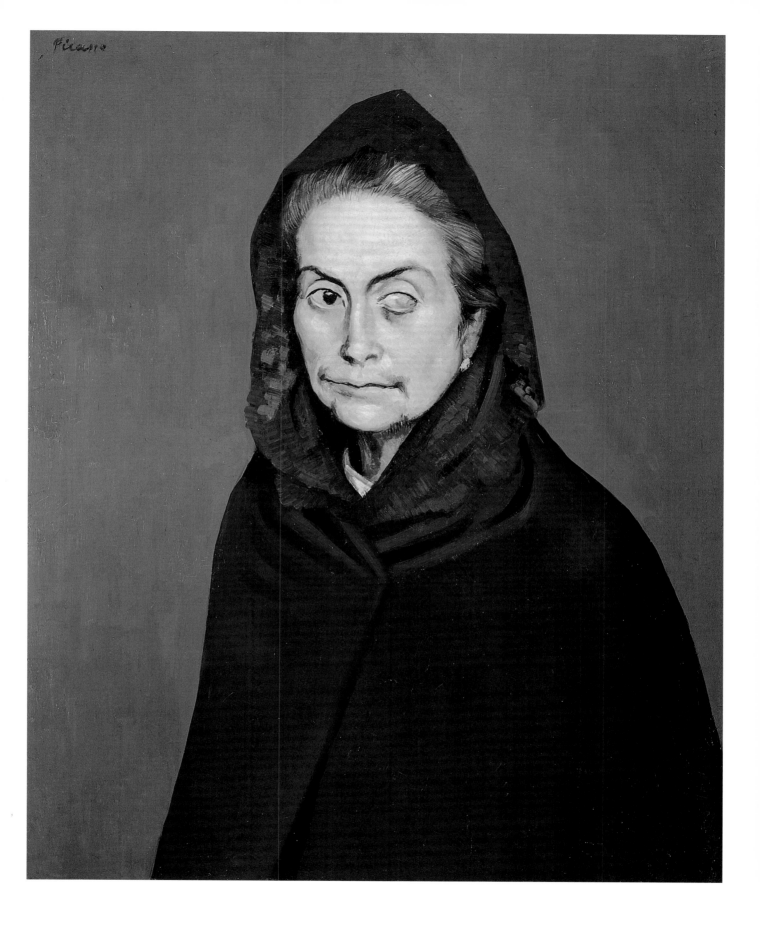

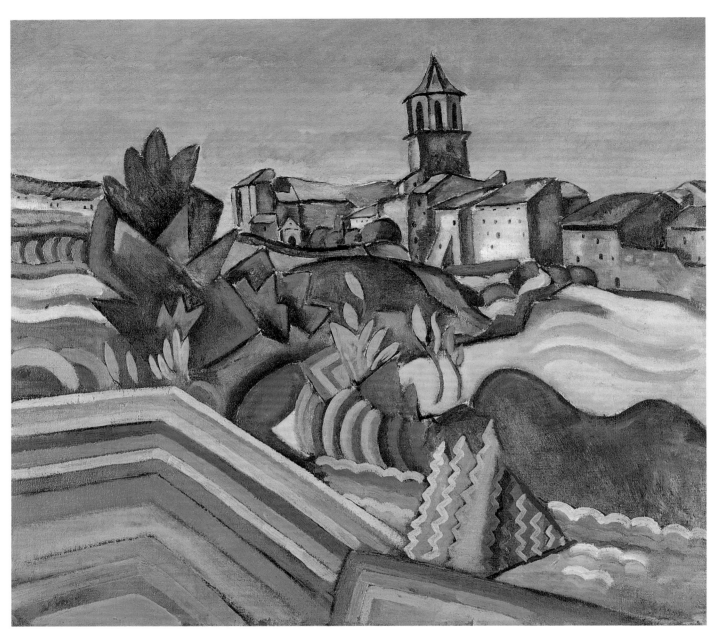

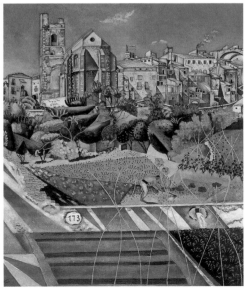

Joan Miró
Mont-roig: Village & Church, 1919
Oil on canvas, 73 x 61 cm
Palma de Majorca, Dolores Miró
de Punyet Collection

Joan Miró
Prades: the Village, 1917
Oil on canvas, 65 x 72 cm
New York, The Solomon
R. Guggenheim Museum

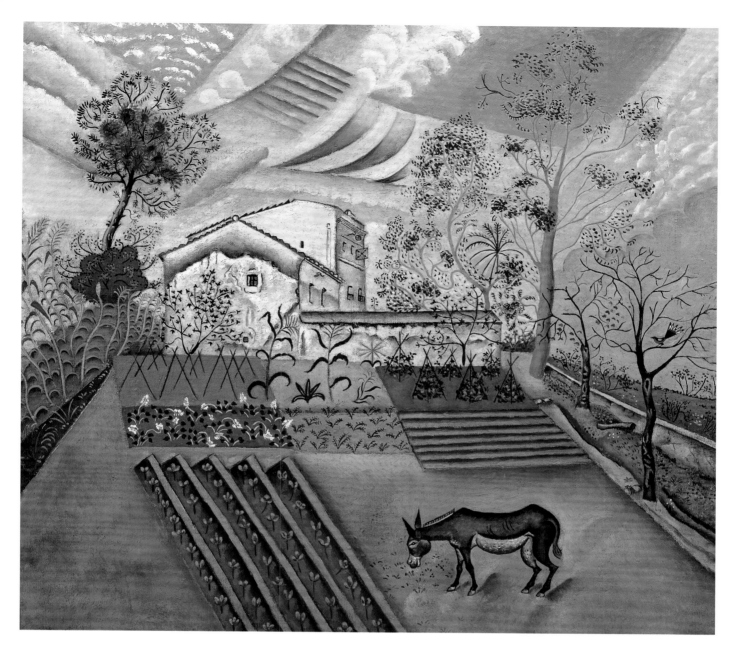

Joan Miró
The Garden with Donkey, 1918
Oil on canvas, 64 x 70 cm
Stockholm, Moderna Museet

Russia

In the first decade of the century, the new artistic developments that were most innovative and capable of generating significant progress were of Symbolist origin. The foundation for this late nineteenth-century development was the work of such painters as Mikhail Vrubel, Valentin Serov and Konstantin Korovin, all of whom were interested in depicting mythological and allegorical subjects in a metaphorical visual language that was perfectly in line with international trends. Vrubel, in particular, who can be considered the founder of the Russian Symbolist schools, brought together a traditional academic education, his knowledge of the Venetian Renaissance, and the new ideas derived from French figurative culture that he had experienced during a number of trips between 1876 and 1894. What emerged was an unprecedented style, also influenced by Byzantine art and icons and his own openly esoteric interests. Vbrubel also showed interest in set design and the applied arts, linking part of his activity to that of the art colony of Abramtsevo, which had been founded by a Russian patron of the arts and endowed with workshops and residences for the artists.

Out of this shared Symbolist origin—which coexisted with such other trends as Impressionism and painting *en plein air*, on the one hand, and academicism and realism, on the other—there developed, in the new century, a wide array of artistic experiences, marked by the formation of groups and movements, such as the foundation of magazines and the organisation of art exhibitions. These were often conceived as 'total artworks' in obedience to concepts from the nineteenth-century tradition developed by all of European Modernism. Vrubel—whose old age was marked by blindness and mental illness—belonged to an association of Symbolist inspiration founded in St Petersburg in 1898 called The World of Art (Mir Iskusstva). Guided by the Franco-Russian painter and set designer Aleksandr Benois and by the future director of the Ballets Russes, Sergei Diaghilev, in 1899 the group first published its own periodical, also called *The World of Art*, that dealt with artistic and literary subjects. The first issue called for a vigorous rebirth of Russian art, rejecting both the slavish imitation of foreign models and allegiance to a narrow nationalism. From a stylistic point of

Mikhail Vrubel
Swan Princess, 1900
Oil on canvas, 143 x 94 cm
Moscow, Tretyakov Gallery

Opposite
Mikhail Vrubel
The Pearl Oyster, 1904
Pastel and gouache on cardboard,
40 x 60 cm
Moscow, Tretyakov Gallery

The Exhibition of Russian Art in Paris (1906)

Valentin Serov
Portrait of Ida Rubinstein, 1910
Tempera and pastels on canvas,
54 x 71 cm
St Petersburg, The State Russian
Museum

Opposite
Léon Bakst
Portrait of Diaghilev and His Old Nurse,
1905
Oil on canvas, 120 x 80 cm
St Petersburg, The State Russian
Museum

Known above all as the director of the famous Ballets Russes, formed in 1909, Sergei Diaghilev (1872–1929) was one of the leading cultural lights in Russia in the late nineteenth and early twentieth centuries. He arrived in St Petersburg in 1890 to study law and soon joined a circle of musicians, writers and artists that then made up the initial core of the magazine *Mir Iskusstva* (The World of Art). The curator of exhibitions and author of monographic studies devoted to Russian painters, he was also assistant director of the Imperial Theatres and in 1905 organised a major exhibition of Russian historical portraits in St Petersburg.

In 1906 he took Russian art to Paris when he arranged an exhibition of his compatriots' work at the Salon d'Automne. Already in 1898 certain painters, such as Korovin, Serov and Bakst, had exhibited in Germany with his assistance, but the Paris show was grandiose and—as the newspapers wrote at the time—was the most important and representative exhibition of Russian art of the decade. Diaghilev selected works of painting and sculpture from the previous two centuries but gave particular attention to more recent ones; he also included a section for icons in homage to the figurative tradition of his country. The number of works came to over 750 and were arranged in the thirteen rooms of the Grand Palais; of these, six were devoted to contemporary painters, among whom Korovin, Serov, Bakst, Larionov and Jawlensky. The staging of the exhibition, which was mainly directed by Bakst, required every room to be furnished with printed fabrics of different colours and decorated with wooden friezes at the top; the sculptures were located in a grove. The exhibition met with great success and among the most appreciated artists was Vrubel. Diaghilev's intentions, which he pursued with fervour throughout his career, are explained well in his own words: 'It is as if [Russian artists] are ashamed to submit themselves to the judgement of Europe and only want to show that they too can paint like Western Europeans. And it never occurred to them to wonder if we are capable of teaching the Europeans what they do not yet know. Can we add a new facet to European art?'

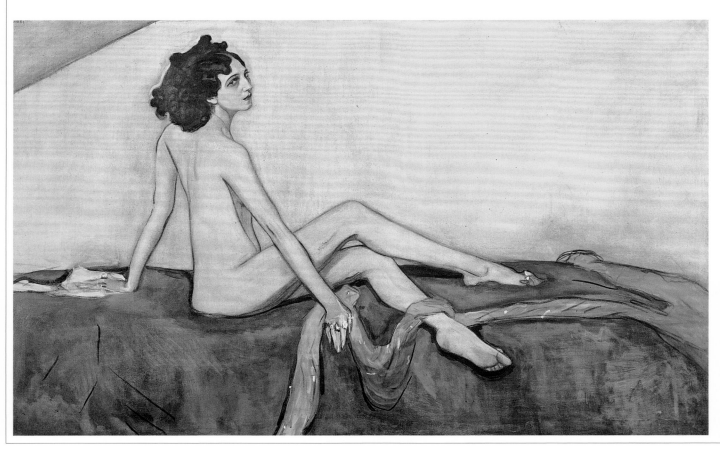

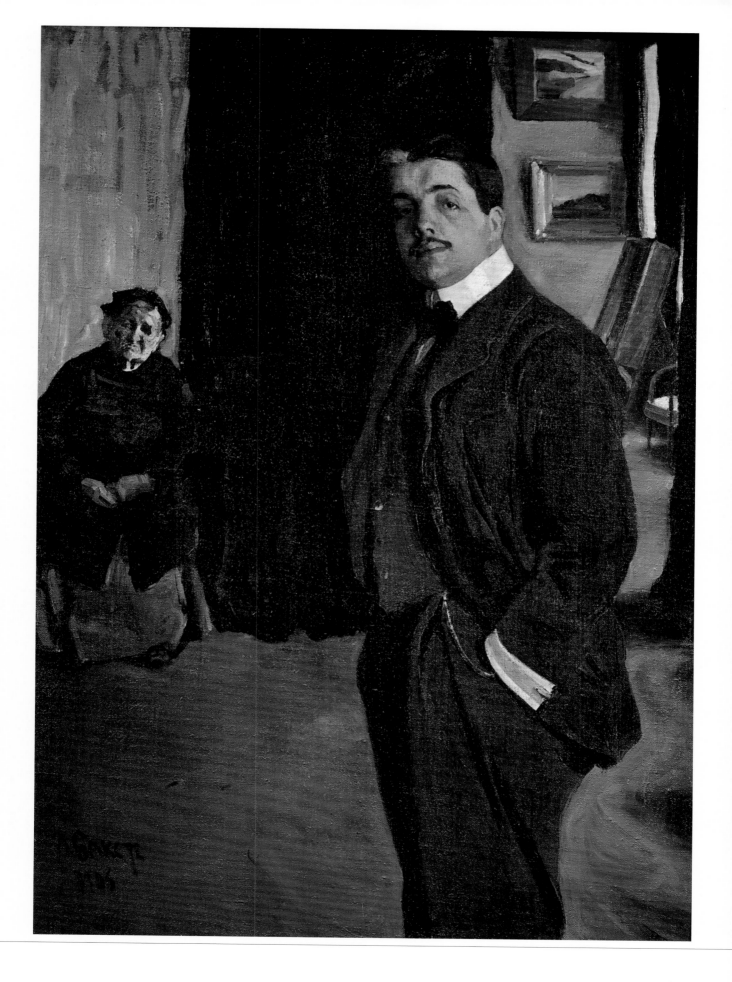

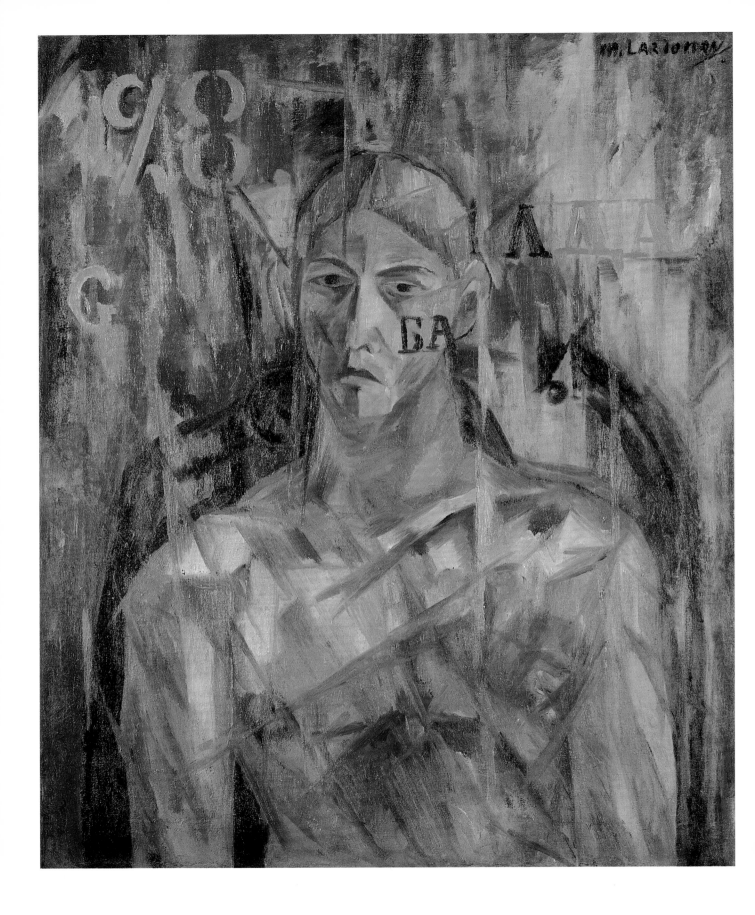

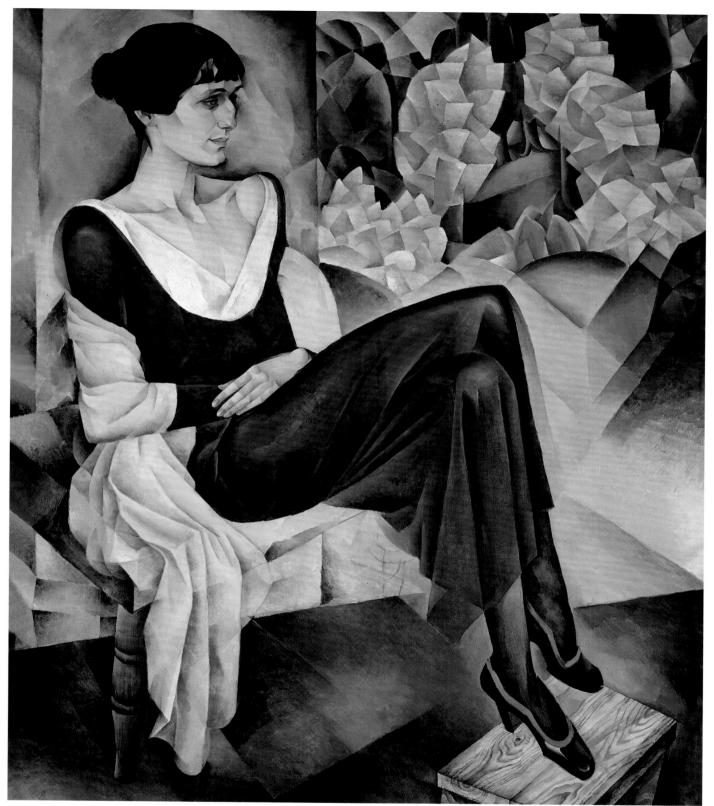

Mikhail Larionov
Portrait of Vladimir Tatlin, 1913
Oil on canvas, 89 x 72 cm
Paris, Musée National d'Art Moderne,
Centre Georges Pompidou

Nathan Altman
Portrait of Anna Akhmatova, 1914
Oil on canvas, 120 x 100 cm
St Petersburg, The State Russian
Museum

view, the group's activity was not exactly consistent, even though certain shared traits can be singled out, such as a sensibility for elegance, a sense of decoration, and an interest in the motifs and themes of European Post-Impressionism and Symbolism. Among the personalities of greatest importance was the painter Léon Bakst, whose works were endowed with a lively taste for colour and a great sense of rhythm; in the years that followed he became a set- and costume-designer for Diaghilev's Ballets Russes, thus incarnating that spirit of a 'unity of the arts' that had been part of the programmatic intent of The World of Art.

At the first international exhibition held by the association (and designed by Diaghilev) in 1899, more than three hundred artworks from nine different countries were displayed in St Petersburg: a prominent role was played by France, with Degas, Moreau and Puvis de Chavannes, while other European Symbolists were Bocklin and Whistler. Subsequent editions of the exhibition, however, featured only Russian artists, with significant presences from St Petersburg but also from Moscow (for instance, Korovin and Nesterov). In 1903, some of the artists in the association gave origin to a new group, the Union of Russian Artists (Soyuz Russkikh Khudozhnikov), which was active in Moscow until 1923 but also included artists from St Petersburg. The Union of Russian Artists set out from the same goals of reform and freedom of art from academic conventions, but pursued them from different aesthetic viewpoints: suffice it in this connection to make clear that many of the members (including Korovin) also participated in the activities of a group that was fiercely opposed by the World of Art, that of the so-called Wandering, or Travelling Painters (Peredvizhniki).

The Association of Travelling Art Exhibitions (which gave its name to the 'wandering' or 'travelling' artists) was founded in 1870 and continued its activity until 1923; it was created to oppose the traditional style encouraged by the Academy of St Petersburg and the system of genres that was accepted within the academy. The group hoped to bring art to the Russian people by organising exhibitions throughout the country. Its mem-

Mikhail Larionov
Still Life with Pears, Flowers and Cactus, 1906–07
Oil on canvas, 150 x 147 cm
Paris, Musée National d'Art Moderne, Centre Georges Pompidou

Paul Cézanne
*Still Life with Sugar Bowl, Carafe
and Dish with Fruit*, circa 1890
Oil on canvas, 61 x 90 cm
Moscow, Pushkin Museum
of Fine Arts

bers, who often sympathised with the progressive, populist and nationalist theories of Mikhail Bakunin, employed in their art a visual language of realist origin, dedicating themselves initially to themes of social protest, but later retrenching to historical topics, as is seen in the frequent illustrations of traditional Russian folk tales and legends. A leading figure in the group was Ilya Repin, who later became a professor and then the rector of the Academy of St Petersburg; beginning in 1932 the Peredvizhniki were officially recognised as the predecessors of Soviet Realism, which proved to be very close to their school of painting, both in style and in the choice of topics.

Within the Union of Russian Artists there was a wide array of visual languages, ranging from lyrical landscape painting to Impressionism, from the experimental art of Vrubel's late stage to the Symbolism of Viktor Borisov-Musatov, who was also an exhibitor at the show that in 1906 concluded (though only temporarily) the activities of The World of Art. Publication of the magazine had already ceased, and even though new artists had joined the association, including Mikhail Larionov and Alexei Jawlensky, the original power and unity were long gone. In 1910, under Benois's guidance, The World of Art resumed holding exhibitions and continued until 1924, organising a total of 21 shows in various Russian cities, featuring works by long-time members but also opening up to new directions in Russian art, even post-revolutionary Russian art.

Back in 1905 in Moscow, the very wealthy patron of the arts Nikolai Ryabushinsky had founded a monthly literary journal entitled *The Golden Fleece* (Zolotoye Runo), which had—at least in its first two years of existence—a markedly Symbolist approach. With exceedingly sophisticated graphics and sumptuous illustrations, the magazine reflected the personality of its founder, an extravagant dandy who loved excess (his house is a masterpiece of the Russian interpretation of Art Nouveau); among the contributors were Symbolist poets, artists of The World of Art, and members of another association of painters, Golubaya Roza ('Blue Rose'), founded in Moscow in 1907 and led by the painter Pavel Kuznetsov. The activity of this association, which ended in 1908, began with the organisation of the art exhibition of the same name—The Blue Rose—which was chosen for its evocative power and as homage to the imaginary flowers that Odilon Redon put in his paintings. The

rooms of the exhibition were decorated with flowers and housed over one hundred artworks. The style of the painters who took part was marked by the use of delicate pastel colours and a predilection for rarefied images, which often depicted dreams and visions with melancholy overtones and populated by twisted figures with hazy outlines. The group never drew up a manifesto or even a charter. The point of reference for the artists of the Blue Rose was Vrubel's art and, especially, that of Viktor Borisov-Musatov, who was a sort of founder and forefather for them.

A fundamental problem facing Russian art in the early twentieth century was that of the relationship between national culture (the origins of which were being rediscovered, along with traditional and popular manifestations) and the European culture of the art avant-gardes. This hybrid was evident in the activity of The World of Art and especially in the work of its leader Diaghilev, who exhibited in the shows, alongside Russian handcrafted pieces by Lalique, Tiffany and Gallé. This led to the first blooms of the 'Neo-Primitivist' school that would develop in the coming decade under the leadership of such personalities as Natalia Goncharova and Mikhail Larionov. It was under the influence of these painters that around 1908 *The Golden Fleece* began to move in a new direction away from Symbolism, to open up further to the latest developments in French art, and to encourage young Russian artists to try new things. The magazine began to publish translations of foreign texts, such as a selection of letters by Van Gogh or Matisse's *Notes of a Painter*, to both of whom special issues were devoted. Rodin and Maurice Denis, among others, were asked to help produce issues. In 1908, at the first exhibition held by the magazine, there were over two hundred artworks, including canvases by Van Gogh, Gauguin, Cézanne, the Neo-Impressionists and Les Nabis. A second exhibition, in 1909, also included the Nabis, alongside a large presence of young Russians, in particular Larionov and Goncharova, who in this phase had already abandoned the Neo-Impressionist style to move closer to the figurative approach of the Fauves. The activity of *The Golden Fleece* came to an end in 1910 due to financial problems; in that same year it held its last salon, which was dedicated entirely to new Russian painting, with works by Goncharova, Larionov, Martyros Saryan (formerly a member of the Blue Rose), Pyotr Konchalovsky and Ilya Mashkov.

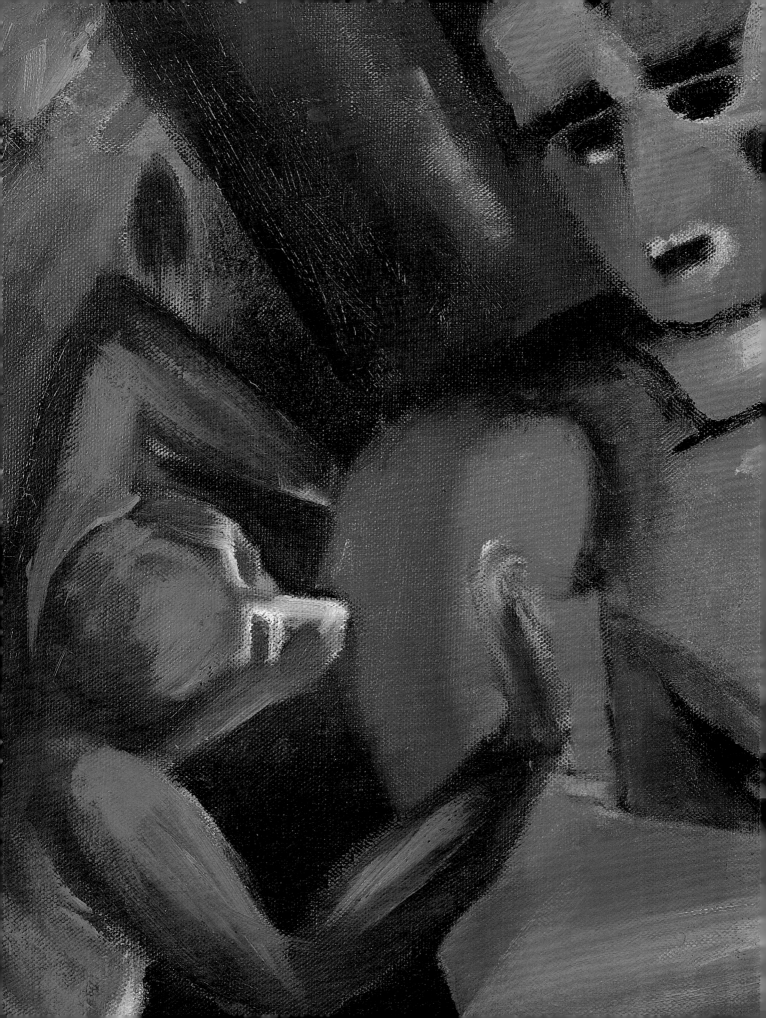

The Rigorous and Geometrical Line of Modernist Culture

Munich

Ready to receive cultural stimuli from outside, Munich was influenced by such lively counterparts as Paris, for example, in the field of satire. In the years around the turn of the century, magazines were founded that have taken their rightful place in the literary, political and artistic history of the time. After his Parisian sojourn in 1893, the publisher Albert Langen chose Munich as a place to live with the intent of spreading German culture in France. He moved to the Bavarian capital in 1895 and one year later founded the magazine *Simplicissimus* (the first issue was dated 4 April), modelled on the French magazines *Gil Blas* and *Le Rire*. From 1907 on, Langen was the editor of the magazine *März*, whose firm objective was to support liberal and progressive ideas and facilitate and encourage cultural exchange between France and Germany. Around 1900, other magazines were born that helped to cement Munich's standing as a large modern city, such as *Süddeutscher Postillon*, *Kunst und Handwerk* and *Decorative Kunst*.

In some of these magazines, a central role was played by the writer and poet Otto Julius Bierbaum, founder of the magazines *Pan* and *Die Insel* and a protagonist in the creation of German cabaret. Another magazine was *Die Gesellschaft* (first published in 1885), which provided a forum for a certain acceptation of modernity typical of Munich. The location that was taken as a symbol of this modernity was Schwabing, the cradle of Munich's Bohemian life and the home of the group known as the Cosmic Ones. The group and its name were inspired by the Dionysian and 'cosmic' approach to life argued by Nietzsche, and by a vision of the world that offered an alternative to the contemporary authoritarian and 'bourgeois' view.

The name *Jugendstil* came from the Munich magazine *Jugend*, which was devoted primarily to the art of the book and illustration. Jugendstil had connotations that were both international and powerfully rooted to the territory, much like the Secession. Inspired by the world of the applied arts, a new trend, which ran parallel with the development of Art Nouveau in France and the Arts and Crafts movement in the United Kingdom, took root in the 1890s. Supported by the magazines mentioned above—with an eye on the Symbolist trends established through other magazines, such as the French *Revue Blanche*, the vehicle of the Nabi group that included the artists Bonnard, Vuillard, Sérusier and Denis—Jugendstil developed as a new and up-to-date style, unprecedented and without any other models of reference, in open contrast with styles of historical derivation. It was characterised by ornamentation, lines, eclecticism and decoration, and by a spare and essential line that often originated from floral motifs.

Franz von Stuck—painter, architect, sculptor, decorative artist and illustrator—represented particularly well the cultural excitement and eclecticism of Munich at the turn of the century. Appointed royal professor and director of the Academy of Figurative Arts in Munich in 1895 at the age of just thirty-two, Franz von Stuck had already distinguished himself by his contribution to the birth of the Secession itself, as he had been one of its founders in 1892. Considered 'the painter with golden frames', because of the magnificence of the frames in which his paintings were set, Von Stuck was a great innovator. The ornamental approach of his paintings was nicely tempered by the eroticism and scandal associated with the subjects he chose (consider *Sin*, 1895, or *Salome*, or *The Guardian of Paradise*, 1889) and by a technique that was new for the period. On one hand this drew upon Impressionism and *plein air* painting—though he used this technique on studio subjects—and on the other it foreshadowed the Expressionist tones of the turn of the century.

Von Stuck was appointed to the Academy, where his teaching between 1895 and 1928 coincided with the birth of private art schools. From the 1890s and through the entire first part of the century, right up until the approval of the new statute of the Academy in 1911, artists like Kandinsky, Jawlensky, Werefkin and Klee enrolled in or taught courses in these schools. A great many of these artists, however, were those who aspired to become pupils in Franz von

Franz Marc
Man and Monkey, 1912 (detail)
Oil on canvas, 52.5 x 35.5 cm
Munich, Stadtische Galerie
im Lenbachhaus

Arnold Böcklin
Centaur Looking at Fish, 1878
Oil on canvas, 43 x 70 cm
Zurich, Kunsthaus

Stuck's school of painting, including Kandinsky (for just one year), Klee, and, later, Josef Albers.

Von Stuck deserves credit, with Henrick von Zügel, for allowing the Munich Secession to reach the highest levels of the Academy, in a situation that was as paradoxical as it was significant in relation to the art of Bismarck's Germany. A Secessionist rebel elevated to the status of professor in the Royal Academy, he became a symbol of a paradigmatic situation, a reflection of the vitality and the cultural and artistic debate of *fin-de-siècle* Munich, which was steeped in Symbolism and influenced by the theories of Nietzsche. In fact, the artist served as a link between the official painting of portraits and military and historical subjects by such artists as Anton von Werner and Ferdinand von Piloty, the idealist Romanticism of the painting of Böcklin and Von Lenbach, and the principles that inspired the Secession and the Jugendstil.

One heir to a painting with spiritual content Böcklin's was the Italian painter Giorgio de Chirico, the father of Metaphysics, who spent four years in Munich from 1906 to 1910. Even though De Chirico's interest in Böcklin and Klinger is understated in his Parisian autobiographical manuscripts (1912), this influence is easy to identify in his early works, as well as being openly avowed in his *Memoirs*. An admirer of the spiritual values of Romantic Germany, De Chirico attributed German decadence to the advent of the Secession and modern painting. One meeting point of those events was identified specifically in the city of Mu-

nich. His discovery of Böcklin and his art took place in the studio of the musician Max Reger, music teacher to De Chirico's brother, Alberto Savinio. Giorgio de Chirico was accompanying his brother in the role of translator, and, during his leisure moments, he had an opportunity to leaf through the many books of etchings by the Basel-born artist, of whom Reger was a great admirer.

Corresponding to the very years in which De Chirico lived in the Bavarian capital, 1906–09, a debate ensued on the subject of Böcklin, who was in progressive decline following the ferocious critical attack made on him by the articles of Julius Meier-Graefe.

Despite this, De Chirico's first paintings in Munich should be considered as belonging to a style still linked to the masters of the Academy, especially Carl von Marr, his teacher from the second half of 1907, a talented painter of monumental and decorative works, from whom De Chirico assimilated a taste for pronounced outlines in his figures.

Another element of interest in the young painter's brief German stay was without doubt the Neoclassical architecture of certain buildings from the early nineteenth century in Munich and other German cities visited by the two brothers, as well as the vitality and the new ideas emerging in the theatrical world on the city's stages: new techniques for set design, artifices of production and spatial presentation in the theories and performances by Appa, Craig and Georg Fuchs (see his book *The Scenography of the Future*, published in Munich in 1905).

Giorgio de Chirico
Siren and Triton, 1908–09
Oil on canvas, 86.5 x 141 cm
Private collection

His first paintings that reveal the influence of Böcklin can be dated to winter 1908–09, where we find a taste for the depiction of the supernatural mixed with everyday elements filtered through the German Romantic art of the nineteenth century. Sea monsters, half-human giants, mermaids, Promethean figures and mythological creatures in such paintings as *Siren and Triton*, *Prometheus* and *Sphinx* (all dating 1908–09) took direct inspiration from works by Böcklin.

De Chirico's Munich years correspond to the period in which Munich had already witnessed a succession of exhibitions by the masters of French art, and a number of paintings by Cézanne were the subject of an exhibition in the context of the Munich Secession in March 1909: many artists were already under the spell of an art that overwhelmed Symbolist tastes and pursuits, among them many friends of De Chirico. He then travelled to Venice to see the Biennale, definitively leaving Germany at the same time.

In 1896 Vasily Kandinsky, at the age of thirty, decided to abandon an established career in the Law Faculty at the University of Dorpat and went to study art in Munich. Despite his distance from home, Kandinsky described the years between 1898 and 1921 as his 'Russian period', because of his frequent trips and unbroken link with his homeland, where he took part in the exhibitions by the Association of Southern Russian Artists and the Association of Muscovite Artists. Russian art critics, however, were not inclined to say anything positive about

their compatriot. At his first shows at the turn of the century, in the most favourable cases emphasis was laid on the influence of the Munich milieu and the art of Böcklin in terms of content, and the Bavarian arts of ceramics and glass painting in terms of style. In other cases, his artworks, and those of his Russian partners and colleagues working in Bavaria, were criticised for the excessive influence of the Jugendstil, the art of caricature and illustration then in vogue in Munich. Kandinsky studied in the German city for two years, from 1897 to 1899, at the school of the Slovenian painter and professor Anton Azbé. Azbé had other Russian pupils, including Alexei von Jawlensky and Marianne von Werefkin—who had also moved to Munich and who were bound by ties of friendship that were both difficult and productive—and André Grabar and Kardovsky.

After two years studying art with Anton Azbé, Kandinsky attempted unsuccessfully to enrol in the Kunstakademie (the Academy of Munich). He was accepted at his second attempt and thus entered Franz von Stuck's painting class in 1900; his teacher was considered at the time the most prestigious representative of the Munich Secession, as well as a renowned painter of canvases with historical, mythological and allegorical themes. Kandinsky attended Von Stuck's painting courses for a year at the same time that Paul Klee and Franz Marc also attended the Academy, though the three did not see one another socially (Marc and Kandinsky were not to meet, in fact, until a decade later).

Franz von Stuck
Scherzo, 1909
Oil on panel, 78 x 84 cm
Trieste, Civico Museo Revoltella,
Galleria d'Arte Moderna

Opposite
Giorgio de Chirico
Dying Centaur, 1909
Oil on canvas, 200 x 100 cm
Private collection

Marianne von Werefkin made an important contribution to the friendship, support, theorising and historic and artistic education of the group that a few years later would create the Blaue Reiter (Blue Rider). After years of inactivity, she began to paint again in 1906, acquiring in just a few months a capacity for evolution and originality truly without precedent. She became an important guide for the art of Alexei von Jawlensky and Gabriele Münter, especially in introducing the manner of the school of Pont-Aven into the painting styles of the two artists, who were still linked to Pointillism. In 1907 (the year in which Worringer wrote his fundamental *Abstraction and Empathy*) and 1908, the path to painting promulgated by Gauguin and his 'school' developed an incredible following in Munich. Sérusier, one of Gauguin's pupils, moved to the city in December 1907, and Jawlensky purchased a painting by Van Gogh in 1908. Jawlensky's stylistic transformation—in contrast with Kandinsky, he would never abandon figurative art, but within it he would go in search of the purity of forms and colours, seeking relief from flat surfaces

and the use of fundamental and complementary colours—was due in part to his encounter with the painting of the Nabis group and the chromatism of Vincent van Gogh.

Until 1906–07, Kandinsky's paintings, which were mostly small format landscapes, were marked by a style similar either to the Jugendstil, on the one hand, or Neo-Impressionism and Pointillism, on the other. These were the years in which he travelled with Gabriele Münter to many European tourist destinations: Paris, Venice, Berlin and Rapallo.

In the summer of 1909, Kandinsky and Münter were once again in their 'Russenhaus' (House of Russians, as their residence in Murnau was called). Here, even if the Impressionist style is still evident, the artist laid the foundation for a revolution in his artistic method. He concentrated increasingly upon a flattened perspective and division of the scenes into broad areas of colour. He also began to reproduce the graphic style of his woodcuts in oil colours. By simplifying and even obfuscating the forms of the local landscape into a sort of stenographic sign, he began to put into practice the ideas that he

Kandinsky's Early Activities in Munich

Vasily Kandinsky
Morocco, 1904 (detail)
Tempera on canvas, 67 x 99 cm
Private collection

Vasily Kandinsky
Russian Scene, 1904 (detail)
Tempera on canvas, 24 x 55 cm
Private collection

Gabriele Münter
Portrait of Marianne von Werefkin, 1906
Oil on canvas, 26 x 20 cm
Munich, Stadtische Galerie
im Lenbachhaus

In Munich in the spring of 1901, having left the academy and finished his brief period of apprenticeship, Kandinsky founded the Phalanx artistic association with the artists Rolf Niczky, Waldemar Hecker and Wilhelm Husgen. He became the president of the association and its attached school, where he taught from 1901 to 1903. With the goal of promoting the artists belonging to the group, as well as the art of the avant-garde of Munich, Germany and Europe, through shows and exhibitions or special courses, Phalanx organised exhibitions initially associated with Jugendstil, then, from 1903, representing contemporary European artistic trends, with particular attention to those centred in France. Exhibitions were held of such painters as Bonnard, Renoir, Van Gogh, Toulouse-Lautrec, Vuillard, Vallotton, Van Rysselberghe and Signac.

The group's first exhibition opened on 15 August 1903 and presented a number of paintings and studies by Kandinsky himself, as well as works by painters, sculptors and illustrators associated with Jugendstil. In all, Phalanx organised twelve exhibitions over a period of four years representing a truly heterogeneous group of artists. In 1902 Kandinsky came to know Gabriele Münter, a student of his in the association's courses, who became his fiancée and companion until 1914. Together they began an artistic association that became fundamental to the development of his art. The themes of Kandinsky's work in those early Munich years were designated as follows by the artist himself: 'small studies in oils' (landscapes and foreshortened views of the city); 'coloured drawings' (tempera paintings inspired by the past and above all by

the Middle Ages); 'paintings' (works on canvas); and 'etchings' (graphical works).

In addition to his relationship with Münter, his friendship with another Russian painter, Baroness Marianne von Werefkin, was also of great importance; at the beginning of his stay in Munich, this gave rise to an artistic community called 'St Lukas'. His apartment in Schwabing in Munich became a salon for the discussion of art and culture, almost an obligatory stopping point for the directors of museums (among those who attended were Hugo von Tschudi and Pauli), painters (Kandinsky and Münter, plus Franz Marc, Verkade, Erbslöh and many others), actresses (Eleonora Duse never failed to visit the Werefkin when she visited Munich), and choreographers, such as the famous Sergei Diaghilev, creator of the Ballets Russes.

August Macke
Woman Playing the Lute, 1910
Oil on canvas, 85 x 43 cm
Paris, Musée d'art moderne
de la ville de Paris

would soon publish in his volume, *Concerning the Spiritual in Art* (*Über das Geistige in der Kunst*), which he finished writing during the months in Murnau (1910–11).

Also in 1909 and following the experience of the Phalanx group, Kandinsky founded the Neue Künstlervereinigung Munchen (the NKVM, or New Association of Munich Artists) with the purpose of encouraging the burgeoning schools of art. Following Jawlensky's refusal to become president of the association, Kandinsky was nominated, partly due to his experience in law and associations (he had been president of the Phalanx group). The NKVM was officially founded on 22 January 1909 with members Kandinsky, Werefkin, Münter, Jawlensky, Adolf Erbslöh, Alexander Kanoldt, Alfred Kubin, Heinrich Schnabel and Oskar Wittgenstein. Other members were added over the years: Paul Baum, Wladimir Bechtejeff, Erma Barrera-Bossi, Carl Hofer, Moissey Kogan, Alexander Sacharoff, Pierre Girieud, Henri Le Fau-

connier, Franz Marc, the art historian Otto Fischer and many others.

Still in 1909, the first exhibition of the NKVM was held at the Tannhauser Moderne Galerie in Munich. The opening was scheduled for 1 December, and the invitation, poster and catalogue were all designed and written by Kandinsky. In an introduction to the activities of the new association, the artist makes clear reference to the importance of the 'interior world' and to the need for the 'liberation of forms', thus heralding one of the chief themes of the reflections that he was developing in the manuscript that was later published in 1912 under the title *Concerning the Spiritual in Art*.

Thus his theoretical work proceeded in conjunction with his artistic work. Fitting into this context were his *Letters from Munich*, written from 1909 for the St Petersburg magazine *Apollon*. This was founded by Sergei Makovsky and abounded in ideas and observations on the artistic life and other subjects in Munich during the years he lived there.

His *Letters from Munich* are also an important document for any understanding of the events surrounding the foundation of the New Association of Artists, as well as a fundamental cultural bridge between the two art capitals at the turn of the decade in the months in which he was creating his first *Improvisations*. The work of popularising European art, especially of French origin,

through an intense series of exhibitions continued in 1910, the year of the second NKVM exhibition, which was again held at the Galerie Tannhauser. The show also featured paintings by such artists as Derain, Braque, Van Dongen, Picasso and Rouault. Between 1910 and 1912, exhibitions featured masters of international avant-garde art, from the Fauves to the Cubists, alongside Oriental woodcuts, sculptures from Borneo, Bavarian painted glass, children's drawings, and votive folk art. The association declared that it chose not to establish ties with any school of art, but preferred to focus on trends and expressions that lay outside of the academic and 'official' circuit.

While Munich was the site of a succession of exhibitions of works by Van Gogh, Gauguin and Matisse, the painter Franz Marc was putting together a number of his thoughts concerning artistic relations between the two nations in his essay *French Art German Art*, and he worked on the Van Gogh show at the Galerie Tannhauser in 1909.

In January 1910 he met the young August Macke in the studio in the Schellingstrasse, which marked the start of an important partnership, and in February he inaugurated his own first solo exhibition at the Galerie Brackl.

The beginning of 1911 marked the acquaintance of artists who would exert an

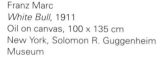

Franz Marc
White Bull, 1911
Oil on canvas, 100 x 135 cm
New York, Solomon R. Guggenheim
Museum

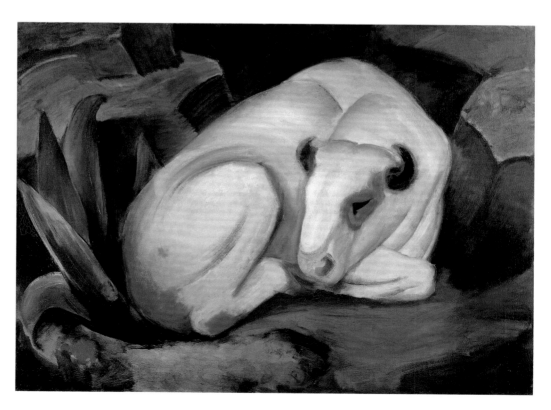

Murnau

Vasily Kandinsky
Ludwigskirche in Murnau, 1908
Oil on canvas, 67.3 x 96 cm
Madrid, Thyssen-Bornemisza Museum

Vasily Kandinsky
Market Square in Murnau, 1908
Oil on canvas, 64.5 x 50 cm
Madrid, Thyssen-Bornemisza Museum

In 1908 Gabriele Münter went for the first time to Murnau, a country resort at the foot of the Bavarian Alps not far from Munich. In the summer of 1909, Münter acquired a house there, near Lake Staffel, and it was there that she moved with Kandinsky. The resort soon became a place of reference for the artist couple and for other painters who were their friends. This was the case of Jawlensky and Marianne von Werefkin, who were referred to as the 'Giselisten' because in Munich they lived in Giselestrasse. Murnau attracted the two artist couples mainly on account of the colours that it offered and—making it an example of urban furnishing—due to a measure taken to safeguard the monuments inaugurated by the city administration during that period. Furthermore, the group of friends and colleagues developed a certain interest in

Bavarian popular art, particularly in ceramics and painting on glass, which were kept alive in Murnau by the local population: simple forms and exuberant colours, capable of communicating universal concepts with great simplicity.

In this period both Kandinsky and the other painters summoned to Murnau began experimenting with colour, compositional rhythm and subjects in a climate of exchange and art-related discussion. In a pictorial context in which forms gradually dissolve, Kandinsky achieved a high degree of abstraction, though in Murnau he painted prevalently landscapes. Yet these were a prelude to his development towards an abstract meaning for his art, which only three years later was to result in large compositions and the *Improvisations*. Constructing a clear-cut contrast

between spatial planes in his landscape canvases, Kandinsky accentuated the dramatic aspect with an unprecedented tension between the colours. In addition, in the resort of Murnau most of his works were large paintings on board that replaced his coloured drawings and small studies in oils. Through the art and teachings of Jawlensky and the exchange of ideas with other artists, Kandinsky came into contact with the most avant-garde painting of the period, particularly that associated with the Fauve movement, from which he derives his interest for chromatic experiments and the lines, to the detriment of the figurative element.

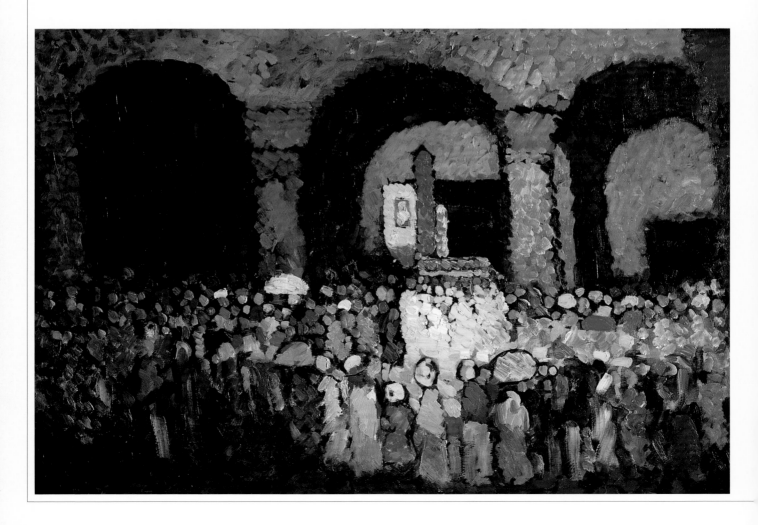

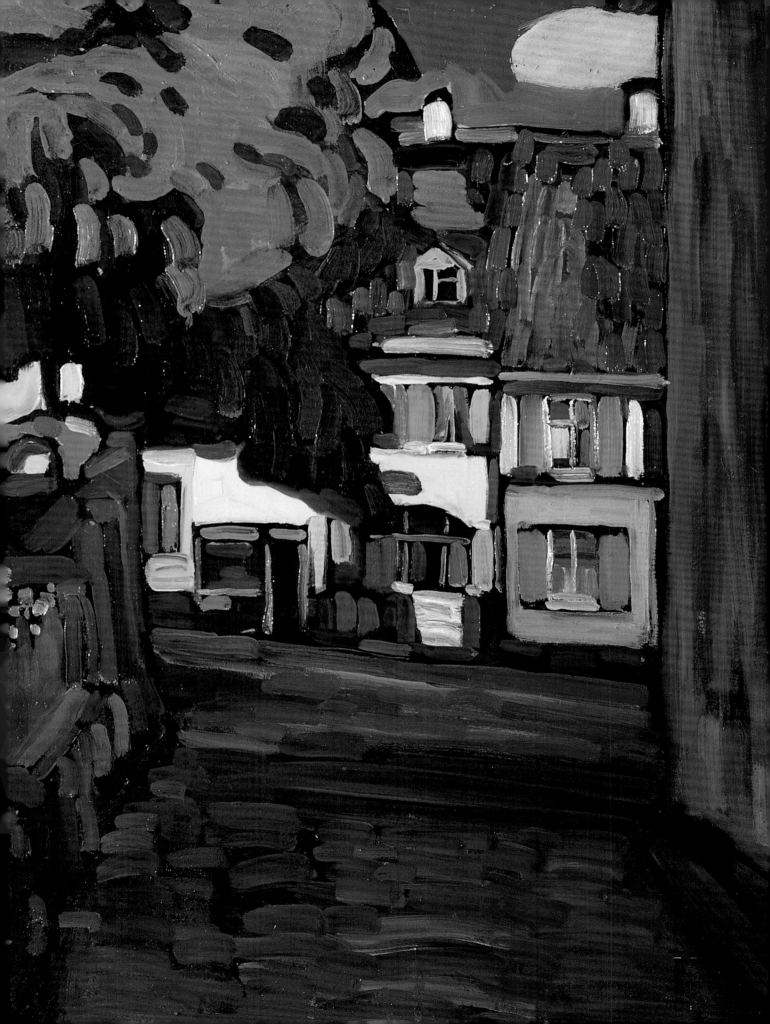

Vasily Kandinsky
Sketch for the cover of the almanac
Der Blaue Reiter, 1912
India ink and watercolour on paper,
28 x 22 cm
Munich, Stadtische Galerie im
Lenbachhaus

Pages 66–67
Franz Marc
Yellow Cow, 1911 (detail)
Oil on canvas, 140 x 189 cm
New York, Solomon R. Guggenheim
Museum

Franz Marc
Large Blue Horses, 1911
Oil on canvas, 103 x 171 cm
The Art Institute of Chicago

Opposite
Franz Marc
Two Cats, 1912
Oil on canvas, 74 x 98 cm
Basel, Kunsthaus

Franz Marc
Horses and Eagle, 1912
Oil on canvas, 74 x 98 cm
Hanover, Sprengel Museum

important influence on Kandinsky: Franz Marc, whom he met on New Year's Day, and the composer Arnold Schoenberg. Attending one of Schönberg's concerts of atonal music inspired Kandinsky to execute *Impression III—Concert* and to start up a lasting correspondence with the musician. In a period of just ten days, Kandinsky completed his first three *Impressions*. In contrast with the *Impressions*, the *Improvisations* demanded an active participation of the imagination, a rethinking of the impression. The *Compositions*, on the other hand, represent the highest point of the series and were a labour of synthesis. The finest compositions were the *Sixth* and *Seventh*, which were executed around 1913.

Just as Kandinsky directed his instinctive creative impulse in his *Improvisations*, *Impressions* and *Compositions*, Schoenberg realised that the liberty he had attained with tonal suspension could generate chaos unless it were contained within an organisation of specific rules. The very subdivision of pictorial space into zones capable of 'narrating' owes a debt to musical theory.

Kandinsky's first four *Improvisations* were shown at the Jack of Diamonds exhibition held in Moscow in December 1910. They were semi-abstract compositions, underlying which was always a landscape. At the centre of the experimentation there remained, however, the intertwining of forms and signs taken as expressions of a personal spirit.

In an article entitled 'Where is "New" Art Heading?' in the Odessa newspaper *Odeskie Novosti*, Kandinsky wrote: 'It is as if art were moving further and further away from life, making use of its own arsenal. Here, in this forgotten arsenal, it finds its own means of expression, endowed with a titanic power and a spiritual sonority so great that they cannot be found anywhere else.'

In the preparation of the third NKVM exhibition, a number of problems arose which soon led to the formation of the Blaue Reiter. Kandinsky came to the decision to resign from the association after one of his paintings was rejected by certain members for the annual show at the Galerie Tannhauser. Following his decision, Marc, Macke, Kubin and Münter also decided to leave the association.

It was with Franz Marc, with whom he had established an increasingly close friendship, that Kandinsky planned the publication of an almanac 'with articles written exclusively by artists', in which it would be possible to set out the thoughts of musicians, artists and painters. In May 1912 the publishing company Piper brought out the almanac *Der Blaue Reiter*, a publication that, in contrast with the initial plans, was much more than an artistic periodical. Kandinsky and Marc were its organisers and signatories. The almanac contained a reproduction of Macke's painting *The Tempest*. In addition to two texts by Kandinsky entitled 'On the Question of Form' and 'On Scenic Composition', there were essays by Macke, Thomas Hartmann, Arnold Schönberg, David Burlyuk, Nikolai Kulbin and Roger Allard. The name selected for the almanac was also *Der Blaue Reiter*, which combined an enthusiasm for mediaeval subjects, such as the knight, and the colour

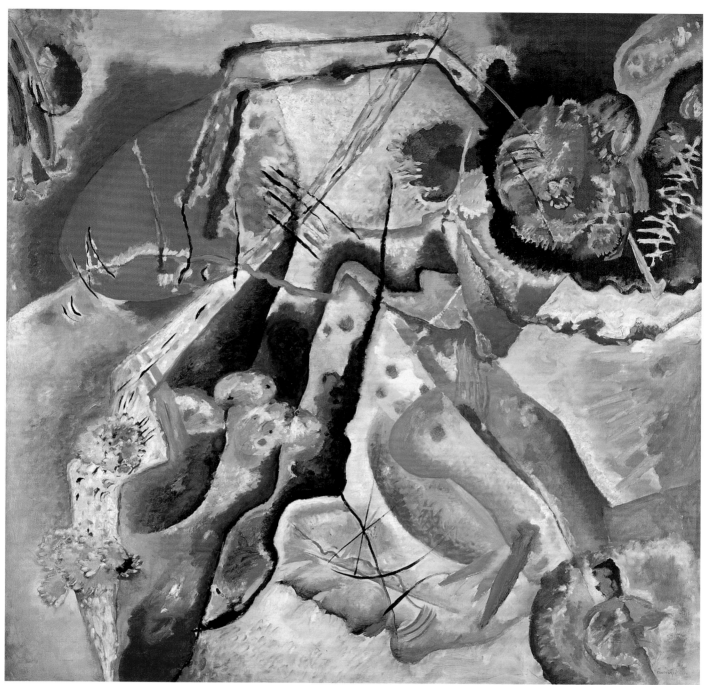

Opposite
Franz Marc
In the Rain, 1913
Oil on canvas, 81 x 106 cm
Munich, Stadtische Galerie
im Lenbachhaus

Franz Marc
Tyrol, 1913–14
Oil on canvas, 120 x 120 cm
Munich, Staatsgalerie Pinakothek
der Modernen Kunst

Vasily Kandinsky
Painting with the Red Patch, 1914
Oil on canvas, 130 x 130 cm
Neuilly-sur-Seine, Nina Kandinsky
collection

Pages 72–73
Vasily Kandinsky
Composition IV, 1911 (detail)
Oil on canvas, 160 x 250 cm
Düsseldorf, Kunstsammlung
Nordrhein-Westfalen

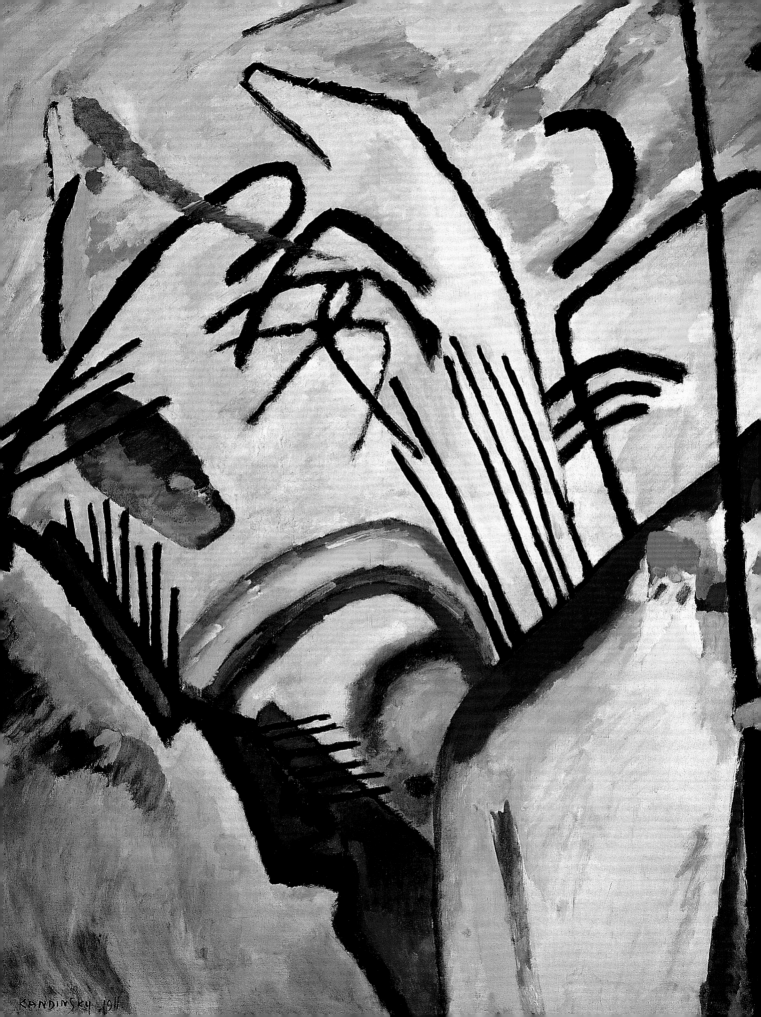

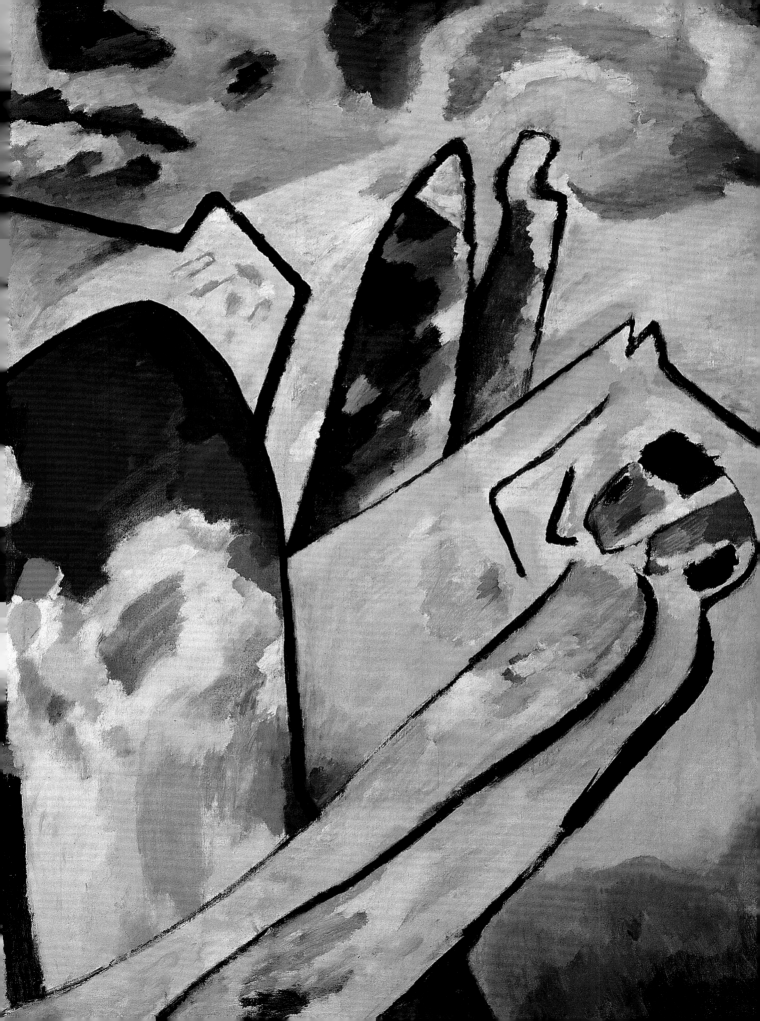

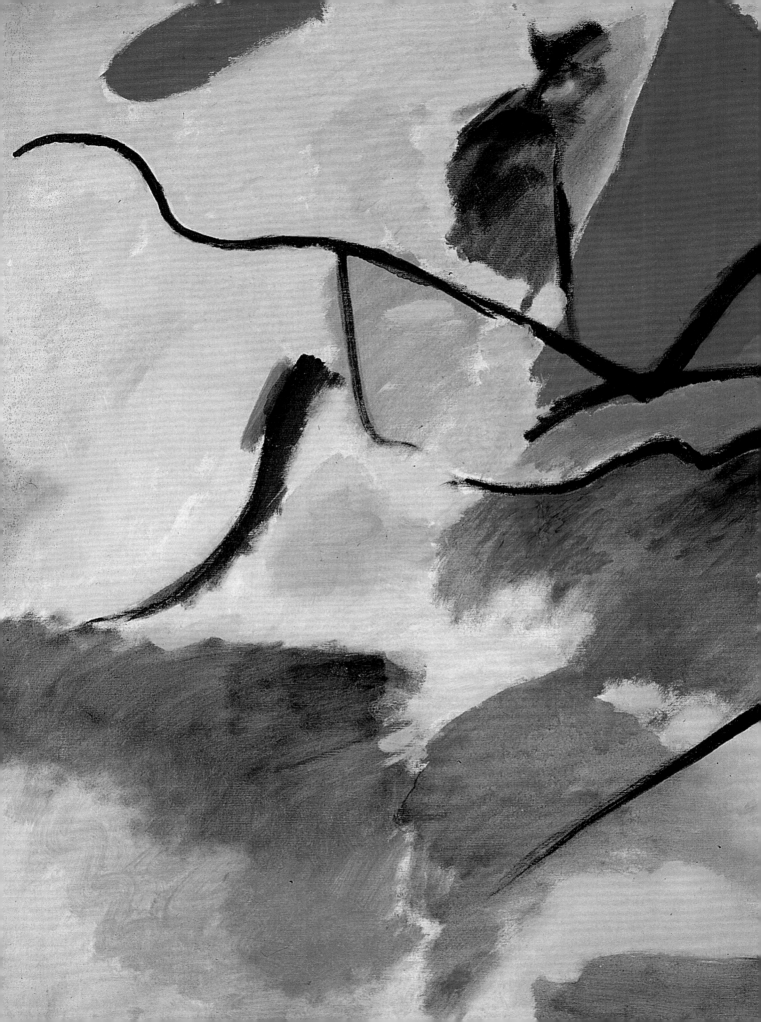

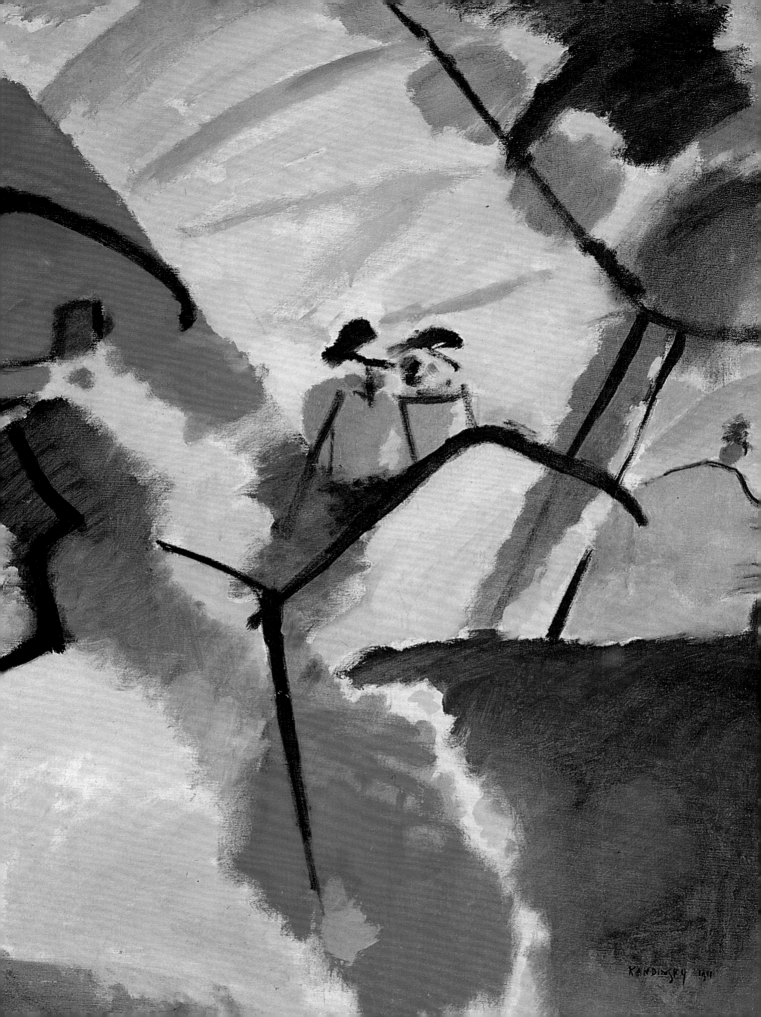

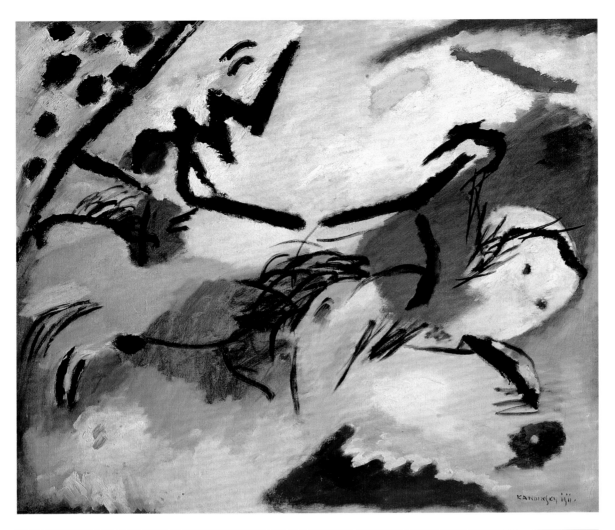

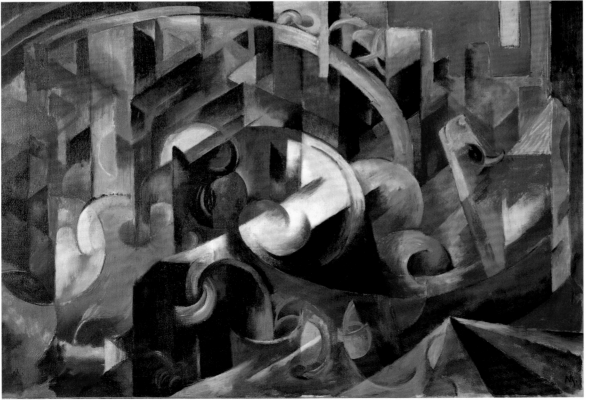

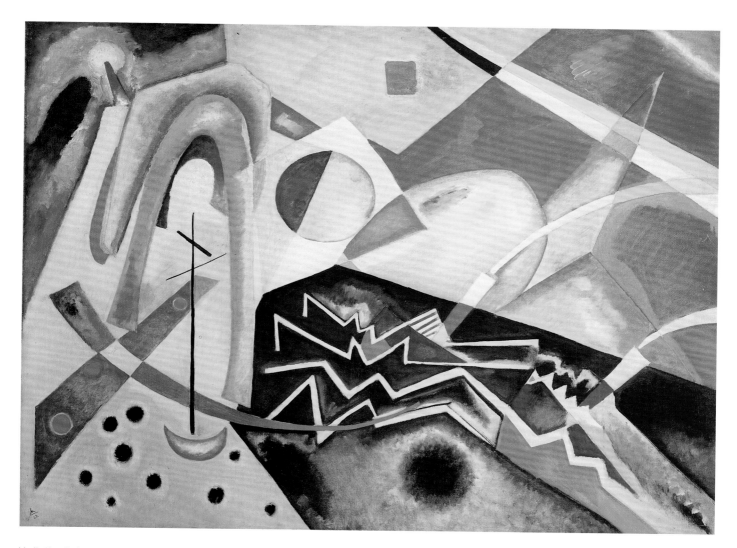

Vasily Kandinsky
White Zig Zag, 1922
Oil on canvas, 95 x 125 cm
Venice, Museo d'Arte Moderna
di Ca' Pesaro

Opposite
Vasily Kandinsky
Improvisation no. 20, 1911
Oil on canvas, 196 x 187 cm
Moscow, Pushkin Museum
of Fine Arts

Franz Marc
Painting with Oxen, 1913–14
Oil on canvas, 92 x 130 cm
Munich, Bayerische Staatsgemalde
Sammlungen

Pages 74–75
Vasily Kandinsky
Impression no. 5, 1911 (detail)
Oil on canvas, 105 x 157 cm
Paris, Musée National d'Art Moderne,
Centre Georges Pompidou

blue, which according to Marc represented in painting 'the male principle, austere and spiritual'.

The art of the protagonists of the Blue Rider underwent a radical turn in these crucial months. Dating from 1911 was Kandinsky's first explicitly non-objective painting, which he titled *Circle and Square*. In December 1911, again in the Galerie Tannhauser, the first Blaue Reiter exhibition was held, in which no fewer than fourteen artists participated. The second show took place in February the following year in the other avant-garde gallery in Munich, the Galerie Hans Goltz. Since, in contrast with Der Brücke, the Blaue Reiter was an association without a genuine stylistic programme and did not focus on creating a homogeneity of stylistic approaches, the works and artists in its exhibitions presented a considerable and multiform heterogeneity.

In 1912 Macke paid a visit with Marc to the Parisian studio of Robert Delaunay; both artists were very impressed by his compositional technique, especially his use of colour. Even though he died just two years later, Macke in particular was profitably inspired by the French painter's theories of colour.

And for Marc—who was also destined to die young in World War I in 1916, 1913 was destined to be a year marked by a different artistic direction, the result primarily of his introduction to Futurist art that autumn in Cologne. In December 1913 he did his first entirely non-figurative painting, entitled *Composition I*.

For Kandinsky the years 1913 and 1914 represented a time of consolidation and growing international fame, as well as a period in which he worked on the production of several of his most important paintings, including one that is considered to be the masterpiece of the Munich period, *Composition VII*, finished between 25 and 28 November 1914 following numerous preparatory studies.

Alexei von Jawlensky, a Russian who studied in St Petersburg but who was living in those years in Munich, painted using

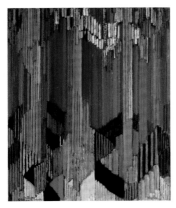

Frantisek Kupka
Study for the Language of Verticals,
1911
Oil on canvas, 78 x 63 cm
Madrid, Thyssen-Bornemisza Museum

small-format *taches*, characterised by a colourism that was already quite intense in 1902, long before the translation of Signac's essay into German and the first German exhibition of the French Neo-Impressionists in Munich.

For each painting Jawlensky emphasised a colour, which he would then allow to expand and propagate throughout the canvas in a primary chromatic sonority that resembled in part Signac's pictorial and compositional procedure.

After his encounter with the Fauves, his *taches* of colour became thicker and broader, and the surface of the painting, in which everything would become unified, became more frontal and anchored.

Anton Azbé, Vasily Kandinsky's teacher during his first years in Munich, recommended that his pupils use pure colours as much as possible.

The first landscapes that Kandinsky painted in Murnau show a clear separation of the luminous colours, which was plainly influenced by Jawlensky's output during the same period: shortly thereafter, the colours would be liberated on his canvases in a surge of autonomy.

Prague

The term 'Secese' was commonly used to indicate the Art Nouveau of Prague. The artists who embraced it largely belonged to the association Mánes, which was active from 1887 to 1949. It had been founded by a group of students at the Academy of Prague with the intention of encouraging a revival of Bohemian artistic traditions first undertaken by the painter after whom the society had been named. In 1896, Mánes underwrote the publication of the first Bohemian art magazine, *Volne Smery*, and two years later inaugurated a successful series of exhibitions that were innovative both in terms of the choice of artworks and the exhibition criteria. In 1902 it opened a major retrospective dedicated to Rodin; in 1905 it was the turn of Edvard Munch, whose paintings with their stylised forms and symbolic contents profoundly influenced the lyrical and melancholic works by Jan Preisler, one of the most important figures in the group. Other leading figures in the Secese were the architect Jan Kotera and the sculptor Stanislav Sucharda.

The Mánes association collaborated with the Hagenbund of Vienna and had as a

Frantisek Kupka
Blue Ribbon, 1910
Oil on canvas, 125 x 137 cm
Saint-Étienne, Musée d'Art
et d'Industrie

Frantisek Kupka
Creation, 1911-20
Oil on canvas, 115 x 125 cm
Prague, National Gallery

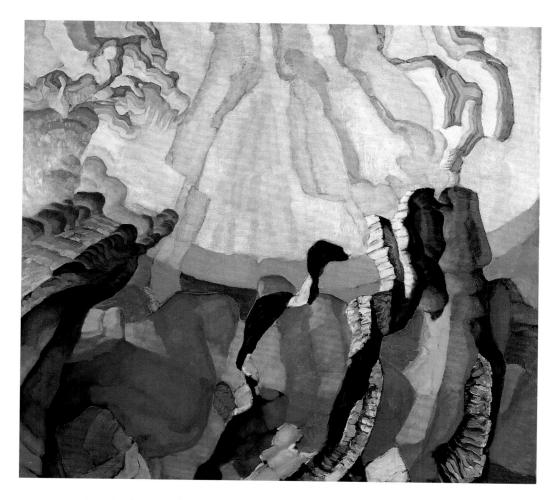

constant point of reference the Art Nouveau of Paris (Paris was actually preferable to Vienna for political reasons). Serving as a liaison with France was the Bohemian-born artist Alfons Mucha, who moved to the City of Lights in 1888 and soon became a successful poster illustrator. His artistic language of female figures in theatrical poses, curving lines and floral motifs, and a balanced interpenetration of realism and stylisation, substantially influenced Bohemian modernism, especially in the field of decoration. In 1908 a cooperative based on the model of the Wiener Werkstätte was founded in Prague to produce everyday objects such as toys, fabrics and jewellery. Within the context of the factory's production, at first typified by a style that mingled folk motifs and geometric decorations, great importance was attributed to the work of the graphic artists.

In 1906, the foundation of the Group of Eight (OSMA) marked a new step towards the opening up of Bohemian art to the European avant-garde. The Eight (among whom were Emil Filla, Bohumil Kubita and Antonin Prochazka) intended to make colour the dominant element of their art, and took their inspiration from Post-Impressionist painting and the nascent Expressionism. The exhibition organised in 1907 in a rented store revealed clear references to the styles of Munch, Van Gogh and Daumier. Following a second exhibition in 1908, the group basically ceased all activity, but it was never officially dissolved. In 1911, Filla and the other members of the Eight were among the founders of the Group of Plastic Artists, which had broken away from the Mánes association. The division was caused by Filla's decision to publish in *Volne Smery* an article in favour of neo-Primitivism, and to reproduce an artwork by Picasso: the magazine witnessed a sudden drop in sales and the younger artists, who were in favour of the new direction indicated by the editor, founded the new movement of Cubist influence. The Plastic Artists published a magazine of their own and organised exhibitions of painting, sculpture, architecture and the applied arts (1911 and 1912). The internal debate between those who were in favour of an orthodox Cubist method and those who were more open towards Italian Futurism led to a break-up in 1912, but this did not keep the group from continuing until 1917, exhibiting works by Picasso, Braque and Derain in Prague.

Gustav Klimt
Nuda Veritas, 1889
Oil on canvas, 252 x 56 cm
Vienna, Österreichisches
Theatermuseum

Opposite
Gustav Klimt
Portrait of Emilie Flöge, 1902
Oil on canvas, 181 x 84 cm
Vienna, Historisches Museum
der Stadt Wien

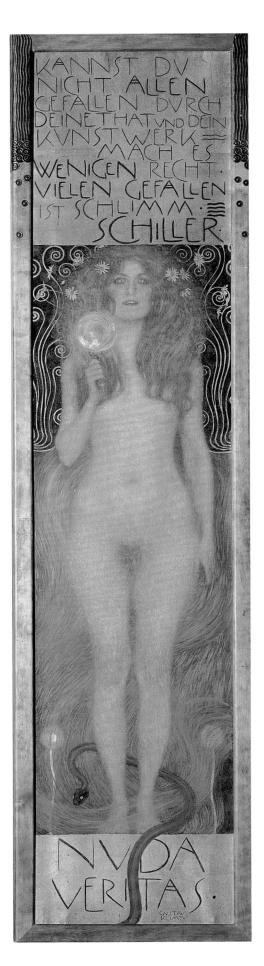

Vienna

As an alternative to the dominant style of Impressionism, Vienna developed its own trend, and there emerged a number of avant-garde clubs from which the Secession would eventually recruit its members. The Austrian Impressionists, for the most part devoted to painting *en plein air*, gathered around Emil Jacob Schindler. Schindler, who had many pupils and followers, painted identical or similar subjects, concentrating above all on variations and giving rise to the so-called *Stimmungimpressionismus* (Impressionism of States of Mind) typical of the Viennese school. The follower of Schindler who had the greatest influence on the painters of the Secession was Theodor von Hörmann, who—a fierce opponent of the artistic policy pursued by the Künstlerhaus, the official association of Viennese painters—had received some of his education in Paris. There were two other groups of artists at the end of the nineteenth century: the Siebenerclub (Club of Seven), which featured several of the most representative personalities of the Secession, such as Josef Maria Olbrich, Josef Hoffmann and Koloman Moser, and the Hagengesellschaft, a club that met in a bistro and had among its members twelve of the future founders of the Secession. In these groups, bound together by their shared rejection of conservative tendencies and the commercialism of official art, a broad array of aspirations found expression, as is demonstrated by the caricatures and satirical cartoons that stood alongside the atmospheric landscapes and canvases inspired by the painting of Franz von Stuck.

These groups, however, had no opportunities to exhibit and become known because of the prejudiced attitude of the Künstlerhaus in the selection of works accepted for exhibitions and other public events. In 1893, the rejection of a work by Josef Engelhart submitted for the annual exhibition exacerbated the disagreements within the Künstlerhaus between the 'young' and the conservative artists. Although there had initially been no intention of breaking away (the Secession initially formed as an internal group within the official association), in 1897 twenty-five artists led by Gustav Klimt handed in their resignations and thereupon gathered under the name of 'Vereinigung bildender Künstler Österreichs', or Association of Austrian Figurative Artists, later known as the Secession. The group had no specific objectives and—despite a generic reference to the Secession of Munich and to French Art Nouveau—showed no unity of intent in stylistic

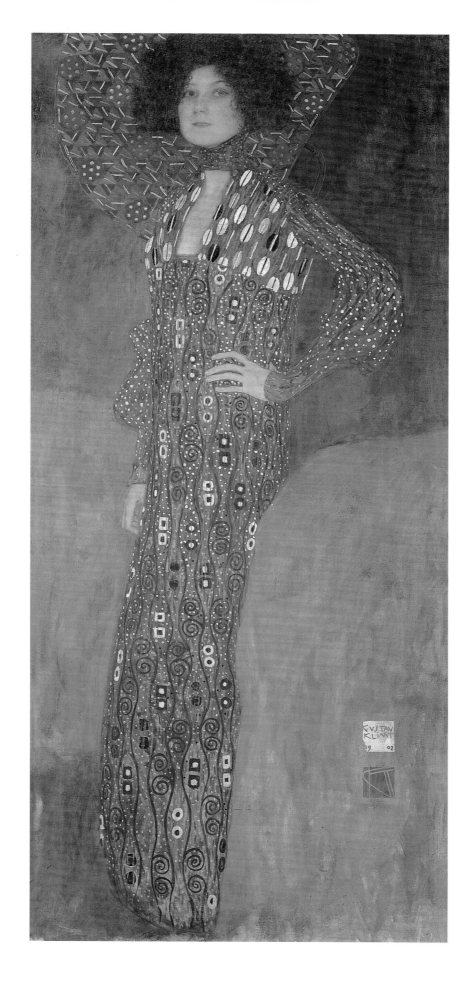

Gustav Klimt
Birch Forest, 1902
Oil on canvas, 100 x 100 cm
Linz, Neue Galerie der Stadt Linz-
Wolfgang Gurlith Museum

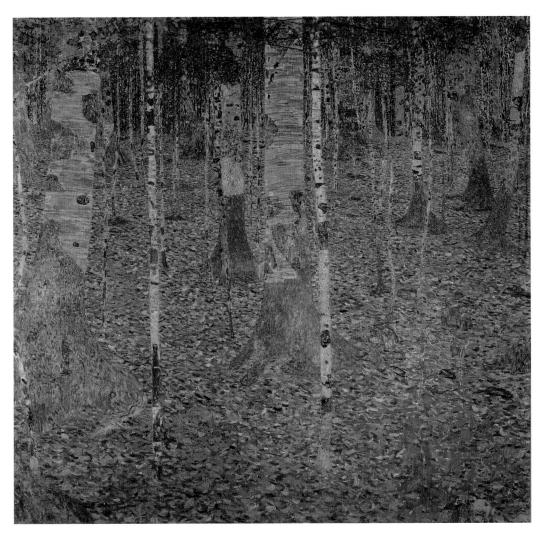

terms, bringing together artists with a quite diverse array of propensities and ideals. The first theoretical texts and declarations of intent contained vague appeals for the liberty of artistic creation and individual expression, as opposed to the constraints imposed by the Academy and the rules of the market.

Until 1905, the year in which the abandonment of the organisation by a substantial group of artists put an end to the most active and innovative phase of the movement, the Secession brought to Vienna a considerable quantity of artworks and European artists that followed a wide variety of stylistic directions, at times not even especially up to date. The Secession had the task of filling a 'historic vacuum' in Viennese culture by organising in 1903 a wide-ranging exhibition dedicated to *The Development of Impressionism in Painting and Sculpture*, a title under which works by Manet, Monet, the school of Pont-Aven, Les Nabis, Cézanne and Van Gogh were shown.

In the twenty-three exhibitions held by the association in its first eight years, great attention was devoted to the masters of Symbolism: Max Klinger, Fernand Khnopff, Ludwig von Hoffmann and Jan Toorop were some of the most important names. Among the sculptors were Rodin, Meunier, Bourdelle and the Belgian Georges Minne. In 1901, the twelfth show was dedicated to Nordic artists, with works by several Russians and Edvard Munch, who was also present with graphical works at the fifteenth exhibition; in 1901 an ample retrospective was dedicated to an Italian maestro, Giovanni Segantini, who was much admired by Klimt.

A number of exhibitions were devoted to monographic themes: the fifth show (1899) was dedicated to Austrian and international graphics, the sixth to Japanese art (also 1899), and the eighth, in 1900, to European artistic craftsmanship. On this occasion, pieces were shown by Richard Ashbee and Charles Rennie Mackintosh, as well as from the Parisian Maison Moderne. In 1902, the celebrated exhibition devoted to Beethoven focused on the statue of that name by Max Klinger, and around it were arranged

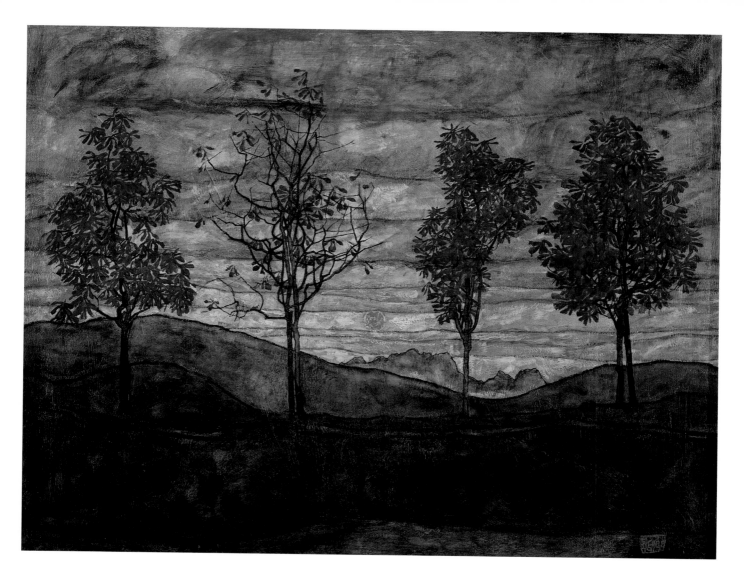

Egon Schiele
Four Trees, 1917
Oil on canvas, 110 x 140 cm
Vienna, Österreichische Galerie
Belvedere

the works by twenty-one artists of the Secession, forming an integral part of the installation and the decoration of the spaces. The visit to the exhibition was presented as a total artwork ('Gesamtkunstwerk').

The association, endowed with a statute, founded a magazine, *Ver Sacrum*, which published its first issue in January 1898. Extraordinarily refined in its graphics and production, the magazine was published for two years as a monthly, then slipped back to bi-monthly issues, and finally ceased in 1903. The name—as explained in a text by Max Burckhardt in the first issue—referred to an ancient Roman ritual in which the infants born in the spring were consecrated to the deities and therefore destined, once they reached adulthood, to leave the homeland to found colonies and new communities. The symbolic universe and the spirit of a revival of antiquity were quite typical of Symbolist culture: the concept of rebirth linked to the idea of spring merged with the idea of 'mission', sacralising

the figure of the artist and conferring upon him a central role in the development of civilisation. The magazine published theoretical articles and reports about Modernism, always clear in diction and easy to understand; extensive space was devoted to illustrations (photographic and otherwise) and to the decorations of individual pages, which were beautifully designed by the artists of the Secession: the broad spaces left blank, the square format of the page, and the style of the ornaments made the issues of *Ver Sacrum* one of the most noteworthy products of the Secession.

Around 1902, the year of the Beethoven exhibition, there began to emerge a tendency towards purism and abstraction which led to an idealised figurative approach, unhindered by the perception of the phenomena of modern life and devoted instead to super-individual archetypes and historic relations. From a formal point of view, the most immediate points of reference for this language were represented by the work of Mackintosh,

Egon Schiele
Artist's Room in Neulengbach, 1911
Oil on canvas, 80 x 53 cm
Vienna, Historisches Museum der
Stadt Wien

Pages 84–85
Oskar Kokoschka
The Pagans, 1918 (detail)
Oil on canvas, 60 x 130 cm
Cologne, Wallraf-Richartz-Museum

with its precise rhythm and the harsh asceticism of the forms, alternating with the purity of the pale-coloured surfaces. In this new vocabulary, affirmation was given to a barbaric and archaic spirit, the predilection for a heroic and solemn gesturality, an interest in a timeless and non-naturalistic nudity that would reveal, among other things, a crisis of the progressive ideals and the magnificence of the Jugendstil: scholars have pointed out, with much attendant consideration, the links between this style and the discoveries of Freudian psychoanalysis, the diffusion of the Nietzschean ideal of the superman and the emergence of a Germanic proto-nationalism. The leader of this development was Gustav Klimt, who had long been a leading figure in the Secession and its first president.

Setting out from positions quite close to nineteenth-century Symbolism and the figurative naturalism of Makart (decoration of the Burgtheater, 1888, and of the Kunsthistorisches Museum, 1891), Klimt progressively developed a personal style rich in ideas, often deriving from the works featured in the exhibitions of the Secession. In his art, the influence of Symbolism and of Art Nouveau (Fernand Khnopff, Jan Toorop and Aubrey Beardsley) merged with references to historic styles, like those from Mycenae and Byzantium, and a distinct decorative sensibility. His painting, which teemed with femmes fatales and allegorical and symbolic figures, often caused a scandal and undermined the official successes of a career that, at the outset, had seemed quite promising. In 1894 Klimt obtained the commission to decorate the ceiling of the great lecture hall of the university of Vienna with a colleague: it was his job to paint three canvases depicting the departments of Philosophy, Medicine and Jurisprudence. The paintings were executed in the years that followed and were shown on three different occasions at the shows of the Secession (1900–03). He produced a two-dimensional, unreal space, with visionary tones and largely undefined figures that were clustered and juxtaposed one against another without any visible order; although the faces and bodies preserved a naturalistic presence, here all realism was eliminated in favour of extraordinary overall effects and an intense atmosphere of pathos. The dark pessimism of the themes portrayed, distant from the traditional allegorical depiction of the departments, and the abandonment of the Positivist spirit that had so long driven nineteenth-century culture were probably—along with the fiercely criticised nude figures, that earned the

artist accusations of pornography—the elements that led to the rejection of these paintings (later destroyed during World War II) by the clients. Klimt's stylistic research was further developed in the *Beethoven Frieze*, frescoed in the Secession Building on the occasion of the 1902 exhibition. Depicting the *Ninth Symphony*, the fresco illustrates the struggle for happiness against hostile forces (the giant Typhoon, the three Gorgons, Disease, Folly and Death) by a warrior who, emerging victorious, leads a feeble humanity into the realm of art. The figures, separated by broad empty spaces, are hieratic and solemn, and they incarnate that 'Nordic' and monumental spirit that the exhibitions of the years that followed would celebrate with increasing determination; the surfaces were filled with decorative textures with all the exquisite detail of fabrics or mosaics.

Klimt's dominant figure played a role, even if unwittingly, in accentuating the distance between the 'naturalists' and 'stylists' to the advantage of the latter. They won considerable attention to their cause first with the retrospective dedicated to Klimt in 1903, and then with the nineteenth show, in 1904, in which they focused on the monumental art of Hans von Marées, Ferdinand Hodler and Edvard Munch, who were appreciated for their extraordinary abstractive capacities and for decorative use of colour. In 1904 the tension became more acute with the prospect of the participation of the Secession in the World's Fair in St Louis in the USA: the artists who constituted the working committee for that year developed a project without communicating with the other members. The proposal was rejected by the ministry and this triggered a lively internal debate that led the members of the committee to state that, alongside the work of the Stylists, there was no room for the 'easel paintings' done by other members. Further questions arose concerning the involvement of one of the Stylists, Karl Moll, in a commercial operation: this led finally to a break up, and in 1905 a group of seventeen artists led by Gustav Klimt (the Klimtgruppe) left the Secession, which still carried on its activity.

Since it had access to a large space suitable for exhibitions, in 1908 the Klimtgruppe organised a show that can be considered the apotheosis of Austrian art of the early twentieth century. The Salon featured works by 179 artists in 54 rooms, with paintings and artworks in both the figurative and decorative arts to demonstrate how the new Austrian style had found a way of express-

Oskar Kokoschka
Portrait of Gino Schmidt, 1914
Oil on canvas, 95 x 68 cm
Madrid, Thyssen-Bornemisza Museum

Opposite
Gustav Klimt
The Three Ages, 1905 (detail)
Oil on canvas, 180 x 180 cm
Rome, Galleria Nazionale d'Arte
Moderna e Contemporanea

the older master. In his posters and in a series of cartoons for tapestries exhibited at the show, it is already possible to note the angular figures, unambiguous line and the juxtapositions of dissonant tones that would characterise his more mature style.

In 1909, success came again with the Internationale Kunstschau, which featured 166 artists from other countries, including Gauguin, Van Gogh and Munch; another Austrian participant was Egon Schiele, whose works reveal the founding characteristics of Expressionism. Accompanying the show was a performance of Kokoschka's play *Murderer, Hope of Women*, which caused great shock and scandal.

Another important group that originated in Vienna was the Hagenbund, which formed in 1900 and remained active until 1930: this was the association of artists who broke away from the Secession under the guidance of the architect Joseph Urban. The group organised various exhibitions and encouraged the diffusion of a marked Art Nouveau style inspired by British models but less extreme than that of Klimt: this choice brought the Hagenbund a certain degree of popularity amongst the middle class, and this fact resulted in its frequent appointment to represent Austria in official shows and expositions.

The so-called Neukunstgruppe ('New Art Group') was quite different in orientation; it was formed in 1909 on the occasion of a joint exhibition at the Viennese gallery, and it gravitated around the charismatic figure of Egon Schiele. Schiele was the author of the group's manifesto, which demanded complete independence from tradition for the artist, with a view to individual creativity. The group, which expressed an aesthetic that was by now quite distant from the style of the Secession, included Franz Wiegele and, on the occasion of the second exhibition, Oskar Kokoschka.

The year 1918 marked the end of the Empire but also of Austrian modernism: Klimt and Schiele both died that year, and the forces that remained active in Vienna were losing incisiveness and momentum. In 1908 the architect and theorist Adolf Loos (who had studied in Vienna and then moved to the United States) published his famous essay *Ornament and Crime*, in which he harshly condemned the aesthetic choices made by the Secession, taking a stance against eclecticism and decoration: Loos is commonly agreed to have been one of the chief inspirations of Rationalism.

ing itself in every aspect of daily life. Alongside the painting, sculpture, architecture and graphics, there was space for fashion, crafts, sacred art and funerary art.

Josef Hoffmann, who was the director of the exhibition, even built a perfectly furnished model house; Kolo Moser directed the installation of the Klimt room; and the Wiener Werkstätte showed a selection of its work in a room painted white. The up-and-coming name was Oskar Kokoschka, a painter whose early development was influenced by Klimt's work, but one capable from his very earliest work of developing a language that was entirely independent of the voluptuous arabesques of

Charles Harrison

Artists' Writings and Critical Debates 1900–1920

When we think back now to the art of the early twentieth century, the names that come to mind are for the most part those of the avant-garde artists whose work was clearly determinant for subsequent developments: Fauvists and Expressionists, Cubists and Futurists, Dadaists and Constructivists, and the various pioneers of Abstract Art. Theirs is the work that we are accustomed to see reproduced in books and hung on the walls of museums. When we now survey the copious writings of these artists and their supporters, it is easy to assume that the foreground of artistic culture must have been occupied from the beginning of the century with their statements and manifestos, with justifications of particular theoretical positions, and with debates about the different alternative means by which art might be continuously developed and transformed.

Yet in any European centre during the first decade of the twentieth century the work of the avant-garde artists would have composed a minority of the art that was generally available to view and likely to be accorded some public consideration in print. When imagining the art exhibited and discussed at the time, we need to take due account of the broad background of work that was still conservative and academic and for the most part officially supported. With that background in place it will be easier to understand the self-assertive tone that tends to characterise the pronouncements of the avant-garde. The declarations by which new initiatives were announced, and the arguments by which they were defended, were for the most part uttered in the face of a press and a public that expected from art just what the avant-garde was not offering: easily recognisable representations executed in familiar styles and with traditional techniques.

Much of the writing that was uttered in the early twentieth century in support of specific modernist developments was first and foremost argument in support of modernism in principle and in general. Its typical objective was to justify the subordination, if not the abandonment, of those naturalistic conventions and practised techniques by which the correspondence of pictorial representation to the visible world had traditionally been secured. It was almost uniformly idealist in character, which is to say that it was concerned with asserting the relative independence of the individual artist's vision with respect to the world of material realities. Even for a relatively moderate modernist such as the German Max Liebermann, the priorities were clear. 'For what is the significance of the most accurate drawing, the most virtuoso execution, the most brilliant colourism, if these extrinsic virtues lack the innermost thing, the dimension of feeling [*Empfindung*]... Imagination alone can animate the canvas...'[1]

By the end of the first decade of the century, however, the circumstances of the avant-garde artists in Western Europe had changed in certain important respects. With the spread of secessions and alternative salons across Europe at the end of the nineteenth century, modern art had at least been assured of some

public presence—occasionally even a measure of institutional sanction—and its audience was growing. Among its supporters were a number of interested aestheticians and art historians who had come to see modern art as a historically distinct phenomenon, requiring a new system of aesthetics, based on a transformed understanding of what constituted technical competence (the German scholar Julius Meier-Graefe was a key figure; his massive *Entwickelungs-geschichte der moderne Kunst* was published in 1904, following some ten years that the author had spent in Paris). Even to its outright detractors, a display of modernist painting or sculpture was usually good for some expression of outrage and for the fomenting of scandal. For a while before World War I in Paris, Milan and London, modern art was treated by sections of the press as newsworthy. As a result a measure both of informed attention and of public exposure could be achieved by those, like the self-proclaimed Futurist Filippo Tommaso Marinetti, who devoted sufficient time and ingenuity to the business of making themselves conspicuous. At the same time a small but growing number of enlightened patrons and dealers were establishing their presence in the centres of art-world activity, Paris foremost among them. For those few artists who established themselves at the forefront of modernist developments, a measure of private financial support and thus of independence was now on offer. As the identified leaders of the Fauve and Cubist avant-gardes respectively, Henri Matisse and Pablo Picasso were early beneficiaries.

In the broad literature of modern art generated by the avant-garde factions of the time, the writings of Matisse and Marinetti might be said to represent opposite poles of authorship: the one occupying himself with the intensification of a personal repertoire, expressing himself rarely in print, and then generally to an audience of already interested parties; the other standing as the impresario and spokesman for a self-consciously radical movement, devoting considerable energy to the delivery of lectures, and to the generation of manifestos and similar programmatic statements. From this specific contrast a general point may be extracted. When we consider the selection of writings by artists and their supporters that is now available to study from the first two decades of the twentieth century, we should bear in mind the now largely inaudible background of standard cultural journalism against which their voices were raised. But we should also take account of the various circumstances that may have decided individual artists' attitudes to the business of writing and publication: not only their personal dispositions and the character of their intended work, but also the nature of opportunities as these may have presented themselves in different centres and at different moments. We should bear in mind that those who were the most productive of artists may not be numbered among the authors of the most extensive texts.

In fact, though his name is not to be associated with any published manifestos, Matisse was responsible for what was to become the canonical statement

of a broad expressive tendency in the art of the early twentieth century. His 'Notes of a Painter' was first published in *La Grande Revue* in December 1908, by which time he had become clearly identified as leader of the Fauves. Although Matisse claims to speak only for himself and for his own approach to painting, the text vividly represents a broad tendency within modernism that was prevalent in the international art and criticism of the period. As a concomitant of the priority placed on the expressive properties of art, it was a central tenet of this 'mainstream' modernism that the virtue of the work of art lay primarily not, as had conventionally been supposed, in its correspondence to the appearances of the world, but rather in the coherence of its formal arrangement. 'Composition is the art of arranging in a decorative manner the diverse elements at the painter's disposal for the expression of his feelings.' Nature was to be submitted to 'the spirit of the picture'. By this means the 'essential character' of a given subject might be uncovered beneath the 'superficial existence of beings and things'.[2] Insofar as it achieved this end, the representative modern work of art partook of the basic aesthetic virtue by which all previous art had actually been distinguished. The defence of a historically specific form of avant-gardism thus assumed the character of a universalising aesthetic system.

Ideas such as these were largely inherited from the Symbolist movement of the late nineteenth century,[3] though they were refined by responses to the work of Paul Cézanne on the part of younger artists who had been involved in the movement. Émile Bernard drew heavily on letters from Cézanne in several accounts of his work printed between 1904 and 1926, and Maurice Denis published an influential appreciation of the artist in 1907, the year after his death. No other artist of Cézanne's generation posed so urgently or so poignantly the dilemma on which modern art's claims to realism were felt to turn: by what was the vitality of the individual work of art established? By its fidelity to the sensation of the actual world, or by its integrity and autonomy as a decorated surface?

It would be hard to overestimate the status of Cezanne's work among the avant-garde and their supporters in the decade before World War I, in particular in serving as the model for an art that was 'pure' in the sense of unadulterated by the literary, the anecdotal and the contingent. To conceive of art as pure was to assume that it was its own justification, requiring no recourse to arguments about the social or historical resonance of its figurative motifs. Conveyed in a letter to Bernard in April 1904, Cézanne's instruction to 'treat nature by means of the cylinder, the sphere, the cone' was taken not as an instruction in basic modelling, but as proof that the older painter's enterprise involved seeing through the contingent and accidental aspects of life to an underlying world of geometrical constants.[4] As represented in similar vein by Denis, Cézanne's distinctive achievement was to blend the empirical responses of a naïve temperament into an essential and classic harmony. 'He is a simple artisan, a primitive

N 5300
.A14
2007
} 30,000
Years of
art...

N 6490
.A146
2006
} Avanguardia
Storiche

who returns to the sources of his art… lim
by what constitutes exclusively the art of pai
mitment to the business of naturalistic repr
associated with his work was to be instru
ralism and in the pursuit of an entirely abs
tion of Reality in Pure Painting' in 1912, Ro
ject of painting was 'exclusively plastic', e
with a 'Realism' that was to be established
nis' essay was translated into English in 1910, the painter-critic Roger Fry re-
ferred to 'a new conception of art, in which the decorative elements preponderate
at the expense of the representative'. It was Cézanne, he claimed, 'who really
started this movement, the most promising and fruitful of modern times'.[7]

First applied to Cézanne in the 1870s, the concept of the artist as a kind
of 'primitive' also played a considerable part in the development of modernist
theory in the first two decades of the twentieth century. It was strengthened by
continuing revaluation of the art of those non-European civilizations previous-
ly derogated as primitive, and by increasing exposure to the artefacts of tribal
cultures brought back from Africa and the South Seas by sailors and anthro-
pologists. If the modernist thesis was that naturalism was not a necessary con-
dition of expressiveness—that it might even be an obstacle to its achievement—
then the evidence in support seemed now to be there in plenty. 'Not long ago',
the painter Emil Nolde wrote in 1912, 'only a few artistic periods were thought
suitable for museums. Then they were joined by exhibitions of Coptic and ear-
ly Christian art, Greek terracottas and vases, Persian and Islamic art. But why
is Indian, Chinese and Javanese art still classified under ethnology or anthro-
pology? And why is the art of primitive peoples not considered art at all?'[8]

Voiced alike by artists and sympathetic critics, the sense of common cause
with the productions of earlier civilizations, of tribal cultures and of children
was a significant aspect of the mainstream modernist critique of the culture of
the modern world, and in particular of its growing commercialisation. Writing
in defence of Expressionism, Hermann Bahr represented a viewpoint typical
of the avant-garde artists of the time. 'The bourgeois rule has turned us into
savages… We ourselves have to become barbarians to save the future of hu-
manity from mankind as it is now. As primitive man, driven by fear of nature,
sought refuge within himself, so we too have to adopt flight from a "civiliza-
tion" which is out to devour our souls.'[9] This identification with the primitive
also further strengthened the process of questioning of those traditional meas-
ures of skill and sophistication by which the relative authority of European art
had been established.

The association of 'primitive' expression with vitality and with refusal of
metropolitan culture was particularly strong among the Dresden-based artists
of Die Brücke, with whom Nolde was associated, and among the Munich-based

group Der Blaue Reiter. In a woodcut broadsheet made in a deliberately primitive style for the first exhibition of Die Brücke in 1906, Ernst Ludwig Kirchner referred to a 'new generation of creators and spectators' united by the kind of 'directness and authenticity' that were found in tribal art.[10] (The qualities he had in mind are particularly well exemplified in the carved and painted sculptures he made circa 1910–12.) Writing in 1912 in the *Blaue Reiter Almanach*, August Macke claimed that 'What we hang on the wall as a painting is basically similar to the carved and painted pillars in an African hut'.[11] At a time when he was in the process of exploring the idea of a wholly abstract art, Vasily Kandinsky expressed a similar sense of kinship with 'the primitives'. 'Just like us, those pure artists wanted to capture in their works the inner essence of things, which of itself brought about a rejection of the external, the accidental.'[12]

The identification of modern art with the primitive had a further implication. To the problem of modern art's relation to tradition it offered a drastic solution: a clean break—the primitive being conceived (quite mistakenly) as unburdened by the weight of inherited culture. By the second decade of the century the suggestion that a fresh start was needed was being widely voiced among the various European avant-gardes. 'The world lies virginal before us', Franz Marc wrote in 1914; 'our steps are shaky. If we dare to walk, we must cut the umbilical cord that ties us to our maternal past.'[13] This proposal to wipe the slate clean and to start again from a new beginning of art may be identified with a radical strain of modernism, not entirely separate from the mainstream but distinguished in its more extreme manifestations. It was adopted in implicit justification for kinds of art that were as varied as were the local forms of bourgeois culture from which different avant-garde groupings marked out their distance.

Where the mainstream modernists tended to stress the fundamental unity and thus continuity of all art at the level of the formal and the aesthetic, proponents of a radical modernism emphasised the distinctiveness of our sensational experience under the conditions of modernity. If art was to match up to this experience, they believed, it would require an entirely new repertoire of forms and rhythms. In rejecting classical tradition and in identifying with the primitive, they effectively proposed an escape from history into an enthusiastic or anarchic vision of the future. In practice, of course, the break with the past was something of a selective process. In many cases the radical tendency within modernism drew support from what remained of the strong vein of Realism in the painting of the later nineteenth century. Much of the work of Manet, Degas, Monet and Renoir had dealt with themes of contemporary social life—and of these four Manet alone was not still alive and working during the first two decades of the twentieth century. While there had been a tendency at the turn of the century to consider Impressionism as an art of landscape and light, and to autonomise its preoccupation with colour in line with Symbolist theories, evidence of the French painters' engagement with an explicitly urban imagery of modernity could be used to sup-

port a quite different understanding of the project of modernism. In the half-dozen years before the outbreak of World War I, the radicals brought a renewed impetus to the Baudelairean concern for a 'painting of modern life', aggressively updating its imagery to take account of the effects of industrialisation, of the spread of gas-lighting and electricity and of the development of the motor-car.

Notable among radical modernist factions in the second decade of the century were the Futurists in Milan, the Vorticists in London, the Suprematists in Moscow, and the Dadas in Zurich, Berlin and New York. Radical modernism was in general a markedly urban phenomenon. Its prospective iconography was first sketched out by Marinetti in a document that celebrated his rejection of the legacy of Symbolism and his violent rebirth into the modern world.

"We will sing of great crowds excited by work, by pleasure, and by riot; we will sing of the multicoloured, polyphonic tides of revolution in the modern capitals; we will sing of the nightly fervour of arsenals and shipyards blazing with violent electric moons; greedy railway stations that devour smoke-plumed serpents; factories hung on clouds by the crooked lines of their smoke..."

This passage is taken from the 'Foundation and Manifesto of Futurism', published on the front page of *Le Figaro* in Paris in February 1909.[14] Although it was written at a time when Marinetti was still conceiving of Futurism as an essentially literary movement, it served as a rallying-call for an emerging avant-garde of Italian artists. It was followed within a year by a 'Manifesto of Futurist Painting', and shortly after that by 'Futurist Painting: Technical Manifesto'. These were both primarily the work of the painter-sculptor Umberto Boccioni, but they were also signed by Carlo Carrà, Luigi Russolo, Giacomo Balla and Gino Severini.

The language of the Futurist manifestos owed much to the work of the philosopher Henri Bergson, who conceived of 'every actual form of things, even the form of natural things, as artificial and provisional', and of reality as 'a perpetual becoming'.[15] In the Technical Manifesto considerable stress is placed on the contingency of appearances and the subjectivity of perception, and on speed and vibration as the characteristic sensations of modern life. 'The gesture which we would reproduce on canvas shall no longer be a fixed *moment* in universal dynamism. It shall simply be the *dynamic sensation* itself. Indeed, all things move, all things run, all things are rapidly changing... Who can still believe in the opacity of bodies...?'[16]

The Futurist programme was widely influential among those who shared the radical sense of modernity by which it had been impelled. In the brief period before war revealed a darker side to the age of the machine, there were widespread calls for a new stylistic repertoire that would be redolent of the age in being dynamic, mechanistic, and anti-naturalistic. All revolutionary painting today has in common the rigid reflection of steel and stone in the spirit of the artist; that desire for stability as though a machine were being built to fly or kill

with.'[17]These were the terms in which Percy Wyndham Lewis announced the grouping in English art that was to emerge in the summer of 1914 as the Vorticist movement. Though Lewis was quick to distance Vorticism from Futurism, the English group derived much of its initial impetus from Marinetti's example, while the style of its publication, *Blast*, owed much to the Futurists' *parole in libertà*.

Although the first Cubist works by Picasso and Braque predated the emergence of Futurism as a movement and as an artistic style, the first Futurist manifestos were issued before these works had been subjected to much critical scrutiny and before any serious attempts had been made to theorise Cubism. Braque's own aphoristic 'Thoughts on Painting' were not published until the end of 1917, while Picasso's first substantial interview on his Cubist work was not given until 1923.[18] In the absence of any available accounts by the originators of Cubism, followers and interested critics tended to resort to the prevailing terms on which modern art had already been defended. The most significant new pictorial style since the Renaissance thus became firmly associated with mainstream ideas about the purification of art, and about the pursuit of essential values—ideas that the often improvisatory and always factitious work of Picasso and Braque did not altogether support. Almost without exception, Cubism was represented in Paris as an essentially classical style of art, in which particular forms were reduced to their underlying geometrical structures. Even the evident impact of African sculpture on Picasso's work was generally explained in terms consistent with this view. It was assumed that what the 'primitive image-maker' reveals is the essential reality of 'men and things' that is hidden beneath the material veil of appearances.[19]

Published in 1910, Jean Metzinger's 'Note on Painting' provides an early example of the representation of Picasso's achievement in standard mainstream modernist terms.

"Rejecting every ornamental, anecdotal or symbolic intention, he achieves a painterly purity hitherto unknown."[20]

In the same spirit, the poet and critic Guillaume Apollinaire wrote eighteen months later of the evolution of an art that 'will be pure painting, just as music is pure literature'.[21] In their influential essay *Du Cubisme*, published in 1912, Metzinger and Albert Gleizes appear to argue against the view that 'decorative preoccupations must govern the spirit of the new painters', placing a greater emphasis than other writers on the subjectivity of the painter's vision of form and space. And yet they too claimed that a successful painting 'should lead… towards the imaginative depths where burns the light of organization' and where 'it harmonizes with the totality of things'.[22] In their account the project of the Cubist painter thus remains the pursuit of the essential and the universal.

It was perhaps inevitable that a mainstream modernist and idealist view of Cubism should have become solidly entrenched, given that it was the very

artist-theorists principally responsible for this view who largely composed the public face of the movement. It was they who were instrumental both in the public launch of the movement at the Salon des Indépendants in 1911 and in the grouping of the 'Section d'Or' represented at the Salon d'Automne in 1912. Even Fernand Léger, writing in 1913, argued that the realism of the new painting lay not in its 'imitative character' but in its specialisation. So far as painting was concerned this involved 'the simultaneous ordering of the three great plastic components: Lines, Forms, and Colours'. 'Each art is isolating itself and limiting itself to its own domain.'[23] Central as it was to mainstream modernist theory, this last thesis was to be reiterated in one version or another until 1960, when the American critic Clement Greenberg gave it its definitive articulation in his essay 'Modernist Painting.'[24]

While there was no country with a modern artistic culture that remained untouched by the influence of Cubism, or of those modernist ideas for which it generally served as a means of transmission, local circumstances played a decisive part in deciding the form in which those ideas were received, and the extent to which they took the more radical form associated with modes of Futurism. In England the artists grouped around Lewis had all responded in some measure to the Cubist work of Picasso and Braque, before exposure to the art and ideas of the Futurists had encouraged them to see themselves as Vorticists. In making this identification a radical faction distinguished itself from a constituency of English 'Post-Impressionists', amongst whom the effects of Cubism were domesticated in a thoroughly moderate manner. This latter grouping was strongly supported by Roger Fry and his associate Clive Bell in terms that were entirely consistent with the mainstream modernist views prevailing in Paris.

In Russia, two particular factors bore on the reception of modernist ideas from the West. The first was the lateness and rapidity with which parts of the country were industrialised from the late nineteenth century onwards. In the words of the painter Alexander Shevchenko, writing in 1913, 'Life appears completely different to us, full of other new forms. The world has been transformed into a monstrous, fantastic, perpetually moving machine...'[25] The fact that Italy had been subjected to a similar late and accelerated process meant that the relatively sudden impact of modernity was an experience that artists working in the major urban centres of Moscow and St Petersburg had in common with the Italian Futurists. The second and related factor was that from the early years of the century Russia was in a state of social and political ferment that was to come to a head with the Revolution of October 1917. Under these conditions the appeal of radical modernist ideas was predictably strong.

In the summer of 1913 a 'First All-Russian Congress of Futurists' was held in the Dacha of the writer Mikhail Matiushin. Kasimir Malevich was among those who attended, and who, like many European artists at the time, adopted

an identification with Futurism as a means to disavow provincialism, to establish impatience with the conservative in culture, and to assert a commitment to the idea of a modernised world. In a pamphlet originally published in December 1915 he acknowledged that 'Whoever has not trodden the path of Futurism as the exponent of modern life, is condemned to crawl forever among the ancient graves and feed on the crusts of the past'. At the same time, however, he made clear that the identification with Futurism could only be transitional. 'Because in pursuing the form of aeroplanes or automobiles, we shall always be anticipating new cast-off forms of technical life... In pursuing the form of things, we cannot discover painting as an end in itself, the way to direct creation.' It was Cubism, he implied, that had shown the true direction. 'If for thousands of years past the artist has tried to approach the depiction of an object as closely as possible, to present its essence and meaning, then in our era of Cubism the artist has destroyed objects together with their meaning, essence and purpose. The new picture has sprung from their fragments.'[26]

The 'new picture' was Malevich's own *Black Square*, 'the first step of pure creation in art', the initiating work of what he called Suprematism. It was a distinctive and significant aspect of Malevich's theorisation of his own development that he brought back together the previously divergent strands of radical and mainstream modernist tendencies. Conceived in radical terms as an explicit expression of the modern age, and as a kind of fresh start or 'degree zero' for painting, the *Black Square* appears at the same time as an extreme demonstration of the purity and autonomy of modernist art as canvassed in mainstream theory.

Suprematist works were shown for the first time in December 1915. When the Russian Revolution came less than two years later, Malevich was quick to claim the relevance of his work to the building of a new culture. 'Our spirit like a free wind, will make our creative work flutter in the broad spaces of the soul.'[27] Over the next ten years, however, he was to find himself increasingly isolated. The grounds of opposition were firmly established in the cultural policies of the Communist party. Following the revolution of 1905, Lenin had established clear limits to the degree of autonomy that the party would tolerate in cultural production, asserting that 'a really free [literature and art] will be *openly* linked to the proletariat'.[28] Seven years later Georgy Plekhanov rounded on the idealist tendency in modernism, as represented in Gleizes' and Metzinger's account of Cubism. 'Subjective idealism was always anchored in the idea that there is no reality save our ego. But it required the boundless individualism of the era of bourgeois decadence to make this idea... the theoretical foundation of a new aesthetics.'[29]

The first explicit opposition to Malevich's work came from a leftist faction within the Moscow avant-garde that sought to recast the practice of art in terms consistent with the materialist politics of the revolution. In the Productivist position represented by Alexander Rodchenko, Malevich's work was as-

sociated with a bourgeois ideology of 'art' and 'style', inimical to the revolutionary demands of construction. 'Construction is the modern requirement for organization and utilitarian use of material.'[30] In due course, however, the Constructivists' attempt to reconcile the demands of materialism and avant-gardism shared the same practical fate as Malevich's Suprematism. As Bolshevik revolution degenerated into Stalinist counter-revolution, the divergent factions of the Russian avant-garde were alike marginalised—if not seriously endangered—by those artists and officials who successfully represented the party's cultural policy, and who conceived of the act of imagination not as an individual right, but as a form of responsibility to the social order and the state.

For much of the rest of the century, arguments about the social function of art and the appropriate means of its discharge were to be conducted under the long historical shadow of the Russian revolution. On one issue in particular opinions remain significantly divided up to the present day. Does the potential critical power of art reside in the last resort in its autonomy, and in its imaginative freedom from social and utilitarian considerations; or should art be measured at any given time according to criteria of correctness consistent with those that might be applied in the judgement of ethical or political matters?

As we might expect, justifications of the development of abstract art tended to favour the first of these alternatives, which was consistent with the type of modernist theory I have characterised as mainstream. Though this body of theory was largely developed in France and in response to tendencies in French art from late Impressionism to Cubism, the major developments in abstract art all took place outside France. Each of the artists principally involved in those developments felt the need to write extensively about the work in question, perhaps as much to assure himself that what he had made was indeed capable of sustaining meaning and value as to explain the results to the public at large. The resulting body of published work added substantially to the corpus of mainstream modernist theory. Moscow was one centre of activity, as we have seen. During the period in which Kandinsky experimented with the idea of an art 'without objects' he was living in Munich. It was there also that he wrote his major treatise, *Über das Geistige in der Kunst*. Published in Munich in 1912, this is a sustained argument for art's 'essential' spiritual function and for abstract painting conceived as an index of mankind's social and spiritual progress.

"In all that we have discussed … lie hidden the seeds of the struggle towards the non-naturalistic, the abstract, towards inner nature… Consciously or unconsciously, artists turn gradually towards an emphasis on their materials, examining them spiritually, weighing in the balance the inner worth of those elements out of which their art is best suited to create."[31]

The association of abstract art with progress—both *in* art and *for* mankind—was similarly made by those Dutch artists associated with the periodical *De Stijl*, first published in 1917, though prompted by contact between Theo van Does-

burg and Piet Mondrian in 1915. Both had been exposed to theosophist ideas, though the decisive turn towards abstraction in Mondrian's work followed his exposure to Cubism in Paris before World War I. The theory of 'neo-plastic' art for which these two were primarily responsible involved a further systematisation of mainstream modernist ideas, conceived as principles for the regulation of human life in general. A manifesto composed by Van Doesburg in 1918 suggested that the 'new plastic art' was the basis upon which all 'artists of today' were united to establish 'international unity' in life, art and culture.[32] The crucial principle of this new art was its autonomy of means. 'The great step forward made by the exact formative work of art consists in the fact that it achieves aesthetic equilibrium by pure artistic means and by these alone.'[33]

Mondrian's definitive statement of his aesthetic position was written in 1920 and published in French, as *Le Néo-Plasticisme: Principe general de l'équivalence plastique*.

"In the New Plastic, painting no longer expresses itself through the *corporeality* of appearance that gives it a naturalistic expression. On the contrary, painting is expressed plastically by *plane within plane*. By reducing three-dimensional corporeality to a single plane, *it expresses pure relationship...*

The new spirit must be manifested *in all the arts without exception...* As soon as one art becomes plastic expression of the abstract, the others can no longer remain plastic expressions of the natural. The two do not go together: from this comes their mutual hostility right up to the present. The New Plastic abolishes this antagonism: *it creates the unity of all the arts.*"[34]

The universalising aspiration to which Mondrian here gives expression was to characterise a broad neo-plastic and constructive tendency in the European art and architecture of the period between the two world wars. His text furnishes one of the most resolute expressions of a belief that later generations have come to see, rightly or wrongly, as paradoxical: that the essentially socialist goal of a harmonious society of equals is appropriately served by an art purged of any apparent reference to the particulars of social and material life.

In fact a powerful strand of opposition to the development of mainstream modernist art and theory had already developed among those in whose eyes its apparent indifference to the actualities of history had come to seem simply indefensible. Between 1914 and 1918 claims for the autonomy of aesthetic values were severely tested by the incidence of war and of the successful and unsuccessful revolutions in Russia and Germany respectively. In England the majority of the Vorticists received appointments as official war artists, usually after a spell of active service, and with instructions to provide a 'visual record of the war' that could hardly have been fulfilled with abstract work. Paul Nash was one of the younger artists drawn to their example before the outbreak of war. Following his appointment as a war artist in 1917, he wrote back to his wife from the battlefield of Passchendaele.

"I am no longer an artist interested and curious, I am a messenger who will bring back word from the men who are fighting to those who want the war to go on for ever. Feeble, inarticulate, will be my message, but it will have a bitter truth, and may it burn their lousy souls."[35]

For those similarly moved on either side of the conflict—or as badly damaged by it as were the German artists George Grosz and Otto Dix—a belief in the moral autonomy of art could hardly have been easy to sustain. Drawn to the German Communist Party in the light of his war experience, Grosz was explicit in his criticism of those painters who aimed 'to be nothing but a creator of form and colour'.[36]

"Today art is absolutely a secondary affair. Anyone able to see beyond their studio walls can see this. Just the same, art is something that demands a clear-cut decision from artists. You can't be indifferent about your position in this trade, about your attitude towards the problem of the masses… You can't avoid this issue with the old rigmarole about the sublimity and holiness and transcendental character of art."[37]

A similar position was taken by those non-combatant artists and writers who gathered during the war at the Cabaret Voltaire in Zurich and who adopted the collective name of Dada, among them Hugo Ball, Jean Arp, Sophie Tauber, Richard Huelsenbeck, Tristan Tzara and Marcel Janco. Also escaping the war, Marcel Duchamp and Francis Picabia frequented the New York apartment of Walter and Louise Arensberg, where they met Man Ray. After the war these three became associated with a Dada group in Paris, and their wartime works were retrospectively claimed for the movement. Further groups met between 1916 and the early 1920s in Barcelona, Berlin and Cologne. Dada activities tended generally to follow patterns established by the Expressionist, Cubist and Futurist avant-gardes. Two exceptional initiatives are deserving of mention, however. The first of these was the introduction of the concept of the ready-made by Marcel Duchamp. This was publicised with his submission of an up-ended urinal in the name of 'R. Mutt' to the supposedly jury-free Society of Independent Artists in New York in 1917. Following the predictable rejection of the 'Fountain', as Duchamp had titled it, a brief and laconic statement of protest was published in the journal *The Blind Man.* Its apparent intention—and certainly its long-term effect—was irrevocably to associate a continuing strand of avant-gardism with scepticism concerning the previously essential demands of artistic authorship and originality.

"Whether Mr Mutt with his own hands made the fountain or not has no importance. He CHOSE it. He took an ordinary article of life, placed it so that its useful significance disappeared under the new title and point of view—thus created a new thought for that object."[38]

The second significant initiative was the explicit identification with revolutionary politics that characterised Berlin Dada. Formed after Huelsenbeck's

return to the city, the group included John Heartfield, Wieland Herzfelde, George Grosz, Raoul Hausmann, Hannah Höch and Johannes Baader, among others. In his 'Notes of a Painter', Matisse had expressed the objectives of his art in the following terms.

"What I dream of is an art of balance, of purity and serenity, devoid of troubling or depressing subject-matter, an art which could be for every mental worker, for the businessman as well as the man of letters, for example, a soothing, calming influence on the mind, something like a good armchair which provides relaxation from physical fatigue."[39]

Speaking ten years later in the chaos of Berlin, Huelsenbeck delivered an address that was subsequently to be adopted as a 'Collective Dada Manifesto'. Towards the end of his text he described the 'Dada state of mind' in terms that suggest an explicit reference to Matisse's 'Notes', and to the mainstream modernist position in general.

"Under certain circumstances to be a Dadaist may mean to be more a businessman, more a political partisan than an artist—to be an artist only by accident. To be a Dadaist means to let oneself be thrown by things, to oppose all sedimentation; to sit in a chair for a single moment is to risk one's life... Affirmation—negation... Blast the aesthetic-ethical attitude. Blast the bloodless abstraction of expressionism! Blast the literary hollowheads and their theories for improving the world..."[40]

For the remainder of the twentieth century, these were to be the two poles between which different theories of modernist art tended to position themselves: on the one hand an art of affirmation, justified by its independence from the conflicts of everyday life and by its achievement of an exemplary harmony; on the other an art of negation and opposition, justified by the urgency of the demands of social and political life and by the need for engagement.

1 Max Liebermann, 'Die Phantasie in der Malerie', *Die neue Rundschau*, vol. XV no. 3, Berlin (March 1904): pp. 372–80. This quotation from the translation 'Imagination in Painting' in C. Harrison and P. Wood, *Art in Theory 1900-2000: an anthology of changing ideas*, Malden (Mass) and Oxford, 2003, p. 31.

2 Henri Matisse, 'Notes d'un peintre', in *La Grande Revue*, Paris, 25 December 1908. Quotations from the version in Harrison and Wood, pp. 70–71.

3 As early as 1891 we find G.-Albert Aurier writing on Gauguin in these terms: 'It is necessary… that we should attain such a position that we cannot doubt that the objects in the painting have no meaning at all as objects, but are only signs, words, having in themselves no other importance whatsoever'. From 'Le Symbolisme en peinture: Paul Gauguin', in *Mercure de Paris*, 11, 1891. This quotation from the version in C. Harrison, P. Wood and J. Gaiger, *Art in Theory 1815-1900* (Malden, Mass. and Oxford: 1998), p. 1027.

4 Paul Cézanne, from a letter to Bernard, 15 April 1904; this quotation from Harrison and Wood, p. 33.

5 Maurice Denis, 'Cézanne', in *L'Occident* (Paris: September 1907). This quotation from the translation by Roger Fry published in *Burlington Magazine*, XVI, London, Jan.–Feb. 1910; reprinted in Harrison and Wood, p. 43.

6 Delaunay's statement was originally published by Apollinaire in the course of his own article, 'Reality, Pure Painting', in *Der Sturm*, Berlin, December 1912. Quotation from the version of Delaunay's text printed in Harrison and Wood, p. 153.

7 See note 5. Fry's brief introduction to Denis's text is reprinted in Harrison and Wood, p. 40.

8 Nolde's text 'On Primitive Art' was included in his autobiographical *Jahre der Kampfe 1912-1914* (Berlin: Rembrandt, 1934), with a note to the effect that it had been written in 1912 to introduce a book that Nolde intended to write on 'the artistic expressions pf primitive peoples'. This quotation from the version in Harrison and Wood, p. 97.

9 Bahr's text was written in 1914 and published as *Expressionismus* (Munich 1914). This quotation from the excerpt in Harrison and Wood, p. 120.

10 Kirchner, programme of Die Brücke, originally published as a woodcut broadsheet to accompany the Brücke exhibition at the Seifert factory, Dresden, 1906. This quotation from Harrison and Wood, p. 65.

11 Macke. 'Masks', in *Die Blaue Reiter* almanach, Munich, 1912. This quotation from Harrison and Wood, p. 96.

12 Kandinsky, from *Über das Geistige in der Kunst* (Munich: Piper Verlag, 1912). This quotation from Harrison and Wood, p. 93.

13 Marc, 'Foreword' to the planned second edition of *Die Blaue Reiter*. Published in K. Lankheit (ed.), *Blaue Reiter Almanach*, London, 1974, p. 260. This quotation from Harrison and Wood, p. 159.

14 This quotation from Harrison and Wood, p. 148.

15 From Bergson, *Creative Evolution*, originally published in Paris, 1907. English translation published in London in 1911. This quotation from Harrison and Wood, pp. 141 and 143.

16 'Futurist Painting: Technical Manifesto' was first published as a leaflet by *Poesia*, in Milan in April 1910. Like Marinetti's 'Foundation and Manifesto' it was translated into English in 1912 in association with a Futurist exhibition at the Sackville Gallery, London. This quotation from the version in Harrison and Wood, p. 150.

17 Lewis, introduction to 'The Cubist Room', at the exhibition 'English Post-Impressionists, Cubists and Others', Brighton, December 1913. Printed in W. Michel, *Wyndham Lewis: Paintings and Drawings*, London 1971, pp. 430–31.

18 Braque's 'Thoughts on Painting' were collected and published by Pierre Reverdy in his journal *Nord-Sud*, Paris, December 1917. The interview 'Picasso Speaks' was first published by Marius de Zayas, in *The Arts*, New York, May 1923.

19 See, for instance, André Salmon, *La Jeune Peinture Française* (Paris: Messein 1912).

20 First published in *Pan*, Paris, Oct.–Nov. 1910. This quotation from the text printed in Harrison and Wood, p. 185.

21 From 'On the Subject in Modern Painting', first published in *Les Soirées de Paris*, Paris, February 1912. Quotation from the version printed in Harrison and Wood, p. 187.

22 From *Du Cubisme* (Paris 1912). These quotations from the version in Harrison and Wood, pp. 195–6.

23 Léger, 'The Origins of Painting and its Representational Value', originally published in *Montjoie*, Paris, 1913. These quotations from the version in Harrison and Wood, p. 202.

24 First published in *Forum Lectures* (Voice of America), Washington D.C., in 1960. Reprinted in *Art & Literature*, no. 4, Lugano, Spring 1965.

25 Shevchenko, 'Neo-Primitivism: Its Theory, Its Potential, Its Achievements', originally published as a pamphlet in Moscow, 1913. This quotation from the version in Harrison and Wood, p. 100.

26 Malevich launched Suprematism at '0.10 The Last Futurist Exhibition' in St Petersburg in December 1915. To accompany the exhibition he published a pamphlet with the title *From Cubism to Suprematism in Art, to New Realism in Painting, to Absolute Creation*. This was republished in expanded form in Moscow in 1916, as *From Cubism and Futurism to Suprematism: The New Realism in Painting*. The present quotations are from the version of the latter text printed in Harrison and Wood, pp. 176, 177 and 181.

27 Malevich, 'To the new limit', originally published in *Anarkhiya* 31, 30 March 1918. This quotation from the version in T. Andersen ed., *Malevich; essays on Art 1915-1933* (London 1969), p. 55.

28 Lenin, 'Party Organization and Party Literature', originally published in *Novaya Zhizn*, no. 12, Moscow, 13 November 1905. This quotation from the version in Harrison and Wood, p. 140.

29 Plekhanov, from *Art and Social Life*, based on lectures given in Liège and Paris in 1912, originally published in parts in the journal *Sovremennik* in November and December 1912 and January 1913. This quotation from the version printed in Harrison and Wood, p. 156.

30 Rodchenko, from 'Slogans', composed in 1920–21 in connection with Rodchenko's teaching at Vkhutemas, the State Higher Artistic and Technical Studios. First printed in *Khudozhestvennokonstructorskoe obrazonavnie*, no. 4, Moscow, 1973. This quotation from the version in Harrison and Wood, p. 340.

31 Kandinsky, *op. cit.* note 12. This quotation from Harrison and Wood, 2003, p. 87.

32 De Stijl, 'Manifesto 1', composed in 1918; first published in *De Stijl*, V, no. 4, Amsterdam, 1922. Quotation from the version printed in Harrison and Wood, p. 281.

33 From Van Doesburg, *Principles of Neo-Plastic Art*, first published as a series of articles in Dutch in 1919; printed as a Bauhaus book in Munich in 1925. This quotation from the excerpt printed in Harrison and Wood, p. 283.

34 Originally published as a pamphlet by Léonce Rosenberg's Galerie de l'Effort Moderne, Paris, Jan. 1921. Quotation from the version in Harrison and Wood, p. 291.

35 Published in notes for the continuation of an autobiography, in Paul Nash, *Outline; An Autobiography and other writings* (London 1949), pp. 210–11.

36 From George Grosz and Wieland Herzfelde, *Die Kunst ist in Gefahr (Art is in Danger)* (Berlin 1925). This quotation from the version in Lucy Lippard ed., *Dadas on Art* (Englewood Cliffs, NJ: Prentice Hall, 1971), p. 82.

37 Grosz, 'My New Pictures', written in 1920; first published in *Das Kunstblatt*, V, no. 1, Berlin, 1921. This quotation from the version in Harrison and Wood, pp. 272–3.

38 'The Richard Mutt Case', in *The Blind Man* (New York, May 1917). Though Duchamp never acknowledged au-

thorship of this text, he was unquestionably responsible for its publication. It was accompanied by a photo of the urinal taken by Alfred Stieglitz. This quotation from the text printed in Harrison and Wood, p. 252.

[39] Matisse, *op. cit.* note 2. This quotation from Harrison and Wood, p. 73.

[40] Huelsenbeck's text was originally delivered as a talk at the I.B. Neumann Gallery in Berlin in February 1918. It was published as 'First German Dada Manifesto' in Huelsenbeck ed., *Dada Almanach* (Berlin 1920). It was reissued in the same year as 'Collective Dada Manifesto', signed by Huelsenbeck, Tristan Tzara, Franz Jung, George Grosz, Marcel Janco, Raoul Hausmann, Hugo Ball, Pierre Albert-Birot, Hans Arp and others. Quotation from the version printed in Harrison and Wood, 2003, p. 259.

Art Nouveau and the Parisian Crucible of the Avant-gardes

Brussels

Modernism took shape in Belgium following the foundation of the magazine *L'Art moderne* in 1881, which was linked to the figures of Octave Maus and Edmond Picard and the birth of the group of artists known as Les XX (The Twenty) in 1883. The group was composed of artists who were all dissatisfied with the conservative official cultural policy that was primarily expressed through an organisation known as L'Essor, a genuine academic stronghold. Among the first eleven founding members were James Ensor, Fernand Khnopff and Théo Van Rysselberghe; joining this core group at a later date were nine artists, including Jef Lambeaux, Jean Delvin and Frans Simons, making a total of twenty associates. The group was supported in the pages of *L'Art moderne*, especially through the fiery rhetoric of Picard, while official critics attacked the young artists with special venom, to the point that some of the associates reconsidered their membership, especially the more traditional ones. These members, such as Lambeaux, Simons, Delvin and Théodore Verstraete were pressured by Maus and Picard and left Les XX after 1887. Replacing them were Auguste Rodin, Paul Signac, George Minne, Jan Toorop, Henry Van de Velde, Félicien Rops and Anna Boch: the works of Boch, who was Maus's cousin, showed the degree to which familiarity with Impressionism, with which she had become familiar through the exhibitions held by the group, had influenced her verist education (*Cliffs of Brittany*, 1901). Similarly, the painter Théo Van Rysselberghe, who had painted a portrait of Maus in 1885, was influenced by the Symbolist works of the American painter Whistler and especially by the Pointillism of Seurat, whose *A Sunday Afternoon on the Island of La Grande Jatte* he had seen in Paris in 1886. He moved to Paris in 1898 and from 1904 he showed a more academically influenced style, nonetheless incorporating some elements of the dominant Fauvist school.

By 1893, the year that Les XX disbanded, membership had risen to thirty-two. The core of the group's existence revolved around the annual exhibition, to which Maus invited rising new artists from Europe and America: Whistler and Sargent, Odilon Redon, Monet and Renoir, Seurat, Signac,

Toulouse-Lautrec and Rodin, but ample space was also devoted to literature and music, with readings of works by Mallarmé and concerts of music by Claude Debussy and Gabriel Fauré. In particular, French and English Symbolist literature found fertile soil in Belgium, where the writer Maurice Maeterlinck, a follower of the poetics of Mallarmé, would become fundamental to the development of Symbolism in Germanic Europe and to the Modern style in Scotland: Charles Rennie Mackintosh and his wife Margaret McDonald were inspired by his *Princesse Maleine* in their design of the decorative panels (1906) for the music room for a Viennese client, Fritz Waerndorfer, who was in turn a founding partner, with Joseph Hoffmann and Koloman Moser, of the art workshops of the Wiener Werkstätte.

The memberships after 1887 represent a major opening to sculpture and the decorative arts, the strong point of the so-called 'Belgian line' which had by this point become synonymous with Art Nouveau throughout Europe thanks to the works of Victor Horta and Henry van de Velde.

Les XX decided to disband in 1893, but at this time Maus founded a new group, *La Libre Esthétique*, which carried on the philosophy of Les XX until its disbandment in 1914, working in parallel with the new art gallery Le Toson d'Or (also founded by Maus in 1894). *La Libre Esthétique* set out to become a new driving force for European art and, in particular, for Art Nouveau: at the first exhibition, half of the rooms were occupied by volumes illustrated by Morris and Beardsley and objects designed by Ashbee. At the inauguration, Debussy performed a number of his pieces in person, explicitly declaring the faith of the new group in the concept of total art developed on the basis of Symbolism, subtle correspondences between the arts and examples of artistic synaesthesia. Many Belgian artists participated in the various Parisian salons of the Ordre du Temple de la Rose-Croix founded by the Symbolist writer Mèrodak Josephin Pèladan, which was a sort of esoteric Templar order. Another artist represented was Fernand Khnopff, the champion of Belgian Symbolism.

Also affected by the esoteric humours of the Rose-Croix were some of the best-known works of the painter Jean Delvin, such

James Ensor
Self-Portrait with Masks, 1899 (detail)
Oil on canvas, 120 x 80 cm
Aichi, Menard Art Museum

Pages 108–09
James Ensor
Christ's Entry into Brussels, 1889
Oil on canvas, 257 x 378 cm
Malibu, The J. Paul Getty Museum

Henry van de Velde
Tropon: L'Aliment le plus concentré,
1899
Colour lithograph, 111 x 77 cm
New York, The Museum of Modern
Art, Arthur Drexler Fund

as *The Treasures of Satan* (1895) and *The Love of Souls* (1900). Despite the fact that his academic education kept him from appreciating the stylistic freedom of Ensor, Monet, Seurat and Gauguin, his works show the influence of the 'whiplash' line, of explicit Art Nouveau derivation, introduced by Horta in his architectural designs; in his many theoretical writings, Delville ventured to criticise all art forms that depict reality, including Impressionism and the art of Khnopff, which he considered to be excessively egocentric and incapable of transmitting profound meaning. Based on these views, in 1896 he founded the Salon d'art idealiste to establish his distance from the avant-garde groups of the capital; joining him were Léon Frédéric and Constant Montald, whose *La barque de l'Idéal*, from 1907, can be considered a sort of manifesto to restore a purely spiritual value to Symbolism rather than the aesthetic connotation chosen in the past. Other voices of Symbolism showed how close the school still was to the turn of the century. Xavier Mellery, who had also trained at the Brussels Academy of Fine Arts but was soon after one of the founders of Les XX, developed a far more intimate and sensitive version of Symbolism. It may have had less flair but it was more domestic and comprehensible: one good example is his *Immortality* (1907), which, like a medieval allegory, invites the observer to reflect on the phases of life. A few verses by Victor Hugo were featured beneath the skeleton, in keeping with the tradition of sacred representations. One remarkable case is that of Léontius-Petrus-Ludovicus Spilliaert of Ostend, a late Symbolist who attained unrivalled levels of emotional tension in early twentieth-century Belgium. His first works still show the visionary influence of Ensor (also from Ostend): his *Self-Portrait* (1904) transmits a strange anxiety through the use of chiaroscuro, linking his art more to that of Munch than of Khnopff.

In Belgium, Symbolist sculpture attained remarkable results, incorporating the expressive formulary of Art Nouveau in an entirely original manner. The dean of the sculptors was Charles van der Stappen who, after attending the School of Fine Arts in Brussels and studying in Paris in 1864 and in Rome from 1877 to 1879, returned to the Belgian capital where he opened his own Atelier Libre. This later became a crucial meeting ground for some of the most notable personalities of the capital, including Horta and Maus; it was in fact his acquaintance with Maus that led him towards the ideas of the

Arts and Crafts movement, encouraging him to found L'Art, a movement devoted to introducing artistic values into industrial production. His best known work, with a theme closely linked to many of Khnopff's works, was the exquisite *Mysterious Sphinx,* from 1897, in bronze and ivory, a veritable Art Nouveau icon, both in the style and in the fluid treatment of the materials. Two of Van der Stappen's students offered an original and highly personal version of Art Nouveau: Georges Minne and Victor Rousseau. Minne, who studied in his native Ghent, soon became interested in Symbolist literature and graphics (he illustrated Maeterlink's *Serres Chaudes* in 1889); in 1890 he showed at the Salon des Vingt and, two years later, at the Salon des Rose-Croix in Paris. In 1895, he moved to Brussels to study at the local Academy of Fine Arts where he had an opportunity to reconsider his various experiences, especially his familiarity with the sculpture of Rodin. What he took from the French artist was not the vigorous plasticism, but his gift for simplifying forms and taking to an extreme the sinuous elegance of Art Nouveau, and it was with these characteristics that he showed repeatedly at the Secessions of Berlin and Vienna, winning the admiration of Klimt and Schiele for the elongated and vaguely Expressionist silhouettes of his figures. Minne counted among his admirers Henry van de Velde, through whom he obtained his most prestigious commission, the *Fountain of the Five Youths*, for the Folkwang Museum in Hagen built and furnished by Van de Velde for the wealthy German collector Karl Ernst Osthaus. The first designs for Minne's work date from 1899, but the final version in marble was completed in 1905.

Victor Rousseau was a very precocious talent (he began to work marble at the age of eleven with his uncle and father in the decoration of the Palace of Justice in Brussels). He joined Van der Stappen's entourage, where he developed a refinement that he successfully applied in small ivory works and in monumental marble groups. An example is *The Secret*, dating from 1916–17, in which elements discreetly harking back to Art Nouveau are merged with a classicist foundation and a type of soft sensuality that was Symbolist in nature. Rousseau seemed to take a few formal ideas from Rodin, as can be seen in the undefined form that emerges from the marble, but without the expressive aggressiveness of the French sculptor, and without the almost extreme simplification achieved by Minne.

Henri Rousseau
Portrait of a Lady, circa 1895
Oil on canvas, 160 × 105 cm
Paris, Musée National Picasso

Paris 1900–1910

At the start of the twentieth century, Paris was the acknowledged centre of European art, and even the most important outlying schools had learned to take their measure against the city. Although Delacroix had still felt the need to journey to England as part of his development, only a couple of generations later it was the turn of artists like the Italian Macchiaioli and Divisionists, Edvard Munch and James Abbott McNeill Whistler to look to Paris or travel there. Obviously, even in France, not everything happened in Paris: indeed, one characteristic of the Post-Impressionist generation was specifically the flight from the city in a quest for remote places suited to solitary research. And yet everything converged upon Paris: it was the site of the major museums, of the institutions that promoted contemporary art and, above all, of the art market and art critics. In this connection, it is interesting to note that every avant-garde movement that was born in or passed through the capital always had its own art dealer and literary supporters, and figures such as Ambroise Vollard, Henri Kahnweiler, Guillaume Apollinaire and Gertrude Stein played decisive roles in the gestation and success of the avant-gardes.

Another element that contributed to Paris' central role was the busy exhibition calendar, where the stale old official fare of the Salon and the radical ideas of the leading galleries were mediated by the activity of the two independent Salons: the Salon des Indépen-

dants, founded in 1894 by an association of artists including Seurat and Signac, and the Salon d'Automne, founded in 1903.

At the turn of the twentieth century, the power of this myth was measured primarily by the magnetism of the French capital, which attracted artists from around the world. Some, such as American painters and future Mexican muralists, spent only a brief time there, though for one and all that stay had crucial importance. For others, such as Vasily Kandinsky or the Italian Futurists, the journey to Paris took place at an advanced phase of their development, almost as if to confirm the validity of the path they had pursued up to that point and to search for a new point of departure. But for a great many, for the most part from Eastern Europe and the countries that neighbour France, the trip to Paris was tantamount to immigration: for example, Amedeo Modigliani (1906), Gino Severini (1906) and, later, Giorgio de Chirico from Italy (1911); Marc Chagall (1910) and Chaïm Soutine (1911) from Russia; and Constantin Brancusi (1903), Alexander Archipenko (1908), Kees van Dongen (1900), Frantisek Kupka (1896), Sonia Delaunay Terk (1905), Louis Marcoussis (1903), Jacques Lipchitz (1909) and Osip Zadkine (1909). All these artists lived in the city at length and established their own ateliers there. An important nucleus, considering the role that it would play in the development of the avant-gardes, was provided by the Catalonians, who created a full-fledged community of their own in Paris. Pablo

Paul Gauguin
Aha oe feii? (What! Are You Jealous?),
1892
Oil on canvas, 68 × 92 cm
Moscow, Pushkin Museum
of Fine Arts

George Seurat
*A Sunday Afternoon on the Island
of La Grande Jatte*, 1884–86
Oil on canvas, 207 x 308 cm
The Art Institute of Chicago

Picasso arrived in 1904; Juan Gris, actually from Madrid, followed him in 1906 and entered into the same Bohemian lifestyle. Aristide Maillol, a generation older, came in 1882. He developed a Synthetist style of painting that owed a great deal to Gauguin and the Nabis, whom he knew and frequented; it was only around 1900 that he began to work in sculpture, inaugurating a forty-year career that clove closely to tradition. Julio Gonzáles, who arrived in Paris in 1900, debuted as a painter, with a line of research very similar to that of Picasso in the Blue and Pink periods, at least in the choice of subjects, atmospheres, and ways of treating the body. The son of a goldsmith, he also created sculptures that were innovative in terms of technique, having borrowed from goldsmithery the technique of cold moulding, but also very traditional in terms of language. In 1927 began to work on sculpture in welded iron, on the one hand developing Cubist concepts, and on the other heralding creations that were already avowedly informal.

Most of these artists found places to live in Montmartre or Montparnasse, hung out in the same bars and cafes, had their studios in the Bateau-Lavoir, and shared the same Bohemian life style. The aesthetic and cultural horizon within which they were working consisted of the heritage bequeathed by the great names of Post-Impressionism, though with a few differences. The teachings of Van Gogh, with his vivid expressionism and powerfully individual style, did not yield much fruit in his homeland, though it would be fully harvested by Expressionism in Germanic countries. Toulouse-Lautrec resonated with the early works of Picasso, who was newly arrived from Spain, and, tangentially, the very earliest Modigliani. But the true masters of the new generation were Gauguin, Seurat and especially Paul Cézanne, and it was to them that both the Fauvists and Cubists would turn their gaze. The historic role of Paul Gauguin, who died in the Marquesas Islands in 1903, would be fully unveiled by the retrospective show dedicated to him by the Salon d'Automne in 1906, which was also the year of the consecration of the Fauves: a role that was not resolved merely in a lesson in style, characterised by the use of flat hues, pure colours, and surface arabesques, but primarily in a lesson of culture for the passion that he showed for Oceanic art, and which he was to transmit intact to the avant-gardes. The following year, another banner year for the destinies of modern art, the retrospective show of the Salon d'Automne would be dedicated to Cézanne. In contrast, the im-

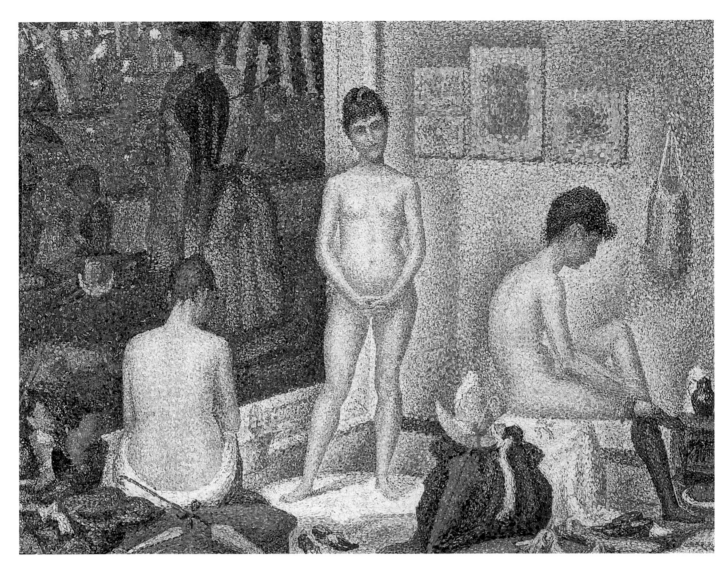

George Seurat
The Models (small version), 1888
Oil on canvas, 39 x 49 cm
London, National Gallery, on loan from
the Berggruen Collection

Opposite
George Seurat
The Circus, 1891
Oil on canvas, 185 x 152 cm
Paris, Musée d'Orsay

portance of Seurat declined during the first years of the decade, and only reached the new generation through the mediation of Signac, a skilled populariser, a friend of Matisse and a protector of the Fauvist generation. A singular figure, an authentic incarnation of the liberty that was felt in a city like Paris, was that of Henri Rousseau, known as Le Douanier; though by birth-date he belonged to the previous generation, the crucial moment of his career came in the first decade of the twentieth century when he won the unconditional admiration of the avant-gardes. Rousseau was self-taught, and he worked for the French Customs bureau until the age of 49, debuting with the independents in 1885 at the Salon des Refusés. The substance of his work, behind the naïve patina, does not differ greatly from the concepts of the great Post-Impressionists: he showed Seurat's careful composition, Gauguin's predilection for bright colours and flat hues, and Cézanne's constructive anxiety. Added to all this, Rousseau showed a gift for

eliminating with relative ease the entire Western tradition, in other words, the perspectival conventions and the methods for construction of figures. This was something that Picasso also achieved following a lengthy process to the same point, but he used an intellectual approach mingled with an envy for Rousseau's immediacy This was conferred by Rousseau's ingenuity and the fact that he was a genuine primitive. Picasso was one of his great admirers, going so far as to buy one of his paintings, *Portrait of a Woman* (1895). And it is easy to understand why: Rousseau had developed a new lexicon, and he had done so with the pure power of intuition, whereas Picasso was laboriously seeking the same thing in Iberian sculpture and in Cézanne. It seems that Rousseau did his portraits with the use of an unusual and completely intuitive process, measuring the limbs of the subject so as to portray them in scale, and bringing his palette close to their faces to match their complexion: at least, this was true for his renowned portrait of Guil-

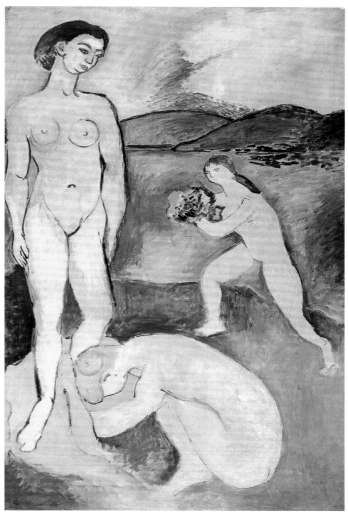

Henri Matisse
Luxe I, 1907
Oil on canvas, 207 x 137 cm
Paris, Musée National d'Art Moderne,
Centre Georges Pompidou

Henri Matisse
Luxe, Calme et Volupté, 1904–05
Oil on canvas, 98 x 118 cm
Paris, Musée National d'Art Moderne,
Centre Georges Pompidou on loan
to the Musée d'Orsay

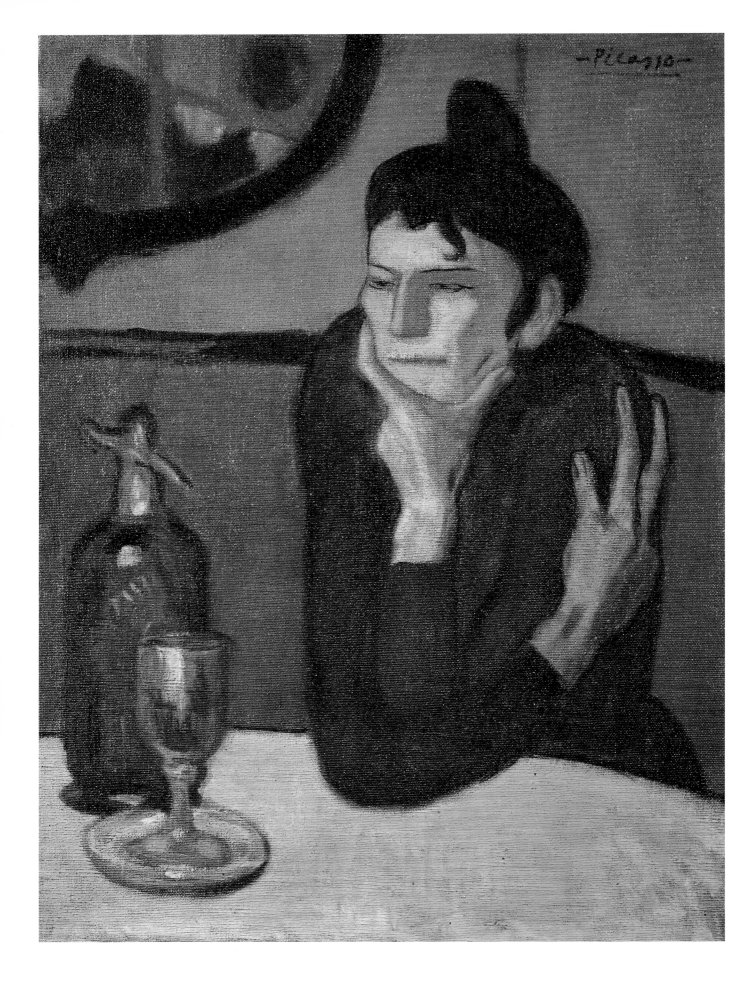

Pablo Picasso
Leaning Harlequin, 1901
Oil on canvas, 82 x 61 cm
New York, The Metropolitan Museum
of Art

Opposite
Pablo Picasso
The Absinthe Drinker, 1901
Oil on canvas, 73 x 54 cm
St Petersburg, The State Hermitage
Museum

Pablo Picasso
Portrait of Jaime Sabartés, 1901
Oil on canvas, 82 x 66 cm
Moscow, Pushkin Museum of Fine
Arts

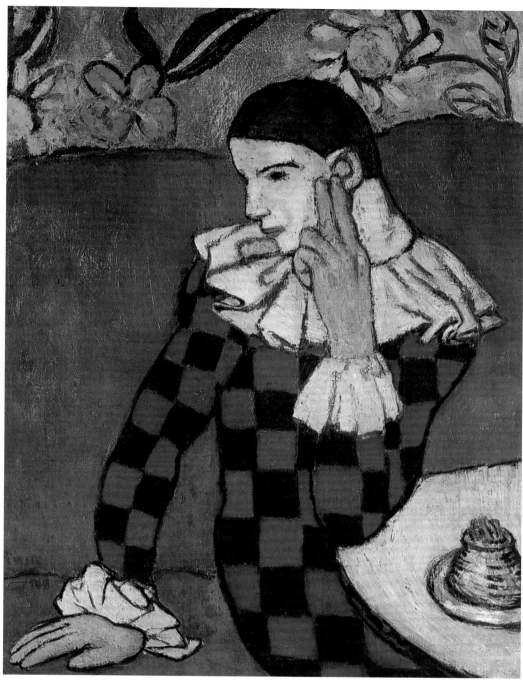

laume Apollinaire, *The Muse Inspiring the Poet* (1908–09). The result, like Picasso's women in 1908, was grotesque mannequins built by dismantling the figure piece by piece and reassembling it on the canvas.

But it was especially with the major narrative paintings, in particular those set in an Orient of the imagination and constructed through book illustrations and the exotic plants cultivated in the Jardin des Plantes, that Rousseau would win the unconditional veneration of the avant-gardes, and not just in France: Kandinsky spoke of 'great realism' and his lesson was fundamental to the Blaue Reiter school. In or-

der to grasp the power and meaning of this fascination, we need only observe a few masterpieces of the series, such as *The Hungry Lion Attacking an Antelope* (1905) and the well-known *Snake Charmer* and *Dream* (1910). In terms of content, Rousseau offers a narrative based on cruelty and suspenseful and unsettling atmospheres: he reveals himself to be an authentic primitive, with a power that was so much greater because it seemed to be extraneous to all cultural mediation, all 'intellectualistic' research. But Rousseau's real strength lies in his conception of the canvas as an independent system, which must be constructed

Henri Matisse
Madame Matisse (The Green Line),
1905
Oil on canvas, 40 x 32 cm
Copenhagen, Statens Museum
for Kunst

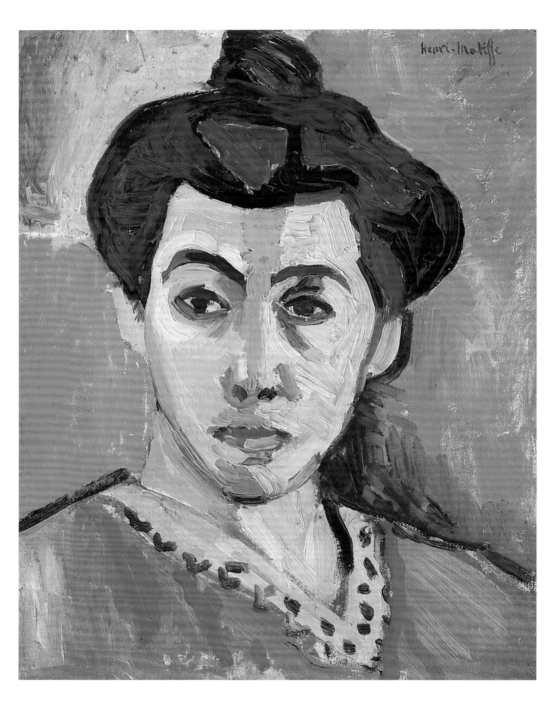

step by step, like a puzzle in which each piece fits perfectly and contributes to the final outcome: a conception that was not extraneous to Cézanne's way of working, but more effective than them inasmuch as they were indifferent to the heritage of any tradition.

The Meteor of Fauvism

It is significant that one of the many legends that has arisen surrounding the term 'Fauve' claims that it was specifically Rousseau's ravenous lion that prompted a critic from *Gil Blas*, Louis Vauxcelles, who was visiting the Salon des Indépendants, to come up with the name that would describe the group of painters who were

exhibiting in the adjoining room. From that moment on, the term Fauves ('wild beasts') would be used by critics to designate a brief, but crucial, period of French painting at the turn of the century. The Fauvist experience has always been viewed as the French version of the Expressionist wave that affected all of Europe in various forms at the turn of the century: this view that may be correct if what we mean by Expressionism, in the broadest sense, is an enhancement of the colour and a simplification of the line in an expressive sense. What was entirely alien to the Fauves was that component of existential disquiet that is considered a crucial element of Expressionism proper: on the

Maurice de Vlaminck
Olive Trees, 1905
Oil on canvas, 55 x 65 cm
Madrid, Thyssen-Bornemisza Museum

other hand, Matisse and his comrades set out, not from the troubled path of Van Gogh, but from the stylistic lessons of Cézanne, Gauguin and Pointillism. It is significant, in this connection, that the only French artist who took his inspiration from Van Gogh was de Vlaminck, since, of them all, he was the only true 'wild beast'.

At the opposite extreme we find the artist rightly considered the key figure of the Fauvist experience, Henri Matisse. One of his thoughts, expressed in 1908, clearly reveals the idea of painting that runs like a thread throughout his entire artistic output: 'What I am dreaming of is an art of equilibrium, purity, tranquillity, without an unsettling or worrisome subject, that might be for every mental labourer … a balm, a mental tranquilliser, something similar to a fine armchair in which to rest from the day's exertions'. This was an ideal that guided even his most radical decisions, and which he failed to respect only in a very few cases.

Matisse's leadership in the Fauvist milieu was not the product, as happened in the other avant-gardes, of a special charisma, or a determination to impose his will, as much as an inborn sense of authority, probably linked to the fact that he was older—at the turn of the twentieth century he was over thirty—and to his balanced, attentive attitude, which was very

stimulating for young artists. He came to painting fairly late and had studied—like many of his fellow painters—in the atelier of Gustave Moreau. The great Symbolist proved to be an excellent teacher and left fond memories in all his students. A great admirer of the art of the past who was also capable of appreciating the qualities of artists very different to him, Moreau was able to impart to them his admiration for the classics, while still encouraging personal styles. In this school, Matisse immediately showed his gifts of being a great draughtsman and having a strong sense of colour. A work like *Male Model* (1900) clearly shows his academic training and the influence of the late Moreau, but also his freedom in exploring other models—such as Cézanne—and a very personal use of colour even at this early date. In 1904, when Ambroise Vollard organised Matisse's first solo exhibition, his qualities as a colourist and his artistic gifts had already won wide recognition. In the summer of that year he went to Saint-Tropez on holiday near Signac's villa. Matisse had already gone through a Pointillist phase at the end of the nineteenth century, and despite his proximity to the great populariser of the division of colours, he was reluctant to return to that path. A key work like *The Terrace of Paul Signac in Saint-Tropez* (1904) already reveals a more confident style, made up of flat hues and characterised by a taste for

André Derain
The Port of Collioure, 1905
Oil on canvas, 60 x 73 cm
Paris, Musée National d'Art Moderne,
Centre Georges Pompidou

Othon Friesz
Woman under a Palm Tree, 1907–09
Decorated ceramics, diameter 24 cm
Private collection

Henri Matisse
The Joy of Life, 1905–06
Oil on canvas, 175 x 241 cm
Merion, The Barnes Foundation

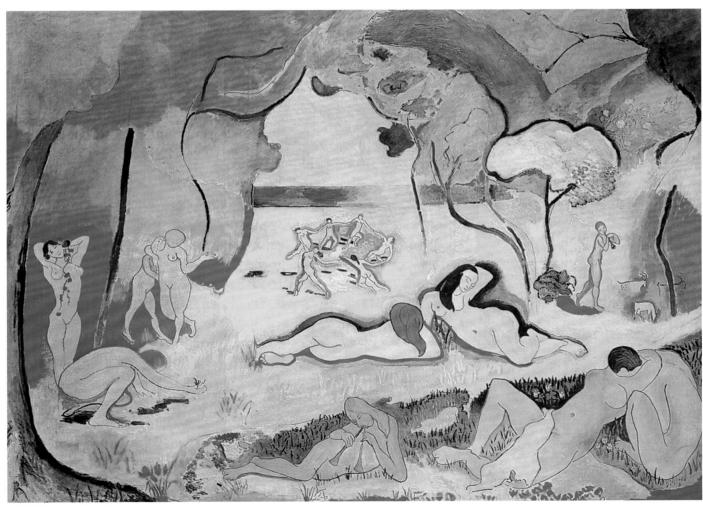

Maurice de Vlaminck
Kitchen Interior, 1904
Oil on canvas, 55 x 46 cm
Paris, Musée National d'Art Moderne,
Centre Georges Pompidou

arabesque lines that certainly harked back to Art Nouveau, and light, muted colours capable of sudden flares of intensity. A return to the Pointillist technique in his subsequent works appears as an expedient for strengthening the colour and adapting it to the light that the Mediterranean atmospheres had revealed to him. The highest point of this research came during the winter of that year: it was *Luxe, Calme et Volupté* (1905), a large canvas into which Matisse distilled the many life studies he had done during the summer. The dots of pure colour were transformed into tiles in a mosaic that fit into a confident, sinuous design. The composition betrays awareness of Cézanne's *Bathers*, but also of the rigorous classicism expressed by Puvis de Chavannes. The colours are bright, but they merge in a persuasive harmony; the contrasts are powerful but not strident: 'It is necessary that the different colours I use be balanced in such a way that they do not destroy one another… The relationship between the colours must be stabilised in such a way that it will lend support rather than demolish them' he wrote in 1908. This discourse can be extended to the lines on which the composition is based, and which balance one another in a dynamic equilibrium. During the same period another large group of painters began to emerge; their distinctive characteristic

lay in the power of their colour. Matisse worked in collaboration with the slightly younger Albert Marquet, his close friend from the time of their apprenticeship under Moreau. A highly skilled draughtsman, Marquet carried on a form of research that was quite similar to, and in many cases every bit as good as that of Matisse, but he failed to develop a fully autonomous naturalism of Post-Impressionist derivation, and this lack can be detected even in one of his finest creations in the heart of the Fauvist period, *The Beach at Fécamp* (1906).

In 1904 Vollard organised the first Parisian solo exhibition for Kees van Dongen, a Dutch artist who had arrived in Paris in 1900. Beginning from a late-Symbolist base, Van Dongen moved to a violent colourism of Expressionist derivation that he applied to a specifically limited series of subjects linked to circus scenes, *cafés chantants* and bordellos. For example, *The Screed* (1905): the dizzying brushstroke, dynamism of the composition and the brilliant colours define it as partly Fauvist and partly anomalous, very close to the German Expressionism with which it also shares the profound decadent atmosphere that informs his paintings. This is created by cold and sulphurous colours, femmes fatales and morbid nudes, from which he would never free himself. Dating from 1907 is the powerful portrait

Henri Matisse
Interior with Aubergines, 1911
Wallpaper and oil on canvas,
212 x 246 cm
Musée de Grenoble

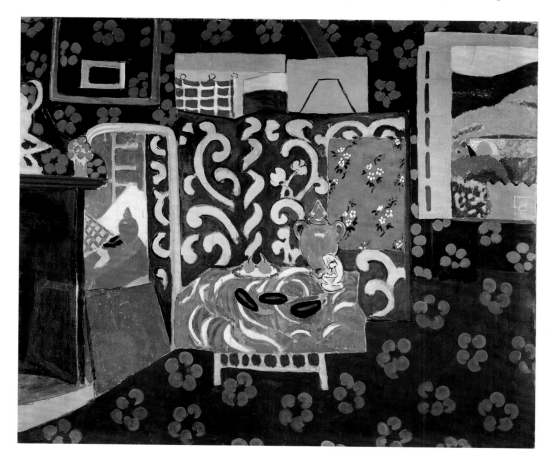

André Derain
Charing Cross Bridge in London, 1906
Oil on canvas, 81 x 100 cm
Paris, Musée d'Orsay

André Derain
Landscape, 1906
Oil on canvas, 84 x 95 cm
Berlin, Neue Nationalgalerie

André Derain
Portrait of Henri Matisse, 1905
Oil on canvas, 93 x 52 cm
Nice, Musée Matisse

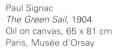

Paul Signac
The Green Sail, 1904
Oil on canvas, 65 x 81 cm
Paris, Musée d'Orsay

of *Daniel Henry Kahnweiler*: the chilly colours and dominant magenta in the background give the German art dealer a vaguely diabolical tone, making him the logical masculine counterpart to the *Salomes* who populate Van Dongen's canvases.

Meanwhile, Maurice de Vlaminck and André Derain were working in Chatou, away from the artistic hurly-burly of the capital, following artistic paths similar to Matisse and Van Dongen. An impetuous country boy with an-archic leanings, de Vlaminck had recently dis-covered Van Gogh, whom he exploded into his already rough and savage style, as in the grotesque *Woman at the Hostelry* of 1900, with her wide mouth, red nose and tousled hair. Matisse went to see them at the beginning of 1905, and invited them to show at the Salon des Indépendants in March of that year. The part-nership with de Vlaminck soon failed, but the young Derain immediately fell under the spell of Matisse's balanced and confident personal-ity and followed him to holiday at Collioure the following summer.

Self-taught, de Vlaminck was the exact opposite of Matisse: he was ostentatiously scornful of museums, he played the violin in dives to make a living, and he always refused to transform painting into a profession; he wanted to be considered 'a painter of the peo-ple', which was one of the reasons he loved Rousseau. In his hands, as Derain put it, the lit-tle tubes of pigment, which he squeezed di-rectly onto the canvas, were 'sticks of dyna-mite'. De Vlaminck wrote a few years later: 'I was a tender-hearted barbarian filled with vi-olence. I was translating, instinctively, without method, a truth that was not artistic, but still human'. The year 1905 witnessed the definitive explosion of his brushstroke: though in a can-vas like the *Restaurant de la Machine à Bougi-val* (1905) he still managed to control his ges-turalness and to attempt a half-hearted Divi-sionism, in his renowned *Picnic in the Country* (1905) it is all a whirling eddy of pure colours, and sabre-strokes of yellows, reds and greens that seem to want to enclose the two lovers in an alcove of warmth and nature. We see this energy again in 1906 in the *Landscape near Chatou* (Stedelijk Museum), in which Van Gogh's vortices are translated into a less-Mediterranean inspiration, balancing the warm colours with chillier hues.

The young Derain found in de Vlam-inck his first, extroverted fellow traveller. But after returning from nearly three years of mil-itary service, he felt the need of a less intrusive foil and decided to follow Matisse to Collioure. Here, at the age of 25, he began a period of feverish work, devoted, until 1907, to an intent and continuous experimentation, which pro-duced an array of varied results always of the highest quality. At Collioure, Matisse persuaded him to start once again using Divisionism, but

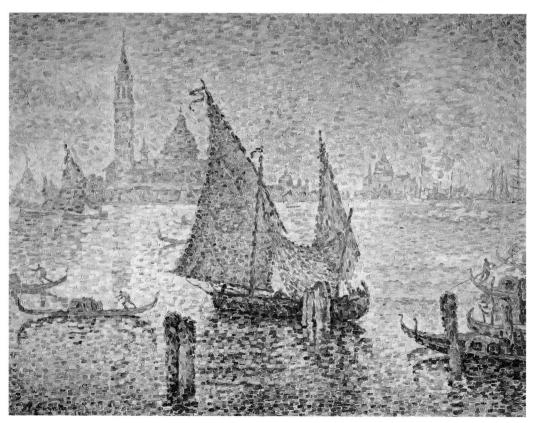

Henri Matisse
L'Algerienne, 1909
Oil on canvas, 81 x 65 cm
Paris, Musée National d'Art Moderne,
Centre Georges Pompidou

Opposite
Henri Matisse
Young Sailor, 1906–07
Oil on canvas, 101 x 83 cm
New York, The Metropolitan Museum
of Art

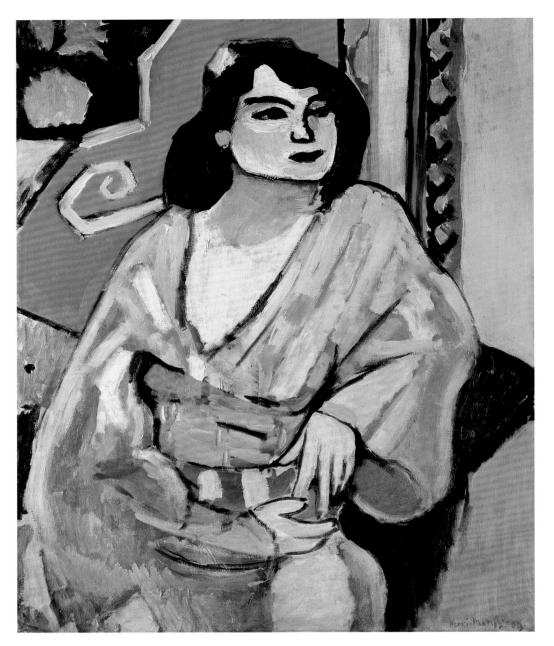

this was a phase that Derain moved past quickly, even more quickly than his elder colleague. A masterpiece such as *The Golden Age* (1905) stands as a 'Baroque' response to *Luxe, Calme et Volupté* and clearly shows the savage, irrational and purely decorative interpretation of the Divisionist brushstroke that the artist utilised: it was a veritable mosaic, in which the juxtaposition of tiles of colour aspired not to an optical fusion, but to a reproduction of the glittering, overheated, and sumptuous surface of a piece of Oriental drapery. Derain derived from it, for the landscapes that followed, a technique that involved a series of chromatic tiles cunningly distributed over the canvas so as to allow the white background to emerge, emphasising the luminosity of the individual compositions. This was the faithful application

of what Derain described, in a letter to de Vlaminck, as the achievement of this period: 'A new conception of light that consists of this: the negation of shadow. Here the lights are very strong and the shadows very light. Shadow is a whole world of lightness and luminosity opposed to light of the sun'. In *The Port of Collioure* every brushstroke seems carefully weighed and instinctive and the persistence of violent, and violently juxtaposed, colours shows how, in the course of a few months, Derain had managed to perfect his own highly personal formula, one capable of finding a balance between de Vlaminck's headstrong work and the profound sense of order in Matisse. Thus, the portraits that the duo painted of one another as a diptych documented an exchange between peers: Matisse captures with great immediacy

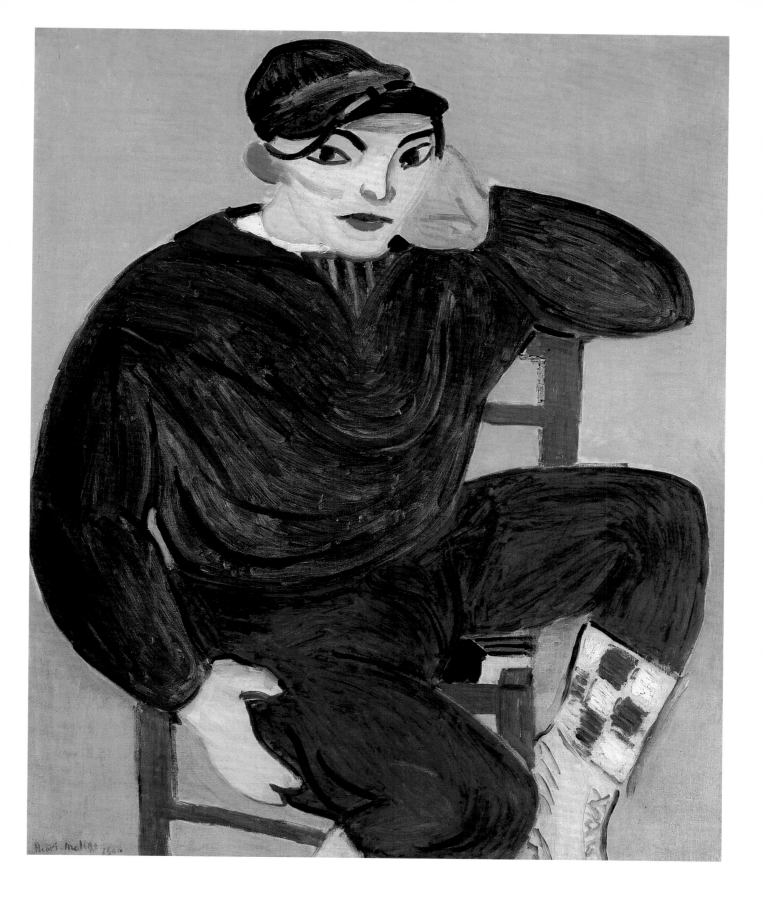

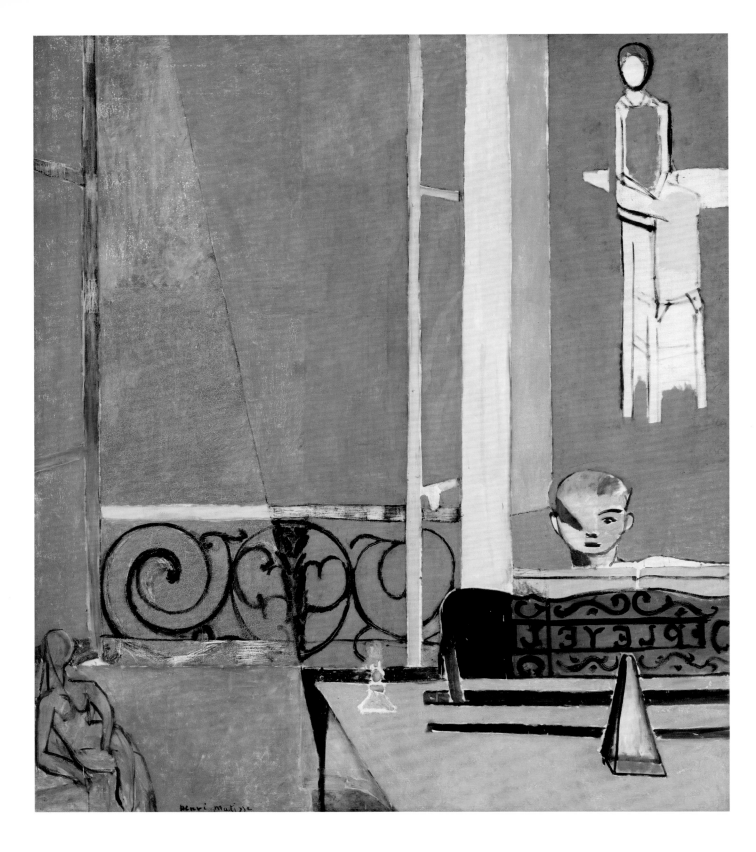

Henri Matisse
Piano Lesson, 1916
Oil on canvas, 245 x 212 cm
New York, The Museum of Modern
Art, Mrs Simon Guggenheim Fund

the youthful lunges of Derain, who is seen in a dynamic pose, and Derain transformed Matisse into a bearded icon, rigidly frontal and defined by confident, rich brushstrokes, which make this portrait, along with Matisse's *Madame Matisse (The Green Line)*, one of the emblems of Fauvism. For that matter, the possession of so confident a style did nothing to prevent him from exploring other paths: for example, his other portrait of Matisse that same year, in which the artist is depicted as a half figure in his atelier, using liquid brushstrokes that replace the usual tiles with broad areas of colour. The result conveys an extraordinary sense of energy, especially given the red of the beard juxtaposed against the white of the face.

With respect to the path followed by Derain, Matisse's approach was slower, more measured: it was thus also better suited to producing definitive results. While Derain con-

sidered himself to be completely cured of it, Matisse continued with the division of colours, though he was fully aware of its inadequacy. It was not until he discovered the late work of Gauguin, whom he studied in the atelier of Daniel de Monfreid, that he was freed of the last residues of Divisionism. This liberation had already taken place in the harmonious *Interior at Collioure*, a large composition in which ample areas of pure colour are juxtaposed, with the few violent hues flanked by more delicate shades of muted pale blues, pinks and greens. The composition is also so solid and balanced that it might suggest an intuitive application of the Golden Section. And even if a few lingering traces of the division of colour persist in the studies for *The Joy of Life*, they vanish entirely in the large and supreme synthesis of this phase, which Matisse executed in winter 1905–06 in Paris. The large composition ex-

Raoul Dufy
Street Decked with Flags, 1906
Oil on canvas, 135 x 75 cm
Paris, Musée National d'Art Moderne,
Centre Georges Pompidou

Pages 130–31
Henri Matisse
Harmony in Red, 1908
Oil on canvas, 120 x 180 cm
St Petersburg, The State Hermitage
Museum

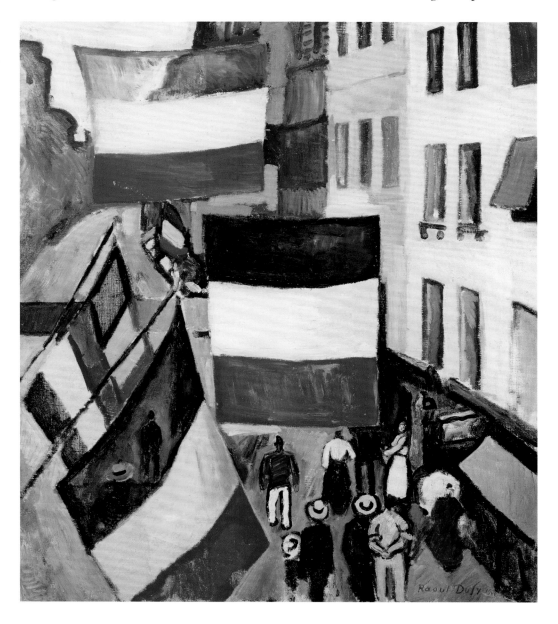

emplifies the artist's predilection for allegorical subjects, already seen in *Luxe, Calme et Volupté*. In that work, the light and anti-naturalistic colours are laid on in broad fields with a liquid and vibrant brushstroke inscribed within precise and sinuous outlines, which are capable of restoring the essential aspect of a form, studied and studied again, and which in the trunks and foliage of trees are sublimated into pure decoration, not for its own sake, but as the consequence of a specific determination: 'Expression, for me … lies in the entire arrangement of my painting… Composition is the art of arranging in a decorative manner the various elements available to painting to express one's emotions… What is not useful in a painting is therefore harmful. An artwork demands an overall harmony'.

The Joy of Life also shows a renewed reflection on the painting of Ingres, to whom the Salon d'Automne of 1905, which witnessed the affirmation of the Fauves, devoted a major retrospective. Gathering around Matisse and Derain, who showed the results of the work they had done at Collioure, were de Vlaminck, Van Dongen and Rouault (though he was never considered a Fauve), Jean Puy, Albert Marquet, Louis Valtat, Henri Manguin and Charles Camoin. Also showing at the Salon was Othon Friesz, a painter from Le Havre who had already become familiar with Matisse, but whose work was still of Impressionist derivation. For him, as for Raoul Dufy and the younger Georges Braque, who were also from the same city, the Salon was a revelation. The trio from Le Havre all studied at the same school under Professor Luillier, and from their first Impressionist efforts they shared a more constructive approach to composition than other Fauves. Braque, who moved to Paris in 1900, had already had an opportunity to study Cézanne, and if the lessons he learned were set aside temporarily in his first Fauvist phase (1905–06), they re-emerged with force, beginning during his stay at L'Estaque. After the 1905 Salon, he stayed briefly in Antwerp with Friesz. If we look at the paintings they did side by side, such as *The Port of Antwerp* (1906), we notice in Braque a predilection for lighter, more luminous and less contrasting hues, as well as compositional solidity. Friesz was, in contrast, more impetuous and Expressionistic, applying darker and more contrasting colours with his distinctive brushstroke. Dufy, on the other hand, worked with Marquet, painting the same subjects together. In their respective versions of *Posters at Trouville* (1906), the chief differentiating elements are the composition—more balanced in Marquet, more lively and vivid in Dufy—and the use of

Pablo Picasso
Self-Portrait, 1907
Oil on canvas, 50 x 46 cm
Prague, National Gallery

Opposite
Pablo Picasso
Portrait of Gertrude Stein, 1906
Oil on canvas, 99 x 81 cm
New York, The Metropolitan Museum
of Art

colour—lighter and more Mediterranean in the former, more northern and chillier in the latter, with a prevalence of dark and light blues.

In October 1906 Braque moved to L'Estaque in the south of France where he would often spend time until November 1907. Here, in the places familiar to Cézanne, he began to meditate on his painting again. In works like *Olive Tree near L'Estaque* (1906), we see that, though the colours may have remained Fauvist, they became layered, while the brushstroke became more controlled, more subject to the demands of the construction. A greater freedom became evident in his summer holiday at La Ciotat, where he was joined by Friesz. Here Braque developed an increasingly fluid brushstroke organised into arabesques of rapid, curving, practically calligraphic lines (*Landscape at La Ciotat*, 1907). He summarised his Fauvist work in a small jewel called *The Little Bay at La Ciotat* (1907), in which he seems to be paying homage, with great success, to Matisse's *Luxe, Calme et Volupté*. Once he returned to L'Estaque, he began to reflect on Cézanne again, drastically reducing his palette and setting off in directions that were already proto-Cubist.

Braque was not the only one following this path. Derain, who had been put under contract by Ambroise Vollard, visited London on numerous occasions, at the art dealer's suggestion, in 1906 and 1907, where he painted about twenty canvases in one of the most successful periods of his career. *Blackfriars Bridge, London* (1906), shows a remarkable compositional confidence, while the colours, with their violent, contrasting hues, are composed in a chilly harmony. The technique, here as in other paintings from the same period, is confident and almost arrogant. It is a confidence that hints at an approaching moment of crisis, which came upon him at L'Estaque. The Derain of this period was experiencing a confluence of conflicting stimuli, ranging from the work of Gauguin to that of the primitives of the Duecento and Oceanic sculpture. A work like *Dance* (1906) mirrors this tormented path, which led him to indulge in a savage decorativism that remains unique in his production. A way out was offered by Cézanne, who led Derain to the threshold of Cubism: see, in this connection, the *Landscape at Cassis* (1907): the palette is reminiscent of Cézanne, the volumes are simplified and powerful. But Derain, having reached such an advanced stage so early (in contrast with the duo of Picasso and Braque), felt a need to slow down his headlong pace and extend his apprenticeship under Cézanne. Bearing in mind the lessons he was learning

from the primitives, his development throughout the second decade of the century took him to a precocious 'return to order'.

Finally, even Matisse, who had produced his Fauvist masterpiece *The Joy of Life*, inaugurated a new phase in 1906. The difference for him was that it did not mark a crisis but was an acknowledgment of an attainment of maturity. The complete chromatic mastery that he had achieved at Collioure allowed him to mute his colours without reducing their expressive power, and though he continued to look to Cézanne, he did so with the liberty offered him by his confidence in his new tools. Moreover, in 1906, he made the first of a series of journeys to North Africa, which enriched his new style of painting with new harmonies and motifs. In his *Still Life with Red Carpet* (1906), the reference to Cézanne is open, but not scholastic; the execution combines broad and Pointillist brushstrokes in an open-handed manner, while the colours harmonise in a more delicate spectrum, with dark brown making its first appearance. Summer 1907 marks the first version of *Luxe, Calme et Volupté* and *Boy with Butterfly Net*: the figures, circumscribed by a wide, dark brushstroke, occupy broad fields of colour that tend to uniformity but which are at the same time vibrant. The path was blazed for the fluid, confident line and the broad fields of sharply contrasting colour in the large decorative panels executed in 1910 that are now in the Hermitage Museum in St Petersburg. The *Dance*, in particular, even if it is taken from the central portion of *The Joy of Life,* becomes, with the unleashed rhythm of the composition and the savage power of the colour, the most Fauvist work of an artist who had by this point moved past Fauvism.

The Salon d'Automne of 1906, which marked the group's triumph, also inaugurated the end of this short season and the beginning of a series of projects that found their common denominator in the interest for primitives and Cézanne, nearly all of them flowing into Cubism. The brevity of this experience, along with the scarce influence that it would have on the direction followed by many who had taken part in it, has led some to speak of Fauvism as a 'failed revolution' and as a transitional phase between Post-Impressionism and the true avant-gardes. In his history of Cubism, John Golding points out that even in the second decade of the twentieth century the most noted artists exhibiting at the Salon d'Automne remained Bonnard, Vuillard, Denis and the Pointillists Signac and Cross, while Impressionism had become a sort of lingua

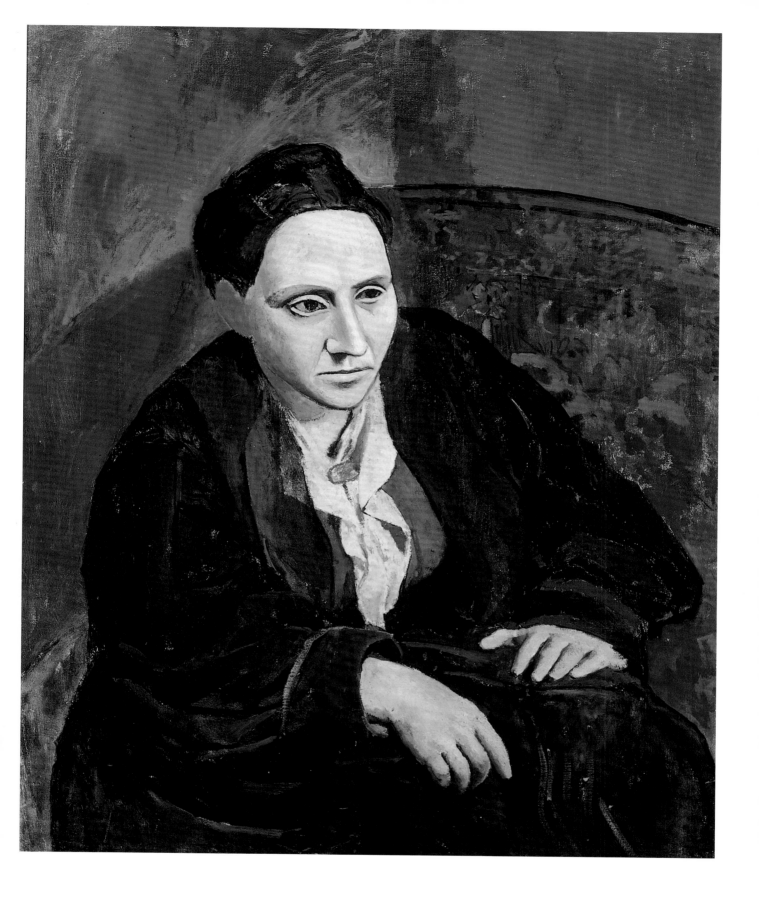

Henri Rousseau
Snake Charmer, 1907 (detail)
Oil on canvas, 169 x 189 cm
Paris, Musée d'Orsay

franca; this was the art establishment that the Fauvist generation had not experienced much difficulty in fitting into. And it is no accident that it was Cubism rather than Fauvism that was immediately perceived as the definitive reaction to Impressionism, yet the Fauvist generation should be given credit for having led, and prepared, this transition. It was in the Fauvist milieu that Derain began to think about Cézanne and the primitives, and it was in the Fauvist milieu that Braque decided to work at L'Estaque; it was in conscious opposition to Fauvism that Picasso sank ever deeper into the quest that would lead to the creation of *Les Demoiselles d'Avignon*.

The Poetics of Cubism

Pablo Picasso arrived in Paris for the first time between October and December of 1900. He returned in June 1901 for his first solo exhibition organised by Ambroise Vollard, at which nearly all the sixty-four works were sold. In this phase, Picasso's style was marked by a brilliant eclecticism that led him to take inspiration variously from Toulouse-Lautrec, Van Gogh, Bonnard and Steinlen, and even the occasional use of Divisionism: he executed, as Max Jacob put it so well, 'many intentional imitations in order to be sure he never made unintentional imitations'. It represented the linguistic

updating of an artist with a solid academic education, already modified by his encounter with the Catalonian modernism of the Quatre Gats. Picasso's Blue Period, which began in Paris at the end of 1901, was mostly developed in Barcelona, where the artist lived until the spring of 1904 except for a brief Parisian interlude in winter 1902–03. In reality, the death of his friend, the poet Casagemas, explains only a part, perhaps the less interesting part, of his new pictorial language. This was composed of sadness, sentimental and pathetic subjects, the Bohemian life that he led in a sort of Cours des Miracles made up of prostitutes, beggars and sick children, and the occasional slippage into the facile allegory of late-Symbolist derivation. Indeed, in the light of his later development, it is not so important that he chose a particular colour or subjects, as much as that he chose a monochrome. When Picasso began his feverish search for the formal medium best suited to express a given element, the first thing that he did was to eliminate colour. That done, he could work on style, which was fairly discontinuous in the Blue Period, with frequent lapses into academism, but which at its finest moments focused on a highly effective simplification of volumes with an expressive function. In particular, simplification seemed to be aimed at weighing down the bodies, folding them in

Pablo Picasso
Factory at Horta de Ebro, 1909
Oil on canvas, 53 x 60 cm
St Petersburg, The State Hermitage Museum

Opposite
Pablo Picasso
Les Demoiselles d'Avignon, 1907 (detail)
Oil on canvas, 243 x 233 cm
New York, The Museum of Modern Art, Acquired through the Lillie P. Bliss Bequest

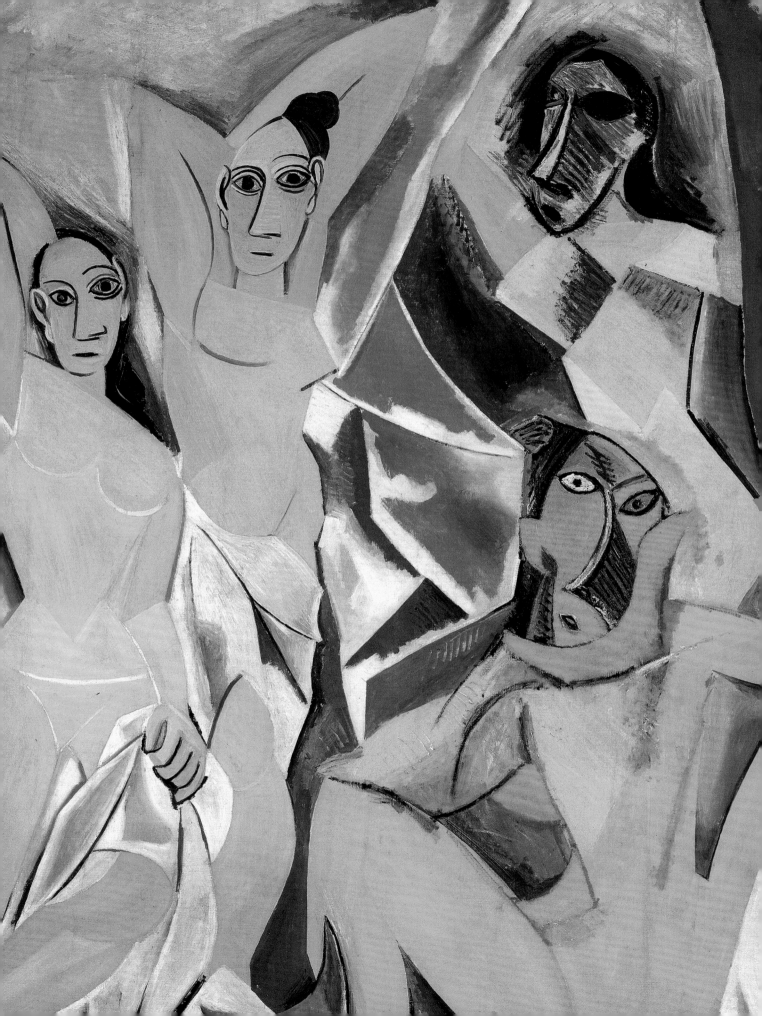

Pablo Picasso
Les Demoiselles d'Avignon, 1907
Oil on canvas, 243 x 233 cm
New York, The Museum of Modern
Art, Acquired through the Lillie P. Bliss
Bequest

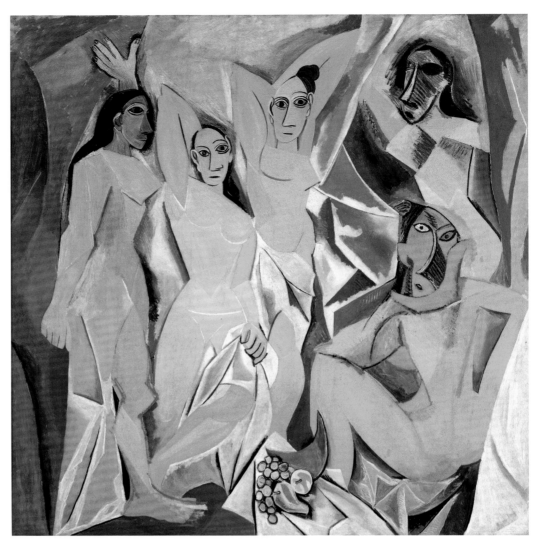

upon themselves in cocoons of melancholy: consider the rough volumes of the *Portrait of Jaime Sabartés* (1901), or the two unsettling subjects of *Two Women Seated at a Bar* (1902), both of which belonged to Gertrude Stein: here Picasso renounced exhibitions of virtuosity in which he indulged when he lingered on a flayed foot or hollow-cheeked face, and focused on two heavy masses. These he rendered more effective by portraying them from behind, thus denying us their gaze. It is significant that right in the middle of the Blue Period Picasso should execute one of the outstanding creations of the period, the *Woman Ironing* (1904) in grey and ochre, in which pathos is set aside in favour of the construction of solid form. The painting derives its power precisely from its renunciation of the academic norm. But, like the successive phase, the Blue Period was also important for another reason: by choosing a single colour, making occasional use of academic elements of style, and selecting his subjects carefully, Picasso was deliberately placing himself outside of the Im-

pressionist and Post-Impressionist tradition, within which the Fauves had remained. If, for the moment, it produced contradictory results, blending innovation and conservatism, this choice, carried forward with consistency, was to become the indispensable premise, through Cubism, for the definitive surmounting of a revolution which had been important, but which now threatened to block, with the weight of its heritage, all and any possible evolution. The Pink Period was nothing more than the natural evolution of this research, when his depression following the death of his friend Casagemas and his Bohemian life were replaced by happiness at his relationship with Fernande Olivier and his newfound sense of security arising from his definitive move to Paris. Picasso rented a studio in the Bateau-Lavoir, a large, run-down wooden building where many other artists had taken refuge; he frequented such writer friends as Max Jacob and Guillaume Apollinaire, and even though it was not yet possible to speak of economic security for him, certainly the support of an art dealer like Am-

broise Vollard and the appreciation his work met with in Paris placed him in an enviable situation compared to other artists. His palette lightened and melancholy blues were replaced by a livelier polychromy, harmonising with his use of ochre and pink. The subjects still came from the same 'Cours des Miracles' illustrated in the Blue Period but now they were viewed from a different, more serene and clear-eyed standpoint. In formal terms, his style was not yet unified, and a more intense reflection upon volumes was at times replaced with a manifest trend towards flattening and refinements still of academic derivation, evident for instance in *Harlequin's Family with an Ape* (1905), which was clearly inspired by the traditional iconography of the *Madonna and Child*. For that matter, the artist tended to develop areas of research that were absolutely independent: and if they took place within the same chromatic and thematic horizon, this does not mean that the Pink Period was a phase of stasis and uniformity of language; on the contrary, it was during that period that he forged and nourished many future lines of experimentation. Thus, if his line of academic and Symbolist derivation, which seems to look back towards Puvis de Chavannes, had its masterpiece in the large *Family of Saltimbanques* (1905)—with its confident composition that balanced the compact, chiaroscuro group on the left against the deli-

cate figure crouching on the right, and with its refined draughtsmanship and colouring—that entire period is crisscrossed by a line of more hidden research that, through the massive volumes of *Acrobat on a Ball* (1905) and the *Actor* (1905), continued in his paintings of Gosol (1906) and the adventurous episode of the *Portrait of Gertrude Stein* (1906). In all of these paintings, the expressive qualities of volumetric mass and composition tend to overwhelm the academic definition of the bodies, to the point of imposing evident deformations, such as the squared shoulders of the acrobat and the hump-backed figure of the wide-hipped and skinny-armed actor. Their allure lies in the fact that in them we see a line of research emerging that leads nowhere and which is offered no niche in the cultural models available to Picasso at that time.

The artist needed a full-fledged revelation, identifiable more in the discovery of the Iberian sculptures seen at the Louvre than in the study of Cézanne's work, and verified against the harsh Catalonian landscape of Gosol and the Romanesque frescoes. And so, dissatisfied after about eighty sittings, he interrupted work on his *Portrait of Gertrude Stein* and completed it, from memory, in a single day after returning from Spain. The colours are those of the late Pink Period, which replaced the more diffuse and sentimental earth tones and

Georges Braque
Port Miou, 1907
Oil on canvas, 50 x 61 cm
Milan, Civiche Raccolte d'Arte,
Jucker Collection

Pages 138–39
Georges Braque
Trees at L'Estaque, 1908
Oil on canvas, 72 x 58 cm
London, Tate Modern Gallery

Georges Braque
The Viaduct at L'Estaque, 1908
Oil on canvas, 70 x 57 cm
Paris, Musée National d'Art Moderne,
Centre Georges Pompidou

Raoul Dufy
Trees at L'Estaque, 1908
Oil on canvas, 56 x 46 cm
Marseilles, Musée d'Art
contemporaine

ochres of the early period; the face, instead, is a mask with a completely new plasticity, thin lips, asymmetrical eyes as if carved in wood, and an unresolved ear. It does not resemble the model which, as Picasso said, would in any case wind up resembling the painting: but it does convey the determined attitude, the powerful gaze, the way that she took possession of space. The next step consisted of his *Self-Portrait* of 1907: the gaze is the same, but the volumes are further simplified, and the colours, with the elimination of any lyrical characterisation, become pure chromatic material, referring to nothing but themselves. At this point, the road lay open to *Les Demoiselles d'Avignon.* This large painting was begun in the spring of 1907 and, in the process leading from the first studies to the definitive—and necessarily incomplete—version, it would seem to offer a synthesis of the years that went before. The initial idea was that of a strange allegory of life and death, with five female nudes, a man with a skull in his hand, a student, and a still-life in the foreground: it is a sort of a cross between the *Sacra Conversazione* of Renaissance tradition, Édouard Manet's *Luncheon on the Grass* and Cézanne's *Bathers.* Progressively, as his experimentation into form continued, the content moved into the background, details vanished, and the figures became more and more monumental. At the end of the lengthy process, documented by a series of sketches and preliminary drafts, what remained were the shapes of five nude women that burst forth energetically from a light-blue drapery. Or perhaps, as André Salmon put it, 'masks almost entirely

devoid of humanity. They are not even divinities, or titans or heroes: nor allegorical or symbolic figures. They are pure problems, white numbers on a chalkboard'. But the equation deriving from it is not solved, or perhaps Picasso bundles together on the canvas all the possible solutions; and when he turned the canvas against the wall of his studio in the Bateau-Lavoir, this was not a finished work, but a 'field of battle' marked by all the problems that he had tried to address there. 'This was the beginning of Cubism, its first casting', wrote Kahnweiler, the first one not to express a negative reaction to the painting, immediately buying studies and sketches of it. 'A desperate battle, an assault on the sky, taking on all the problems at once. And what are these problems? They are the fundamental problems of paintings… It is not a pleasing "composition", but an inexorable and articulated structure'. The bodies are flattened, devoid of chiaroscuro, hewn with an axe and recomposed on the flat surface of the canvas in accordance with a new order, now relegating the steel drapery to the background, now interpenetrating with it or allowing it to move to the foreground. But the most shocking component of the painting, its radical new aspect, are the faces of the five women. Ultimately, as Salmon says, the intellectual public of the time had already been accustomed by Cézanne, Matisse and Gauguin to the deformation of the body. The problem, he said, arose when a smile became a grimace, when good taste was 'repudiated as an inadequate standard'. It was precisely these grimaces that were not accepted and by that very milieu that boast-

Pablo Picasso
Woman with Mandolin, 1909
Oil on canvas, 92 x 73 cm
St Petersburg, The State Hermitage
Museum

Pablo Picasso
Girl with Mandolin, 1910
Oil on canvas, 100 x 73.6 cm
New York, The Museum of Modern
Art, Nelson A. Rockefeller Bequest

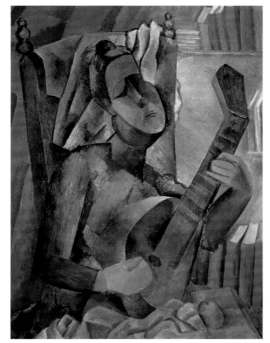

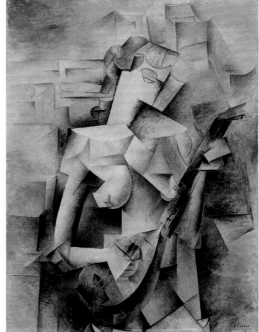

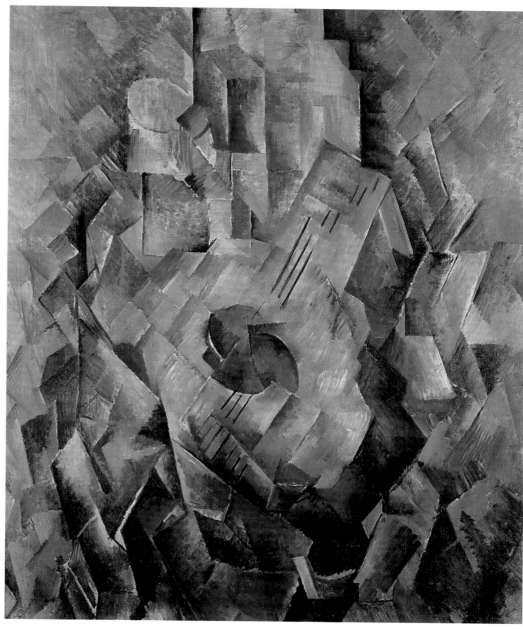

Georges Braque
Mandola, 1910
Oil on canvas, 72 x 58 cm
London, Tate Modern Gallery

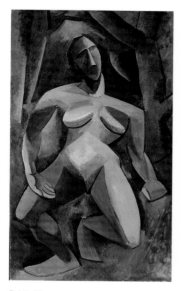

Pablo Picasso
The Dryad, 1908
Oil on canvas, 185 x 108 cm
St Petersburg, The State Hermitage
Museum

ed of having been the first to admire African and Oceanic sculpture. Matisse, Leo Stein, Derain and Braque himself stood in front of the painting and decided that Picasso was venturing onto untenable ground, when, from his point of view, he was simply proceeding from the assumption of African sculptures as a new model of thought and a gaze upon the world, freeing them from their role as being simply objects to be collected. Picasso was not interested in the magical value of these sculptures, or the entirely literary mystery that issues from them, but their method of depicting the human body. This was not a fascination linked to a love for the primitive and the diverse, but a plastic revelation that led him to repaint the faces of the two figures on the right, attempting a pictorial translation of this new model:

with a liberty and an expressive force which he would not attempt again for years, channelling the fury that produced *Les Demoiselles* into the slower paths of a method that found a development, canvas after canvas, of that which he attempted to resolve at a single blow, accumulating, as he was later to say, 'a summation of destructions'. In response to the question of who can be called the father of Cubism, the best answer came from Picasso himself, when he said: 'Braque is my wife'. With a witticism, the artist pointed out that it takes two to have a child and that both parents played a decisive role in its creation. Braque, the 'mother' of Cubism, remained, like everyone else, astonished by Picasso's large painting, but in it he also intuited a new step forward in the research that he and Derain were carrying forward at

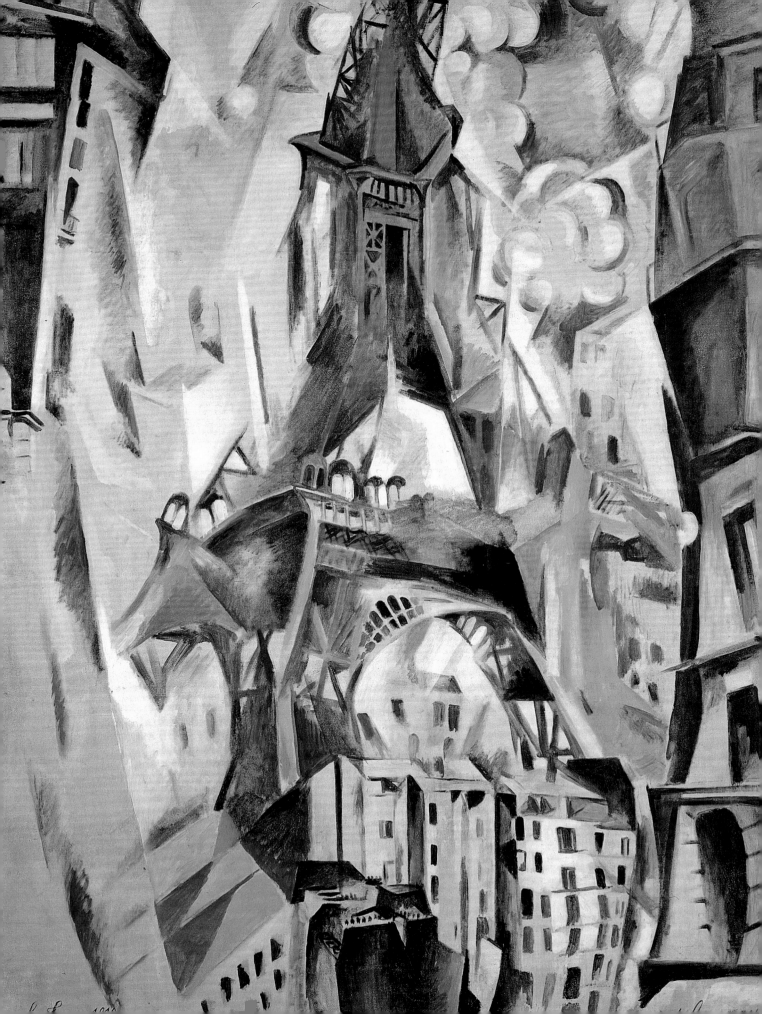

Georges Braque
Still Life with Clarinet, Fan and Grapes,
1911
Oil on canvas, 54 x 43 cm
Rome, Galleria Nazionale d'Arte
Moderna e Contemporanea

Opposite
Robert Delaunay
The Eiffel Tower, 1910 (detail)
Oil on canvas, 202 x 139 cm
New York, Solomon R. Guggenheim
Museum,Gift of Solomon
R. Guggenheim, 1937

Pablo Picasso
*Memories of Le Havre (Violin, Glass,
Pipe and Inkpot)*, 1912
Oil on canvas, 81 x 54 cm
Prague, National Gallery

L'Estaque, in the wake of Cézanne. In fact, 1907 could be called the year of Cézanne. The major retrospective show of the Salon d'Automne powerfully attracted attention to him and his great formal lesson. It was not that previously he had been unknown amongst the avant-garde: but, just when the power of the Fauvist ideas was beginning to fade, the exhibition cast a strong and favourable light upon his great mastery and wound up answering questions that the Fauvist dissolution had made more pressing. Even Matisse, who years before had purchased the *Three Bathers* (1879–82), now at the Petit Palais, seemed to look on his work with new eyes. But the one who took the longest step on the road to Cézanne at this point was unquestionably Derain, because during his time at L'Estaque he drastically reduced his palette and simplified the master's prismatic volumes to the point of designing broad planes that only roughly sketch out the forms. The power of this simplification was a product, certainly, of his combing elements of Cézanne with those of his beloved primitives. This is shown, perhaps even more than by the paintings, by his sculptures of this period, such as the powerful *Crouching Figure* (1907), a cube of stone just roughed out to form a monumental figure concealing its face between its knees. In comparison, in 1907 Braque seemed to move towards a cautious Cézannism, albeit in rapid evolution. In *The Viaduct at L'Estaque*, the oblique brushstroke designed powerful, squared-off volumes; even the light blue that emerged almost everywhere, mixed with the yellows and greens, seemed to obey the Cézannian dictate of placing some light-blue in all of the elements of the composition in order to create an atmospheric filter. The acid and unnatural chromatic range remains Fauvist. But by the time of the *View of L'Estaque from the Hotel Mistral*, this last heritage had been definitively overcome with the emergence of greens and earth tones. Familiarity with *Les Demoiselles* did not seem to introduce any sharp shifts in direction on this path but it certainly offered an encouragement to continue with confidence. And when, at the turn of the year, Braque decided to respond to Picasso's provocation,

he did so with moderation, yet with confidence, free of any attempt to emulate the Spaniard's stylistic elements. If the *Large Nude* (1908) seems less revolutionary than *Les Demoiselles*, this is essentially a result of his avoiding any references to primitive sculpture, which in fact never formed part of his cultural models. But Braque's strength lay precisely in the way he moved forward consistently and steadily, leading him—in the definition of body and in the relationship with space—to go beyond Picasso, as is shown by the difficulty one has in determining the figure's position: is she lying down or standing against the drapery background? In contrast, in this phase Picasso seems to slow his pace, as if checking a whole series of steps that he took for granted in *Les Demoiselles*. In order to understand this, it is enough to compare his nudes in this period with Braque's *Large Nude*. *The Dryad* (1908) is certainly more violent and shocking because of the savage exhibition of the sexual attributes and the deformation of the faces, but the outlines are much more clearly defined and their relationship with space is much clearer and more traditional. The same thing can be said about the other works from the same period: what the pair seem to have been doing was progressively realigning their positions as if in preparation for the period in which they would be working side by side. In the figure paintings, Picasso seemed to be gradually getting over his love for primitive sculpture, until ridding himself of it entirely, but not before it could leave a permanent influence on the ways in which he deconstructed. The work that settled that account and symbolically marked the end of Picasso's 'Negro Period', is unquestionably the monumental *Three Women*, executed in the winter of 1908–09. The enormous figures in red earth loom majestically against the greenish background, and the broad fields of colour intersect one another but they remain largely linked to the volumes of the body. These volumes are the heritage of Michelangelo, hinting at the *Prisoners* which could be seen at the Louvre. The faces still showed some influence of the primitive masks, but without that charge of violence that so distinguished *Les Demoiselles*. In the

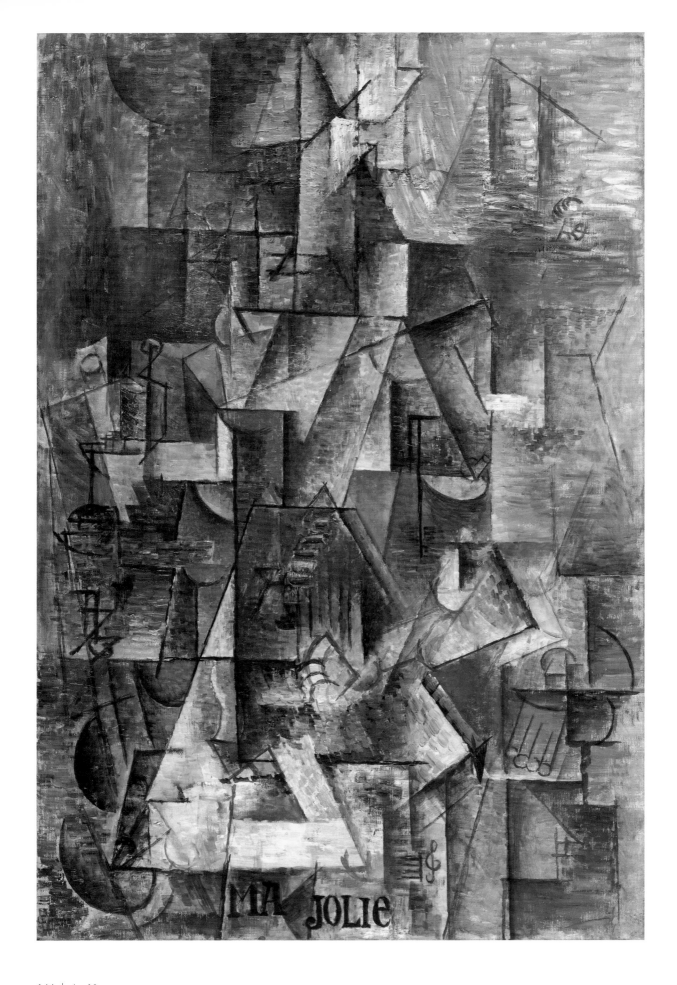

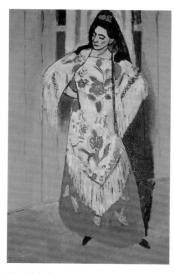

Henri Matisse
Manila Shawl (Madame Matisse), 1911
Oil on canvas, 118 x 75 cm
Basel, Kunstmuseum

Pablo Picasso
Guitar Player, 1912
The Philadelphia Museum of Art,
The Louise and Walter Arensberg
Collection, 1950

Opposite
Pablo Picasso
Ma Jolie, 1911–12
Oil on canvas, 100 x 65 cm
New York, The Museum of Modern
Art, acquired through the Lillie P. Bliss
Bequest

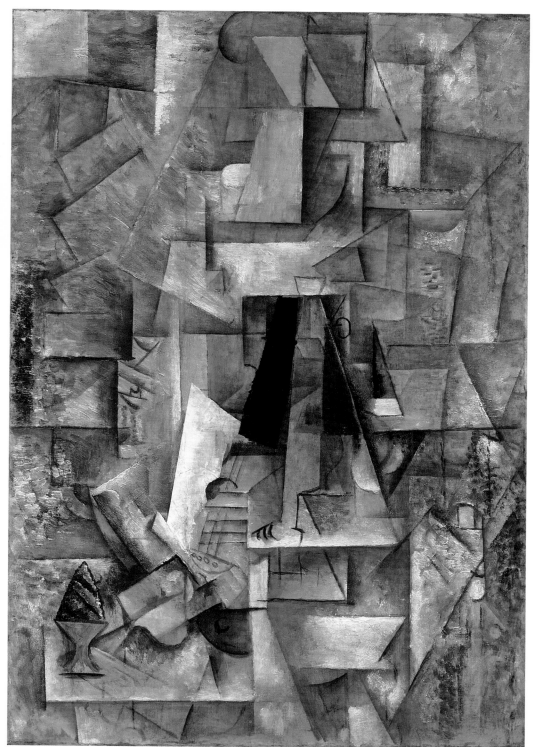

Russian Collectors: between Tradition and the European Avant-garde

The mixing of the revival of tradition and folklore, on one hand, and openness towards the more advanced European artistic trends, on the other, was typical of Russian culture in the early twentieth century and partly determined its subsequent developments. Two important muscovite collectors active at the turn of the century exemplified this dichotomy. Ilya Ostroukhov was a painter of landscapes and linked with the association called the Wanderers; he was a passionate collector of Russian art and brought together a valuable collection that included a superb group of icons. His collection was nationalised in 1918 and turned into the National Museum of Icons and Paintings. Housed in Moscow, the museum had Ostroukhov himself as its director. After his death, the exhibits were inherited by the Tretyakov Gallery, of which he had been one of the administrators.

At the same time as Ostroukhov, another major collector was operating in Moscow, Sergei Schukin, who was an enthusiast of French modernism. A rich cloth merchant, Schukin had studied in Saxony and was a polyglot; another stimulus for his closeness to the cultural climate of Western Europe was his frequent trips to Paris, where he went to visit his brother and where he very soon began to make art acquisitions. In 1897 he saw the works of the Impressionists at the gallery of Paul Durand-Ruel and bought a canvas by Monet, the first to enter Russia. In 1903 his interests gravitated towards Post-Impressionism and then converged on the Fauves and finally Matisse, of whom he was a leading patron, acquiring, among others, *Dance II* and *Music*. In 1911 he even invited the French painter to Moscow so that he could prepare the presentation of his collection, which he then opened to the public.

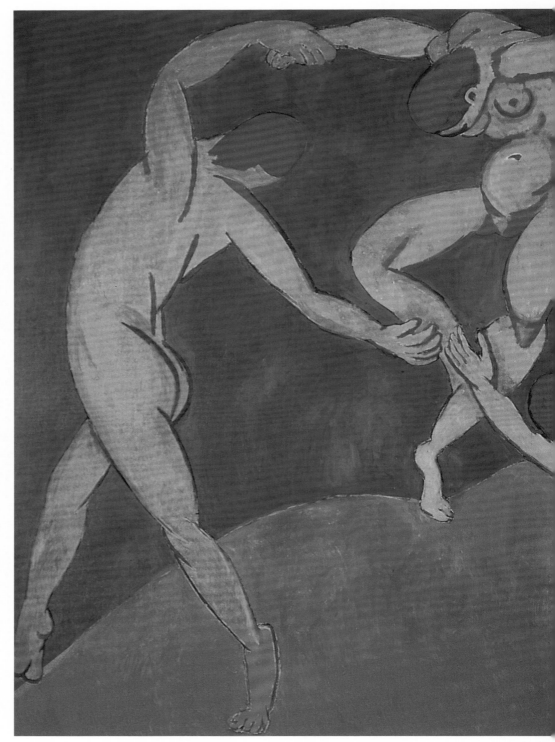

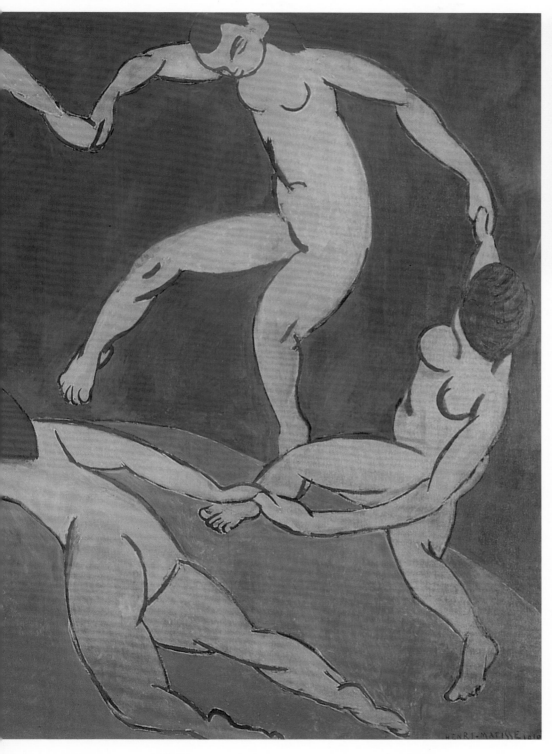

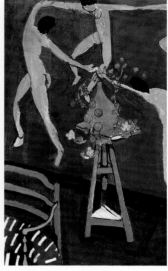

Henri Matisse
Dance, 1909–10
Oil on canvas, 260 x 391 cm
St Petersburg, The State Hermitage
Museum

Henri Matisse
Vase of Nasturtiums with 'Dance',
1912
Oil on canvas, 190 x 114 cm
Moscow, Pushkin Museum
of Fine Arts

Pages 148—49
Henri Matisse
Music, 1909–10
Oil on canvas, 260 x 398 cm
St Petersburg, The State Hermitage
Museum

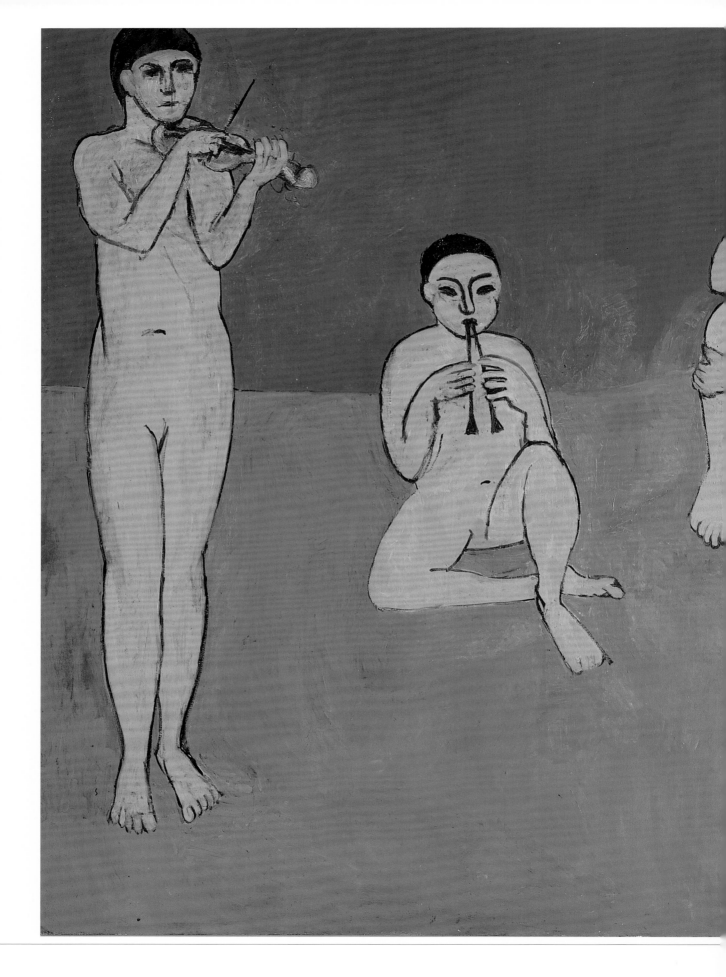

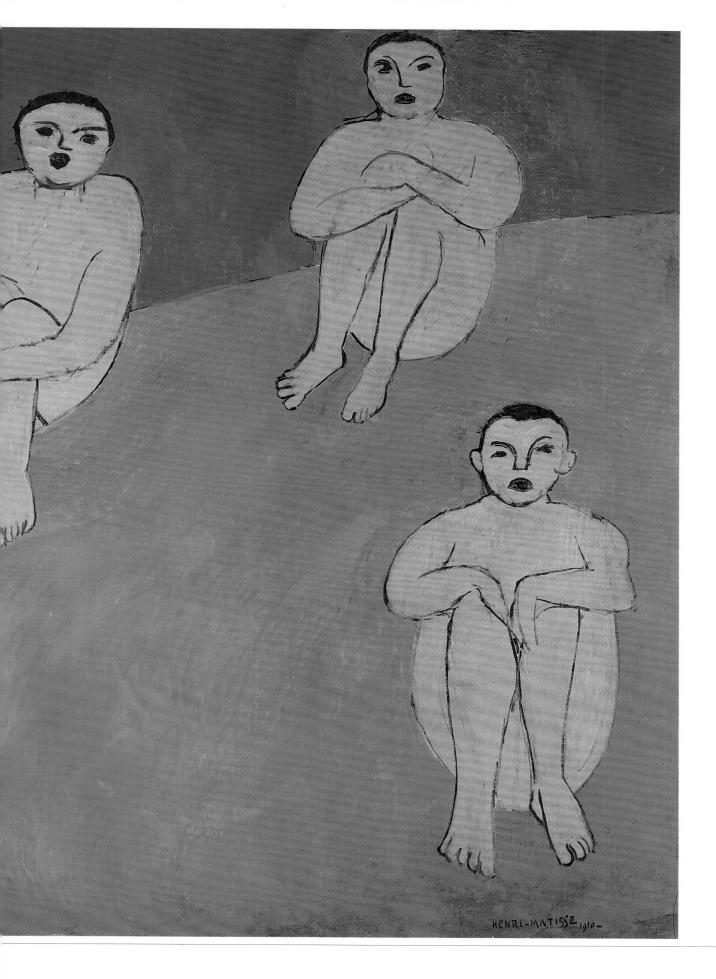

Pablo Picasso
Still Life with Chair-Caning, 1912
Collage of oil, oilcloth, rope, and
pasted paper on canvas, 27 x 35 cm
Paris, Musée National Picasso

figure paintings of the following year, such as the well balanced *Woman with Mandolin* (1909), the reference would vanish entirely. In the landscapes and the still- lifes, however, he carried on a careful meditation on the work of Cézanne, but his colours remained wan and burnt out, less airy than those that Braque was patiently selecting on the basis of the maestro's teachings. Let one painting serve as an example for all of them: *Little House in the Garden*, painted in the summer of 1908 at La Rue du Bois, where he was staying with Fernande: the colours are wan, the forms are geometrical and sharp and closed; while the little house, with its clearly mistaken perspective, transmits an unpleasant sensation of imbalance, which would never have been found in Braque and which looks more to Rousseau than Cézanne. After the *Large Nude*, Braque determinedly abandoned his figure studies and returned to them only rarely during his entire Cubist phase, focusing instead upon the themes of landscape and still life. In the landscapes of L'Estaque, he simplified the volumes, reducing them to fundamentals (cube, cone, cylinder) and setting them like jewels in a vegetation that already tested the path of interpenetration: see, for example, *Houses at L'Estaque* or *Road near L'Estaque*, which both date from summer 1908, in which loyalty to Cézanne did not exclude a clear obsolescence, not in the sense of negation, but rather of a development of his positions. It was in the face of these canvases that Matisse (on the jury of the Salon d'Automne, which rejected them) and Vauxcelles (on the occasion of Braque's one-man show at Kahnweiler's gallery in November 1908) spoke of 'little cube' and 'cubical whimsies'. These two events, with the Indépendants of March 1908, where Braque showed the *Large Nude*, would also be the only public appearance of the nascent trend for some time. Picasso, who had always refused to participate in Salons, avoided solo exhibitions in France and participating in subsequent group shows, while showing frequently abroad: and from this point on, Braque did the same thing. Beginning in the autumn of 1908, the two began to meet almost daily to compare their paintings and to paint together. With good cause, the

term 'workshop' has been used in speaking of Cubism. In effect, Picasso and Braque were no more than two scientists with vision who, independently and with continuous experimentation, came to comparable results, got to know one another, each valuing the work of the other, and deciding to join forces in an effort to limit the chance of error. That such an alliance should have been necessary was the direct consequence of the fact that their path did not proceed from theory to application, but rather from experiment to a practice of painting that contained its own theory without ever finding verbal expression, and that these experiments were invested with the overwhelming task of freeing painting from a tradition dating back many centuries. Until at least 1910 their paths, however interlinked they might have been, remained quite distinct in terms of inspiration and method. It is interesting, in this context, to compare the different results achieved by the pair in the field of still-lifes and landscapes during the summer in their respective holiday spots. *Bread and Fruit Bowl on a Table*, painted by Picasso in 1908–09, is a composition with heavy chiaroscuro, in which the individual details, however deconstructed and arranged due to inaccurate perspective, preserve a certain unity as objects. *Guitar and Fruit Bowl*, painted by Braque at a slightly later date, with its lighter colours that confer a crystalline appearance, and the light, vibrant brushstroke, is apparently more harmonious and balanced: a harmony that almost keeps us from noticing that the deconstruction and the liberation from the 'traditional' representation of objects has attained an extraordinarily advanced stage. Likewise, in the landscapes exe-

Robert Delaunay
Window, 1912
Oil on canvas, 145 x 113 cm
Paris, Musée National d'Art Moderne,
Centre Georges Pompidou

Opposite
Pablo Picasso
The Poet, 1912
Oil on canvas, 61 x 50 cm
Basel, Kunstmuseum

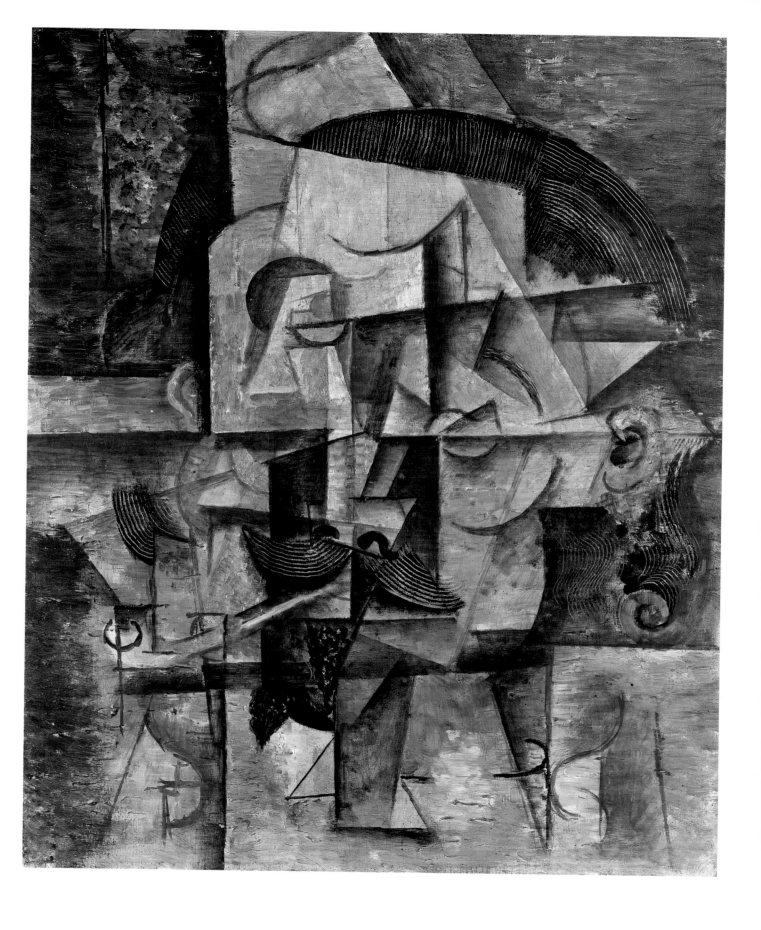

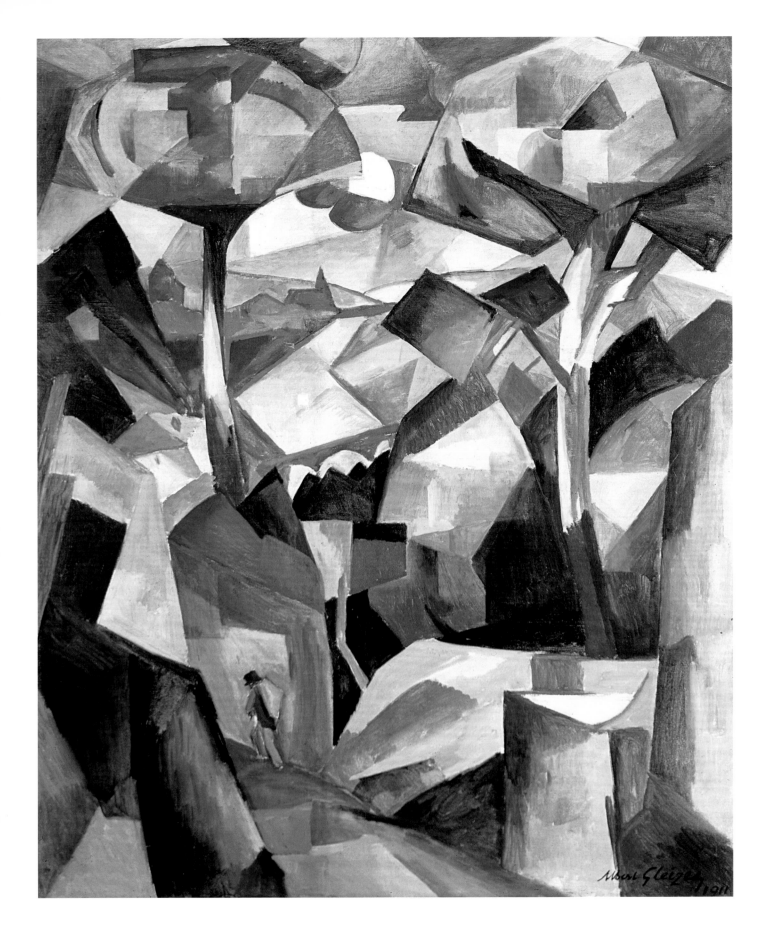

Georges Braque
Mandolin, Violin and Newspaper, 1913
Mixed media on paper, 92 x 65 cm
Private collection

Georges Braque
Young Girl with Guitar, 1913
Oil on canvas, 130 x 70 cm
Paris, Musée National d'Art Moderne,
Centre Georges Pompidou

Opposite
Albert Gleizes
Landscape with Figure, 1911
Oil on canvas, 101 x 90 cm
Paris, Musée National d'Art Moderne,
Centre Georges Pompidou

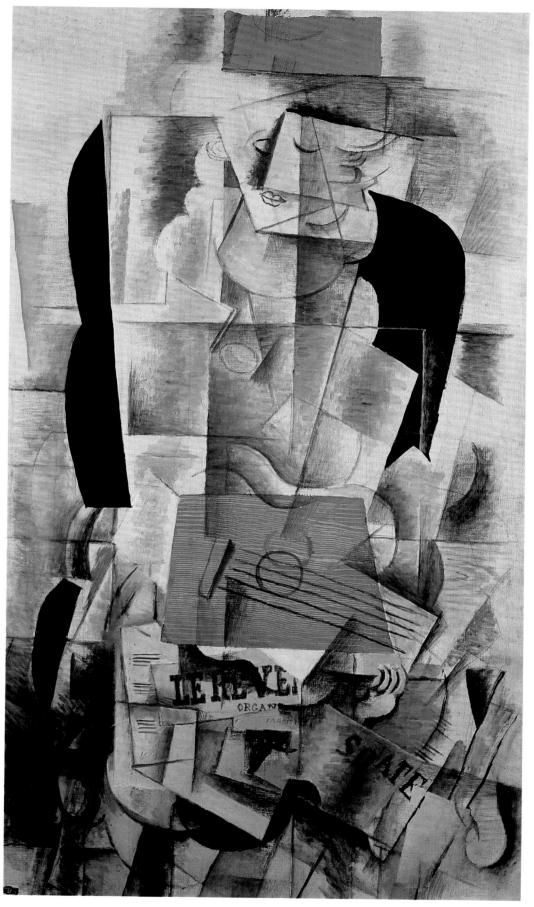

Fernand Léger
Woman in Red and Green, 1914
Oil on canvas, 100 x 80 cm
Paris, Musée National d'Art Moderne,
Centre Georges Pompidou

Opposite
Juan Gris
The Smoker, 1913
Oil on canvas, 130 x 96 cm
Madrid, Thyssen-Bornemisza Museum

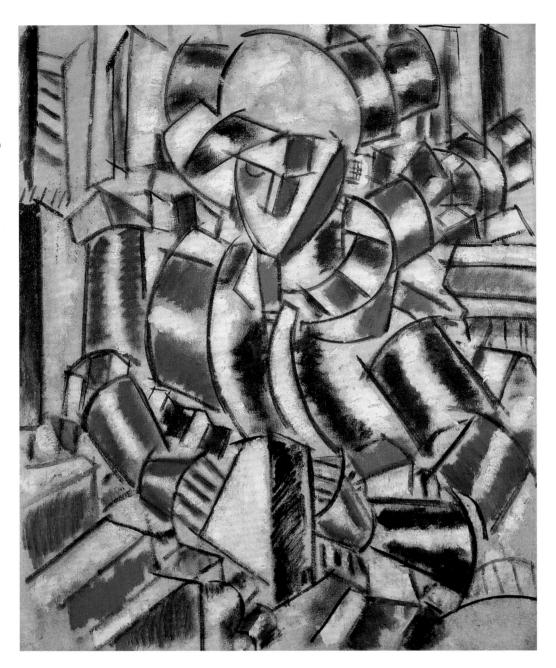

cuted during the summer in Normandy and at La Roche-Guyon, Braque showed no hesitation in deforming and fusing the planes, and had clearly attained an unprecedented level in the development of a new, non-perspectival spatial quality. But, at the same time, Braque was able to harmonise the deformations and balance the diagonals, conferring a crystalline luminosity upon everything that had little in common with the dirty greys and mistaken perspectives of *Houses on the Hill* or *Factory at Horta de Ebro*. And yet, despite the diversity of their respective poetics, the pair attained very similar results. Having rendered perspective obsolete, they both attempted to create a new articulation of space, based upon the coexistence of a foreground and a background on the surface of the canvas, and upon the depiction of a single object from various points of view, or better, upon the coexistence, in a single representation, of various visions. The colours are unleashed from reality, freeing themselves from form and reducing themselves to a few chromatic ranges (green, earth tones, ochre and grey). In all this it is clear that they were at the brink of a precipice that would lead to the loss of recognisability of the object. On their return to Paris in autumn 1909 Braque and Picasso both took a qualitative leap; Picasso was slightly ahead in the last canvas that he painted at Horta de Ebro, *Still Life with Liqueur Bottle*: in this we clearly see the frosting of the glass of the liquor bottle against a background fragmented into tiny segments, in which the

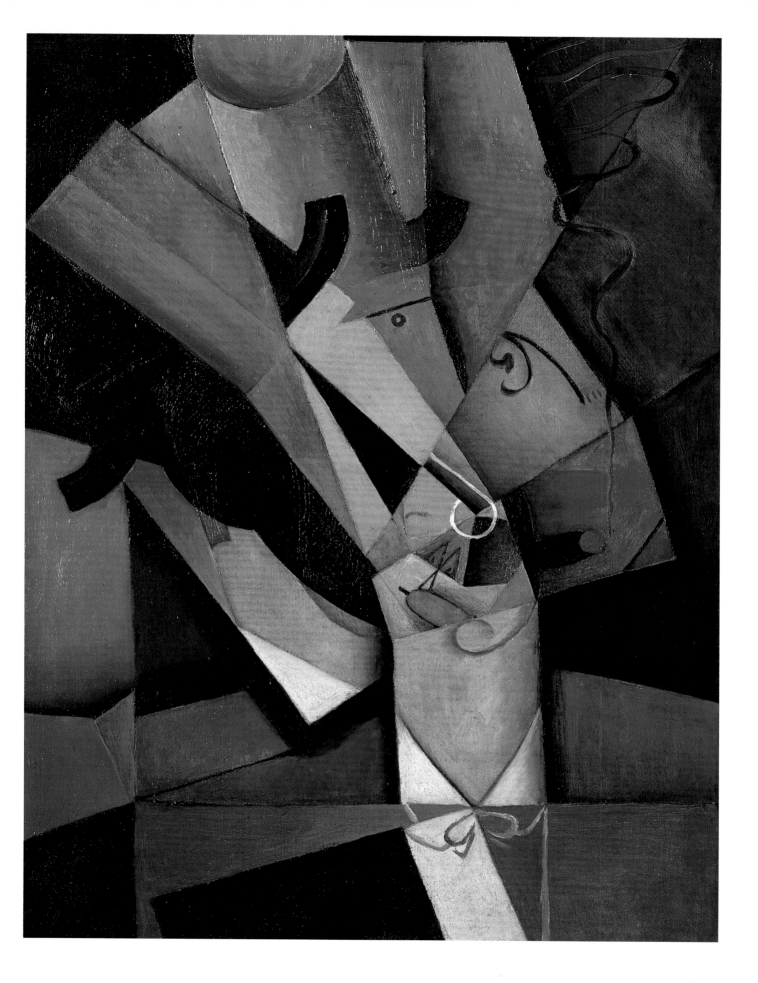

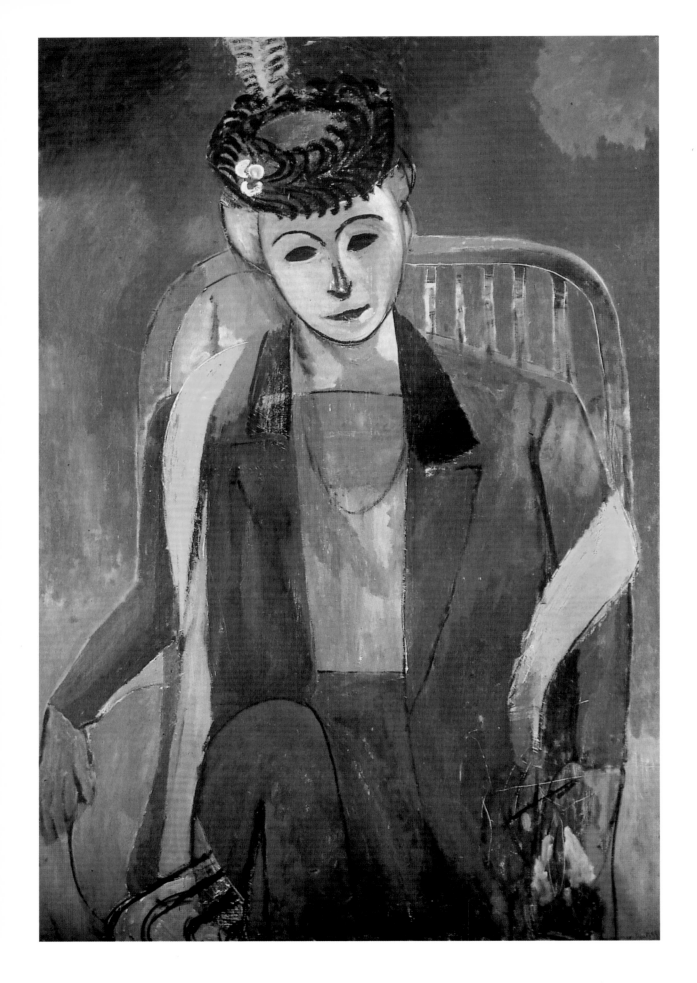

Henri Matisse
White and Pink Head, 1914
Oil on canvas, 75 x 47 cm
Paris, Musée National d'Art Moderne,
Centre Georges Pompidou

Opposite
Henri Matisse
Madame Matisse, 1913
Oil on canvas, 145 x 97 cm
St Petersburg, The State Hermitage
Museum

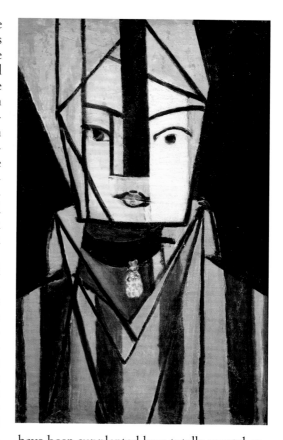

folds of a green drape and a white cloth in the foreground are scarcely recognisable. Here, as in the two masterpieces that mark the same turning point in Braque, *Violin and Palette* and *Piano and Mandola*, we immediately recognise the expedient that, for all analytical Cubism (late 1909–12), was to constitute the only device that kept it from slipping into abstraction and a loss of contact with reality: reliance upon detail, either realistic or hyper-realistic (the frosted glass in Picasso, the nail casting a shadow in Braque) or even signs, extracts from reality: the violin tuning-key and the annotated line of music in the examples cited, which would become cancelled letters and writings in the years that followed.

Still working side by side, Braque and Picasso were slowly abandoning those elements that still marked their style in order to attain an absolutely uniform language, which in the more hermetic results of 1911–12 began to make it difficult to distinguish stylistically between the two artists. Use of colour was further reduced to dark browns and earth tones, while Braque renounced his crystalline brushstroke and Picasso gave up the solidity of volumes for a common system of signs and for the use of a minute brushstroke. The subjects, too, began progressively to be reduced to the single theme of the still-life with musical instruments and the parallel theme of the musician, as Braque progressively renounced landscapes, and Picasso renounced the portraits that had guided him through the central phase of analytical Cubism. It is interesting to compare the three portraits made at the end of 1909 (*Ambroise Vollard*) and the first few months of 1910, one of *Wilhelm Uhde* and, later, *Daniel-Henry Kahnweiler*: not only for their psychological penetration and emphasis on the different friendships that tied Picasso to his three art dealers and patrons (qualities that persisted despite the increasing hermeticism of the style), but more specifically for the forms that this evolution took.

In the *Portrait of Vollard*, the dark silhouette of the art dealer seems to be filtered through ground glass, recognisable even though segmented by a series of small fragmented planes, straight and oblique lines, which in the face still tend to follow the physiognomy of the broad forehead, large nose and rounded jaw. In the *Portrait of Uhde*, painted a few months later, this deconstruction has definitely gained control, while the distinguishing features of the skinny, controlled face seem to have been forced into a vibrant, almost completely abstract surface. Finally, in the *Portrait of Kahnweiler*, all attempts at representation

have been supplanted by a totally mental approach that no longer makes any distinction between the figure and the background: the canvas is no different from a still-life of the same period and any reference to the subject is no longer contextual to this style but a conceptual insert that evokes instead of representing: consider the small half-circle for the moustache, the dark patch of the ear and the undulating and parallel lines of the hair. In the same way, in Braque's *Violin, Glass and Knife* (1910), in an equally evolved deconstruction, the subject is evoked by an almost perfect blade, the tuning-key of the violin, and the parallel lines of the strings. Braque's painting is symptomatic of the evolution of Cubism in this phase. First, the subject: a still-life with musical instrument. The artist explained: 'I began at that time to do chiefly still-lifes, because in the still-life there is a tactile, I would almost say manual space... And that corresponded for me with the desire that I have always had to touch things, not just see them... The colour played nothing more than a modest role, and the only aspect of colour that we cared about was the light...'. There is more: 'In that period, I painted many musical instruments... I had already begun moving towards a tactile, manual space, as I like to call it, and the musical instrument, as a subject, had the particular quality of being able to be animated, by being touched'. And also because of the very shape

Pablo Picasso
Harlequin, 1915
Oil on canvas, 183 x 105 cm
New York, The Museum of Modern
Art, acquired through the Lillie P. Bliss
Bequest

Opposite
Henri Matisse
Interior with Goldfish, 1914
Oil on canvas, 147 x 97 cm
Paris, Musée National d'Art Moderne,
Centre Georges Pompidou

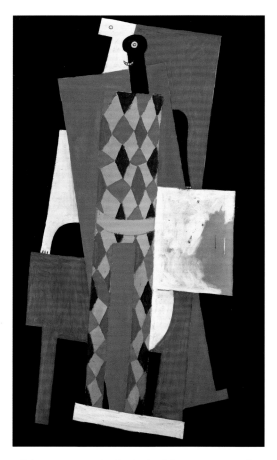

of the canvas, which shifted from rectangular to oval. This was not a gratuitous decision but a practical consequence. In analytical Cubism, the efforts of Braque and Picasso seemed to focus on the centre of the canvas, where the aggregation of forces and contrasting thrusts was strongest, and to ignore the corners, where the composition slackened and the fields became larger. 'The oval', explained Jolanda Nigro Covre, 'is interpretable as an expedient for restraining the thrusts and counterthrusts of the canvas; it is an archetypal form of dynamic equilibrium'. The rectangle of the canvas was, for that matter, the inevitable consequence of the Albertian window: it should come as no surprise that it was abandoned as soon as a new conceptualisation of space was proposed. Finally, the choice of the oval format marks a further step in the transcendence of the canvas-as-representation in favour of the canvas-as-object, autonomous and in turn subject to articulation in space.

After the summer of 1910, which they spent temporarily apart (Braque at L'Estaque, Picasso in Cadaqués), the pair further strengthened their human and professional partnership, which continued during the holidays of 1911 and 1912, and expanded to include Juan Gris. It was only towards the end of 1912 that the two painters, confident of what they had

created to that point, allowed themselves the freedom to reintroduce more personal accents in their works, and to return to an independent development founded on their common base. Braque's *The Pedestal Table* and Picasso's *The Mandolin Player*, both from 1911, prove to be emblematic in this sense: the two paintings are rectangular, but the composition is oval; they share a composition constructed around a rain of descending lines, a chromatic reduction, and a freedom towards the subject, that is not depicted but reconstructed. In both cases, the reference to the subject is made through conceptual inserts, the musical notes and the curving handle of the violin in Braque, and through the hyper-realistic strings and the F key in Picasso. In Picasso's *Ma Jolie* and Braque's *Le Portugais* (1911–12), the language is uniform, save for a prevalence of warm tones in Picasso and a re-emergence of Braque's beloved white lead. Moreover, in both cases, the more the rejection of representation is radicalised, the more any reference to actual objects is conceptualised: notes and extracts from reality are replaced by writing, and even dry stamping of letters and numbers in Braque. At this point Braque and Picasso were just a step away from the invention of collage, at which they arrived simultaneously, though for detectably different reasons. Whereas Braque, an artisan by training, found in stamping letters—as he later found in sand mixed with pigment and in collage—an answer to a predilection for refinement in making, and for the painting as object, Picasso seemed to find in these new solutions the possibility of developing Cubism in an expressive, poetic direction, and in *Ma Jolie* he actually quotes a popular song to sing to his new love, Eva Gouel.

This point represented the threshold of a new phase in the evolution of Cubism. With the emergence of Gris, who began his research in 1911 with a style that was already confident, the twosome was transformed into a threesome, and in Paris a group of 'Cubists', led by Albert Gleizes and Jean Metzinger, began to exhibit their own works, both speaking about themselves and causing talk. And once Braque and Picasso had transcended the asceticism of the previous months, new elements returned to the surface in their works: a taste for pale colours, a heavy impasto and the refinement of Braque's *Sorgues, Still Life with Grapes* (1912); the return of colour, the taste, in the wake of Gris, for more solid geometries, and the determination to restore to painting its capacity to communicate ideas and feelings in Picasso.

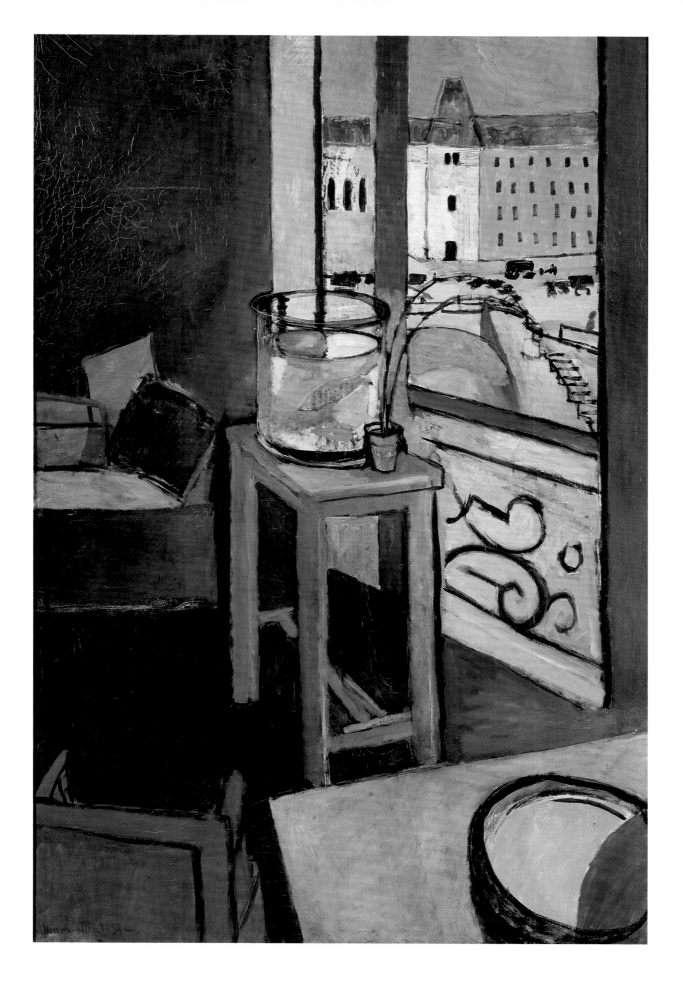

Radu Stern

Fashion and Anti-Fashion at the Turn of the Twentieth Century

During the latter half of the nineteenth century, it was not only the pace but also the very *nature* of fashion that changed. A subtle observer, Baudelaire was the first to perceive this shift: fashion around 1850 was no longer the same; it had become the veritable fermentation of *modern life*. Nothing could be more useful than fashion to demonstrate the historicity of beauty with a view to relativising the classical canon of an absolute and eternal beauty, nor could anything be more useful than fashion in freeing us from the hold of tradition and calling into question our very conception of the time that passes. With its worship of the new and its exaltation of change, fashion favours the transitory, inaugurating what Gilles Lipovetsky called the 'empire of the ephemeral'.[1] In the view of this French philosopher, fashion is not only a central component of *modernity* in aesthetic terms, which paved the way for modern art, but one of the essential forces that made possible the affirmation of the individual and the emergence of democratic societies. Though for centuries fashion had remained the privilege of the nobility of the court, and had little or no effect upon the other social classes, it underwent an unprecedented democratisation during the last quarter of the nineteenth century, thanks chiefly to the proliferation of major department stores and their catalogues, even more than of fashion magazines. Their display windows looking out upon major boulevards affected many more people, allowing everyone to participate, at least visually, in the cult of the new, thus founding a 'democracy of aesthetics' and a 'market modernism'.[2]

Occupying the peak of the pyramid of the fashion market of the time was Haute Couture, which was previously unknown. Its unquestioned founder was the Englishman Charles Frederick Worth who, in 1858, opened his shop, which was dubbed, significantly, 'maison de hautes nouveautés', at 7, Rue de la Paix in Paris. In contrast with the *faiseurs* and the *tailleurs* (seamstresses and cutters), who produced garments to order, Worth was the first to come up with the idea of offering ready-made models of clothing. Instead of responding to specific requests from his customers, his models of clothing were the product of his creative imagination. This unprecedented daring made Worth the first *couturier*, a term that was invariably used in the masculine, because *la couturière*, feminine, was nothing more than an implementer, a *petite main* (term used to describe an apprentice couturier). This made him, to use a term not yet invented, the first *fashion designer*.

As his shop's name indicated, he brought out new models of clothing at least once a year, a practice lay at the origin of the modern idea of a collection. While Rose Bertin, Marie-Antoinette's 'minister of fashion', used mannequins dressed in clothes to introduce the new trends, Worth went one step further, presenting his clothing models worn by living mannequins. Towards the end of the century, another priestess of Haute Couture, Jeanne Paquin had her models march before the clientele in a line: the first fashion show had just been invented.

The quality of workmanship of Worth's dresses was legendary. The clothing was richly ornamented, and reminiscent of the excesses of the architectural eclecticism of the time. Occasionally, he allowed himself to be tempted by more mod-

ern themes, such as with his dress *Fer forge* ('Wrought Iron'), inspired by the Eiffel Tower, or the dress *Electricité* ('Electricity'), worn by Mrs Vanderbilt for her annual ball in 1885.

If, to use Walter Benjamin's famous phrase, Paris was 'the capital of the nineteenth century', it certainly remained the world's capital of fashion for the first quarter of the following century. No one epitomised Parisian supremacy in fashion better than Paul Poiret. Following an apprenticeship with the famous Jacques Doucet, Poiret was hired by the children of Worth. His dresses sold well but the absence of ornamentation on his cloak *Confucius* shocked Princess Bariatinsky, the wife of the Czar's ambassador, who thought that it resembled one of the sacks used in Russia to contain severed heads. The incident convinced Poiret to set up in business for himself, and he opened his own shop in 1903. He declared war on the corset, and not for the health reasons set forth by the advocates of dress reform,[3] but 'in the name of Liberty!'[4] Because of the corset, wrote Jean Cocteau, 'the idea of undressing a woman was a demanding enterprise, and it required planning, like moving house'.[5] Although he eliminated the suffocating corset, Poiret still kept the *cache-corset*, or corset-cover, which he evolved into the *brassière*, the French ancestor of what is now known in French as the *soutien-gorge* (brassiere, or bra). In so doing, Poiret profoundly modified the appearance of modern women: the silhouette went from an 'S' to straight, with a high waist reminiscent of the Directoire style. Simplicity replaced excessive decorations, because 'to dress a woman does not mean covering her with ornaments'. Aside from the *brassière*, he invented the *jupe entravée* (hobble skirt) the *jupes-culottes* (also known also as trouser-skirts and harem-skirts), and the *robe sac* (sack dress). Influenced by the designs of the Ballets Russes by Léon Bakst and Alexandre Benois, Poiret made use of flamboyant colours and proved to be very susceptible to the influence of Orientalism: kaftans, three-quarter-length tunics, puffy bloomers, and turbans. His outfits had names of their own: names taken from major historical personalities, such as *Josephine*, or names of celebrities from the past or the present day, such as *Lola Montes*, *Eleonora* or *Isadora*, in honour of the actress Eleonora Duse and the dancer Isadora Duncan, alongside the names of exotic places, such as *Isfahan*, *Caucasus* and *Baku*. Rather than a simple way of identifying various models, this practice of Poiret's should be seen as an attempt to position his outfits as fully accepted artistic creations. 'Am I mad when I dream of putting art into my dresses or when I say that Couture is an art?'[6] A friend of artists, Poiret asked them to collaborate with him: Raoul Dufy would create fabrics for him, while Erté designed both theatrical costumes and garments for him.

In order to better acquaint the public with his creations, Poiret had them photographed by Edward Steichen for *Art et décoration* in 1911 and, a year later, for Lucien Vogel's *Gazette du Bon Ton*, making him one of the first *couturiers* to use fashion photography. Nonetheless, even better than Steichen's photographs were two picture books, *Les idées de Paul Poiret racontées par Paul Iribe* (1908) and *Les choses de Paul Poiret vues par Georges Lepape* (1911), both produced in silkscreen, which did the most to contribute to Poiret's triumph. Despite the fact that they were

produced in what amounted to private print runs, their images were reproduced in almost all of the fashion magazines of the time.

The price of success was the pirating of his models and counterfeiting: 'People have made caricatures with inventions that, in order to slip into excess, should be treated with the 'artistic' taste of those who invented them. The counterfeits of what could be called the Poiret style are comparable with the difference between a good genuine champagne and the champagne made by Germans. Connoisseurs will not be fooled; others drink confidently, and are promptly poisoned'.[7]

Establishing the difference between the original and the copy was for Poiret merely an economic question. Since he conceived his clothing as works of art, the distinction was far more complex, and the aesthetic component of the dilemma became an essential factor.[8]

The outbreak of World War I forced Poiret to close his business until 1918 while he served as a military tailor. But the decline had already begun: the hardships of war demanded a more practical type of fashion than Poiret's fantasies[9] and new *couturiers* like Coco Chanel entered the marketplace. Jean Cocteau immortalised this moment in a lithograph entitled *Poiret s'éloigne, Chanel arrive*. Legend has it that Poiret, seeing Coco Chanel dressed in the little black dress that had made her famous, asked her, 'For whom are you dressed in mourning, Mademoiselle?' and that she replied, 'Why, for you, Monsieur!' The *bon mot* was an accurate prediction; the 1920s and 1930s consecrated the triumph of Mademoiselle. But the little black dress, the tapered but flexible cocktail dress that she introduced in 1914, which brought a certain degree of masculinity to the feminine silhouette, possibly prompted by the war, would become her signature item and the hallmark of the Années Folles, as the French refer to the 'crazy years' between the two World Wars.

In parallel with these avatars of fashion and the success stories of the *couturiers*, the domain of clothing also prompted a growing interest among artists. In part, this interest was motivated by the re-evaluation of the hierarchy of the fine arts and the applied arts, beginning with the Arts and Crafts movement.

In the eyes of certain artists, this new taste for the so-called applied arts went hand in hand with a determination to intervene more directly in everyday life. The abandonment of painting in favour of the 'decorative' arts was, for the Belgian Henry van de Velde, for instance, a logical conclusion deriving from his conception of the artist's social mission, which was to surround people with beautiful objects, with a goal that was purely aesthetic, for an environment governed by beauty could not help but make men better. Clothing formed an integral part of this environment. They had to be conceived as elements forming part of a *Gesamtkunstwerk*, a total artwork, which must constitute the universe of the home. In order to achieve this, it was absolutely necessary to remove them from the dominion of fashion. If a garment was a genuine artwork, by its nature it could not go out of fashion. Fashion, then, was the enemy to be abolished:

'The best trump card of the designer is to state: *That is fashion*—without arousing the slightest protest, the least complaint… Fashion is the great enemy,

causing at the same time the decline of all the decorative and industrial arts, and even causing the degeneration of what is called *great* art.'[10]

Perfect utopian that he was, van de Velde imagined that the best way to fight the commercialism and immorality of fashion was to establish an opposing anti-fashion[11] based upon clothing created by artists. Inspired by the 'artistic dress' of the Pre-Raphaelites and the 'aesthetic dress' that followed it, van de Velde himself created dresses for his wife which, as a supreme piece of refinement, were not merely designed to match the architectural decoration, the carpets, and the furniture of their mansion, *Bloemenwerf*, in Uccle, but also the colours of the dishes served at their meals.

In 1900, an exhibition devoted to *Künstlerkleid*, artistic clothing, opened at the Kaiser Wilhelm-Museum in Krefeld. Alongside such artists as Alfred Möhrbutter, Bernhard Pankok and Richard Riemerschmid, van de Velde presented six models. Compared with those made by the *couturiers*, his dresses were far simpler, though not without ornamentation. For Van de Velde, ornament was not merely a fixture but an element that was meant to enhance the structure of the garment.

In Vienna, Gustav Klimt was also exploring the field of clothing. Not only did he paint daring dresses for his models in his paintings but he also designed actual dresses for his lover, Emilie Flöge. These dresses were quite different from the commercial production of the very chic fashion house that Emilie Flöge ran with her sister. Instead of respecting the 'S' silhouette and the wasp waist obtained with the help of the corset, then fashionable, these dresses possessed an unusual spaciousness that resembled the outfits that Klimt used for painting. In place of the countless accessories and fixtures, their decoration was limited to geometric motifs printed on the fabric.

Klimt's interest for artistic clothing and his opposition to fashion were shared by Josef Hoffmann and Koloman Moser, the founders of the Wiener Werkstätte. Both of them believed it was necessary to fight against the dictatorship of fashion by creating artistic garments that should be coordinated with the architecture, the furniture, the wallpaper, and all the other objects of the domestic environment, so as to achieve the indispensable *Gesamtkunstwerk*, or total work of art. While Hoffmann and especially Moser most often preferred geometric motifs like those they used for their furniture, official director of the Mode-abteilung that was established in 1911, Eduard Wimmer-Wisgrill was more susceptible to the Orientalist influence; in 1914, he actually designed an outfit made up of a long tunic to be worn with harem pants. For the most part, the creations of the Wiener Werkstätte, which were either too difficult to produce or too impractical, remained on the drawing board.

Among the garments designed by artists, those by Mariano Fortuny enjoyed a singular status: to own an outfit designed by Fortuny was, at the time, the fondest dream of fortunate women seeking elegance.[12] In *The Remembrance of Things Past*, Proust dressed in Fortuny the Duchesse de Guermantes, who surpassed all other women in 'the art of dressing', and especially so for Albertine, whose cloak designed by Fortuny was modelled on one worn by a character in a painting by

Carpaccio.[13] Resolutely set against the fashion of his time, Fortuny sought his inspiration in the Venetian Renaissance or, as for his most renowned creation, the *Delphos* dress of 1907, in ancient Greece. Very light, made of hand-pleated silk, the *Delphos* was astonishingly fluid, almost vaporous, in total contrast with the corseted stiffness of the dresses in fashion at the time. Far lovelier than the models that emerged from dress reform, the *Delphos* allowed an unprecedented freedom of movement and was daringly moulded to women's bodies. Its pure line descended from the ancient Greek *chiton* and its pleats in particular were reminiscent of the garment worn by the charioteer in the *Delphic Charioteer*, hence the name. Each of these *Delphos* dresses was made unique by its special colour, obtained by hand-dying the fabric with vegetal dyes and, in some cases, with decorations made of Murano glass beads, which emphasised hem and shoulders. Sarah Bernhardt and Isadora Duncan wore them, and the *Delphos* continued to be produced until 1952.

While Mariano Fortuny reused forms from bygone eras in order to escape the toils of fashion, the Italian Futurists took on fashion on the terrain of modernity. In 1913, Giacomo Balla asked his wife Elisa to sew for him, to his design, a first Futurist outfit, whose cut was no longer symmetrical and did not take anatomy into account. A large triangular swath of fabric on the chest was thought to make the outfit more dynamic. On 20 May 1914, Balla published the first version of the *Futurist Manifesto of Men's Clothing*, in which he argued in favour of the abolition of mourning dress, neutral and faded colours, striped fabrics, the harmony of colours, symmetrical cuts, useless buttons, detachable collars, and wristbands. In contrast, he advocated dynamic Futurist clothing, asymmetrical, designed to increase the body's flexibility, hygienic, and illuminating because of the use of phosphorescent fabrics, with vivid and, especially, joyful colours, because

'What will emerge is a bewildering array of clothing, which will brighten the cities with incessant gaiety, even if their inhabitants are completely without imagination or a colourist sensibility.'[14]

In order to be changed often, Futurist clothing did not have to be particularly durable and, most importantly, it needed to be variable. This variability was a product of the use of *modifiers*, 'fabric appliqués (of varying width, thickness, and colour)' which the wearer of the garments could change as chosen with the use of 'pneumatic buttons'. Some of the *modifiers* were even scented. In so doing, Balla not only invented the transformable outfit, but he also reinvented with his *modifiers* the very nature of the relationship between the creator and the utiliser of the garment, conceived as a work of art: the utiliser was no longer passive, but now collaborated, to a certain extent, with the artist.[15]

Again on the terrain of modernity, the artistic clothing created by Sonia and Robert Delaunay caused a sensation at the *Bullier Ball* in 1913, to the point that their creators were dubbed 'reformers of clothing' by Guillaume Apollinaire.[16] The impression was sufficient to justify a telegram from Gino Severini, who loved to dance at the Bullier dance hall, to Marinetti about it. Others had even more notable re-

actions: fascinated by Sonia Delaunay's Simultaneist dress, Blaise Cendrars dedicated one of his most famous poems to it, *Sur la robe elle a un corps* ('On the Dress There Was a Body').

In contrast with Balla, the Delaunays did not change the cut, which remained quite traditional. The field in which they excelled and which they hoped to revolutionise was that of colour. According to the description of the poet who was the chronicler of anti-fashion, she wore 'a purple cocktail outfit, with a long purple-and-green belt, and, under the jacket, a bodice divided into zones of bright, delicate, or pastel colours, blending shades of pink, tango orange, light blue, scarlet, and so on, which appeared, juxtaposed, on different materials, such as serge, taffeta, tulle, moire, and *poult de soie*, a fine ribbed silk'. He, instead, wore a 'red cloak with a blue collar, red socks, yellow and black shoes, black trousers, a green jacket, and sky-blue waistcoat with a red tie'. The difference between the array of colours adopted by Sonia Delaunay and women's clothing in the fashion of the period was considerable; but that difference was negligible if we compare the clothing of her husband Robert with the clothing worn by his contemporaries, invariably dressed in black. Despite the fact that they still used the traditional cut, the silhouette was visually altered by the juxtaposition of colours and the mixture of textures.

The relationship between Simultaneist clothing and the Orphist experimentation in painting of Robert Delaunay is quite evident. A Simultaneist dress can be considered an Orphist creation in three dimensions, and the movements of the body of the woman wearing it only increase the overall dynamism of the creation.[17]

In order to escape the war, the Delaunays moved to Spain, where they lived until 1920. During her stay there, Sonia Delaunay's interest in clothing grew to the point that it became her main activity. Quite soon, she designed clothing and accessories for the daughters of the Marquis d'Urquijo and for the Marquise de Valdeiglesias. Having been accepted by the high society of Madrid, she created her own chic boutique, *Casa Sonia*, on the Calle Columela in Madrid, and, shortly thereafter, two other outlets in Barcelona and Bilbao. We need not consider these activities as anything more than business enterprises, certainly important for Sonia, who could no longer rely upon the money of her family, which had been ruined by the Russian Revolution. Still, for her the creation of clothing was especially a way of incorporating her research into the dynamism of colour into a creation that involved real life, thus achieving, at least in part, the avant-garde dream of uniting art with life.

[1] Gilles Lipovetsky, *L'Empire de l'éphémère: la mode et son destin dans les sociétés modernes*. Paris: Gallimard, 1987, English translation : *The Empire of Fashion: Dressing Modern Democracy*. Princeton, N.J.: Princeton University Press, 1994.

[2] Lisa Tiersten, *Marianne in the Market: Envisioning Consumer Society in Fin-de-Siècle France*. Berkeley and London: University of California Press, 2001, p. 219. See also Vanessa R. Schwartz, *Spectacular Realities: Early Mass Culture in Fin-de-Siècle Paris*. Berkeley and London: University of California Press, 1998.

[3] For the debates over the corset, see Valerie Steele, *The Corset: A Social History*, New Haven: Yale University Press, 2001 and Leigh Summers, *Bound to Please*, New York: Berg Publishers, 2001.

[4] Paul Poiret, *En habillant l'époque*, Paris: Grasset, 1930, p. 63.

[5] Quoted in Palmer White, *Poiret le magnifique,* Paris: Payot, 1986, p. 75

[6] Yvonne Deslandres, *Poiret 1979-1944*, Paris: Edition du Regard, 1986, p. 106

[7] Jean-Louis Vaudoyer, 'Georges Lepape', *Art et Décoration*, XXXIV, July-December 1913, p. 71.

[8] For the contradictions between the economic dimension of Haute Couture and Poiret's ambition to present himself as an artist, see Nancy J. Troy, *Couture Culture: A Study in Modern Art and Fashion*, Cambridge, Mass.: The MIT Press, 2002.

[9] Florence Brachet Champsaur 'French Fashion during the First World War', *Business and Economic History On-Line*, Vol. 2, 2004 http://www.thebhc.org/publications/BE-Honline/2004/Champsaur.pdf

[10] Henri van de Velde, *Die Künstlerische Hebung der Frauentracht*, Krefeld, 1900, p. 12.

[11] For a history of the anti-fashion established by the historic avant-garde, see Radu Stern, *Against Fashion: Clothing as Art 1850-1930*, Cambridge, Mass.: The MIT Press, 2003.

[12] For Fortuny see: Guillermo De Osma, *Mariano Fortuny, His Life and Work*, New York: Rizzoli, 1994, and Anne-Marie Deschodt; Doretta Davanzo Poli *Fortuny*, New York: Harry N. Abrams, 2001.

[13] Anna Favichon, *Toilettes et silhouettes féminines chez Marcel Proust*, Lyon: Presses Universitaires de Lyon, 1987.

[14] Giacomo Balla, *Le vêtement masculin futuriste. Manifeste,* in Radu Stern, *A contrecourant: vêtements d'artistes 1900-1940*, Bern : Benteli Verlag, 1992, p. 117.

[15] Radu Stern, *Against Fashion: Clothing as Art 1850-1930*, p. 32.

[16] Guillaume Apollinaire, 'Revue de la quinzaine: Les Réformateurs du costume', *Mercure de France*, no. 397, 1 January 1914.

[17] Radu Stern, *Against Fashion*, pp. 65–66.

German Expressionism

It is no simple matter to establish just when the term 'Expressionism' was first used to describe the artistic phenomenon that was developing in Germany between the earliest years of the twentieth century and 1920, since the artists themselves never called themselves 'Expressionists'. This was, therefore, more of a critical formulation that in Germany was commonly applied to the Fauves and, more generally, to Post-Impressionism; the term was used by Paul Cassirer as early as 1910, by Worringer in 1911 and, with a greater degree of awareness, by Paul Fletcher, who applied it to the painters of Die Brücke and the Blaue Reiter, and to Kokoschka (1914).

The objectives of Expressionism were assembled and expressed effectively by the group Die Brücke (The Bridge), founded in Dresden on 7 June 1905 by four young artists: Ernst Ludwig Kirchner, Fritz Bleyl, Erich Heckel and Karl Schmidt-Rottluff, all of them students of architecture and originating from various German regions. The first two met at the Technische Hochschule of Dresden in 1901. Heckel and Schmidt-Rottluff became friends in the same period at Chemnitz lyceum; Heckel's brother put them in touch with Kirchner in 1904 and a strong friendship immediately developed. In various ways, their interests shifted from architecture to painting and to other graphic techniques, as they discovered a shared intolerance of academic art but also of Impressionism. The group displayed their works for the first time in 1906 in an exhibition held in a light bulb factory in Dresden; on this occasion, they also produced their manifesto which, rather than laying down out a specific programme, set out certain shared positions: 'With faith in the future, in a new generation of creators and users of art, we are calling together all young people and, as the youth which bears within itself the seeds of the future, we want to acquire for ourselves freedom of action and life, against the old, deep-rooted forces. We count as one of us anyone who reproduces with immediacy and without falsification that which drives him to create'. These words made explicit reference to freedom of creation, the power of youth and expressive authenticity against all academic norms. Even though the artists of Die Brücke might insist

upon their independence from previous artistic expressions, there were many references to the European cultural panorama, which found in Expressionism an almost complete synthesis. Flowing into it were Gauguin's lines of formal research, those of Les Nabis and, in the Germanic context, those of the late works of Hodler, a member of the Berlin Secession who was held in high regard by German collectors. There were also echoes of the landscapes with simplified forms and the intense expressivity of the art colonies of Worpswede and Dachau, which were established just before 1900 having been inspired by the *plein air* approach of the Impressionists and the lines of the Jugendstil. The most direct references, however, must be sought in Neo-Impressionism and in the Fauves. Inasmuch as they were champions of the expression of their own interior worlds, Van Gogh, Munch and Ensor became the chief sources of inspiration: Van Gogh's pure colours took on powerful expressive connotations, while Munch's figures and landscapes transposed onto canvas the artist's spiritual and psychological tensions; the masks of Ensor constitute the most direct precedent for that sense of alienation that was to mark the more mature phase of Die Brücke. These were widely known artists; two major exhibitions of Van Gogh's work had been held in Dresden, one in 1905 by Arnold and one in 1908 by the Richter gallery; Munch had a first solo exhibition with twenty works at the Sächsischer Kunstverein in 1906; there were also many exhibitions of work by the Impressionists and the Viennese Secession (Arnold showed 317 pieces in 1907). The exhibition of works by Matisse in Berlin in 1908 contributed to an accentuation of the two-dimensional approach and a love of pure colour on the part of the Expressionists. The polemic against the traditional forms of art caused the younger generations of German artists to turn also to non-European art, in particular to the art of Africa and Oceania, as a result of the magnificent pieces displayed in the Dresden Völkerkundemuseum and the journeys made to the islands of the Pacific by certain members of the group, for example, Pachstein and Nolde. The determination to make a break with traditional aesthetic hierarchies also led many members of the movement to practise the technique of engraving, especially

Otto Müller
Three Nudes in the Forest, 1910
(detail)
Oil on canvas, 70 x 53 cm
Essen, Folkwang Museum

Edvard Munch
Moon Light, 1895 (detail)
Oil on canvas, 93 × 110 cm
Oslo, Nasjonalgalleriet

Edvard Munch
The Scream, 1893 (detail)
Tempera on cardboard, 83.5 × 66 cm
Oslo, Munch-museet

Pages 172–73
Edvard Munch
The Sun II, 1910–16
Oil on canvas, 162 × 205 cm
Oslo, Munch-museet

woodcuts, the emotional line of which creates a powerful response due to strong contrast and its particular affinity for primitivism; in this sense, Frederick Augustus II's impressive collection of engravings on display in Brühl Palace was of the greatest importance. New inspiration came to the artists from the literature of Dostoevsky and writers from countries that had until then been considered marginal in cultural terms, such as the Norwegian Henrik Ibsen and the Swede August Strindberg (a friend of Munch who was often in Germany), whose profound disquiet went perfectly with the central role that Die Brücke attributed to the inner world. Die Brücke also fell heir to the ideal mingling of art and life typical of Late Romanticism, a logical development of a similar synaesthetic approach: Kirchner and Heckel decorated their studios in the working-class outskirts of Dresden with furniture and sculptures that they had personally engraved and with large, specially painted panels.

All of these elements explain the name chosen for the group: a 'bridge' linking different forms of culture and towards a new world. This image open to various suggestions was traditionally attributed to the imagination of Schmidt-Rottluff, who may have taken inspiration from a passage of *Thus Spake Zarathustra* by Friedrich Nietzsche. Despite the predictable criticisms originating from the realms of the official art world, the most observant gallery-owners in Dresden would give extensive space to the artists of Die Brücke, to the point that as early as 1907 they were able to exhibit annually in the prestigious gallery of Emil Richter and, beginning in September 1910, in

that of Ernst Arnold. Although they did not live in a community, many of these artists were linked by personal friendships, which encouraged shared activity of painting in the open air near the lakes of Moritzburg, not far from Dresden. The members were in contact especially during the period of the annual exhibition, with Heckel assuming a dominant role in its organisation and publicity, even though Kirchner, in his *Chronik der Künstlergemeinschaft Brücke* (Chronicle of Die Brücke), completed in 1913, insinuated that he had been the true leader of the group.

In 1908, Pechstein moved to Berlin, followed three years later by Kirchner, Heckel and Schmidt-Rottluff. In contact with the exciting milieu of the German capital, relations between the members progressively slackened, but a new theme entered their art: the big city, with aspects of contemporary life, often explored in its more alienated and morbid aspects, from the squares teeming with strollers and prostitutes to the life of the circus and the music hall. In Berlin, Expressionism succeeded in producing its most emotionally intense works through direct, and in certain ways, traumatic confrontation with modernity and with the polemics that were stirring the milieus of artistic institutions: in 1910, the Berlin Secession rejected twenty-three works by other young Expressionist artists such as Müller, Nolde (whose *Pentecost* was one of the most fiercely attacked works) and Pechstein. The latter then founded the New Secession of Berlin. Present at its first exhibition were also works by Die Brücke, which were met with great acclaim to the point that many of the New Secessionists

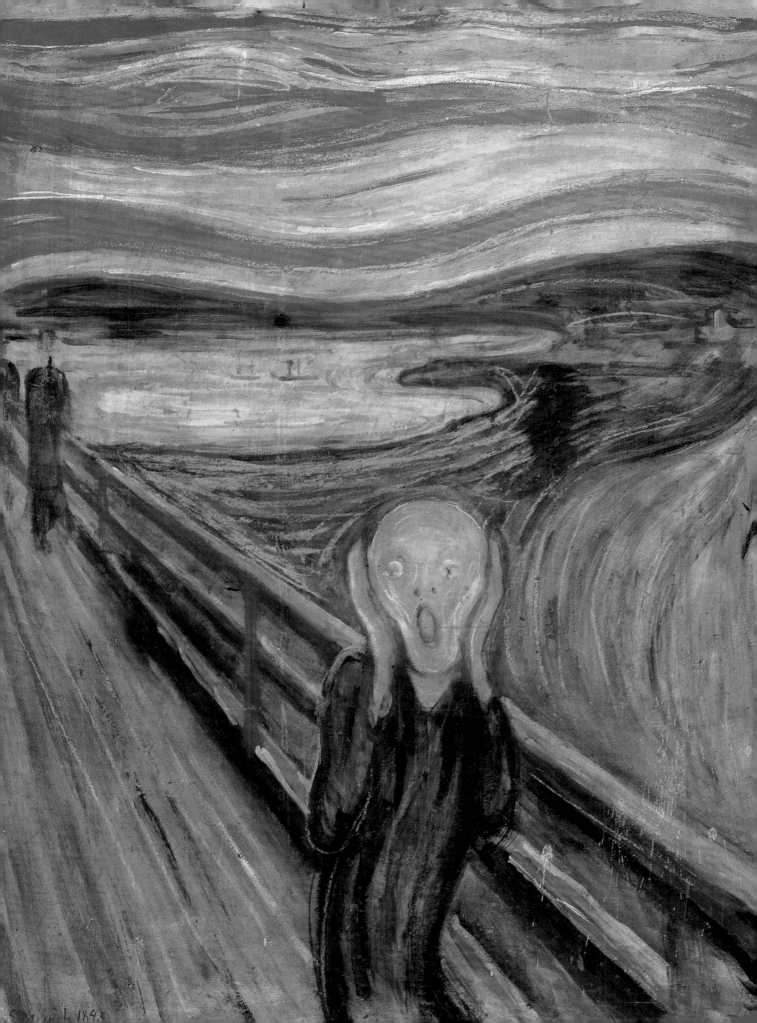

joined the group; a number of foreign artists also joined, helping to expand the group's international dimension, among them Cuno Amiet, Lambertus Zijl, Akseli Gallen-Kallela and Kees van Dongen. The programme of the Dresden group was still quite strict in its distinctions between new and old art, and, in the belief that the young artists of the New Secession were not sufficiently radical in their choices, in 1912 Die Brücke abandoned the association.

In 1912, the exhibition of the Soderbund in Cologne formally endorsed the group's success, but the individual members had by this point attained their personal evolution and their paths diverged; consequently, the polemics that arose around Kirchner's *Chronik* were almost mere pretexts for its disintegration, which took place in 1913.

By taking a position as the unquestioned leader of Die Brücke, Ernst Ludwig Kirchner prompted resentment among the other members, but his role has been amply acknowledged by critics and history. While still a student at the polytechnic of Dresden in 1903 and 1904, he went to Munich twice where he attended the school of Hermann Obrist. There he had an opportunity to admire the work of the French Post-Impressionists at the 1903 exhibition by Kandinsky's group Phalanx. These were important experiences, because it was from these works that he would derive, by his own admission, fundamental ideas about the use of pure colour and rapid and synthetic line; the writings of Obrist, in contrast, sang the praises of art as the highest expression of the human being, a basic concept in the formation of an Expressionist style, which intended to express life through art. Although the artist insisted on the absolute originality of his own work—going so far, in his own writings, as to move forward the foundation of Die Brücke to 1902 in order to make his 'own' movement a precursor to Fauvism—the work of Matisse pushed him towards a more luminous and two-dimensional style of painting. After 1910, his study of the sculpture of the Pacific islands led him to a adopt a harder brushstroke and more angular forms. The human figure remained at the centre of his interests; dating from these years were his lovely female portraits, including those of the very young Marcella and Franzi, the daughters of a widow who lived near the painter and Heckel; in their faces we rediscover the features of Polynesian sculpture but also the style of Lucas Cranach's *Venuses*, especially in his tendency to recover the thin and angular lines of Altdorfer and Dürer. After moving to Berlin, where with Pechstein he founded the largely unsuccessful school of painting,

Ernst Ludwig Kirchner
Street, Dresden, 1908
Oil on canvas, 150 x 200 cm
New York, The Museum of Modern Art

Erich Heckel
Village Dance, 1908
Oil on canvas, 146 x 196 cm
Berlin, Neue Nationalgalerie

Opposite
Karl Schmidt-Rottluff
Village in the Erzgebirge, 1905
Oil on canvas, 90 x 130 cm
Berlin, Brücke Museum

Karl Schmidt-Rottluff
Autumn Landscape, 1907
Oil on canvas, 75 x 97 cm
Madrid, Thyssen-Bornemisza Museum

Ernst Ludwig Kirchner
Franzi before a Carved Stool, 1910
Oil on canvas, 75 x 49 cm
Madrid, Thyssen-Bornemisza Museum

Ernst Ludwig Kirchner
Marcella, 1909–10
Oil on canvas, 71.5 x 61 cm
Stockholm, Moderna Museet

Opposite
Ernst Ludwig Kirchner
Street with Prostitute in Red, 1914
(detail)
Oil on canvas, 120 x 90.5 cm
Madrid, Thyssen-Bornemisza Museum

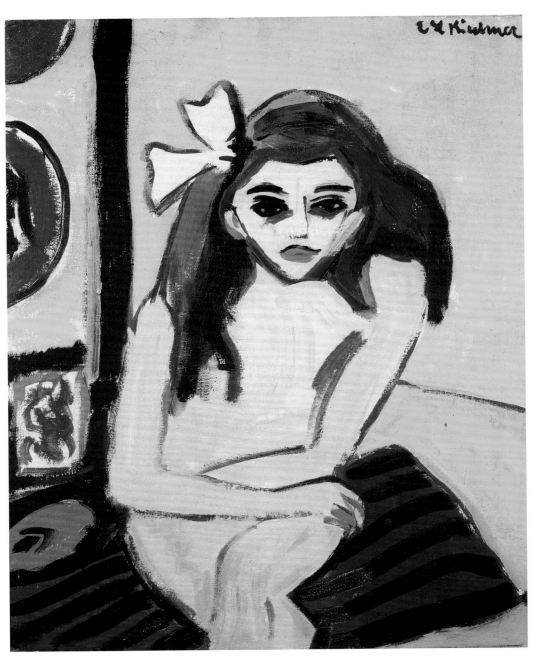

Moderner Unterricht in Malerei-Institut, the broad fields and luminous colours of the Fauves made way for a more nervous sign and more contrasting hues, no longer based upon brilliant juxtapositions of complementary colours. These elongated forms, which permeated a teeming, 'inhuman' Berlin with erotic tension, also appear in the bathing women he painted during his summer holidays on the island of Fehmarn in the Baltic Sea and in the landscapes of Moritzburg.

When war broke out, he was called to serve as a gunner in Halle, and his fear and unease provoked a physical and psychological crisis that, thanks also to the intervention of his instructor Hans Fehr, a friend of Nolde, al-

lowed him to win his discharge and sent him to a clinic for many months of treatment. Dating from this painful period were some of his finest woodcuts, including the series based on Adalbert von Chamisso's book *Peter Schlemihl's Remarkable Story* (1915). Following a continuous series of health problems, his friends helped him to leave the country for Switzerland in 1917 where, after continual treatment in a clinic, he moved to Frauenkirche, near Davos, where he remained until he died.

The artist also applied the style of his Berlin view paintings to Alpine subjects, at least until 1920, when his works begin to show a new monumentality and an opening to broader and more homogeneous fields of colour. This was

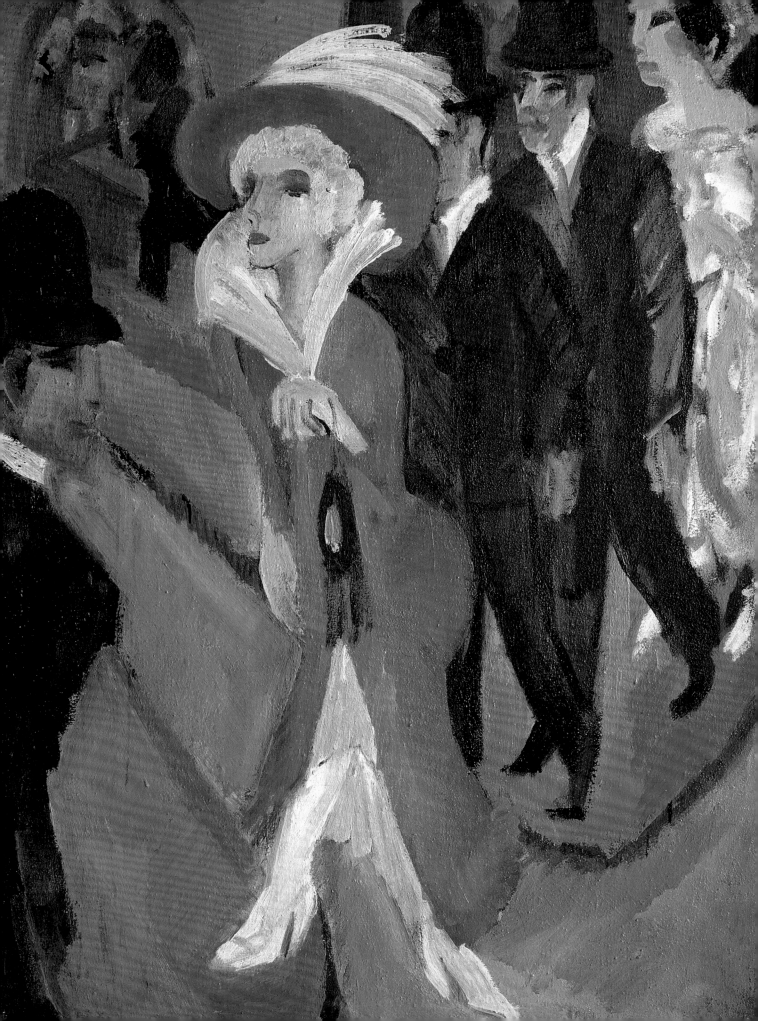

Erich Heckel
Pechstein Sleeping, 1910
Oil on canvas, 73 x 42 cm
Munich, Staatsgalerie Moderner Kunst

Emil Nolde
Dance around the Golden Calf, 1910
Oil on canvas, 68 x 101 cm
Munich, Neue Pinakothek

Emil Nolde
Pentecost, 1909
Oil on canvas, 70 x 103.5 cm
Berlin, Neue Nationalgalerie

Opposite
Emil Nolde
Flowers, 1909 (detail)
Oil on canvas, 78 x 67 cm
Venice, Museo d'Arte Moderna
di Ca' Pesaro

Max Pechstein
The Horse Market in Moritzburg, 1910
Oil on canvas, 154 x 184 cm
Madrid, Thyssen-Bornemisza Museum

Marianne von Werefkin
The Black Women, 1910 (detail)
Oil on canvas, 53 x 81 cm
Hannover, Sprengel Museum

the beginning of the approach that he described as 'tapestry style': Kirchner in fact began to take an interest in textiles, and collaborated with the weaver Lise Gujer who produced twenty-four tapestries based on the artist's designs from 1922 on.

The exhibition at the Basel Kunsthalle in 1923 attracted a number of young disciples to Kirchner, including Hermann Scherer. Kirchner remained popular in Germany too, where he returned repeatedly between 1925 and 1930. Commissions for large mural paintings for the concert hall of the Folkwang Museum in Essen occupied a great deal of the painter's thoughts, but the project did not come to completion. In the preparatory drawings that he executed between 1927 and 1934, Kirchner showed a progressive approach to abstract modules inspired by Cubism, a last approach to the avant-garde before returning to that monumental naturalism that would inform his

last works after 1935. Erich Heckel was Die Brücke's promoter. His studio, near that of Kirchner (to whom he was very close), became the true centre for the management and organisation of the group. His works show characteristics that are in some ways quite similar to those of Kirchner, but with a greater emphasis on the graphic element and the technique of the woodcut, which naturally led him to accentuate a formal simplification, especially in his works of 1908 and 1909. Like the other members, after 1911 he adopted a softer, paler palette (*Canal in Berlin*, 1912). He moved to Carinthia after the war, during which his studio had been destroyed, and dedicated himself to a more relaxed style of painting in which the elements of Die Brücke made way for a more traditional kind of art.

Karl Schmidt—in 1905 he would add the name of his birthplace to his surname—stood apart from the other members of the

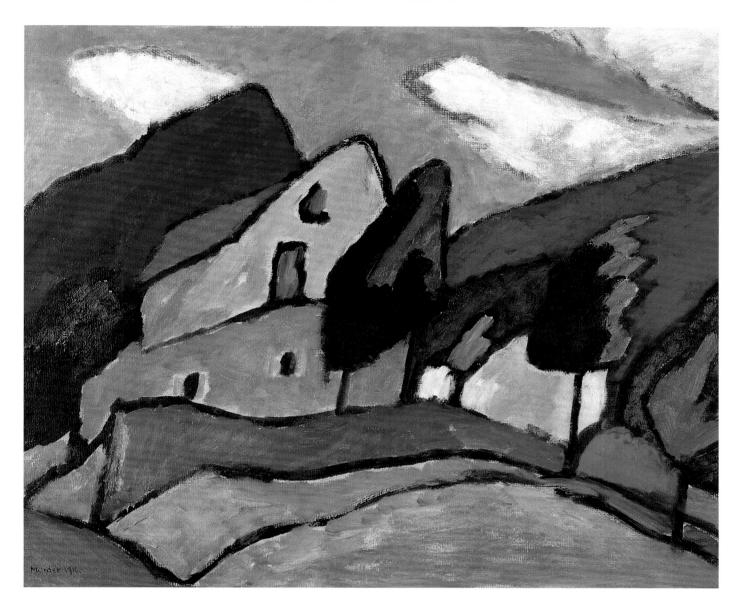

Gabriele Münter
Wind and Clouds, 1910
Oil on canvas, 38 x 59 cm
Hanover, Sprengel Museum

Pages 182–83
Alexei von Jawlensky
Girl with Peonies, 1909
Oil on panel, 101 x 75 cm
Wuppertal, Museum von der Heydt

Jean Metzinger
*Woman, Depicted Facing
and in Profile, with Glass*, 1919
Oil on canvas, 65 x 50 cm
Paris, Musée National d'Art Moderne,
Centre Georges Pompidou

group for his clear love of landscape. He began, like the others, with the ideas of the Jugendstil and Neo-Impressionism, but only rarely did he attain Kirchner's level of expressive violence, except in the works prior to 1907. From 1908 on, his work became less emphatic in form and colour, and occupied increasingly broad and regular surfaces. Kirchner liked to describe Schmidt-Rottluff's style as 'monumental Impressionism', specifically because of the constant link with nature, an increasingly simplified form and a very balanced composition. Emil Nolde was invited to join Die Brücke by Schmidt-Rottluff but only remained a member for a year and a half (1906–07). Born in a small town in Schleswig, his art was always distinguished by nature, the simple country life and a quiet sense of provincial religiosity. From 1892 to 1898 he lived in St Gallen in Switzerland where he taught drawing at the city's *Gewerbemuseum*; here he became familiar with

the works of Böcklin and Hodler, which struck him with their mystical and allegorical allure. He then took the inevitable trips to Munich and, in 1899, to Paris. It was his landscapes, rich in colour and expressivity, that interested and powerfully influenced the other members of Die Brücke, to whom Nolde also taught the technique of etching. In 1909 and 1910 he sold his best known religious works, in which the simple forms of provincial pietism were combined with violent and expressive colour: *The Last Supper* (1909) caused a scandal when it was purchased by the museum in Halle. Exasperated by the criticism, he returned to the themes of nature in canvases inspired by the German colonies of the Pacific, where he travelled in the entourage of a government expedition—for example, *Tropical Sun* (1914)—or by the calm landscape of Schleswig, where he went to live in 1916. As for Max Pechstein, his participation in Die Brücke began in 1906 and lasted

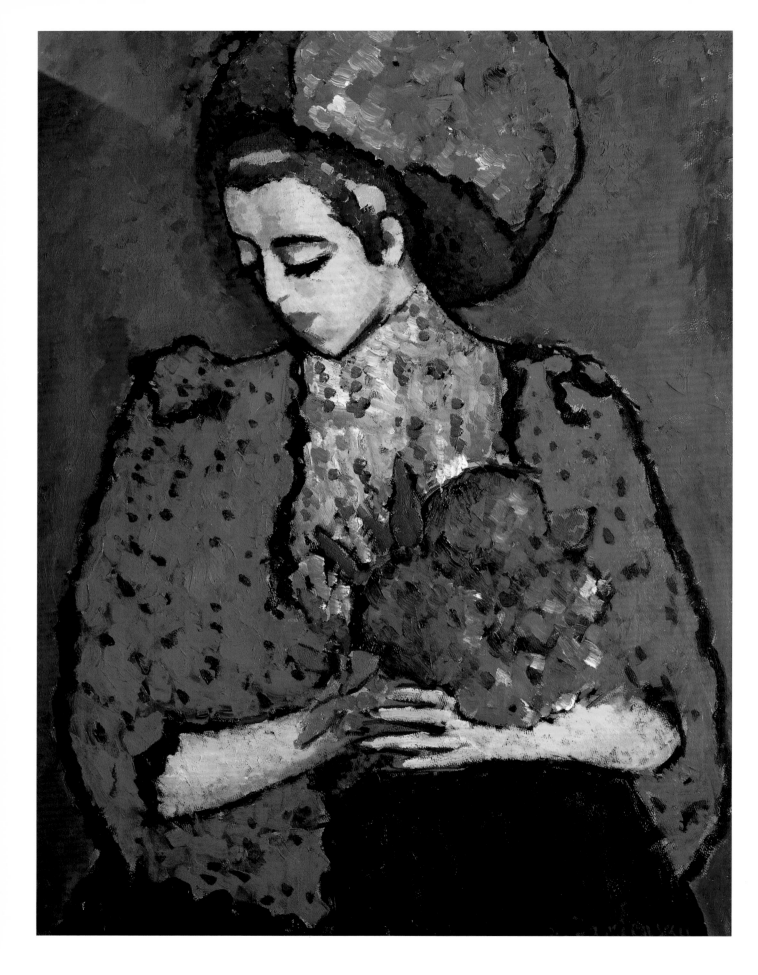

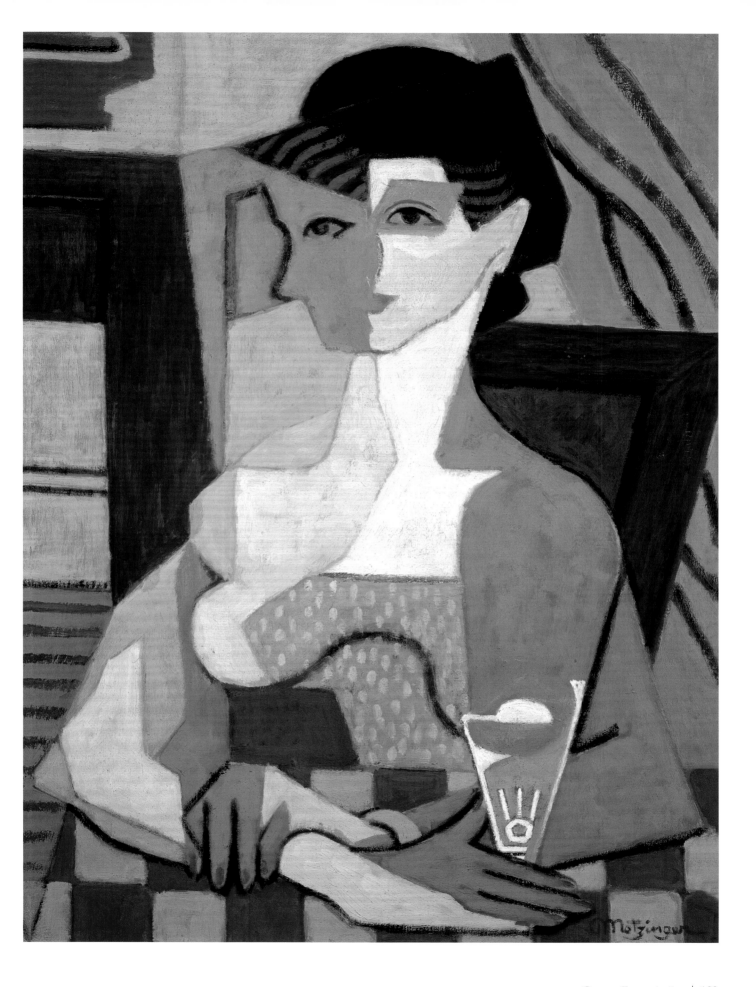

Alexei von Jawlensky
The Cocotte, 1912
Oil on cardboard, 49.5 x 53.5 cm
Private collection

about a year; in 1907 the artist travelled to Rome and Paris, and then returned to Dresden for a few months before moving definitively to Berlin in 1908. Although it featured violent chromatic contrasts, his art immediately proved to be less problematic and more serene than that of the other Expressionists. Perhaps for that reason, he became the best known of the Die Brücke artists, though he was helped by his conciliatory personality, disposed to compromise; it was no accident that he was the first member of the group to exhibit—and sell—a number of paintings at the Berlin Secession, to which he returned in 1912.

Otto Müller came into contact with Die Brücke in 1910. His art would always be characterised by a quest for harmony between man and nature. This is apparent in his most distinctive works, which, composed like canvases by Matisse and Cézanne, depict groups of gypsies and female nudes in a landscape. His angular figures had a considerable influence upon Kirchner himself.

In Rhineland, too, Expressionism experienced an especially productive period: in 1909 in Düsseldorf the first exhibition of the Sonderbund Westdeutscher Kunstfreunde und Künstler (Special Association of the Artists and Friends of Art of Western Germany) was held. The name perfectly described the nature of the institution: its members were not only artists but

also collectors and museum directors. The first president was Karl Ernst Osthaus, who had inaugurated his own very important museum in 1902, the Folkwang Museum in Hagen, exhibiting works by Gauguin, Van Gogh, Cézanne and other European Post-Impressionists and contributing considerably to the education of the Expressionist artists of central Germany. The intention of the Sonderbund was to alternate showings of French and German paintings. At the 1910 exhibition, paintings by Die Brücke and Kandinsky were featured. This model of exhibition—which influenced the New York Armory Show—triggered a singular groundswell of protest, expressed in the *Protest deutscher Künstler* (Protest of German Artists) in 1911, a text published by eminent academic professors led by Karl Vinnen, in a polemic against the space offered to French art, which they considered excessive and harmful to the dignity of German art. It was not an entirely fruitless critique, since the numerous responses from critics and collectors led to an appreciation of modern German art in a way that had never existed before. The highest expression and the greatest result of this debate—carried out at the very top levels of German culture—was the international exhibition held by the Sonderbund in Cologne in 1912. For the first time the term 'Expressionism' was used in the catalogue in a consistent manner, ac-

August Macke
Pierrot, 1913
Oil on canvas, 75 x 90 cm
Bielefeld, Kunsthalle

Opposite
August Macke
Large Bright Shop Window, 1912
(detail)
Oil on canvas, 105 x 85 cm
Hanover, Sprengel Museum

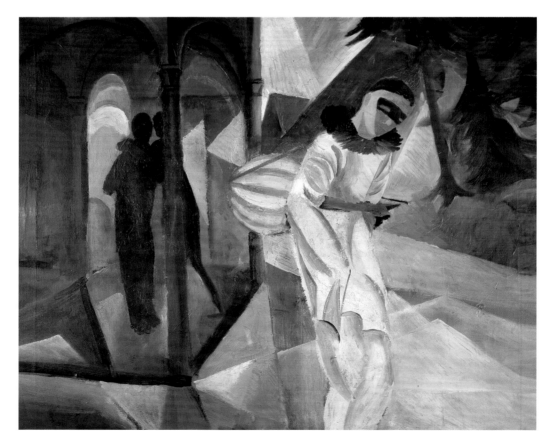

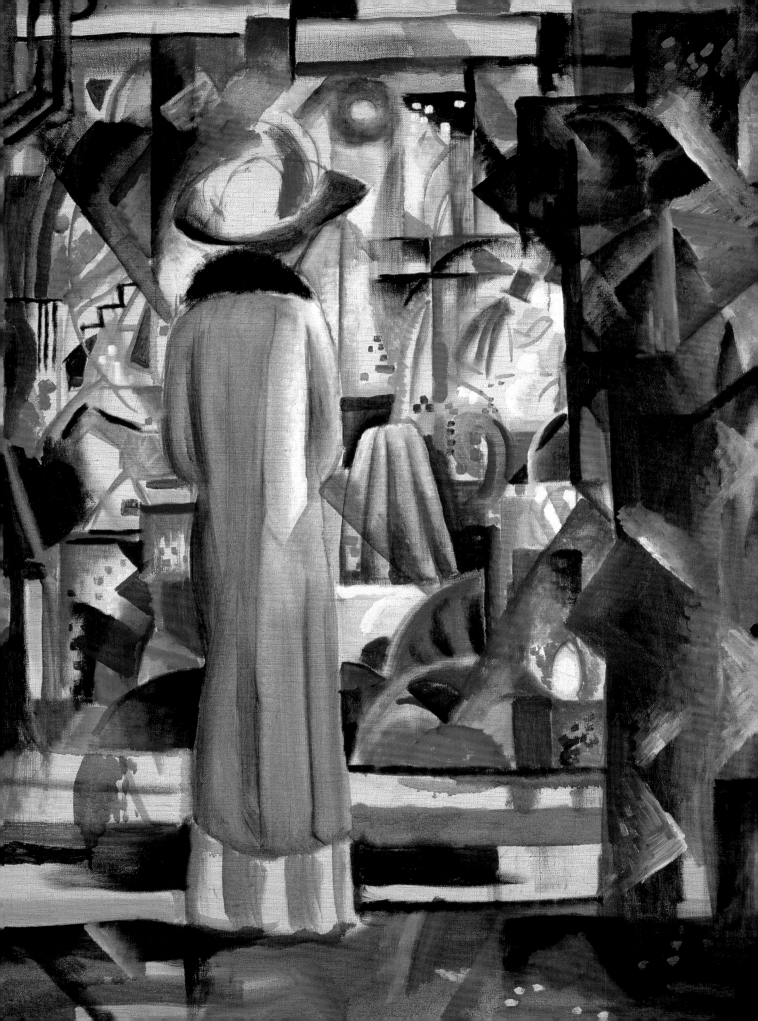

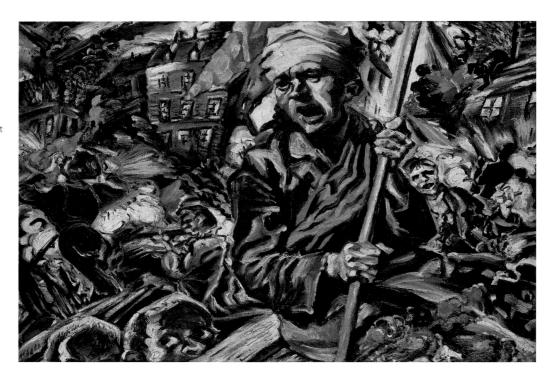

Ludwig Meidner
Revolution (Barrikadenkampf), 1912
Oil on canvas, 80 x 116 cm
Berlin, Neue Nationalgalerie

Opposite
George Grosz
Metropolis, 1917
Oil on panel, 68 x 47.6 cm
New York, The Museum of Modern Art

August Macke
Park with Pond, 1913
Oil on canvas, 65 x 85 cm
Hanover, Sprengel Museum

Pages 188–89
Ludwig Meidner
The Corner House, 1913 (detail)
Oil on canvas, glued to wood,
92.7 x 78 cm
Madrid, Thyssen-Bornemisza Museum

Erich Heckel
Day of Glass, 1913
Oil on canvas, 138 x 114 cm
Munich, Staatsgalerie Moderner Kunst

knowledging the school's roots in Naturalism and Impressionism and identifying its essence in the 'intensification of expressive forms'; a retrospective section of the catalogue attempted to seek German Expressionism's precedents in Van Gogh, Gauguin and Cézanne, thus performing an important exercise in historicisation.

After the 1912 exhibition the Sonderbund dissolved and many artists who had been affiliated with it received help from Herwarth Walden, who invited them to exhibit in his Erster Deutscher Erbstsalon in Berlin, though the group of Die Brücke refused to take part.

The Sonderbund made its mark in the art of Rhineland, creating an awareness among many artists of the area who held an exhibition of their work entitled Rhineland Expressionism in 1913 at the Cohen gallery in Bonn. Among the artists were many who had also showed in Cologne the year before: Heinrich Nauen, in whose cluttered paintings the influence of the French could be sensed in a particular way, Max Ernst, Heinrich Campendonk and August and Helmut Macke. In particular, August Macke, originally from Meschede, a small town on the banks of the river Ruhr, was one of the most interesting cases of German Expressionism. Even though he was always linked with the Blaue Reiter, that experience was only one facet of his career, and he established a certain distance from it on repeated occasions. In the early years of the century (1904–06), he attended the Kunstakademie in Düsseldorf and, through his friendship with the playwrights Wilhelm Schmidtbonn and Herbert Eulemberg, he

painted sets for the Düsseldorfer Theater. His career was marked by numerous trips to Paris: in 1907 he was swept away by the painting of Manet and Degas and, a year later, by that of Cézanne and Gauguin. A lengthy stay with his friend Schmidtbonn on the Tegernsee and direct contact with nature helped Macke define his relationship with reality: 'By his nature', wrote his friend Lothar Erdmann, '[Macke] has no interest in the transcendental, his sensibility is perhaps even too deeply rooted in life'. His love of things and of life would keep him from ever moving closer to any theoretical scaffolding and to abstract art. He met Kandinsky and Marc in 1910, and they became close friends. A member of the Neue Künstlervereinigung München, he was also invited by the founders of the Blaue Reiter to write for its Almanach, which was generously financed by Macke's uncle, Bernhard Köhler. The encounter with Futurism and Cubism—which he had admired in an exhibition at the Flechtheim gallery in Düsseldorf—represented a fundamental step for the artist: the two movements allowed him to fuse into a single vision landscape, people, and animals, taking advantage of the brilliant chromatism that had made such a powerful impression upon him at the Matisse exhibition in Munich in 1910. During his trip on the Swiss lake of Thun and to Tunis (with Klee and Moilliet), the artist produced his well-known watercolours, light and redolent of all these experiences, precisely like his very last composition, *Girls among the Trees* (1914). The experiences of the Expressionists

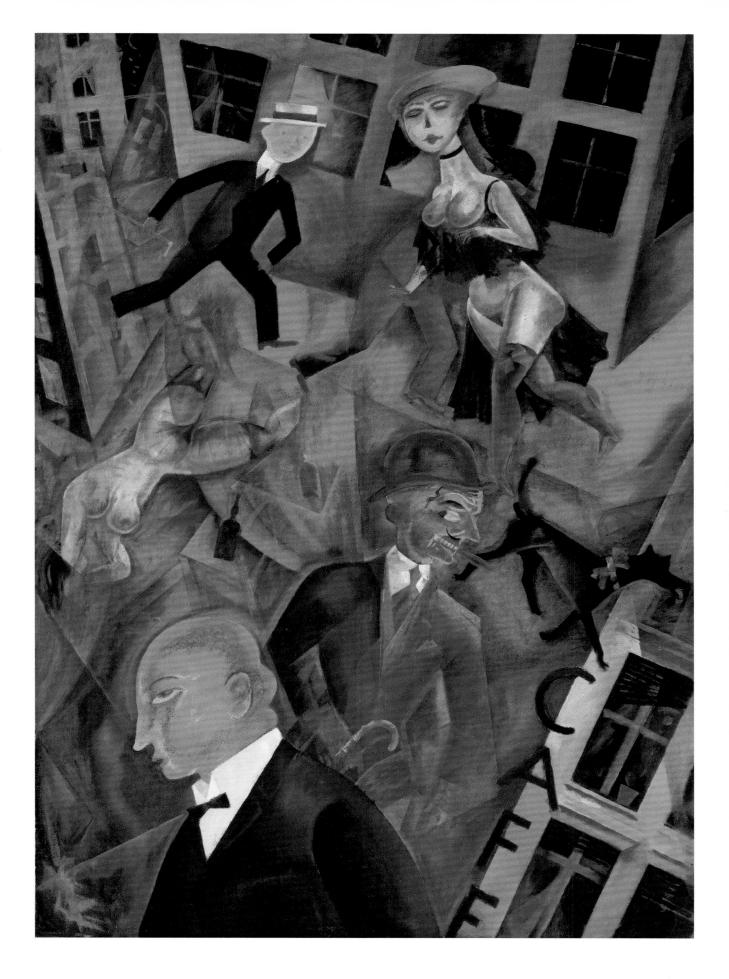

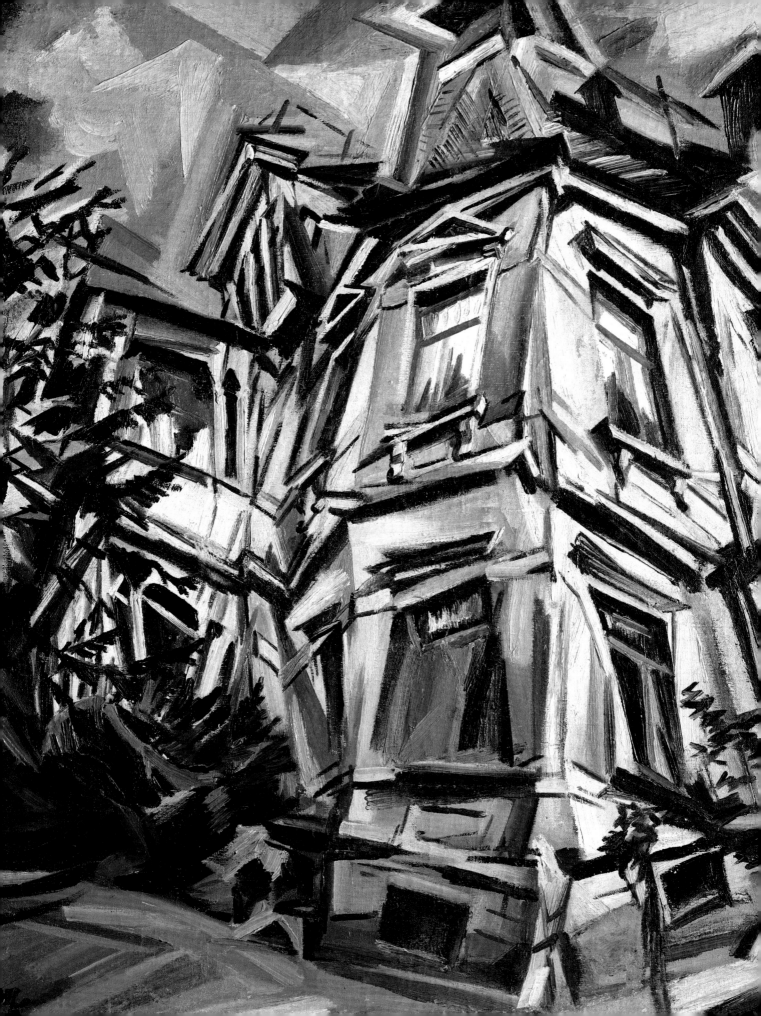

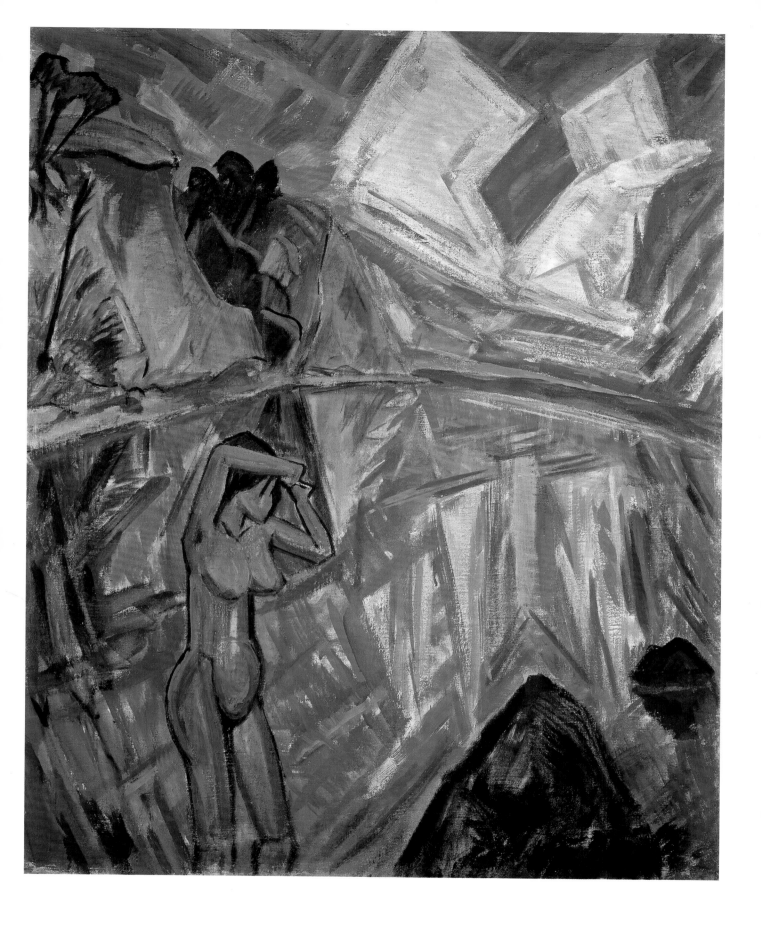

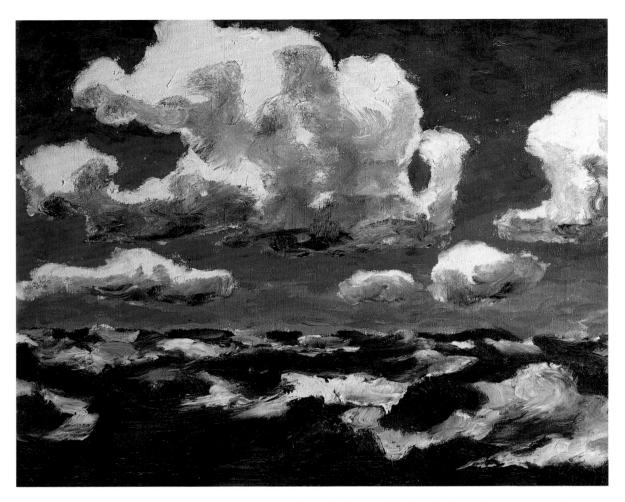

Emil Nolde
Head of Woman, 1914
Oil on canvas, 40 x 25 cm
Hannover, Sprengel Museum

Alexei von Jawlensky
Bordighera, 1914
Oil on canvas, 54 x 49 cm
Hanover, Sprengel Museum

Pages 190–91
Emil Nolde
Summer Clouds, 1913
Oil on canvas, 73.5 x 89 cm
Madrid, Thyssen-Bornemisza Museum

Emil Nolde
The Sea B, 1930
Oil on canvas, 73.7 x 101 cm
London, Tate Modern Gallery

Erich Heckel
Path in the Forest, 1914
Oil on canvas, 87 x 44 cm
Hanover, Sprengel Museum

Pages 194–95
Ernst Ludwig Kirchner
The Red Tower at Halle, 1914
Oil on canvas, 92 x 120 cm
Essen, Folkwang Museum

Ernst Ludwig Kirchner
Five Women in the Street, 1913
Oil on canvas, 120.5 x 75.5 cm
Cologne, Wallraf-Richartz-Museum

demonstrated that, even though Dresden, Cologne, Düsseldorf, Bonn, Munich and Bremen had established themselves as very active art markets at the end of the first decade of the twentieth century, the capital of the new art was confirmed as Berlin; one piece of evidence was the formation of the New Secession, as has already been pointed out in connection to the history of Die Brücke.

In 1913, a new division in the heart of the Secession of 1898 led to the formation of the Freie Sezession (Free Secession) under the sponsorship of Paul Cassirer, the most important gallery owner in the capital and already a founder of the first Secession. The real beneficiaries of these continual break-ups were actually the gallery owners, who managed to create events of great cultural and commercial resonance. In this way, the first exhibition of the Freie Sezession, in 1914, was a spectacular success. The most controversial gallery owner of the period, a freelance journalist and a writer, was probably Herwarth Walden, who assured himself the greatest attention by founding the magazine *Der Sturm* and an art gallery that brought to Berlin the leading figures of the European avant-garde.

Cassirer and Walden had one thing in common: both of them sensed the importance of the art of Oskar Kokoschka, who moved from Vienna to Berlin in 1910. Walden hired him immediately as editor of *Der Sturm*, and devoted the weekly's first monographic article to him; also in 1910, Cassirer signed a contract with the Austrian artist for one painting a year. In tandem with Kokoschka, the name of Egon Schiele began to become known in Germany; he had exhibited at the Sonderbund show in Cologne and at the Folkwangemuseum in Hagen, and a supplement of the Berlin magazine *Die Aktion* in 1916 confirmed his definitive, if late, success.

Schiele and Kokoschka arrived from the milieu of Vienna, which was quite different to that of Berlin and its much younger Secession. The differences were both politi-

Herwarth Walden and 'Der Sturm'

Oskar Kokoschka
Dolomite Landscape, 1913
Oil on canvas, 79.5 x 120.3 cm
Vienna, Leopold Museum

Herwarth Walden began his studies as a musicologist, in particular an enthusiast of Schönberg's dodecaphonia on which he published various articles. After various co-editorships of magazines he founded *Der Sturm*, the first issue of which appeared on 3 March 1910. Walden thus dealt for the first time with figurative arts, even if the publication was also open to literature and poetry. The layout of the issues of the first year was still dominated graphically by Jugendstil, but then veered gradually towards Expressionism the following year, due in particular to the collaborators that the publisher called upon from time to time: Kokoschka, the members of Die Brücke, Klee, Bauer and, subsequently, the artists of Der Blaue Reiter. Major space was also devoted to the promotion of Walden's own gallery in Berlin, Der Sturm, which opened onto the

city's main business and shopping street, Potsdamerstrasse. With a particular eye for the commercial aspect, the gallery displayed works of the European avant-garde on a monthly basis, starting with those of Der Blaue Reiter (1912), followed by the Futurists and the German and French Expressionists. From September to April 1913, Walden organised a special exhibition —the 'Erster Deutscher Herbstsalon' (The First German Autumn Salon)—which brought together seventy-five works by European artists from the most diverse tendencies. Perhaps Walden was lacking a certain consistency comparable to that of Cassirer, and the commercial approach of his gallery was often criticised by the artists themselves; nevertheless, this openness towards all fields fostered the circulation of many ideas and launched a few little-

known artists, including Archipenko and Campendonk. Having become a political activist against National Socialism, in 1932 he moved to Moscow, together with his fourth wife, Ellen Bork; there he wrote novellas and founded the magazine for emigrants, *Das Wort*, but in 1941 he was imprisoned in Saratov on political grounds, and there he was to die.

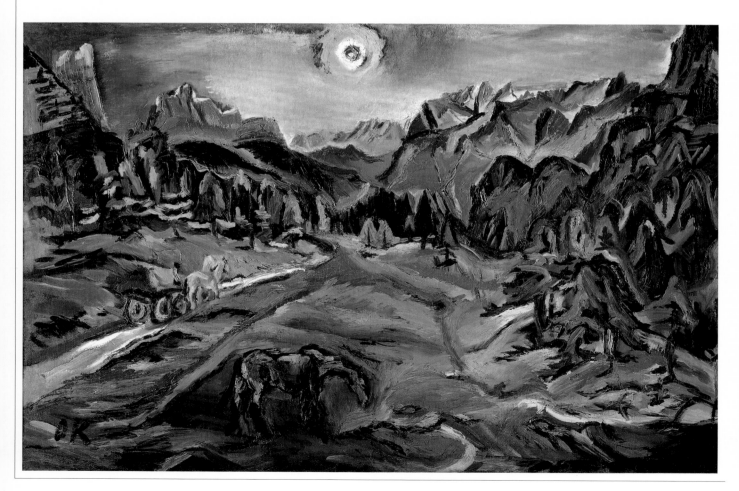

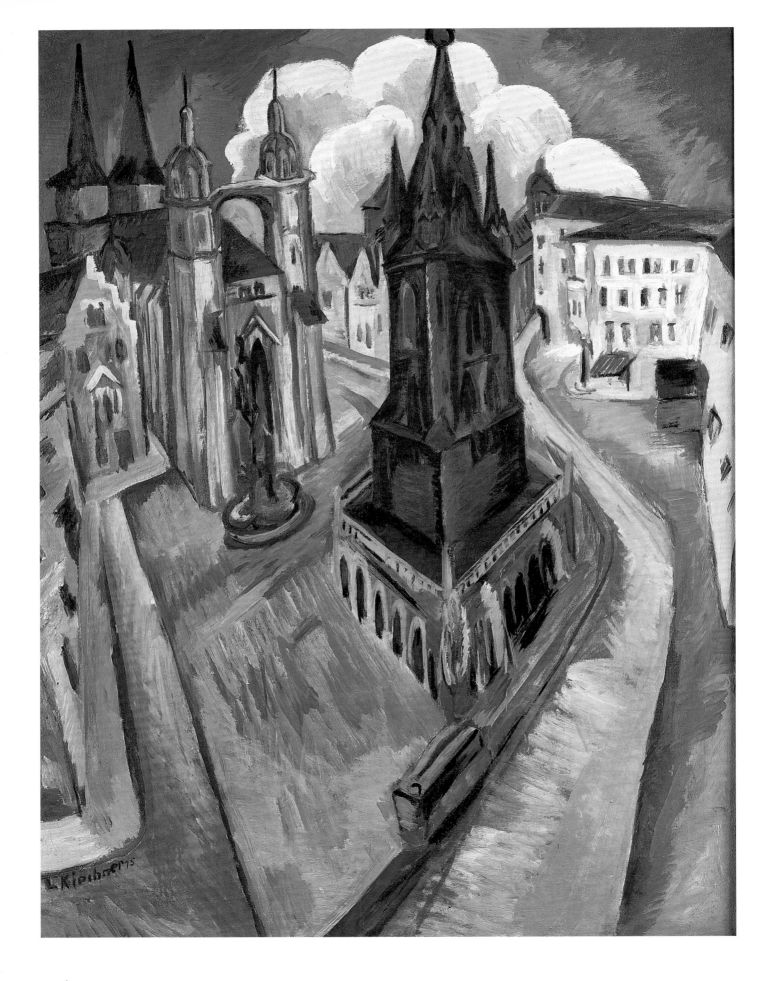

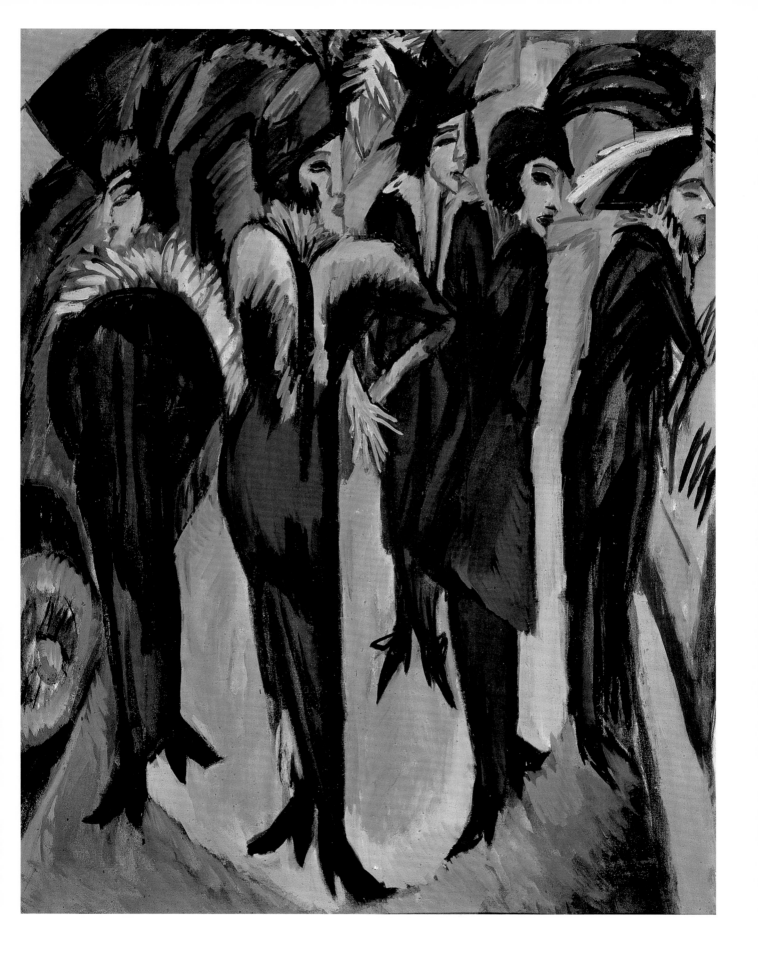

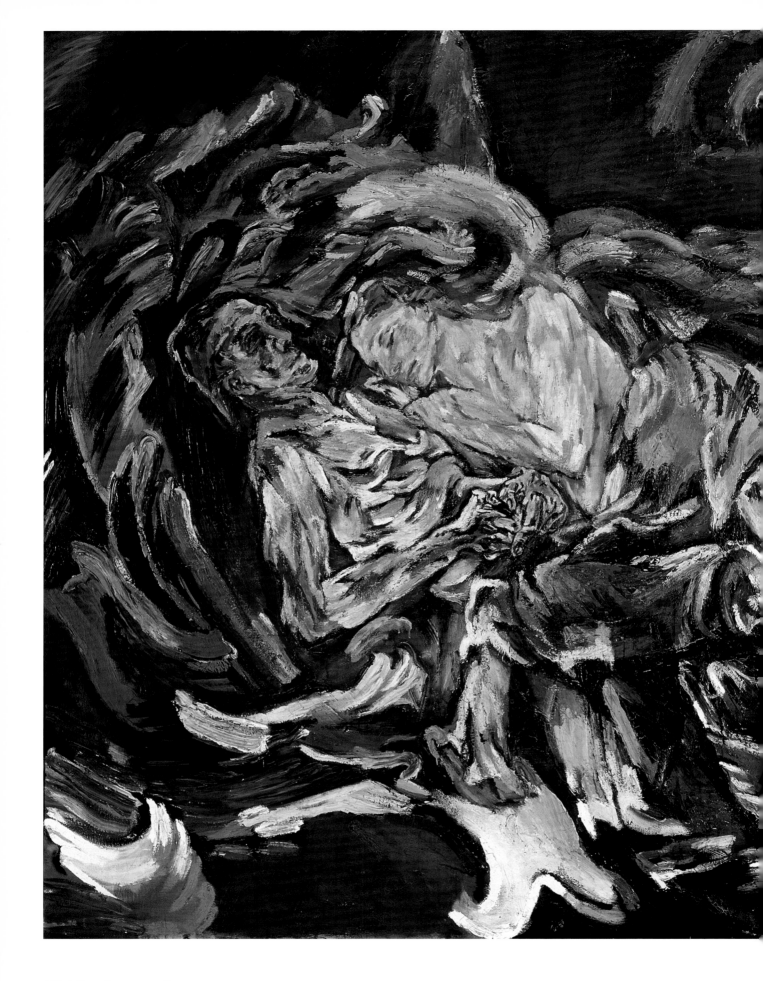

cal and cultural, and they proved fundamental to any understanding of the diversity of Austrian Expressionism with respect to that of the German Empire. It would seem superfluous to make any reference to the feeling of *finis Austriae* that had already begun to appear in the canvases of the Secessionists of Vienna, in a splendour that had already begun quite some time before to transform itself into decadence; the artists of Austria lived in a world that was on the brink of disintegration, as opposed to a Germany immersed in its own massive industrial development. The dehumanising aspects of this industrial progress were regularly recorded by the Expressionists of Berlin, as well as in the prints and paintings filled with suffering humanity by Käthe Kollwitz. It was the Vienna of Freud which—without venturing into the somewhat contrived interpretations offered by critics in recent years—was exploring the world of the subconscious and which, at the very least, pondered human fears and drives. In purely artistic terms, it was a Vienna dominated by the tortuous line of the latest Klimt and by the more gleaming line of the architects who matured with the Secession, such as Olbrich, Hoffmann and Loos. The latter, with the *Steiner House* (1910), affirmed the superiority of the straight, sober, functional line, in accordance with the theories in his book *Ornament and Crime* (1908). The typically Viennese love for the use of lines, as seen in the works of Schiele and Kokoschka, can surely be called a contrived formulation, but never a suppression.

These were the foundations of the art of the two greatest Austrian Expressionists, and they reveal a more tormented and certainly more lucid psychological analysis, far from shy about unveiling all sorts of moral and sexual tensions, the final catharsis in an attempt to prevent the destruction of a world with age-old foundations.

When he arrived in Berlin, Oskar Kokoschka had already found his protectors in the intellectual milieus of Vienna, among them Adolf Loos—of whom he painted the *Portrait* in 1909—and the publisher Karl Kraus. His art had already caused considerable scandal, because his subjects violently expressed that sense of decadence and transition that, in the sophisticated elegance of the Secessionists, were only hinted at. In his play, based entirely on the clash between the sexes, *Murderer, Hope of Women* (1908)—his *Pietà* of 1909 was used as a poster for it—he was already able to express an instinctive and latent carnality suffocated by the socio-cultural

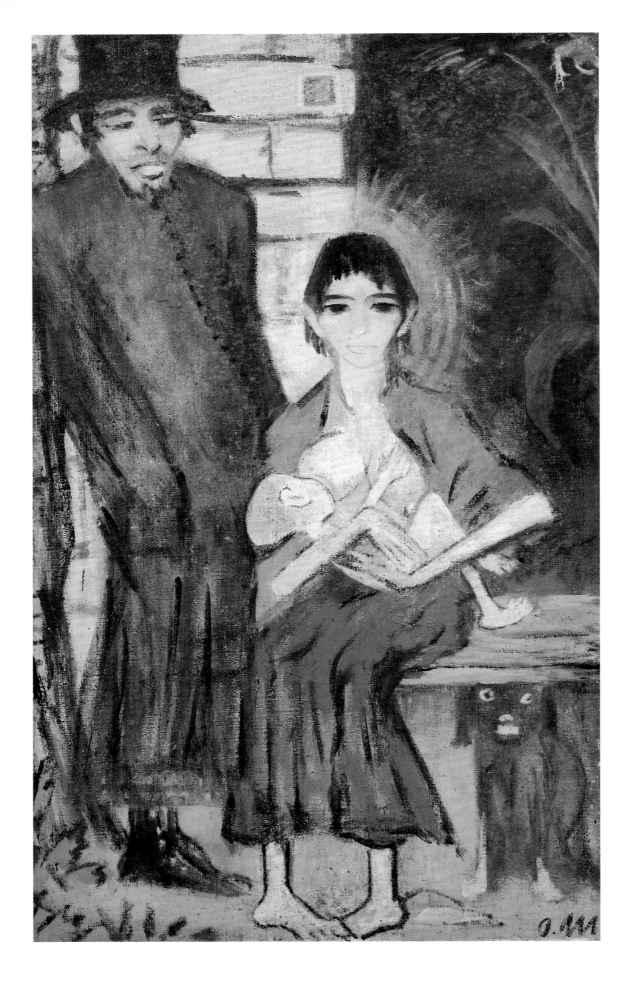

The major possibilities offered by the medium of cinema—which was capable of realising the idea of a total work of art that was pursued by many artistic movements starting from the late nineteenth century—were embraced very favourably by the historical avant-gardes; in contrast with the cinema of a Futurist and Surrealist vein, Expressionist cinema in the period of the silent film did not tie itself explicitly to the works of contemporary painters, even though inevitably many correlations on an emotional level were established. The first universally recognised masterpiece of Expressionist cinema was *The Cabinet of Dr. Caligari*, which was made in 1920 by Robert Wiene after taking over from Fritz Lang, who was busy making *Spiders*. The internalised vision of reality reached its peak in the disturbed set designs —characterised by an obsessive use of distorted diagonals—created by set designers Walter Reimann, Herman Warm and Walter Röhring; the theme of mental illness essentially placed the truthfulness of facts in doubt and opened up cinema to psychological relativism.

Still in the sphere of the silent movie, in a similar way to the Berlin works of Die Brücke, *Metropolis* by Fritz Lang (1926) placed the accent on the alienating and dehumanised life of modern cities, introducing the phenomenal figure of the woman-automaton, which gave concrete form to the theme of 'splitting' and emotional relativity also dealt with by painting. The motif of erotic tension that underlies so many Expressionist paintings is the pivotal element of *Variété* (1925), a sound film by Ewald André Dupont. For the first time, almost direct citations appeared of works by Pechstein, Nolde, Dix and Grosz, but the director's ability was expressed through exquisitely cinematic means—such as the alternate use of objective and subjective, and shots from different viewpoints that also continually alter the perspective—though still remaining in a naturalistic context. Furthermore, the actors managed to become 'expressive machines' to the extent that the commentators of the period stated that actor Emil Jannings 'even succeeded in making his shoulders expressive'.

Heinz Schulz-Neudamm
Metropolis, 1926
Lithograph printed in colour,
300 x 100 cm
New York, The Museum of Modern Art

Opposite
Otto Müller
Family of Gypsies, 1915
Tempera on canvas, 179 x 112 cm
Essen, Folkwang Museum

Pages 196–97
Oskar Kokoschka
The Bride of the Wind, 1914
Oil on canvas, 181 x 220 cm
Basel, Kunstmuseum

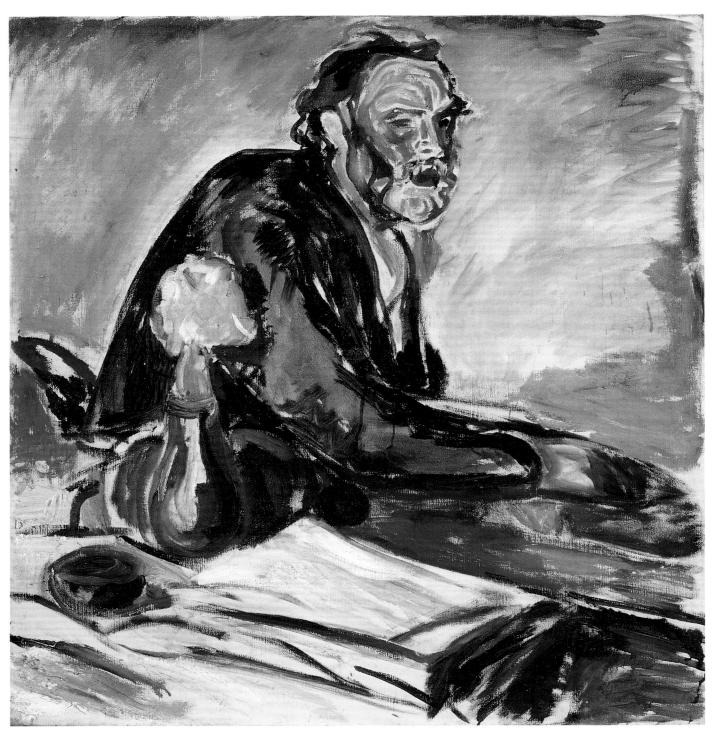

Edvard Munch
Self-Portrait with Spanish Flu, 1916
Oil on canvas, 83 x 73 cm
Oslo, Munch-museet

Opposite
Egon Schiele
Family, 1917
Oil on canvas, 191.8 x 152.5 cm
Vienna, Österreichische Galerie
Belvedere

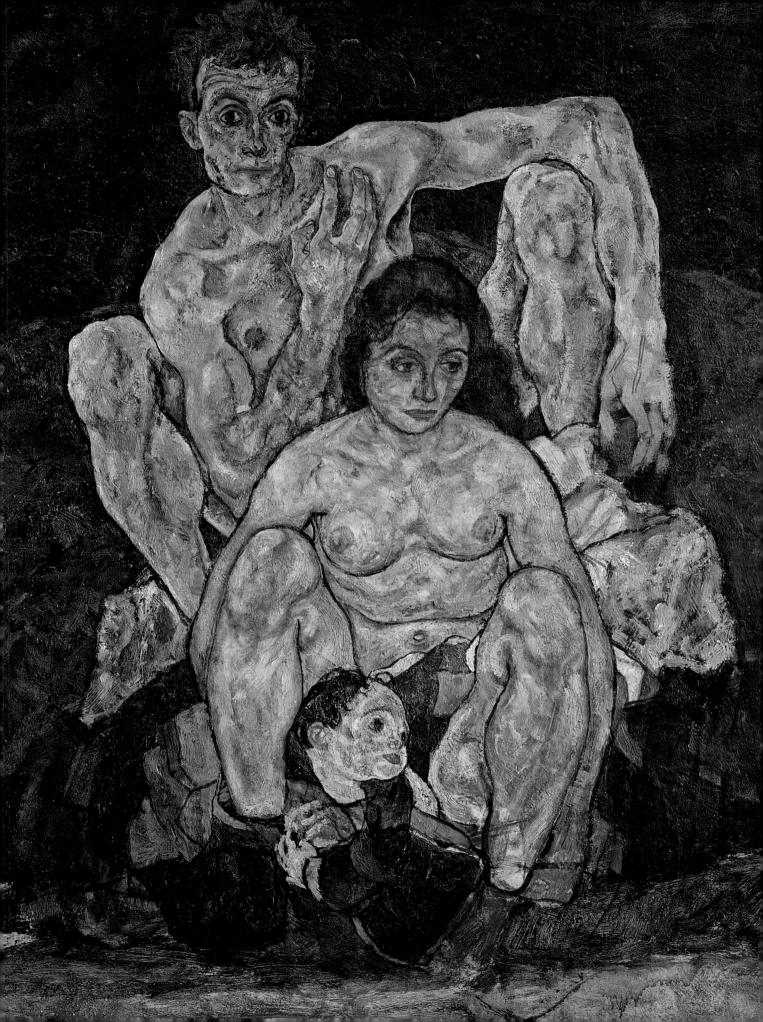

Karl Schmidt-Rottluff
Village Square, circa 1919
Oil on canvas, 119 x 137 cm
Prague, National Gallery

structures of the time. The end of his relationship with Alma Schindler inspired him to create his most intense and vital works, such as *Bride of the Wind* (1914) and *Knight Errant* (1915), which were commonly interpreted as metaphors for the tragic war ravaging Europe in those years. After his return from military service in the Ukraine and his long recovery, he found a surrogate for his lost love in a life-sized doll that he painted in various poses (the theme of the fetish would also characterise some of the Expressionist cinema). From 1919 to 1923 he lived in Dresden, where he became a professor at the Kunstakademie; his lines of research into the states of mind of humans and the effects of sensations—the last examples of his most authentically Expressionist phase—gave life to *The Power of Music* (1920). There followed a decade of travel throughout Europe, of which there are still views of the main cities; these he captured as if they were living creatures, organisms teeming with life thanks to his increasingly rapid and excited signs. He then returned to Vienna but was forced into exile following the events of 1934: he went to Prague, London, and in the last years of his life, Villeneuve, on Lake Geneva. Not entirely different were the poetics of the younger Egon Schiele, who took further the Austrian use of line and form, making his figures twist, bend and open the fingers of their hands in an entirely unnatural way in his numerous nudes and many portraits; his carnality was far more open than that of Kokoschka, but almost devoid of voluptuousness. His canvases mostly depict landscapes with no topographical precision or idyllic sentiment, and are almost deconstructed and geometric. Examples are those of Krumau, the small Bohemian town where his mother was born (present-day Cesky Krumlov) where he withdrew in 1910–11; he was forced to leave the place because the inhabitants tormented him for his cohabitation with his girlfriend Wally Neuzil and because he painted portraits of the local girls. His drawings and watercolours were more concerned with the nude body, and as a result of these works, once he had moved to Munich, he was arrested on suspicion of having seduced a minor. A more serene vein appears in Schiele's art only in the last years of his life. Although marked by a bold dark line, the embraces and gestures become more relaxed, and even the last landscapes seem to hint at a coming reconciliation with the world (*View of Krumau*, 1916).

Ernst Ludwig Kirchner
Moonlit Night in Winter, 1919
Oil on canvas, 148 x 143 cm
Hanover, Sprengel Museum

Marco Pogacnik

Artistic Creativity and Idea of the City 1900–1914

The case of Munich

In September 1928 the magazine *Der Baumeister*, edited by Hermann Jansen, published an issue devoted to the theme 'München als Kunststadtwerk' (Munich as a work of art), as a response to the debate in progress in those months around the problem of the decline of the Bavarian city in the competition that saw it set against the other major German cities, such as Berlin, Dresden, Hamburg and Frankfurt.[1] The issue was organised around the two essays by Hans Rose (art historian) and Fritz Beblo (Munich's *Stadtbaurat* [city council representative]): the first was devoted to the programme of embellishment promoted in the nineteenth century by Ludwig I with the construction of the *via triumphalis*, the Ludwigstrasse; the second to the functionalist plan for the modern rational city based on the decentralisation of residence into the suburbs bathed in greenery. What both contributions kept silent about, however, was the fact that the very idea of 'city as a work of art' had its own history, a history that in the late 1920s it was considered not topical to mention, as it would have involved having to cite the protagonists of a vision of modernity that was considered outmoded at that time. The names of these protagonists were Camillo Sitte, Karl Henrici, Theodor Fischer and Adolf von Hildebrand, but also August Endell, Richard Riemerschmid and Hermann Obrist. The activities of these artists (urban planners, architects, sculptors, painters and designers) were conducted in the two decades spanning the nineteenth and twentieth centuries, starting from the premise that the design of space was the noblest task of art and that this objective was only achievable through close interaction between the various art forms. *Fin de siècle* Munich can be considered a kind of laboratory devoted precisely to the problem of a higher form of artistic activity centred on the theme of spatiality. Art, architecture and applied arts were a single object of study for this generation of artists, as is shown by their biographies. From painting Bruno Paul, Bernhard Pankok, Emil Orlik, Hermann Obrist, Richard Riemerschmid and Peter Behrens were to move on first to the applied arts and then to architecture. The event indicated as one of the beginnings of the modern era is the 1897 event of the annual exhibition held at the Glaspalast, where a section was devoted to the applied arts with two rooms designed by Martin Dülfer[2] and Theodor Fischer[3] and furnishings designed by Riemerschmid, Obrist, Endell, Pankok and Paul. The following year the same artists founded the Vereinigte Werkstätte für Kunst im Handwerk,[4] an association created for the commercial promotion of the furnishing objects produced by its members, and an anticipation of the Dresdner (1898) and Wiener Werkstätte (1903). Thanks to these initiatives, Munich, which at the time did not possess significant industrial activities, became the German capital of the applied arts, a role that was confirmed in 1907 by the foundation of the Werkbund[5] in the Bavarian capital.[6]

Munich's modest scale—in the first decade it had around 500,000 inhabitants[7]—and the fact that it was not the seat of central political power made this city a kind of chosen place for artists and intellectuals who were indifferent to the call of the great metropolitan capital or hostile to the intrusive Wilhelmian cultural politics; for all those, in short, who could not handle breathing 'the sourish air of the

Americo-Prussian metropolis'.[8] Thanks to its theatres[9] and its refined musical culture,[10] a dynamic art market[11] and a new generation of innovative publishers,[12] during the last decade of the nineteenth century, Munich was one of the liveliest German cities from an artistic and cultural point of view. Ahead of both Vienna and Berlin, the first Secession of artists that left the Künstlergenossenschaft (the artists' association chaired by Franz von Lenbach, who was in charge of organising the major art exhibitions in the Glaspalast[13]) took place in Munich in 1892. Among its members we find the names of Peter Behrens, Franz Stuck and Max Liebermann. Franz Stuck, Bavarian by birth and trained at the Munich Academy, had won the gold medal in 1889 at the annual exhibition at the Glaspalast with his painting *The Warder of Paradise* and it was in his studio that the painters of the twentieth-century avant-garde were to be trained: Paul Klee and Vasily Kandinsky. Peter Behrens, born in Hamburg and trained in Düsseldorf, moved to Munich in 1890, becoming one of the protagonists of the modern movement in painting. In Munich he began to become involved with the applied arts, an interest that was to lead, at the end of that decade, to his participation in the experiment of the Künstlerkolonie in Darmstadt with Josef Olbrich.

In 1892, the year of the Secession, Bernhard Pankok moved to Munich after studying in Düsseldorf and Berlin, and remained there until 1901 when he was summoned to Stuttgart, where in 1913 he became director of the local Kunstgewerbeschule. Arriving from Dresden in 1894 to study painting, Bruno Paul remained in Munich until 1906 when a professorial post was offered him at the Kunstgewerbeschule in Berlin; the young Mies van der Rohe worked in his studio before ending up with Peter Behrens. In 1895 Hermann Obrist, a Swiss artist who had studied medicine and botany as well as studying art in England and Scotland, moved there from Florence, where he had visited to study stone-working techniques and where he had founded a weaving studio. Obrist was one of the keenest promoters of the movement for the reform of the arts in the Munich of those years, and was involved in significant theoretical and didactic activities.[14] With Wilhelm Debschitz, in 1902 he founded a school of experimental art, the 'Lehr- und Versuch-Ateliers für angewandte und freie Kunst', based on workshops (metals, ceramics, photography), art's relationship with industry, the study of nature and the equal dignity of applied and visual arts. The school was to serve as a model for similar institutes, such as the academy of Breslau and the Weimar Bauhaus.[15]

Obrist was to exercise a particularly profound influence on the young August Endell.[16] After interrupting his philosophy and psychology studies begun in Berlin, Endell stayed in Munich from 1896 to 1902, where he followed the lectures of Theodor Lipps[17] and began to write his doctoral thesis on the theme 'Gefühlskonstruction', the problem of construction in relation to feelings. From his first much admired article, published in 1896, with which Endell made his debut as a theorist, he set himself the problem of vision as the central theme of his reflection, the problem of learning to recognise that 'alongside the world of objects, which we know, there exists a second, the world of the visible'.[18] Seeing means knowing how to dis-

tinguish between the world of objects and the world of the visible. According to Endell, those who first discovered this parallel reality of vision were the French painters. Their pictures no longer represented the objects we see in natural reality, but strange manifestations of perceived reality; they no longer painted 'men, bridges, towers, but rare apparitions, and they made them air, light, dazzle, dust. The active man is forced to see and recognise through this veil'.[19] This art, based on the visible through the sacrifice of the object, was defined by Endell as 'Formkunst', as expressed in the title of an aphorism that he published in the first year of *Dekorative Kunst*: 'there is an art of which nobody still seems to know anything: Formkunst, an art that stirs the soul of men only with forms that do not resemble anything known and that symbolise nothing, acting solely through freely invented forms, like music with free notes. … Yet the time will come when monuments will be erected in the parks and public squares that will represent neither men nor animals, [but] fantastic forms…'. With the sculptures of Obrist in mind, Endell imagined an art freed from the tyranny not only of historical styles and of every naturalism, but of the object itself. The outcome in painting was to be abstraction, the 'gegenstandslose Malerei'; in architecture, the shifting of the accent onto its negative element: space. 'Those who think about architecture, always understand it in the first instance as construction, façades, columns, ornaments—yet all of this is secondary. What counts is not the form but its negation, the space, the void that is rhythmically stretched between the walls, that is defined by the walls, but the vitality of which is more important than the walls themselves.'[20] The space to which Endell refers is the flat retinal image on which the point in movement represented by the human figure traces axes that only evoke depth in an 'approximate, indistinct and ambiguous' way.[21] This conception of space was surprisingly close to the regulating systems described by painter Adolf Hölzel in an article that appeared in *Ver Sacrum* in 1901.[22] According to the Moravian painter, who moved from Vienna to Munich in 1876, the composition of the image was constructed following the rules of 'Kontrapunkt und Harmonie', a theory of harmony based on the equilibrium between contrasting polarities: line and surface, light and dark, heat and cold, horizontal and vertical, solid and void, rough and soft, large and small. It is through these oppositions that the eye of the observer is perceives formal hierarchies that are independent of the representation of real objects.[23] The presuppositions of an abstract painting, however, were not grasped by Hölzel solely at a theoretical level for it was he who made the first abstract painting of the twentieth century, *Komposition in Rot I*, in 1905. It was Peg Weiss[24] who highlighted the extraordinary coincidence of these compositional studies by Hölzel from the Dachau period with those that Vasily Kandinsky was to publish in his *Punkt und Linie zu Fläche*.[25] Another theme of his research in painting to be considered in relation to the artistic debate of the time is that of 'abstract ornament',[26] i.e. the hieroglyph obtained through a procedure of automatic writing, a theme that we find again in the work of artists like Obrist and Endell, such as the project by the latter for the Elvira Photographic Studio.

Until 1905 Adolf Hölzel lived in Dachau in a kind of spiritual retreat, away from the spotlights of the Munich artistic scene.[27] In 1906 he moved to Stuttgart where he had earned a place as a professor at the local Academy and embarked on an intense relationship with architect Theodor Fischer, then engaged in the challenging task of reforming the teaching approach at the faculty of architecture. Documents remain of the close collaboration with Fischer in the form of the pictorial decorations of the Pfullinger Hallen (built by Fischer between 1904 and 1907), the monumental fresco of the *Christ Crucified* in the Garnisonkirche in Ulm (1910)[28] and a large number of drawings conserved in the Fischer legacy in the Munich Architekturmuseum with pictorial studies executed following Hölzel's compositional principles.

The last fundamental element to take account of in reconstructing pictorial research in Munich in the two decades spanning the nineteenth and twentieth centuries involves the events relating to the reception of the work by painter Hans von Marées,[29] from whose school came sculptors of the calibre of Adolf von Hildebrand and Wilhelm Lehmbruck. His patron, the art philosopher Conrad Fiedler, had moved to Munich back in 1880 and thanks to a donation by him the Munich art gallery came into possession of a significant number of works by Marées, which went on public display in 1892 in the castle at Schleissheim, a locality between Munich and Dachau. This place became the destination of a full-blown artistic pilgrimage, as is documented, among other things, by an article published in *Ver Sacrum*;[30] Hölzel even went there several times himself. Besides a series of publications that brought him to the attention of the public and critics, in 1891 Fiedler organised a major exhibition in Munich on the painter who had died four years earlier. In the centenary exhibition organised in Berlin in 1906 by Alfred Lichtwark and Hugo von Tschudi[31] with the collaboration of Julius Meier-Graefe, Marées was one of the best represented painters, with no fewer than 32 paintings; in 1910 his success reached its apex with the publication of the monumental monograph in three volumes[32] devoted to his work. In Marées' cycle of the *Hesperiden* we find orange groves and nude figures, paintings without any narrative action. The background is nocturnal, the bodies seem to swallow the cold light that illuminates them. The composition of the painting is formed by the verticals of trunks and bodies and by the horizontal lines of the ground and the extended or folded arms. Every Böcklin-style symbolism has been forgotten, as has every form of realism, naturalism or historical painting.

In Munich the interest in Marées' work was interwoven with the work on the critical edition of the theoretical legacy of Conrad Fiedler[33] and with the artistic and theoretical activity of Adolf von Hildebrand. With the latter we encounter one of the protagonists of the reflection on spatiality in sculptural work, a theme to which he devoted an important theoretical text, *The Problem of Form in the Figurative Arts*, developed during his Florentine stay, which he spent in close contact with his friends von Marées and Fiedler. The book exercised an enormous influence on a whole generation of artists.[34] Hildebrand's interest in the problem of urban space was not episodic and was nourished by his particular passion for architecture. Hildebrand con-

sidered himself a complete artist in the Renaissance mould: a sculptor and an architect together. He designed the Zoological Station in Naples, where, together with Marées, he frescoed the walls of the library (1873), followed by various villa projects for Fiedler himself, the Hubertusbrunnen pavilion in Munich (1895–1919), the design for the Stuttgart theatre (with Carl Sattler and August Zeh, 1907/08), and the design for a museum dedicated to Hans von Marées (1910).[35] Hildebrand's vast literary output clearly highlights the object of his interest, what he himself defined as the problem of 'Sichtbarmachen', 'making visible' as a fundamental problem of artistic activity. Making an object visible no longer means focusing on the object itself, but studying the mechanisms of perception in the relationship between vision close up and far away, between object and background, between solids and voids, between illuminated and shaded parts. The writings on optics by Hermann von Helmholtz[36] also had a fundamental importance in Hildebrand's thought, and in the whole of the art philosophy of the late nineteenth century. In a stimulating essay from 1901, Hildebrand described an optical apparatus presented at the natural history museum in Florence, which consisted of an empty box with one side missing and a small plaster bird inside. By changing the colour of the object in relation to the background and the incidence of light, it was possible to study the ways nature helps animal species in their struggle for survival making them invisible to the eye of predators. Hildebrand talks of a clever demonstration of Darwinian scientific principles, which the artistic work should have successfully appropriated by studying the mechanisms that govern the perception of the plastic object in relation to the background.[37]

The core of Hildebrand's sculptural work consists in a large number of fountains and monuments, which he made for the squares of some of Germany's major cities: Jena, Strasburg, Worms, Köln and Bremen, even if his most famous work was the monumental fountain dedicated to the Bavarian royal family, the Wittelsbachs, which he created in Munich between 1890 and 1895. In a 1900 essay devoted to the design of green spaces in the modern metropolis,[38] this fountain was cited by Sitte himself as one of the most excellent examples of the contribution made by plastic art to the urban space. Apart from its technical and artistic completeness, what the critics admired about the work was the mastery with which the sculptor resolved the topographical complexities, developing the fountain on two levels to close off the head of the ancient city walls.[39]

Hildebrand's commitment to promoting the importance of the design of the urban space was expressed not only through his work as a sculptor, but also through the institutional role that he fulfilled in important bodies such as the Monumentalbaukommission (1901) in Munich and the Bau- und Kunstkommission in Hellerau (Dresden),[40] and also through his vast literary output.[41] The problem of the relationship between sculpture and open space was considered in an essay that Hildebrand published in the magazine *Die Raumkunst*[42] in which he discussed four exemplary cases: the Piazza della Signoria and Piazza Duomo in Florence, Piazza San Marco in Venice and Castel Sant'Angelo in Rome. Hildebrand's effort was exactly

what had already been accomplished by Sitte: to demonstrate that the historical city, even in the absence of an urban planning scheme, had not in fact developed by chance, but obeyed precise rules associated with our perceptive mechanisms. According to Hildebrand, the position of Michelangelo's *David*, and that of the bell-tower in Piazza San Marco, highlighted how space is not an objective item of data *a priori*, but the product of visual strategies playing with the contrast between vertical and horizontal elements, foreground and background, and parts in light and others in shade.

The editor-in-chief of the magazine *Die Raumkunst*, founded in Munich in 1908, was Walter Riezler[43] and on the editorial team, among others, were Theodor Fischer, Richard Riemerschmid and Max Läuger;[44] Fischer wrote the first editorial. The themes dealt with by the magazine ranged from urban art (such as the article cited by Hildebrand and that by Karl Hocheder devoted to the competition for the cathedral square in Ulm,[45] and the essays by Leberecht Migge on the art of gardens[46]) to subjects dear to the Werkbund, such as the problem of the relationship between form and technique or the aesthetic value of new materials like iron. The magazine, which published articles by Otto Bartning[47] and designs by Hugo Häring and Max Läuger, was an important laboratory in which Sitte's ideas on urban space were considered in the light of the contemporary debate involving the youngest generation of architects. Significant, in this regard, was the participation of Max Läuger; he was the architect of one of the most surprising buildings constructed in those years, the Palmenhalle exhibition pavilion for the 1907 Gartenbauausstellung in Mannheim,[48] a volume closed by a series of perfectly smooth construction belts with a compositional system based on the overlap of wall thicknesses that created the idea of spatial depth thanks to the interplay of the shadows cast. The volume was without any frame or appeal of the tectonic-constructive type; it had become pure texture, an architectural background to the garden space in which a large number of statues used in the form of visual hinges had been cleverly positioned. Without any reference to a historical style or to any type of naturalism masked by a functionalist programme or by an ethics of construction transparency, Läuger's architecture constitutes the most convincing outcome of how a reflection on space (begun with Semper and then continued in Munich by artists such as Obrist and Endell) could translate into an architectural language consistent with the results that experimentation in painting and science reached at the beginning of the twentieth century.

Thanks to Hildebrand, plastic culture in Munich reflected on the problem of context, the primacy of architecture and a study of antiquity that was never to degenerate into a repertoire of formal motifs. Hans Karlinger, the art historian, has indicated the presence in Munich of a group of artists who had been trained in the teachings of Hildebrand:[49] these were Josef Floßmann, Hubert Netzer, Georg Wrba and Bernhard Bleeker. As a result of the work of these artists, the architecture in Munich boasted a quality in sculptural parts that few cities in Germany could equal in those years. See Floßmann's collaboration with Theodor Fischer on the

design for the Bismarckturm (1899), the Haimhauserschule (1899) and the Max-Josef Bridge (1900). Georg Wrba worked with the major architects of the time: Alfred Messel, Fritz Schumacher, Ludwig von Hofmann and Theodor Fischer himself. He collaborated with the latter on the Wittelsbach Bridge and on the Cornelianum in Worms.

The relationship between the arts, the problem of abstraction and ornament and the centrality of the urban space as a factor to use as a point of departure for a reform of the arts and architecture are the central elements of the debate that we have reconstructed so far from the point of view of painting and sculpture. The artistic practices focused on by this research were those of Wandmalerei and Reliefkunst, wall painting and bas-relief sculpture.[50] The framework within which this research was conducted is described by the historical phase that coincides with the contemporary urban planning transformations that occurred in Munich starting with the competition announced in 1891 for the city's new urban planning scheme. The Bavarian capital also played a totally innovative role in this field, anticipating major cities such as Berlin and Vienna.[51] The jury for the competition in Munich had the most important urban planners of the age as its members: Reinhart Baumeister, Camillo Sitte, Joseph Stübben and the architect of the Reichstag in Berlin, Paul Wallot, a very heterogeneous commission, who concluded their works assigning four prizes *ex aequo*. The moral winner of the competition was Karl Henrici, an architect from Aachen, previously the author of two other planning schemes, for Dessau (1890) and Hanover, and for a long time an enthusiastic supporter of the urban planning approaches of Camillo Sitte. Hermann Jansen, the urban planner who won the competition for greater Berlin, was trained at Henrici's school. Henrici's project[52] was characterised by the total lack of any technical type of table and focused on the design of a large number of monumental plazas that were to adorn the ring of the new suburbs of Munich like a crown. The design for each square was presented with a plan and at least two perspectives in an original work produced by one of Henrici's students, the architect Friedrich Pützer. Loggias, porticos, fountains, terraces, stairways and sculptural monuments form a space closed by buildings devoid of axes of symmetry and without any stylistic uniformity. The road network accommodates the traffic along curvilinear thoroughfares, attempting to avoid any abrupt orthogonal interruption. The outcome of the competition was the establishing in late 1893 of an office in charge of the planning scheme, in which, for the first time, not an architect, Theodor Fischer,[53] rather than an engineer was employed as manager. This was in recognition of the fact that there was no solution to the problem of the growth of the modern city that could be separated from the intervention of art and the artist[54] or from the contribution—as the title of the book published by Sitte in 1889 stated—of urban planning, architecture and sculpture together.[55]

Fischer's interpretation of Sitte's notion of urban space was translated in Munich into his wide-ranging activities as an architect and urban planner, the most important part of which was the drafting of the detailed plans for a large number of districts (Giesing, Laim, Bogenhausen), the construction of the system of bridges

that cross the river Isar (Wittelsbacher-, Luitpold- and Max-Josephbrücke) and the design for a series of public buildings based on the context of the urban surroundings (the schools on the Guldeinstrasse and on the Elisabethplatz are exemplary in this regard). The three bridges built by Fischer on the Isar were celebrated by the press of the period as one of the greatest creations that German architecture could boast at the beginning of the twentieth century. They were bridges with three steel hinges and an arch of stone quoins; the abutments were made of *Stampfbeton* [compacted concrete], the roadway made of concrete. The raw materials were supplied by Dykerhoff, and the calculation techniques were perfected by one of the most important German engineers of the period, Johann Bauschinger, director of the mechanical technical laboratory of the Munich Polytechnic. The Wittelsbacherbrücke, with its four depressed arch bays, was the most external bridge; essential in forms, the only ornamentation was the equestrian statue by Georg Wrba supported on a high pedestal by the solid central pier. The Luitpoldbrücke has a single 62-metre arch, a kind of *via triumphalis* that connected the important artery of the Prinzregentenstrasse with the system of terraces that led towards architect Max Littmann's Prinzregententheater on the other side of the Isar; the direction of the sculptural part was entrusted to Hildebrand and worksite management to architect Hermann Sörgel.

With a single arch, the Max-Josephbrücke connects the city to the new district of Bogenhausen, one of the most beautiful districts designed by Fischer; the sculptural works by Flossmann, Düll and Heilmeier seem to have been created with a single casting into the structures of the bridge.[56] Construction of the bridges was part of a plan to redesign the urban landscape in order to redefine the relationship between the city and the river. In this way the river was included in the routes of the Englischer Garten, Munich's large urban park. The aim was to create a synthesis of the city and the landscape, urban scale and sculptural detail, architecture and high technical characteristics.

The crowning of this plan, according to Fischer, would have been the construction of the island located in the middle of the bed of the river Isar, the Kohleninsel, the place where the Deutsches Museum stands today. This project, initially conceived in 1899 to create provisional exhibition spaces to be used on the occasion of the celebrations for the fiftieth anniversary of the Kunstgewerbeverein,[57] was transformed in 1900 into the proposal for a permanent district devoted to art and industry. The project took on the form of a small acropolis with libraries, schools, shops and workshops, post office, archives and exhibition rooms. Despite many affinities, it was different to the Künstlerkolonie, which had recently been inaugurated at the Mathildenhöhe in Darmstadt. The complex culminated in the Stadthaus, a building that 'only serves ideal purposes', a location devoted to meetings, festivals and music.[58] According to Fischer's statements a few years later in an article published with the title *What I would like to build*, the Stadthaus was supposed to be 'a house not ... [where one can] study and become wise, but simply happy.... Therefore not a school, nor a museum, nor a church, nor a concert hall ... and yet

something of all this and also something more'.[59] In Fischer's project, access was gained to the new district by passing through a series of connected urban gates to a system of plazas adorned with porticos, open galleries, fountains and monuments. In his layout plan and front view, Fischer used all the spatial devices already described by Sitte: the long market square with wide porticos, the curtain of houses folding like an amphitheatre, and the Stadthaus out of alignment with the optical telescope formed by the market square and the Stadthaus square. The project for the Kohleninsel was to give physical shape to a decade of studies on the city and on the ways in which art could make a contribution to governing its growth. To use an image coined by Theodor Fischer' brightest student, Bruno Taut, the island of the arts in the middle of the Isar was to represent a kind of 'Crown of the city', while the Stadthaus was its 'Crystal Palace'. In an essay of 1914 – when a sort of exodus had taken place from Munich, with the departure in a few years of Endell and Fischer (from 1902 to 1908 in Stuttgart), Pankok, Bruno Paul, Slevogt and Lovis Corinth – Taut took up the idea of a large building to be used as a common home for the arts and a place for general study and reflection: 'We are all putting our hand to a grandiose building! To a building that is not only architecture and in which everything, painting and sculpture, together form a great architecture. … This building … [must] contain spaces capable of welcoming the new art: in the large windows the bright compositions of Delaunay, on the walls the Cubist rhythms, the painting of a Franc Marc and the art of a Kandinsky. The pillars outside and inside must await the constructive sculptures of Archipenko, the ornaments will be entrusted to Campendonk. In the new art all the chatter on the 'applied arts' will be struck dumb all by itself…'[60] From the cocoon of fin-de-siècle Munich, the multicoloured butterfly of the artistic avant-gardes of the 1920s had emerged.

[1] The debate on the decline of Munich as a city of art began at the start of the twentieth century with two articles devoted to this theme by the Berlin art critic Hans Rosenhagen, 'Münchens Niedergang als Kunststadt' in *Der Tag*, nos. 143, 145 (1901). See also, Winfried Nerdinger, 'Die "Kunststadt" München' in Christoph Stölzl, *Die Zwanziger Jahre in München* (cat., Munich: Münchner Stadtmuseum, 1979), pp. 93–120.
[2] Dieter Klein, *Martin Dülfer. Wegbereiter der deutschen Jugendarchitektur*, Arbeitshefte des bay. Landesamt für Denkmalpflege no. 8, Munich, 1993.
[3] Winfried Nerdinger, *Theodor Fischer* (Milan, Electa, 1990), pp. 23 ff. German ed., Berlin, 1988.
[4] See the first production of the Vereinigtes Werkstätten in *Dekorative Kunst* 2 (1898), pp. 137–81.
[5] Joan Campbell, *The German Werkbund. The Politics of Reform in the Applied Arts* (It. ed. Venice: Marsilio) 1987. Original ed.

Princeton, 1978. The first president of the Werkbund was named Theodor Fischer.
[6] This primacy was challenged by the most conservative group of the artistic culture of Munich: Franz Stuck, Franz Lenbach, Gabriel Seidl. Franz Stuck strongly criticised the results achieved by the Vereinigtes Werkstätten. The reasoning was that a picture by Böcklin could not be hung in a room designed by Bruno Paul. As Hermann Obrist wrote: 'And so Munich is suffocated by its own fat. An excellent, independent fat in Renaissance style', Hermann Obrist, *Götterdämmerung*, in *Münchens 'Niedergang als Kunststadt'*, edited by Eduard Engels (Munich, Bruckmann, 1902) pp. 29–38.
[7] The great intellectual and artistic vivacity of the Munich of the late nineteenth century, in the panorama of European cities, is very similar to that of other small capitals, such as Brussels and Barcelona.
[8] Thomas Mann, *Reflections of an Unpolitical Man*, original ed. (Berlin: Fischer

Verlag) 1918. Munich was the ideal incubator for works like *Buddenbrooks*, *Death in Venice* and *Magic Mountain*. Here Mann began his literary apprenticeship as editor of the magazine *Simplicissimus* and it was here in 1929 that the news reached him of the conferral of the Nobel Prize for Literature. On Thomas Mann in Munich, see Jügern Kolbe, *Heller Zauber. Thomas Mann in München 1894-1933* (cat., Berlin: Siedler) 1987.
[9] In 1890 Munich had 380,000 inhabitants and four theatres, to which were added, in the following decade, the Deutsches Theater for prose, the Münchener Schauspielhaus with the new building constructed in 1901 by Richard Riemerschmid in the Maximilianstrasse for drama and, in the same year, the Prinzregententheater built by Max Littmann. Finally, in 1908 the Künstlertheater was built, again by Littmann, following the programme of Georg Fuchs, an important reformer of German theatre.
[10] From 1880 to 1900 Hermann Levi, the

great interpreter of Wagner and Brahms and friend of Konrad Fiedler, lived in Munich. Here Richard Strauss and Hans Pfitzner conducted; from 1913 to 1922, the director of the Munich Opera was Bruno Walter. The musical experience was of key importance for artists and people of letters; we need only recall the unbelievable impression felt by Thomas Mann on 12 September 1910 on the first performance of Gustav Mahler's eighth symphony, which he heard in Munich with Max Reinhardt (Gustav Aschenbach of *Death in Venice* is none other than the great Bohemian composer) or the concert by Schönberg, string quartet op. 10 and for piano op. 11, performed in Munich on 1 Jan. 1911, which Kandinsky heard with Franz Marc and which was the beginning of a long and fruitful friendship between the two artists.

[11] See the Galerie Tannhauser, where in 1911 the *Blaue Reiter* was exhibited for the first time, and Hans Goltz' Neue Kunst gallery; the latter was also an art publisher, founder of the magazine *Ararat* and gallery director for Paul Klee; Galerie Littauer on Odeonsplatz where, in 1906, the first and much debated exhibition of Hermann Obrist's works was opened.

[12] Reinhard Piper was the publisher of Julius Meier-Graefe and Kandinsky (he published the almanac of the *Blaue Reiter* and had the logo of the publishing house drawn by Paul Renner); Friedrich Bruckmann was among the founders of the Werkbund in Munich in 1908 and the publisher of important magazines such as *Decorative Kunst*, founded in 1898; Albert Langen was the publisher of the magazine *Simplicissimus* and of Wedekind. The magazine *Simplicissimus* which Thomas Mann defined 'the healthy part of Munich', was founded in 1896 and the following year already had a circulation of 15,000 copies, which in 1904 touched 85,000. The magazine, the main themes of which were satire and topical politics, had the best writers (Rainer Maria Rilke, Thomas Mann, Frank Wedekind) and the best illustrators (Bruno Paul, Theodor Thomas Heine) then active in Munich. In 1896 Georg Hirth's magazine *Jugend* also began publication. This magazine gave its name to the German Jugendstil movement.

[13] The Glaspalast was the glass palace built by architect August von Voit in 1853–54 near the railway station on the occasion of the first great industrial exposition of 1854. See Winfried Nerdinger (ed.), *Zwischen Glaspalast und Maximilianeum. Architektur in Bayern zur Zeit maximilians II 1848-1864* (cat., Munich: Stadtmuseum) 1997.

[14] Hermann Obrist, 'Die Zukunft unserer Architektur: Ein Kapitel über das Persönliche und das Schöpferische' in *Dekorative Kunst* 4 (1901), pp. 329–49. Hermann Obrist, 'Die Lehr- und Versuch-Ateliers für angewandte und freie Kunst', in *Dekorative Kunst* 7 (1904), p. 228 ff.

[15] Helga Schmoll gen. Eisenwerth, *Die Münchner Debschitz-Schule*, in Hans Maria Wingler (ed.), *Kunstschulreform 1900-1933* (Berlin: Gebr. Mann, 1977) pp. 68–92. Among the students of the school, I will mention Paul Renner, who, trained as a painter, in 1911 with Emil Preetorius

founded the Münchner Schule für Illustration und Buchgewerbe, which in 1914 merged with the Debschitz-Schule. In 1926 Renner became the head of the Graphischen Berufsschulen der Stadt München and, from 1927, of the Meisterschule für Deutschlands Buchdrucker, where he also called upon Jan Tchihold to teach. Renner designed the Futura font.

[16] Endell was to show the same passion as Obrist for didactic activity when in 1918 he became director of the Kunstakademie in Breslau. Here he called upon the young Hans Scharoun and Adolf Rading to teach. On Endell, see: Tilmann Buddensieg, *Zur Frühzeit von August Endell. Seine Münchner Briefe an Kurt Breysig*, in *Festschrift für Eduard Trier*, Justus Müller Hofstede and Werner Spies (ed.), (Berlin, 1981), p. 224 ff; Helge David (ed.), *August Endell. Vom Sehen. Texte 1896-1925 über Architektur, Formkunst und 'Die Schönheit der großen Stadt'* (Basel: Birkhäuser, 1995). August Endell's main theoretical contributions are: *Um die Schönheit. Eine Paraphrase über die Münchner Kunstausstellungen* (Munich: Franke, 1896); 'Möglichkeiten und Ziele einer neuen Architektur', in *Deutsche Kunst und Dekoration* 1 (1897–98) pp. 141–52; 'Originalität und Tradition', in *Deutsche Kunst und Dekoration* 9 (1901–02), pp. 289–96; *Die Schönheit der großen Stadt* (Stuttgart: Strecker & Schröder, 1908).

[17] Theodor Lipps, from 1894 professor of philosophy at the Ludwig-Maximilian university in Munich, was one of the founders of the theory of *Einfühlung*.

[18] August Endell, *Beauty of the metropolis*, in Massimo Cacciari, *Metropolis. Saggi sulla grande città di Sombart, Endell, Scheffler e Simmel* (Rome: Officina, 1973) p. 139.

[19] Ibid., p. 142.

[20] Transl. by the author. August Endell, *Die Schönheit der großen Stadt* (Stuttgart: Strecker & Schröder, 1908) in Helge David (ed.), *August Endell. Vom Sehen, Texte 1896-1925* (Basel: Birkhäuser, 1995), p. 200.

[21] Ibid., p. 197. Transl. by the author. The translation of the text contained in Cacciari's book is very approximate.

[22] *Ver Sacrum* was the magazine of the Viennese Sezession. Adolf Hölzel, 'Über Formen und Massenverteilung im Bilde', in *Ver Sacrum*, 2 (1901) 15, pp. 243–54. The reflections contained in this essay were to be considered in depth in a long contribution published eight years later, Adolf Hölzel, 'Über bildliche Kunstwerke im architektonischen Raum', in *Der Architekt* 15 (1909) pp. 34–37, 41–46, 73–80; 16 (1910) pp. 9–11, 17–20, 41–44, 49–50. The article by Hölzel was required by the editors of the magazine to illustrate the problem of the relationship between painting and architecture and, in particular, the case of the Pfullinger Hallen.

[23] In one of the manuscripts of Adolf Hölzer's legacy, held in the archive of the Staatsgalerie in Stuttgart, we read: 'Die künstlerische Urkraft liegt in den künstlerischen Elementen und nicht im Gegenstande'. Published in *Adolf Hölzel 1853-1934. Der Kunsttheoretische Nachlaß* (cat., Stuttgart: Staatsgalerie, 1998), p. 33.

[24] Peg Weiss, *Kandinsky und München: Begegnugen und Wandlungen*, in Arnim Zweite (ed.), *Kandinsky und München:*

Begegnugen und Wandlungen 1896-1914 (cat., Munich: Prestel, 1982), pp. 29–83.

[25] Vasily Kandinsky, *Point and Line to Plane. Contribution to the Analysis of the Pictorial Elements*; original ed., *Punkt und Linie zu Flache: Beiträge zur Analyse der Malerischen Elemente* (Munich: Langen, 1926).

[26] See also Wolfgang Venzmer, *Adolf Hölzel. Leben und Werk* (Stuttgart: DVA, 1982), pp. 74–79; Carl Haenlein (ed.), *Adolf Hölzel. Bilder, Pastel Zeichnungen, Collagen* (cat., Hanover: Kestner Gesellschaft, 1983); Arthur Roeßler, 'Das abstrakte Ornament mit gleichzeitiger Verwendung simultaner Farbkontraste', in *Wiener Abendpost (enclosure)*, 6 Oct. 1903.

[27] Among Hölzel's students we find painters with the most diverse orientations, such as Willi Baumeister, Emil Nolde and Oskar Schlemmer. The latter also brought the master's teachings into Gropius' Bauhaus.

[28] Th. Fischer's interest in the problem of mural painting is documented until the end of his life. See Theodor Fischer, 'Das Wandbild', in *Die Kunst* 71 (1935), pp. 170–72, 193–98.

[29] See J.A. Schmoll von Eisenwerth, *Zur Marées-Rezeption in der Malerei*, in Christian Lenz (ed.), *Hans von Marées* (cat., Munich: Prestel, 1988), pp. 151–62.

[30] Ernst Schur, 'Hans von Marées und Ludwig Hofmann', *Ver Sacrum* (1902) 9, pp. 141–48.

[31] Along with Alfred Lichtwark (director of the Hamburg Kunstmuseum), Tschudi was one of the most important German museum directors of those years. He was one of the directors of the Nationalgalerie in Berlin until 1908, when he was removed by the Kaiser himself because of his policy of acquiring works of French modern painting: Manet, Cezanne, Renoir. He moved to Munich, where in 1909 he was appointed director of the Art Gallery and where he died in 1911.

[32] Julius Meier-Graefe, *Hans von Marées. Sein Leben und Werk* (Munich: Piper, 1909).

[33] It is no coincidence that the most important critical work on Fiedler was again published by Reinhard Piper. Hermann Konnerth (ed.), *Konrad Fiedler. Schriften zur Kunst* (2 vols., Munich: Piper, 1913–14). Reprint edited by Gottfried Boehm, Munich, Fink, 1971. Equally symbolic is the fact that Konnerth was an enthusiastic apologist for the Blaue Reiter.

[34] Adolf Hildebrand, *Das Problem der Form in der bildenden Kunst* (Strasbourg: J.H.E. Heitz, 1893).

[35] Sigrid Esche-Braunfels, *Adolf von Hildebrand 1847-1921* (Berlin: Deutscher Verlag für Kunstwissenschaft, 1993).

[36] See in particular, Hermann von Helmholtz, *Die Tatsachen in der Wahrnehmung*, 1879 (rest. Darmstadt: 1959), p. 29. 'Our eye perceives what it sees as an aggregate of coloured surfaces in the visual field; this is its manner of knowing. Which particular colours appear in one or another circumstance, in what combination and order, is a result of the external actions and is not determined by any organisational principle'. 'If the quality of our sensation provides us with information on the characteristic of the external actions by which

it is stimulated, it can be considered a sign of those actions but not one of their images. Indeed, we expect a certain similarity between the image and the object. ... However, a sign need not have any sort of resemblance to what it is a sign of...'.

[37] *Wie die Natur und wie die Kunst arbeitet*, in Adolf von Hildebrand, *Gesammelte Aufsätze* (Strasbourg: Heitz, 1909), pp. 25–31.

[38] Camillo Sitte, 'Großstadt-Grün', in *Der Lotse. Hamburgische Wochenschrift für deutsche Kultur*, 1 (1900) pp. 139–46, 225–32.

[39] The planning of the Wittelsbacherbrunnen was very complex and also saw the participation of art historian Heinrich Wölfflin, who discussed the actual scale model made in 1891 with the sculptor. Wölfflin's meetings with Hildebrand dated back to 1887, when the former participated in the funeral of Hans von Marées in Rome. Two years later he got to know Hildebrand directly, being able to read the manuscript of his *The Problem of Form*, on the publication of which the art historian devoted an enthusiastic review to it. In 1915, in his *Principles of Art History*, he spoke of the book as the 'catechism of a great new school'. Heinrich Wölfflin, *Principles of Art History* (New York: Dover, 1932). Original ed., *Kunstgeschichtliche Grundbegriffe* (Munich: Brickmann, 1915). In Munich in 1886 Wölfflin wrote his doctoral thesis *Prolegomena zu einer Psychologie der Architektur*; here he taught as a Privatdozent until 1893 and, after leaving Berlin, he returned there in 1912 to remain until 1924.

[40] With Muthesius, Fischer, Schumacher and Hellerau Riemerschmid, in 1907 Hildebrand was named as a member of a commission that was to evaluate the artistic quality of the building projects for the new garden city.

[41] Adolf von Hildebrand, *Gesammelte Schriften zur Kunst*, edited by Henning Bock (Cologne: Westdeutscher Verlag, 1969).

[42] Adolf von Hildebrand, 'Beitrag zum Verständnis des künstlerischen Zusammenhangs architektonischer Situationen', in *Die Raumkunst*, 1 (1908) 19, pp. 289–96.

[43] After the closure of the magazine in 1909, in 1911 Riezler moved to Stettin (Szcecin), where he was appointed director of the Städtisches Museum and in 1925 he became editor-in-chief of the magazine of the Werkbund *Die Form*. Riezler had graduated in archaeology with Adolf Furtwängler and was the educator both of his son Wilhelm—the famous orchestra conductor—and of one of Adolf Hildebrand's children. For this information, see Bernhard Sattler (ed.), *Adolf von Hildebrand und seine Welt. Briefe und Erinnerungen* (Munich: Callwey, 1962), p. 782.

[44] See Uta Hassler, *Max Läuger und die Gartenbauausstellung in Mannheim 1907*, in *Mannheim um 1900*, exhibition catalogue, (Mannheim: 1985), pp. 257–93.

[45] Carl Hocheder, 'Gedanken über das künstlerische Sehen im Zusammenhang mit dem Ausgamg des Wettbewerbes zur Umgestaltung des Münsterplatzes in Ulm', in *Die Raumkunst*, 1 (1908) 2, pp. 17–21.

[46] Leberecht Migge, 'Der Hamburger Park, Läuger und Einiges', in *Die Raumkunst*, 1 (1908) 17, pp. 257–67.

[47] Otto Bartning, 'Das Raumkörperliche in der Münchner Ausstellung', in *Die Raumkunst*, 1 (1908) 15/16, pp. 228–31.

[48] Published in Max Läuger, *Kunsthandbücher*, vol. 2, *Grundsätzliches über Malerei, Städtebau, Gartenkunst und Reklame* (Pinneberg/Hamburg: Beig, 1938).

[49] Hans Karlinger, *München und die deutsche Kunst des XIX Jahrhunderts* (Munich: Knorr&Hirth, 1933), p. 205 ff.

[50] It is no coincidence that we find among Hölzel's students artists that made wall painting a specific object of their research. Wulf Herzogenrath, *Oskar Schlemmer, Die Wandgestaltung der neuen Architektur* (Munich: Prestel, 1973).

[51] In Vienna the competition was announced on 3 Nov. 1892 and concluded in 1894 with the victory of Otto Wagner. See Otto Antonia Graf, *Otto Wagner. Das Werk des Architekten 1860-1892* (Vol. 1, Vienna: Böhlau, 1994), pp. 87–122. Another protagonist of the Viennese urban planning debate was Karl Mayreder, whose project for the competition for the Vienna planning scheme won second prize. From 1894 to 1902 Mayreder was Chief Architect of the *Stadtregulirungsbüro* of the city of Vienna, a councillor with responsibility for urban planning. He was responsible for the introduction of the first urban planning course at the Vienna Polytechnic.

[52] Karl Henrici, *Preisgekrönter Konkurrenz=Entwurf zu der Stadterweiterung Münchens* (Munich: Werner, 1893).

[53] Fischer remained as head of the office until 1901 when he moved to Stuttgart. Before departing, he drafted the town planning scheme according to the principle of the 'Staffelbausystem', an urban planning instrument that remained in force until the 1980s.

[54] This is also the position of Otto Wagner, see the report on the project for the town planning scheme published in Otto Antonia Graf, *op.cit.*, p. 89.

[55] Camillo Sitte, *Urban planning according to its artistic bases. A contribution to resolving the most modern questions in the field of architecture and monumental sculpture*. On these themes, see my essay *Camillo Sitte architetto e urbanista. Il progetto per il centro civico di Privoz/Oderfurt*, in *Camillo Sitte e a circulação das idéias em estética urbana. Europa e América Latina: 1880-1930*, Donatella Calabi, Heleni Porfyriou and Adalberto da Silva Retto Junior (ed.), (São Paulo: USC, 2005) (in publication).

[56] Philipp M. Halm, 'Die neuen Münchner Brückenbauten', in *Moderne Bauformen*, V (1906), pp. 146–56; *Prinzregenten= Brücke München*, edited by the Bauunternehmung, Sager&Woerner, 1900-1901.

[57] The Kunstgewerbeverein, an association of craftsmen and artists in the applied arts, was one of the most important professional associations in Munich, with around 2000 members.

[58] *Denkschrift. Die würdige Ausgestaltung der Kohlen=Insel und die Jubiläums= Ausstellung des Bayerischen Kunstgewerbe=Vereins* (Munich and Leipzig: Oldenbourg, 1900).

[59] Theodor Fischer, 'Was ich bauen möchte', in *Der Kunstwart* (1906) 1, pp. 5-9.

[60] Bruno Taut, 'Eine Notwendigkeit', in *Der Sturm*, IV (1913–1914), pp. 174–75.

From Scapigliatura to Futurism

Milan

The prismatic separation of colour was applied in Italy in an off-hand, empirical, intuitive manner; there were numerous individual solutions as well as a more realistic restitution of the subjects, characterised by a more lively and evident expressivity. Italian Divisionism, in the persons of Giovanni Segantini, Gaetano Previati and Giuseppe Pellizza da Volpedo, proceeded not through a fixed juxtaposition of identical *taches* of colour, but through material filaments that were overlaid and interlinked: because of the oblique and unstable directions of those traces, the gaze slipped over and through a constant state of instability. The *Manifesto of Futurist Painters* of 1910 paid tribute to the Italian Divisionists, and especially to Previati and Segantini: in that document there was mention of the necessity of capturing dynamic sensations and the most radiant visions of clarity. Corresponding to these theories were paintings such as *The City Rises* (1910–11) by Umberto Boccioni, a monumental work that, setting out from the three primary colours, saw the artist searching in the chromatic array for a plastic formula that corresponded to the flow of consciousness. Then there were the works of Balla and Severini, who were more in tune with French trends. Severini explicitly stated that he had taken the formula of the Neo-Impressionists as a base, and extended it to the hues of black, grey, and white. Balla's first Futurist painting, *Arc Lamp* (1909 or 1910) seemed to be a response to the canvas by Pellizza, *The Rising Sun* (1904), which associated positivist precision with the Symbolist interpretation of light.

Colour then was first of all interpreted as pure energy, itself a brilliant and brutal expression, which gradually loses its pictorial exclusivity and becomes a medium for a vast field of expressions.

The Esposizione Internazionale del Sempione in Milan in 1906 made official the city's role as protagonist in the Italian cultural panorama, but in the capital of Lombardy there was room for more than just the debate over the Modernism: in the field of painting, the radicalisation of the Post-Impressionist milieu laid the foundations and heralded the advent of Futurism.

In the first decade of the century, the city underwent intense economic and industrial development, which made it quite rapidly the stimulus for the country's economy. Meanwhile, the consolidation of an industrial bourgeoisie (which had also been the clientele for work in the Liberty style) developed the capitalist politics promulgated in the age of Giolitti. At the start of the Novecento, Milan was still a provincial city wrapped up in its own tradition: a somnolent environment against which the caustic Futurist revolt was unleashed.

The painting of the Academy of Brera, still 'Scapigliata', and publicised by the teachings of Cesare Tallone, seemed reluctant to evolve towards the new avant-garde trends from across the Alps. Milan was the capital of Divisionism, even if Segantini and Pellizza lived there only briefly, but the actual point of diffusion of Divisionist ideas was the gallery of Vittore and Alberto Grubicy. In their halls, exhibitions of the works of Italian Post-Impressionist painters came and went, reluctant to engage in the social whirl of Milan, while the works of Gaetano Previati enjoyed increasing success. The Milanese point of contact with French Impressionism was represented by the sculpture of Medardo Rosso and his relations with Grubicy.

It was into this culturally thriving landscape that, in 1907, Umberto Boccioni moved, following his youthful education in Rome and the short trips that he had taken to Paris, Russia, Venice, and Padua. It had been specifically in the Roman milieu that he had his first encounter with Divisionism, a result of his apprenticeship in the studio of Giacomo Balla, along with his friend Gino Severini. Balla was the only painter to diffuse Divisionist ideas in the Italian capital, with which he had become familiar during his own education at the Accademia Albertina in Turin, through direct contact with the works of Pellizza and Segantini, and which he had come to know in greater depth during his stay in Paris on the occasion of the Exposition Universelle of 1900. Balla's personal mediation of Divisionism translates, in conceptual terms, into an idealism of social origin by virtue of his interactions and strong friendship with Giovanni Cena, a Piedmontese poet and writer, and an assiduous frequenter

Giacomo Balla
Arc Lamp, 1909 or 1910 (detail)
Oil on canvas, 174.7 x 114.7 cm
New York, The Museum of Modern Art, Hillman Periodicals Fund

Gaetano Previati
Madonna of the Lilies, 1894
Oil on canvas, 137 x 113 cm
Milan, Civica Galleria d'Arte Moderna

Opposite
Giuseppe Pellizza da Volpedo
The Rising Sun, 1904 (detail)
Oil on canvas, 155 x 155 cm
Rome, Galleria Nazionale d'Arte
Moderna e Contemporanea

Pages 219–20
Umberto Boccioni
The City Rises, 1910–11 (detail)
Oil on canvas, 199.3 x 301 cm
New York, The Museum of Modern
Art, Simon Guggenheim Fund

of Roman literary salons who was devoted to 'verist' writing. The social theme characterises Balla's works in this period, even if it is interpreted in an idealist-social context, avoiding all verist-realist temptations. In stylistic terms, the Turinese painter was strongly attracted by the use of light in Post-Impressionist paintings and by the passion for photography handed down from his father, who was a photographer by profession: from that field he borrowed the practice of framing and cutting, or to be more precise, the idea of infield and off-field, in order to develop a structural and perspectival approach that was entirely new and original, and highly influential upon his pupil, Boccioni. But what Balla insisted upon was the necessity of developing a meditation, rather than on how framing is done, upon the photographic gaze as a metric of comparison and as a specifically imposed 'diaphragm' of pictorial vision: all of these considerations led him to paint an emblematic work characterised by a system of 'montage', the 'polyptych' *Villa Borghese*, in which the apparently traditional depiction, in the context of landscape and decorative arts conceals a distinctly Futurist arrangement of the space and visual simultaneity.

The Divisionist lexicon, the attention to light that defines and animates volumes, the photographic perspectival approach are all el-

ements that Boccioni learned from the Turinese master, but at the same time he absorbed from the Roman milieu the peculiarities of the Secessionist climate, and particular, from Duilio Cambellotti, Mario Sironi and Emilio Prini, he learned a specific use of the graphic line. Unlike Balla, or even Pellizza, Boccioni insisted on the use of design structure, which in turn had been dissolved, or better, chewed at by the light and the colour that bathed it, the product of the powerful diffusion in Rome of a flourishing graphic production led by Cambellotti. The Roman milieu was a valid middle ground for the artist in his approach to Expressionist painting, especially to Munch and Van Gogh, ideal points of reference for the Munich and Berlin Secessions. These aspects in the use of colour and line flowed into his *Self-Portrait* (1905–06); in particular, the recurring use of pastel technique (in this Roman period and immediately afterward) reveals Boccioni's interest in the Divisionist direction, alongside his more obvious and 'scholastic' investigation into the Post-Impressionist field.

The failure of the two artists in Rome—in truth partial for Boccioni and total for Severini, caused by a lack of understanding and a superficial analysis of the official criticism with respect to their ideas, which were too personal in comparison with the first generation of Divisionists (foremost Pellizza but

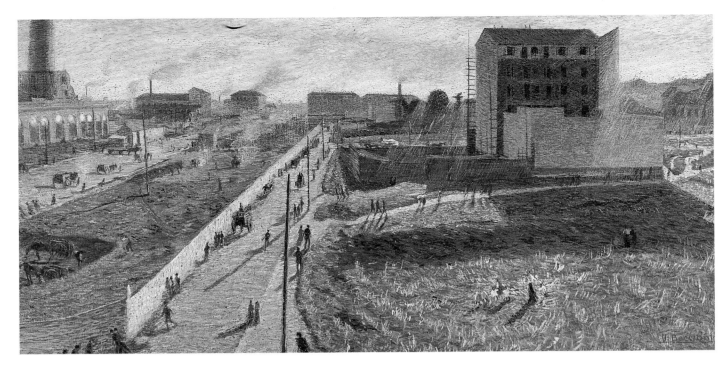

Umberto Boccioni
Works at Porta Romana, 1910
Oil on canvas, 75 x 145 cm
Banca Intesa Collection

Umberto Boccioni
Self-Portrait, 1908 (detail)
Oil on canvas, 70 x 100 cm
Milan, Pinacoteca di Brera

also Morbelli and Segantini), stripped of the recurrent symbolisms or the marked influence of the painting of the master Balla—led them to leave the city in 1906 and go to Paris. Severini settled permanently in the French capital, while Boccioni stayed for a few months and then left for Russia.

Following a brief stay in Venice and Padua, in 1907 Boccioni arrived in Milan: his adherence to Divisionism led him to become more familiar with the work of Segantini and especially of Previati, which joined the new ideas he had encountered in his short stay in Paris. In reality, Post-Fauve painting, along with Cubism, was at first rejected, only to be accepted during the Futurist period, with the exception of Cézanne. The French painter's influences were brought to light in Boccioni's painting *Portrait of a Sculptor*, executed in Padua, in particular in the construction of the luminous planes and in the landscape of the composition, while in the figure we see a re-emergence of the Expressionist stamp, particularly in the rapid and violent brushstrokes.

Previati represented a further development in Boccioni's education, who, while still recognising the importance of Balla, began to sense his social-verist limitations. A more marked Symbolism drove him to fall increasingly under the spell of the creative world of the Ferrarese artist, whose *Technique of Painting* he read ecstatically and whom he met personally in 1908. The capacity to push Post-Impressionist research into a pictorial synthesis that moves away from the 'panic' sentiments of Segantini, to push to extremes the lev-

el of chromatic expressivity through a seductive, filamentous line in a quest for greater idealism and especially making use of light in a psychological and symbolic context—these were the fundamental elements that attracted Boccioni. While the *Self-Portrait* (1908) was a transitional work that, in the reproposal of the 'photographic and perspectival' approach in the manner of Balla, reveals an interesting study of the space in which the painter and the landscape are immersed, without the preceding diaphragm of the window that divides subject and environment (as in the *Portrait of a Sculptor*), the splendid *Controluce* and *Portrait of a Woman (or of My Sister)* represent the test bench of Previati's lesson: the filamentous, even dynamic line of the portraits delineates a very intentional psychological investigation of the personalities, the powerful colour base with its warm and livid hues, with intense chiaroscuro, diffuses the images while seeking a degree of the ideal and rejecting all naturalistic and veristic aspects: this represents Boccioni's evolution towards ideas, concepts, abstractions and 'states of mind'.

Industrial life in Milan, general strikes, factory shifts, and the emerging outskirts of town were all social themes that became the recurrent subjects of the artworks of this period, motifs that were inevitably inherited from the painting of his master Balla. *Works at Porta Romana* exemplifies the stage the Reggio-born painter had reached in the Divisionist period in the immediate wake of Futurism: the desolate outskirts of the *Self-Portrait* (1908) are populated by the welter of tiny figures of

Luigi Russolo
Flashes, 1910
Oil on canvas, 100 x 100 cm
Rome, Galleria Nazionale d'Arte
Moderna

workers, while a degree of movement, not yet dynamism, points to the outcome of *The City Rises*; the artist's astonishing mastery of Divisionist technique and the 'Previatiesque' use of light with symbolic and emotional goals represent the perfect synthesis of his formative years in Rome and Milan. By this time Boccioni was ready to develop an entirely autonomous and innovative artistic poetics.

The theme of industry and the world of physical work, in whatever allegorical context, was also the subject of Carlo Carrà's *Allegory of Labour*, where the rhetoric of the composition, required by the client, the Federation of Cooperatives, did nothing to conceal the artist's personal adherence to the Divisionist elements of style, by which he had been strongly impressed when he had viewed, many years before, the works of Segantini and Previati in the Grubicy gallery in Milan. The Piedmontese painter had moved to the capital of Lombardy in 1895 as a member of the entourage of a number of Valenzan decorators. It was during these years that he spent in Milan, together with his trip to Paris at the end of 1899

to do some decoration work at the Exposition Universelle, that his self-education took place. His beginnings, to a certain degree still under the influence of Milanese Scapigliatura, as seen in the unfinished atmospheric quality of his early composition *Portrait of a Man*, gave way to the convinced adherence, like Balla, Boccioni, Severini and Sironi, to Divisionism. Initially identified with Segantini, and in time increasingly with Previati, this tendency of Carrà is indicated by the warm tones with chiaroscuro and the sinuous line of the *Allegory of Labour*.

The Horsemen of the Apocalypse confirms Carrà's Divisionist sedimentation and maturing: the filamentous and dizzying brushstrokes, the vigorous rhythm of the oil painting suggest a reflection upon the works of Boccioni, while for that matter in 1906 Carrà enrolled in the painting course taught by Cesare Tallone at the Brera Academy and, little by little, made his way into the 'official' Milanese artistic milieu, where he met and befriended Boccioni. Soon after, Mario Sironi also came to Milan; he had met both Boc-

Umberto Boccioni
Riot in the Galleria, 1910 (detail)
Oil on canvas, 76.5 x 64 cm
Milan, Pinacoteca di Brera,
Jesi collection

cioni and Severini through Balla, whom he had met in turn while attending courses at the Free School of Nude Studies at the Academy of Rome, during the cultural soirées often attended by the protagonists of the impending Futurism. His first visit to Milan took place in 1906, where he frequented the artistic milieu, but he returned in 1910 following two significant trips to Germany. His *Portrait of My Brother* (1910) documents the artist's maturity following the advent of Futurism: the background exemplifies the use of the Divisionist technique, which he certainly learned and developed in Rome, but was overwhelmed by the use of violent, sweeping brushstrokes that conferred upon the composition a marked plastic rendering and volumetrics that tended to develop in a closed and delimited space. Sironi's interpretation of the Divisionist lesson is fleeting and original, clearly moving towards an Expressionism of German origin, underscored by the 'psychological' use of the shadows, by the posture and face of the young man. Sironi would have a transitory and personal position in Futurism as well, which he would soon abandon in favour of a plastic and vol-

umetric painting, distant from the movement's pictorial production.

The last major figure to join the still pre-Futurist group was Luigi Russolo, who met Boccioni in 1909 in one of his first shows of etchings at Milan's Famiglia Artistica. Russolo, still quite far from the development of *The Art of Noise*, arrived fresh from his education at the Academy of Brera and from his frequenting of the official Milanese cultural clubs, where debate was ongoing over the Symbolist-Secessionist culture, closely linked to the ruling style of Art Nouveau. The etching *Nietzsche and Madness* translates the painter's formative experience, Previati's pulviscular atmosphere conceals a partial understanding of the master of Divisionism and an adherence to a decorative Symbolism that is closer to the cadences of Liberty than to Previati's idealism. Unquestionably, in pictorial terms, Russolo was the least 'mature' of the protagonists of the coming Futurism, but his total loyalty to the movement and his investigations into the field of music would be fundamental in conferring a sense of interdisciplinarity and completeness to the new artistic conception purveyed by the Milanese group. In the cultural panorama, a

decisive figure was that of the poet and man of letters Filippo Tommaso Marinetti. Neither painter nor sculptor nor, at first, even linked to the art milieu of Milan, Marinetti nonetheless quickly became the leader and theorist of the nascent Futurist movement. He had moved with his family from Egypt to Lombardy capital at the end of the nineteenth century, and in the early years of the new century he took a laureate degree in jurisprudence and then devoted himself to poetry. He contributed to the *Anthologie Revue de France et d'Italie*, an important Parisian bilingual journal, and in 1902, 1904 and 1908 he published, respectively, *Le conquête des étoiles*, *Destruction*, and *La Ville Charnelle*, poems in which he introduced the new concepts of dynamism and force associated with other symbols of the modern era, such as the locomotive, the automobile and the city. In 1905 he founded the international journal *Poesia,* and soon thereafter became its editor-in-chief. In its pages were published new works by Gustave Kahn, Catulle Mendès, Giovanni Pascoli, Gabriele d'Annunzio and Guido Gozzano. The experience of publishing the journal was of fundamental importance for Marinetti, because through it he succeeded in publicising, through purely promotional means, his own aesthetic development, attracting the interest and collaboration of many figurative artists. Quite soon, the battle for the acceptance of free verse in the literary field, which was given space in the pages of *Poesia,*

took on more profound, social, and increasingly philosophical tones. D'Annunzio established a certain distance from the ideas of the editor-in-chief, and the Crepuscolari withdrew from the journal entirely. Marinetti was by now ready to proclaim the *Manifesto of Italian Futurism* which, in a very short time, by virtue of its innovative and explosive content, broadly supported by the figurative artistic world of Milan, and won the adherence of the painters Boccioni, Balla Carrà and Russolo, and shortly thereafter, Severini.

Futurism originated in Milan, inasmuch as it was a modern and industrialised city, where all the social (proletariat, industry, strikes, etc.) and structural (construction sites, new means of transport, new technologies) aspects of modernity coexisted. Velocity, in its various manifestations, whether tangible or not, became the medium and the unit of measurement of the Futurist analysis of contemporary reality, contributing, in its various acceptations and interpretations at the hands of the artists of the movement, to punctuate existence. The individual, understood in the collectivity 'against all solipsism', the simultaneity translated from velocity, and the 'poetics' of the 'state of mind', all became the mediums of the interior human investigation of Futurism into the relationship between reality, psyche and psychology. If the themes of speed, the city and the individual are common to and practically 'endemic' to Futurism, state of mind

Carlo Carrà
Leaving the Theatre, 1910–11
Oil on canvas, 69 x 91 cm
London, Estorick Collection of Modern Italian Art

Pages 226–27
Carlo Carrà
Funeral of the Anarchist Galli, 1911
Oil on canvas, 198.7 x 259.1 cm
New York, The Museum of Modern Art, acquired through the Lillie P. Bliss Bequest

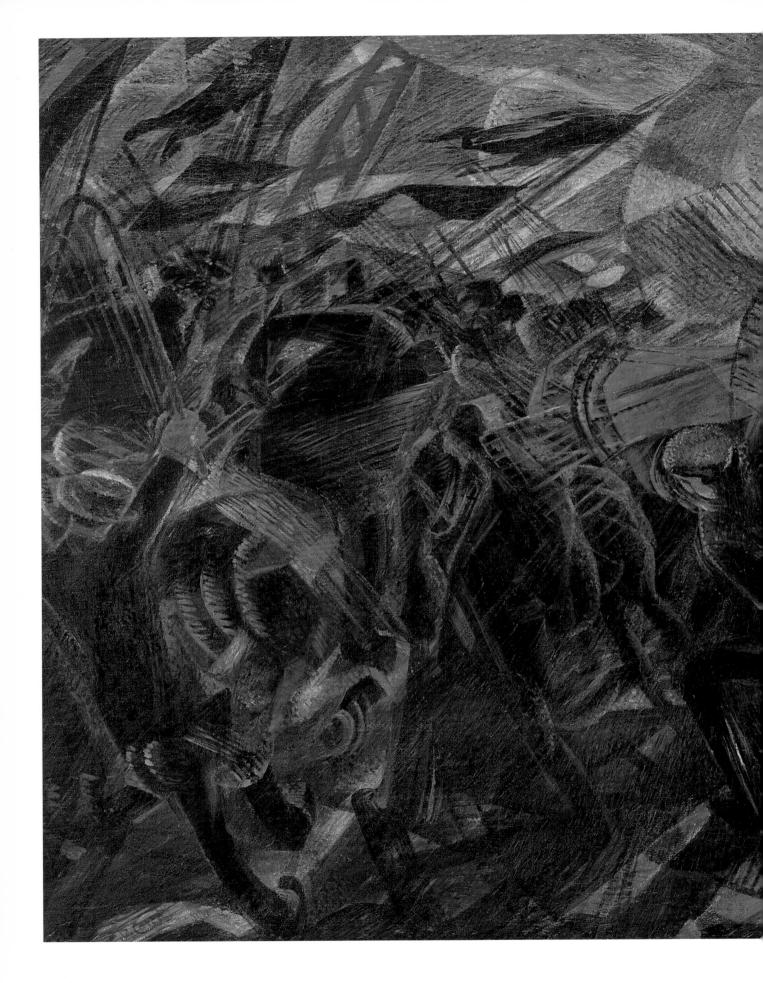

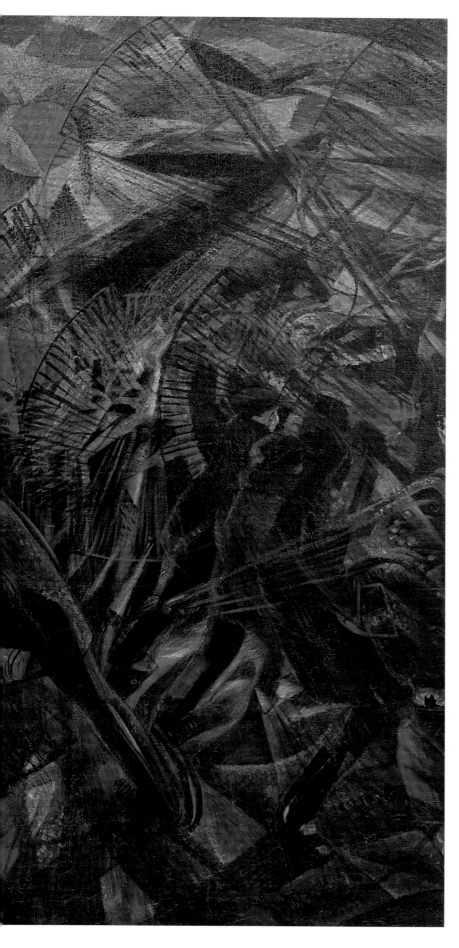

and simultaneity were especially sought out by the artists of the early phase and, in particular and successfully, by Umberto Boccioni. War and scientific progress were the parameters for comparison and inspiration for the entire group; in specific terms, the theme of war should be separated from the intensely politicised ideas of Marinetti and from the biographical developments of the movement, to be evaluated in its role of dynamic bearer of revolutionary intentions and destruction of historical and nostalgic reality. Scientific progress and the continual updating of Futurism in terms of new scientific philosophies, which literally exploded at the turn of the century, represented a fertile hinterland for the formulation of new ideas. Nature, the redefinition of a universe and the 'shaping' of a new spirituality are all themes that had more to do with the second phase of Futurism, tied to the formulation of the *Futurist Reconstruction of the Universe* (1915): this is especially true for the concept of spirituality that found, perhaps in a latent manner, its own dimension in Boccioni's poetics and became, with the second generation, the spirituality of the machine alongside the esoteric research conducted by Balla and Russolo.

On 20 February 1909, Marinetti published the first *Manifesto of Italian Futurism* in the French newspaper *Le Figaro*: this was the opportunity for the man of letters to assemble and summarise his own thinking, which had matured over the course of the first decade of the twentieth century. The invitation to fight against all forms of traditionalism and academicism comes alongside the exaltation of dynamism and the 'eternal omnipresent velocity', represented by the myth of the automobile, the urban revolution, and the advent of progress and industry. Marinetti's enthusiastic invitation, expressed in the *Manifesto*, to have courage, audacity, rebellion, aggressivity and struggle became the *verbum* of a new poetics of modernity, impressing a radical break with the contemporary Italian cultural climate. The battle against all sentimentalism and relics of the past found, two months later, in April, further confirmation in the well-known text *Tuons le clair de lune!*, published in *Poesia*, a celebration of the war against all forms of attachment to the past.

The *Manifesto* of 1909 was in any case addressed to the literary world and at first did not consider the world of painting at all; it was not until January of 1910 that the meeting with Boccioni, followed by meetings with Carrà and Russolo, took place.

The three artists met on the Milanese art circuit, exhibited together, and often spent time

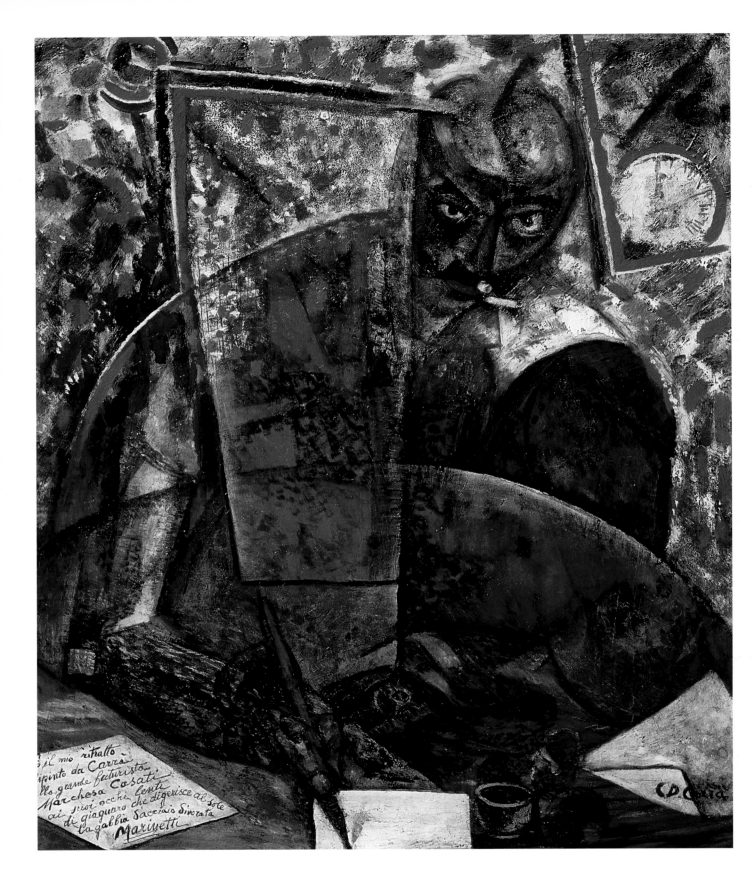

Umberto Boccioni
Simultaneous Visions, 1911
Oil on canvas, 70 x 75 cm
Wuppertal, Von der Heydt-Museum

Opposite
Carlo Carrà
Portrait of Filippo Tommaso Marinetti,
1910–11
Oil on canvas, 100 x 82 cm
Private collection

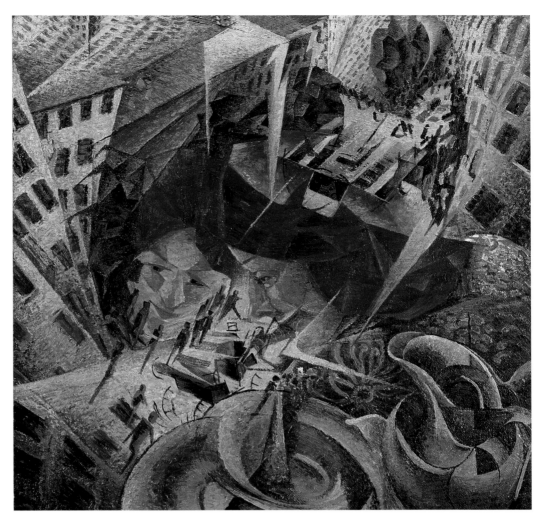

together in the city's cafés. The search for new ideas led them to contact Marinetti: soon, his enthusiastic ideas infected the three young men, who decided to develop a specific manifesto of painting. On 11 February 1910 a pamphlet was printed, published by *Poesia* and entitled *Manifesto of the Painters*: the ideas expressed in it were still 'raw' and generalised. In the meanwhile, alongside the historic signatories Boccioni, Russolo and Carrà, came Severini and Balla to replace those of Aroldo Bonzagni and Romolo Romani, who had been intimidated by the violent reaction of public opinion against the pamphlet. The more complete and elucidated version of the *Manifesto* was proclaimed by Boccioni at the Teatro Chiarella of Turin on 8 March, and was in turn further explained in the subsequent edition, dated 11 April, of the *Technical Manifesto of Futurist Painting* signed by the final group: Boccioni, Carrà, Russolo, Severini and Balla.

Probably the first draft represented the major involvement of Marinetti himself, and for that reason a lesser degree of technicality in the contents that were expressed; in later versions the 'pictorial questions' became in-

creasingly profound, revealing a certain conceptual development that can probably be attributed to Boccioni. The 'religion' of light, which all the signatories shared, had a considerable influence on him, and it is no accident that the artists who were spared the iconoclastic fury of the *Manifesto* all formed part of the first generation of the Divisionists: Segantini and Previati, as well as the case of the Impressionistic sculpture of Medardo Rosso. In the *Technical Manifesto*, the concept of 'congenital complementarism' was expressed, a sort of evolution of the Divisionist theories, which were overcome in their scientific and methodical form in virtue of a spontaneous and intuitive relationship between art and science. The deduction of this theory is based upon the writings of Previati and on the polemical distancing of the French Neo-Impressionists, such as Seurat and Signac, as well as the application of the ideas of Marinetti concerning the violent and emotional use of colour, linked, especially in Boccioni, to a lively influence of the proto-Expressionism of Van Gogh and Munch. Alongside the 'congenital complementarism', the *Manifesto* upholds the

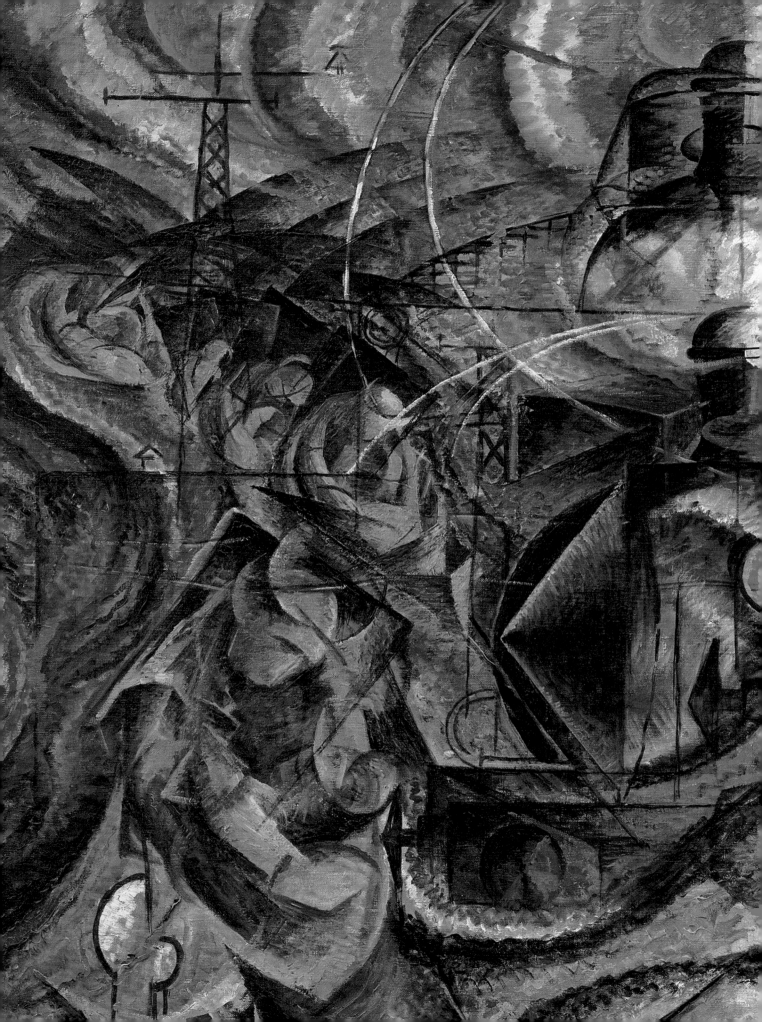

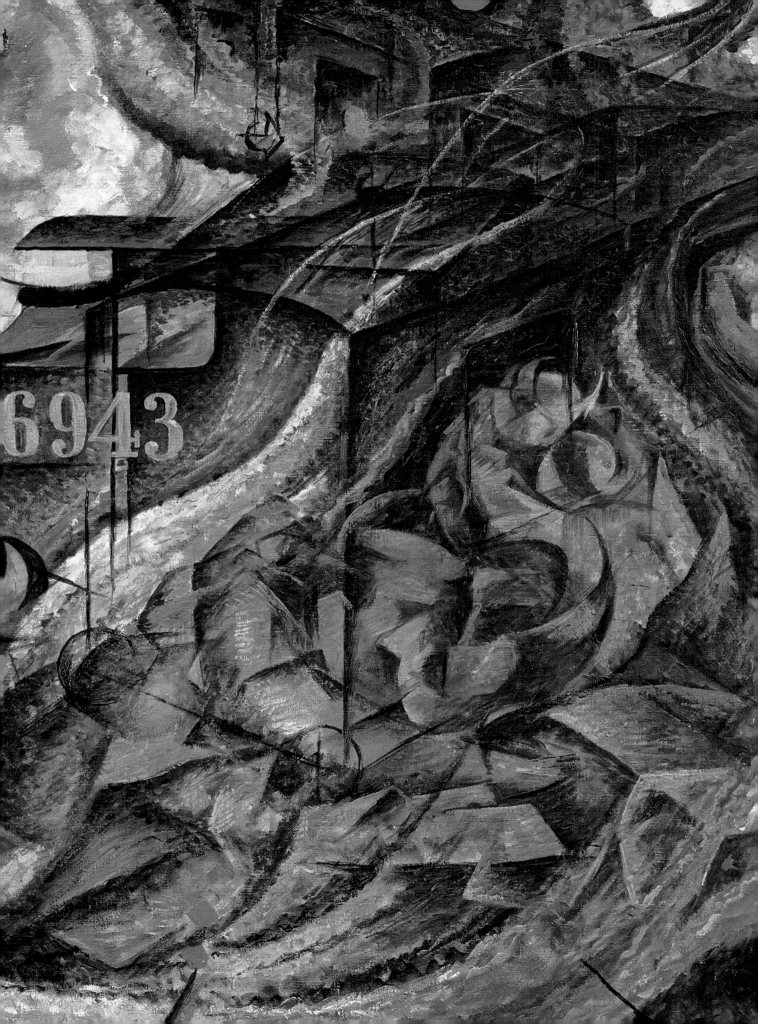

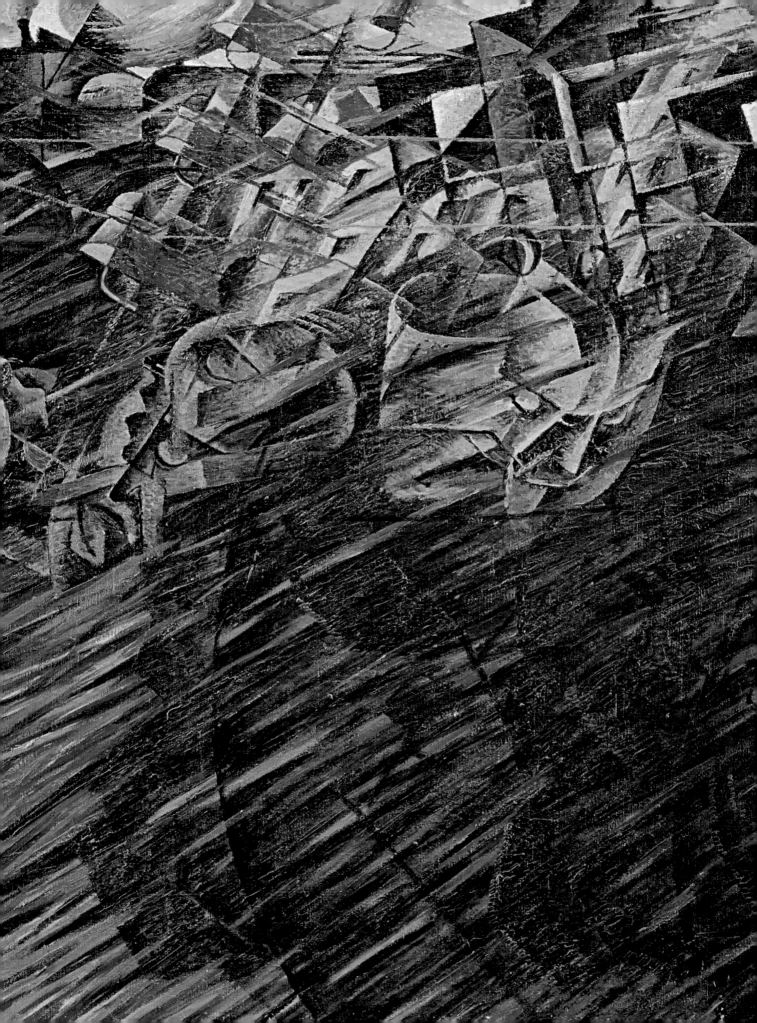

Pages 230–31
Umberto Boccioni
States of Mind II—The Farewells, 1912
(detail)
Oil on canvas, 70.5 x 96.2 cm
New York, The Museum of Modern
Art, Gift of Nelson A. Rockefeller

Umberto Boccioni
States of Mind II—Those Who Stay,
1912 (opposite, detail)
Oil on canvas, 70.8 x 95.9 cm
New York, The Museum of Modern
Art, Gift of Nelson A. Rockefeller

Umberto Boccioni
States of Mind II: Those Who Go, 1912
(detail)
Oil on canvas, 70.8 x 95.9 cm
New York, The Museum of Modern
Art, Gift of Nelson A. Rockefeller

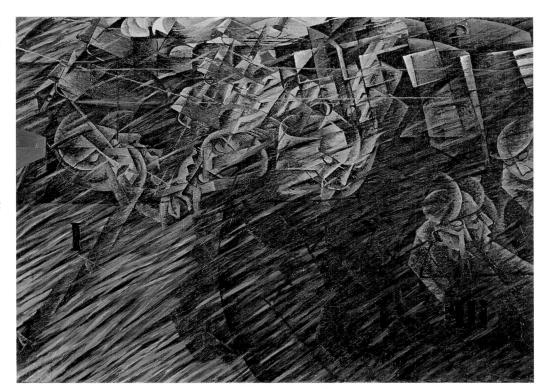

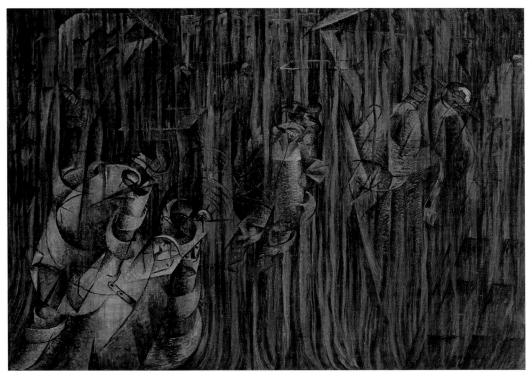

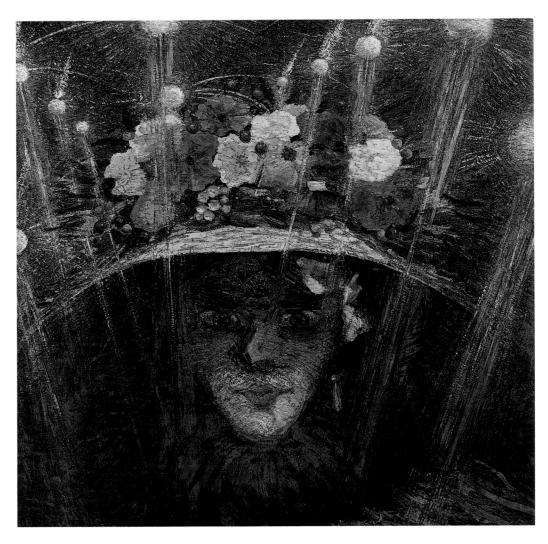

Umberto Boccioni
Modern Idol, 1911
Oil on panel, 59.7 x 58.4 cm
London, Estorick Collection of Modern
Italian Art

Umberto Boccioni
Anti-Gracious, 1912 (detail)
Oil on canvas, 80 x 80 cm
Private collection

theory of the multiplication of movement and its deformation, a fundamental element of the Futurist poetics that culminates, in the introduction written by Boccioni for the catalogue of the Paris show of 1912 at the Bernheim-Jeune gallery, in the most articulated definition of 'simultaneity'.

This tendency to deal intuitively with the relationship between art and science emerged in part from the Milanese and European cultural environment of the time. The scientific theories of relativity, already expressed in 1905 by Einstein in an article entitled *On the Electrodynamics of Moving Bodies*, were probably not known to Marinetti, but the echo of this scientific research seems to have reached the movement through the studies of the nature of matter and energy. Faith in progress and science is one of the foundations of the philosophy of Futurism, which corresponds to the general urbanistic evolution of Milan. At the turn of the century, in the middle of the age of Giolitti, the city enjoyed a partial prosperity: the development of electric lighting and the tram network, the ap-

pearance of the first automobiles, bicycles and in general of new technologies (trains, planes, etc.) profoundly stimulated the ideas of the Futurists. In parallel, it was here that the anti-reactionary, anarchist impulses first spread (the ideas of Turati), along with Wagnerism, by now firmly rooted throughout Europe along with modernist ideas, which in Milan found adepts in the figures of Boito and Catalani. In addition there were the ideas of Nietzsche, who had a profound influence upon Marinetti and Boccioni.

The most important figure in the movement Boccioni, who was in continuous dialogue, and later also rivalry, with Marinetti: quite soon, he became the theorist of Futurist ideas in the field of painting, applying them rapidly in his own works and soon achieving astonishing results. His painting, *Mourning*, shown at the Famiglia Artistica in Milan at the end of 1910, represented the evolution of the painter from his Divisionist to Futurist phase. The dramatic subject is developed with a transverse arrangement of the figures, beginning with the daring foreshortening of the coffin in

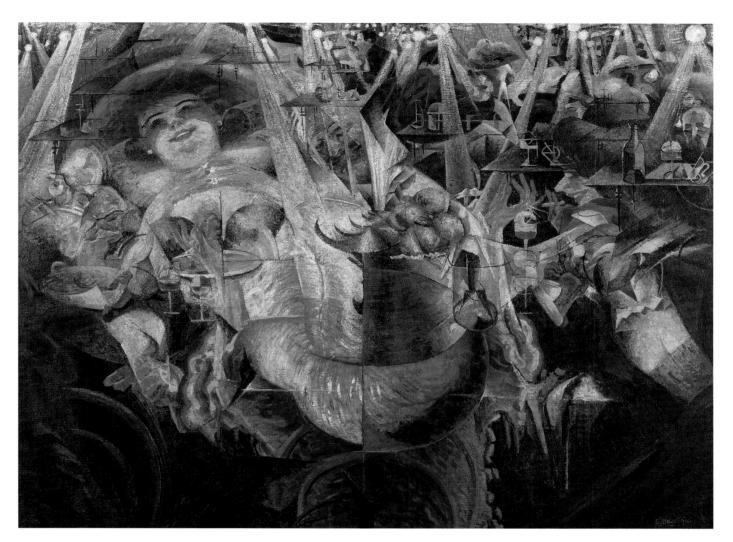

Umberto Boccioni
The Laugh, 1911
Oil on canvas, 110.2 x 145.4 cm
New York, The Museum of Modern
Art, Gift of Herbert and Hannette
Rothschild

the upper left corner of the composition, and developing further in the figures of the weeping women, thus establishing a compositional equilibrium in the Previatiesque symmetries of the bouquets of chrysanthemums set on either side. The powerful Expressionist influence of Munch's painting justifies the use of 'congenital complementarism' in the colours, which are in fact violent and expressive, while the Divisionistic use of the brushstrokes did not limit the innovative scope of the concept of simultaneity. The women portrayed here can be reduced to two major figures repeated in different poses and expressions in the space of the painting: this is not the simultaneity made up of photographic 'flashes', so typical of Balla and Russolo, but rather a conceptual simultaneity, an attempt to represent movement while rejecting the spiritualisms and symbolisms of the Divisionist phase.

For that matter, during the same months Boccioni was hard at work creating *The City Rises*, which was previously known as *Work*: the large canvas, presented in April 1911, had a lengthy genesis, lasting roughly a year and documented by various preparatory sketches. It is the emblematic artwork of the Futurist revolution, even though it preserves a link with tradition in the choice of the social subject of the construction yard and in a certain figurative formalism, which is delineated in the background by the house in construction and harking back to the Expressionist use of the line, already present in the morphology of *Mourning*. The central theme of the runaway horse and the workers who are trying to rein it in is the pretext for reasoning—in figurative terms—about the concept of simultaneity. The different placements and repetitions of the subject give the work a degree of dynamicity and movement but, as with *Mourning*, this is still the idea of movement anchored to the observation of the real and translated into painting. The amazing horse in the foreground becomes the energetic synthesis of movement, while violent hues and the 'ignition' of the colours confers a sense of drama to the event. The artwork indicates the path taken by Boccioni in the most authentic development of his poetics, following various attempts and

Luigi Russolo
The Revolt, 1911
Oil on canvas, 150 x 230 cm
The Hague, Haags Gemeentemuseum

Opposite
Luigi Russolo
The Solidity of Fog, 1912
Oil on canvas, 100 x 65 cm
Gianni Mattioli collection, temporary
storage, Venice, Peggy Guggenheim
Collection

experimentations. *Riot in the Galleria*, exhibited with *Mourning*, summarised these efforts, not distant from the conceptions developed later in *The City Rises*, but with results that brought it closer to Seurat's Pointillism, suggested by Severini, the Futurist closest to the French, and in particular by Carrà's works (*Night Scene in Piazza Beccaria*).

This further passage in the evolution of Boccioni's poetics is represented by the execution of the *States of Mind*: the two different versions, the first now in Milan, and the second in New York, document, in a similar manner to *The City Rises*, a complex and thoroughly articulated creative gestation, punctuated by Boccioni's stay in Paris, accompanied by Carrà and Russolo, to organise the renowned exhibition of the Futurists, staged in 1912, and which broadcast, in its European itinerary (London, Berlin, Brussels), the chief lines of the movement. The idea of the *States of Mind* emerged from the painter's urgent need to express a physical transcendence that takes its distance from the idealistic spiritualism of Divisionist origin, based on the translation of the matter-energy dichotomy. This theory, developed in the 1914 book, *Trascendentalismo fisico e stati d'animo plastici*, took form with the double series

of triptychs. For Boccioni there thus originates a determination to give shape to a state of mind, to concretise in painting the emotional essence, sensation, while losing the objective references of reality and underscoring sentimental and psychological evocations. If the first series remains stylistically linked to Divisionist influences, with the exception of a tendency towards an almost abstract figuration detectable in *Those Who Stay*, the second series casts light on a new stylistic development. The criticisms of the Futurists by Ardengo Soffici, who was newly returned from Paris, in *La Voce* of June 1911 and a description of the Cubist poetics led Boccioni to find out more about the latter, seeing their works directly during his stay in Paris. The painter remained sceptical and reluctant about the Cubist experimentations, but there can be no question that they influenced him, as is evinced in the second version of the *States of Mind*. The dynamic rhythm of the artworks was punctuated by Cubist volumetrics, and in *Those Who Go* the juxtaposition of the points of view, typical of Picasso's work, was used to underscore the paintings emotional quality. *Those Who Stay* and the *Farewells* reveal an evident geometric structuring of space. Prior to Soffici's article,

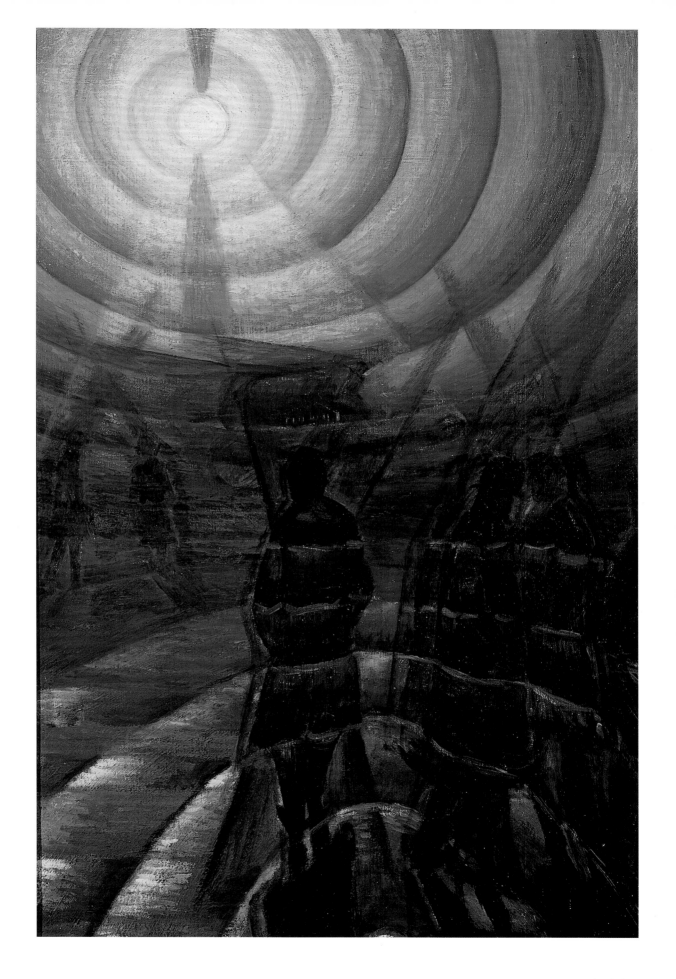

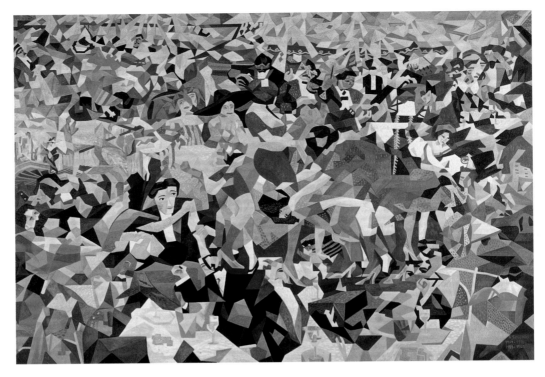

Gino Severini
Dancing the Pan-Pan at the Monico,
1909 (redone in 1959)
Oil on canvas, 280 x 400 cm
Paris, Musée National d'Art Moderne,
Centre Georges Pompidou

Opposite
Gino Severini
Blue Dancer, 1912
Oil on canvas, 61 x 46 cm
Gianni Mattioli Collection, temporary
storage, Venice, Peggy Guggenheim
collection

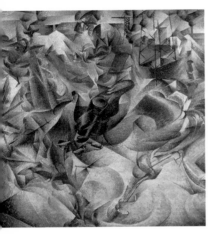

Umberto Boccioni
Elasticity, 1912 (detail)
Oil on canvas, 100 x 100 cm
Milan, Civiche Raccolte d'Arte,
Jucker collection

Boccioni had almost entirely ignored Cubism and, though remaining influenced by it, he condemned its monumental and static character and its figurative repetitivity, which he did not hesitate to describe as academic. But Cubism to Boccioni was the key to the solution of the relationship between an object and its environment: while in the Divisionist period and the initial period of Futurism, the fusion of the two realities took place stylistically with the dissolving of the outlines through colour, with the Cubist lexicon this same fusion took place through the interpenetration of spaces, with the intersection of planes and different perspectival applications, and yet it conferred dynamism to the compositions through the creation of spiral movements, vector lines of force, and rotations. Also working to enrich the Futurist language was the theory of simultaneity. This is evident in a work like *The Laugh*, which was almost certainly repainted in the fall of 1911 to repair the damage suffered over the course of the spring during his first show in Milan. The Cubist lesson helped Boccioni to structure the subject in different visual planes: the artist's intention was to represent simultaneously and from different sides, all of the objects and persons present. The theory of simultaneity was based on a re-elaboration of the theses of Henri Bergson, who believed that time is not mathematical, i.e., quantifiable in instants, but rather the very essence of life, definable in terms of duration. To Bergson, time was circumscribed by the per-

sistence of the contents of awareness and is actualised in the dimension of memory, and therefore the characters and subjects of one of Boccioni's artworks are depicted as being present in the painter's memory, in an optical and mnemonic synthesis. This conception was already expressed in *Mourning*, in *The City Rises* and in all of his subsequent works, but with a value that was more perceptual than philosophical; now it was refined and structured in theoretical terms in the wake of his understanding of Cubism. In *Simultaneous Visions*, the two female faces looking out the window constitute a synthesis of the two different points of view, the entire composition was developed into an interpenetration of planes and of different points of view: the dynamic engine of the artwork is, in fact, Bergson's time-memory in Boccioni's acceptation.

In the *Technical Manifesto of Sculpture*, also published in 1912, Boccioni again took up the concept of energy and dynamism, theorising the 'dynamic force-line' that was recognised in the form of the straight line extending into infinity, but especially, the following year, in *Futurist Painting and Sculpture. Plastic Dynamism*, published in 1914. Here he explored the theme, putting forward the concept of dynamic continuity as a unique form and amplifying the theory of the states of mind, evolving them to plastic states of mind, as a pure emotional composition, devoid of all literary and psychological references, but consisting of and dominated by the

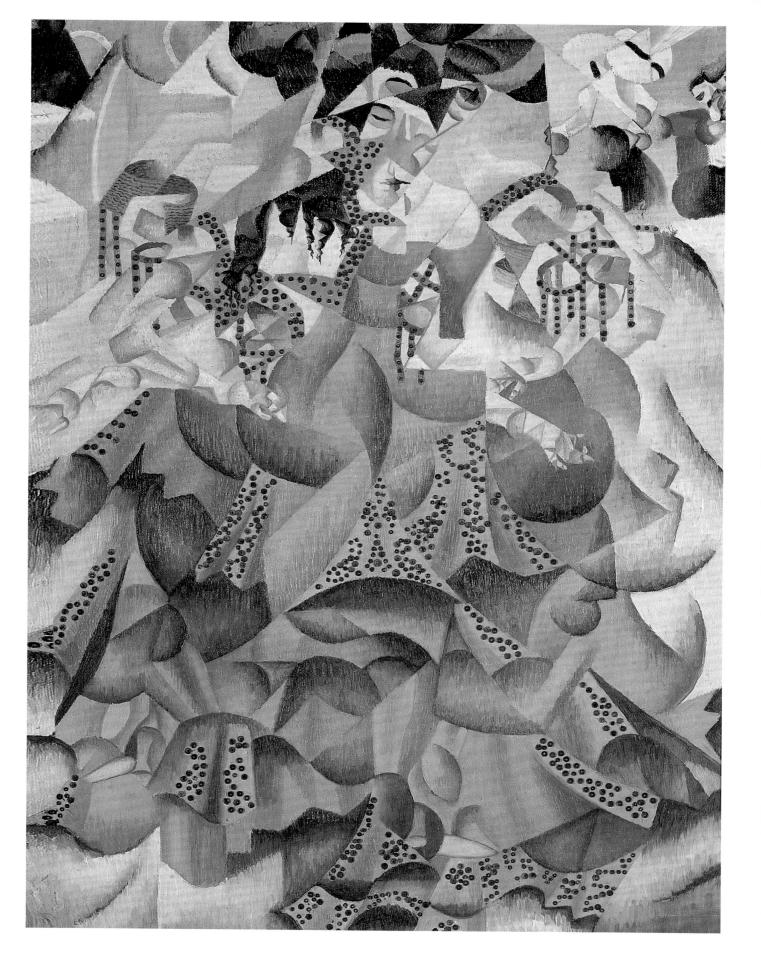

Giacomo Balla
Dynamism of a Dog on a Leash, 1912
Oil on canvas, 90.8 x 110.2 cm
Buffalo, Albright-Knox Art Gallery,
Gift of G.F. Goodyear

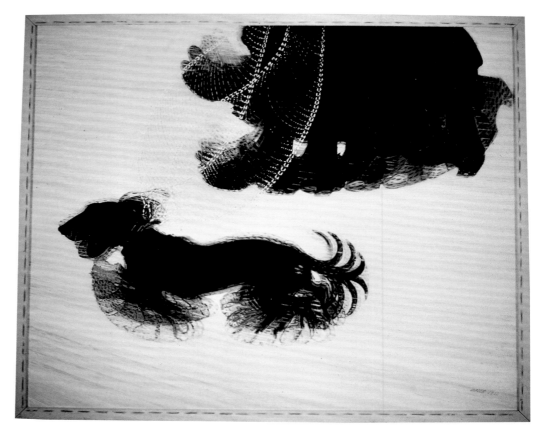

very energy that is unleashed by the state of mind. Boccioni thus intended to give a structure to emotion, as he had previously done with the series of the *States of Mind,* but seeking a more structured and articulated mode of representation. Helping to formulate dynamic continuity as a unique form in space, Boccioni in *Futurist Painting and Sculpture. Plastic Dynamism* introduced the definitions of absolute and relative movement: the former is intrinsic to the object per se 'in power' and takes place according to its own form and structure, while the latter is the very movement of an object that shifts in space, in relation to the surrounding environment. It was once again the Divisionist problem between object and environment that with Boccioni took on an entirely new outlook, now the object fit into the environment, no longer losing focus through light and colour, but opening itself through force-lines and interpenetrating into the surrounding space: the force-lines, in their tension towards infinity, 'place the observer at the centre of the canvas'. But Boccioni took a further step from Bergsonian simultaneity to the 'unique form', which restored continuity to forms in space: this became the spiral and in part the linked forms, such as the ellipse (as for instance in *La risata*), and in sculpture the dialogue between concave and convex.

The spiral form was already recognisable in *Simultaneous Visions,* but it became evident with *Horizontal Construction,* in which the figure of the mother tends to interpenetrate with the surrounding urban environment through a dynamic 'spiralling' motion created by the force-lines; this is unquestionably an experimental canvas that alludes to the research undertaken by Boccioni at the same time in the field of sculpture. *Unique Forms of Continuity in Space* masterfully summarises, and not only in the title of the work, the experimentation that had hitherto been conducted by the artist: the alternation of concave and convex spaces, the total interpenetration of the planes, the twisting of the spirals, all worked together to create a unique dynamic form, totally immersed in the surrounding space, a synthesis of velocity and energy. The tendency towards abstraction, detectable in the sculpture, was the point of arrival of Boccioni's artistic experience, and with *Dynamism of a Footballer,* the subject became pure form. It is difficult to identify the points of reference of the subject; Boccioni painted the energetic concept of dynamic continuity and in some way insinuated into the artwork a tendency towards an almost conceptual abstraction, a tending towards the infinite accentuated by the diagonal and oblique lines of the composition.

The painter came, in 1915, to a pause for reflection: justifying this sudden halt were the powerful debates going on within the Futurist movement, leading to the defection of Papini, the brutal criticisms by Carrà (who was increasingly distant from the group) about Boccioni's writings, and the outbreak of World War I. There followed a period of reflection and productive rethinking, a return to figuration, for which the artist adopted a neo-Cézannian style, harking back to traditional and youthful subjects, such as portraits, landscapes, and still-lifes. It was probably the experience of the war that deprived him of the stimuli for artistic meditation, but his abandonment of Futurism was also predicted in the sculpture of the *Anti-Gracious*, in which the head, defined by a spatial rhythm characterised by 'solids' and 'voids', revealed a reflection on the sculpture of 'impression' by Medardo Rosso and on the sculpture of Rodin, almost an attempt to get back to his own education in order to recapture those Impressionist influences that he had at first ignored. It is significant that the *Portrait of Ferruccio Busoni* of 1916 (his patron and collector) should, in turn, hark back to strongly neo-Cézannian forms, and so *Plastic*

Synthesis of a Seated Figure (Sylvia) seems to soften the pre-Cubist volumetric synthesis and Boccioni's research and retrospection actually seem to be a pause for reflection on the ideas of Futurism and a sort of 'return to order'.

Among the historic signatories of the *Manifesto*, Carlo Carrà was the artist who was closest to Boccioni's ideas, even though he soon took his distance to follow his own artistic path to creative successes quite remote from Futurism. Much like Boccioni, the painter made use of Divisionist theories and technique to accentuate the use of light in an emotional function. The 'proto-Futurist' artwork *Leaving the Theatre* conceals any open references to reality: the title of the painting, the presence of the couple, the man shovelling snow, and the carriage allow us to guess that the setting is a city, while the dense filamentous brush-strokes create a chromatic impasto enlivened by the glowing illumination given by the street lights, rather like electric moons. The logical continuation of this work is presented in the subsequent *Night Scene in Piazza Beccaria*, in which the depiction of the lamp-moons ignites lively luminous colourisms and projects on the canvas an intrinsic emotive purpose

Giacomo Balla
The Hand of the Violinist, 1912
Oil on canvas, 52 x 75 cm
London, Estorick Collection of Modern Italian Art

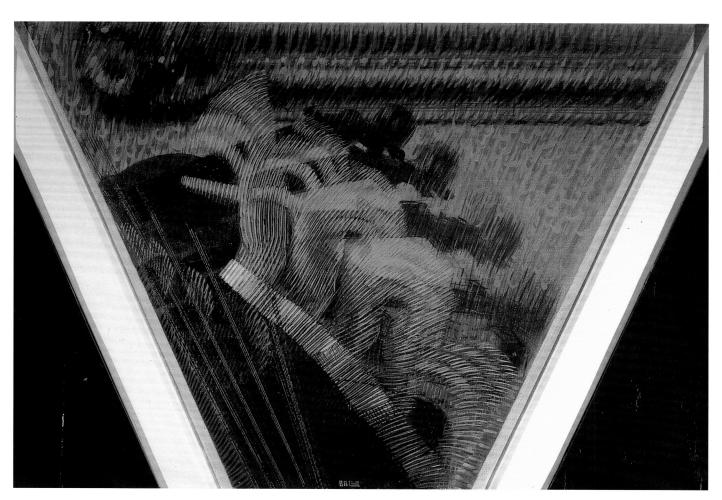

Giacomo Balla
Young Girl Running on a Balcony, 1912
Oil on canvas, 125 x 125 cm
Milan, Civiche Raccolte d'Arte

and pictorial emotionalism, placing this work in the line of Boccioni's 'congenital complementarism'. The turning point in the Futurist direction finds confirmation in the work *Funeral of the Anarchist Galli*, in the earnest translation of the *Manifesto*'s proposition, 'we will place the observer at the centre of the painting'. The space of the canvas was conceived to involve observers in the dynamism of the composition: the trajectory of the wobbling coffin, underscored by its correspondence to the sunlight, gives a sense of movement to the entire image, entering into a rhythmic harmony with the agitated crowd, in a welter of

banners, clubs, axes, something resembling spears, rays of light and luminous sheens. The geometric forms in the foreground draw the spectator into the painting, a chromatic lyricism confers drama upon the composition and seems to evoke its racket and noise, almost a forerunner of the theoretical findings of the *Manifesto* of 1913 entitled *The Painting of Sounds, Noises and Smells.* The movement of the image is fully in keeping with Boccioni's theory of simultaneity, mentioned above, in the evocative Bergsonian essence of the projection of memory, which finds its application in the optical and mnemonic synthesis; for

Giacomo Balla
Iridescent Interpenetration no. 7, 1912
Oil on canvas, 77 x 77 cm
Turin, Galleria Civica d'Arte Moderna
e Contemporanea

Giacomo Balla
Shouting Forms—Long Live Italy, 1915
Oil on canvas, 135 x 188 cm
Rome, Galleria Nazionale d'Arte
Moderna e Contemporanea

that matter, the episode of the police charging procession in *Funeral of the Anarchist Galli*, to which Carrà was referring, was experienced by the artist at first hand six years before he executed the painting.

That Which I Call the Tram is a testimonial to Carrà's attainment of maturity in the context of the Futurist movement: the theme of the city and of machinery finds a new synthesis in the image of the trolley car; vector lines and multiple vanishing points create the spatial fabric, structuring the various geometric planes that interact and interpenetrate. The two-dimensional quality of the canvas is echoed in the organisation of a space within which men, animals and objects are joined together, in an energetic fusion of space, atmosphere, machinery, city and man.

A further step towards the deconstruction and recomposition of space is the work *Milan Station*, in which the interpenetration of spaces is resolved in a simultaneous fusion of the oblique trajectories in the helicoidal movement that gives origin to the core of the composition, impressing dynamism on

a sort of complex and abstract cosmos, devoid of any real points of reference: movement, light, and colour are the means of destruction of traditional space, and at the same time, the units of measurement for the reconstruction of a new reality.

The trips to Paris in 1911–12 to organise the famous exhibition at the Bernheim-Jeune gallery also allowed Carrà to be brought up to date on Cubist art, especially the work of Picasso and Braque, and to transpose Futurist themes into the context of the stylistic methods of the French movement. *Rhythm of Objects* presented a compositional rhythm punctuated by lines that break down objects to create empty forms. Empty space was a material for the Futurists, but in the work of Carrà dynamism was translated into a solid and compositional structure. It is possible to recognise the total assimilation of the new Cubist-Futurist language as well in the work *Noises of the Night Café*, which was associated with the new ideal of painting sounds, noises, and odours that had been theorised shortly before in the *Manifesto* of that name published in

Umberto Boccioni
Force-lines of a Bottle, 1912
Bronze, 39.5 x 59.5 x 32.8 cm
Milan, Civiche Raccolte d'Arte,
gift of Ausonio Canavese

Opposite
Umberto Boccioni
Anti-Gracious, 1912
Plaster, 58 x 50 x 40 cm
Rome, Galleria Nazionale d'Arte
Moderna e Contemporanea

Lacerba. Oblique vectors punctuate the modular space that allows fragments of musical instruments and notes to filter through, the dynamic description of a musical architecture is meant to depict the introduction into painting of sounds and odours, diffused by chromatism as a means of expression. The work represented the point of arrival of Carrà's Futurist research with the depiction of a 'sonic painting'; in reality, adherence to a Cubo-Futurist style of depiction underscores the artist's determination to overcome the field of Futurist orthodoxy in order to embrace Cubist poetics. The gravitating solidity of the forms in these last works was accompanied by the Picasso-influenced collages that testify Carrà's increasingly accentuated love of all things French, and nourished by closer relations in Paris with Picasso and Apollinaire.

This position was certainly shared by his friend Ardengo Soffici, who in the same period attained similar formal results through the use of collage. Carrà played an important role in the relations between the Milanese set and the Florentine group that had gathered around *Lacerba*. He participated actively to the critical articles written in the magazine and served as an intermediary between Marinetti and Soffici. The inexorable fracture between the two groups, which took place in 1914 and 1915, became an occasion for deep thought for the artist on his identity as a Futurist and resulted in his eventual and gradual departure from the movement. All the same, Carrà joined Futurism because he was attracted by the new aspects of the visual language proposed by the signatories, and contributed to the enrichment and development of that language, but without ever fully recognising, compared with Marinetti and Boccioni, the poetics of machinery and the industrial city. The true subject of his research remained the metropolis consisting of individuals and crowds and the sensations and evocations they stimulate. This is not a romantic heritage, but the emotional quest of an individual, which found its point of reference in the harsh life that Carrà led from his earliest years. This new cultural position would lead him to abandon Futurism, pass through Cubism during the so-called phase of the *Anti-Gracious*, and wind up in Metaphysics and a new and organic relationship with natural reality.

Luigi Russolo completed the list of the artists who were signatories to the first Futurist *Manifesto*, which was dedicated to painting. Divided between his passions for music and painting, and following Divisionist-Symbolist experiences he came into contact with in Milanese artistic circles, he joined Futurism enthusiastically, in part due to his friendship with Boccioni and Marinetti. Russolo's pictorial development proved from the very outset to be totally in tune with the movement's ideas: *The Revolt*, shown at the movement's first Milanese exhibition, contained within it the prerequisite of representing motion through the structuring of space, thanks in part to the tension towards the infinite, expressed by the force lines, which mark off the dynamic 'wedges' extending into space beyond the painting of the surface. The next work, *Dynamism of an Automobile,* also featured the same stylistic elements adapted to Marinetti's theme and which were in keeping with the studies that Balla had conducted on motion. *The Solidity of Fog*, which came between the two previous works, also emphasised the direction of movement and consisted, on the one hand, of the concentric cone of fog that radiates from the moon, and on the other, of the hyperbolic arc described and traced by the shadow-persons of the composition, who meet in the central axis, and there vanish. These works represent the painter's solid understanding of the theories expressed by Futurism, but limited by a methodical application that is at times unproductive and non-innovative. Indeed, Russolo did not take active part in the formulations of Boccioni and Carrà, in the field of painting, and wound up abandoning it

Umberto Boccioni
*Unique Forms of Continuity
in Space*, 1913
Bronze, 112 x 40 x 90 cm
Milan, Civiche Raccolte d'Arte

entirely in 1913 and going back to work on music with the *Art of Noise*, which he dedicated to his Futurist master, Balilla Pratella. The essay theorised the use of sound-noise in musical compositions: setting out from these ideas, with Ugo Piatti the artist designed the *Intonarumori*, musical instruments designed to modify the intensity of sound-noises. The studies and applications of the painter-composer, becoming valid points of reference for future experimentations in concrete music, following World War II. Russolo, collaborating with Pratella, continued his research in this field, creating full-fledged musical works and developing Futurist theories, alongside Marinetti's onomatopoetic *Words in Liberty*, Carrà's *The Painting of Sounds, Noises and Smells*, and Prampolini's *Cromophony*. It was not until 1929 that he once again abandoned his musical research to dedicate himself to the occult sciences.

In the same period, aside from fulfilling the roles of promoter, inspiration director of the Futurist movement, Marinetti theorised *Words in Freedom* in the *Technical Manifesto of Futurist Literature* in May 1912, developing the idea to the point of attaining impressive results with the composition of the poem–*reportage Zang Tumb Tumb* dedicated to the siege of Hadrianopolis (Edirne). The process of revolution of the *Words in Freedom* involved the total deconstruction of traditional syntax and grammar. After free verse, the introduction of simultaneity, dynamism and states of mind, the artist formulated a new structural poetics based on a new onomatopoetic syntax that found its visual dimension in the plates of *Parolelibere*, a synthesis of poetic-visual research translated into pictorial terms

in the later Cubist-Futurist *collages* by Carrà, Soffici and Severini, and in the use of mathematical signs in the titles of artworks by Boccioni, Balla and Depero.

In March 1914 in Milan, alongside the activities carried out by the members of the Futurist group, there took shape a parallel, para-Futurist movement with the name Nuove Tendenze, which was accompanied by the composition of a charter-manifesto and the organisation of an important exhibition at the Famiglia Artistica. The group of Nuove Tendenze brought together theorists, architects and artists who were emerging from the educational experience at Brera Academy and who, in any case, gravitated around the Futurist sphere of influence, even though they did their best not to align themselves mechanically with the ideas supported by the movement.

Ugo Nebbia, along with Leonardo Dudreville, occupied a position that was entirely comparable with that of Marinetti for Futurism. His activity as a critic and connoisseur of the most recent French, Mitteleuropean and Russian figurative cultures, as well as the publication of articles and essays in the magazine *Emporium*, helped to establish his role as a source of inspiration.

Dudreville looked after the most technical issues, such as the recruitment of artists who would support the movement's programme, including Giulio Ulisse Arata, Mario Chiattone and Antonio Sant'Elia among the architects, Decio Buffoni, Gustavo Macchi and Ugo Nebbia among the writers, Carlo Erba and Achille Funi among the painters, and Giovanni Possamai as a sculptor. Later, the painter Adriana Bisi Fabbri joined, along with Marcello Nizzoli and Alma Fiori.

The group was active for about a year and can be summarised by the exhibition held at the Famiglia Artistica. It is interesting to emphasise that within the group prominent roles were played by the future protagonists of the Italian 'return to order', including a number of habitués of Margherita Sarfatti's artistic salon, known as Novecento.

Through its members, Nuove Tendenze represented a bridge between the stylistic and decorative goals of Liberty and the Secession and the Parisian avant-gardes, but without ignoring the direct influences of Milanese Futurism.

Dudreville, as documented in a letter from Boccioni to Severini, was supposed to be a signatory to the *Manifesto of Futurist Painters*, with whom he shared a Divisionist education, but his friendship with Severini led him to pursue a style of painting that he

Carlo Carrà
The Galleria in Milan, 1912
Oil on canvas, 91 x 51.5 cm
Gianni Mattioli collection, temporary
storage, Venice, Peggy Guggenheim
collection

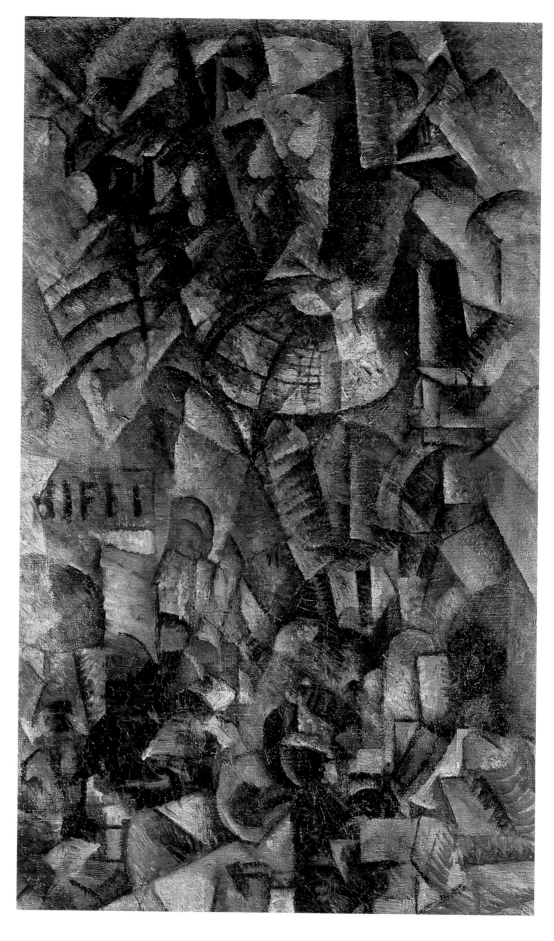

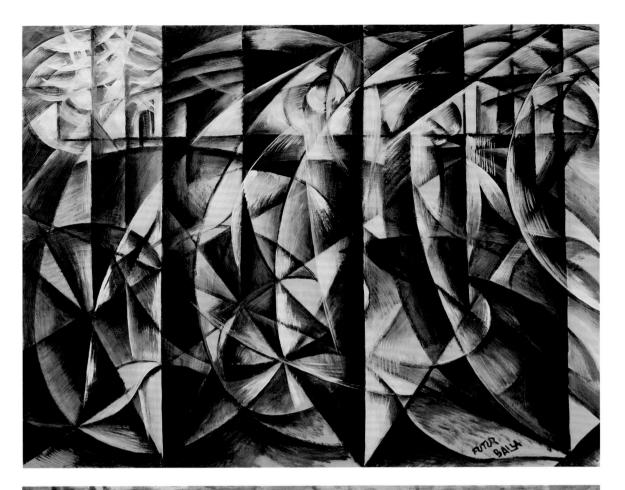

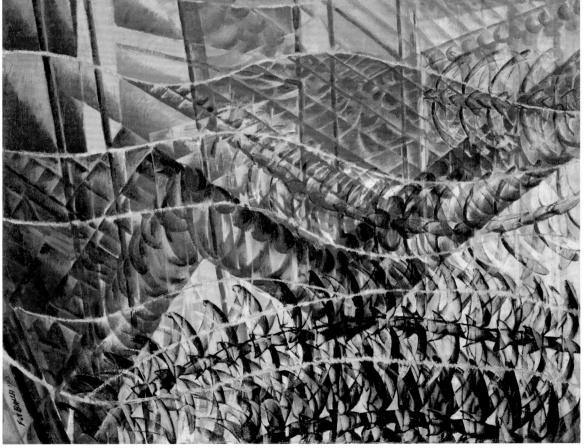

Giacomo Balla
Speeding Automobile, 1912
Oil on wood, 55.6 x 68.9 cm
New York, The Museum of Modern Art

Opposite
Giacomo Balla
The Speed of a Car + Light, 1913
Oil on paper, 84 x 109 cm
Stockholm, Moderna Museet

Giacomo Balla
*Swifts: Paths of Movement
and Dynamic Sequences*, 1913
Oil on canvas, 96 x 109 cm
New York, The Museum of Modern Art

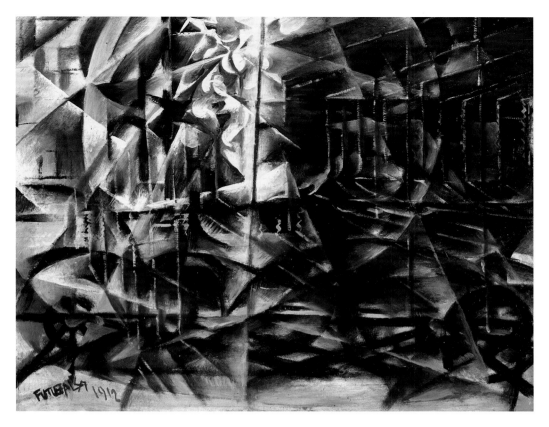

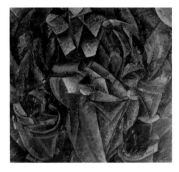

Umberto Boccioni
Spiral Construction, 1913–14
Oil on canvas, 95 x 95 cm
Milan, Civiche Raccolte d'Arte

referred to as 'abstract', in which the concept of frame was abolished. The purpose of this was to overcome analogical representation in order to acquire and expound an interior expressive essence that was translated graphically into an array of form, colour and depth. All of this was exemplified by the *Cycle of the Seasons*, which was stylistically comparable to several works by Severini, such as *Dancing the Pan-Pan at the Monico*, borrowing its concept of plastic movement and also certain chromatic and expressive solutions. In 1920 Dudreville was active in the second Futurism with the manifesto *Against All Steps Backwards in Painting*, which documented once again how close he was to such ideas. During the brief life of Nuove Tendenze, these led him to recognise the qualities of the young architect Antonio Sant'Elia, to the point that he insisted on his membership in the group.

Sant'Elia presented his drawings of *The New City* at the Nuove Tendenze exhibition, resolving the more utopian and creative aspects of his design: his education at the Brera Academy led him at a very young age to collaborate on different projects in various Milanese architectural studios, such as the one for a small modern villa for the Milanino cooperative, for the new cemetery in Monza, and for the competition for the new Milan Railway Station, which was won by Ulisse Stacchini. Although his designs were not selected for construction, they did come in first in the competitions and they aroused particular interest. *The New City* is a translation of the Futurist conceptions that were later expressed in the *Manifesto*: converging in it were the powerful influences of the Secessions and the Liberty movement, the latter being linked in particular to the language of Giuseppe Sommaruga. They were also infused with a personal revision of the architectural archetypes stripped of all decorative appearance, and emphasis placed on the purist character of the buttress and the arch, thus creating a type of eclectic castle-building characterised by towers and bridges, and conferring on these distilled elements a new constructive role. This function took form in the decision to erect buildings in which there is an accentuation in the dynamic tension expressed by the sloping lines that translate the centrifugal force of the interior space of the buildings turned towards the exterior, expressing the adherence to the Futurist dynamism, which in its turn reappeared in the salient points of the *Manifesto*. The architect's *New City* consists of a complete array of studies of buildings, stations and airports, built with emphasis on grandiosity, ascensionality and obliquity, dictated by the recurrent use of the design technique of the 'elevation', oblique perspective, and the step configurations of the

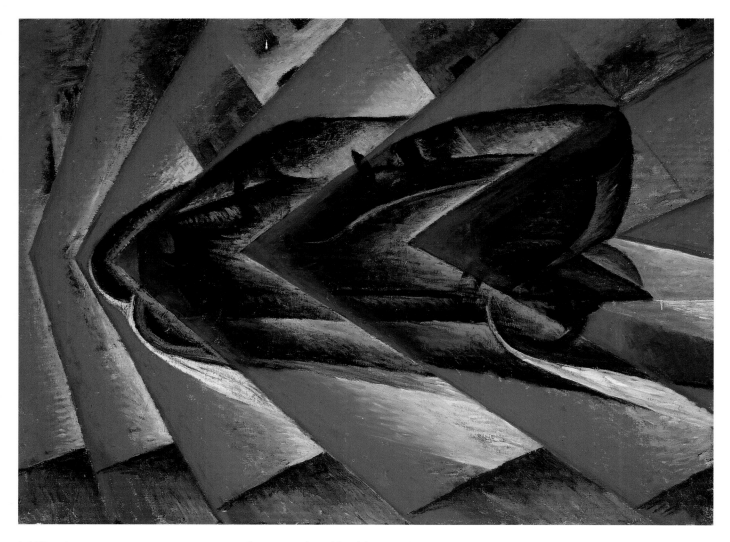

Luigi Russolo
Dynamism of an Automobile, 1911
Oil on canvas, 139 x 184 cm
Paris, Musée National d'Art Moderne,
Centre Georges Pompidou

Opposite
Giacomo Balla
Mercury Passing Before the Sun,
1914 (detail)
Tempera on canvas on board,
120 x 100 cm
Gianni Mattioli collection, temporary
storage, Venice, Peggy Guggenheim
collection

structural 'pyramids' of buildings. This re-
sulted in a variety of modernist skyscrapers
that contrasted with their North American
counterparts in the complexity and context
of the urban structure. Roads on different
levels, lifts, bridges and flights of steps all de-
scribe these parameters in specific terms.
Further dynamic tension is added by con-
tinuous straight lines, the segments and
crosshairs, which provide an analogical and
abstract reference to vehicles. The Futurist
city in the *Manifesto* (published in 1914 in
Lacerba in a fanfare of buildings and 'ma-
chines' and the tumultuous principle of re-
newal) was given a consciously utopian rep-
resentation in Sant'Elia's designs. Affinities
with Boccioni's contemporaneous but un-
published *Manifesto dell'architettura* are seen
in the intentions of both authors—though
from different 'points of view': pictorial for
Boccioni, architectural for Sant'Elia—of
treating in the same manner the relation-
ship between subject and environment, the
dynamic theme of the spiral, and the need
to resolve the notion of movement in an ab-

stract but analogical manner. Like Boccioni,
Sant'Elia died young in a battle in 1916.

Florence
The Futurist circle in Florence was charac-
terised by the presence of Ardengo Soffici,
who became—thanks to his powerful artistic
personality and considerable familiarity with
the ideas spread by the various avant-garde
movements of the period, especially in Paris—
the point of reference for an artistic group that
was initially independent and then, despite the
divergences, linked to that of Marinetti and
Boccioni. Soffici spent his years of education
and training in Paris, from 1900 to 1906, es-
tablishing a close friendship with Guillaume
Apollinaire and Serge Ferat. He approached
painting as an autodidact, influenced by the
language of the Impressionists, in particular
by the works of Cézanne and Picasso, of whom
he became a great admirer. He also developed
a 'popular' poetics suggested by his contacts
with Max Jacob and the painting of Rousseau.
His rejection of all forms of symbolism and a
greater adherence to the ideas of Cubism led

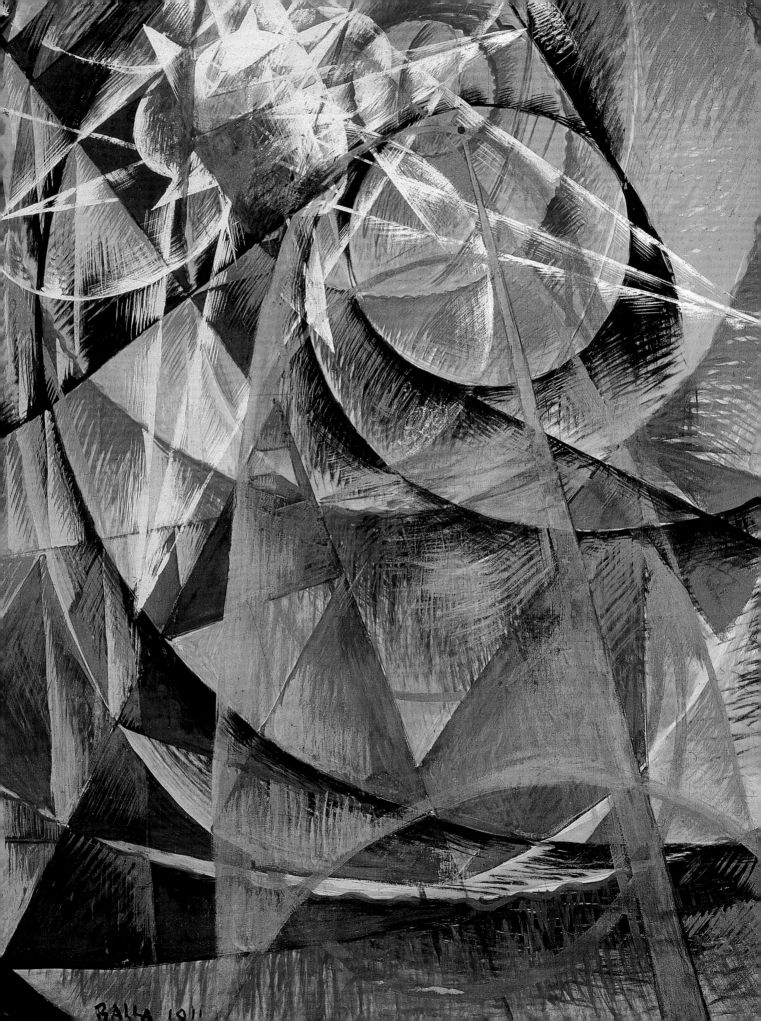

Umberto Boccioni
The Drinker, 1914
Oil on canvas, 86 x 87 cm
Milan, Civiche Raccolte d'Arte,
Jucker collection

him to develop a personal and autonomous style, initially quite distant from the Futurist poetics, objecting to its rejection of the art of the past and a certain political sectarian conflict.

Soffici's adherence to Cubism was more formal than content-related: theorising and idealising left the Tuscan painter cold, and he wound up moving towards Futurism, attracted by its subversive and innovative power. *Decomposition of the Planes of a Light* presents a robust Cubist construction that foreshadows, not only in the choice of the theme of light, but in an apparent dynamism suggested by the interpenetration of the planes, a personal

interpretation of Futurist stylistic ideas. Soffici began to develop a personal stylistic identity, borrowing the dynamism of Futurism while placing emphasis on structure, and conceived a personal chromatism based on reddish-browns and ashy-greys. Still lifes, landscapes and popular subjects were recurrent themes in his paintings, though far removed from those of Marinetti. *Fruit and Liqueurs* represented a technical influence of Cubist origin mediated by a personal poetics. This was linked to popular subjects but did not fall into provincialism, and contributed to the creation of a painting that was very influential not

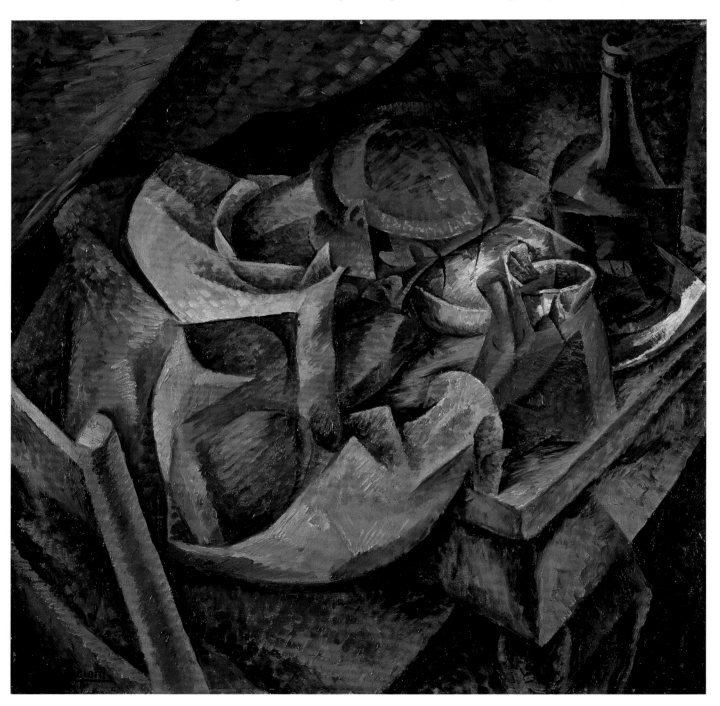

Ottone Rosai
Bar San Marco, 1914
Mixed media on paper, 53 x 42 cm
Private collection

Carlo Carrà
Interventionist Demonstration, 1914
Tempera and collage on cardboard,
38.5 x 30 cm
Gianni Mattioli collection, temporary
storage, Venice, Peggy Guggenheim
collection

Pages 254–55
Umberto Boccioni
Charge of the Lancers, 1915
Tempera and collage, 32 x 50 cm
Milan, Civiche Raccolte d'Arte,
Jucker collection

Bottom
Umberto Boccioni
Dynamism of a Bicyclist, 1913
Oil on canvas, 70 x 95 cm
Gianni Mattioli collection, temporary
storage, Venice, Peggy Guggenheim
collection

Umberto Boccioni
Materia, 1912–13
Oil on canvas, 226 x 150 cm
Gianni Mattioli collection, temporary
storage, Venice, Peggy Guggenheim
collection

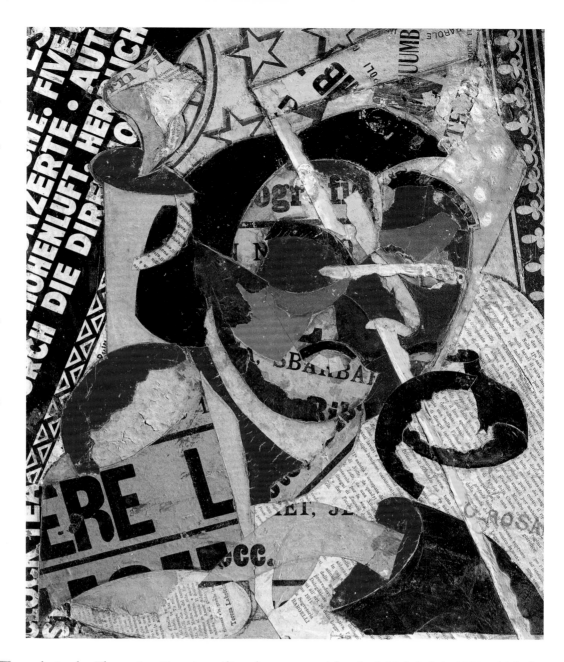

only in the Florentine Futurist milieu, but elsewhere, notably upon Ottone Rosai and Primo Conti. The initial publications in *La Voce* contributed to a clarification of the artistic relationship between France and Italy, informing the Italian artists of the new developments in Paris and inviting the Futurists, specifically Boccioni, to learn more about Cubism. At first, in 1910–11, Soffici, the writer Giuseppe Prezzolini and the philosopher Giovanni Papini, who took part in the artistic debate in *La Voce*, formed the heart of the Florentine group, which was still distant and in conflict with Milanese Futurism. All the same, Soffici was fascinated by and shared fully in the youthful energy and desire for change implicit in the determination of the movement to found a new Italian and international cul-

ture. After the initial clash in 1910, which degenerated into a brawl following Soffici's rejection of Futurism in *La Voce*, relations improved and became increasingly friendly, thanks to a fervent clash-debate between the two factions, Milanese and Florentine, and the attainment of the common intent of creating a new form of artistic expression.

In 1913, with the foundation by Papini and Soffici of the independent magazine *Lacerba*, the groundwork was laid for the union—however brief—between the Futurism of the two cities. From the very outset, *Lacerba* was the chosen vehicle for the diffusion of Futurist theories. In its pages, the new manifestos were published and three chief blocs took form: the philosophico-literary school with Papini, the poetic group with Marinetti

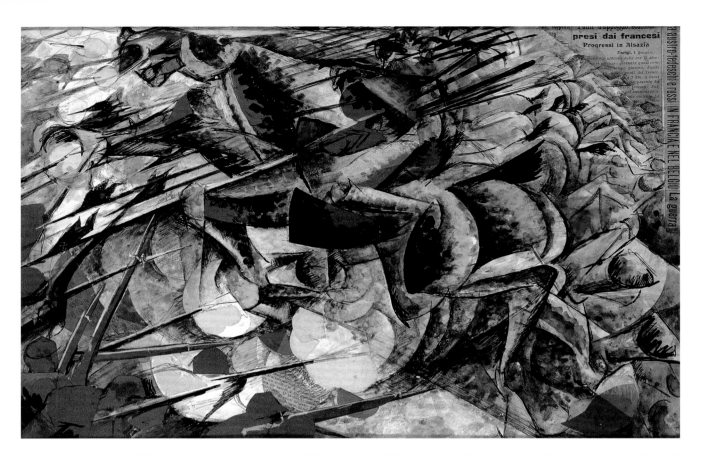

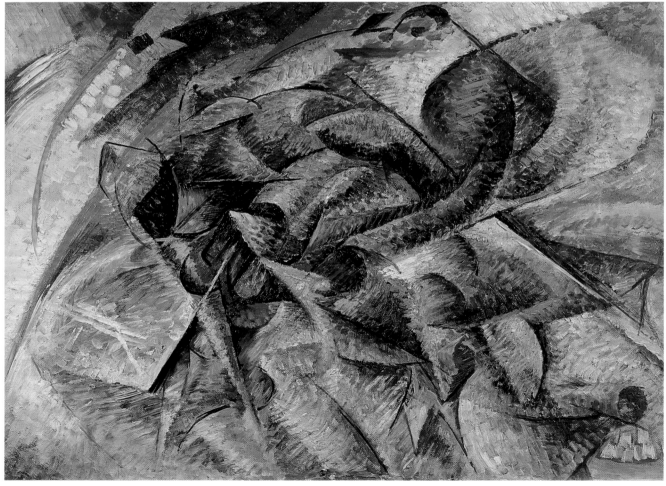

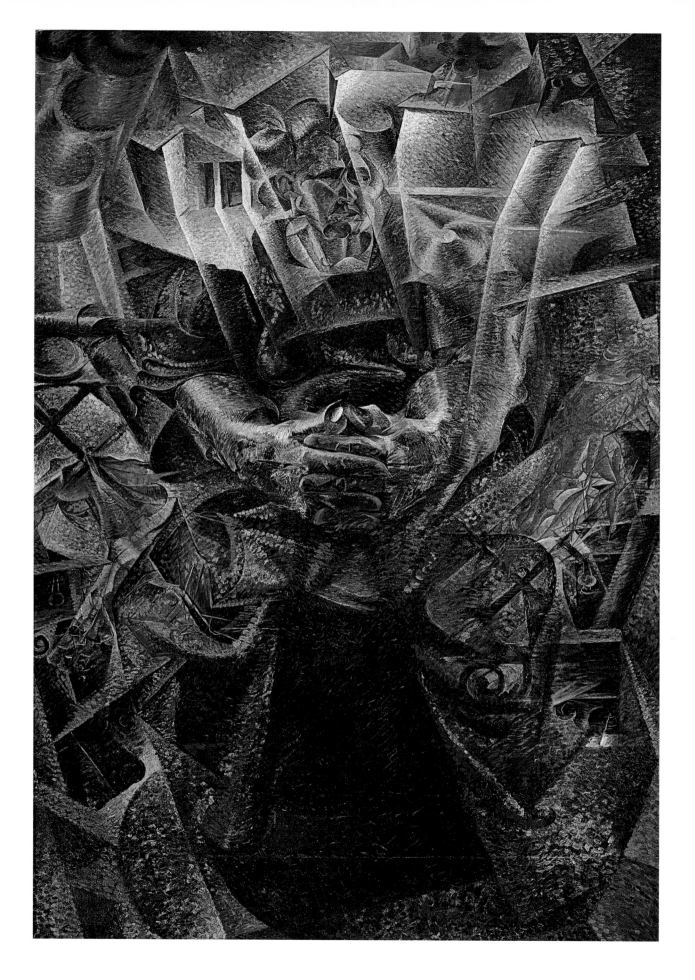

Giacomo Balla
Sketch for the set of the ballet *Feu d'artifice* by Igor Stravinsky, 1917
Oil on paper, 19 x 15 cm
Milan, Museo Teatrale alla Scala

Giacomo Balla
Risks of War, 1915
Oil on canvas, 75 x 115 cm
Rome, Galleria Nazionale d'Arte
Moderna e Contemporanea

and the set of painters and writers with Boccioni, Carrà and Soffici. All the same, set against the rigid structure of the Milanese group's ideas was the subtle irony and the anti-dogmatism of the Florentines: Soffici followed his personal and independent path which led him to break slowly away from Marinetti and Boccioni; in particular he did not agree with their view of the dichotomy between art and life. This considerable difference was grafted onto a different cultural background represented by the disparities between the two cities: science-based progress, mechanical and industrial development, and the theme of urban Milan left the Florentines indifferent, linked as they were to an agrarian and peasant civilisation. Following an intense exchange of articles, around the end of 1914 and beginning of 1915 the Florentine group dissociated itself once and for all from Futurism in its Milanese acceptation, and thus from Marinetti and Boccioni.

The break was significant: Carrà, who had been a link between Milan and Florence because of his good relations with the various members of both groups, abandoned the movement at the end of 1915 and was followed a year later by Severini, who, like Carrà, shared Soffici's motives for dissent, especially those that concerned the cultural 'proselytism' practised by Marinetti. Having used up its charge of novelty and creativity, *Lacerba* ceased publication immediately at the end of the war.

Soffici's cultural activities also justified the creation of a Florentine Futurist group that continued to work around the new magazine *L'Italia Futurista*. Radically different from *Lacerba* and decidedly pro-Marinetti, it was esoteric and aimed at the development of total art as argued by Giacomo Balla.

With Gino Severini, Balla was asked be a signatory to the *Manifesto of the Futurist Painters* of 1910. Balla was honoured by the invitation from his pupil Boccioni, whose artwork he respected, but at the same time he was aware of the difficulties involved in transposing the new ideas of the Futurist movement into painting. In 1911 he painted *Villa Borghese*, perhaps meant for the Futurist exhibition in Milan that same year, but the clear influence of the Divisionist tradition ensured that it would be rejected from any exhibition held by the group. In reality, *Villa Borghese* was painted with virtuoso use of Post-Impressionist technique, but it also conceals a proto-Futurist conception of space: the fifteen panels that make up the work each have their own point of view, and each edge coincides with that of the adjacent panel, revealing a skilful work of 'montage' of individual views designed to create a visual panorama. In the work we see a conceptual rough draft of the idea of simultaneity, testimonial to Balla's ongoing quest for a language of his own within Futurism, but without betraying the ideas laid down by Marinetti or, especially, Boccioni. The Divisionist tradition and the strong link with the milieus of the Secession and Liberty movement in Rome hindered the painter's efforts: in *Arc Lamp* the favourite theme of light was depicted in the form of a geometrised light source covered by a blanket of chromatic filamentous wedges. This represented Balla's personal translation of the 'congenital complementarism', though it did not grasp or attain the emotional values theorised and applied by Boccioni. Not surprisingly, even though this work was in the inventory of the Parisian exhibition at the Bernheim-Jeune gallery, it was not shown. Dating from this period were Balla's experimental works called *Iridescent Interpenetrations* that sprang from a decorative idea from the Secessionist field during the work commissioned from the artist in the villa of his former pupil Margherita Löwenstein in Düsseldorf. All that remains of the cycle, which was destroyed, are a few photographs that record the decorative work linked stylistically to these compositions. The *Interpenetrations* were experimental creations that Balla originally entitled *Irises*, and which critics later renamed *Iridescent Interpenetrations*, but they are considerable distant and distinct from Boccioni's theme. The *Irises* are the product of Balla's enthusiasm for science: intertwining triangular, rhomboidal, circular and sinusoidal forms, they are studies of light and electromagnetism that take their inspiration from the refraction of light through glass or crystal, in order to show the invisible process of the creation of the electromagnetic spectrum. These works are an important passage in Balla's evolution as a Futurist.

In 1913 the artist exhibited, for the first

Ardengo Soffici
Fruit and Liqueurs, 1915
Oil on canvas, 65 x 54 cm
Gianni Mattioli collection, temporary
storage, Venice, Peggy Guggenheim
collection

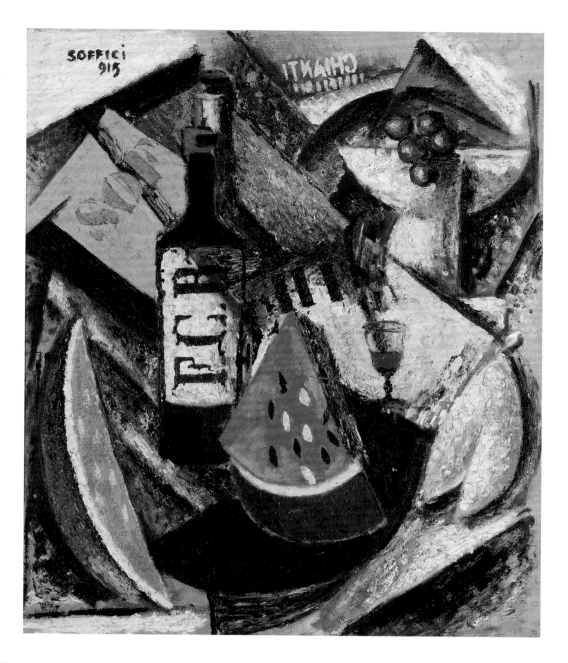

Giacomo Balla
Vortex, 1914
Tempera on paper, 65 x 84 cm
Rovereto, MART

time with the Futurists, four paintings at the Teatro Costanzi in Rome, including the *Dynamism of a Dog on a Leash, The Hand of the Violinist* and *Young Girl Running on a Balcony.* The three paintings speak of Balla's love of photography, a love that characterised his output since his debut. The references to the photodynamics of his friend Bragaglia are undeniable. That same year, Bragaglia published *Futurist Photodynamism,* in which he expressed his own agreement and closeness to the movement, even though he was not one of the signatories. He took his ideas from the chronophotographic theories of Marey and Muybridge and focused on the theory of 'movementism', the analysis of destructured movement, in order to depict real dynamism. Balla agreed with Bragaglia's analysis of move-

ment and applied his theory in the motion of the two subjects in *The Hand of the Violinist,* which was broken down into the succession of instantaneous depictions. The dynamism was reinforced by the triangular, photographic format of the composition, by the 'flat' background, and by the burnished monochromy.

The flat two-dimensional nature of the composition brings together *The Hand of the Violinist* and *Young Girl Running on a Balcony*: here colour was reintroduced, made responsible for the description of the movement, and the open references to photography present in the previous work were abandoned. In order to bring a greater pictorial essence to the artwork, Balla painted the figure of the little girl in such a way as to make it take shape and life across the

Giacomo Balla
Waving of Flags + Crowd, 1915
Oil on canvas, 20.5 x 30 cm
Milan, Civica Galleria d'Arte Moderna

entire surface of the canvas, and to interpenetrate with the railing in the background, thus punctuating the dynamic rhythm. The two paintings bear witness to a maturing of the artist, and an increasingly clear and original appropriation of the painting itself. This was made apparent in Balla's subsequent work, *Swifts: Paths of Movement and Dynamic Sequences*. The lines 'of movement' suggest and structure the motion, but they differ from Boccioni's force-lines and are closer to Bragaglia's 'movementism'; the flight of the swallow in the composition, very different from its photographic equivalent, takes on its own complex rhythm constituting space even in the depth of the painting. The simultaneity of the points of view of the trajectory of flight confers different perspectives, causing space to fragment and disintegrate. The painting sanctions the autonomy of Balla's artistic language on the interior of the poetics of movement: finally the painter has discovered his Futurist identity. The analysis of movement and the interpenetration of space gives way to that of velocity in the 1913–14 series of works of automobiles at speed: the reflection in the windshields of cars passing on the road is the realistic pretext for creating a series of paintings (most of them lost) on the Marinettian theme of the velocity of the automobile. Balla definitively abandoned the theme of nature in order to deal with abstraction, with spirals emerging from the sudden motion of the wheels, vortices, the intersection of planes, the depiction of dynamic space and the use of the glistening enamels that he used to paint the broad fields of colour of the canvases. Although some references to reality still appeared in *Abstract Velocity*, the transition to abstraction was complete in Balla's subsequent works, in particular in the canvases with political themes such as *Shouting Forms —Long Live Italy*. These works he gradually flanked with the study and depiction of sounds and noises. On this subject, in 1913, while disputing with Boccioni, Carrà published *The Painting of Sounds, Noises and Smells*, Luigi Russolo composed the musical manifesto *The Art of Noise*, and Marinetti diffused his onomatopoetic *Words in Freedom*.

With the introduction of the representation of noise in full keeping with the movement's artistic research, Balla's work attained the formulation of the 'plastic synthesis' in which evocative abstraction took on the role of protagonist, as in the canvas *Abstract Speed + Sound*, in which the 'ideal' theme of speed, illustrated by a chromatic

Joseph Stella
Battle of Lights, Coney Island,
1913–14
Oil on canvas, 99 x 75 cm
Lincoln, Sheldon Memorial Art Gallery,
University of Nebraska, Lincoln

Stanton MacDonald-Wright
Airplane Synchrony in Yellow-Orange,
1920
Oil on canvas, 61.6 x 60.8 cm
New York, The Metropolitan Museum
of Art

vortex taken from the movement of wheels, represented the synthesis of dynamic energy. Noise was identified with a broken line, a sort of pictorial sound, a figurative representation of the roar of the engine that interrupted the speed-lines of the composition.

At the beginning of 1915, Balla was to all intents and purposes a protagonist of Futurism, especially in Rome, where he became the charismatic leader and once again master of the group. This included his pupil Sironi, Prampolini, Ginna, Morandi and the young and exuberant Depero. It was with Depero from Rovereto that he composed the *Manifesto of the Futurist Reconstruction of the Universe*, a sort of summary of the experience of the first years of the movement and a relaunching of Futurist poetics. The manifesto promulgated the idea of total art, a diffusion of the Futurist elements of style in all aspects of life, a sort of social, interdisciplinary art that involved all the aspects of artistic production, from furniture to clothing and the applied arts. Taking his inspiration from the manifesto, it was during these years that Balla created the now-lost *Plastic Complexes*, sort of multi-material sculptures, sometimes playful, of fantastic forms; unfortunately, because they were destroyed, it is not now possible to guess whether they emitted sounds, smells or kinetic effects, but they surely constituted a major step forward in the field of sculpture, heralding the imminent advent of the Dadaist ideas of the montage.

Rome

The presence of Fortunato Depero in Rome marked the advent of a Roman path to Futurism. Till then, Marinetti had compared the city to Venice and Florence, branding it as stuck in the past and locked in death, with its dusty and crushing past. But already in 1913, with the opening of Giuseppe Sprovieri's Futurist gallery and the Futurist maturing of Balla, Rome became the third important centre of the movement. In actual fact the city was the site of the second generation of Divisionists, who had almost completely flowed into the ranks of Futurism, and its earlier attempts to participate actively in the group's cultural politics had been the work of Bragaglia and the Neapolitan poet Francesco Cangiullo. It was the relationship between the poet and Marinetti that led the 'mentor' of the movement to reconsider his drastic judgment of the city and to take greater interest in relations with the artists who lived there. Unquestionably, Balla's role and artistic growth were fundamental ele-

ments in the birth of a Roman version of Futurism, regardless of his relationship with Depero and Prampolini, who in 1913 had published his theories on 'chromophony', which extended the field of pictorial research to include sound experiences.

Fortunato Depero came to Rome at the end of 1913 after a brief stay in Florence that revolved around *Lacerba*. In the capital his meeting with Balla, perhaps at Sprovieri's gallery, proved fundamental for both artists. Ever since his time in Rovereto, Depero had adhered to the ideas of the Futurists, but his physical and cultural remoteness in the Austrian province prevented his education from developing: furthermore, too many ties with a Symbolist and Jugendstil realm of painting prevented him from embracing the stylistic elements of the group completely. His encounter with the works of Boccioni and, especially, with Balla led him to mature artistically in a very brief time: Balla's motion-lines became Depero's form-lines, which served to structure the pictorial volumes constituted by the fields of flat, shiny colour derived from Balla's enamels. And yet, the original and autonomous development of a picto-sculpture, also termed 'picto-plastic' by Depero, suggests the possibility of a reciprocal influence.

It is therefore possible to state that Balla was in part indebted to Depero and the new ideas that he had brought with him: Balla continued to develop his work on the formal analogy of dynamism and abstract research, as well as his 'polymaterial' experimentation (derived from Boccioni's sculpture), while Depero took Balla's analogical-abstract research further in the direction of kineticism. The title of his work *Movements of Birds* reflected his intentions, but also the execution of a 'picto-plastic', a sort of painting of 'dynamic volume' that was to herald the *Complessi plastici motorumoristi* (which might be roughly translated as 'three-dimensional engine sound complexes'). These were personal interpretations of Balla's *Plastic Complexes*, from which they differed specifically in their kineticism. With Balla, Depero was the author of the *Manifesto of the Futurist Reconstruction of the Universe*, a veritable bridge between the first and the second Futurism.

The second Futurism introduced a new creative parenthesis within the group, not betraying the initial ideals but modifying, expanding and integrating them and attaining new creative results. The *Manifesto of the Futurist Reconstruction of the Universe* received the heritage of all efforts made up to that point

Percy Wyndham Lewis
Figure Composition, 1912–13
Pencil, ink, and gouache on paper,
23.5 x 31 cm
Private collection

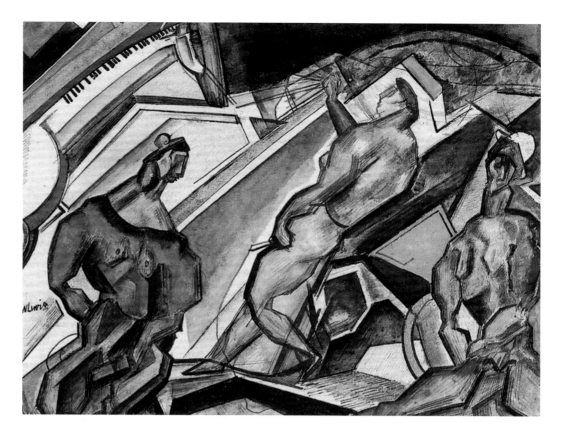

Christopher R.W. Nevinson
Grenade Explosion, 1915
Oil on canvas, 75.5 x 55 cm
London, Tate Modern Gallery

by the movement in order to formulate the idea of total art. The research carried out by the historic signatories had substantially been limited to their field of expertise, that is, painting, with the sole exceptions of Russolo, who with *The Art of Noise* explored the field of music, and Carrà, who with *The Painting of Sounds, Noises and Smells* expanded his own artistic investigation. As the group's leader, Marinetti served as intermediary between the various disciplines and produced a theoretical work in the literary field.

All the same, the interests of the Futurists began to take specific and expanded form as represented by the individual members and documented in the *Programma politico futurista* signed by Marinetti, Boccioni, Carrà and Russolo in October 1913. The *Manifesto of the Futurist Reconstruction of the Universe* took the next step in redefining the creative universe by bringing together all the results of the movement's experimentation in the reformulation of an interdisciplinary, synaesthetic and global art, which would be accessible to one and all in its different and manifold manifestations. One factor driving the signatories of the manifesto was also the optimistic, positivist and utopian concept of a popular art, perhaps even populist, which would strongly differentiate Futurism from the other avant-garde movements of the same period and especially from the intellectualistic and complex—and therefore elitist—developments of Cubism. The path of the *Plastic Complexes* was Balla and Depero's solution to the theory of the *Manifesto*, but quite soon painters, sculptors and photographers were working together on the creation of a Futurist universe: in 1916 Balla, Marinetti, Corra, Settimelli, Ginna and Chiti wrote the manifesto on *Futurist Cinematography*, preceded by the one on *Scenography* (1915) and followed by those on *Dance* (1917), on *Mechanical Art* (1922), and on *Aeropittura* (1929), to name the most important, to which should be added the publications by Marinetti on *Tattilismo* (Tactilism) and even on *Futurist Cooking*; as well as the birth, in the 1920s, of a mechanical analogism and a fascination with the automaton-machine, which once again indicated the depth and scope of the area of interest of the second Futurism. A direct response to the declarations of the *Manifesto* were the theatrical commissions given by Diaghilev to Balla and Depero for his Ballets Russes. Moreover, the presence of the renowned impresario in Rome represented a point of linkage with the avant-gardes of the period: in 1913 he contacted Mikhail Larionov and Natalia Goncharova to commission them to design the set and costumes for *Le coq d'or*, in 1916 he went to Paris to commission the set design

Fortunato Depero
Rotation of a Dancer-Girl with Parrots,
1917–18
Oil on canvas, 142 x 90 cm
Rovereto, MART (storage)

Fortunato Depero
Double Portrait of Filippo Tommaso
Marinetti (Synthetic Architecture
of a Man), 1917
Oil on canvas, 110 x 60 cm
Rovereto, MART

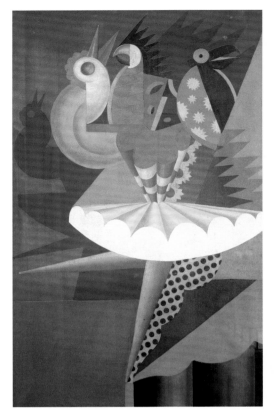
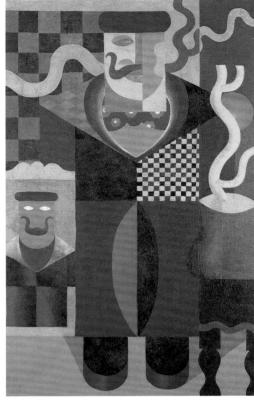

of *Parade* from Cocteau and Picasso, and in the meantime he asked Balla to do Stravinsky's *Feu d'artifice*. The ballet debuted in 1917 in Rome and the characterless set design, prepared the year before, was the result of the entire experience of the 'plastic complexes', Prampolini's 'chromophonic' research, and Marinetti's theories on theatre, studies on light and colour theatre. The *Feu d'artifice* were the tangible codification of the theories of the *Futurist Reconstruction of the Universe*, also pursued by Depero, with the concurrent commission, again from Diaghilev, for the *Chant du rossignol*, for which he designed an astonishing set characterised by a plastico-kinetic flora, sadly never executed because the impresario decided not to undertake the project.

After the theatrical interlude, Balla's prolific creative activity suffered a brief pause. At the end of the war, Futurism took on a strongly political connotation in support of the Fascist ideology: a new phase began, unquestionably less intense and clear than the beginnings, especially in painting, but in no sense inferior in terms of the general creative results obtained, such as '*paroliberismo*' in the theatre.

Also working in Futurism in Rome was Mario Sironi, with results that immediately brought him close to the other European movements. Sironi joined the activities of the movement in the Italian capital in 1913, gravitating around the milieu of the Sprovieri gallery, in part due to his friendship with Boccioni. Sironi's Futurist poetics, quite similar to his Divisionist education, developed personal characteristics. Sironi's presence in the group soon ended (in 1918) with the work *Venus of the Ports*, which marked his convinced adhesion to the poetics of de Chirico.

While on the subject of Futurism, a brief mention should be made of Vorticism, which came into being in England in 1914 with a programmatic and fundamental focus on the world of machines. It was distinct both from Italian Futurism (which was represented in London by the works of Christopher R.W. Nevinson) and from the poetics of Parisian Cubism. The Vorticist movement was drawn to engineering drawing, geometric expression and pure colours. It reached its apex in 1915 with the *Vorticist Exhibition*, which transferred to New York in 1917, and closed definitively in 1920.

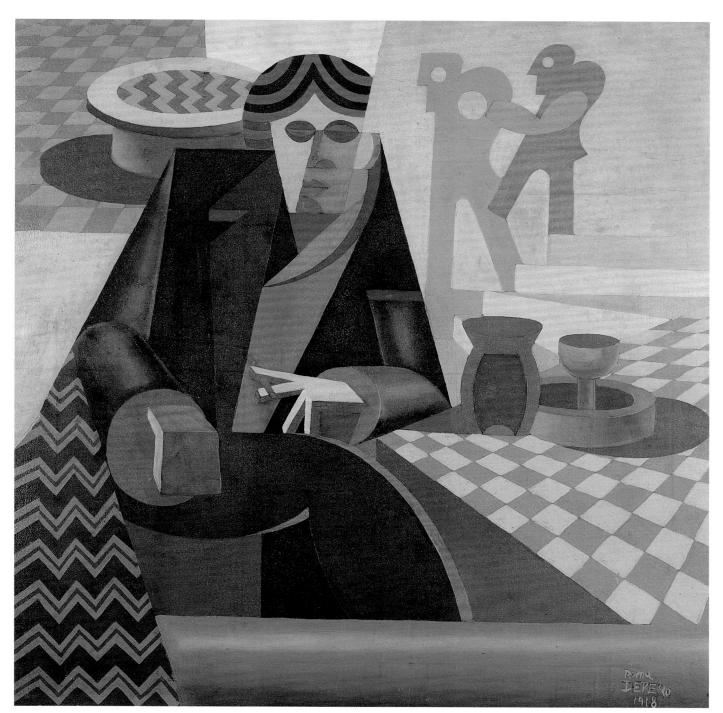

Fortunato Depero
*Figure Seated at a Café Table
(Portrait of Gilbert Clavel)*, 1918
Oil on canvas, 59 x 59 cm
Milan, Civiche Raccolte d'Arte

Antonio Costa

Art and Cinema 1900–1920

The birth and development of cinema produced a series of changes in the system of the arts. The dynamics of the exchanges between diverse forms of expression altered with the changing organisation of movie language. Noël Burch refers to an evolution from the PMR (Primitive Mode of Representation) to the IMR (Institutional Mode of Representation). André Gaudreault & Tom Gunnings, on the other hand, talk of an evolution from the SDA (System of Demonstrative Attractions) to the SNI (System of Narrative Integration).[1] This second phase, irrespective of the name given to it, was already well defined in the 1920s, during which the most important interactions were recorded between the traditional arts and cinema: the new art measured itself against the tradition of literary fiction and became capable of articulating its various discursive possibilities. In other words, it is in this phase that the principle of 'sovereign montage' was established both within narrative cinema and in the various manifestations of the avant-garde (from Dada to Surrealism, from the Soviet avant-garde to the social documentary).

Arnold Hauser, in the concluding chapter of his *Social History of Art*, places the adventure of twentieth-century art ideally 'Under the aegis of film'.[2] But for Hauser the twentieth century is a short century, which started in the 1920s after the end of World War I.[3] Consequently, the relations between the most innovative artistic experiences of the century and cinema concern the decade of the maturing of film language, in the direction mentioned above. However clever and fascinating, Hauser's treatment of the subject almost totally ignores the first twenty years of the century. Even admitting, as some affirm with good reason, that cinema is a nineteenth-century invention, the 'source' moment, so to speak, of the relationship between cinema and the other arts cannot be neglected, even if this coincides with a 'primitive' stage, in the same way that the problem of the relationship with movements such as Impressionism, Symbolism and other manifestations is habitually posed; though undoubtedly located in the nineteenth century, these too conditioned the artistic developments of the new century.

1. Paris 1900

Cinema and electricity were unchallenged in their domination of the Exposition Universelle in Paris in 1900: if the former was king, the latter was queen.[4] Although announced as an 'appraisal' of the century just concluded, the exhibition indicated the prospects for the new century at the same time. The Salle des Fêtes, located inside the Palais des Machines, which had been the major attraction in the previous exhibition (1889), offered a new wonder, made possible by the combination of cinema and electricity. Whereas the 1889 exhibition had been dominated by metals and the forms and devices of industrial products, then that of 1900 was dominated by the immateriality of electricity, the light flow of the projector and of fleeting images on screen.

In the grandiose, ingenious device of the Cinématographe Géant of the Lumière brothers, located in the Salle des Fêtes in Champ-de-Mars, an audience of 25,000 people could see an amazing spectacle. At the centre of the huge pavilion, for every performance, a system of winches raised a screen measuring 21 × 18 metres from a pool in which it was kept immersed (the purpose was to keep it wet so as to guarantee its

transparency and allow the images to be viewed from both sides): 15 animated views and 15 colour photos (*autochromes*) were projected onto this surface in succession, with a luminosity made possible by the development of electric light bulbs (a 150 amp projector was used).[5] With this 'installation' the Lumières revisited the gigantism of nineteenth-century panoramas. And above all they used the cinematographic device as an architectural object. The illuminated screen, the light beam of the projector, the images in sequence (alternating fixed images and images in movement): all this is configured as a kind of architecture of light fitting into a large iron and glass construction. On the other hand, the 1900 Paris Exposition offered starting points to transform different forms of architecture in turn into a film object. Among the images shot for the occasion by the Lumière operators, we find two views of *Vieux Paris* taken from a boat on the Seine. These reproduced the visual experience of visitors who could admire the scenographic reconstruction of medieval Paris, the work of Albert Robida, the famous illustrator and author of adventure and science fiction novels. Through attractive travelling shots—fluid movements obtained by placing the movie camera on the same boat where the visitors were—the two views of the Lumière catalogue allowed the viewer's gaze to follow the path envisaged by the exhibition 'programme'. The cinema device repeated the crossing of the urban space rendered spectacle by Robida's scenography, which had reconstructed, as in a theatre, that same medieval Paris that the police prefect Georges Haussmann had 'disembowelled' not long before.

The Cinématographe Géant of the Exposition Universelle in 1900 can be taken as the emblem of the turn of the century: it takes up the models of nineteenth-century optical shows and highlights, with that particular pictorial quality of the colour *autochromes* that were so close from the point of view of technique and effects to *pointilliste* painting, and the relations between spectacle, photography and painting; furthermore, with this exhibition of an architectural object as a spectacular attraction and of cinema equipment that intervenes in the organisation and perception of the urban space, it orients us towards the extreme proposals of the avant-garde, starting with that of the Futurists, who had probably already exhausted their provocation by the end of the second decade of the century.

2. The Attractions of Cinema

Cinema, even if it does not derive—as is often incorrectly stated—from the magic lantern, it does share with it the nature of the image produced by the projected and modulated light: these are no longer images in which light is in the representation, but images that are literally *made of light*. Cinema has the modulation of the intensity and the chromatic qualities of light in common with optical views (and with the various devices that allow these to be enjoyed). Furthermore, the temporal dimension is no longer abstract virtuality, as there is a coincidence between time represented and time of the representation (this is what happened with the effects of passage from day to night in the spectacles of Louis Daguerre's diorama).[6] Besides the dimensions of the duration of the modulation of the projected light, cinema was to have another aspect in common with panoramas and dioramas, one no less important: the iden-

tification of the viewer, that is, the possibility of capturing the subject within the space-time dimension of the vision.

Various scholars have dealt with the interconnections between the evolution of painting and the development of photography and movie techniques, passing through the various forms of optical shows (magic lanterns, panoramas, dioramas), and have sought to define the dynamics of the exchanges between the different techniques of representation, which became particularly lively in the late nineteenth century and the first decades of the twentieth century[7].

Jacques Aumont, continuing along a line already indicated by the works of Keith Cohen and Peter Galassi, starts with the revolution that occurred in painting between the late eighteenth century and the first decades of the nineteenth: a revolution no less important than that of Renaissance perspective. In synthesis, it stems from the conquest by painting of a 'mobile gaze', a thought-provoking expression that indicates the capacity of the new painting to grasp the fleeting moment and, at the same time, to understand it as a *short-lived, ordinary* moment (in contrast to the 'pregnant instant' of traditional painting). This happens with the passage from the *ébauche*, that is, from the sketch understood as a technique for the rapid recording of elements already assumed with a view to a future painting, to the *étude*, the study understood as a technique for the rapid fixing of the first impression, which therefore tends to value the impression in itself, and this was soon to be encoded as an autonomous pictorial genre. In the wake of what had already been affirmed by Galassi, and adapting it for cinema, Aumont saw a new statute of nature and, at the same time, of the image being established in these phenomena: a new statute of nature, since it ceased to be a network of divine or human symbols to be deciphered (nature as the book of God) and imposed itself as a 'theatre of ephemeral phenomena' that have meaning in their own right; and a new statute of the image, since a viewer is implied who accepts as the only horizon that of the visible ('a new faith granted to sight as an instrument of knowledge and—why not?—of science') and in this way becomes a point of meeting (and of confirmation) of the spectacle of the image and the spectacle of the world. Aumont then shifts the attention onto the devices that define the new horizons of visual experience, in which are included both painting and cinema.[8] If cinema has freed itself from the need for the pregnant instant and raised the ordinary image to the object of representation, this is also due to the fact that it derives its objects and its very method of representation from the boundless territory of the forms born and developed at the margins of painting (and of the major arts). Cinema not only proposes the same themes and iconographic motifs, in an interweaving of play, documentary and narrative functions, it also shares its exclusion from the sphere of aesthetic value. The meeting point between cinema and this complex area of representative techniques at the margins of painting is in the common belonging to the 'art of wonder'. As Manlio Brusatin recalls, a tradition of thought that joins the Arab Alhazen with the Pole Witelio has for centuries codified the confines separating aesthetic perception from stupefaction.[9] Cinema, on account not only of its common origin, but also of its structural characteristics, has no small number of those encoded 'aesthetic defects' that de-

fine the field of the arts of wonder: the image produces magnifying or miniaturising effects, the rapidity and suddenness of the exhibition; the viewer is in some way predisposed and 'usefully idiotic'.[10] It is sufficient to consider the descriptions of the first *séances* of projections by Lumière brothers or by the 'magician' Georges Méliès to find these typical characteristics of the art of wonder, belonging to the 'primitive' cinema of attractions and to the current cinema of special effects.

Cinema accomplishes a kind of synthesis of various arts and expressive forms, progressively bringing into the sphere of art those manifestations relegated to marginal areas and sub-art, with the decisive contribution of new technologies. At the same time, twentieth-century art, from Futurism to Surrealism, is irresistibly attracted by all those forms of popular imagery in the sphere of which cinema occupies a primary position.

3. The Dynamics of Exchanges

The dynamics of the exchanges between cinema and the visual arts in the first two decades of the century followed two tendencies. On one hand, cinema took up the models of painting (mostly academic) with the intention of finding an aesthetic legitimisation. On the other, artists looked with interest at cinema, in the same way as at photography, as a factor of innovation, and they paid attention to it, as indeed to all those phenomena that have marked modernity and constitute important accelerators of the renewal of aesthetic experience. Painting was looked on by the pioneers of the new art not only in its more—let us say—traditional aspects, but also as a model for checking the elements in play in the shot. On the other hand, in cinema painters could be tempted to experience a kind of painting in movement. This was the case of the Italian painter Giulio Aristide Sartorio, the author of various attempts, the most famous among which was *Il mistero di Galatea* (1918), to transpose the iconography and the very academic style of his pictorial production onto film. But exchanges of this type also occurred between Modernist painting and cinema. This was the case of *Thaïs* (1917) by Anton Giulio Bragaglia. Though presented by *La Stampa* newspaper of Turin (1.12.1918) as 'audacious futuristic fantasy', in reality it revealed very few similarities with the poetics and ideology of Futurism. In the final sequence, that of the suicide of the protagonist, who withdraws into the remote recesses of his own home, where he prepares eccentric sets inspired by contemporary art, there is an attempt to integrate the actor's body into a fascinating set design with a vaguely Art Nouveau flavour, rather than Futurist. The space 'pictorially' designed by Enrico Prampolini is 'separated' from the film action (the actor's presence in this space, his gestures, his expression). The experiment is not without interest, if nothing else because it was in advance of those analogous ones perhaps conducted with greater coherence as well as with different models of reference. This was the case of *Das Kabinett des Doktor Caligari* (1920) by Robert Wiene, created in a manner akin to Expressionism, or of *L'Inhumaine* (1924) by Marcel L'Herbier, in which the collaboration of an architect such as Mallet-Stevens and of a painter such as Fernand Léger created particularly scenographic spaces. In all cases these were attempts to 'artisticise' cinema, to endow it with an added value borrowed from arts of greater prestige: we

need only consider that the film by L'Herbier was presented on the Italian market with the title *Futurismo*; and the film by Robert Wiene was inappropriately defined 'Expressionist', even if the set designs by Walter Reimann and Walter Röhrig and the costumes by Hermann Warm are characterised by a taste for distortion and stylisation that it is generically theatrical and pictorial, rather than specifically expressionist.

The opposite tendency was a great deal more innovative, namely that of *cinematographising* art, of developing forms of expression inspired by cinema and integrated into the aesthetic revolution introduced by it, the revolution that Walter Benjamin summarised as follows: 'Then came the film and burst this prison-world asunder by the dynamite of the tenth of a second, so that now, in the midst of its far-flung ruins and debris, we calmly and adventurously go travelling'.[11]

A special place must be allocated for the attempts of Arnaldo Ginna and Bruno Corra to create effects of chromatic music by spreading colours directly on the film, from which they had removed the emulsion, and then putting them in movement through projection. Copies of their experiments have not survived to our day. Nevertheless, from one text, published in 1912, we know that the encounter with film enabled them to intensify their research into the relations between music and colour, which also developed in parallel and alternative directions to cinema, such as in the chromatic piano, the chromatic drama, the environments of colour, etc.[12] We therefore have detailed information, from which the sense clearly emerges of a search for—to use their own words—the 'effect of a mix of colours stretched over time'.[13] The pre-Futurist and, in many respects, pre-cinematographic character perhaps lies at the basis of the lack of success of the proposals of Ginna and Corra, which did not find adequate developments in Futurist circles (if not in certain theatrical-type outcomes, such as in Depero, for instance).[14] In all cases, they were in advance of the projects and experimentations of abstract film (from Survage to Eggeling, from Ruttmann to Richter); or of certain solutions adopted by Man Ray in *Emak Bakia* (1926), such as the quick combinations of material and abstract vibrations and naturalistic images. As regards pre-cinematographic research, we find the influence of the chronophotograph both in the plates of *Futurist Photodynamism* (1913) by Bragaglia[15] and in the pictorial experimentations of Marcel Duchamp: in the two versions (1911 and 1912) of the famous *Nu Descendant un Escalier*, Duchamp was inspired by the chronophotographs of the pioneers Muybridge and Marey, who had long worked on the photographic fixing of the various phases of a body in movement.[16]

4. Starting with Futurism

The *Manifesto of Futurist Cinematography* appeared in 1916, that is, relatively late with respect to the proclamations with which Filippo T. Marinetti and his companions had declared war on all the traditional forms of art.[17] It is true that already in previous interventions, and particularly in the theorisations and theatrical experimentations, the Futurists had shown, even without naming it, that they had been influenced by cinema in various ways. After all, the potent beauty of the locomotive, exalted by Marinetti in the founding manifesto of the movement (1909), had enchanted and frightened the first

audiences of the Lumières' cinema. Furthermore, the attention devoted to the modifi-cations of perceptive experiences in the urban space seems to presuppose an assimila-tion of the visual experience of cinema, both as regards the logic of spectacular attrac-tions and as regards the manipulation of space and time.

In the *Manifesto of Synthetic Futurist Theatre* or in a drama such as *Le Basi* by Marinetti[18] the relations between the Futurists' theatrical proposals and cinema and the forms of spectacle in the sphere of which it had made its appearance are evident. In particular, we must cite *Pedestrian Love* (1914) by Marcel Fabre, which, as a passion-ate melodrama told exclusively by showing the feet of the protagonists, anticipated the Marinettian synthesis *Le Basi*, in which the curtain is raised only enough to show the feet of the actors performing on stage. Certainly, expedients of this type were anything but isolated in film and in humorous graphics, but this only shows that Futurism was inspired by the most popular forms of communication in its programme to free art from its academic and bookish fixity. In the same way, it must be highlighted that the visual poem by Corrado Govoni, *Il Palombaro* [The diver], published in *Rarefazioni e parole in libertà*, Futurist Editions of 'Poetry' in Milan 1915,[19] takes up an iconography that Marcel Fabre had used in *Le avventure straordinarissime di Saturnino Farandola* (Am-brosio, 1914), a film version of the novel by Albert Robida.[20] Beyond the indisputable analogies, the problem is posed here of cinema as a reservoir of mythologies and evoca-tive elements from which the avant-garde draws (and not the other way round). The two verses of Govoni '*becchino mascherato/che ruba cadaveri d'annegati*' ['masked grave-digger/ who steals bodies of the drowned'] irresistibly call to mind the images of an *ac-tualité reconstituée* by Méliès, *Visite sous-marine du Maine* (1898), dedicated to an episode from the Hispanic-American War, which was widespread in the popular iconog-raphy of the turn of the century, in which we do indeed see a diver extracting a corpse from the wreck of a sunken ship.[21]

Mitry's judgement is certainly restrictive when he states that in his manifesto Marinetti 'enunciated truths that the worst American films had made evident years ago (simultaneity of actions, movements in space and time, the significance of objects, close-ups, etc.)'.[22] In reality, the *Manifesto of Futurist Cinematography* seems interested above all in prefiguring a film realisation of the provocations and experimentations already made by the Futurists with poetry and theatre, during their 'evenings'. Dissolution of art in the very turmoil of modern life, in action: this is what the Futurists advocated. Seen first of all as one of the expressions of modernity rather than as art (together with the automobile, electricity, speed, music-hall, etc.), cinema is one of the tools or mod-els for the realisation of this dissolution. Consistent with this assumption, cinema can be a tool for the documentation of *action art*, of the Futurist gesture, of lifestyle. In the Futurist use of film, there is a unitary line that connects the film *Futurist Life* (1916) with the project, not realised, by the painter Fortunato Depero, *Futurismo italianissi-mo* (1933), even if today between the two it is possible to place *Speed,* a film scenario by Marinetti that had long been unpublished.[23]

From the documentation and from the testimonies on the lost *Vita futurista*, it can be inferred that Marinetti succeeded in imposing his own line, not entirely re-

spectful of Ginna's original project.[24] There therefore prevails the choice of improvisation and the absolute fragmentary nature of heterogeneous materials, even if elements dear to Ginna's research into abstract forms are not entirely absent. Film could be considered as a kind of documentary on those political-spectacular performances so dear to Marinetti and can be considered among the realisations of art as exemplary gesture, as provocation.

The unpublished screenplay *Velocità* [Speed], dated by Lista between late 1917 and the first half of 1918,[25] shows that the father of Futurism conceived a cinema as a set of stunning effects, implemented and organised according to the model of that 'music-hall' to which one of the most important Futurist manifestos was devoted (1913) and with which early cinema maintained close links (Méliès, Fregoli, etc.). On this 'canvas', which places in sequence a series of situations of violent clashes between the 'Pastist' and the Futurist visions of the world, there are explicit references not only to the system of trick shots in an 'astonishing' succession of transformations, as happened in the cinema of Méliès, but also to all the attractions typical of the spectacularised urban space of the universal expositions and the halls of progress. It is not difficult to see in this project something very close to the 'montage of attractions' that Eisenstein was soon to theorise and practise, first in the theatrical and then in the cinema sphere, both as regards the explicitly propagandistic purposes of these renewed aesthetic forms, and for the emphasis with which the links of these 'eccentric' practices with music-hall, sport, circus and, above all, cinema in its most popular expressions, are exhibited.

[1] N. Burch, *La lucarne de l'infini* (Paris: Nathan, 1990); A. Gaudreault and T. Gunning, *Le cinéma de premiers temps. Un défi à l'histoire du cinéma?*, in J. Aumont, A. Gaudreault and M. Marie (eds), *Histoire du cinéma. Nouvelles Approches* (Paris: 1989), pp. 49–63.

[2] Arnold Hauser, *Sozialgeschichte der Kunst und Literatur* (Munich: C.H. Beck, 1951).

[3] *Ibid.*, p. 451: 'the 'twentieth century' started after the First World War, that is, between 1920 and 1930, just as the "nineteenth century" only started in 1830'.

[4] René Jeanne, *Cinéma 1900* (Paris: Flammarion, 1965), p. 54.

[5] See Emmanuelle Toulet, 'Le cinéma à l'Exposition Universelle de 1900', in *Revue d'Histoire Moderne et Contemporaine*, XXXI-II (April–June 1986), pp. 179–208.

[6] H. and A. Gernsheim, *L.J.M. Daguerre* (New York: Dover Publications, 1968), pp. 14–47. For an overview of panoramas, see Silvia Bordini, *Storia del panorama* (Rome: Officina, 1984).

[7] See K. Cohen, *Film and Fiction. The Dynamics of Exchange* (New Haven: Yale University Press, 1979); Peter Galassi, *Before Photography. Painting and the Invention of Photography* (New York: The Museum of Modern Art, 1981); J.Aumont, *L'Œil interminable. Cinéma et peinture* (Paris: Séguier, 1989).

[8] See Aumont, *L'occhio interminabile*, cit., pp. 23–32.

[9] M.Brusatin, *L'arte della meraviglia* (Turin: Einaudi, 1986), pp. 3–15.

[10] *Ibid.*

[11] W. Benjamin, *Das Kunstwerk im Zeitalter seiner technischen Reproduzierberkeit* (1936) in Id., *Schriften* (Frankfurt am Main, 1955).

[12] The text in question is reproduced in M.Verdone (editor), *Manifesti futuristi e scritti teorici di Arnaldo Ginna e Bruno Corra* (Ravenna: Longo, 1984), pp. 155–66.

[13] *Ibid.*, p. 164.

[14] On the 'abstract' and 'filmic and visionic' character of Futurist theatre, cf. the classification of M. Verdone, *Teatro del tempo futurista* (Milan: Lerici, 1969), pp. 83–106.

[15] Nalato, Rome 1913; reprinted in Bragaglia, *Fotodinamismo futurista* (Turin, Einaudi, 1970).

[16] Cf. P. de Haas, *Cinéma intégral. De la peinture au cinéma dans les années vingt* (Paris: Transédition, 1985), pp. 19–72.

[17] *La cinematografia futurista*, in *L'Italia Futurista*, 11 weeks 1916, reproduced in L. Scrivo (editor), *Sintesi del Futurismo. Storia e documenti* (Rome: Bulzoni, 1968), pp. 150–51.

[18] Marinetti published *Le Basi* in the first of the two volumes of *Teatro Futurista Sintetico* (Milan: Istituto Editoriale Italiano, 1915). The Manifesto *Il teatro futurista sintetico*, dated 11 Jan.–18 Feb. 1915, is reprinted in Scrivo (ed.), *Sintesi del Futurismo...*, cit., pp. 116–19; *Le Basi* is reprinted in Marinetti, *Teatro*, edited by G. Calendoli (Rome: Vito Bianco Editore, 1960), vol. II, pp. 299–303.

[19] E. Sanguineti, *Poesia italiana del novecento*, Vol. I, (Turin: Einaudi 1971), p. 293 (on the definition of *Rarefazioni e parole in lib-*

ertà as the first authentic example of visual poetry, see. p. 263).

[20] A. Robida, *Voyages très extraordinaires de Saturnin Farandoul [dans les 5 ou 6 parties du monde et dans tous les pays connus et même inconnus de M. Jules Verne]* (Paris: Librairie illustrée M. Dreyfous, 1879–1880).

[21] On the relations between Marcel Fabre and Futurism, see A. Costa, *I leoni di Schneider. Percorsi intertestuali nel cinema ritrovato* (Rome: Bulzoni, 2002).

[22] J. Mitry, *Storia del cinema sperimentale* (Milan: Mazzotta, 1971), pp. 33–35.

[23] Marinetti, *Velocità*, preceded by G. Lista, 'Un inedito marinettiano:Velocità, film futurista', in *Fotogenia*, II, 2 (1996), pp. 6–25. For an overview of the relations between Futurism and cinema, See G. Lista, *Cinema e fotografia futurista* (Milan: Skira, 2001).

[24] See Lista, 'Ginna e il cinema futurista', in *Il Lettore di Provincia*, XVIII, 69 (September 1987), pp. 17–25.

[25] G. Lista, *Un inedito marinettiano...*, cit., p. 8.

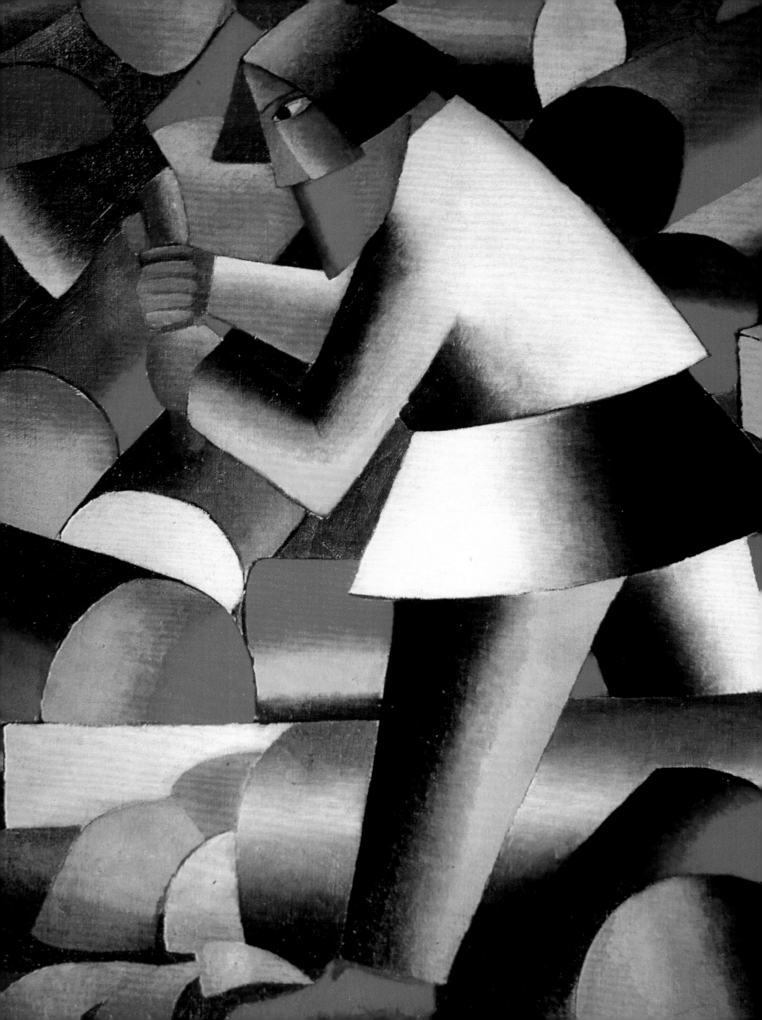

The Fusion of the New Languages

Russian art between Cubo-Futurism and Suprematism

At the end of the first and the beginning of the second decade of the century, the cultural world of Moscow was shaken by the works of the French Post-Impressionists, which arrived primarily through two channels: the exhibitions encouraged by the magazine *The Golden Fleece* between 1906 and 1909 and the collections of the wealthy businessmen Ivan Morozov and Sergei Schukin, who purchased the finest pieces directly in Paris. The second of the two businessmen in particular collected numerous canvases by Matisse, an artist who was twice his guest in Moscow, and whose presence had consequences for the younger artists; for example, while visiting the Schukin collection, Martiros Sergeevich Sarjan was inspired to create works like *Armenian Woman Playing the Tar* (1915), and, stirred by the colours of Matisse's *Dance* and *Music*, which he saw displayed in the stairway of Schukin's mansion, Kuzma Petrov-Vodkin painted his canvases. His *Thirsty Warrior* (1915) is also informed by a neo-Renaissance spirit, which he had become aware of directly in Italy during a lengthy trip through Mediterranean countries (1905).

Many Moscow artists, who had already won recognition through *The Golden Fleece*, formed the group known as 'Bubnovy Valet' (Jack of Diamonds), founded in 1910 by Mikhail Larionov, David Burlyuk, Natalia Goncharova, Pyotr Konchalovsky, Ilya Mashkov, Robert Falk, Aristarkh Lentulov and Aleksandr Kuprin, and which lasted until 1917.

The Jack of Diamonds can be considered the first instance of organisation of the Russian avant-garde, whose subversive charge already appears in the name itself: it was not merely an allusion to the irreverent spirit of the group's members, but also an explicit reference to Russian folk art, which found a playful and complete synthesis in graphics and in old playing cards. The group held its first official showing in an exhibition in Moscow in 1910. The approach was the same as that used in the events of *The Golden Fleece*, thanks primarily to the presence of Larionov, who had been a contributor to the renowned magazine since the year it was founded. Exhibiting were thirty-eight artists, representatives of all the most modern European trends: the Cubists Albert Gleizes and Albert Le Fauconnier; the members of the Neue Künstlervereinig of Munich, among them the 'emigrants' Kandinsky and Jawlensky, whose presence exemplified the two-fold nature of the nascent Russian avant-garde: internationality and a strong link with the national tradition. It was not by chance that the works by Larionov and Goncharova in particular had close affinities with *lubok*, Russian folk prints produced between the seventeenth and nineteenth centuries, typified by a very broad and distinct line (in the style of woodcuts) and vivid colours. Among the Russians present were the 'Cézannists' Robert Falk and Pyotr Konchalovsky; the latter translated the book by Émile Bernard on Cézanne's painting (1912). Ilya Mashkov instead took inspiration from the arabesques in Matisse's *Portrait of Vinogradova*, circa 1909 (Moscow, Tretyakov Gallery).

The three successive exhibitions held by the Jack of Diamonds in Moscow between 1912 and 1914 featured an even broader array of artists, largely French: in addition to Matisse, Van Dongen and de Vlaminck, the entire Blaue Reiter exhibited. It was, however, the Cubist works by Picasso, Braque, Léger and Delaunay that made the most profound impression, which was intensified by the publication of the essay *La sensibilité moderne et le tableau* by Le Fauconnier in 1913 in the Jack of Diamonds' almanac, as well as the return to Moscow of Ljubov Popova, who worked in Paris with Le Fauconnier himself and Jean Metzinger; at the exhibition, works were also on display by Marc Chagall, who continued to send his canvases back to his homeland from Paris, canvases that combined the Cubist verve and the attachment to folk tradition dubbed 'neo-Primitivist' during that period.

The experimental attitude often led the members of the group to directions that varied widely, thus undercutting its unity; as early as 1911 Larionov and Goncharova broke away from the Jack of Diamonds to found the group 'Osliny Khvost' (Donkey's Tail), a name inspired by a scandalous painting shown in Paris in 1905 that had been executed by ty-

Kasimir Malevich
The Woodcutter, 1911 (detail)
Oil on canvas, 94 x 71.5 cm
Amsterdam, Stedelijk Museum

The Ballets Russes

Léon Bakst
Official Programme of the Ballets Russes, 1912
(Vaslaw Nijinsky dances *L'Après-Midi d'un Faune*)
Litograph on paper, 21 x 15 cm
Paris, Bibliothèque Forney

Mikhail Larionov
Portrait of Sergei Diaghilev, 1916
Pastel on cardboard, 40 x 32 cm
Private collection, Moscow, Bolshoi Theatre Museum

Alexandre Benois
Sketch for Igor Stravinsky's ballet, Petruschka, 1911
Watercolour on cardboard, 50 x 70 cm
Moscow, Bolshoi Theatre Museum

In 1909 the impresario Sergei Diaghilev created the dance and opera company the Ballets Russes. The principle around which it was founded was the fusion of all forms of art through special care in preparing the scenes and choosing the music, in accordance with the theories of *Gesamtkunstwerk*, the total work of art. The idea found fertile terrain on the pages of *Mir Iskusstva* (The World of Art), an art magazine from St Petersburg. By the time it was wound up on Diaghilev's death in 1929, the company had staged around seventy shows, performing particularly in Paris—where the most flourishing Russian colony in Europe resided—but also visiting Spain, Italy, the USA and Monte Carlo, where, from 1922, it found its fixed quarters for the winter season. Among others, Diaghilev entrusted the music to Stravinsky, Prokofiev and Satie; the most famous choreographers called upon to collaborate were Vaslav Nijinsky and Michail Fokine; among the leads were Anna Pavlova, Lydia Sokolova, Anton Dolin and Ninette de Valois. In an early phase (1909–14) the company staged ballets clearly inspired by the world of fables and with a clear literary-symbolist approach: *Scheherazade* (1910), *Petruschka* (1911) and *Le spectre de la Rose* (1911). The arrival of Larionov and Goncharova rapidly steered the ballets in a Futurist direction, resulting in *Contes russes* (1917) and *Le renard* (1922). With *Parade* by Satie—sets by Picasso and Cocteau—the most controversial and experimental phase of the Ballets was launched, and from that moment they invited artists from the avant-garde to collaborate: Delaunay (*Cléopatre*, 1918), Derain (*La boutique fantastique*, 1919 and *Jack-in-the-Box*, 1926), Matisse (*Le chant du rossignol*, 1920), Braque (*Les fâcheux*, 1924 and *Zéphir et Flore*, 1925); Gris designed many performance programmes, including for *La Colombe* by Gounod (1924). De Chirico, Miró and Ernst gave a Surrealist touch to various shows, while Gabo and Pevsner made the Constructivist ballet, *La Chatte* (1929).

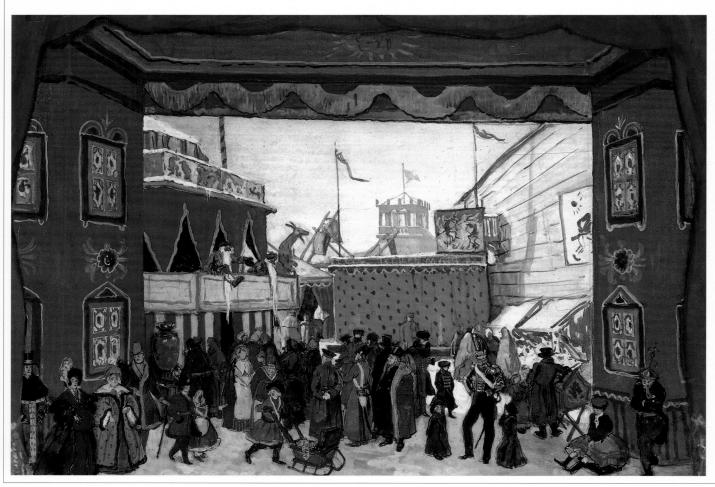

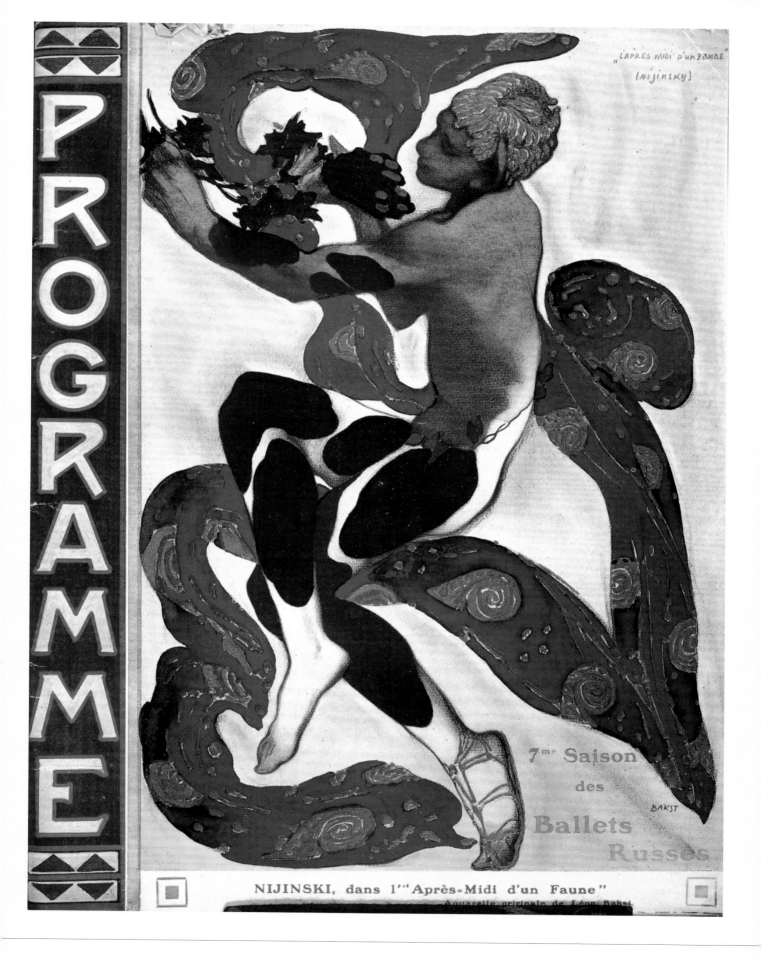

PROGRAMME

L'APRÈS MIDI D'UN FAUNE
(NIJINSKY)

7me Saison
des
Ballets
Russes

BAKST

NIJINSKI, dans l'"Après-Midi d'un Faune"
Aquarelle originale de Léon Bakst

Kasimir Malevich
Peasant Woman with Water Pails,
1911
Oil on canvas, 73 x 73 cm
Amsterdam, Stedelijk Museum

Opposite
Kasimir Malevich
Bather, 1911
Oil on canvas, 105 x 69 cm
Amsterdam, Stedelijk Museum

ing a paintbrush to a donkey's tail. The reason for the break with the other members was basically linked to the determination of Larionov and his partner to take greater inspiration from Russian tradition, though without diminishing the achievements of Cubism, but only Kasimir Malevich and Alexei Morgunov followed them. The first exhibition was a triumph, winning popular enthusiasm and critical acclaim, in part due to an intelligent publicity campaign launched by the members, who presented themselves as the most radical avant-garde in the land; critics immediately noted the connections with *lubok*,

but also with the icons of the Orthodox tradition and the Oriental-style themes that were such an integral part of the soul of the Russian Empire. From 1913 on, the group changed its name to 'Mishen' (Target), but the substance remained unchanged; to emphasise its non-conventional and international nature, children's drawings were exhibited at that year's annual show—thus revealing an interest in what was going on in Germany—together with work by naïve artists and sign painters. This nationalistic tendency to make use of folk art and Eastern art was dubbed 'neo-Primitivism', from the title of a book by

Pages 278–79
Natalia Goncharova
Peasants Dancing, circa 1910
Oil on canvas, 180 x 140 cm
St Petersburg, The State Russian
Museum

Natalia Goncharova
Cat and Tray, 1910–11 (detail)
Oil on canvas, 99.5 x 92 cm
Paris, Musée National d'Art Moderne,
Centre Georges Pompidou

Mikhail Larionov
Venus of the Boulevards, 1913
Oil on canvas, 117 x 87 cm
Paris, Musée National d'Art Moderne,
Centre Georges Pompidou

Aleksander Shevchenko (1913), who noted the components of the slightly crude and simplified style adopted by the members of Donkey's Tail even before its foundation.

In spite of the fact that they continued to cultivate their own neo-Primitivist tendencies, it was only through careful consideration of the most advanced achievements of Cubism that Larionov and Goncharova managed to create the manifesto of Rayism, which was published in 1913 in the group's almanac. The following year, many members, including Malevich, broke away, while the last exhibition in 1914, entitled *No. 4: Futurists, Rayists, Primitivists*, significantly set forth in the title the three spirits and the three achievements won by the group before its disintegration, which took place in 1915, and Larionov and Goncharova's departure for Paris.

The 1914 show also sanctioned the recognition of the importance of the Italian avant-garde in the development of the ideas of its Russian counterpart. On 26 January of that same year, Marinetti was in Russia—a trip he made there in 1910 had been highly controversial—at the invitation of Nikolai Kulbin, president of the Society for International Conferences, to deliver eight lectures in Moscow and St Petersburg. His trip was a popular triumph and generally met with crit-

Mikhail Larionov
Winter, 1912
Oil on canvas, 100 x 122.3 cm
Moscow, Tretyakov Gallery

Natalia Goncharova
The Mirror, 1912
Oil on canvas, 115 x 92 cm
Private collection

ical acclaim; but the ideas of Futurism were already well known in Russia and had been since 1909, when the theoretical texts of the movement were published quite early in a number of Moscow magazines. In May 1910, long before Marinetti's arrival, the first collection of Russian Futurist writings entitled *Sadok sudej* also came out, written, among others, by Velimir Khlebnikov and David Burlyuk. In December 1912 Burlyuk, a painter and the brother of Futurist artists, published the manifesto of Russian Futurism, entitled *A Slap in the Face of Public Taste*. The text was more literary than figurative because a number of Burlyuk's poet friends had contributed to its compilation, including Alexei Kruchenykh and Khlebnikov himself, and they did not hesitate to find analogies between Cubist painting and the writing of the Futurist school, especially in the disintegration of grammar and diction. The year of the manifesto, Kruchenykh and Khlebnikov also published the Futurist poem *Game in Hell*, with illustrations by Larionov and Goncharova. And it was Kruchenykh—in his book *Troye* (The Three), on which the young Malevich also worked—who first coined the term '*zaum*' to describe the 'trans-rational language' of poetry and, by implication, of Futurist art.

With reference to literary experiments, in 1913 the art critic Korney Chukovsky

coined the term 'Cubo-Futurism' to signify the synthesis of the two schools; the definition was later applied to the figurative arts, which found a specialised forum for development in two groups formed after 1909 in Moscow: *Stephanos* (Crown), led by Burlyuk, and Treugolnik (The Triangle) led by Nikolai Kulbin. All of the artists of the Russian avant-garde went through a Cubo-Futurist phase, a national synthesis of two foreign currents.

Through his tireless organisational activity among the artists working between the two decades, it was the Moldavian Mikhail Fedorovich Larionov who established this current. Beginning in 1898 Larionov studied at Moscow's School of Painting, Sculpture and Architecture under the direction of Valentin Serov and Konstantin Korovin; here, he also met Natalia Goncharova, who became his lifelong companion. From his very first creations, Larionov was hailed by Russian critics and collectors, who invited him to exhibit at the prestigious Union of Russian Artists and at the display of Russian art at the Salon d'Automne in Paris (1906). His style was initially oriented towards Impressionist landscapes, but his encounter with Nikolai Ryabushinsky, director of *The Golden Fleece*, changed that style. Involved in the organisation of the exhibitions underwritten by his new patron, he came into contact with French

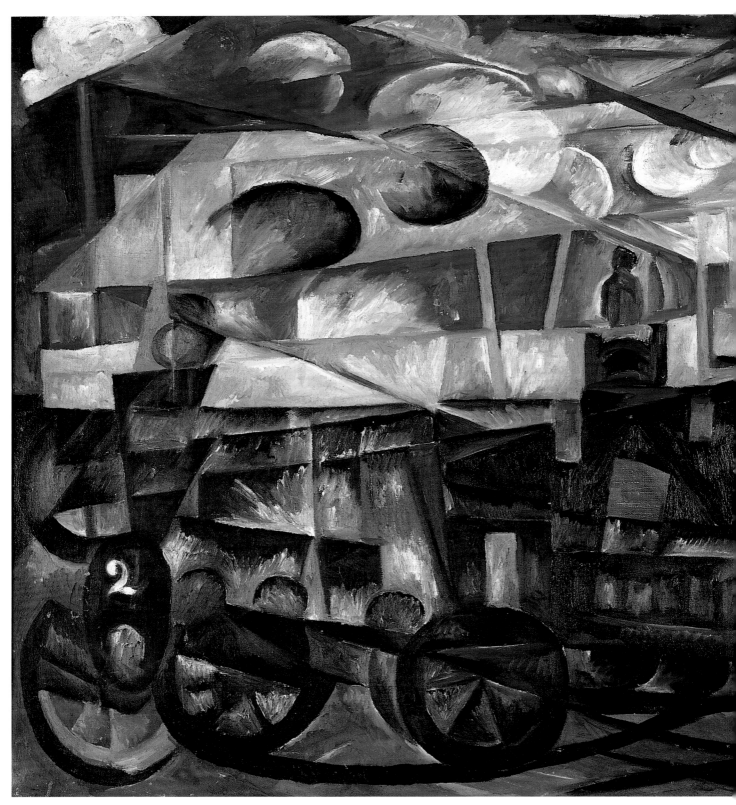

Natalia Goncharova
Aeroplane over Train, 1913
Oil on canvas, 55.7 x 88.3 cm
Kazan, Museum of Fine Arts

Post-Impressionism, and because of his anti-academic sympathies he was expelled from the Moscow School of Painting in 1910. After returning from his military service, he founded the Jack of Diamonds. He was acknowledged as the leader of the movement when, at the group's first exhibition, his canvas *Soldiers* prompted the greatest scandal: the colour and brushstrokes were violent, and a number of legends made the canvas especially vulgar.

It was only through the experience of the Donkey's Tail that Larionov brought to a state of completeness all of his meditations on neo-Primitivism, Cubo-Futurism, and Rayism. He worked on all these directions at the same time, and in the 1913 exhibition displayed three canvases, each complete in its different style: *Autumn* and *Venus of the Boulevards* (both at the Centre Georges Pompidou, Paris) and *Rayist Method* (at the Guggenheim, New York), which is considered to be the first genuine Rayist artwork.

Although Larionov claimed that he was painting in that style as early as 1909, the manifesto of Rayism was published in the almanac of the Donkey's Tail in 1913. Rayism was based on a very simple concept: in the construction of canvas it was not necessary to take into account the object itself, but rather the rays that linked it to the eye of the observer, intersecting one with another: 'The ray is conventionally depicted on the plane by a coloured line', there was no longer the arabesque of Matisse, but rather a dynamic element that took on a new expressive power, as can also be noted in the numerous *Rayist Landscapes*. It seems that the artist developed this idea while studying the physics of radioactivity and the exposure of objects to X-rays, but clearly the theory was the product of the intermingling of the various currents of the avant-garde that had emerged in Europe: in the manifesto itself we read that Rayism is 'a synthesis of Cubism, Futurism, and Orphism'.

The application of the method was not consistent, in contrast with what Larionov himself tried to have others believe: the *Portrait of Vladimir Tatlin* still shows the influence of Cubism and Boccioni, even though his propensity to extend the brushstrokes already anticipated the forms of Rayism. The artwork was produced in 1913 even thought the artist preferred to date it two years earlier.

After the summer of 1913, Larionov finally came to abstraction, creating works that depicted only rays reflected from surfaces, and thus bringing to completion the formal ideas latent in Cubism and in Futurism. With the

Mikhail Larionov
Street with Lights, 1912–13
Oil on burlap, 51 x 34.5 cm
Madrid, Thyssen-Bornemisza Museum

Opposite
Mikhail Larionov
Rayism, 1912–13 (detail)
Oil on canvas, 52.5 x 78.5 cm
Ufa, Bashkirian Museum of Fine Arts

elimination of all objective formal requirements, he could concentrate on the use of colour (thus revealing his contacts with Orphism) and the line. The definitive distancing from the object was made possible by his familiarity with the theories of the so-called 'fourth dimension': from this concept developed in the context of geometry and mathematics at the end of the century, philosophical conclusions were immediately drawn that had vast repercussions in Europe and the United States, harking back to a more profound dimension of space, capable of extending well beyond our immediate sensory perception.

Natalia Goncharova was attentive to the developments of her partner's art; originally from the province of Tula, she concentrated on sculpture until, having met Larionov in 1898 at the School of Painting, Sculpture and

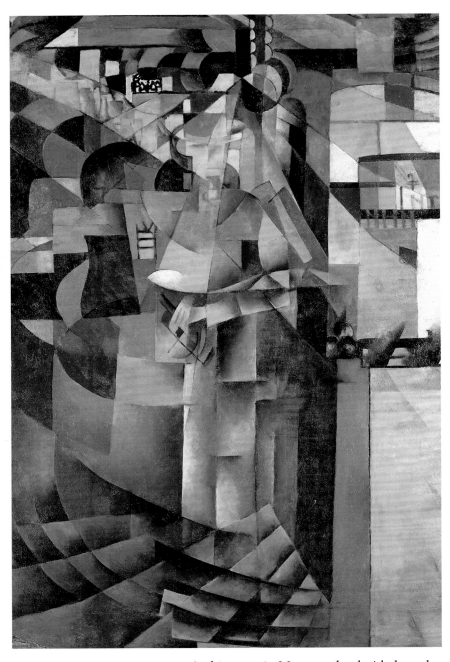

Kasimir Malevich
Life at the Grand Hotel, 1913–14
Oil on canvas, 108 x 71 cm
Saratov, State Museum

Opposite
Natalia Goncharova
Electric Lamps, 1913 (detail)
Oil on canvas, 105 x 81.5 cm
Paris, Musée National d'Art Moderne,
Centre Georges Pompidou

painted at the same time as the same subject treated by Balla), which later culminated in Rayism. Her best known work from the Rayist milieu was *Bicyclist* (1913); much like the experiments done at the same time by her partner, it took time before Goncharova could break away entirely from the depiction of an object. Even more than Larionov, she became a fierce proponent of neo-Primitivist ideas, which she expressed in a manifesto. This was published as an introduction to the catalogue of her personal show in August 1913 in Moscow, where she presented over seven hundred works of art. The manifesto was configured as an explicit attack against Western art and a reaffirmation of the superiority of the Russian tradition. The nationalism of these ideas was obviously taken as an expression of that *vis polemica* so typical of the avant-gardes, but also as a symptom of the widespread fear among Russian artists of every period of losing their identity in the face of foreign movements and the emigration of the best Russian artists. But the degree to which Goncharova's art was an international phenomenon is demonstrated by the enthusiastic acclaim for *A Woman in a Hat* at the Erbstsalon held by the Sturm gallery in Berlin in 1913.

Larionov and Goncharova's work with Sergei Diaghilev's Ballets Russes from 1914 was only the prelude to their permanent move to Paris in 1919. Those five years were anything but a betrayal of their 'nationalism', indeed it was a way of diffusing Russian art throughout Europe, from France to Spain. The two artists travelled to Paris in spring 1914 to execute the set designs for the ballet *Le coq d'or* at the Opéra, and it only took a few months before they were exhibiting at the Paul Guillaume gallery and had become friends with Apollinaire, who identified Rayism as the best response to the developments of Western art. With Diaghilev they travelled to Spain and Italy (1916); to Natalia in particular, attentive as she was to all aspects of folk tradition, Spain with its costumes was an endless source of ideas, culminating in her luminous series of *Espagnoles*. It did not much matter that most of the costumes designed by Larionov and his companion were never created because of the cancellation of many of the shows, since the watercolours were exhibited and published in exquisite albums, like the one for the 1915 ballet *La Liturgie*, which was published two years later.

In 1916 the Jack of Diamonds exhibited forty-five works by Marc Chagall in Moscow, as had the Dobitchina gallery in St Petersburg a few months before. The artist

Architecture in Moscow, she decided to take up painting. She exhibited at *The Golden Fleece* show in 1908, and was overwhelmed by the experience of the work of the French Post-Impressionists, which helped her to break free of the Symbolism that marked the work of her youth. From this time on her favourite motif, figures of peasants, showed a greater awareness of the use of colour and simplified forms that owed a considerable debt to the paintings of Gauguin, Cézanne and Bonnard, all of whom were present at the 1908 show. Along with Larionov she founded the Jack of Diamonds and, later, the Donkey's Tail, developing neo-Primitivist (*Cat and Tray*, where the black line is clearly derived from *lubok* woodcuts) and Futurist tones (*Electric Light*,

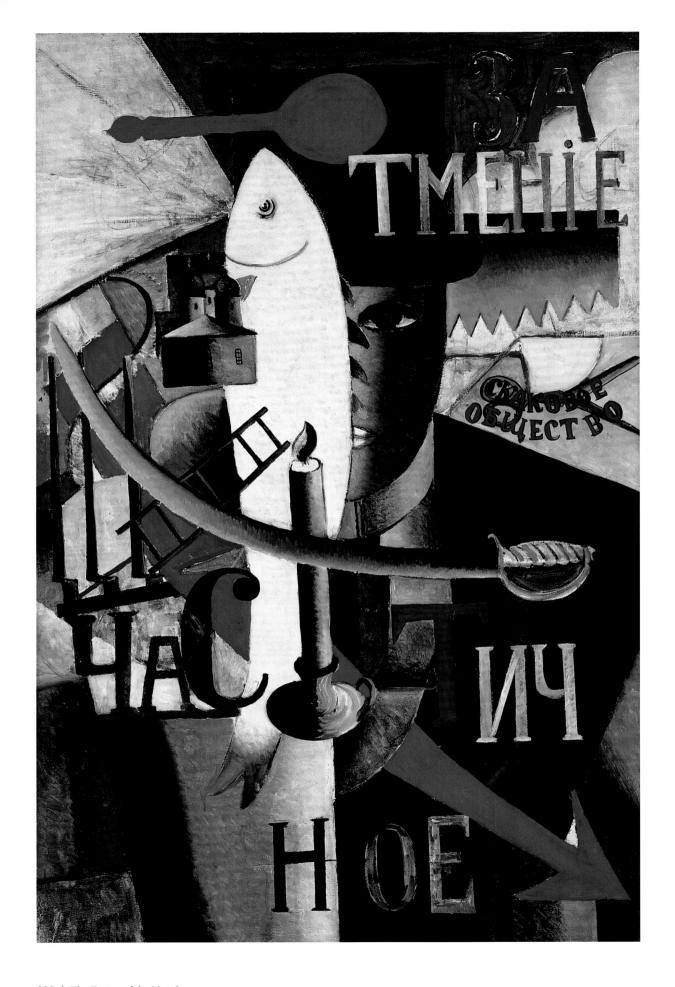

Kasimir Malevich
Woman at Poster Column, 1914
Oil and collage on canvas, 71 x 64 cm
Amsterdam, Stedelijk Museum

Opposite
Kasimir Malevich
An Englishman in Moscow, 1915
Oil on canvas, 88 x 57 cm
Amsterdam, Stedelijk Museum

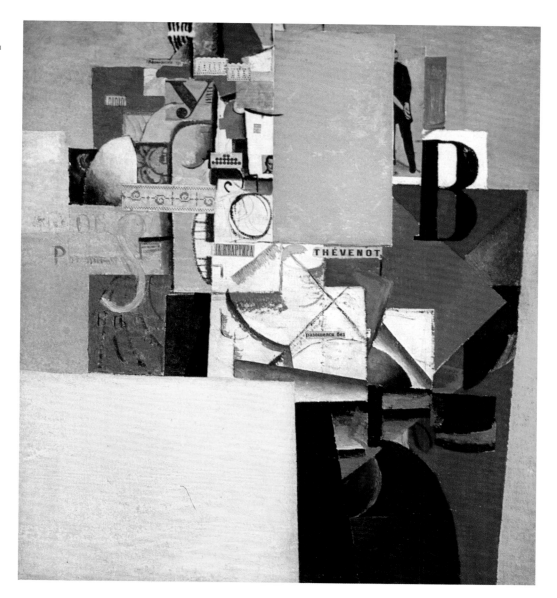

had gone back to his homeland from Paris, where he had moved in 1910, two years earlier on the outbreak of World War I. In Paris he had established ties with the avant-garde and had exhibited at the Salon des Indépendants, revealing his interest in Cubist deconstruction but already rendering it with his own personal sense of the fantastic.

The abolition of the anti-Semitic legislation in the wake of the 1917 revolution further freed the artist's propensity to treat themes from Jewish life and village life; strong attention upon the use of primary colours, which took on specific symbolic meanings, aligned Chagall with other research being undertaken at the same time in Europe, though with wholly original results. In 1918 be became the director of the Academy of Vitebsk; he summoned Malevich and many other Suprematists to the city, but they succeeded in ousting him from his position,

and this led to his definitive move to France in 1922.

In this phase, the art circles of Petrograd began to accept the ideas of Cubism and Futurism with great enthusiasm, especially as a reaction to the overwhelming cultural superiority of Moscow. It was in this spirit that in February 1910 the Soyuz Molodyozhi (Union of Youth) was founded, featuring many of the artists who had debuted with works of Cubist and Cubo-Futurist derivation, for example, Ivan Puni, Natan Altman, Pavel Filonov, Alexandra Ekster, Kasimir Malevich and Vladimir Tatlin.

The six exhibitions organised by the group between 1910 and 1914 (the year it was dissolved) focused almost exclusively upon the most radical avant-garde, turning their backs even on the neo-Primitivist artists.

Nikolai Konstantinovich Rerich was the representative of those artists who re-

Kasimir Malevich
Black Rectangle, Blue Triangle, 1915
Oil on canvas, 66.5 x 57 cm
Amsterdam, Stedelijk Museum

Kasimir Malevich
Self-Portrait in Two Dimensions, 1915
Oil on canvas, 80 x 62 cm
Amsterdam, Stedelijk Museum

Kasimir Malevich
Yellow, Orange and Green, 1915
Oil on canvas, 44.5 x 35.5 cm
Amsterdam, Stedelijk Museum

mained more closely tied to the Symbolist world of the magazine *Mir Iskusstva*, influenced by the atmospheres of Puvis de Chavannes and Les Nabis. Roerich later became famous as the set designer of the Ballets Russes, for whom he did Stravinsky's *The Rite of Spring* (1913).

At the first exhibition of the Union of Youth (1910), the figure of Pavel Filonov emerged among the founding members of the group. Orphaned at a young age, he was forced to do whatever work he could, an experience that gave his art its distinctively pragmatic character. After a phase of Primitivism and Cubism, in which he was especially interested in the art of Goncharova and African masks, he moved towards more analytical forms, pushing to fragment the form and crystalise it; he expressed this style in an autonomous artistic system that he himself called 'analytical painting', whose formal principles found their first formulation in an essay written in 1914, *Sdelannyye kartiny* (Paintings Made). In it, Filonov expressed the idea that art is *sdelannost*, a neologism that can be translated roughly as 'craftsmanship'. He consistently represented objects with a skill and attention to detail that, though it partly drew on Cubist deconstruction, investigated every individual aspect of it, with a kaleidoscopic wealth of decorative details. It was only in the 1920s that he took these ideas to their logical extremes, isolating himself from the art scene and taking a position against all ideology, whether academic or proletarian. Naturally, this did not endear him to the authorities and in 1929 he was prohibited from opening a solo exhibition in Leningrad.

Natan Isaevich Altman, an artist of Ukrainian origin who had recently returned from a productive stay in Paris, enjoyed special success; his *Portrait of Anna Akhmatova* preserves a certain degree of realism, but it is especially in the background that it opens up to Cubism.

It was in St Petersburg between 1913 and 1915 that the Futurist experience reached its culmination and then came to an end. At the Luna-Park Theatre in winter 1913, the Futurist opera *Victory Over the Sun* by Kruchenykh, and set to music by Matyushin, alternated with *Vladimir Mayakovsky*, an autobiographical tragedy of the poet. The set and costume designer of the first productioin was Kasimir Malevich, who also contributed to the composition of the play during a meeting with the authors in a Finnish dacha, pompously remembered thereafter as the First Pan-Russian Congress of the Writers of the Future. According to accounts from the time, the scenes were dominated by numerous lighting effects and by complex, typically Futuristic machinery. The backdrop used in the first act featured a large black square appeared for the first time (the symbol of the victory over the sun), which Malevich himself identified as the debut of the Suprematist aesthetic. The costume designer for the tragedy of Mayakovsky was Filonov, who forced the actors to move like puppets by trapping them in cardboard boxes.

Despite these first indications of a new direction, the exhibition *Tram V. The First Futurist Exhibition of Painting* (1915) still featured a solid synthesis of the Cubo-Futurism of the old capital; Ljubov Popova, in partic-

Kasimir Malevich
Four Squares, 1915
Oil on canvas, 50 x 50 cm
Saratov, Regional Museum

Alexandr Rodchenko
Composition with Circles, 1919
Watercolour on paper, 33.5 x 29 cm
Geneva, Musée d'Art et d'Histoire

Pages 292–93
Ljubov Popova
The Philosopher, 1915
Oil on canvas, 89 x 63 cm
St Petersburg, The State Russian
Museum

Ljubov Popova
Still Life, 1915–16
Oil on canvas, 54 x 36 cm
Gorky, Museum of Fine Arts

ular, exhibited *Male Figure + Air + Space*; the painter had learned Cubist deconstruction directly in Paris, studying with Le Fauconnier, but her works had an unprecedented force because of the Futurist dynamism that seemed to proceed from a direct familiarity with the art of Boccioni. Malevich exhibited paintings that were still Cubist in style, and, though explicitly declaring that he had no idea of the content of certain of his works, he had already implicitly completed his transition to abstraction.

In December the same year, the *0.10. Last Futurist Exhibition* organised by Ivan Punin opened its doors at the gallery of Nadezhda Dobytchina. Events had moved quickly and already there was a division in the heart of the Russian avant-garde: Tatlin exhibited his *Reliefs and Counter-Reliefs*, taking inspiration from Picasso's collages and

giving rise to Constructivism, whose history largely belonged to the decade that followed; and Malevich presented *Black Square on White Background* and a separate programme from Tatlin; the first lines echoed the beginning of his new book, first offered for sale at the exhibition, entitled *From Cubism to Suprematism. New Realism in Painting*. Tatlin's material culture was opposed to the non-objective nature of Malevich's new painting, which called for an art devoid of practical ends and led to the birth of a new system of art.

The debut of Kasimir Severinovich Malevich took place in parallel with the experiences of Larionov. Contact with the Jack of Diamonds group placed Malevich—a native of Kiev and a veteran of the teachings of Rerberg's private academy in Moscow—in touch with the neo-Primitivism of Goncharova and the exhibitions of Cubist and

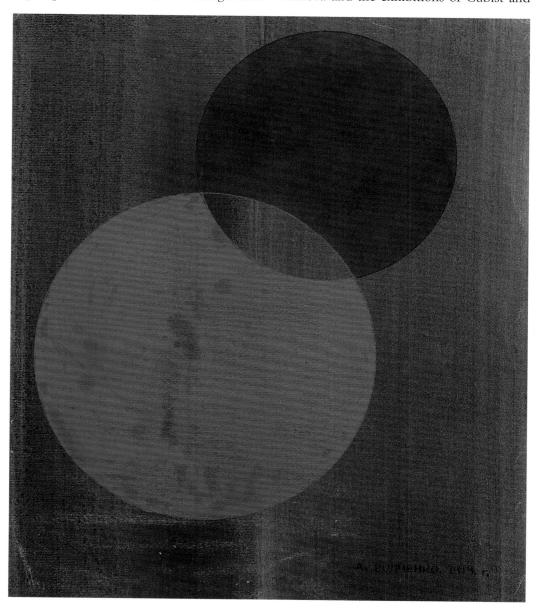

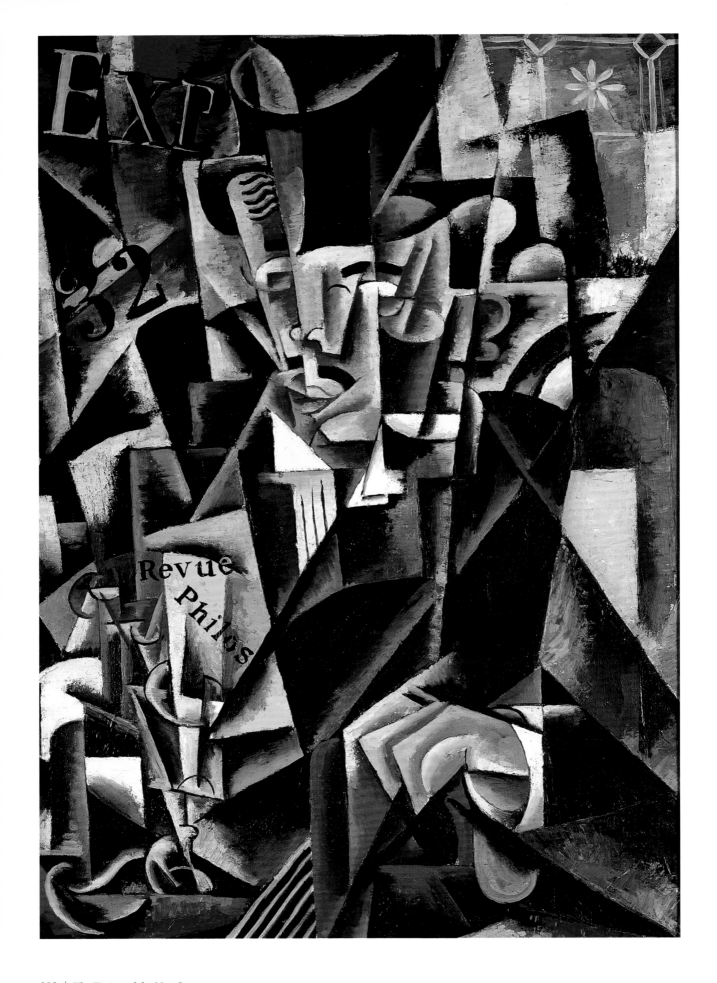

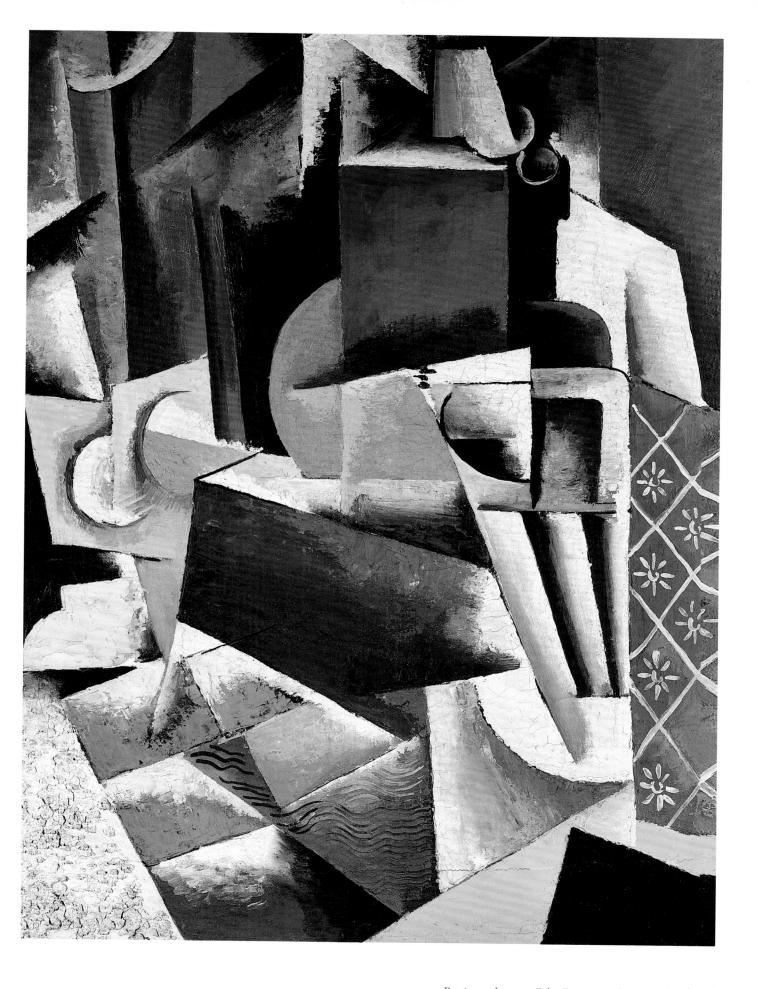

Alexandr Rodchenko
Kiosk, 1919 (rebuilt model)
Courtesy of Galerie Gmurzynska,
Cologne

Alexandr Rodchenko
Plan for a Kiosk, 1919
Coloured ink on paper, 53.2 x 34.3 cm
Moscow, Pushkin Museum of Fine
Arts

Opposite
Vladimir Tatlin
Monument to the Third International,
1920, construction of the model

The collective of Tatlin's studio
standing before the model of the
Monument to the Third International

Vladimir Tatlin
Monument to the Third International,
1919, sketch of the inclined axis

Vladimir Tatlin
The second model of the *Monument to
the Third International* at the Exposition
Internationale de Paris, 1925

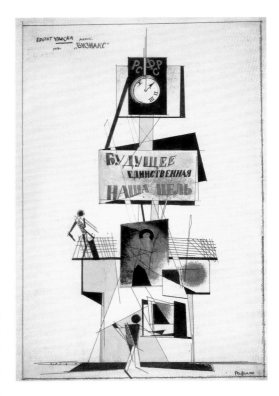

Futurist works. The discovery of *lubok* art and an innate aptitude for pure geometric forms gave rise to such works as his renowned *Woodcutter*, while a desecratory impulse originating from Futurism underlay such works as *Cow and Violin* (1913). On the back of this work is written 'A-logical confrontation between two forms, "violin" and "cow", as a moment of struggle against bourgeois logic, naturalness, common sense and prejudice'. In Rayism, to which he cautiously subscribed, he saw an effective and coherent means by which he could arrive at abstraction. By moving to Petrograd, he came into contact with the most advanced exponents of Cubo-Futurism, and Popova Altman in particular.

With the events linked to the exhibition *0.10*, Malevich seemed literally to sublimate this baggage of experiences into Suprematism where the geometry of Cubism was simplified into forms that were almost mystical: 'By Suprematism I mean the supremacy of pure sensibility', wrote Malevich. 'The object itself has no meaning for a Suprematist.' In his works, pure geometrical forms are distributed over flat, monochrome surfaces, often arranged according to a tightly arranged proportional calculation; pure geometry was identified as one of the realities that was most distant from the proteiform appearance and irregularity of objects; it was a means to attain the truth, not a means to attain sincerity of vision. The black square was the 'formal zero', the beginning of a new artistic language, finally unleashed from all practical purposes.

It is possible to follow the steps towards the new system thanks to *Suprematism—34 Drawings*, which the artist wrote in Vitebsk in 1920 in an attempt to analyse historically the developments of that style over the course of the years. 'Suprematism can be divided into three stages, according to the number of black, red and white squares: the black period, the coloured period, and the white period. In the latter, white forms were painted on white. All three phases of development took place from 1913 to 1918'. Malevich's experience was engendered out of a foundation of powerful mysticism, in a quest for the 'truth of things' and a 'formal principle'. In the titles of his works the term 'fourth dimension' recurs, and was transformed from a merely geometrical concept into a mystical one as a result of the theosophical speculations of Pyotr Uspensky. At a more strictly formal level, the idea of a black square not perfectly centred on a white background is a reference to the typology of the icon, which was traditionally hung in a corner of the house: just like the artworks of Malevich himself and the installations of Tatlin. The final phase of Suprematism, the 'white' phase (*White Square on White Background*, 1918), brought absolute form to coincide with nothingness; the 'white sea' that stretches out before the artist—as Malevich himself would say—is 'a space without ending', a 'void unveiled': these were radical results that have led some to reference Schopenhauer's nihilism.

Vladimir Evgrafovich Tatlin also turned to Abstractism as his chief means of expression, but with a sense that was much different from that of Malevich. After the usual studies at the School of Painting in Moscow, between 1908 and 1911 he met Larionov and the Burlyuk brothers; he moved into the milieus of Russian Futurism and exhibited his art with the Jack of Diamonds and the Donkey's Tail. He travelled widely as a musician in a folk group and in 1913 visited Berlin and Paris where he met Picasso and Archipenko: their collages, made using various materials and sharply protruding elements, captured the young man's imagination and, after returning to Moscow, he executed his own reliefs, exhibited them in his own studio and, in 1915, at the exhibitions *Tram V* and *0.10*. At the latter, a break took place between Male-

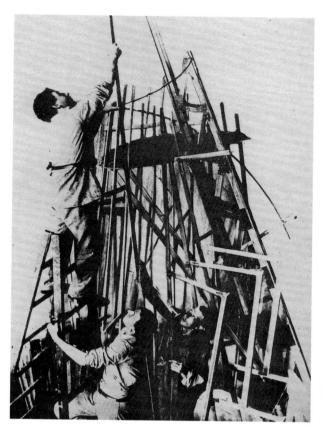

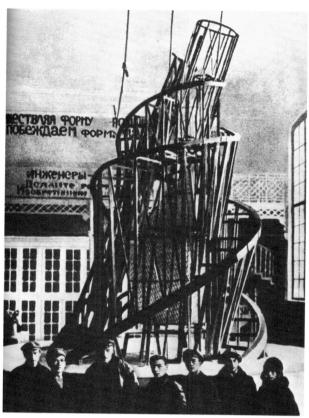

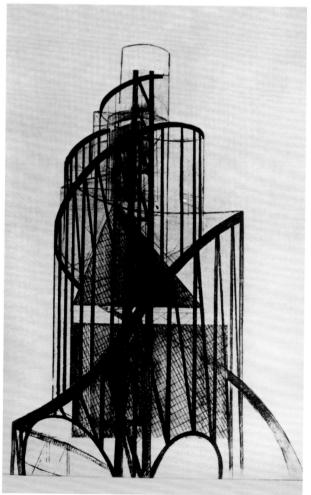

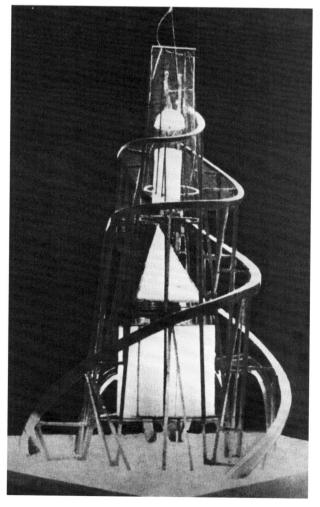

Pages 296–97
Alexandr Rodchenko
Abstract Composition, 1920 (detail)
Oil on canvas, 105 x 175 cm
Moscow, Rodchenko Archive

Alexandr Rodchenko
Composition, 1918
Gouache on paper, 33 x 16.2 cm
New York, The Museum of Modern
Art, Gift of the Artist

vich and Tatlin: in the pamphlet that he had printed independently, Tatlin reiterated his autonomy from all artistic groups, including Rayism, Futurism and 'Tatlinism', perhaps in order to establish his distance from any theoretical scaffolding that might bring him close to Suprematism.

The artist noted that his art was based on tangible and concrete 'materials' as opposed to the absolute stylisation of the works shown by Malevich: 'Wood, metal, glass, plaster, cardboard … and coloured asphalt'. His emphasis on construction materials would be the foundation of Constructivism a few years later, whose manifesto, written by Naum Gabo in 1920, opened the doors to the art of the following decade. At *0.10*, Tatlin exhibited his famous *Corner Counter Reliefs* (*Uglovye kontr-rel'efy*), since lost, but faithfully reconstructed by Martin Chalk in 1980. Aside from the extreme evidence of the materials, their power derived from the determination to break away from the heritage of traditional art, oil painting and canvas. The complexity and articulation of these works still have the flavour of the machines of Futurism, with which Tatlin's art shared the need to open up to modernity and technology (he was defined as a 'technological artist'). A hymn to a new world and to technology was indeed the plan for the *Monument to the Third International* (1919–20), destined to celebrate the new historical direction of Russia, a utopian faith in the future, and—as Tatlin himself would write—a tribute to the state and to works of art in the service of society. With these ideas, the artist fit successfully into the structures of the nascent Soviet state; in 1918, he was named director of the IZO, the Fine Arts department in charge of the administration of academies and schools of art, and professor at the Svomas (Free Art School) of Moscow.

But it was Suprematism that proved to be the current of avant-garde art that had the greatest number of followers in Russia, even in the period immediately following the 1917 Revolution. Malevich also designed the group's magazine, *Supremus*, though it would never be published due to the political turmoil of those years. Among the group's members were Ivan Puni, Olga Rozanova and Mikhail Menkov. If the *X State Exhibition. Non-objective Creation and Suprematism*, which opened in Moscow in 1919, documented the vitality of the movement, it was also the context in which divisions began to emerge concerning the meaning of art and which would explode in the next decade.

The conflict that had caused the break between the Suprematist wing and the Tatlinist wing at the exhibition *0.10* in 1915 re-emerged from the depths: Malevich's stubborn non-objective choice clashed with Tatlin's desire for action, the foundation of Constructivism, which, at least theoretically, originated at that very exhibition.

Many of Malevich's followers abandoned their master: among them Ivan Klyun, one of the most loyal members of the Supremus group and the creator of some of the most rigorous Suprematist artworks. Others were Rozanova, Popova and, especially, Alexandr Rodchenko.

The latter exhibited his *Composition no. 64 (84)*, where he added to the geometric form of Suprematism a spatial depth that already opened up to the successive *Constructions*; the preference for three-dimensions pushed the young artist into Tatlin's orbit, and it was at Tatlin's invitation that he exhibited a number of Cubist collages at the Magazin exhibition in 1916. His initial attention to Suprematism did nothing to keep him from becoming one of the most emphatic supporters of an art that would have an active role in the world, one that went against Malevich's ideas and were in keeping with the principles of nascent Productivism, which Rodchenko himself founded in 1920 to take to the limit some of the ideas of Constructivism.

This clash between pure art and 'useful' art dominated the years immediately following the Revolution. Artists were integrated into the structures of the new state which, in this first phase, accepted the objectives of the avant-garde in the name of a freedom of aesthetic expression. In this climate, Russian Futurism experienced a last moment of splendour: in 1918, the painter Lunacharsky was commissioned to establish the IZO, while the following year Mayakovsky, Kamensky and Burlyuk founded the *Gazeta Futuristov* (Futurist Gazette).

Having become a member of the IZO, Malevich devoted himself to teaching and theory. After the 'betrayals' of his followers in 1919, he moved to Vitebsk at the invitation of Chagall, who had returned home attracted by the Revolution. Malevich only returned in 1922 to what had been renamed Petrograd to teach at the Museum of Artistic Culture, where he continued his architectural studies: this was his last attempt to reconcile the forms of Suprematism with the theories of Productivist Constructivism, the two poles of Russian art that were still vital before the advent of State Art.

Alexandr Rodchenko
Yellow Composition, 1920
Oil on canvas, 183 x 183 cm
Moscow, Rodchenko Archive

Jeffrey T. Schnapp

The Utopia of Total Art

The phrase 'total art' and the constellation of projects, myths and ideals to which it refers would have had little meaning for a practitioner of the arts before the nineteenth century. Until that time, the arts had been envisaged as a stable, interconnected set of practices of craft and cultural communication, operating in the service of society's most powerful individuals and institutions, and in support of the values championed by the latter. Art didn't need to aspire to the status of 'total' inasmuch as it was already complete and belonged to a whole held together by overarching belief systems like those provided by religious faith. Within such a context, art's use-value was a given.

Total art arises as an ideal only when three conditions, fundamental to an understanding of modernity, are met. The first is a *fragmentation*, perceived or real, that disjoins the arts from one another and decouples art as a whole from traditional sources of patronage, 'natural' clienteles and audiences, and tradition-bound crafts. Questions of art's usefulness, of its ability to communicate, of the distinction between art and non-art practices, thus become central to art practice itself. The second condition is *autonomy*. As the arts become decoupled from traditional social functions, they assume a stance that increasingly places them in tension with or outside the ordinary orbit of economic production, communication and social reproduction. They become a key locus for assertions of freedom, independence and even revolt. The third is *secularisation*. The assault of modern rationalism upon the core beliefs and institutions that served as the foundation stones of early modern society, notably the Church, brought with it an overall secular turn, a shift away from the other-worldly and towards the 'this-worldly'. This decline in the prestige of religion was accompanied by the rise in prestige of certain forms of art as a potential locus for forms of experience, belief and communion that heretofore had belonged to the sphere of religion. Art steps into the breach opened up by the death of God.

The phrase 'total art' is thus endowed with a mix of compensatory and positive meanings that was to remain remarkably constant in the course of its history, from its debut in mid-nineteenth-century spectacle forms, through early avantgardist experiments with hybrid performance and art genres, to the environmental artwork, happenings, and performance art of the 1960s and on to contemporary multimedia work. In all of these iterations, total art encompasses some combination of the following objectives: fusion of the arts along the lines of early modern craft traditions yet in harmony with the new conditions provided by the era of industry; erasure of the boundary line dividing art from life, nature and/or society; endowing the artwork with a vastly expanded capacity for interactivity and social action; hyperbolic forms of multimediality; experiences of total immersion, absolute mimesis, and even hallucination; collapsing the distinction between science and art; transformation of the artwork into a privileged site for the forging of new social formations; creation of a new language of the sacred or the absolute. However varied in character, these iterations of totality share a common core. As a remedy to fragmentation, they promise experiences of community and integration of the arts, old and new, static and dynamic, live and non-live. As a remedy for the crisis in belief,

they promise experiences of communion, emancipatory visions of total order or total chaos, even access to the absolute. In so doing, total art stakes out the claim that art is a realm of freedom endowed with a higher use-value that transcends mere instrumental usefulness or instrumental reason.

During the first two decades of the twentieth century, total art projects tended to fall into one of two categories (even if the split is artificial and criss-crossings predominate): the symphonic or the mechanical. The *symphonic* is of Romantic derivation, is traceable to eighteenth century accounts of the sublime, and tends to assume subjectivist forms. Its most characteristic manifestations in the art of the first decades of the twentieth century may be found in early abstractionism and in certain totalising trends within experimental theatre. The *mechanical* can be traced directly back to Enlightenment utopianism. It is animated by visions of a future universe in which art has become one with technics within the fold of an integral rationalisation of human life that bears emancipatory consequences. Its most crystalline formulation was that advanced within the fold of the Bauhaus, particularly as the Bauhaus matured in the course of the 1920s.

The symphonic model of total art reached its first acme in Richard Wagner's *Das Kunstwerk der Zukunft* (1849) with its influential theorisation of the *Gesamtkunstwerk* (or total work of art). For Wagner, the total work of art is one in which each of the arts—architecture, painting, dance, music and poetry—attains its full expressive potential thanks to the freedom that is achieved by joining together all of the faculties that make up artistic man. Whereas modern art is largely irrelevant to public life, a mere elite trinket that is at once a luxury and a superfluity, the total work of art instead aspires to the status of an inner necessity nourished by deep popular (*volkisch*) roots. Its consummate expression is the drama: an all-enfolding living, breathing and moving spectacle in which the artist-poet fulfils his mission by dissolving into a community that has been forged within the fold of the artistic vision. Such was the purpose of Wagner's own Festspielhaus in Bayreuth: a spectacle factory for modern times whose 'mystical gulf' placed the orchestra below the threshold of spectator vision in order to grant the vision unfolding on stage an almost hallucinatory immediacy.

Wagner's symphonic model interacts suggestively with an array of projects extending back into the eighteenth century and forward into the early decades of the twentieth: projects that, for instance, set out to expand the communicative horizons of paintings by altering their format, increasing their scale, and/or altering their language in order to bridge the gap between vision and music. Nineteenth century interpretations of 'expanded painting' included everything from life-size battle scenes to works in celebration of the heroism of labour, such as Pellizza da Volpedo's 293×545 cm *The Fourth Estate* from 1898–1901. But their most symptomatic expression can be found in that special category of immersive representations known as panoramas. The term and device were patented by their inventor, the Irishman Robert Barker, to promote an 'improvement on painting which relieves that sublime Art from a restraint it has ever laboured under'.[1] These efforts at improvement

typically assumed the form of 360-degree environments that provided spectators with the illusion that he or she was physically present in the locale depicted. They also gave rise to proto-cinematic scrolling structures presented as stage shows like John Banvard's 4-metre-tall and 430-metre-long portrait of the eastern bank of the Mississippi from the mouth of the Ohio River to New Orleans—a painting whose explicit ambition was to become as large and compelling as the landscape that it portrayed. The nineteenth century was launched under the sign of the panorama: with the London opening of 'Mr. Barker's Interesting and Novel View of the City and Castle of Edinburgh'. It concluded with an electrical updating of the same immersive project: with the inauguration of the 1900 Universal Exposition in Paris featuring a Cineorama, Stereorama and Pleorama. A new century followed, dominated by a dazzling array of media devices, from the cinema to kinetic light machines and optophones to Cinerama to virtual environment caves.

Panoramas were tradition-bound in their reliance upon realist representational conventions. The effort to go beyond retinal art in the pursuit of a higher, lower, deeper, more complete language became integral to a second strain within the 'symphonic' current of total art experiments: namely, that represented by early abstractionism. Formulated in explicitly Wagnerian terms by Wassily Kandinsky, but resonant also with the early explorations of artists from Ciurlionis (the Lithuanian painter-composer) to Klee and Mondrian to Julius Evola, as well as with the musical experiments of synaestheticists such as Alexander Scriabin, abstraction became a tool for piercing the material veil of the world and for resacralizing what had been desacralized by modernity.[2] When understood in this way, 'abstraction' opens up the prospect of an art that, following in the footsteps of pure philosophical inquiry, symphonic music and hermetic expressions of spirituality, finds in geometry not only the new vernacular of the era of industry but also the secret language of the psyche or of the cosmos or of the psyche as cosmos; an art that is 'abstract' inasmuch as it has withdrawn from the realm of appearances in the pursuit of something anticipating the noumenal.

Music led the way in this procession beyond the retinal, as illustrated by symptomatic works like Ciurlionis's *Sonata of the Stars # 6* (1908) and Kandinsky's *Fugue* (1914): works that are 'total' less in their integration of various media, or pursuit of absolute mimesis or interactivity, than in their metaphysical ambitions. And here music continues to mean just the sort of orchestral music championed by Wagner, composed of dense layering and oceanic ebbs and flows, a universe of sound whose visual counterpart is an art that aspires to the status of hallucination.

Wagnerian models of totality tended to dominate well into the first decades of the twentieth century. But it is essential to note that other strains of experimentation with visual-musical hybrids coexisted and interacted with the Wagnerian mainstream, and pointed towards fusions of the symphonic with the mechanical, particularly in the total art projects of the early avant-gardes. The modern history of attempts to bridge the gap between different senses long predates the mystical effusions of Wagnerians like Scriabin whose *Prometheus* was first performed on a

colour organ in 1911, but whose lifelong dream remained the integration of music, colour projections and perfumes. The endeavour can be traced back at least as far as the Jesuit Louis Bertrand Castel whose *clavecin oculaire* was intended not as a hallucinogen but as an instrument of science, capable, among other things, of performing music for the deaf. The *clavecin oculaire*'s many descendants include Bainbridge Bishop's 'Color Organ' (1885), Claude Bragdon's kaleidoscopic 'Light Festival' (1915), and Vladimir Baranoff-Rossiné's *piano optophonique* (patented 1923).

The last of these is the most significant for understanding the connections between 'visual music', early abstractionism and total art. With its hand-painted colour discs inserted into a light projector arrayed with filters, lenses and mirrors, Baranoff-Rossiné's Optophone produced keyboard-driven mobile projections reminiscent of the works of Orphism and Synchromism. The reminiscence is no accident for in the paintings of Kupka, Picabia and the Delaunays, as well as in those of American counterparts like Stanton Mac Donald-Wright and Morgan Russell, not to mention Futurists such as Russolo, Balla, and Arnaldo and Bruno Giannini-Corradini, music continued to stand for an 'improvement on painting which relieves that sublime Art from a restraint it has ever laboured under' (to recall Barker). The restraint to be removed was that of immobility. Among the means to this end were the introduction of implicit motion into traditional easel paintings, the development of transport devices that permit easel paintings to scroll, the creation of two- and three-dimensional kinetic artworks, the development of new media devices for sound-image projection, and, eventually, recourse to what was to become known as the 'abstract cinema'.

Two cases in point will have to suffice. The first is a work by the gay Scottish painter Duncan Grant. Founder of the Omega Workshops and a member of the Bloomsbury group, Grant began a series of experiments in the early 1910s with moving paintings that culminated in his *Abstract Kinetic Collage Painting with Sound* in 1914. Three metres long and nearly one third of a metre tall, it was to be viewed through an aperture as it scrolled to the music of one of Bach's *Brandenburg Concertos*. Russell and Macdonald-Wright were living across the Channel during the very same period and were hard at work on a series of easel paintings based on swirling spatial rhythms and dynamic colour harmonies. These Synchromist canvases stage virtual motions that were meant to spill over into actual three dimensional motions by means of the kinetic light machines which they devised for the projection of abstract animations. Begun in the mid-1910s, the project was brought to term a decade later when Macdonald-Wright completed construction of a colour-light machine he entitled the Synchrome Kineidoscope.

The ultimate means for overcoming the immobility of static artworks has already been alluded to: namely, their introduction into live forms of performance and spectacle. The forms in question were to prove highly variable in character during the first decades of the twentieth century. They included vaudeville- and cabaret-inspired events like the important *serate* staged by the Futurist movement from early January 1910 until the outbreak of World War I, with their volatile mix of poet-

ic declamations, political harangues, presentations of paintings, theatre performances, and concerts of *intonarumori*. Like such Dada descendants as the performances staged by Hugo Ball at the Cabaret Voltaire in Zurich during the war, these forms of spectacle qualify as 'total' to the degree that they staged collisions between different art and media forms, they promoted intensified forms of audience-performer interaction, and they sundered the barriers between art and life. They stood entirely at odds, however, with the sort of seamless, dream-like fusion of the arts that would have satisfied a true Wagnerian.

For models of spectacle more rigorously affiliated with the symphonic model, one has to turn to attempts to craft a post-Wagnerian concept of and architecture for the total theatre. One such effort stood out in the first decades of the twentieth century: Max Reinhardt's 'theatre for five thousand [spectators]', realized within the setting of Hans Poelzig's Berlin Grosses Schauspielhaus (1919). The Grosses Schauspielhaus was a state-of-the-art theatre facility where the visual arts found themselves at the centre of Reinhardt's sometimes titanic Expressionist and Symbolist stagings of an eclectic repertory extending from Shakespeare to Ibsen. Temple-like, thanks to a vast main cupola ringed by concentric circles of stalactites, and due to the architect's extensive recourse to indirect coloured lighting effects (enhanced by mirrors), it sought to immerse the spectator both in the action on stage and in a magical overall environment where the real had been transfigured.

In the very same year as the Grosses Schauspielhaus was built, Walter Gropius published the founding manifesto of the Bauhaus.

The manifesto's cover featured a woodcut by Lyonel Feininger of a crystalline cathedral woven into its environment thanks to a dazzling array of light vectors emanating from stars atop its steeples. This radiant temple of the future, later referred to as the cathedral of socialism or of freedom, stood for an overcoming of everything that ailed modern art—alienation, the loss of community, the feeling of uselessness, the lack of sense of a higher purpose—an overcoming that was to become the central mission of the Bauhaus for the decade to come.

[1] Cited from Scott X. Wilcox, 'Unlimiting the Bounds of Painting', in Ralph Hyde, *Panoramania. The Art and Entertainment of the 'All-Embracing' View* (London: Trefoil, 1988), 21.
[2] On this subject one may consult the catalogue of exhibition *The Spiritual in art: Abstract Painting 1890–1985* held at the Los Angeles County Museum of Art, ed. Maurice Tuchman (New York: Abbeville Press, 1986).

The Experiences of Abstraction

De Stijl

In the context of the cultural and artistic processes that led to the development and diffusion of abstract artistic language, the Dutch De Stijl movement was dominant.

Theo van Doesburg identified the presuppositions for the formation of Dutch abstractionism in the activity of the Moderne Kunstkring (Modern Art Club) founded in Amsterdam in December 1910 by Conrad Kikkert, a Dutch painter and critic who lived in Paris. The meetings of the association took place in Paris and Amsterdam, depending on the availability of the members, many of whom lived in the French capital. It was precisely because of this direct connection that the Moderne Kunstkring decided to bring to Holland the most important examples of modern French art. The first exhibition was held at the Stedelijk Museum in Amsterdam in October and November 1911 to great public success: 166 works were exhibited, half of them coming from abroad. Alongside the Cubist works of Picasso and Braque, there were twenty-eight works by Cézanne, all from the Hoogendijk collection. The painter Lodewijk Schlefhout, who experimented with Cubism in Paris, sent twelve canvases. Among the Dutch, Piet Mondrian in particular was noted, his work, like that of Kees van Dongen and Jan Sluyters, revealing the influence of the Fauves.

The exhibition the following year (October–November 1912) marked the beginning of Abstractionism in Holland, with the dominant presence of analytical Cubism and the first abstract works by Jacob Bendien. The association confirmed its own interests in abstraction with the major exhibition of 1912, where eighteen works by Franz Marc and fourteen by Kandinsky were presented. Here Mondrian exhibited his first series of *Trees*, still strongly influenced by Picasso's Cubism; the true triumph however was that of Le Fauconnier with a style that, in those years, had already returned to a fairly traditional figurative structure. In the wake of internal tensions that arose following the expulsion from the group of Léo Gestel—accused of being an Impressionist sympathiser—the Moderne Kunstkring dissolved (1914). Abstractionism found a first consistent formulation with the publication of *De Stijl* (Style), a magazine published in 1917 by Theo van Doesburg, which continued publication in Leyden until 1932. The term was later used to indicate the style developed by the artists who published articles in the magazine or who demonstrated formal affinities with its two leading promotors, Van Doesburg and Mondrian. The idea of founding a magazine was proposed by Van Doesburg to Mondrian as early as 1915, but Mondrian was unsure whether the Dutch art milieu was ready to accept ideas linked to abstraction. In April 1916 he met the painter Bart van der Leck, who seemed to share the same ideas and who persuaded him that the cultural situation might ripe. It is possible to detect homogeneous elements among the members of the group only in the very first few years of the magazine's life, between 1917 and 1921, when the three manifestos were published. The first one, from 1918, was compiled in four languages and was signed by Van Doesburg, Mondrian, Van't Hoff, Huszár and the poet Antony Kok, a friend of Van Doesburg, whose involvement indicated the magazine's total openness towards all art forms. In this essay, it is still possible to detect the emphasis of the historic avant-gardes, in its fervent appeal to all those seeking a new culture and a new art with universal values: 'There exist an old and a new artistic awareness: the old one addresses the individual, the second, the new one, addresses the universal'. As in all avant-gardes, it was necessary to destroy 'traditions, dogmas, and the predominance of the individual (the natural)'. In 1920 the second manifesto appeared, signed only by Mondrian, Kok and Van Doesburg; the latter gave this document a marked poetic imprint with the addition of a few poems Dadaist in character under the pseudonym of Bonset. The last manifesto (1921) was quite brief and unsigned. The artists' determination to open up to all forms of artistic activity had no real follow-up: Kok never had a chance to express ideas or write poems that could be described as neo-Plastic, since the magazine had, from the outset, a figurative approach.

The most recent studies point out that De Stijl was not actually a cohesive group comparable with the other avant-gardes. Even in the period when the agendas were being developed, the members basically stayed in touch by letter, with Van Doesburg as a central point

Piet Mondrian
Church in Domburg, 1910 (detail)
Oil on canvas, 114 x 75 cm
The Hague, Haags Gemeentemuseum

Piet Mondrian
Red Tree, 1908
Oil on canvas, 70 x 99 cm
The Hague, Haags Gemeentemuseum

of reference; collective meetings were rare, because the artists lived in different areas of Holland. Equally singular is the fact that during the life of the magazine, there has never been an exhibition that involved the participation of all the contributors. Communication between members often took place through the magazine itself, which, in this sense, took on a fundamental importance in the internal economy of the group, not merely as a populariser of ideas to the outside world. Beside the signatories of the first manifesto, some of the most assiduous contributors were Van der Leck, Oud and Rietveld, though the latter preferred not to add his name at the end of the 1918 text.

In contrast with what has always been stated, there were actually very few foreign artists who worked on the magazine. Although the names in the first issue were of Picasso, Berlage, Toorop and Archipenko, none of them ever played an active role, appearing essentially as supporters of avant-garde ideas. The only foreigner with whom regular contact was maintained, at least between 1917 and 1919, was Gino Severini, who lived for many years in Paris and who wrote many articles for *De Stijl*: his artistic research however never moved

in the neo-Plastic direction. The formal principles to which *De Stijl* aspired were organised and expressed by Mondrian from the very first issue of the magazine, and summarised with the expression *De nieuwe beelding* (The new language). The best-known term, 'neo-Plasticism', which became synonymous with *De Stijl*, was not coined by Mondrian until 1920 in an essay in French (*Le Néo-Plasticisme*) which was destined to diffuse the ideas of the group across Europe. On other occasions, the artist used the terms *abstract-reële schilderkunst* (abstract-real painting) and neo-Cubism. Independently of the various denominations, neo-Plasticism was based on a few principles that, in its most 'classical' form, could be summarised as follows: an abstract art, characterised by a few elementary components: the use of primary colours, and the division of the surface into quadrangular and absolutely flat areas, separated by straight horizontal or vertical lines.

This process of purification of form and style began, for all the members, with the taking of a position against the other art movements to which they had once belonged, especially the school of Amsterdam. The relationship of neo-Plasticism with the other avant-

Piet Mondrian
Silver Tree, 1912
Oil on canvas, 78.5 x 107.5 cm
The Hague, Haags Gemeentemuseum

garde movements was in reality quite complex; on the one hand, *De Stijl* shared with Constructivism (to which it dedicated a special issue of the magazine in 1922), with Purism, and with late Expressionism the determination to direct the subversive impulse of the early avant-gardes into aesthetic systems that would play an active role in the construction of the world. Consequently, the latter movements oriented their artistic reflections from a figurative plane to a more specifically architectural one. On the other hand, De Stijl took up once more those spiritualist tendencies that had been distinctive elements of the first avant-gardes, and against which the Constructivists and the last Dadaists had moved: the spiritualist accent derived from Mondrian's interest in theosophy. By often publishing the Dadaist poetry of Van Doesburg and by dedicating in 1922 a special issue to the visual poem *The Two Squares* by El Lissitsky, the group—perhaps chiefly due to the determination of its founder—regained the subversive content of the early avant-gardes.

This position, which set De Stijl between a stern formal rationality and an intimate universal aspiration (that was per se irrational), caused consternation among a number of critics, who discussed the matter in tones that veered chiefly towards the ironic. Even though he was a close friend of Van Doesburg's, the critic Erich Wichman in 1919 defined neo-Plasticism 'an immobility, which is curious especially from a national point of view, because this immobile movement, this impetuous negation of life itself, this rigid and sterile art, this patient dilettantism that has curdled and frozen into little coloured squares and orthodox straight lines that sadly dangle in the void, cannot be imagined in any other place but the Netherlands, these extremely Nether Lands'. A few years later, the Belgian Dadaist painter Paul Joostens wrote that, for neo-Plasticism, 'anything that has legs is immoral'. Wichman and Joostens considered separately the two aspects of De Stijl: the former noticed only its formal rationality, interpreting it as chilly sterility; the latter detected its ideal and 'moral' content, but scorned its abstract form.

Almost two thirds of the articles in the magazine up till 1922 were signed by Mon-

Piet Mondrian
Apple Tree in Bloom, 1912
Oil on canvas, 78 x 106 cm
The Hague, Haags Gemeentemuseum

Opposite
Piet Mondrian
Lighthouse at Westkapelle, 1910
Oil on canvas, 39 x 29 cm
Milan, Civiche Raccolte d'Arte,
Jucker collection

Piet Mondrian
*Composition in Oval with Light
Colours*, 1914
Oil on canvas, 107 x 78 cm
New York, The Museum of Modern Art

drian; he had the basic role of developing, not only in theoretical terms, neo-Plasticism.

Piet Mondrian was sent at a very young age to study draughtsmanship, and in 1889 he was certified to teach the subject in primary schools. After attending the Rijksakademie van Beeldende Kunsten (Academy of Fine Arts) in Amsterdam between 1892 and 1894, he became a member and exhibited with the groups of St Luke and Arti et Amicitiae. During the 1890s, he engaged with various art schools: inspired by the school of The Hague, he did landscape paintings of the area to the south of Amsterdam with that completely Dutch realism that was more interested in broad fields of colour than the minute rendering of details. His attention to Symbolism emerges from the numerous figures of rapt and melancholy girls, but also from the numerous landscapes. It was from the Symbolist paintings of Munch and Hodler that Mondrian seemed to derive his first impulse towards formal simplification, an aspect that more recent studies have tended to re-evaluate as a fundamental step towards the abstraction of neo-Plasticism. An exhibition of works by Van Gogh in Amsterdam in 1905 left a mark on the young artist's work, as in that of many of his contemporaries; he learned to use colour as an expressly emotional element, simplifying the form and eliminating the details, as well as emphasising the role of the outlines. These were all characteristics that would return and be taken to far more extreme consequences in his neo-Plastic works.

After abandoning the naturalism of the school of The Hague, between 1908 and 1910 he did work similar to that of the Fauves and the Cubists. He was also stimulated in this direction by his frequentation of the group of artists that had gathered in the little town of Domburg around the painter Jan Toorop, especially to paint landscapes: *Lighthouse at Westkapelle* reveals how the vibrant sentiment of the landscape could coexist with a Pointillist technical approach and a Fauvist colouristic technique, in which the brushstrokes take on a mosaic structure analogous with the works of Kandinsky in the same years.

Beginning in 1899 the artist became interested in theosophy and anthroposophy; in 1909 he joined the Theosophical Society, even though he had already surrounded himself for years with people who were interested in the topic, including the painter Spoor and the philosopher Bolland. According to a number of recent studies, however, it was the writings of Helena Petrovna Blavatsky and the Austrian Rudolf Steiner that most influenced the painter and led him, at least in ideal terms, towards abstraction, as a result of meditation and detachment from sensory reality as a way of reaching God. Of great importance in this cultural climate was Fiedler's theory of 'pure visibility', whose principles of clarity and harmony found a sublimated implementation in Mondrian's geometric and two-dimensional pictorial vision. Alongside Steiner and his privileged vision of the vegetable kingdom as the

Piet Mondrian
Composition with Lines—
Plus-and-Minus, 1917
Oil on canvas, 108 x 108 cm
Otterlo, Kröller Müller Museum

Opposite
Vilmos Huszar
Composition, 1918
Tempera on wood, 40 x 30 cm
Lodz, Muzeum Sztuki

place of unawareness, he was also affected by his knowledge of Goethe and his love for nature. It is no accident that the theme of the tree recurs constantly in Mondrian's work: the form emerging from the soil symbolises his tension towards the heavens and towards the deity. In a process that developed this image, Mondrian succeeded in rendering the form of the tree abstract and blending it with the sky in a representation of the fusion between the earthly world and the spiritual world sustained by theosophy. Theosophical doctrines also emerged in the triptych *Evolution* (1910–11), in which the Star of David effectively symbolised the fusion of the two realities.

His interest in philosophy progressed at the same rate as his attention to the historic avant-gardes, which furnished formal ideas that gave substance to his highly active spirituality. He moved to Paris in the winter of 1911–12 where he entered into direct contact with Cubism; he also exhibited at the Salon des Indépendants in 1913, where Apollinaire guessed at the complex relationship between the Dutch artist and the avant-garde, defining

Mondrian's as a 'very abstract Cubism … that follows a different path from that of Picasso and Braque'. In his article 'Neo-Plasticism in Painting', published in *De Stijl* in 1920, Mondrian himself made explicit reference to the abstract creations of Léger's Cubism and, in the same essay, also revealed his predilection for Picasso, whom he considered to be a more 'abstract' painter even than Kandinsky: he preferred the Spaniard's straight line to the Russian's organic line. Mondrian was included among the Cubists at the Sonderbund in Cologne in 1912, at the Erbstsalon in Berlin in 1913 and at the exhibition of the Moderne Kunstkring in the same year. During the years that he spent in Holland because of the war (1914) he did some of his renowned ovals. The oval form with symbols of the juxtaposition and conciliation of opposing principles, male and female, transcendence of contrasts and restoration of a lost harmony, is a recurring motif in the works of Frantisek Kupka and Kandinsky, both of whom were interested in theosophy. In his numerous versions of *Pier and Ocean*, beginning in 1914, the abstraction was com-

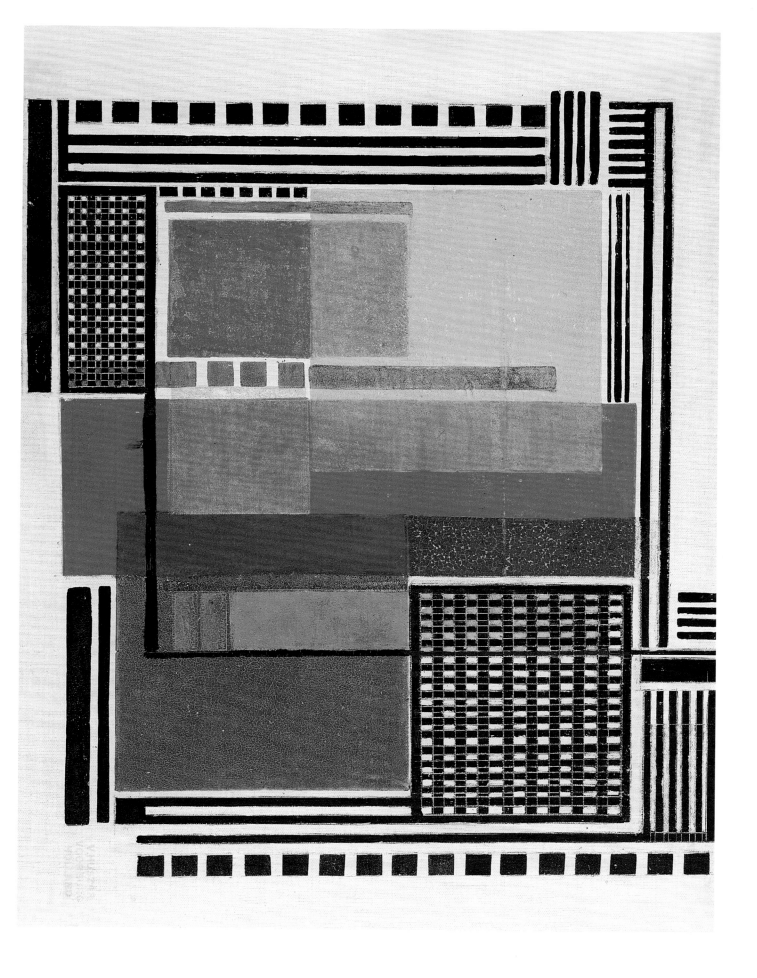

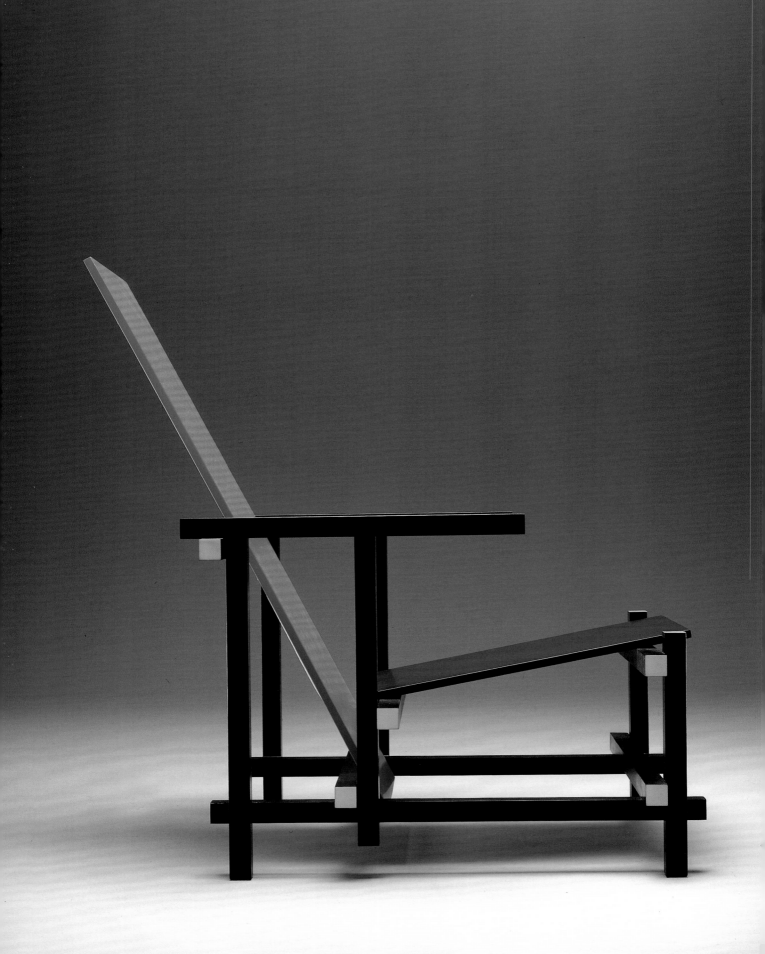

Piet Mondrian
Composition A, 1919
Oil on canvas, 130 x 130 cm
Rome, Galleria Nazionale d'Arte
Moderna e Contemporanea

Opposite
Gerrit Rietveld
Red and Blue Chair, 1918
Painted wood, 86.7 x 66 x 83.8 cm
Munich, Staatliches Museum
für Angewandte Kunst

plete; the two forms merged and interpenetrated; the line thinned out; the vertical line, already identified in the writings of Blavatsky as the male principle, was juxtaposed with the horizontal line, the female principle. This formal research lay at the foundation of the 'new plastic art' that would find full theoretical elaboration after the foundation of the magazine *De Stijl*, and especially in the essay 'Neo-Plasticism in Painting' of 1920. Prior to that date, his *Lozenges* also appeared, an attempt to suggest with their orientation the form of the Greek cross, another symbol that was especially dear to theosophy. The conquest of the primary colours beginning in the early 1920s was nothing more than the point of arrival of a simplification process that tended towards the purity of the pictorial elements.

From this point on Mondrian's style remained substantially unchanged. In 1919 he returned to Paris where he joined the abstractionist group Cercle et Carré (1930) and the movement Abstraction-Création (1932). After a two-year stay in London, in 1940 he moved permanently to New York, where his colourful *Boogie-Woogies* were his abstractionist response to the artistic and economic fervour of the New World. The life of Theo

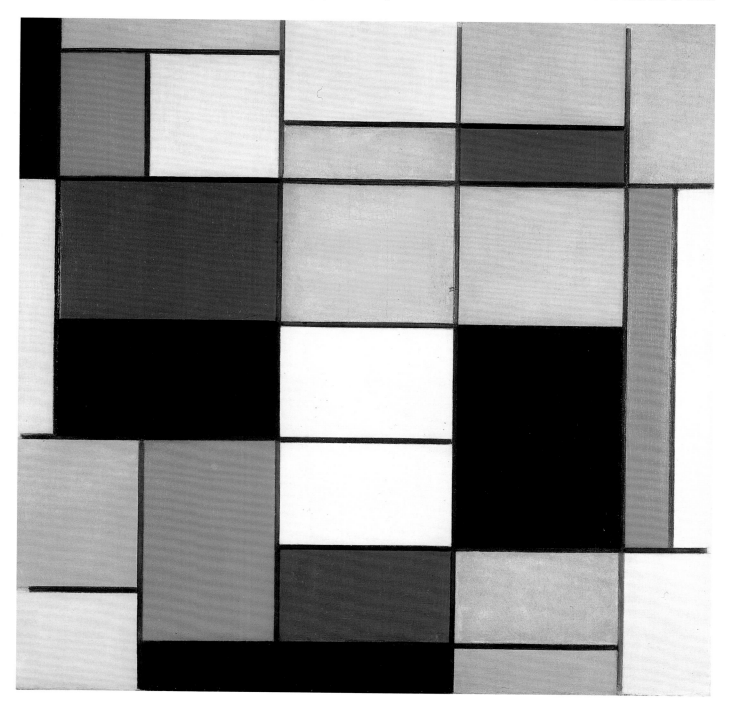

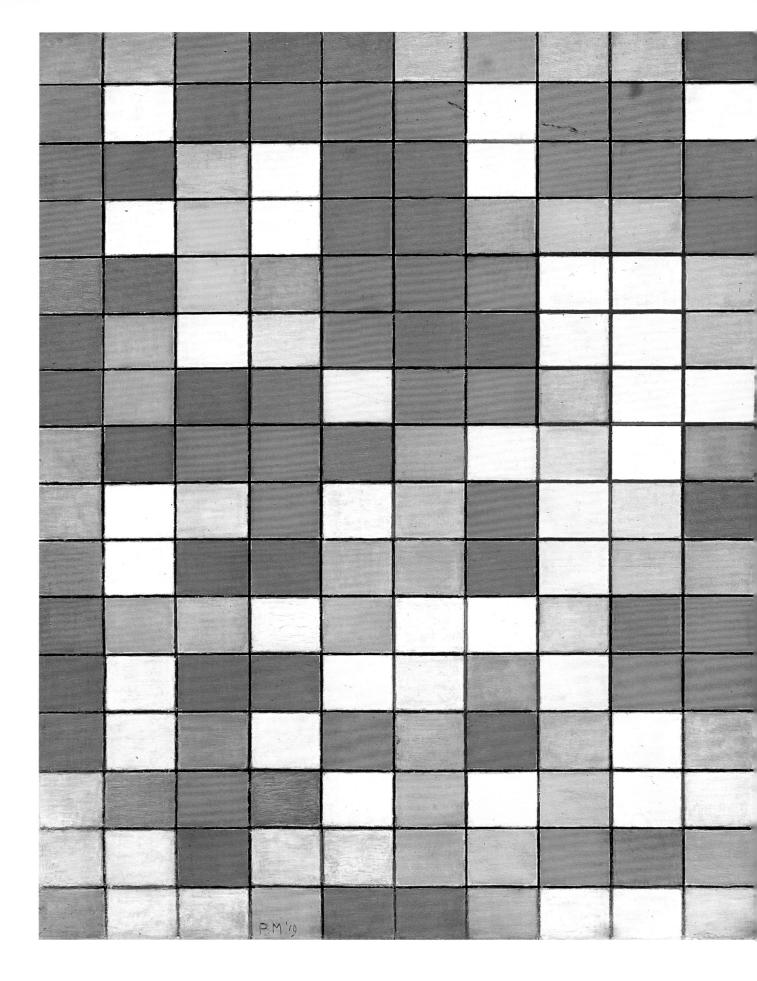

van Doesburg was also marked very early by theosophy. He began as a naturalist painter but once he learned about the Fauves and Kandinsky he soon moved towards abstract painting. In 1903 he met his first wife, Agnita Feis, a poetess and theosophist, and in 1916 he was introduced to the painter Janus de Winter, also a theosophist. That same year he met Mondrian, whose abstract art constituted a dazzling alternative to the mystical naturalism of De Winter. For two years Van Doesburg planned *De Stijl*, despite Mondrian's initial misgivings. In the meanwhile, the artist executed his first collaborative work, with Jacobus Oud, who became one of the founders of the magazine. In 1916, the architect Oud commissioned Van Doesburg to make a number of stained-glass windows for a house in Broek-in-Waterland, the first of a long series of projects they would do together, which allowed Van Doesburg to study the interrelation between details and architecture, and especially to engage with the flat form of stained-glass windows. It was in the same milieu that he began to produce abstract works; these were simplified and based on precise mathematical calculations, and inspired by the research being done at the time by the Cubist painters. These were the works that brought Van Doesburg closest to Mondrian, but he applied them with great success to stained-glass windows and to interior decoration. After the foundation of *De Stijl* his work as a theorist and writer (under the name of Bonset in the role of Dadaist poet and with the name of Aldo Camini in the role of Futurist) became frenetic, and after 1923 reached the point of monopolising the magazine, thus engendering bad feelings among the members of the group and hastening the end in the third decade when they went their separate ways. Van Doesburg contributed independently to many magazines, especially in France, and founded a periodical of Dadaist and literary inspiration called *Mécano*.

At some time in 1922 or 1923 came the final break with Mondrian. This may have been the result of personal differences but had important results in formal terms. Van Doesburg had already published articles in other magazines that went against Mondrian's ideas, but their differences became insoluble in 1922 when the pair moved to Paris: these were the years in which Van Doesburg began to apply to neo-Plasticism the diagonal line in a dynamic sense (and he spoke significantly of counter-compositions), a concept that, according to the principles upon which Mondrian's *Compositions* were based, violated the

Theo van Doesburg
Composition 22, 1920
Oil on canvas, 169 x 160 cm
Eindhoven, Van Abbemuseum

Pages 316–17
Piet Mondrian
*Checkerboard Composition with Light
Colours*, 1919
Oil on canvas, 86 x 106 cm
The Hague, Haags Gemeentemuseum

Theosophy and anthroposophy

Piet Mondrian
Evolution, 1910–11
Oil on canvas, 183 x 87.5 cm (central panel), 178 x 85 cm (side panels)
The Hague, Haags Gemeentemuseum

The metaphysical and spiritualist tendencies of the late nineteenth century found a place for expression in the Theosophical Society, founded in New York in 1875. Among its members was the Russian, Elena Petrovna Blavatsky, author of the very successful work *The Secret Doctrine* (1888), which combined Western occultist traditions with the foundations of great Oriental religions, above all Hinduism and Buddhism. The founding principle of every theosophical idea is 'ascesia', understood as detachment from the earthly world to arrive at the most intimate and profound meaning of things and 'knowledge of God', as the name of the doctrine itself

indicates. Blavatsky's ideas were taken up in subsequent years by theosophists such as Annie Besant, Charles Webster Leadbeater—authors of an important illustrated book called *Thought Forms* (1905) for artists of the period—and Rudolf Steiner. The latter, as a reaction to the emphasis given by theosophy to Oriental religions, founded the Anthroposophical Society (1913), which was based on the principle that occult science can be dealt with in exactly the same way as any other modern discipline, and concentrated above all on observation of the natural world: beneath the chaos of the perceptible world it is possible to achieve universal harmony.

The principle constitutes a late elaboration of ideas already extant in the spirit of German Romanticism and in the writings of Goethe. At the figurative level, the progressive ascensis from the earthly world passes through the discovery of geometrical figures as forms that are particularly pure and universal in their simplicity and in their proportional clarity ('sacred geometry'). Among the first to be attracted by theosophy were Kandinsky, Mondrian and Malevich, the fathers of European abstract art; during his formulation of the principles of Suprematism, the latter came into contact with the theosophist Pyotr Uspensky.

Theo van Doesburg
Composition XV, 1925
Oil on canvas, 98 x 98 cm
Lodz, Muzeum Sztuki

ideal static nature and the motionless equilibrium that underlay the 'new plastic'.

Van Doesburg's collaboration with leading architects marked the successful beginning of the period of De Stijl architecture; the most significant achievements, however, belonged to the subsequent decade, when the birth of Elementarism marked a strong point of disagreement among the members of the group. The years between 1917 and 1922 marked the time of the architectural experiments closest to neo-Plasticism and most consistent with the approaches of De Stijl, to whose poetics Van Doesburg recruited many architects: with Oud

he built the De Vonk vacation home at Noordwijkehout (1918), with Rietveld he built a room for Bart de Ligt (1919), and with Jan Wils he built the De Lange House at Alkmaar (1917) and the Hotel De Dubbele Sleutel at Woerden (1918). In 1920–21 he designed the colours and the upholstery of several buildings at Drachten for the architect Cornelis de Boer. During a conference at the Bauhaus in Weimar (1922), Van Doesburg met the Dutch architect Cornelis van Eesteren, with whom he collaborated on the exhibition *The Architecture of De Stijl* in the prestigious gallery belonging to Léonce Rosenberg in Paris. Three

Theo van Doesburg
Counter-Composition XIII, 1925–26
Oil on canvas, 50 x 50 cm
Venice, Peggy Guggenheim Collection

years before, the gallery owner had commissioned Van Eesteren to build an 'ideal' De Stijl house, but this did not happen until 1923, when it was constructed by Rietveld.

Beginning in 1918, the very young Jacobus Oud became the chief architect of the city of Rotterdam, where he built the first working-class houses (1918–19) based on neo-Plastic ideas. They featured large flat geometric surfaces, and a harmonious array of white volumes in which the squares of the windows and other fixtures were painted with the pure colours favoured by Mondrian. Oud, however, proposed a concrete solution to the neo-

Plastic theoretical speculations that, by their very 'universal' nature, admitted no deviations based on contingent circumstances. The first disagreements between Oud and Van Doesburg arose in connection with the use of traditional materials, such as brick, and the utilisation of uniform volumes in the working-class houses in the district of Tusschendijken (1920): according to Van Doesburg, juxtaposed elements in neo-Plastic architecture must be different, since harmony arises from the interplay between heterogeneous forms. Gerrit Thomas Rietveld began his activity in Utrecht as a carpenter working with his father, and in

Paul Klee
Laughing Gothic, 1915
Watercolour and pencil on paper glued
to board, 29 x 16 cm
New York, The Museum of Modern Art

1911 he opened his own workshop specialising in furniture decoration. After developing an interest in architecture, he was one of the first to join the De Stijl group; he was not a signatory to the group's manifesto but he fully shared its ideas. An example of neo-Plastic design that he had already undertaken was the renowned *Red and Blue Chair*, a perfect interpenetration of Mondrian's rectangular forms and the primary colours. New furnishings followed, including the studio of Dr Hartog in Maarssen (1920) and the G.Z.C. jewellery shop in Amsterdam (1920–22); the latter is considered one of the architectural manifestos of the new style. His collaboration with the interior decorator Schröder-Schräder led to the construction of *Schröder House* in Utrecht (1924), which opened the episodes of Elementarism and the architecture of the decades that followed. Interior decoration also became the field chosen by Vilmos Huszár, of Hungarian origin, who had moved to Holland in 1905 after completing his studies in Budapest and Munich. From 1921 he adopted primary colours for his furnishings, but his unwillingness to compromise and the demands of his clients prevented him from finishing many projects. The distinctly Jugendstil milieus of these two cities guided him very early towards a simplified and abstract form, so he was an enthusiastic adherent of De Stijl but without the idealism that drove Mondrian, whose research he shared. He devoted himself to graphics: *Composition 1916* which, despite the title, must have been executed around 1920, emulated one of the first covers of the magazine. After 1920, perhaps stimulated by the research being done by Van Doesburg, he took up use of the diagonal line and followed Van Doesburg when he joined the abstractionist group Cercle et Carré with Georges Vantongerloo in 1931. Vantongerloo, who was one of the founders of *De Stijl*, was close to abstraction and neo-Plasticism in particular because of his talent for mathematical and proportional calculations, which allowed him to compose highly calibrated *Compositions*. He was one of the neo-Plastic artists who also practised sculpture, and he followed the poetics of Oud, often quarrelling with other artists because of the plastic solidity of the elementary volumes that he juxtaposed in his works (*Interrelation of Volumes*, 1919).

Even more than in the cases of Kandinsky, Marc and Jawlensky, the experience of Paul Klee cannot be dismissed as mere research into abstract form. It became affiliated with the Blaue Reiter only in the second exhibition, and it shifted easily from figuration to abstractionism and back again without any specific theoretical requirements, yet he always felt called upon to explain his artistic ideas in numerous writings, for example, the diary that he kept between 1898 and 1918, his articles for the Bern magazine *Die Alpen* and for *Der Sturm*, and the important lecture he gave at the University of Jena in 1924 entitled *On Modern Art* (published in 1945). All of these contributions can only be understood and explained with the help of the poetic imagery that the artist used, and not with references to the theories on abstract form developed by Kandinsky. The focal point is always the act of artistic creation, in other words, the personal mediation between reality and finished artwork, inexplicable in itself, that is carried out by the artist. Klee constantly reiterated that nature and the world were the basis from which creation began. His debt to the spirituality of the Blaue Reiter and Kandinsky here becomes quite evident, even if Klee was supported by a more vivid imaginary esprit and a profound sense of irony.

After receiving a Jugendstil education from Franz von Stuck at the Academy of Munich (1900–01), Klee's poetics developed through numerous trips to Italy (where the artist was impressed by the ancient painting of Pompeii) and France (where in Paris he identified Cézanne as his true master). After the experience of the Blaue Reiter, his art received important stimuli from Cubism and Futurism, which were crowding the galleries of Germany. But it was especially the work of Delaunay and a trip to Tunisia with August Macke and Louis Moilliet that opened his eyes to the path of colour, bringing him closer to the central matrix of his research. His Tunisian watercolours showed the two sides of Klee's soul: the naturalist aspect, which did not give up its fascination with nature and was exalted through warm and nuanced colours, and the more abstract aspect, according to which objects underwent a geometric deconstruction comparable to the one carried out by Delaunay. *Red and White Domes* is an example of how drawings of objects that recognisable as domes could be grafted onto an abstract base.

In 1920, Gropius summoned Klee to the Bauhaus where the artist was able to indulge his passion for engraving by supervising the bookbinding workshop, and his own aptitude for the juxtaposition of coloured forms by teaching in the workshop for stained glass. Here, moreover, Klee developed a more in-depth approach to colour theory that ran parallel to, and in certain areas converged with, that of Kandinsky: to Klee colour was like mu-

Paul Klee
Villa R, 1919
Oil on cardboard, 26.5 x 22 cm
Basel, Kunstmuseum Öffentliche
Kunstsammlung Basel

Paul Klee
Wald bau, 1919
Mixed media on canvas on cardboard,
27.5 x 26 cm
Milan, Civiche Raccolte d'Arte,
Jucker collection

sic, since they both take our senses well beyond rational comprehension. Colour is a rhythmic and dynamic element, not only in the case of abstract artworks, but also in the presence of clearly recognisable elements. Until 1933, the year that the Bauhaus closed, the artist's works were an expression of this theory. Constant elements in Klee's paintings were archetypal and symbolic forms taken from nature (moon and stars), from geometry (triangle-pyramid and square), and often also from the Western hermetic tradition (ladder, Star of David, and serpent): these are figures that strike the most intimate chords in humans—inasmuch as they are archetypes—but which have no explanation that is necessarily logical within the artwork. In his output it is also possible to identify several compositional schema derived from the ideas of the Blaue Reiter, such as the so-called 'magical square', where overlapping zones of colour, square or rectangular in shape, are juxtaposed in increasing or decreasing order, so that they tend simultaneously to merge and separate; others were the 'meandering' structure typical of the Bauhaus period or else the 'mosaic' structure, also derived from Kandinsky and Delaunay.

Often, stylised human figures similar to marionettes or dolls were present in the canvases, in a reference to the theatrical workshops of the Weimar school. Dominating all Klee's constructive logic was his 'childlike gaze', which looked on reality with amusement: unsurprisingly it was Klee who wrote several of the finest articles on infant expressiveness published in the Blaue Reiter almanac.

The Semantic Revolution of the Avant-gardes

Metaphysics

To tell the story of Metaphysics means, first, attempting to free oneself from the critical misunderstandings that have rendered it, on one occasion or another, the first episode of the return to order and the prerequisite to the Surrealist exploration of the subconscious, the work of a group or the invention of an individual. Contributing to these misunderstandings were the Metaphysicians themselves, the intricate history of the phenomenon, the various accounts of that history, and the hostility between its two chief protagonists, De Chirico and Carrà. In the first place, Metaphysics has at least two different historic phases: the authentically avant-garde work of de Chirico from 1911 to 1917 that was to have an enormous influence on Dadaism and Surrealism; and the Metaphysical school, which sprang from the Ferrarese partnership between De Chirico and Carrà, which represented a moment of theoretical construction, polemics and a return to tradition. The misunderstanding of anti-avant-garde Metaphysics, the standard-bearer of tradition, originates here, from the theoretical contributions of the magazine *Valori Plastici* (1918–22), and the central role attributed by the majority of Italian criticism to the path followed by Carlo Carrà, who was much more influential than de Chirico in the Italian art of the 1920s and 1930s; but also by de Chirico's very anti-modernism, which he exhibited on numerous occasions from the 1920s on and on his own account also extended retrospectively to his earlier phase.

Giorgio de Chirico was born in Volos, in Thessaly, to Italian parents (his father, an engineer, was working on the construction of a railroad). There, amidst the ruins of the classical world and an up-to-date, stratified and cosmopolitan culture, he spent an unusual childhood, which certainly had its effects on his artistic career. Following his father's death in 1905 he left Greece with his mother and his brother Andrea, who would use throughout his own career, as a man of letters, composer and later also painter, the pseudonym Alberto Savinio. Despite the version given in his late *Memoirs* (1945), the intention was probably to take up residence in Florence, the De Chirico family's place of origin. After a brief stay in Venice and Milan (where he had an opportu-

nity to study the paintings of Segantini and Previati), he took up residence with his family in Florence until autumn 1907. Given the artist's reluctance to talk about this period, it is hard to say what role it played in his education, but it is likely that it was in Florence that De Chirico became acquainted with the painting of Arnold Böcklin and first began to gather notions of German philosophy. His fascination with this, and other factors, led him to go to Munich with his mother and brother and enrol in the local academy of art. During his stay there, he began to explore those affinities that would fascinate him for the rest of his life: the classicistic symbolism of Arnold Böcklin, the mysterious and very modern etchings of Max Klinger, and the philosophy of Nietzsche, Schopenhauer and Weininger. In the summer of 1909 he was back in Milan, and from there returned to Florence at the turn of 1910, remaining there until July of the following year, when he moved to Paris.

However De Chirico attempted to minimise with determination the role played by this stay in the gestation of Metaphysics because of his later hostility towards Giovanni Papini, but also due to the specific intention of underscoring the unique nature of his education and his independence from the Italian and French intellectual milieu. In Florence, De Chirico fell under the spell of Papini's philosophical short stories, which were published as a book called *Tragico quotidiano* (1906). The Florentine author became the link (and the filter) for an approach to the work of Nietzsche and Schopenhauer. To prove this, one need only adduce, along with the atmosphere of his stories, a few of the arguments and ideas expressed in the introduction: the theme of the child-artist, the philosopher-poet, of oblivion, the mystery of ordinary things and time standing still, and man observed in his quality as a 'thing'. In stylistic terms, as he moved away from the influence of Böcklin in his early work, there was a combination of fourteenth-century frescoes, the Venetian tonalism he had studied at the Uffizi, and Gauguin's synthetism. And so we witness the birth, in the distorted perception caused by a troublesome intestinal influenza, of *The Enigma of an Autumn Afternoon* (1910): 'One clear autumn afternoon, I was sitting on a bench in the middle of the Pi-

Giorgio de Chirico
Hector and Andromache, 1917 (detail)
Oil on canvas, 90 x 60 cm
Private collection

Giorgio de Chirico
Serenade, 1909
Oil on canvas, 82 x 120 cm
Berlin, Neue Nationalgalerie

azza Santa Croce in Florence... I had just emerged from a long and painful intestinal disease and I was almost in a state of morbid sensibility. The whole world surrounding me... seemed convalescent to me... I had the strange impression that I was looking at those things for the first time, and the composition of the painting revealed itself to my mind's eye'. The theme of disease is Nietzschean, and equally Nietzschean is the *Stimmung* of the autumn afternoon, which became a recurring feature in De Chirico's Metaphysics: likewise, the lengthening shadows, the statue seen from behind, and the theme of the voyage, evoked by the sail that can be glimpsed beyond the oracular drapery that closes off the horizon. Even if it was inspired by a real landscape, the painting is a sort of mental distillation, devoid of all contingent factors, with flat, understated hues, and simple, precise lines.

Dating from 1910–11 is *The Enigma of the Hour*, which also harks back to a piece of Florentine architecture, that of the fifteenth-century Spedale degli Innocenti. At the middle of the composition, a stopped clock does nothing more than consent to the suspension of the midday hour; the two figures in the scene are extraneous one from the other, as granitic and phantomlike as the architecture that they

inhabit, while an empty pedestal introduces the key-theme of absence. Here too, it is difficult to set the work in a clear genre: as Ardengo Soffici wrote in *Lacerba* (1914), 'the painting of De Chirico is not painting in the sense that is attributed nowadays to the word. It could be described as the writing of dreams'.

In July 1911, De Chirico moved to Paris where his brother Alberto Savinio was already living. This first Parisian period, which was interrupted in 1915 by the outbreak of war, was fundamental to the development of Metaphysics. Although he always held himself somewhat aloof from the others, De Chirico established himself in the avant-garde intellectual milieus: he frequented the salon of Guillaume Apollinaire and was introduced by Picasso to his first Parisian gallery owner, Paul Guillaume. In 1912 he showed three artworks at the Salon d'Automne, where he returned in 1913, and that same year and the next, he also showed at the Indépendants. Apollinaire spoke glowingly of his painting, and Jean Paulhan, a very influential collector in Paris at the time, bought some of his works. These interactions alone would be enough to debunk the myth (fuelled by De Chirico himself) that Metaphysics was a first episode of a return to order following the war. De Chirico, who had ulterior motives for

Giorgio de Chirico
The Enigma of the Oracle, 1910
Oil on canvas, 42 x 61 cm
Private collection

Pages 328–29
Giorgio de Chirico
The Enigma of the Hour, 1910–11
(detail)
Oil on canvas, 55 x 71 cm
Private collection

emphasising certain traditional aspects of his painting in order to claim that he had always been a 'classical' painter, actually paid close attention, as we learn from his notes, to certain leaders of the reform movement, such as Gauguin, Van Gogh and Cézanne, though he later feigned disdain. And he does not hesitate to take on the challenge of the rejection of perspective proposed by the Cubists, to which he responds with a perspective drained of meaning, transformed into an abstract medium, a purely theatrical expedient. In the *Squares of Italy*, he introduces the first falsified perspectives, the multiple vanishing points, and the inclined planes, which he later accentuated to the point of rejecting all spatial quality, in both still-lifes and such compositions as the renowned *Portrait of Apollinaire* (1914). His painting becomes increasingly flat and anti-academic, setting—alongside the broad zones of uniform and opaque colour—the summary lines, the outline that abolishes the chiaroscuro, and the linear hieroglyphic that often becomes a hermetic sign like the cipher of an unknown alphabet. He is attentive to the mystery of life and the contemporary city, which he incorporates in his themes (trains, stations, smokestacks), his electric, unnatural colours, and in the subjects of his still-lifes (bunches of bananas, the fish mould, and the toys present, for instance, in *The Sailors Barracks* 1914). He indulges in spatial and temporal absurdity, and he is not immune to deformations (like those that twist the many Ariadnes that people his piazzas). That said, it should be made clear that the revolution, the one that unfailingly characterised Metaphysics as avant-garde, is not so much a matter of formal order but rather an issue of 'spiritual' content. The unique quality of De Chirico's Metaphysics lies precisely in its avoidance of the dead end of the formal revolution undertaken by Impressionism and abandoned by the avant-gardes, in order to determinedly try another path, once again following a route interrupted by Symbolism, and taking it to its extreme consequences. For De Chirico, as later for Surrealism, painting was not a goal but a medium: the chosen medium to translate into imagery the 'profound significance of the meaninglessness of life', in order to transmit a poetic and philosophical content, because 'the good new craftsmen are philosophers who have outdone philosophy'. The revolutionary potentials of such an approach were enormous, as would soon be understood by the Dadaists and the Surrealists, who would al-

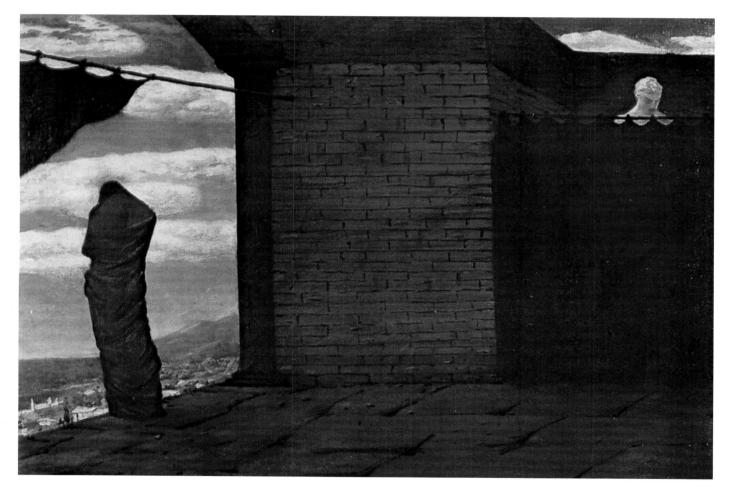

ways recognise their profound debt towards the 'fatal' art (André Breton) of De Chirico.

The foundations of the poetics of Metaphysics were publicly set forth by De Chirico later, with the writings he published in *Valori Plastici* and in *Convegno* between 1918 and 1920; but it is worth our while to examine a few extracts, because they make it possible to unravel certain enigmas. In his essay *Sull'arte metafisica* (which appeared in *Valori Plastici*, April–May 1919) De Chirico discusses the ability, shared by madmen and visionaries, to discover in certain moments a mysterious aspect of the most ordinary objects and situations, and describes art as 'the fatal net that captures in flight, like great mysterious butterflies, these strange moments, which elude the innocence and distraction of ordinary men'. Making reference to Schopenhauer, he explains these revelatory moments as the loss of memory, the momentary suspension of the continuity of recollections: 'I enter a room, I see a man sitting on a chair, I see a cage hanging from the ceiling, with a canary inside, on the wall I see a number of paintings, in a library I see a number of books; all of this makes an impression upon me, it does not amaze me because the chain of memories linked one to another explains to me the logic of what I am seeing; but let us agree that for a moment, and for unknown reasons, independent of my will, the links of this chain are broken, then who can say how I would see the seated man, the cage, the paintings, the library? Who can say what amazement, what terror, and perhaps even what sweetness and consolation I might feel as I looked at this scene? The scene itself would not have changed, I would see it from a different angle. And here we have the Metaphysical aspect of things'. And that is the union, in a single image, of a plaster bust, an orange rubber glove, and a green glove (*Love Song*, 1914), or a zinc fish, a classical bust with dark pince-nez glasses, and a target-silhouette (*Premonitory Portrait of Apollinaire*, 1914) can trigger such turmoil in the observer: the absence of a key for interpretation and a substrate of memory provokes a short circuit triggered by De Chirico through the creation of an atmosphere, the shrinking of perspective (which creates a psychic, non-physical space), the introduction of signs that belong to a geometry of mystery, and which disturb us precisely because they are in no way nebulous, but in fact show a precision that we are unable to decipher. Well ahead of Surrealism (and in parallel with the analogies of Lautréamont), De Chirico saw reality on various levels, which he blended into a single image, creating mysterious liaisons, in a lucid and overheated atmosphere. In his

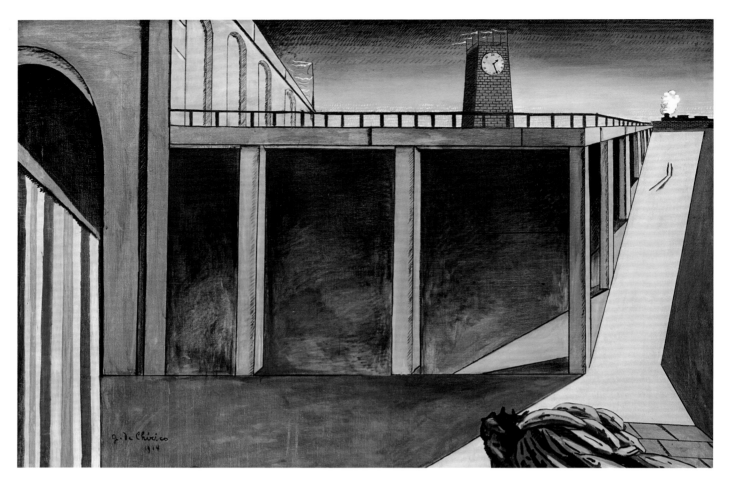

Giorgio de Chirico
Gare Montparnasse (The Melancholy of Departure), 1914 (detail)
Oil on canvas, 140 x 184 cm
New York, The Museum of Modern Art, Gift of James Thrall Soby

Opposite
Giorgio de Chirico
Premonitory Portrait of Guillaume Apollinaire, 1914
Oil on canvas, 81 x 65 cm
Paris, Musée National d'Art Moderne, Centre Georges Pompidou

words, a Metaphysical painting is an 'inhabited depth': a calm and serene surface that, like the ocean, unsettles us 'not so much by the idea of the distance in miles that lies between us and its bed as much as for the unknown things that lie hidden in that bed'.

It is worth insisting further on this 'serenity', which allowed De Chirico to move rapidly past the mists of Symbolism and open up to the irritated and hypersensible gaze of Surrealism. As he states in *Noi metafisici* (February 1919): 'Now, in the word "Metaphysics" I see nothing shadowy or dark; it is the very tranquillity and senseless beauty of material that appears "Metaphysical" to me, and all the more metaphysical appear those objects that in their clarity of colour and exactitude of dimensions are the polar opposites of all confusion and all nebulosity'. But the serenity of De Chirico's Metaphysics is negative in nature, the serenity of those who note the enigma and recognise, with superior irony, the absurdity and meaninglessness of life. A negative that was accentuated, instead of fading, during the Ferrarese years, and which would lead in the final analysis to the break with the other Metaphysics set forth by Carrà. Among the subjects that incarnate, without unveiling it, the mystery of the world, a special interest pertains to

those, intimately correlated, of the toy and the mannequin. The first harks back to childhood, the source of so many Metaphysical phantoms, the Nietzschean theme of the artist-child and the childhood of the world. De Chirico wrote in his notes from those years: 'To live in the world as if in an immense world of strangeness, of curious multi-coloured toys that shift their appearances, which we children sometimes destroy in order to see what they look like on the inside, only to discover, to our disappointment, that they are empty'. The other one is the mannequin, which nourishes itself on many references—from Pinocchio to the mannequins glimpsed in the seamstress's display windows, from futuristic automatons to classical statuary, and, finally, to the writings of his brother Savinio, such as the *Chants de la Mi-Mort* (1914) and the fundamental work *Hermaphrodito*, penned in the Ferrarese years and published in 1918. The mannequin represented the poet as seer, intent upon deciphering the mystery of the world, but it is also part and source of this mystery. Often, as in the *The Prophet* (1914–15), he is placed before a painting or a blackboard, intently deciphering the mystery, and upon the faceless head is depicted a single, cyclopean eye, in turn a sign that is difficult to decipher.

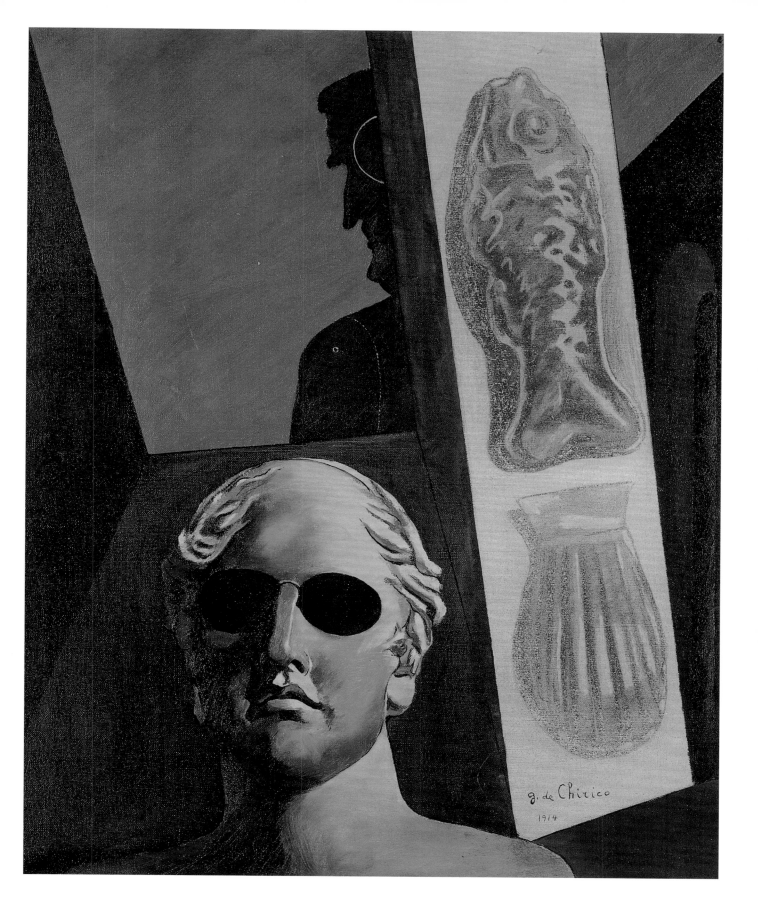

Giorgio de Chirico
The Enigma of a Day, 1914 (detail)
Oil on canvas, 186 x 140 cm
New York, The Museum of Modern
Art, James Thrall Soby Bequest

Giorgio de Chirico
The Child's Brain, 1914
Oil on canvas, 81 x 54 cm
Stockholm, Moderna Museet

De Chirico reached Ferrara in the summer of 1915, sent by the military command of Florence, along with his brother Savinio. After a few days in the barracks, a major hired them as accountants, allowing them to 'live a little more like humans', to sleep at their mother's house (in the meanwhile, she had caught up with them), to tour the city, to spend time writing and painting, and to get to know a few local inhabitants, 'more or less mad', among whom was Filippo De Pisis, alias Filippo Tibertelli: 'he lived in a strange room, full of anomalous and bizarre objects: stuffed birds, strangely shaped {inguastade}, flasks and flagons and fragments of every sort, old leaves that would crumble at the merest touch. He lived in this sort of sorcerer's workshop, a true Surrealist *ante litteram*'. A cheerful and ironic poet, De Pisis painted in those years a number of canvases of Metaphysical inspiration, but his writing especially was influenced by the poetics of the two brothers. The city of Ferrara intrigued De Chirico with its overheated and vaguely mad atmosphere and for the Metaphysical glimpses that opened out at every street corner and shop window. This period also witnessed the birth of the first Metaphysical interiors, which developed in a yet more hermetic and spatially innovative direction, the foundations laid by the Parisian still lifes. In the interiors of 1916 we see stacked and bundled maps, blackboards, rulers, geometric and decorative motifs, paintings within the painting, strange objects whose function and significance is lost to

Giorgio de Chirico
The Seer, 1914–15
Oil on canvas, 89 x 70 cm
New York, The Museum of Modern
Art, James Thrall Soby Bequest

Giorgio de Chirico
The Philosopher and the Poet, 1915
Oil on canvas, 83 x 66 cm
Private collection

 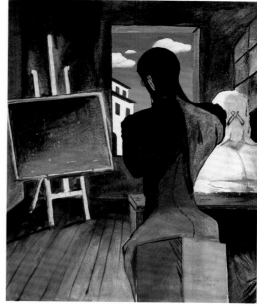

us, and above all the dried crackers whose bizarre shapes seem to synthesise the Metaphysical mystery of Ferrara. *Greetings from a Distant Friend* (1916) show in a significant manner the leap forward made in Ferrara by De Chirico: space is annulled by a succession of flat and inclined planes, devoid of depth but rendered concrete by the glancing light. Painted in a hyper-realistic manner (like the *trompe-l'œils* of Cubist still lifes), two dry biscuits bounce violently in the foreground with their brusque materiality: one of the two takes the form of an X, a sign and depiction of the unknown. In the background, a sheet of paper presents a stylised version of an eye ('It is necessary to find the eye in everything', he wrote in 1918 in *Zeuxis the Explorer*).

Another distinctive theme of the Ferrarese period is the painting within a painting, which along with the maps and the windows brings the exterior into the interior, and alludes to the motif of the voyage, of exploration: as in *Metaphysical Interior (with Sanatorium)* (1917), which transforms the landscape into a still-life, and opens the road to an entirely mental journey. It was in April 1916 that he met Carlo Carrà, who had been transferred to the same hospital where De Chirico was being treated during the final months of the war. The friendship that emerged did not last long, but it was fundamental to the later developments of Metaphysics. During the month of August, Carrà left the military hospital for Milan where he organised a show of his Metaphysical paintings (from December 1917 to January 1918). Latent disagreements began to arise between them, until the final break, marked, in December 1919, by the publication of Carrà's book, *Pit-*

tura metafisica, in which De Chirico's name was not even mentioned. Around 1915 Carrà began to feel a growing dissatisfaction with Marinetti's—and Milanese—Futurism, which led him first to approach the Florentine group of *Lacerba* (centred around Soffici and Papini), and then to reconsider the value of tradition that had been so much reviled in previous years. In reality, this return to tradition constituted (at least at first) a contradictory amalgamation among the re-emergence of primitivist tendencies, present in all the avant-gardes, and the need to return to an affirmation of the values of form. Therefore, Carrà's models were not so much the Douanier Rousseau and Malevich of the early period, as Paolo Uccello and Giotto. From this spirit there emerged, in late 1915 and 1916, the formidable phase of the 'Anti-Gracious', in which the Futurist vortex found reinforcement in simple, enclosed, almost childish forms, while the colours, laid out patiently in overlapping layers, were consolidated into rich and magmatic masses. The figures were often isolated against an empty background devoid of spatial connotations and suspended in a mythical and timeless atmosphere; in other cases, such as 'Anti-Graciuos' (*Little Girl*, 1915–16), they were set in cubic formulations inspired by the volumes of the painting of the Trecento. Certainly, prior to their meeting in Ferrara, Carrà was already familiar with a number of works by De Chirico but gave no indication of holding them in high esteem. When Soffici suggested he take them as a model, as an example of 'modernity that harks back to the majesty of antiquity', he replied that 'his form of painting, the more I think about it, the more it seems to me a chilly *literary rationali-*

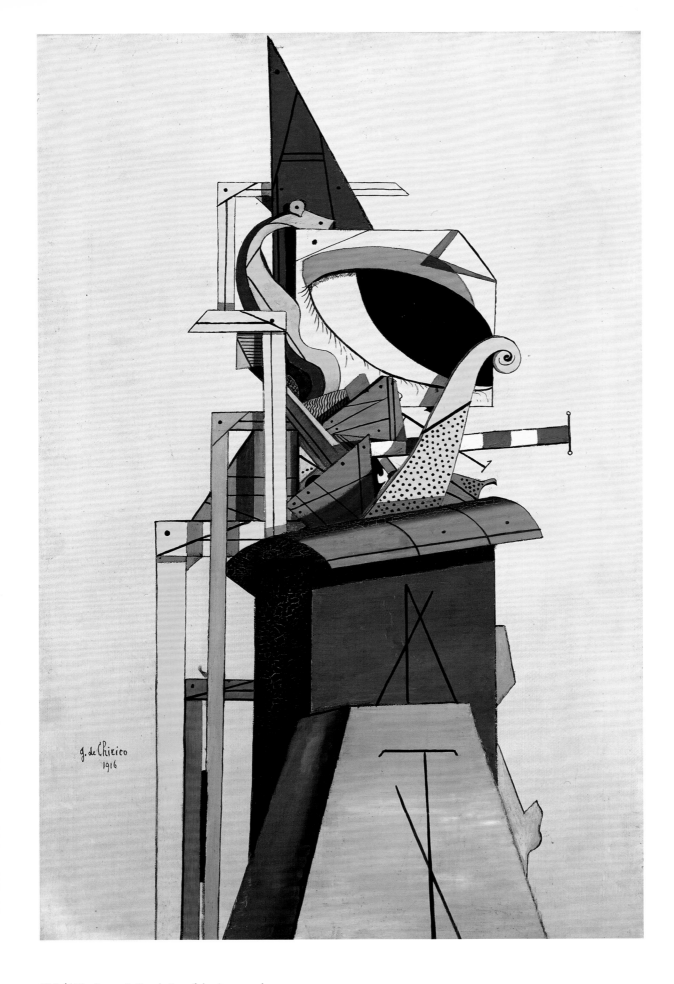

g. de Chirico
1916

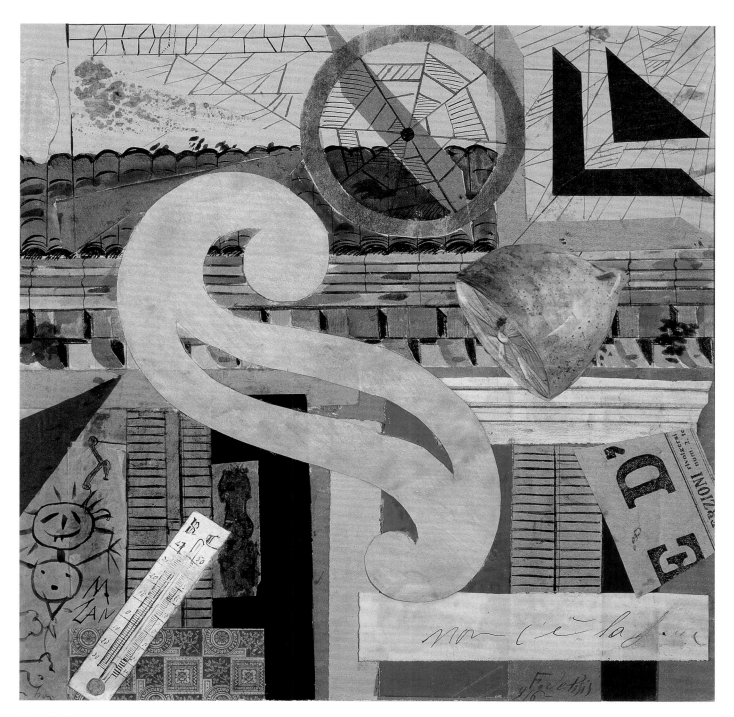

Filippo De Pisis
No End, 1916
Oil and collage on canvas
Private collection

Opposite
Giorgio de Chirico
The Jewish Angel, 1916
Oil on canvas, 67 x 43 cm
Private collection

sation'. Even Papini made an attempt to bring the two painters together. Though the two personalities could hardly have been more different, for a number of months there was a true friendship between them. Carrà found mannequins useful to his research (which was a development of his mannequins of the 'Anti-Gracious'), as well as the return to perspective, atmospheres of suspense, blocked movement and the set squares (which were not references, as in De Chirico, to the mystery of the triangle, but rather to the myth of the builder, the artist-engineer). He did not limit himself, as De Chirico charged, to replicating the same

subjects in rough copies: Carrà took a number of the themes for himself, and twisted them with such energy to his own new poetics that he changed their fundamental nature. One excellent example can be seen in *The Metaphysical Muse* (1917): typical of De Chirico are the lengthening shadows, the map, the target, the painting within the painting, the bright colours of the pyramid in the background, the cross, and the mannequin. But this is as simplified, rough and childish as the little girl in the 'Anti-Gracious'; the perspective determines a real space, slightly undersized but still inhabitable and based on straight lines. The painting

Giorgio de Chirico
The Melancholy of Departure, 1916
Oil on canvas, 52 x 36 cm
London, The Trustees of The Tate
Gallery

Opposite
Giorgio de Chirico
Metaphysical Interior
(with Sanatorium), 1917
Oil on canvas, 96 x 70 cm
New York, The Museum of Modern
Art, Gift of James Thrall Soby

Pages 338–39
Carlo Carrà
Western Horseman, 1917 (detail)
Oil on canvas, 52 x 67 cm
Private collection

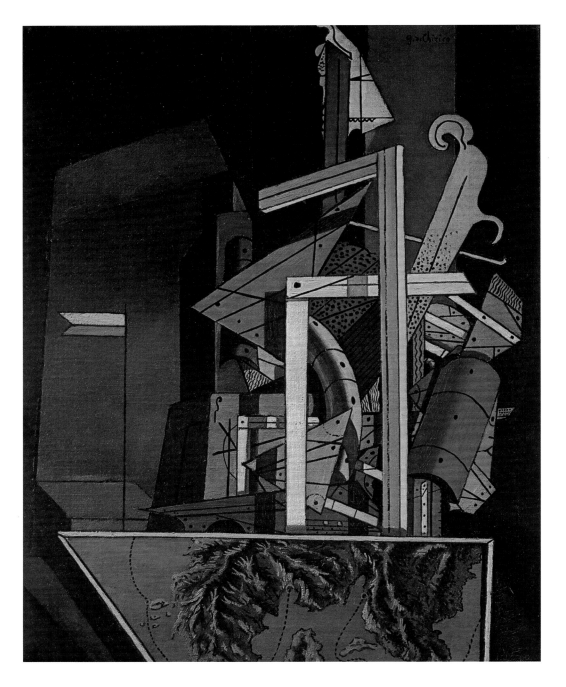

contains an enigma, but it is a mystery that has a solution. In this, and in the other paintings of the period, just as in his own writings, Carrà set out another Metaphysics that was opposed to De Chirico. In contrast to De Chirico's nonsense and irony, Carrà offered a healthier, more stable vision, based upon rationality and a sense of order; against the sense of absurdity and nullity, he set out a determination to resolve enigmas; against the 'uncommon', his poetics of 'ordinary things'; against the unhinged space, a normalised space; against the subversion of the negative, the conformity of the positive.

These two radically differing visions could not long coexist, if for no other reason

than the strong personalities of each. But something more was developing, between the end of 1917 and 1919, and it took shape as a fully-fledged strategy for the exclusion of De Chirico from the future of Metaphysics, set in motion by none other than Papini, Soffici and Carrà. It was a strategy that proved victorious, at least in Italy, in part due to the support of the critic Roberto Longhi (who, in February 1919, panned De Chirico, dubbing him an 'orthopedic God' and a 'cruel machinist' and his painting as a bric-a-brac of 'visions terribly illustrative of ancient style fables', 'atrocious and whimsical illustrationism' and 'poverty-stricken painting'). It was not so much, in De Chirico's view, a plot designed to harm him, as it was

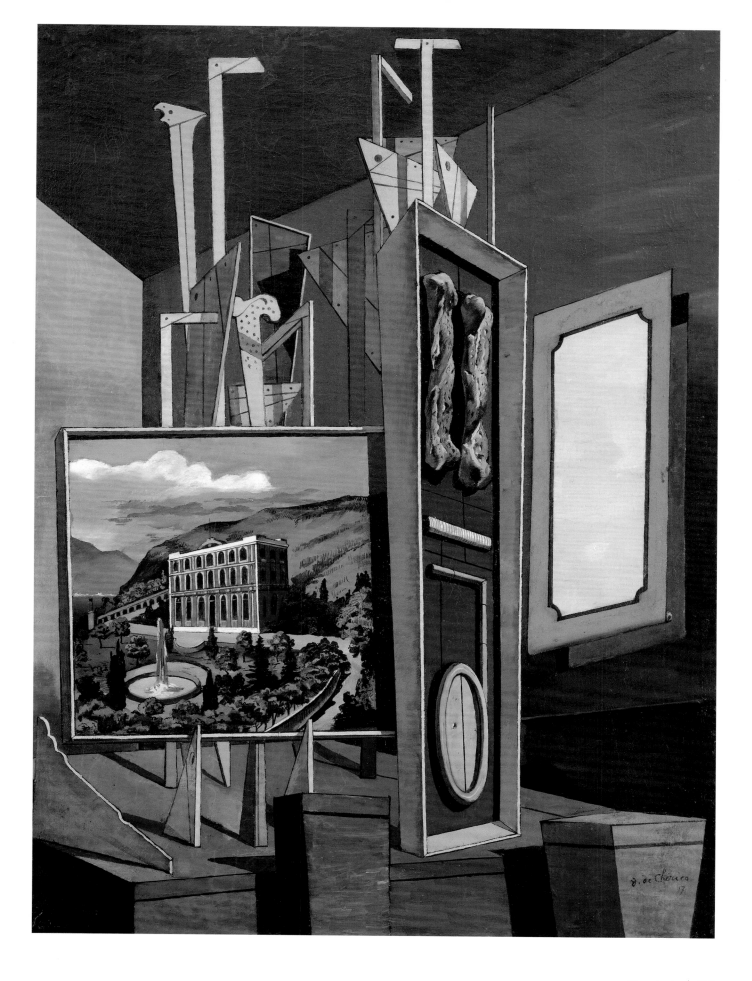

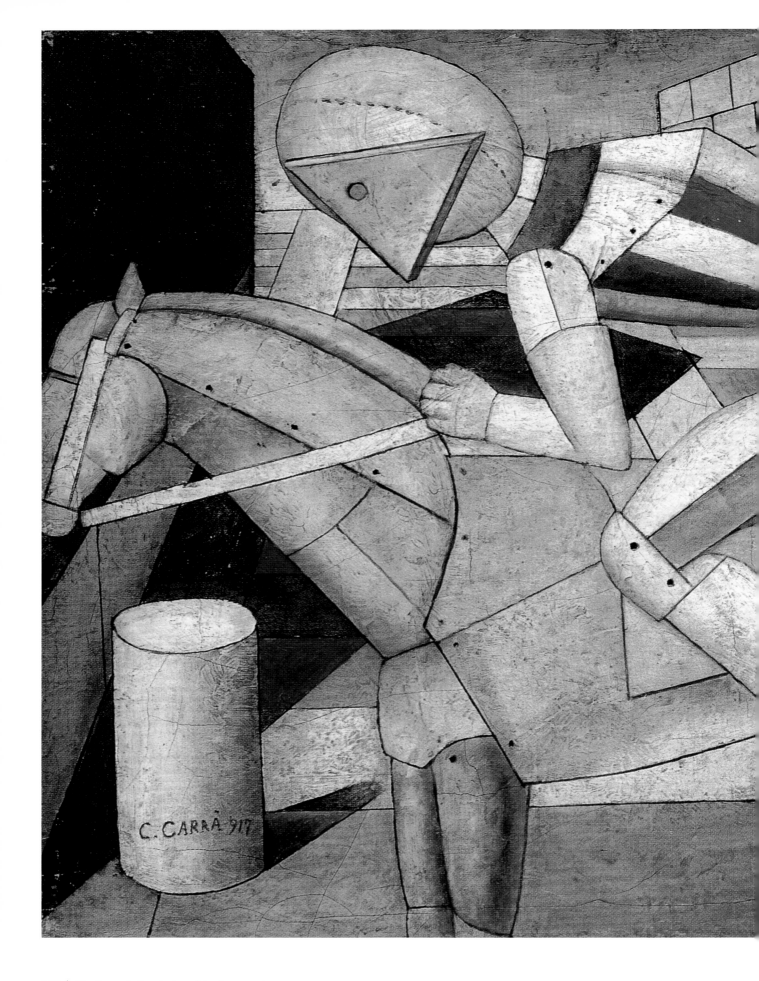

an affirmation of a line of Italianness and a return to tradition, at the expense of a poetics of the negative, that black humour that so fascinated the Surrealists.

De Chirico, for that matter, was not merely the victim but also the ultimate cause behind this exclusion, given his natural tendency to self-isolation and solitude. And so it remained to Carrà to come up with the idea of making Metaphysics into a school; and even if De Chirico often made use of the adjective 'Metaphysical', it was Carrà who invented and popularised the label 'Metaphysical painting', which his colleague immediately attempted to appropriate as his own. Finally, it was to the 'clear' Metaphysics of Carrà that Alberto Savinio would look, in his critical writings, as did Giorgio Morandi, Mario Sironi and Felice Casorati in their works.

In isolated Bologna, focusing on landscape and especially on the theme of the still-life, Morandi had closely studied Cubism and Futurism, and finally found in Metaphysics the key to the consolidation of the object and the revelation of the mystery that made it the catalyser of an inexhaustible attention, a continual exercise. In his brief Metaphysical phase (1918–19), the painter added a mannequin's head and a few geometric solids to the few subjects to which he constantly returned, such as vases, bottles and glasses, but especially that silence and the suspended and afternoon atmosphere that he never abandoned.

Sironi too came to Metaphysics in 1918, in a phase of reconsideration of volumes and the blocked form that also ran through Cubism, replacing the Metaphysical enigma with that crude existentialism that especially characterised the painting. As for the Turinese Casorati, his interest in Metaphysics was the culmination of a long and isolated activity in the fields of Symbolism and Liberty (Italian Art Nouveau), and pointed forward at the same time to the measured and disquieting classicism that he was to produce with great quality in the 1920s. Between 1918 and 1920 he painted a number of large works in tempera, which marked his attainment of a very personal chapter of Metaphysics: masterpieces such as *Interior or Girl with a Ladle* and *Man with Barrels* (1919), in which Casorati worked on the solitude of one or more figures in an interior, accentuated by the perspective of the rooms and the parallel solitude of the objects (cups, bottles), in a dry, chilly and cerebral atmosphere.

For all of these artists, Metaphysics provided the occasion—and the first episode—for a 'return to order' that affected all Italian painting, and which found one of its leading figures in none other than Carrà. De Chirico allowed

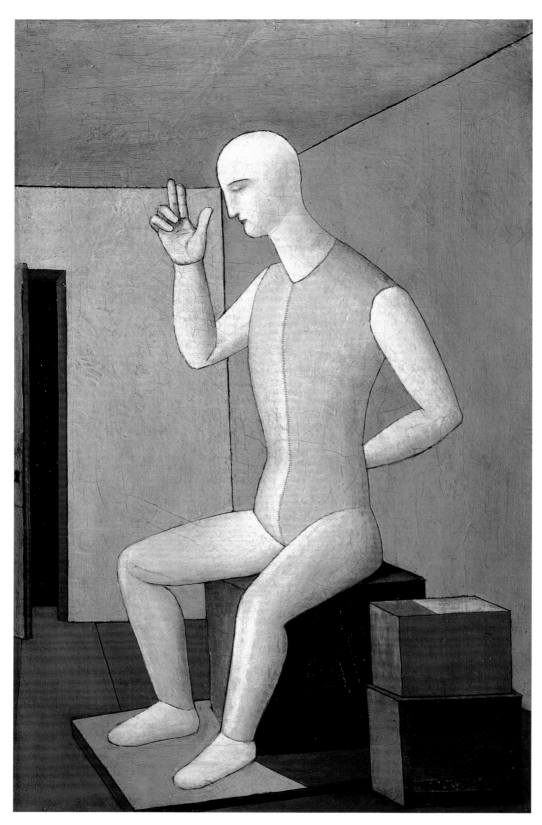

Carlo Carrà
Hermaphroditic Idol, 1917
Oil on canvas, 80 x 60 cm
Private collection

Carlo Carrà
The Metaphysical Muse, 1917
Oil on canvas, 90 x 66 cm
Milan, Pinacoteca di Brera,
Jesi collection

Pages 342–43
Carlo Carrà
Mother and Son, 1917
Oil on canvas, 87 x 58 cm
Milan, Pinacoteca di Brera,
Jesi collection

Giorgio de Chirico
The Disquieting Muses, 1918
Oil on canvas, 97 x 66 cm
Private collection

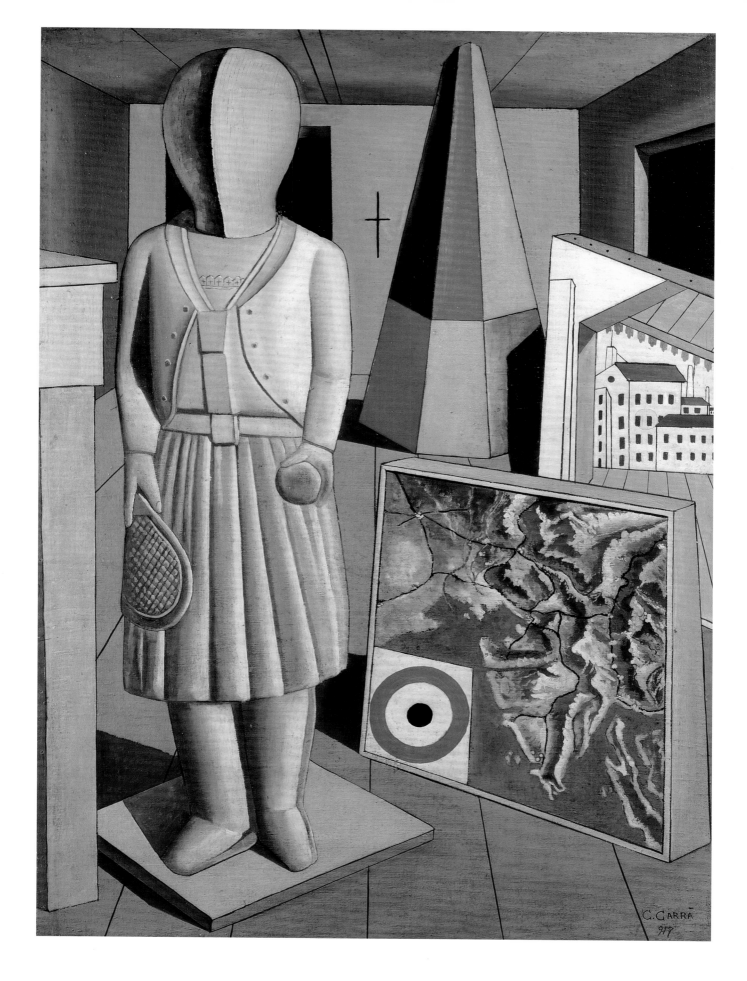

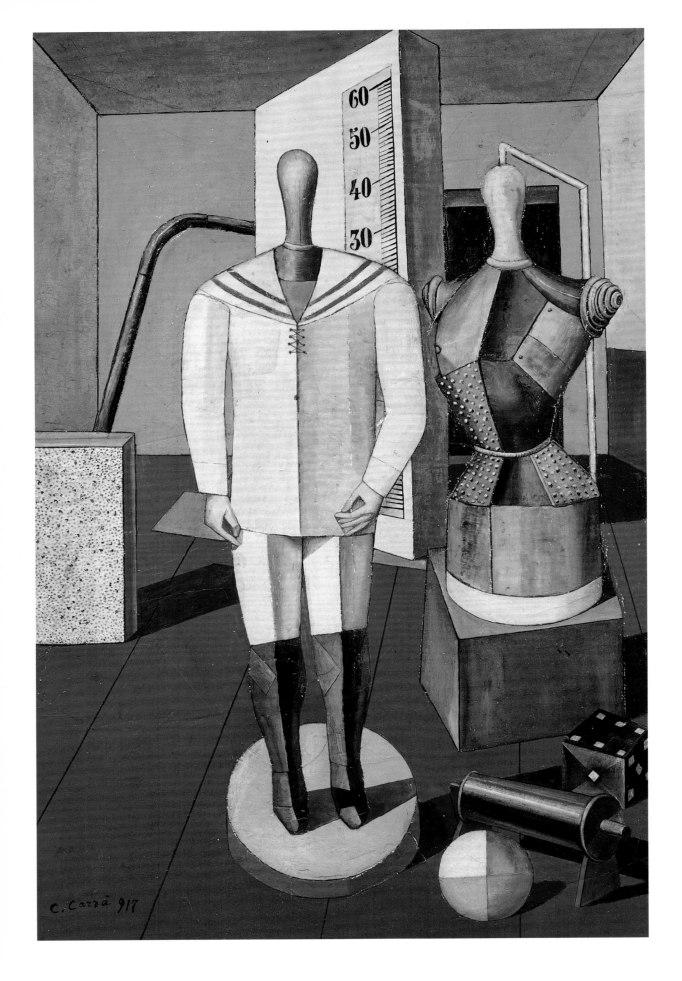

C. Carrà 917

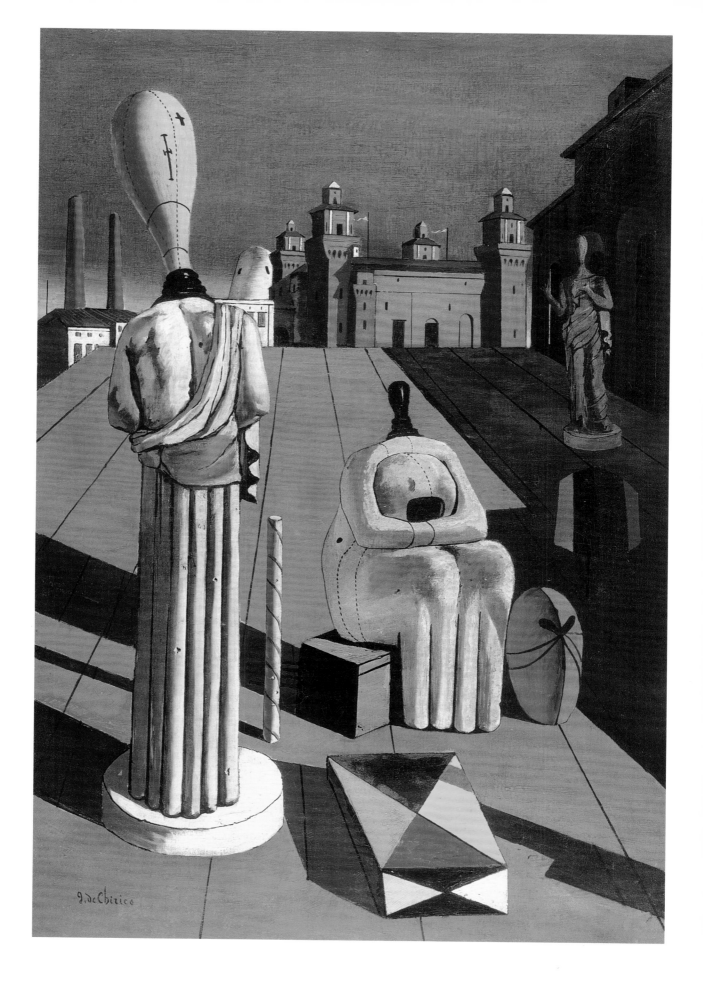

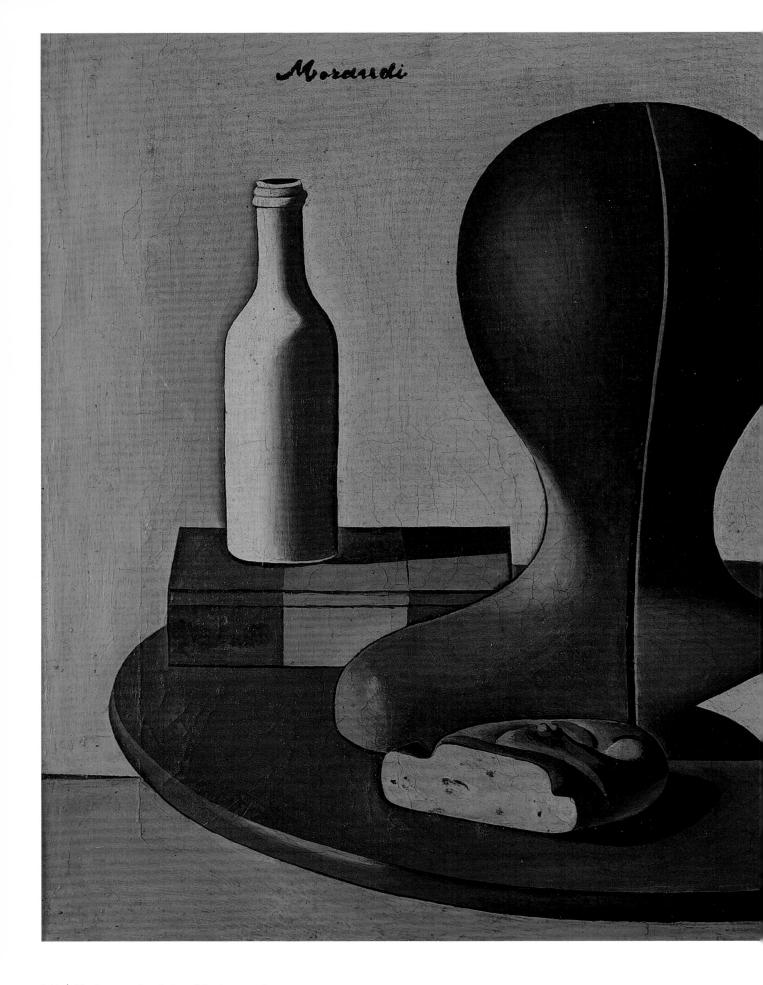

Giorgio Morandi
*Metaphysical Still Life with
Square Ruler*, 1919
Oil on canvas, 57 x 47 cm
Milan, Pinacoteca di Brera,
Jesi collection

Giorgio Morandi
*Metaphysical Still Life with
Mannequin*, circa 1918
Oil on canvas, 68.5 x 72 cm
Milan, Pinacoteca di Brera,
Jesi collection

Felice Casorati
The Waiting, 1919
Oil on canvas, 139 x 130 cm
Private collection

Bottom
Giorgio de Chirico
The Sacred Fish, 1919 (detail)
Oil on canvas, 75 x 72 cm
New York, The Museum of Modern
Art, Lillie P. Bliss Bequest

Opposite
Giorgio Morandi
Still Life, 1916
Oil on canvas, 82 x 57 cm
New York, The Museum of Modern
Art, Lillie P. Bliss Bequest

himself to be drawn in as well, but in a contradictory manner, laying claim (in his renowned article, 'Il ritorno al mestiere', which appeared in *Valori Plastici* in 1920) to his own continuity with respect to tradition, the fact that he had always been a 'classic', and triggering, with his contribution, the re-evaluation of Metaphysics in a traditionalistic sense that many critics had adopted. But his return to order, already visible in the increased pictorial solidity of the Metaphysical paintings of 1918 and 1919, constitutes a further anomaly in the Italian art of the period, harking back to his own models (such as Klinger and Böcklin) and inaugurating that remarkable and paradoxical episode which is De Chirico's post-Metaphysical work. Among the last of his paintings that were 'formally' Metaphysical, *The Disquieting Muses* (1918) seems to be the most clear-eyed, disquieting and highly modern reply to the solid and serene Metaphysical muse of Carrà. The space remains inconsistent, an improbably oblique backdrop against which objects are placed according to various vanishing points; things maintain their mystery and cannot be understood; antiquity transmits no message or value; stolid and impenetrable, it turns its back on us, bending its empty swollen head of orange rubber. In the meantime, *Valori Plastici* had caused his work to circulate, and while the artist rediscovered himself as a *pictor optimus*, neo-Classical and a follower of Böcklin, he was selected first by the Dadaists, and later the Surrealists, as the godfather of their revolution. André Breton wrote in 1922: 'I believe that a true modern mythology is being formed. And the responsibility for establishing its deathless memory lies with Giorgio De Chirico'. And so De Chirico's Metaphysics, betrayed at home, was understood in its true essence abroad, but in ways and forms that at the time were no longer of any interest to the great and solitary artist. What arose from it was a new love and, inevitably, a new war.

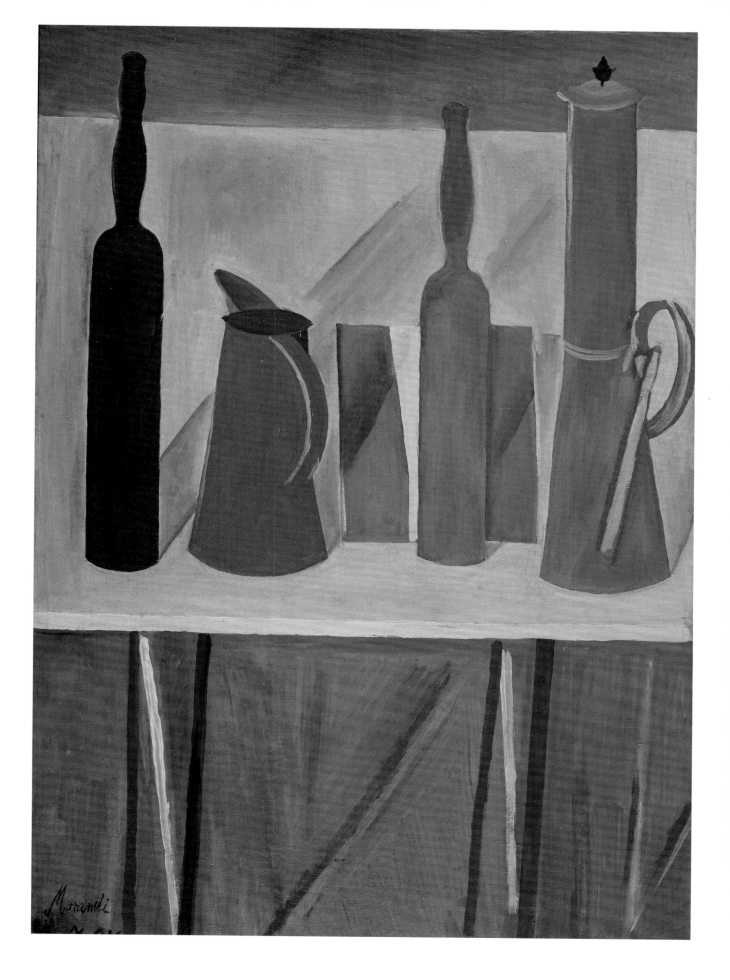

Paris 1910–1919

The start of the second decade witnessed the capillary diffusion of Cubist language in Paris. Leaving aside a very few cases, it would seem that the renewal of artistic language could not avoid a comparison with the radical ideas of Picasso and Braque, even for those areas of research that seemed to point in another direction entirely, for example, the Parisian phases of Chagall and Modigliani. Even De Chirico, who was undertaking quite a different direction in Paris, proved to be open in his Metaphysical interiors to the sharp cuts and the anti-perspectival stacking of Cubism.

Cubist language allowed many artists who were still fettered by Impressionism and Post-Impressionism to take a leap forward. This inevitably led to a complication of the situation and a proliferation of proposals with respect to the first part of the decade, which saw Fauvism as the only radical alternative to the continuation of lines of research that were by this point exhausted. In this connection, Gleizes and Metzinger (1912) stated that Cubism appeared 'as the only possible conception of pictorial art'.

In this situation, Picasso and Braque pursued their solitary paths without ever seeking the company of the minor Cubists, and allowing themselves to be joined, only after 1911, by Juan Gris. The Madrid-born artist, who came to Paris in 1906, at first earned a living as an illustrator. With his studio neighbouring Picasso's in the Bateau-Lavoir, he had an opportunity to study Cubism from a privileged viewpoint and, when he began to paint, he did so with remarkable confidence, immediately inventing his own autonomous way into the Cubist lexicon. He wrote: 'Cézanne made a bottle into a cylinder, I set out from a cylinder to paint a bottle. Cézanne moves towards architecture, I start out from it'. With this statement, and with the paintings of 1912, Gris moved beyond analytical Cubism and blazed a new path that replaced analysis with synthesis. For the Cubists, the painting is no longer the forum for a mimesis but a reconstruction of reality according to autonomous laws, proper to painting as a medium. All the same, analytical Cubism

still based its work on reality, which it broke down in order to make it fit, more or less successfully, with these laws. For Gris, the abstract construction of a painting quite simply comes before, not after, the gaze onto reality: first the painting is constructed in compliance with the rules that govern its universe and then a still-life, a landscape, or a human figure is adapted to it. It is only at this point that sensibility intervenes, an attention to the characteristic elements of that which enters into the composition: 'I begin by organising my painting, then I qualify the objects… I attempt to concretise that which is abstract. I move from the general to the particular, that is, I set out from an abstraction to reach the actual fact'. And that is why Gris responded to Braque's aphorism, 'I love the rule that corrects emotion', with his own reversal, 'I love the emotion that corrects a rule'. In his famous *Portrait of Picasso* (1912) and *Flask, bottle, knife* from the same year, the still-life and Picasso's massive body were both constrained within a regular geometric structure organised along diagonals, and which existed prior to the reality depicted. And they are both adapted, with precision and awareness, to the internal order of the painting, without ever forcing it.

The grey monochromy of analytical Cubism was not substantial with this type of research and was soon abandoned for a return to colour, and other expressive components set aside by the formal rigour of the Picasso-Braque duo: from the pre-Dada irony of the *The Man in the Cafe* (1912), in which the rigorous geometric grid fails to prevent humorous notations in the face and stance of the model, to *Uva* (1913), where the complex chromatic texture is completely restored. Meanwhile, Gris's acquired confidence allowed him to integrate, in the same flat and geometric areas of the grid, *trompe-l'œil* (the wood of the table, the bottle, the panel) and images reduced to symbols of themselves, without any of this producing any friction. This hybrid of different stylistic manners can also be found in the poetic *Place Ravignan* (1915), which juxtaposes the Cubist deconstruction in the foreground with the magical realism *ante litteram* of the background, and which marked all of Gris's later output. This re-

Constantin Brancusi
Maiastra, 1910–12
Marble and wood,
233.7 x 32.5 x 27.1 cm
New York, The Museum of Modern Art, Katherine S. Dreier Bequest

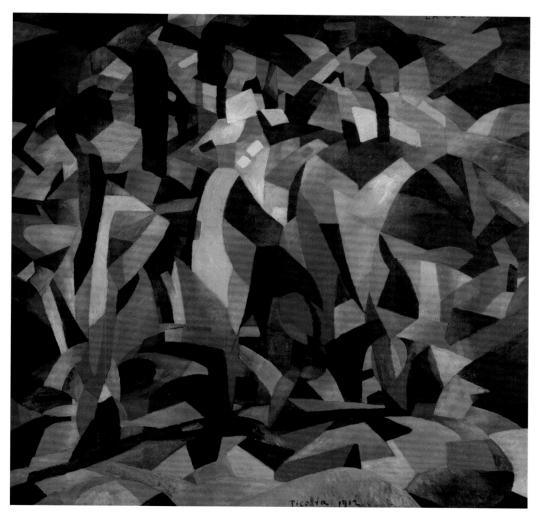

Francis Picabia
The Spring (La Source), 1912
Oil on canvas, 251.8 x 248.9 cm
New York, The Museum of Modern
Art, Eugene and Agnes E. Meyer
Collection, Bequest

mained faithful to Cubism until the end of the decade, and then only twisted towards a highly personalised synthesis of Cubism and classicism, abstraction and representation. This development linked him to the Severini of the 1920s, to whom so much was owed by both Joan Miró and Salvador Dalí in their early years.

As for Braque and Picasso, their familiarity with Gris explains only in part their development, which was perfectly consistent with their earlier progress. Just at the point when analysis brought them dangerously close to the threshold of abstraction, the two felt it was necessary to insert into their paintings new links to reality, first through *trompe-l'œil*, in which the craftsman Braque excelled in particular, and then through the direct harvesting of reality, that is, through the invention of collage. Cubist collage, then, originated from a need for realism, but this was a conceptual realism, not a mimetic one. Faithful to their own a-systematicness, Picasso and Braque obeyed no rules but explored various applications, from the harvest of reality that represented itself (thus Braque in *Still Life with Playing Cards*, 1913), to the insert that, through an illusion,

represented something else (*Still Life with Chair Caning*, 1912), to the total independence between included materials and the final result of Picasso's first *assemblages*. Even colour was returned to canvases through the polychromy of collage, and from there into the paint, while the abandonment of a rigorous formal research of analytical Cubism led to the re-emergence of differences in style between the two artists who, though they continued to work side by side, began to diverge in the paths they were following. In Picasso, through such paintings as *Woman in a Shirt* (1913) or *Portrait of a Young Girl* (1914), we see once again stylistic eclecticism (which led him to return, in the second painting, to Pointillism), as well as irony and a savage expressive power that led him, in the first work, to pre-Surrealist results, while in Braque there came a renewed expression of an entirely French love for balance and proportion that was reinforced by references to music (Mozart and Bach in *Aria of Bach*, 1913–14) and an exceedingly high level of artisanal quality.

Picasso and Braque refused decisively to transform their research into a system and to translate their practice into theory. In refer-

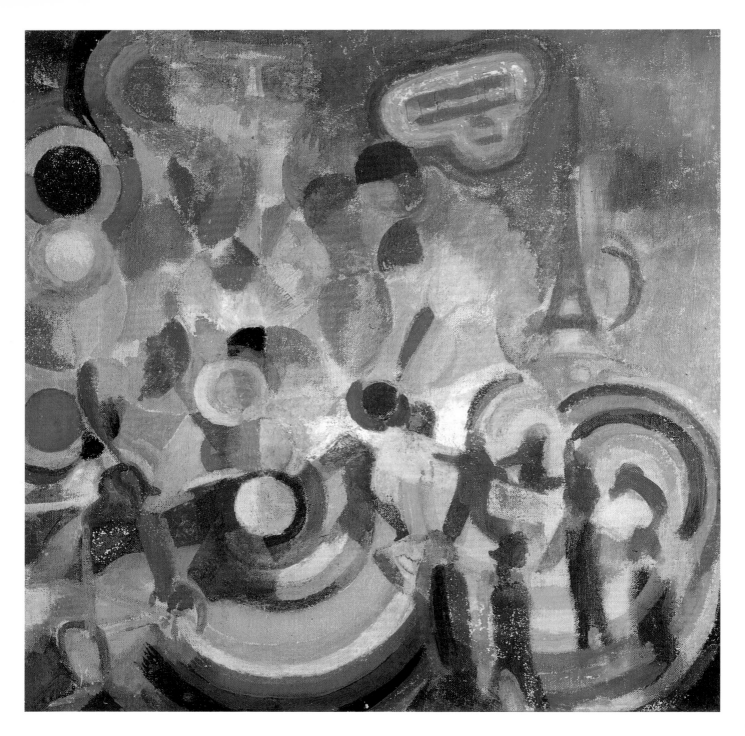

Robert Delaunay
Homage to Blériot, 1914
Oil on canvas, 48 x 46 cm
Musée de Grenoble

Opposite
Francis Picabia
Pépé, 1909–1910
Oil on canvas, 100 x 81 cm
Private collection

Pages 352–53
Francis Picabia
Impetuosité Française, 1913–14
Tempera on paper, 50 x 70 cm
Private collection

ence to Gleizes and Metzinger's text *Du Cubisme* (1912), Braque stated: 'It was Gleizes and Metzinger who constructed the theories, who drew up a code. As for me, I never applied these theories nor did I ever follow any code. I did not wait for them to start painting and, believe me, I never painted according to someone else's watchword'. Their refusal to exhibit in France was only partially compensated by the possibility of seeing their works shown by Kahnweiler, Vollard and in certain collections. All the same, over the course of a few years, Cubism established itself decisively as the new lin-

gua franca of art in Paris. It was an exceedingly flexible language, rich in an infinite variety of dialects, and always 'unfaithful' to the mother-tongue spoken by Braque and Picasso that was contaminated by the various paths of research emerging from Cézanne's revelation of 1907, as for instance with Léger and Delaunay. There even developed a current of Cubist sculpture: almost a paradox, if we consider that Cubism was developed to resolve the problem of how to reconcile space in three or four dimensions with the two-dimensional nature of the canvas. This evolution was for that matter predictable,

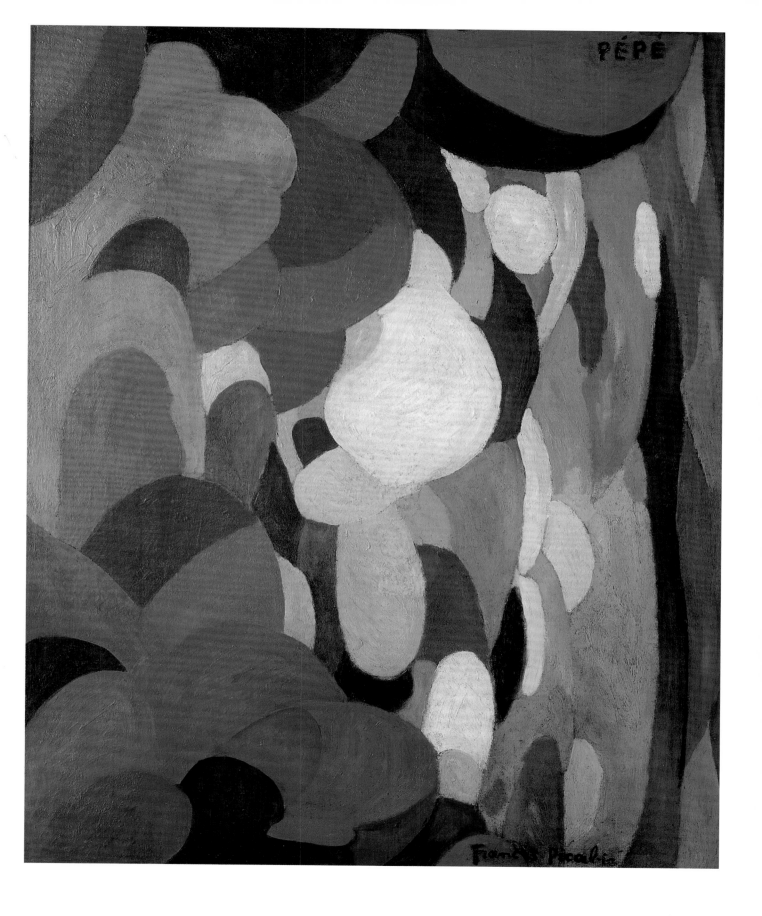

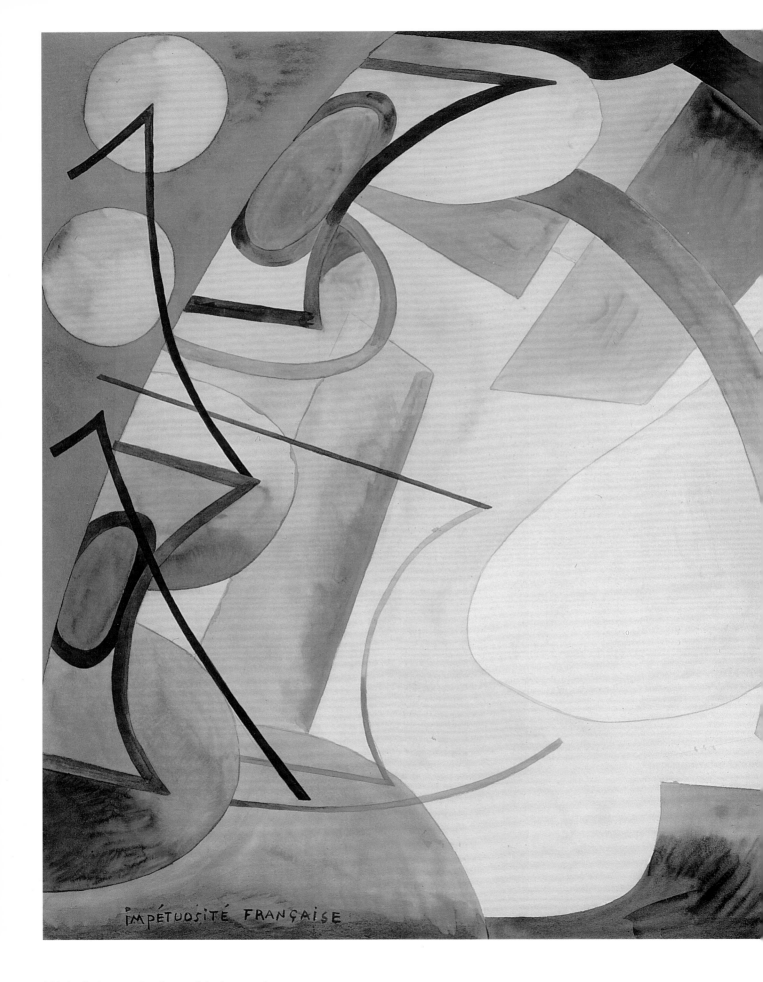

Picabia

if we consider that the first 'grammar' of this language, the book by Gleizes and Metzinger, already constituted, as Braque implicitly noted, an unauthorised evolution: it speaks of geometry, the fourth dimension, and the golden section, all issues alien to the original Cubism. The same can be said for their paintings, faithful and often scholastic applications of these postulates. Albert Gleizes painted in a Post-Impressionist style from the turn of the century until, around 1909, he established a friendship with Jean Metzinger and Henri Le Fauconnier. The trio often met in the house of the Socialist writer Alexandre Mercereau, which was also often frequented by Robert Delaunay and Fernande Léger. The research of the latter two, along with the examples of Braque and Picasso, led the trio to limit their palettes and focus on volumes. They showed at the Salon d'Automne of 1910, by chance all displayed in the same room: suddenly they were a school. They met more frequently, now in the studio of Le Fauconnier, who was working on *The Abundance* (1910–11): a painting that would seem to belong to moderate Cubism, and still strongly indebted to Cézanne, with the added burden of an allegorical subject, which at the time was considered to be of great importance, practically a manifesto. At the Salon des Indépendants in April 1911 the trio, along with Léger, Delaunay and Marie Laurencin (but also Kandinsky, Mondrian and Modigliani), presented themselves as a group, and were given an entire room, while other 'Cubists' not welcomed by the Salon, such as André Lhote and Roger de La Fresnaye, exhibited in a nearby gallery. This was a very conscious operation of self-promotion, very successful and supported by such intellectuals as Apollinaire and Maurice Raynal. In the meanwhile, the group expanded to include La Fresnaye, the sculptor Archipenko, Francis Picabia and the Duchamp brothers, whose studio at Puteaux became yet another meeting place. The union yielded its results, and there were growing numbers of opportunities to exhibit in France and abroad. In March 1912, the model of a Cubist house by Raymond Duchamp-Villon was the talk of the Salon des Indépendants, but the most important exhibition, which, with more than two hundred canvases, assembled the entire Cubist front with the exception of Picasso and Braque, was that of the 'Section d'Or', inaugurated at La Boétie gallery in October 1912. The title alone—the Golden Section— suggested by the Duchamp brothers and taken from mathematics, is enough to indicate how far the group had come from the entirely empirical research of its two initiators.

With the *Section d'Or* exhibition and the

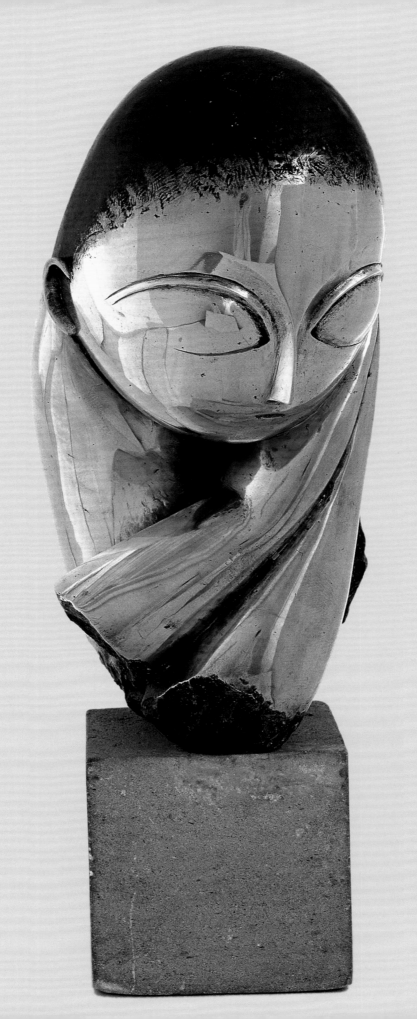

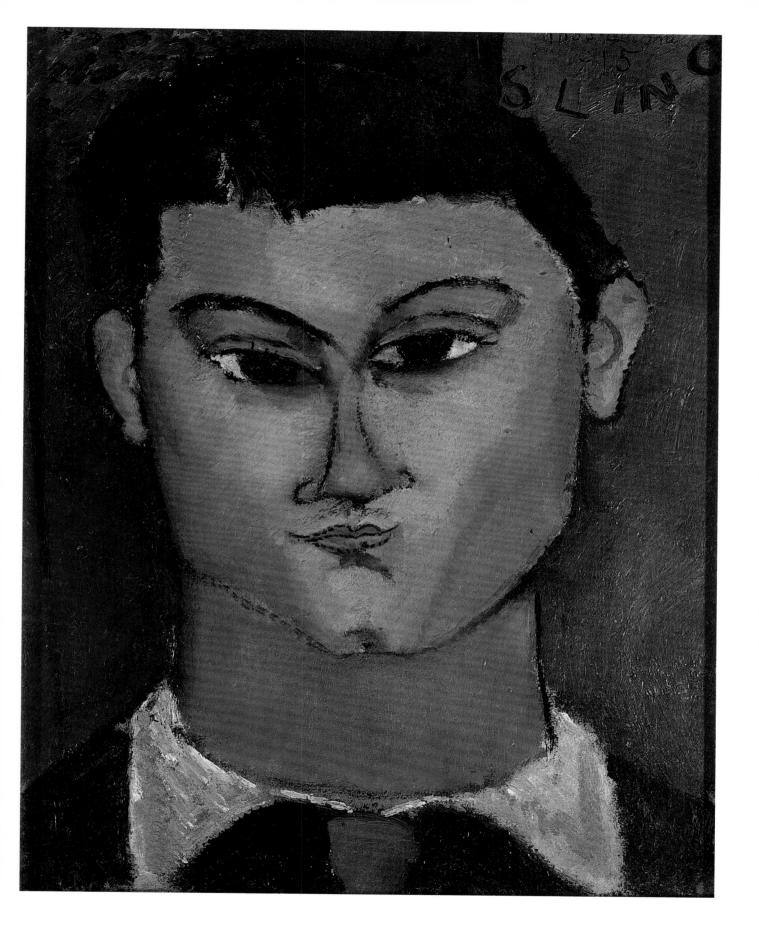

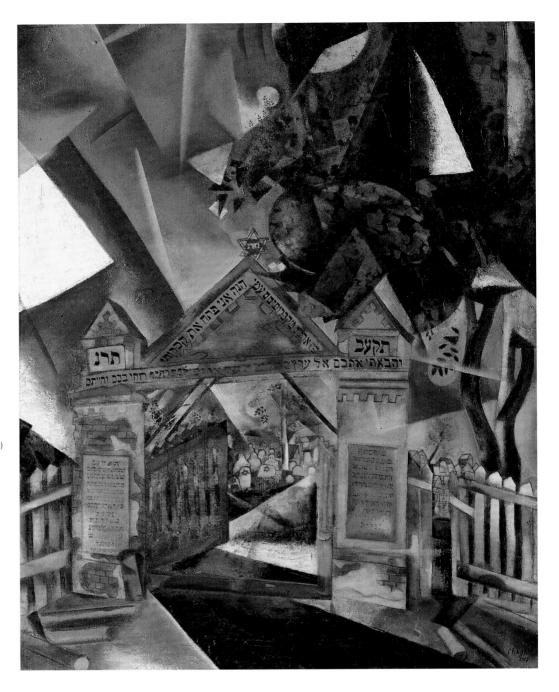

Marc Chagall
The Cemetery Gate, 1917
Oil on canvas, 87 x 68 cm
Paris, Musée National d'Art Moderne,
Centre Georges Pompidou

Opposite
Marc Chagall
Acrobat, 1914
Oil on paper mounted on canvas,
44.5 x 33 cm
Buffalo, Albright-Knox Art Gallery

Pages 354–55
Constantin Brancusi
Mademoiselle Pogany, 1913
Gilded and burnished bronze,
43.8 x 21.5 x 31.7 cm
New York, The Museum of Modern
Art, acquired through the Lillie P. Bliss
Bequest

Amedeo Modigliani
Portrait of Moise Kisling, 1915
Oil on canvas, 37 x 29 cm
Milan, Pinacoteca di Brera,
Jesi collection

Pages 358–59
Marc Chagall
The Jew in Pink, 1915
Oil on cardboard, 100 x 80 cm
St Petersburg, The State Russian
Museum

Amedeo Modigliani
Portrait of Paul Guillaume, 1916 (detail)
Oil on canvas, 81 x 54 cm
Milan, Civiche Raccolte d'Arte

Indépendants in 1912, Cubism, supported by powerful dealers and intellectuals, established itself once and for all as a cohesive front, to the point that it triggered unexpected reactions (including a parliamentary inquiry). But the more fiery the debate, the greater the number of members, with the resulting loss of that fragile communion of poetic that characterised the movement at its outset. Cubism became a synonym for avant-garde, new, opposition to the ordinary and the routine (to the point that it entered daily language to describe an unrestrained girl or an unorthodox politician), so that it included revolutionaries of all stripes and academics disguised as revolutionaries.

Even militant critics got busy: in 1912–13 *Du Cubisme* was published by Gleizes and Metzinger, *Les Peintres Cubistes* by Apollinaire, the *Historie anédoctique du Cubisme* by Salmon, and a series of articles by Hourcade and Raynal. As early as 1913, Apollinaire seemed ready to allow the establishment of a new 'ism': referring at first to the works of Delaunay, he began to speak of 'Orphic Cubism' and 'Orphism', a label that soon became almost as all-inclusive as the first, and which dominated the Salons of 1913 and 1914. Originating as a form of experimentation pursued by very few, on the eve of World War I Cubism became the idiom of the artistic avant-garde par excellence.

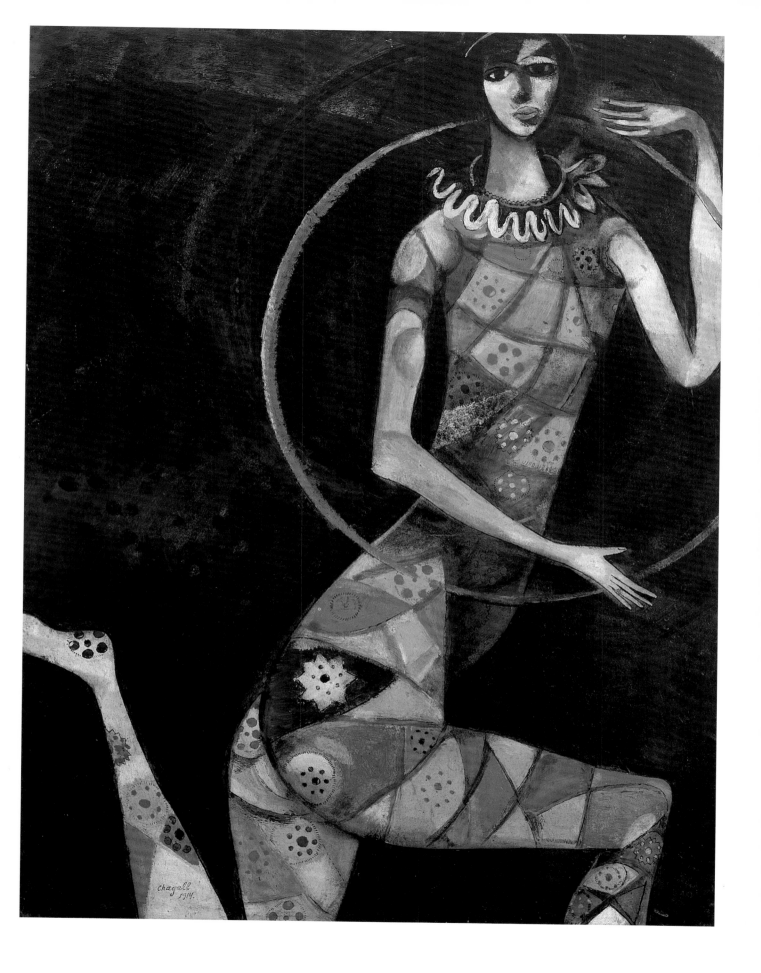

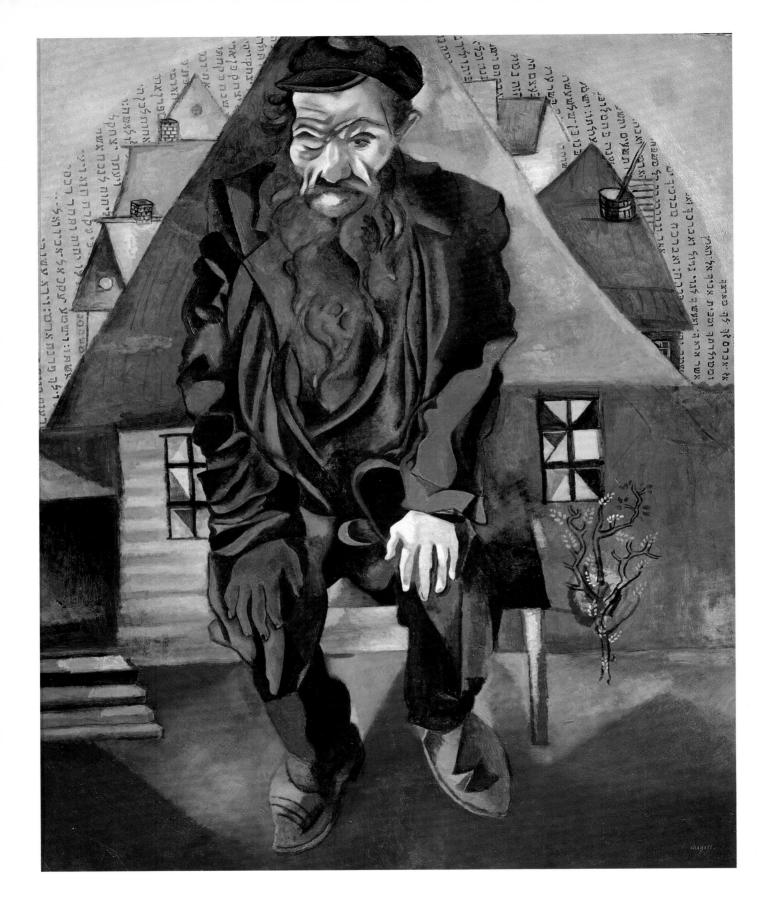

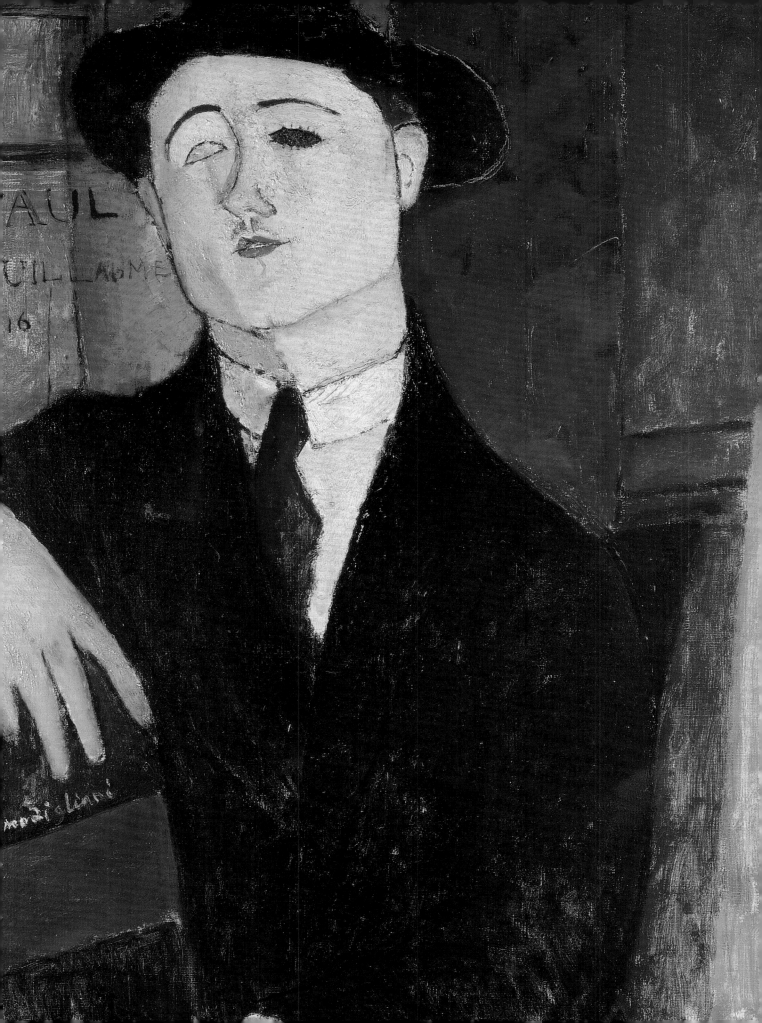

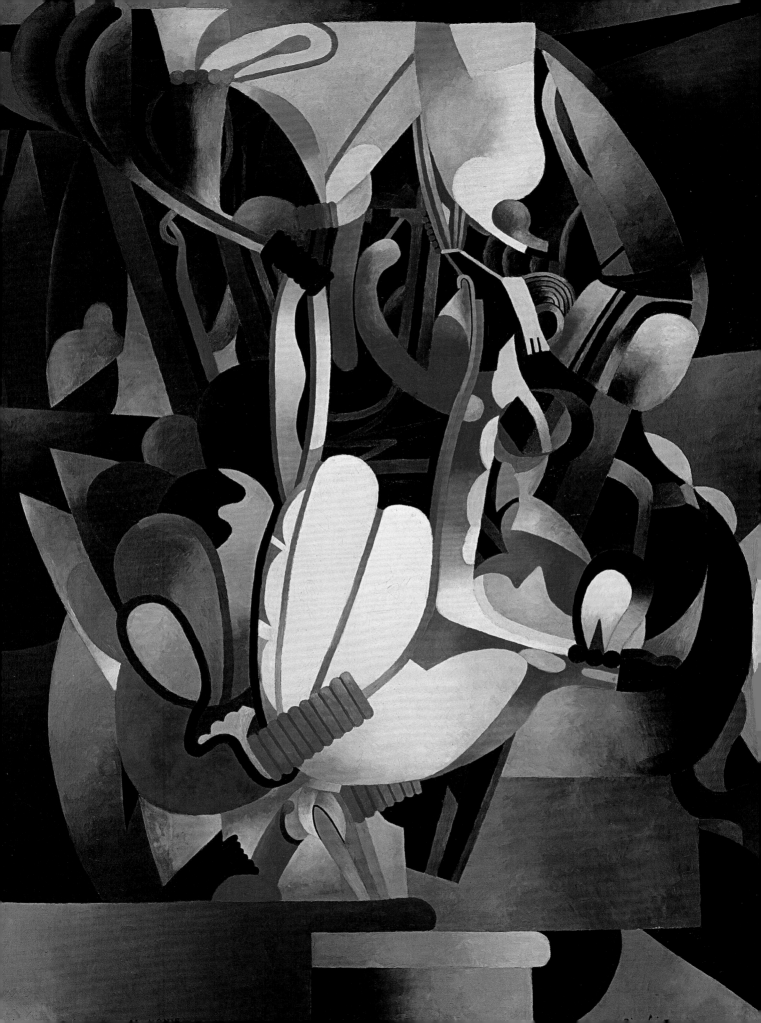

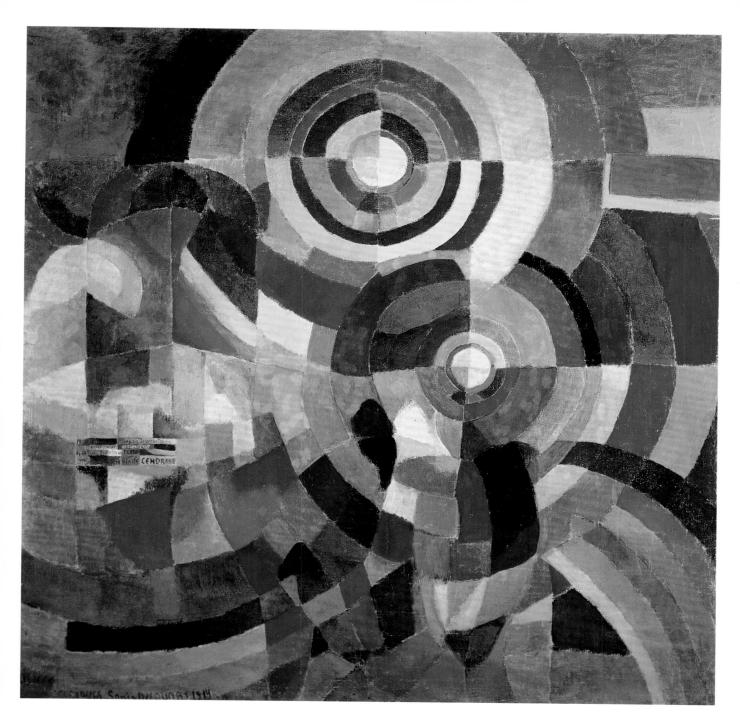

Sonia Delaunay
Electric Prism, 1914
Oil on canvas, 124 x 124 cm
Paris, Musée National d'Art Moderne,
Centre Georges Pompidou

Opposite
Francis Picabia
See Again in Memory My Dear Udnie,
1914 (detail)
Oil on canvas, 250 x 199 cm
New York, The Museum of Modern
Art, Hillman Periodicals Fund

There was no lack of detractors, but the triumph of Cubism at the New York Armory Show in 1913, confirmed its power; and the high prices reached at auction in the March 1914 sale of the Peau de l'Ours collection proved that there was a solid group of buyers who believed in the validity of the trend. The situation changed radically after the war: the sale of the Kahnweiler collection intentionally aimed to achieve low prices and group action was set aside, so that the few who carried on their work in the context of Cubism, like Braque and Gris, did so alone. But in the meantime, Cubism had long since left the stage in

Paris, conditioning the language of nearly all the movements of the European avant-garde, from Futurism and De Stijl to the Blaue Reiter and the Russian avant-gardes. As François Mathey (1967) noted: 'As we understand it historically, Cubism would be no more than a very limited moment in time and space, but the new awareness which it brought to artists far surpasses the scope of a style. It was, rather, a way of being and seeing, and in this context, it lies at the origins of a universal and total art, in gestation throughout Europe...'. Returning to the exhibitions of 1912, it becomes immediately evident that, however compact it might have

Constantin Brancusi
The Newborn, 1920
Bronze, 14.6 x 21 cm
New York, The Museum of Modern
Art, acquired through the Lillie P. Bliss
Bequest

been in terms of strategy, the group was not at all in unison in its poetics. The largest core was what might be described, with no pejorative sense intended, as 'the academy of Cubism', that is, those artists who worked diligently to apply the rules developed by Gleizes and Metzinger without ever losing touch with reality, indeed even going so far, in some cases, as to engage in the depiction, almost, of the anecdotal: suffice it to consider such works as *La goûter* (1917) by Metzinger, or *Women Sewing* (1913) by Gleizes. The latter, in particular, seems to have been an attempt to translate classical themes into Cubist forms, from the genre painting to the 'historical' canvas: a propensity also revealed by the size and complexity of certain of his compositions. A painting like *Threshing* (1912) is an example of this tendency: there emerges a consolidated language, confident, quite distant from the tireless experimentation of Picasso and Braque which, by no accident, focused on simple subjects, while Gleizes was willing to engage with broad scenes rich in figures and large in size; the dominant earth tones do not exclude flashes of colour and movement was introduced, in part following the example of Léger. More subtle and less theoretical, and cleaving more closely to the line of Picasso and Braque, whom he knew personally, was the painting of Louis Marcoussis, a Polish artist who had emigrated to Paris. Marcoussis remained faithful to monochrome, small canvases and still lifes, which he developed in a more sophisticated and speculative direction. Roger de La Fresnaye seemed intent on reconciling tradition and the Academy with the innovations introduced by the Fauves and the Cubists: the results of this synthesis, such as the *Seated Man* of 1914, were never exceptional, but they did much to contribute to the popularisation of Cubism, rendering it acceptable even to those who adhered to more moderate positions.

A completely different type of inspiration appears in the research of Jacques Villon, the oldest of the three Duchamp brothers, and the theoretical fulcrum of the 'Section d'Or'. A delicate intimist, Villon elaborated a language that was at once sober and esoteric, filtered as it was by his mathematical studies and his refined culture; he preferred light colours and pastel tones, which he laid out in a sober and rarefied style of painting, with interpenetrations of light and planes. His *Soldiers on the March* (1913) showed a division of the canvas into pyramidal sections in which, as in Gris, the structure of the canvas seemed to precede, rather than follow, the gaze on reality. The result is a strongly mental painting, which does not exclude abstraction and which developed in a secluded path that

Raymond Duchamp-Villon
Seated Woman, 1914
Bronze, 71 x 22 x 28 cm
Paris, Musée National d'Art Moderne,
Centre Georges Pompidou

Alexandr Archipenko
Woman Combing Her Hair, 1915
Bronze, 35 x 8.3 x 8 cm
New York, The Museum of Modern
Art, acquired through the Lillie P. Bliss
Bequest

nonetheless gave rise to many consequences in French painting in the 1930s.

But it was especially for the younger Marcel Duchamp and Francis Picabia that Cubism proved to be little more than a means to break free from the shackles of Post-Impressionism and a projection towards a line of research that was entirely separate from the formal concerns of the relatively orthodox Cubist painter. Duchamp combined a refined and esoteric culture, which ranged from philosophy to mathematics, with alchemy, a marked interest in the depiction of movement and the world of machinery: all of which was filtered through a sense of irony and light-heartedness that was clearly of Dadaist derivation. The celebrated *Nude Descending a Staircase* (1912), which was shown to great shock at the Armory Show in New York, was a perfect example of the complexity of this language, in which the study of movement was combined with an interest for photography, and the mechanisation of the human with a stratification of meanings never fully explicable. In the same manner, the *Bride* and other paintings from the same period show the ironic hybrid of alchemy and study of the mechanical world, a visualisation of movement and a love of chess, as well, of course, as fitting into that complex path that would lead to the *Large Glass*.

Less intellectual and more vital, Picabia, who was born to a Cuban father and a French mother, moved through all the stages of the required path for artists of the time—Impressionism, Divisionism and Fauvism—winding up with a more intellectual style of painting that had a constant interaction with music. Attracted, like Duchamp, by the world of machines, light and movement, he invented a metallic and highly coloured Cubism steeped in symbols, nonsense and eroticism, as was clear from the titles: consider *Udnie (Young American Girl: Dance)* or *Catch As Catch Can (Edtaonisl)*, painted following his return from those trips to New York that were of such importance in the birth and circulation of Dada poetics.

Even more fragile prove to be the links between the Cubist movement and artists such as Kupka, Delaunay and Léger, who associated with it temporarily, but without making much of a detour from their own paths, which at that time were already pretty strongly defined. When Frantisek Kupka reached Paris in 1896 from a small Slovakian village (after passing through Prague and Vienna), he already had a long history behind him in late Symbolist painting. He had taken an interest in philosophy, occult sciences and Eastern religions, he had been initiated into spiritualism, and had earned a living for many years as a medium. He was also familiar with Oriental symbolism and German painting, which had strongly affected his own work, and he practised Art Nouveau illustration. This symbolist and esoteric background was not lost in his work between 1910 and 1920. His output emerged from the study of light and movement, influenced by the research of Muybridge and Marey, and by the purely nineteenth-century love of the world of science and technology. This singular mixture of science and esotericism made Kupka one of the first European artists to cross the boundaries of representation, and allowed him to produce a fully abstract painting structured in terms of vertical planes and circular vortices, as seen in the *Study for 'The Language of Verticals'* (1911).

Although they demonstrate his distance from Cubism, Kupka's study of light, resumption of research into the perception of colour and his arrival at abstraction still clearly indicate the affinity of his research with that of Robert Delaunay, who attained very similar results, though the two set out from very different points.

Once again it was Cézanne who guided Delaunay's first steps, but a Cézanne revisited in a very different manner compared to his Cubist interpretation. This is demonstrated by the series of circa 1909 dedicated to the cathedral of *Saint-Séverin*, which explored the Gothic interiors of the church. In his progress there was a comparable reduction in chromatism justified by the subject, but the colours were not, as in Picasso and Braque, greens and ochres, but greys and light blues. The structure was not simplified into the more common solids, nor was it destructured or decomposed, rather it curved, organising itself along the sloping lines that Gothic architecture has in common with the arboreal backdrops in Cézanne's *Bathers*. In addition, light played a fundamental role, invading and organising the space.

Attention to the importance of light came to Delaunay from the Divisionist painting of Seurat and Signac, which formed another fundamental component of his educa-

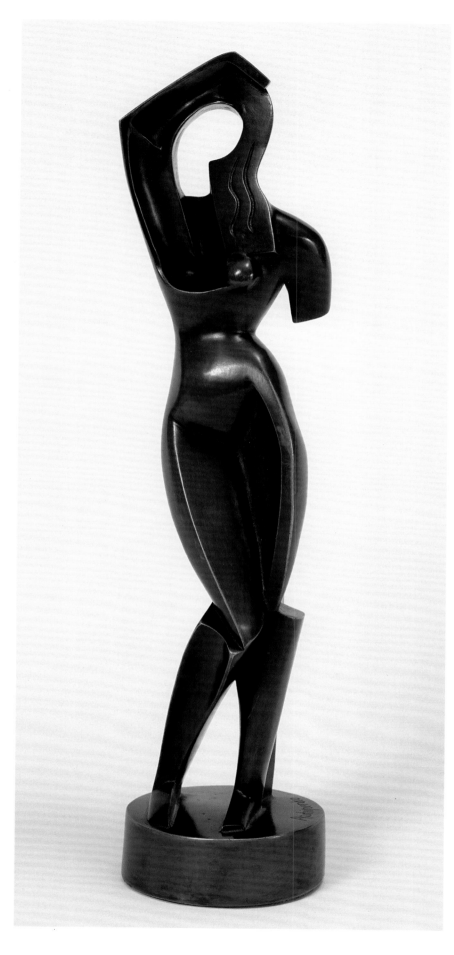

tion. It was Pointillism that stimulated his interest in the theories of Chevreul on the perception of colour; these had a lasting influence on his work and guided its new direction towards abstraction and the chromatic studies of 1912–13. Less evident in the series of *Saint-Séverin*, the Divisionist component re-emerged forcefully in the painting entitled *City* (1910–12), in which certain portions of the canvas were treated with a mosaic-tile-brushstroke to create a vibrant mosaic of lights and shadows. By this point, Delaunay had certainly had the opportunity to study a number of Cubist works, and from these he took certain methods for the deconstruction of forms and interpenetration of planes, but without ever allowing them to deflect his research from its main goal. It focused on the concept of 'simultaneity', a vague and confused concept that has been widely abused, and which returns with various connotations in Cubist and Futurist texts. Delaunay made use of this term in reference to Chevreul's 'simultaneous contrasts': as his wife Sonia Delaunay Terk, also a painter, explained in 1926, 'the pure colours become planes and, opposed in simultaneous contrasts, create for the first time a new form, constructed not by chiaroscuro, but by the depth of the relationships between the colours themselves'. Thus, having travelled briefly with the Cubists, he parted ways with them at the 'Section d'Or' exhibition by not taking part. In the meantime, Delaunay was strengthening his friendship with Apollinaire, who coined the term 'Orphism' to describe the lyricism and relationships with music in his painting, but also to the use of pure forms, not derived from reality: in other words, abstract. Or, as Delaunay himself put it: 'It was the birth of an art that no longer had anything to do with an interpretation or description of the forms of nature. Instead of being, like music, an auditory art, it is a visual art, whose forms, rhythms and developments set out from painting itself, just as music does not deduce its sonority from nature, but from musical relationships. Painting becomes painting'.

Delaunay reached this painting-becomes-painting level by degrees around 1912–13 in a largely natural and almost obligatory manner, as is revealed by almost all the series the painter inaugurated in parallel during this period, each of which led to abstract results. Elements of the Cubist language still persisted in the famous series dedicated to the *Eiffel Tower* (1910–11), but by now colour had exploded, deconstruction was accompanied by other means of execution and dynamism came to prevail over Cubist staticity, crushing and deforming space, with results that would have a decisive influence

Raymond Duchamp-Villon
The Horse, 1914
Bronze, 440 x 440 x 260 cm
Paris, Musée National d'Art Moderne,
Centre Georges Pompidou

Opposite
Constantin Brancusi
Endless Column, 1918
Wood, 203.2 x 25.1 x 24.5 cm
New York, The Museum of Modern
Art, Gift of Mary Sisler

on the Futurists (in particular, Boccioni) and on the German school of the Blaue Reiter. An affinity with the Futurists, which Delaunay would never admit to, is also apparent in the choice of theme, with the exaltation of the hypermodern architecture of the tower (this has a parallel in the Gothic way he treated space, as was previously seen in his *Saint-Séverin*). *The City of Paris* (1912), with the apparition of the Three Graces in the urban space and with its unusual dimensions, rendered definitive the break with Cubism in favour of a 'total' painting. His research into colour was the prelude to a revolution in which he intended to develop a vocabulary that involved music and poetry. The next step was the series of *Windows* in which Delaunay reached the point of fully-fledged abstraction. In one of the canvases it is still possible to recognise the dynamic silhouette of the Eiffel Tower at the centre, but this is lost in a succession of planes of colour that even flow off the edge of the canvas. They then invade the frame in a process that was at once decorative and justified by his conception of the painting, which he conceived as a fragment of a space-time continuum that goes well beyond its limits. At the same time, with the *Simultaneous Disks*, his painting becomes the science of colour and vision, an inex-

haustible study of the possibilities of colours more than a definitive result.

Delaunay's studio became a place for meetings and discussions that attracted, among others, his wife Sonia, Apollinaire, the poet Blaise Cendrars, and the Russian Marc Chagall; the magazine *Montjoie*, founded by a friend of Apollinaire's, became the vehicle for the group's ideas, which presented itself to the public at the Salon des Indépendants in 1913. As usual, Apollinaire attempted to remain quite vague about the meaning of the term and to extend it to the greatest possible number of names. At the Salon, in addition to the Delaunays, Room 45 featured artists like Kupka, Picabia, Duchamp, Léger and the American Synchromists: these were very different artists, but all brought together by a return to colour, an interest in movement and 'simultaneity', and a brief shared past linked to Cubism, whose leading exponents were displayed in Room 46. All the same, the alliance functioned, and the next years the dimensions of the works proposed obliged the jury of the Salon to award them the largest hall.

Delaunay's development was unquestionably stimulated by his wife Sonia, whom he married in 1910 on her divorce from Wilhelm Uhde. Her preferred media were gouache and

watercolours, and her works in the decorative arts underwent a significant evolution (for instance, her famous simultaneous outfits). They were no less radical than that of her husband, as is shown by *Prose du transsibérien et de la Petite Jeanne de France de Blaise Cendrars* (1913), a 'simultaneous poem' that unrolled to a length of nearly two metres. They developed in partnership with Cendrars, with the visual part accompanying, not illustrating, the text.

Equally solitary and autonomous, although occasionally intersecting with both Cubism and Orphism, was the path followed by Fernand Léger. Following his Impressionist and Fauvist efforts, in 1907 his eyes too were opened to the work of Cézanne. In 1909, in his studio at the Ruche in Montparnasse, he painted the *Seamstress*, in which the only detectable link to Cubism lies in its reduced chromatism, though it is already possible to see his very personal use of elementary and accentuated volumes, which seem to represent more a mannequin or a modern robot than a human figure. Once it had been tried out, this language was developed into more complex forms in the monumental *Nudes in the Forest* (1909–10) which was exhibited at the Salon d'Automne in 1911. His palette was further reduced to a harsh, metallic *grisaille*, while the volumes were organised into polyhedrons, cylinders and truncated cones. Léger was later to say about this painting: 'I wanted to "disarticulate" the bodies. All of this was impossible to pursue without moments of discouragement. I spent two years struggling with the volumes of *Nudes in the Forest* … It was nothing other than a battle of volumes…'. The next step was the reintroduction of colour, which Léger pursued in parallel with his friend Delaunay: 'Delaunay was moving towards nuance and I was moving towards a straightforward quality of colour and volume, contrast. A blue remains a pure blue if it is next to a grey or a non-complementary hue. If it is opposed to an orange, the relationship becomes constructive, but it does not colour'. Colour appears in *The Wedding* (1911) in which the painter also began to combine his 'tubular' volumes with an airier, less suffocating and clustered composition. The style of this period had a considerable influence on the more orthodox Cubism, and Gleizes in particular, but this was still a phase of rapid transition that saw the use of simpler, more ample forms, underscored by a bold black outline and a further reinforcement of colour the following year. But it was the various versions of *Ladder* and *Houses under the Trees* in 1913–14 that inaugurated the most successful period of Léger's painting prior to the war. The palette was reduced to a few pure colours: red, yellow, blue and green, which exploded in all their energy against the grey background. The shapes (cones, cylinders and parallelepipeds) were sketched in rapidly with confident strokes and filled in powerfully with colours that became a simple white in the flashes of light. Any reference to reality—still present in the automatons of *Ladder* and the toy-houses of *Houses Under the Trees*—was purely a pretext, and often made way for the simple *Contrasts of Forms*, which might be described as abstract had Léger not declared that 'the quality of an artwork is in direct proportion to its quantity of realism'. Obviously, by realism Léger did not mean the depiction of reality, but, to use a term that would be widely used during the 1930s, the concretism of painting, its 'being form and colour'. In August 1914 Léger departed for the front. War was an experience that left a deep mark on him, both in human and artistic terms. The renewal of contact with ordinary people, the world of workers from which he came, persuaded him of the importance of providing a solid, simple language for a specific moral choice: 'Their free way of speaking, their dialect was my mother tongue. I wanted my work as a painter and the images that I created to be as solidly based as that dialect… It was in the trenches that I grasped this point'. Contact with the civilisation of machinery worked in the same direction: 'I was dazzled by the breech of a 75-calibre cannon open in the bright sunlight… This breech… taught me, for my own plastic evolution, more than all the museums in the world. I found myself face-to-face with the object, in all its naked crudity, built by the hand of man and dependent upon geometric determination…'. These are very important passages, which document how a propensity for simplified geometric forms, the rediscovery of the object, and the elevation of ordinary people and labour, which were to dominate his work over the years that followed, all shared the same root. He did a lot of sketching at the front and when, in 1917, he was hospitalised for intoxication, he returned to painting and executed the monumental *Card Players*. With respect to his paintings of 1914, the canvas is more solid and full, though it still shows the preference for the use of a few pure colours, yellow, red and blue; the volumes evolve in a clearly mechanomorphic direction, and narrative and description reappear, evident for instance in the imposing and at the same time ridiculous figure of the officer on the left. A new streak of irony, linked to Dadaism—which also shared a love of machinery—lurks throughout the painting.

Constantin Brancusi
The Artist's Studio, 1918
Tempera and pencil on panel,
32.8 x 41.1 cm
New York, The Museum of Modern
Art, The Joan and Lester Avnet
Collection

If Cubism was born as a language that attempted to offer a new solution to the relationship between three-dimensional reality and the two-dimensional surface of the painting, the idea of a Cubist sculpture might seem a contradiction in terms, one that posed other plastic problems and demanded different sorts of solutions. That could happen only at the point at which Cubism, from being a solution of the problem of the depiction of space, was transformed into an aesthetic. The transfer actually took place quite early, in part because it satisfied a demand for a renewal of the sculptural language, which might seem, at the turn of the twentieth century, to have been a 'dead language'.

After the great example set by Rodin and Degas, the only artist capable of providing an authentic contribution to the development of the medium was the Catalonian Aristide Maillol. An academic by training, and later a member of Les Nabis, Maillol nonetheless remained a stranger to the avant-gardes, developing a language that steeped his classicism in a moderate primitivism. Maillol would have his great moment between the two World Wars, when he created the Junoesque figures that constituted a bridge to the sculpture of the years after World War II. In the first decade of the century, sculpture needed very different elements to keep up with the feverish progress of painting. An interesting, but excessively episodic contribution had been given in this direction by Matisse and Derain, with a number of sculptural exercises that showed the path to be followed in Gauguin and African art. And it was to this latter model that the first efforts of the Cubists seemed to look with great focus, as seen in Brancusi's first efforts and the sculptural work of Modigliani. In 1909, when he first emerged from his 'Negro' phase, Picasso did the *Portrait of Fernande* in bronze. The work was certainly effective on its own terms, but it was still

Constantin Brancusi
Bird in Space, circa 1928
Bronze and marble,
137.2 x 21.6 x 16.5 cm
New York, The Museum of Modern Art

transitional as a sculpture because it relied too heavily on the solutions that he had set down in painting, to the point that it seemed like the solidification of a portrait, a figure emerging from a canvas of the same period.

Cubist sculpture underwent a period of incubation in 1911 and 1912 before producing its first significant results in 1913. Its points of reference were African sculpture and Cubist painting, taking the latter's characteristics of stylisation and fragmentation of the traditional form.

An example of this development is Raymond Duchamp-Villon (the brother of Marcel Duchamp) who borrowed from primitive sculpture a process of simplifying the form; this can be seen in the taut surfaces and stylised eyes of his portrait of *Baudelaire* of 1911 (Rouen, Musée des Beaux-Arts). This work blazed a path that joined the stylisation of the outlines to a moderate deconstruction of form, a process that would attain its culmination in the *Horse* of 1914. This powerful sculpture, familiar with Boccioni's experiments in the field, blended the static and the dynamic, traditional subjects and a new mythology of machines (the steam horse). Duchamp-Villon generally made use of traditional sculptural materials, as did all those sculptors who attempted to transpose the aesthetics of Cubist painting into their art.

The Hungarian sculptor Joseph Csaky, who came to live in Ruche in 1908, also used traditional materials: his *Standing Woman* (1913) makes use of gilt bronze to embody a modern idol, hieratic in its frontal presentation (which also shows its debt to painting) and in its broken lines.

More closely tied to the example of the primitives was the sculpture of the Russian Osip Zadkine, who arrived in Paris in 1909. The artist made use of bronze, stone and wood, concentrating on solids and spaces, alternating sudden slashes, concave and convex surfaces, and obtaining results of great beauty though they were both rough and refined at the same time. In the *Woman with a Fan* (1920) he again explored a subject that was widely used in early Cubism, imbuing it with a powerful expressiveness created with the use of crushed surfaces and sudden flashes of light. The sculpture by the Lithuanian Jacques Lipchitz (a close friend of Juan Gris) instead seemed to aim at an almost architectural solidity, whose vertical thrust was pro-

duced with alternating straight and curved lines. His attention to structure led him, in his late Cubist phase, to results that were practically abstract, followed by a profound crisis that led him to a more moderate Cubism. Even though he favoured stone and bronze, Lipchitz sometimes created sculptures with assemblages of various materials, such as found or sculpted pieces of wood.

In 1912 the Russian Alexandr Archipenko also began to use found materials in his sculptures as well as the traditional ones, obtaining in both cases results of high quality. The bronze *Draped Woman* (1911) represented the complete synthesis of the influence on his work of African sculpture, fundamental to his early activity, with the geometrisation of forms typical of Cubism. The result has a sacred quality, midway between the primitive idol and the maternity of Christian iconography. He turned to assembled materials in the series based on the Médrano Circus, the first piece of which, from 1912, has sadly been lost. The theme demands a playful development of technique, as shown both by the lively polychromy, and the grotesque appearance of these deformed marionettes.

Irony was always present in assemblage, which originated in 1912 as a descendant of the Cubist collage, as the technique was by its very nature playful. Besides Archipenko and Boccioni (who in 1911 had already produced *Fusion of a Head and a Window*, since destroyed), one of the first artists to take the collage of various elements outside of the canvas was Picasso, with his guitars made of cardboard or sheet metal from 1912. Like the use of collage in painting, the assemblage technique was the greatest stimulus that Cubist sculpture could offer to the sculpture of the years to follow. Its influence can be seen in ready-mades, the *Merzbau*, combine paintings and installations, and it still has an effect on present practice.

According to recent criticism, the French artist Henri Laurens was the most interesting creator of Cubist assemblages. This is because the majority of his creations, which were developed during the war, went unnoticed at the time and were put in the background by the success of the artist in the years after the war. Having trained on the example of Rodin, in 1910 he moved to the Ruche where he met Léger and Archipenko. In 1911 he became a friend of Braque, and this

Gino Severini
Maternity, 1916
Oil on canvas, 78 x 59 cm
Cortona, Museo dell'Accademia
Etrusca

Pablo Picasso
Portrait of Olga in the Armchair, 1917
Oil on canvas, 130 x 88 cm
Paris, Musée National Picasso

Opposite
Pablo Picasso
Pierrot, 1918 (detail)
Oil on canvas, 92 x 73 cm
New York, The Museum of Modern Art

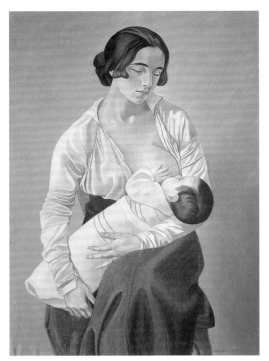

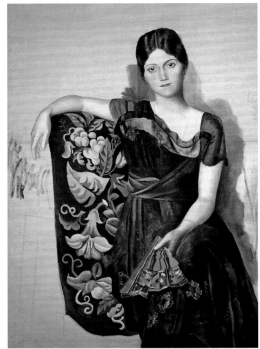

acquaintance induced him to take a stab at painting as well. His first assemblages date from 1915 and were characterised by a refined language and a playful approach reminiscent of Archipenko's *Médranos*. The *Clown* of 1915 was an assemblage in painted wood that joined hemispheres, cones and cylinders to form a grotesque figure, even if the sobriety of the chromatism reveals an affinity with the controlled language of Braque. This is a model that returns in his still lifes of 1916–18, as in the *Bottle of Rum*, executed with fragments of wood and bent and painted sheet metal. On the subject of colour, he would say in 1967: 'I wanted to suppress the effects of the variation of light on the statues… a statue that is not polychrome undergoes the shifting of light and shadows and is continually modified. For me, polychromy meant constructing a statue that has a light of its own'.

In the years following World War I, Laurens returned to traditional materials and to the figure, specialising in female nudes, which he developed in a volumetric, Junoesque direction, though not devoid of irony.

A curious conjugation of Cubism in an architectural and decorative sense was offered in 1912 by the Cubist house designed by André Mare, a friend of the Duchamps. The interior decoration was designed by Cubist sculptors and painters working together, while the façade was the work of Duchamp-Villon, who proposed an adaptation of 'Louis XVI' architecture in Cubist taste: it featured clean geometric lines and rejected all ornamentation.

The most interesting element was perhaps the 'ethical' character that the austerity of style took on at the moment that it was transferred from 'pure' art to furnishing. Despite the disgusted reactions of the critics, the result was really not very revolutionary, as shown by the enthusiastic response to the interior decoration and furniture. Nonetheless, the *Maison cubiste* had the merit of suggesting the application of the movement's formal innovations to the sphere of architecture, and opening itself to the design proposals made by the Italian Futurist Sant'Elia and the idea of the renewal of European architecture.

In parallel with Cubist sculpture, another great, solitary experience demonstrated that, even setting out from the same point, the renewal of sculpture could yield completely different results. After attending the School of Arts and Crafts at Craiova in Romania, and taking a degree at the Academy of Bucharest in 1902, Constantin Brancusi decided, like many other East European artists, to move to the centre of art in Paris. Having no money, once he reached Munich he set out on foot, walking almost all the rest of the way. Having reached Paris in July 1904, his first works caught the attention of Rodin, whose studio he frequented for a time. But it was his encounter with the early sculptures by Derain and Picasso that showed him the way. In 1907 he got a place to live in Montparnasse, where he executed the first version of the *Kiss* (1908), a single block of limestone in which the embracing figures, rough and simplified, are in-

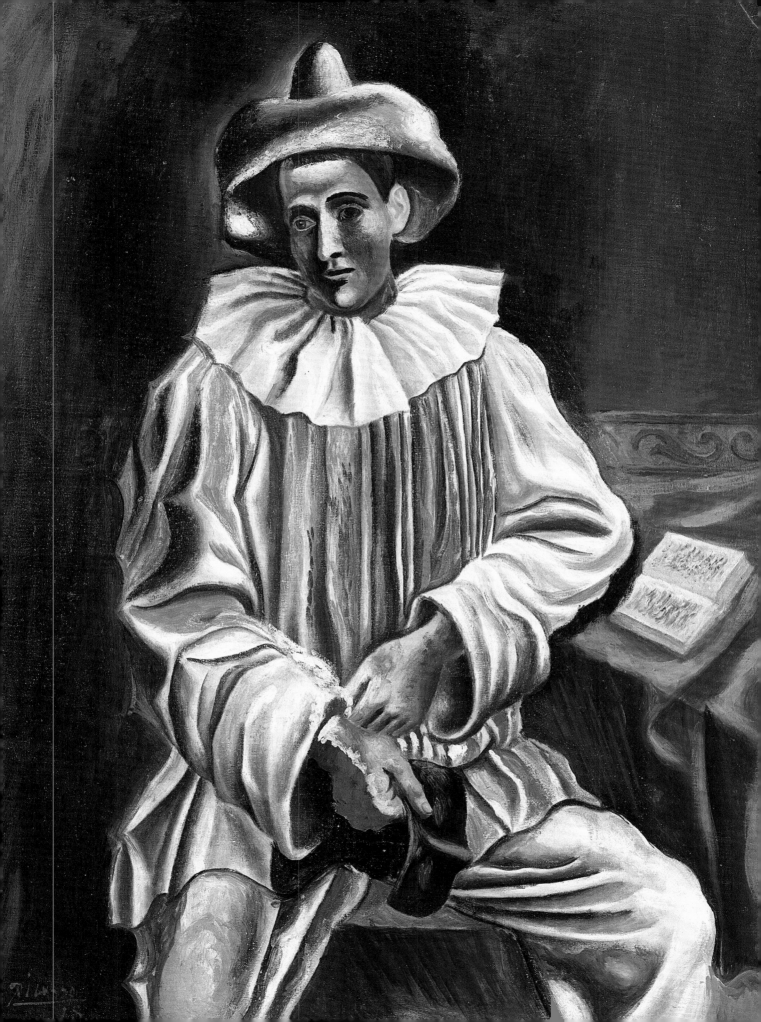

scribed without harming the unity of the cube, the arms creating an indissoluble unity, the eyes and the mouths joined to form a single figure. The work might have been hinting at a future Cubist evolution, but this was not the case: the next step, represented by *Portrait of the Baroness R.F.* (1909) and its metamorphosis into the various versions of the *Sleeping Muse*, demonstrates that what interested Brancusi was to refine the essentiality of that first attempt, to move towards an extreme simplification and synthesis, because 'simplicity in art is, in general, a complexity that has been resolved'. At the same time, and with the same calm, the sculptor was constructing his own personality. Fascinating but solitary, courteous and hospitable but in no way a social butter-

fly, he did not go out but lived simply in the studio where he worked. He combined the simplicity of his peasant origins with the refinement of his intelligence and the part of his nature that was Parisian. He spent time with attractive and well-to-do women, but without ever becoming involved in a relationship that might distract him from his work. He was astute in promoting his art but never chased after success; he enjoyed the friendship and respect of all the major artists of his time, but he stayed out of all schools and movements, seeking within himself, in his origins and his spiritual formation, the foundations of the slow and constant maturing of his work.

The investigation into his identity as a Romanian was one of the key elements of his

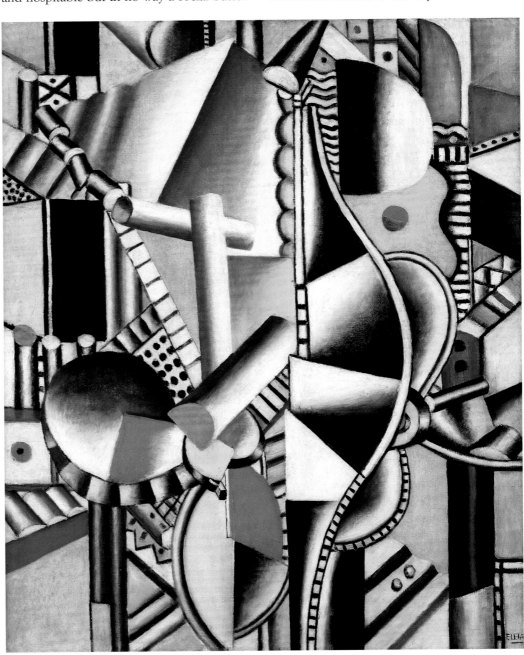

Fernand Léger
Propellers, 1918
Oil on canvas, 81 x 65.4
New York, The Museum of Modern
Art, Katherine S. Dreier Bequest

Chaim Soutine
White House on a Hill, 1918
Oil on canvas, 65 x 50 cm
Paris, Musée de l'Orangerie

culture: 'My heart has remained in the land of my youth. My code is the code of Craiova, where I spent the most important years of my youth'. Added to this aspect of his work was Oriental spirituality, the faces of the Buddha that he studied in the Musée Guimet (seen in the *Sleeping Muse*) and African and Oceanic sculpture, through the mediation of Gauguin.

Brancusi's working method makes it difficult to break up his oeuvre by decades. In contrast with many other artists, the two wars did not for him constitute watersheds. Almost all of his subjects were first elaborated in the second decade of the century, but nearly all of them were further developed at various points,

refined, placed on pedestals, and adapted again to become pedestals for other works. These were then placed alongside other works to form 'mobile groups', that is to say, temporary installations that closely bound together two or more works in a unitary artwork. The only trace of many of these passages are the photographs taken by the artist himself. In fact, dissatisfied with how photographers worked with his creations, Brancusi decided quite early to document his work personally. In 1921, with help and advice from Man Ray, he set up a darkroom in his studio and, from that point on, photography became an integral part of his oeuvre and creative process. The importance

Pablo Picasso
Glass, Bouquet, Guitar and Bottle,
1919
Oil on canvas, 100 × 81 cm
Berlin, Sammlung Berggruen,
Staatliche Museen zu Berlin
Preussischer Kulturbesitz

that Brancusi attributed to his place of study and work, as well as to the position and installation of his creations, is demonstrated by the condition with which he bequeathed the contents of his studio to the Musée d'Art Moderne of Paris: that it should be reinstalled precisely as he left it.

The *Sleeping Muse* introduced into his body of work the essential, rarefied and pregnant form of the egg, a symbol of life and beauty, which then returns in the various versions of *The Newborn*. In 1910 he began the first version of the *Maiastra*, now at the MoMA in New York. The legendary bird from Romanian folklore, with its golden plumage and human voice, is transformed into an essential form, at once big-bellied and sleek, made of white marble, which stands on a tall pedestal that alternates two simple parallelepipeds with two caryatids, side by side, rough and barely sketched out. The version in the Guggenheim collection—made of bronze polished to a mirror-like reflection to express the protean character and splendour of the creature—is placed on two simple stacked rhomboidal forms. The form of the Maiastra, often echoed in the pedestals, in 1918 became the starting module for the first version of the *Endless Column*: a visualisation of the yearning towards infinity, a cord linking heaven and earth or, in his words, 'an eternal song that brings us into the infinite, beyond all grief and all apparent joy'. Different versions of this work were to follow, until it culminated in the dizzying iron column that rises thirty metres above the Tirgu-Jiu complex in Romania

(1937–38). The *Maiastra* instead evolved into the purified and dynamic form of the *Birds*, described by him as 'the joy of the soul freed from material' and sublimated into flight. The elimination of a depiction as traditionally understood does not necessarily mean that these sculpture should be considered abstract: 'Those who consider my sculptures abstract are mad. What they think is abstract is as real as can be, because real does not mean the exterior form of things, but the idea and the essence of phenomena'.

This way of proceeding towards the essence can be clearly detected in the series devoted to his young friend Margit Pogany. In the first version of her portrait, done in bronze in 1913 and now at the MoMA, we already see the approach that he maintained throughout the rest of the series, with the girl's face reclining on her long neck and flanked by her tapered hands. The large eyes, whether closed or wide open, still show the influence of primitive sculpture, while the treatment of the hair and of the 'cuts', black against the shiny, reflective surface of the gilt bronze, shows a faint persistence of naturalism. In the successive versions, the search for the essential, for the soul within the portrait, leads to a progressive refinement of the forms. In the second version, in plaster, the hands are purified into a highly refined curving line, and the face becomes a simple oval; the sculpture was then combined with an intentionally rough-hewn pedestal, decorated with the mo-

Alexandr Archipenko
Two Giasses on a Table, 1919–20
Painted papier-maché on wood,
56 x 46 x 4 cm
Paris, Musée National d'Art Moderne,
Centre Georges Pompidou

Pages 376–77
Amedeo Modigliani
Red Nude, 1917 (detail)
Oil on canvas, 60 x 92 cm
Private collection

Henri Matisse
Woman at the Window, 1920
Oil on canvas, 101 x 135 cm
Saint Tropez, L'Annonciade,
Musée de Saint Tropez

Opposite
Henri Matisse
Painter and His Model, 1916–17
Oil on canvas, 146 x 97 cm
Paris, Musée National d'Art Moderne,
Centre Georges Pompidou

Pages 378–79
Henri Matisse
Odalisque with Red Culottes, 1921
Oil on canvas, 65 x 90 cm
Paris, Musée National d'Art Moderne,
Centre Georges Pompidou

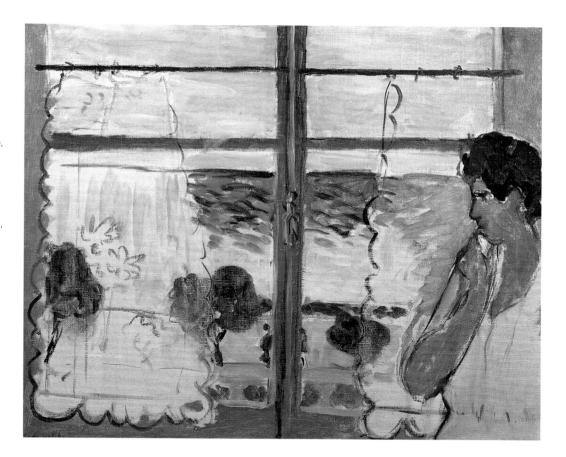

tif of the *Kiss*. 'In the final version (but is anything ever final?), the head, the hands, the hair, all flow together in unison'.

Brancusi's example, aside from offering an exceptional lesson in style (a lesson taken to heart by Modigliani, but also Dadaism and Surrealism), is above all a marvellous example of freedom: freedom from the obligation to follow the latest 'ism', and from the constrictions and difficulties of life and history; freedom, also, to be completely oneself in the capital of art, in the centre where all new ideas converge, where movements are born and die. A freedom that Paris itself made possible.

It should be said in this connection that the predominance of Cubist language—which was hardly monolithic in nature—did not at all exclude alternatives. Between 1910 and 1920 Kandinsky, Macke, Klee and Jawlensky spent time in and exhibited repeatedly in Paris; and in Paris, between 1912 and 1914, the Dutch artist Piet Mondrian also worked, refining the transition from his initial language to the prerequisites of neo-Plasticism in the years leading up to 1920, and the Mexican painter Diego Rivera developed his energy-filled language in relation to Cubism. In Paris in 1909, Filippo Tommaso Marinetti published the 'Manifesto of Italian Futurism' in *Le Figaro*, and, at the behest of Gino Severini, who had been living there since 1906, Boccioni, Balla and Russolo

arrived in October 1911 to renew their own language, then returned to great acclaim in February 1912 at the time of the Futurist exhibition at the Bernheim-Jeune gallery, inaugurating a productive period of exchange between the Parisian avant-garde and Orphic Cubism. Paris was also a necessary stopping point for American authors and intellectuals, who developed their artistic maturity there and carefully studied the ateliers of the artists in preparation for that remarkable event, the Armory Show of 1913. In the French capital, Giorgio de Chirico was developing and showing his Metaphysical painting for the first time: his research was based on German philosophy and Symbolist painting, but developed into a radical experience as a result of confrontation with the Cubist sense of space, the poetry of Apollinaire, and the more advanced ideas in literature. And it was in the fertile soil of the city that the 'Paris School' came into being, whose common denominator was the artistic freedom that existed there alone: freedom from all political directives and tradition; freedom to draw upon one's own culture, and to make reference to that of all other civilisations; freedom to be one of the people or one of the more refined classes, to engage with tradition or reject it as a whole. It was a freedom underwritten by the most vigorous art market in the world, but also by the feeling that, whatever part of the

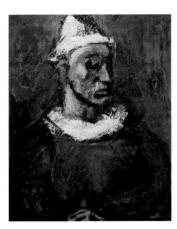

Georges Rouault
The Clown, 1912 (detail)
Oil on canvas, 90 x 62.2 cm
New York, The Museum of Modern
Art, Gift of Nate B. and France
Spingold

world you came from, you were at home. By these very assumptions, the name 'Paris School' cannot identify a unitary style or a community of masters and followers: it rather indicates an atmosphere and lifestyle shared by artists from around the world who, in the capital of art, brought themselves up to date on the various trends, without necessarily adhering to any of them, thus leading to the creation of artworks that are difficult to classify, and are for that very reason invaluable. The heart of this freedom moved in the years between 1910 and 1920 from Montmartre, where the first Cubists still lived, to Montparnasse and its heterogeneous *bohème*, made up of Russians, Hungarians, Poles, Romanians, Germans, Jews, Japanese, Italians and, of course, French.

Marc Chagall was Russian, and he arrived in Ruche in 1911, where he lived a totally bohemian life for three years: 'He painted naked and never complained. On Mondays he would eat the head of a herring, and Tuesday the tail, and all the other days of the peak, crusts of bread', wrote Dan Franck. Of course, he was attracted by Cubism, but he did not value its scientific approach to reality. He arrived from Russia with a visual language that was already partly formed, adapted to the folk memories of his childhood, and from which he had already taken a number of subjects that he used for the rest of his life: births, weddings, violinists and cows. Adopting the deconstruction technique typical of Cubism, he adapted it to his own purpose, fusing not the various planes of external reality but the symbols of an entirely interior world. Cubism freed him from the last leavings of Naturalism; Orphism and Fauvism gave new fire to his palette, but nothing more. The *Self-Portrait with Seven Fingers* (1912) is exemplary in the way that Chagall succeeded in bending these languages to his own needs, moving from Cubist synthesis to analogy: the moon descends to the earth, the roof of a hut merges with the sky, the nanny-goats fly into a blood-coloured sky, and a woman's womb opens to show the child contained within. Even as he rejected the criticisms of those who accused him of indulging in literature, he preferred to frequent poets like Apollinaire and Cendrars rather than painters. By the time, in 1914, he went to Germany for his first solo exhibition, taking advantage of the opportunity to visit Russia (where the World War and the Revolution would keep him for many years), his language had been completely shaped and he was ready to undertake one of the most interesting adventures of the twentieth century. Far shorter, and entirely enclosed within the horizon of the *bohème* of Montparnasse, was

the story of Amedeo Modigliani. Born in Leghorn in Italy, at a young age he absorbed a complex culture not restricted to painting, and which would become in later years an integral part of his personality as a handsome and intelligent dandy, elegant and aristocratic even in the depths of poverty. After a stay in Venice, where he had an opportunity to learn about the latest developments from Vienna and the north (1903–05), he moved to Paris (1906), living first in Montmartre and later in Montparnasse. His first Parisian paintings, dating from 1908, show a visual culture that was still largely Post-Impressionist, and in the process of incorporating the Decadent and Jugendstil components that he absorbed in Venice. Also apparent are the influences first of Toulouse-Lautrec and Picasso's Blue Period, and then Cézanne, whose work would play a central role in the definition of his style. In 1909 he met Brancusi and despite their great differences in temperament they became fast friends. The sculptor awakened Modigliani's interest in primitive art, from African masks to the Egyptian collection in the Louvre, and led the Italian to devote himself to sculpture, which remained his chief pursuit until 1914. It almost seems that sculpture and drawing were the only way for Modigliani to solve the outstanding issues in his painting. Whatever the case, when he began to paint again in 1914, after nearly five years of stone heads and caryatids, every element of Secessionist refinement had been stripped from his style, and that what had replaced it was now capable of combining Cézanne, African art, the Italian Trecento, certain Cubist stylistic elements, brutality and great refinement. In the portraits of 1914 and 1915, the sign is rapid and ungainly, the eyes are small, the noses deformed, the lips contracted; his painting alternates various solutions with nonchalance and irony, from clumped brushstrokes to small rapid touches, from compact areas to others that allow the canvas to show through. All of them were functional in rendering the psychology of the character portrayed, usually a friend, on rare occasions a model. The more turbulent and difficult his life, the more his style acquired confidence and elegance: the line softened, becoming a sinuous arabesque that has been almost excessively compared to the Sienese art of the Trecento. Relationships between hues were also refined, while the colour was laid down in a more measured, calm and sensitive manner. Soon, alongside the portraits, a few female nudes began to appear, ideal heirs to the caryatids of the years till 1915: in their way, these too were portraits, given their capacity to join the sensuality of the nude with the study of the

Chaim Soutine
Altar Boy, 1928
Oil on canvas, 69 x 49 cm
Paris, Musée de l'Orangerie

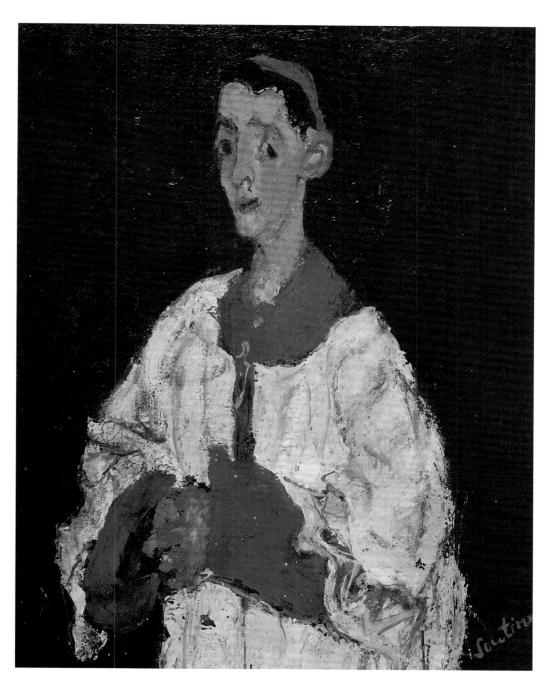

various poses with which a woman yields, each time, to our gaze.

The death of Modigliani in 1920 from tubercular meningitis seemed to end a phase in the life of Montparnasse and the 'Paris School': the lively and turbulent bohemian phase that the cynical and growing art market transformed in a radical manner in the 1920s and 1930s.

One interesting case is that of Chaim Soutine, a young Russian Jew who arrived at Ruche in 1913 and immediately became a close friend of Modigliani, who painted his portrait many times and introduced him to Leopold Zborowski, a Polish-born art dealer, who became the primary supporter of his painting for years. Soutine, who came from a culture that saw painting as a sin and from a family that punished him to make him stop, was dominated by an instinctive and savage propensity to paint, though at the same time he rejected art, going so far as to slash dozens of works with a knife throughout his life. Tormented and suffering from continued bouts of gastritis, in 1915 he began to produce a forceful body of painting that, with the violence of his brushstrokes, the deformations and the anguish that it radiates, can be placed in an Expressionist context for lack of a better definition, even though his ties to the Expressionism of his time were few and far between, and which more probably developed out of his study of Realism, from Rem-

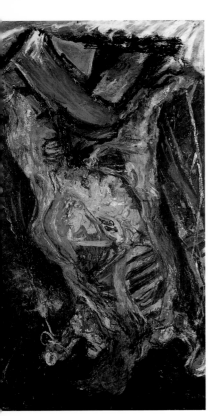

Chaim Soutine
Flayed Ox, 1928 (detail)
Oil on canvas, 70 x 52 cm
Musée de Grenoble

brandt to Courbet. After years of poverty, in 1922 he met Dr Albert C. Barnes, a great American collector who fell in love with his work and who, over the course of a single year, caused his prices to rise sharply, ensuring him economic security. This, however, did nothing to put an end to his suffering and cyclical depressions, driving him to destroy entire phases of his work (including many canvases from the Céret period of 1919–22). In 1925 he began work on two of his most famous cycles of paintings, those of the *Flayed Oxen* and the *Altar Boys*, which perhaps, more than his dramatic landscapes, managed to embody two different sources of his anguish, the drama of childhood and the issue of the decay of the flesh, which Soutine depicted in many paintings with a blend of fascination and terror.

Other foreigners, living in or passing through Paris in the second decade of the century, remained relatively alien to the circuit of Montparnasse, while still contributing substantially to the complexity of that cultural milieu. Between 1912 and 1914, the Dutch artist Piet Mondrian lived in the French capital, and radically reformed his language there. This was based on an Expressionism of Symbolist derivation and enriched by his interest in theosophy via reflections on Cézanne and Cubism. His extremely rapid maturing led him from the Cézannesque second version of *Still Life with Ginger Pot* (1912) to the analytical Cubism of his oval compositions, and from these he moved without interruption to the grid of straight lines he employed in his works in 1914. Beginning from Cubism, Mondrian arrived at geometric abstraction, pushing his way down a path that orthodox Cubists were frightened to follow, even if there is nothing more concrete than an abstraction that depicts the structure that underlies reality. From the labyrinths of 1914, with their pinkish, light blue, ochre and grey areas, it was only a short step to neo-Plasticism, but Mondrian would take that step in his homeland, thus founding the second pole of abstract art of the 1920s.

Gino Severini had a much stronger tie with Paris, where he arrived after his education in Rome at the school of the Divisionist Giacomo Balla, but once in the French capital he updated his Divisionism on the basis of Seurat's experience. In the meantime he preserved his ties with the situation in Italy, and in 1910, at Boccioni's invitation, he joined the Futurist movement. In part due to his distance from the nucleus of the movement, his early Futurist works appeared anomalous, as well as being less provincial and more worldly-wise than its Milanese counterpart. And yet, surprisingly, his cultural points of reference in 1910–11 were not those to which Futurism was turning its eyes at the end of 1911, that is to say, Cubism and its Orphic declensions. If we look at *Travel Memories* (1911) or *The Obsessive Dancer* of that year, we see that Severini preserved his Pointillist brushstroke, transforming it into a tile of a mosaic and allowing the colour to explode. Even his Cubist technique of decomposition, which soon came to replace the deformations in his first canvas, was resolved entirely on the surface, and seemed to aim more at a simultaneity of images and memories and their obsessive repetition than any decomposition and dynamic interpenetration. *The Chahut Dancer* (1912) reveals a more orthodox Futurist language that does not exclude, as in Balla, repetition of the limbs to indicate movement, and was soon resolved into nearly abstract compositions. The link was still more with Orphism than with Italian Futurism, even though the underlying ideology and the explosive joy of the colour remained Futuristic. Full abstraction was attained in the highly coloured *Sea=Dancer* (1913–14), a synthesis of the ideas expressed in the manifesto *The Plastic Analogies of Dynamism*: 'The sea as it dances in place, zig-zag movements and glittering contrasts of silver and emerald green, evokes in my plastic sensibility the far-off vision of a dancer covered with dazzling sequins…'

Marinetti's invitation to support the war effort with his own works led him to a renewed return to figuratism. But there can be no denying that this appeal coincided with his need to slow his hurtling headlong course, returning to a reflection on Cubism in order to confer upon his works a less haphazard order. Severini read the texts on mathematics and geometry that had already been of interest to the 'Section d'Or', and he began, in 1915, the series of considerations that led him, in 1921, to publish one of the key texts of the return to order, *From Cubism to Classicism*. What was at issue was a classicism in composition, one that could be implemented equally well in figurative works such as the elegant *Maternity* (1916) and in such post-Cubist works like *Bohemian Playing the Accordion* (1919). In both cases, underlying the final result was a careful study of the geometric structure of the canvas and the overall chromatic balance, which attenuated the apparently immense differences. Severini was not the only artist to veer early, in the heart of the avant-garde, towards a return to order and a renewed classicism. In 1917, Picasso painted *Olga in the Armchair*, a portrait of his new girlfriend which seems to cancel, at a sweep, the entire Cubist

Chaim Soutine
Landscape, 1921
Oil on canvas, 89 x 120 cm
Private collection

adventure, replacing it with a classicism that looks to Ingres. That this was not Picasso's intent is demonstrated by the parallel development of the so-called 'grand Cubism', which evolved the language of the movement in an equally classical direction. The eclecticism of both Severini and Picasso seemed to imply that the important thing is not so much the final result but the underlying logic of the canvas, which was in these years, for both of them, unquestionably conservative and classical. In addition to Mondrian, this was also the case with Charles Édouard Jeanneret (Le Corbusier) and Amédée Ozenfant, who, on the ashes of Cubism, together founded Purism towards 1920. Purism was a rigorous, Calvinist, crystallized Cubism, devoid of all decorative components and any empirical or chance derivation. The same things can be said for Henri Matisse who, during the second decade of the century, renewed his own language by looking towards Cubism from a rigorously autonomous and already fully defined position, enriching his highly refined palette with a number of trips to North Africa. But he too, towards the latter half of the decade, seemed to sense the need to mute his tones and render his composition a little more severe. An effective demonstration is offered in the *Piano Lesson* (1916), with its broad geometrical planes, simple lines and chromatic structure.

Whereas these had always been very defined, now they were decidedly tending towards tones of grey.

The true champion of this early *rappel à l'ordre* which lurked in the heart of the avant-garde was undoubtedly André Derain. After his first proto-Cubist efforts in 1907, rather than moving on to Cubist decomposition, Derain lingered with Cézanne to consolidate his volumes. In parallel, he carried forward his interest in the 'primitive', that is, African art, folk painting and frescoes from the Duecento and Trecento. His *Portrait of Iturrino* (1914) is one of the acknowledged masterpieces of this process: the chromatic reduction, the awkward dryness of the design, the revival of ancient methods and recipes for painting were nearly a decade in advance of the comparable evolution that European painting was to undergo, and which did so, paradoxically, from avant-garde presuppositions: the very same premises and models that would lead others to far more radical innovations. Derain's pioneering role would be acknowledged with admiration by the proponents of magical realism in the 1920s, and this is shown by the monograph, among other things, that Carrà dedicated to him and which was published in *Valori Plastici*, the mouthpiece of the Italian return to the qualities of tradition.

The End of the Artistic Object

Marcel Duchamp
Nude Descending a Staircase (No. 2),
1912 (detail)
Oil on canvas, 146 x 89 cm
The Philadelphia Museum of Art,
The Louise and Walter Arensberg
Collection

The Dada Revolution

If one wished to provide an unexceptionable definition of Dada, it could be called the avant-garde of contradictions. To the present day none of what has been said about this phenomenon can be considered anything more than a partial truth; and, for that matter, it has been precisely this complexity rich in contradiction of Dada that has made it such a fertile source of inspiration for the art that followed, right up to the middle of the 1990s. In its simplest form, this complexity is nicely synthesised by the title that Hans Richter gave to his renowned monograph of 1964: *Dada art and antiart*. In the years between 1916 and 1921, when it existed as a movement, Dada was at the same time a negation of art and a proposal for a new art. Both militant and apolitical, it was a movement without any consistent stylistic proposal, and yet it bestowed upon twentieth-century art some of its most significant linguistic innovations, such as ready-mades, photomontages and the artistic use of photography and film; it engaged in polemics with all the avant-garde movements, but at the same time it exposed the works and absorbed the styles; it was born during the war in an oasis of peace and yet, at the same time, it was never born since it was a spirit rather than a movement, a vision of the world and a way of life: or, as Richter claims, a new artistic ethics, that 'manifested itself sometimes in a positive way, and at others in a negative way, now as art, and now as the negation of art; at times it appeared as profoundly moral, at others, absolutely amoral'.

Dada itself encouraged this confusion, by variously attaining contradictory definitions or rejecting the very possibility of having a definition: 'Dada is a harlequinade made of nothing, which contains within itself all the most elevated problems', stated Hugo Ball in 1916; 'Dada means nothing', replied Richard Huelsenbeck; and, in the conclusion of a renowned manifesto of 1918: 'To be against this manifesto is to be a Dadaist'. Dada is the freedom to say and to deny, to make and unmake, to contradict oneself: it is play and prank, it is an irrational revolt against the intention to impose order upon the world: and for that reason,

it exhausted itself as a movement when the will to play died or, as was the case in France, when some of its adherents began to take themselves too seriously.

Even Dada's date of birth, conventionally established as 5 February 1916, the day of the foundation of the Cabaret Voltaire in Zurich, is only a partial truth, for at least two reasons: first, the Zurich-based group took at least a few months longer to establish itself as a new movement; second, the affirmation of the spirit of Dada took form a few years prior to that date and had nothing to do with that location. Even without reaching back, as Richter did, to the paradoxes of Zeno, it is fair to say that Dadaism constitutes the explosion, radicalised by the tragedy of World War I, of a series of ideas that had long been incubating in European culture. With their lives and writings, such authors as Alfred Jarry, Raymond Roussel and Isidore Ducasse, comte de Lautréamont, affirmed, as early as the late nineteenth century, the taste for play, the absolute freedom of the artist from aesthetic and moral strictures, the suppression of meaning and sense in art. This was a suppression that, through the German philosophical tradition, re-emerged in the second decade of the century in the painting of de Chirico, another crucial reference point for Dadaism. Anarchism constitutes the ideal and political point of reference for artists of the most varied extraction.

Meanwhile, the civilisation of machines contributed to the birth of a new aesthetic and the introduction of new symbols. The idea of a 'pure' art was contaminated by a fascination with the new communications media, from print to advertising, and from photography to cinema: an evolution that introduced that complex dialectic between hermetism and communication that ran through the century, and upon which a key figure like Marcel Duchamp moved with the grace and agility of a tightrope walker. It was in the midst of this contrast that there originated, with Futurism, the 'manifesto', experimentation with photography and cinema, the adoption of advertising strategies, and the bad painting of de Chirico in Paris and Duchamp's *Chocolate Grinder (No. 2)* (1914). It was from this assault upon the late nine-

Marcel Duchamp
The Shrub, 1910 (detail)
Oil on canvas, 127 x 92 cm
The Philadelphia Museum of Art,
The Louise and Walter Arensberg
Collection

Marcel Duchamp
Portrait of Chess Players, 1911
Oil on canvas, 108 x 101 cm
The Philadelphia Museum of Art,
The Louise and Walter Arensberg
Collection

Opposite
Marcel Duchamp
Nude Descending a Staircase (No. 1),
1911
Oil on canvas, 96.7 x 60.5 cm
The Philadelphia Museum of Art,
The Louise and Walter Arensberg
Collection

Pages 390–91
Marcel Duchamp
*The King and Queen Surrounded by
Swift Nudes*, 1912 (detail)
Oil on canvas, 114.5 x 128.5 cm
The Philadelphia Museum of Art,
The Louise and Walter Arensberg
Collection

teenth-century concept of 'art pour l'art' that the anti-artistic polemic also arose, finding its first, radical expression in the ready-mades that Duchamp began to select in 1913.

The outbreak of war, with its imperious demand that a position be taken, prompted many artists to express their loyalties, to take sides according to their nationalities, and to fight and perhaps die at the front; in contrast, others radicalised their libertarian and pacifist tendencies, having been forced to take a position in response to public opinion and propaganda that condemned them as defeatists and cowards. The artists who could not resign themselves to this changed state of affairs were obliged to take refuge in neutral states in order to avoid the war. There were two especially popular destinations: Zurich and New York. By June 1915, the American city had welcomed Marcel Duchamp (who had arrived two months before), Francis Picabia and Jean Crotti, the future husband of Marcel's younger sister, Suzanne, who was herself a Dada artist and an intellectual figure of considerable inter-

est. This was Duchamp's first trip to the United States, even though the acclaim paid at the Armory Show of 1913 to his *Nude Descending a Staircase (No. 2)* had already won him numerous supporters and friends, including Stieglitz and the Arensbergs.

Picabia, who had already visited New York during the Armory Show, re-established old friendships. In November, he held a solo exhibition at Stieglitz's Gallery 291, exhibiting his new 'mechanomorphic' works of art.

Picabia and Duchamp fitted easily into New York's lively cultural milieu interested in the new ideas of the European avantgarde. Gabriella Buffet-Picabia (1949) described a 'mad city that had become the refuge of all the conscientious objectors of a world at war', an 'overheated climate… favourable to the spirit of anti-traditionalist revolt'. It was in this climate that what would later be called the 'New York pre-Dada' developed, something that Gabriella Buffet-Picabia preferred to call an atmosphere rather than a movement: 'The Dadaists of

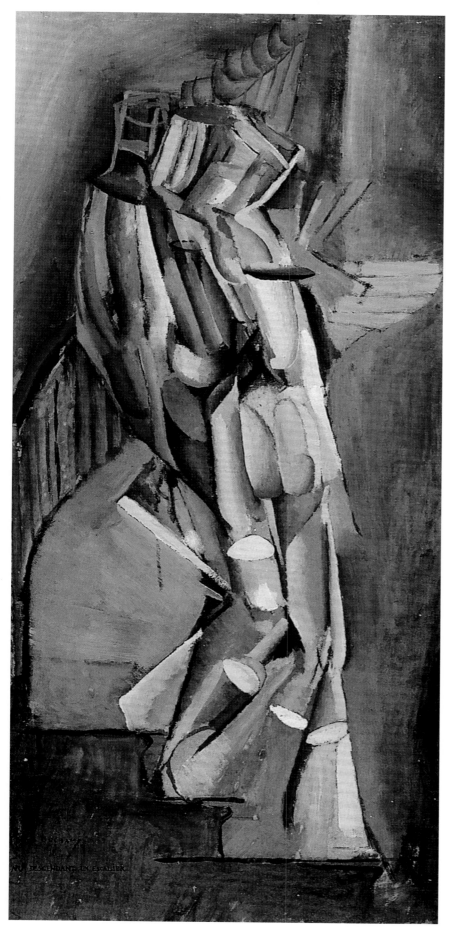

Zurich celebrated with well organised ceremonies that cult of heedlessness that in New York was content merely to live… the activity of New York was completely gratuitous and spontaneous, and never had a programme, nor a profession of faith'.

Two events in 1917 nicely summed up the characteristics of this anarchistic activism, spontaneous and devoid of proclamations: in March, at the Grand Central Gallery in New York, a fairly heterogeneous organising committee put together a Salon des Indépendants modelled on the example set by the Indépendants of Paris: an exhibition of contemporary art at which anyone, for a fee of six dollars, could show their own artwork. Marcel Duchamp, who was on the organising committee, decided to put them to the test by submitting, under the pseudonym of R. Mutt, an overturned urinal, entitled *Fountain*. The more conservative members of the committee were inflexible and rejected it for exhibition. Duchamp, who had orchestrated the prank to perfection with the help of his friends, resigned from the committee, while Walter Arensberg offered to purchase the sculpture and Stieglitz photographed it. Shortly thereafter the photograph was published in the second issue of *The Blind Man*, a magazine founded by Duchamp, as part of a measured defence of the work, which was also a manifesto of the poetics of the ready-made: 'It is not important whether or not Mr. Mutt made *Fountain* with his own hands. He CHOSE it. He took an ordinary everyday object and placed it in such a way that its functional significance vanished under its new title and a new point of view—he created a new way of thinking about that object'.

With this operation, which came nearly a century before the tactics of the media prank and 'guerrilla marketing', Duchamp ensured the greatest visibility to his revolt against the 'turpentine intoxication' that he had been carrying on for a number of years, through his ready-mades and *The Large Glass*. In other cases, these attacks upon the establishment, bourgeois mentality and art took on more spontaneous, anarchistic and gratuitous forms, though they were no less effective for that. This was the case of the lecture 'on modern art' delivered by Arthur Cravan (alias Fabian Lloyd) on 12 June 1917: the lecturer arrived completely drunk, began to strip off his clothes before the audience of respectable matrons, and was finally arrested and jailed for performing obscene acts in public. It was nothing more sophisticated than a student prank of questionable taste, but it indicated

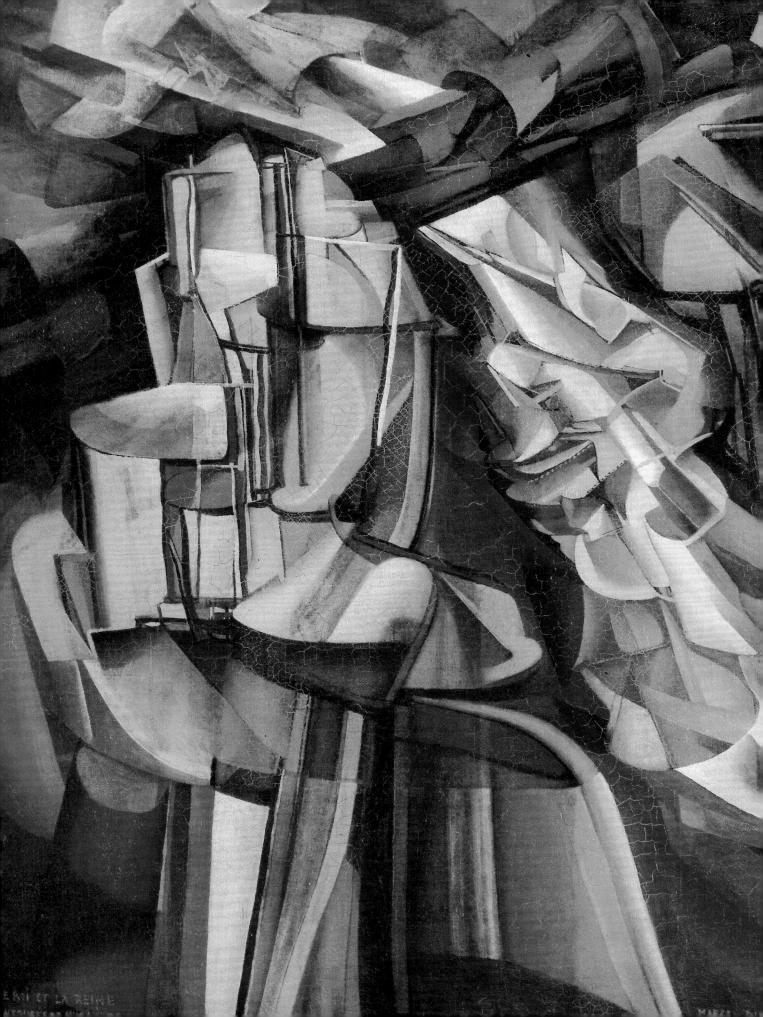

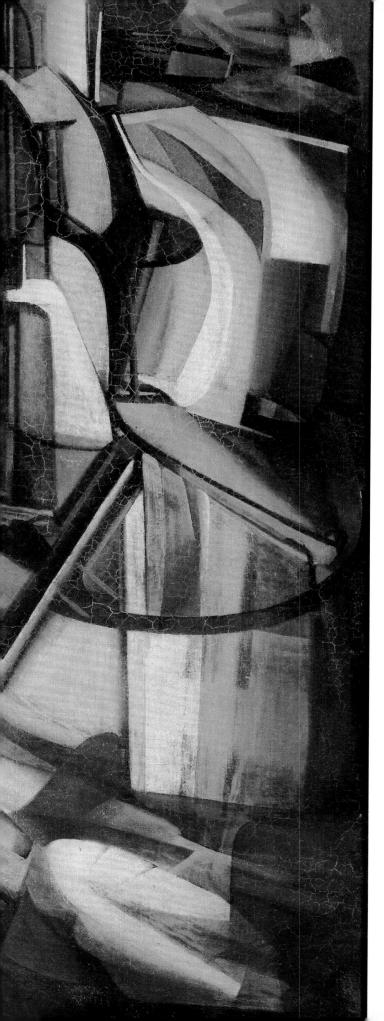

as few other Dada events had done the level of saturation which the yearning for liberty and the anti-artistic revolt of the war years had reached.

A writer, polemicist and poet, the 'lecture' was not Cravan's first exploit: in 1912 he had founded the magazine *Maintenant* in Paris, a proto-Dadaist publication in which he attacked everything and everybody, including his friends, and in 1916, in Barcelona, he challenged the world heavyweight champion, Jack Johnson, to fight, organising a boxing match in which he was knocked to the canvas in the first round. An adventurer and a cosmopolitan, in 1920 he took ship on a voyage from which he would never return, vanishing into the ocean and thus carrying to its most extreme consequences his radical rejection of art and life.

After the two events in 1917, New York Dadaism continued primarily on the strength of individual initiatives and the subversive power of the artworks. Its exponents travelled a great deal, and none of them were particularly interested in feeling that they were part of an organised movement. In November 1916, Picabia left for a brief stay in Barcelona, where he met a number of fellow travellers from the French period, such as Marie Laurencin, Gleizes and Arthur Cravan, and where he founded a magazine that, in homage to Stieglitz's *291*, he named *391*. The first four issues, which came out in Barcelona between January and March, were relatively moderate, but already one can detect in them Picabia's nihilistic and anti-artistic spirit. In June, he was back in New York, where he published three more issues of the magazine. In autumn he took refuge in Switzerland in order to escape the wartime draft: it was here the following August that he began an exchange of letters with Tristan Tzara, whom he met in person in February 1919. This was the moment of the first encounter between the two movements, through their most active and aware agitators: Dada was relaunched, thus preparing its transplantation to Paris.

Duchamp, who continued to work on *The Large Glass*, also felt the need in 1918 to change location, and took ship for Buenos Aires, where he frequented the local chess clubs; from July 1919 to February 1920 he was in Paris, where he established contact with the newborn local Dadaist group. This relationship gave new life to New York Dada, which became aware that it formed part of an international movement: once he returned to New York, Duchamp published

Marcel Duchamp
Bicycle Wheel, 1913
Bicycle wheel (diameter 63.8 cm) with
fork, mounted on a painted stool,
height 128.3 cm (re-elaboration
authorised by the artist)
New York, The Museum of Modern
Art, The Sidney and Harriet Janis
Collection

Opposite
Marcel Duchamp
Bride, 1912 (detail)
Oil on canvas, 89.5 x 55 cm
The Philadelphia Museum of Art,
The Louise and Walter Arensberg
Collection

Marcel Duchamp
Bottle Rack, 1914
Readymade: bottle-rack made
of galvanised iron, 57 x 36.5 cm
(re-elaboration authorised by the artist)
Staatsgalerie Stuttgart

with Man Ray and Stieglitz the only issue of *New York Dada*.

A project that was never completed, but which was described in a letter from Duchamp to Tzara, provides a good idea of the odd nature that Duchamp and Man Ray impressed upon New York Dada in this second phase. The idea was to create a 'DADA' plaque to be distributed in the American provinces through a shrewd promotion campaign, turning it into a sort of all-purpose amulet, as desirable as a horseshoe over the door: 'Nothing literary or "artistic": pure medicine, universal panacea, a fetish in that sense: if you ever have a toothache, go see your dentist and ask if he is Dada'. The project was not followed up, but the silent process of infiltration of avant-garde ideas into American culture carried on by Duchamp also followed other paths: for example, the Société Anonyme, founded in March 1920 with Man Ray and Catherine Dreier, which led to the establishment of a leading group of collectors; the consulting services that he offered other collectors, still detectable in the collections of several major American museums; and irony, scorn for purely visual painting, the anti-artistic polemic, and a reflection on the nature of art, and the inclusion of used objects in art, which would come to constitute one of the cores of twentieth-century American art.

Though emphasis should be placed on the simultaneity and the independence of the Dada activities in Zurich and the United States, it should be pointed out that Dada, as a movement, originated in Zurich, which represented the other pole for those who objected to the arms race that was sweeping all of Europe. It was here, towards the end of 1915, that the German philosopher and writer Hugo Ball arrived, accompanied by his partner Emmy Hennings.

Driven by the belief 'that in Switzerland it would certainly be possible to find some young people who not only cared about enjoying their own independence, but documenting it as well', and by the determination to create a gathering place for artists, on 5 February 1916 he founded a cabaret named after the Enlightenment philosopher Voltaire. Young people soon showed up: at the opening, Ball met Marcel Janco and Tristan Tzara, two young Romanians who had recently arrived in Zurich, and the Alsatian artist Hans Arp. Soon after, the German Richard Huelsenbeck, one of Ball's long-time friends, joined the group. At first, the Cabaret Voltaire did not differ much from other literary cabarets that had flourished in Europe before the war: it was a place for entertainment and culture, where music was played, avant-garde artwork was exhibited, and poetry was recited. In time, however, the tone became more aggressive and violent, and a polemic against bourgeois drabness began to be heard: in Huelsenbeck's exotic poetry, incomprehensible words appeared, and the music imitated the Futurists' technique of introducing unorganised sounds; Janco's savage masks and plaster reliefs appeared, as did Arp's paper and wood collages: in the group's feverish work, one invention prompted another, and it was a short step from the masks to the decision to use them in zany dances and improvised performances. Richter wrote: 'There were six members in the Voltaire's orchestra. Each one played his own personal instrument, that is, himself, with passion and all his soul ... Each sang his own song with all his strength... until, as if by miracle, they discovered that they formed a single being, belonging one to another, indispensable one to another'.

In such a state of unison, it makes little sense to determine which lips, and when, first pronounced the two syllables of Dada. Each account emphasises one

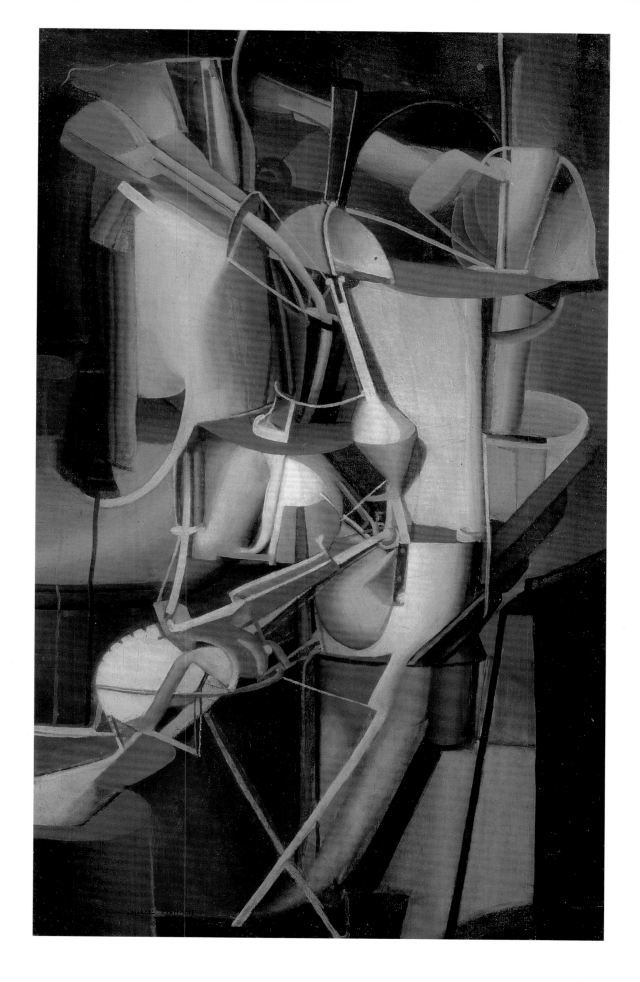

Hans Arp
Automatic Drawing, 1917–18
Ink and pencil on paper, 42.6 x 54 cm
New York, The Museum of Modern Art

Opposite
Hans Arp
*Collage with Squares Arranged
According to the Laws of Chance,*
1916–17
Torn-and-pasted paper on blue-grey
paper, 48.5 x 34.6 cm
New York, The Museum of Modern Art

aspect, without expressing the full meaning. Whether it came from 'da da' (yes, yes), the affirmatives that Janco and Tzara exchanged, or from a dictionary lying open to a chance page, or from a child's name for its rocking horse, Dada remains an exceedingly effective nonsense word that reflects all the characteristics of the movement: chance and found objects, the love of childhood, its international nature, its enthusiasm and its rage. The term appeared for the first time on 15 May 1916 in the only issue of *Cabaret Voltaire,* the first magazine published by the group, which was followed in 1917 by *Dada.* It was at this time that the owner of the Meierei beer hall, where the evenings of the Cabaret took place, cancelled his agreement with Ball, most likely because of the turmoil and excessive conspicuous nature of the events. On 14 July the first major Dadaist *soirée* was held in the Zunfthaus Zur Waag in Zurich: Ball, wearing a rigid cardboard costume designed by Janco, appeared be-

fore a packed hall and recited his first onomatopoetic poem, composed of disjointed and incomprehensible sounds: 'Gadji beri bimba glandriri laula lonno cadori…'. The reaction of the audience was immediate and explosive. But Ball's intentions were not merely provocative; he had an almost priestly attitude, a profound sense of ethics, and his desecration of language actually sprang from his faith in the sacredness of words. Following this event, Ball withdrew for a few months to the mountains of the Ticino, returning to Zurich at the turn of 1917, when he resumed his Dada activity. In the meantime, the leadership of the movement was passing slowly into Tzara's hands, who impressed upon it his negativity, his anti-artistic spirit and his profound nihilism. Soon Ball no longer identified with it ('I examined my conscience scrupulously, I could never welcome chaos'), and in June 1917 he withdrew to Magadino and then to Bern, dedicating himself to journalism, to a re-

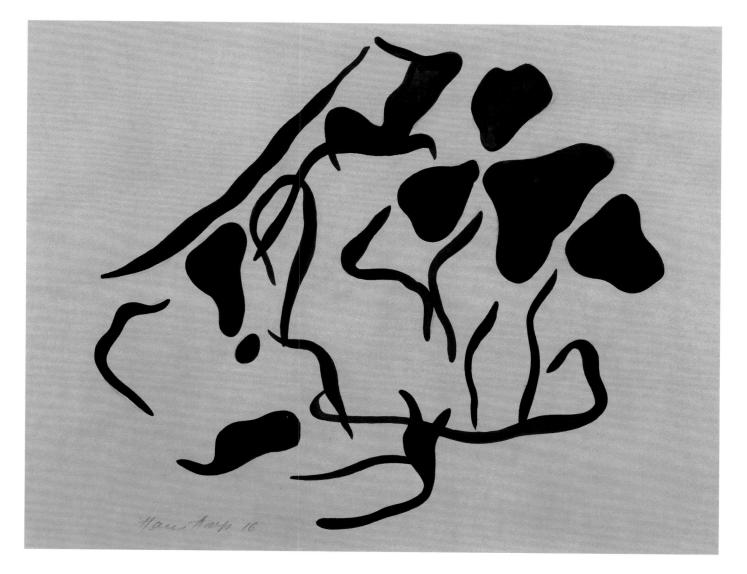

Marcel Duchamp
With Hidden Noise, 1916
Readymade: ball of twine enclosed
between two slabs of brass, fastened
with four screws, 12.9 x 13 x 11.4 cm
The Philadelphia Museum of Art,
The Louise and Walter Arensberg
Collection

thinking of Christianity, and to writing his memoirs, which he significantly titled *Flight out of Time* (1927).

While all this was going on, the Corray gallery, which from March 1917 was renamed the Dada gallery, began to attract attention. In addition to the Dadaists, the gallery exhibited avant-garde art in its great variety of forms, from Kandinsky (a friend of Ball since the times of the Blaue Reiter) to De Chirico. The group had expanded, with the participation of the Germans Hans Richter and Christian Schad, and Doctor Walter Serner, 'the cynic par excellence of the movement, the avowed anarchist', as well as being an elegant and charismatic dandy. While the group's cultural models remained decidedly heterogeneous, the art of Dadaist painters and sculptors seemed to move forward by great leaps towards abstraction, whether it proceeded, as was the case with Janco, from a substantially Cubist lexicon, or whether it set out, as with Richter and Schad, from German Expressionism, or whether it was following, as was true of Arp, a totally autonomous path.

As early as 1916, Arp had made his first assemblages in shaped wood, held together by glue and screws, which, despite their biomorphic configuration, transcended any reference to reality. The next step came the following year, with the series of col-

lages executed *In Accordance with the Law of Chaos*, which were forerunners of Tzara's formula for writing Dada poetry: taking random newspaper clippings from a hat and transcribing them in the order in which they had been extracted. Similarly Arp dropped paper clippings onto the floor, carefully studied their (entirely chance) arrangement, and then used them to create carefully calibrated and elegant abstract collages.

Meanwhile, the public Dadaist activities in Zurich began to slow. In 1918, Tristan Tzara offered a first reading of the *Manifesto Dada 1918*, which appeared in December in the third issue of *Dada*: 'I am writing a manifesto… and I am against manifestos on principle, just as I am also against principles… I am against action; in favour of continual contradiction and for affirmation, I am neither in favour nor against because I detest common-sense… DADA means nothing… Those who belong to us preserve their freedom. We do not recognise any theories… I am against systems, the most acceptable system is not to have any systems, on principle … there is a great task of destruction to carry out. Sweep away, clean…' With this text, the other pole of Zurich Dada confirmed its leadership and readied itself to inaugurate the final phase, which included the collaboration of Picabia and an large group of Parisian literati, while many early Dadaists now began to leave the Swiss city.

Like Ball and his girlfriend, Huelsenbeck returned to Berlin at the beginning of 1917, and Richter joined him in the first few months of 1919 with Viking Eggeling, a Swedish abstract artist who participated in the final phase of Zurich Dada and undertook a highly rigorous line of research into the relationship between music and painting. In the same period, Arp moved to Cologne, while Janco, though he remained in Zurich, broke away from Tzara, not wishing to comply with the 'negative velocity' impressed upon Dadaism by the writer. The conclusive event of Zurich Dada was held in the so-called 'Salesmen's Room' on 9 April 1919: Tzara's careful supervision alternated increasingly provocative interventions and performances in a space decorated by the 'cucumber plantation' painted by Arp and Richter. The party was a success, both in terms of box office receipts and the brawl that forced it to be called to a halt during Serner's lecture. In Zurich, the eighth issue of *391* came out, as did the double issue of *Dada 4-5* and the only issue of *Der Zeltweg*, with the co-editor-

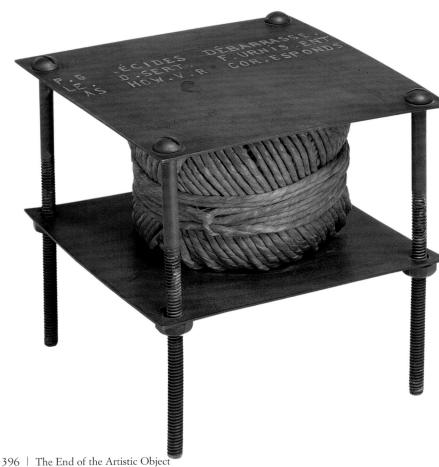

Marcel Duchamp
Fountain, 1917
Readymade: white porcelain urinal, height 62.5 cm (re-elaboration authorised by the artist, 1967)
Private collection

Pages 398–99
Marcel Duchamp
L.H.O.O.Q., 1919
Pencil on a reproduction of Leonardo da Vinci's *Mona Lisa*, 19.7 x 12.4 cm
Private collection

Marcel Duchamp
Glider Containing a Water Mill in Neighbouring Metals, 1913–15
Oil and semicircular glass, lead, lead wire, 153 x 83.5 cm
The Philadelphia Museum of Art, The Louise and Walter Arensberg Collection

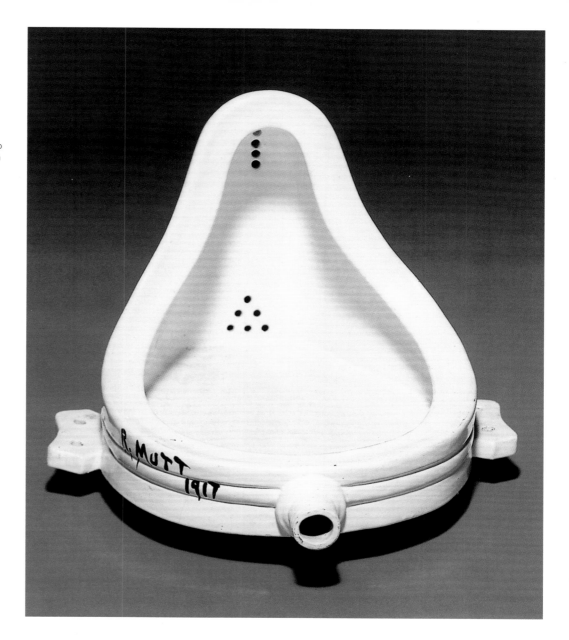

Marcel Duchamp
Apolinère Enameled, 1916–17
Readymade: enamelled advertising poster, 24.5 x 33.9 cm
The Philadelphia Museum of Art, The Louise and Walter Arensberg Collection

ship of Otto Flake, Walter Serner and Tristan Tzara. Overall, this was a phase of theoretical clarification, proselytising and the consolidation of international contacts, leading up to Tzara's and Picabia's move to Paris.

In Berlin, meanwhile, Huelsenbeck had established contact with a lively group of artists and poets led by the writer and philosopher Franz Jung and the artist Raoul Hausmann. At the beginning of 1918 the Club Dada was proclaimed, which was also the name of the magazine published by the group beginning in April. In the summer, this first group, which also included Hausmann's girlfriend, Hannah Höch, was joined by three new recruits actively involved in far-left political organisations: George Grosz and the brothers Wieland and Johann Herzfelde. Wieland founded the publishing

house Der Malik Verlag, which put out nearly all the Berlin Dada publications, and Johann anglicised his name to John Heartfield in scorn for his own nationality, which was so proudly trumpeted in the rhetoric of Kaiser Wilhelm.

In 1918 and 1919, the collapse of the Empire, the flight of Wilhelm II, the proclamation of the Weimar Republic, the civil war and the defeat of the Spartacists generated in Germany an unstable and extremely troublesome political situation that Dadaism could hardly ignore. This was the reason for the political colouring that seeped into many of the Dada events in Berlin and the ideological content that can be detected in the artworks. While most of Berlin's Dadaists remained within the camp of orthodox Communism, their input to the complex German

political situation was far more complex, and well exemplified in the bizarre figure of the architect Johannes Baader, the 'Oberdada'.

Introduced to the Club Dada by Heartfield, who had been attracted by Baader's charismatic personality and lucid folly (which was certified as a genuine disability), in 1914 Baader had published the *Fourteen Letters of Christ*, presenting himself as the reincarnation of Jesus Christ and founding around himself (with the complicity of Hausmann) a fully-fledged religious sect. He went on to claim for himself a series of non-existent offices, as well as presenting himself as a candidate for election to the Reichstag in 1917, and proclaiming himself—on the day of the inauguration of the Weimar Republic—president of the universe. In the spring of 1920, while on tour with Hausmann and Huelsenbeck in the main cities of Germany, he quarrelled with his fellow travellers and made off with the kitty. During his Dadaist phase, Baader executed a limited number of photomontages, but his interesting contribution to the visual arts was the *Plasto-Dio-Dada-Dramma*, an assemblage of monumental size presented at the First International Dada Fair in 1920: a tower and self-portrait, made of heterogeneous materials, including a mannequin, whole newspapers, posters, and such everyday objects as a mousetrap and a piece of stovepipe. According to an absurdly didactic structural division, the column was split up into five stories: 'First Floor: the preparation of the superdada; Second Floor: the autophysical examination; Third Floor: consecration; Fourth Floor: world war; Fifth Floor: world revolution'. The artwork was destroyed while being dismantled, but it produced a powerful effect upon Kurt Schwitters and can be considered one of the earliest examples of assemblage, as well as one of the many instances of a total artwork.

Inaugurated on 5 June 1920, the First International Dada Fair remained the most significant artistic event organised in the Berlin milieu. The political connotations were still quite strong, as demonstrated by the mannequin of a German officer with the head of a pig hanging from the ceiling, which triggered fierce debate with its subversive and anti-military character. Alongside the movement's official publication, *Der Dada* (three issues published between 1919 and 1920), there was a proliferation of manifestos and publications, often highly political pamphlets. In 1920 Huelsenbeck published *En avant Dada*, which, along with the *Dada Al-*

Max Ernst
Katharina Ondulata, 1920
Painted paper with gouache
and pencil, 30 x 24 cm
Private collection

Opposite
Marcel Duchamp
The Large Glass, 1915–23
Oil, varnish, lead foil, lead wire
and dust on two glass panels,
278 x 176.5 cm
The Philadelphia Museum of Art,
Katherine S. Dreier Bequest

Marcel Duchamp
Chocolate Grinder (No. 2), 1914
Oil and wire on canvas, 65 x 54 cm
The Philadelphia Museum of Art,
The Louise and Walter Arensberg
Collection

manach, published the same year, offered a first historical overview of the movement and marked its ending.

While Berlin's Dadaism exhausted itself in the dilemma of reconciling art and political engagement, aesthetic revolution and social revolution, matters were different in Cologne, where the initial political engagement of the young Max Ernst and Johannes Theodor Baargeld, exhausting itself with the publication of the Communist periodical, *Der Ventilator* (which had a print run in 1919 of 20,000 copies), made way for an equally radical activity, but only in aesthetic and intellectual terms. Contributing to this turning point must have been the arrival of Hans Arp, who actively joined the Cologne group, bringing with him his Zurich experiences. Aside from the individual ef-

forts of the three artists, of particular interest—in part because it was a forerunner of the Surrealist technique of the *cadavre exquis*—was the experiment that led to the creation of the *fatagaga*, 'fabrication of guaranteed gasometric paintings': collective and anonymous artworks, done by four or six hands.

The event with which Dada in Cologne attained its culminating moment was the Dada collective show at the Winter beerhall, inaugurated on 20 April 1920. In order to enter the show, it was necessary to pass through the beerhall's latrines, where guests welcomed by a '*comunicanda*' reciting obscene verse; Baargeld presented a tub full of a reddish liquid in which a lock of a woman's hair floated; Ernst presented a block of wood with an axe, and the invitation to

George Grosz
Grey Day, 1921
Oil on canvas, 115 x 80 cm
Berlin, Neue Nationalgalerie

Opposite
Raoul Hausmann
P, 1921
Collage on paper, 30 x 21 cm
Hamburg, Hamburger Kunsthalle

Marcel Duchamp
Fresh Widow, 1920
Readymade: painted wooden window
frame and eight panels covered with
black leather, 119 x 54 x 10.2 cm
The Philadelphia Museum of Art,
Katherine S. Dreier Bequest

destroy it; Arp presented a provocative egg table. The public had a negative reaction and the show was closed for obscenity (and then reopened when it was discovered that the cause of the obscenity charges was actually a fragment by Dürer included in a collage).

After this astonishing event, the only notable development was the publication, in 1920, of the portfolio *Fiat Modes*, with texts by Arp and lithographs by Ernst.

Soon Arp left again for Zurich and then for Paris, where in 1921 Ernst joined him; having given up art all together, Baargeld died in an avalanche in 1927.

The arrival of Arp and Ernst in Paris was no coincidence: once the war ended, international Dadaism seemed to converge slowly on the French city, which between 1919 and 1922 became the centre of its final explosion and subsequent evolution into Surrealism. Paris thus recovered its status as the capital of the avant-garde, thanks to the return of a number of illustrious exiles (such as Picabia and Duchamp) and of a very active group that took note of the new ideas arriving from Zurich, New York and Cologne. This was a core group, primarily writers, that gathered around the magazine *Littérature*, which had been founded at the beginning of 1919: the group included André Breton, Louis Aragon, Philippe Soupault and Paul Éluard. *Littérature* was a creation that emerged from the attention to international Dadaism, and out of the cult of certain personalities that had worked in Paris before and during the war. One example was Arthur Cravan, who had published five issues of *Maintenant* in the city between 1912 and 1915; another example was Jacques Vaché.

Like Cravan, rather than producing artworks Vaché made his life a work of Dada art. Instead of deserting or fleeing abroad, Vaché took part in the war, concealing his refusal 'behind a mask of purely formal acceptance, pushed almost to an extreme: all of the exterior signs of respect, of an adherence that was in a sense automatic precisely to that which the intellect finds most senseless'; and substituting for desertion 'another form of disobedience, which we might call desertion within ourselves' (Breton, 1939). Having refused to be killed in war, he committed suicide, at the age of twenty-four, shortly after the armistice.

The arrival of Picabia in March 1919 laid the foundation for a return to Dadaist activities, which happened with the 'Premier vendredi de Littérature' on 23 January 1920, immediately after the triumphal arrival of Tristan Tzara. Between January and March, other events ensued, with exhibitions and the reading of manifestos, right up to the complex and well-planned show of 27 March at Lugné-Poe's Maison de l'Œuvre, which called for four theatrical productions, the usual manifestos, and the presentation of a new painting by Picabia. The 'painting' had a stuffed chimp (originally it was to be live) attached to a canvas, surrounded by legends reading 'Portrait of Cézanne... Portrait of Rembrandt... Portrait of Renoir... Still lifes'. Many other events followed, while the ranks of the Dadaists swelled and publications proliferated. Among the most noteworthy events were a major solo exhibition of Picabia's work and protests against a Parisian conference by Marinetti, on 12 January 1921, with the distribution of the pamphlet *Dada solleva tutto*[1].

This rediscovered aggressiveness nonetheless concealed a profound crisis resulting from the differences between the *Littérature* group and the Picabia–Tzara pair, and from the hostility that began to grow between the latter two. It would appear that Max Ernst's one-man show, inaugurated on 2 May 1921, had been an attempt on Breton's part to dethrone Picabia from his position as the sole Dada artist in Paris. On 11 May Picabia published an open letter in *Comoedia* in which he announced that he would abandon Dadaism: 'Dada, you see, was not serious, and that is why it conquered the world like a bolt of lightning, and if anyone takes it seriously now it is because it is dead!' And just how seriously Breton's group took it is demonstrated by the farcical trial of the nationalist writer Mau-

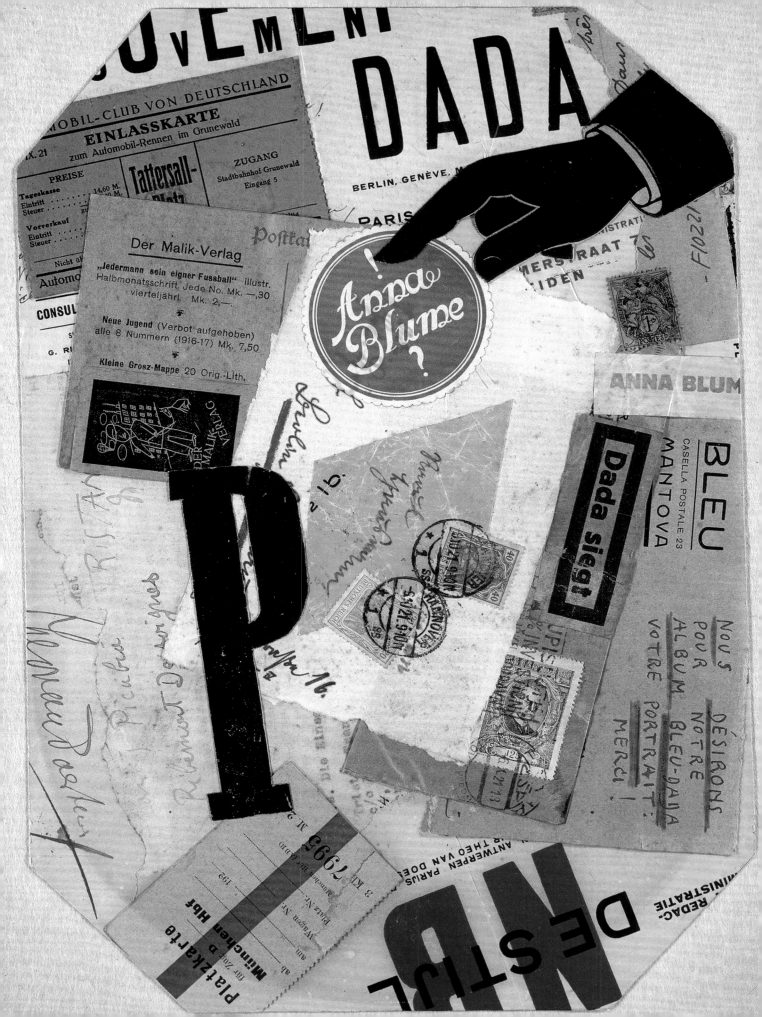

Kurt Schwitters
Small Column, circa 1922
Painted wood, 23 x 22 x 16 cm
Berlin, Neue Nationalgalerie,
Property of Association of Friends
of the Nationalgalerie

Man Ray
Cadeau, 1921
Painted iron with nails,
15.3 x 9 x 11.4 cm
New York, The Museum of Modern
Art, James Thrall Soby Fund

rice Barrés, held on 13 May. Picabia commented: 'Now Dada has a court, lawyers, and as soon as possible, probably, its own gendarmes… I have separated myself from certain Dadaists because I was suffocating amongst them, day by day I was growing sadder, I was terribly bored…'.

On 6 June 1921 the great Salon Dada was inaugurated at the Montaigne gallery, the last collective event of the movement. In the show, all of the Dada Internationale was represented with the notable exception of Breton, Picabia and Duchamp. In summer 1921, in hopes of relaunching the movement, a sort of summit meeting was organised in the Tyrol mountains, with the participation of Breton, Arp, Ernst, Tzara and Éluard. A special issue of *Dada* was published, *Dada au grand air*, entirely based on the war against Picabia. But even this anti-Picabia union had a brief life: soon Tzara attacked Breton, Breton attacked Tzara, and the minuet of attacks and counterclaims began that would end, in a sad way, the history of the movement. However, it had been said from the beginning that 'Dada only endures by ceasing its existence'. In April 1922, Georges Ribemont Dessaignes wrote in *Der Sturm*: 'Dada is not dead. But it has pimples'. And Tzara, at the Weimar Congress in September 1922: 'Another characteristic of Dada is the incessant separation from our friends… The first one to resign from the Dada movement *was me*. Everyone knows that Dada is nothing…'. In short, the death of Dada was Dada and in its death Dada produced some of its finest fruit.

Dada configured itself, then,

as an international avant-garde, woven out of a dense network of relationships, sharing a negative poetics that was therefore capable of gathering within itself a diverse array of stylistic attitudes; an avant-garde that lives on a continuous activism, of events, manifestos, and publications, even more than artworks; which brings together a great many contributions, coordinating artists, philosophers, political agitators and men of letters, many of whom vanished from sight after their Dada adventure, either because they had taken to extreme consequences their rejection of art and life, like Cravan and Vaché, or because they took other paths, like Ball, Baader, Serner and Huelsenbeck.

The new role that Dadaism conferred upon the artist's cultural and social activity should not make us lose sight of the importance of the artworks and formal innovations they introduced, some of which were fundamental to the development of art. Dadaism excluded any consistent linguistic proposal, it claimed paternity both from Klee and De Chirico, and it did not reject interaction with ideas of opposing movements from the same period, such as Constructivism and De Stijl. All the same, all the most innovative and authentically Dada creations fell under the twin headings of found objects and the use of new media (photography, film). The use of used objects in art derived from the Cubist collage

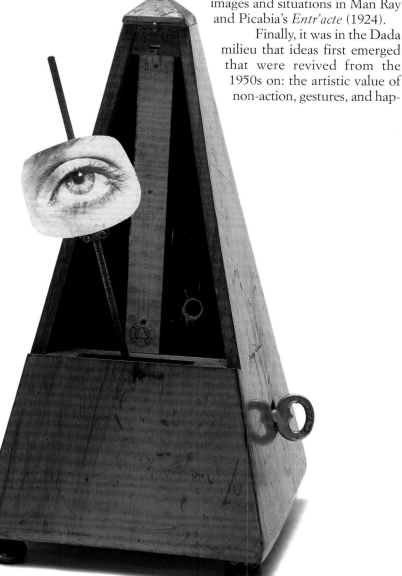

Man Ray
Object to Be Destroyed (Indestructible Object), 1922–23
Metronome and photograph,
22.5 x 11 x 11.6 cm
New York, The Museum of Modern Art, James Thrall Soby Fund

and its sculptural counterpart, the assemblage, and was developed in the forms of accumulation (the *Merz* by Schwitters), photocollage (which its creators chose to call photomontage, in tribute to the anti-artistic and industrial connotations that the term 'montage' carried with it); ready-mades, in their various forms; and the object-artwork, which found its prototype in Duchamp's *The Large Glass*. Photography was considered an authentically artistic medium and enriched with a series of technical expedients, ranging from rayography to solarising, which moved it away from its eminently representative purpose; while cinema was attractive less as a medium for depicting reality and telling stories than as a medium which allowed a succession of images in movement and as the bearer of a new aesthetic of the machine: and it was from this that emerged the abstract cinema of Richter and Eggeling, or the poetic and analogical succession of disconnected images and situations in Man Ray and Picabia's *Entr'acte* (1924).

Finally, it was in the Dada milieu that ideas first emerged that were revived from the 1950s on: the artistic value of non-action, gestures, and happenings, life as a work of art, and the artwork as process, of which the material remains have value strictly as documentation.

The technique of the assemblage had already been developed both in Cubist and Futurist circles. In both cases, it was given both a mimetic and a formal interpretation: assemblages made of cardboard, painted wood and metal pieces by Archipenko, Laurens, Picasso and Boccioni were meant to reconstruct an external reality, whether it was a still-life, a juggler, or a galloping horse. The elements utilised were meant to represent themselves or else to refer to something else, but always in a context of deconstruction and reconstruction of reality. Even Arp's abstract assemblages clove to this procedure.

It was in the Dada of Berlin that a first determined revision of the Cubist techniques of collage and assemblage first emerged. First of all, collage was accepted as an avowedly anti-artistic technique, replacing the traditional techniques of painting with the juxtaposition and 'montage' of culturally low materials, taken from the context of everyday use, communications and technology. Second, the juxtaposition of elements no longer had a representative purpose: they were no longer aimed at a formal equilibrium but an explosive communication based on mental associations, symbolic ties and analogies. The artist became an engineer of communication. Exemplary in this sense was *Mechanical Head (The Spirit of Our Time)* of 1920 by Raoul Hausmann: it comprised the head of a wooden mannequin around which had been wrapped a tape measure, the works of a watch, a leather wallet, part of the mechanisms of a camera, a portable drinking glass, a plaque bearing a number, and a jewel box containing a printing roller. It is difficult to understand the meaning of this juxtaposition of heterogeneous elements, which in Hausmann's intentions was meant to 'show how human consciousness consists merely of insignificant accessories, applied to the exterior' (1966). There clearly emerged an aesthetic of the mannequin, which owed a debt to de Chirico's mannequin and linked both to the machines of Duchamp and Picabia as well as to the new ethics set forth in the same years by the Russian Constructivists, who demanded for art a social purpose and who exalted the figure of the artist-engineer whose task was to reconstruct a society devastated by war and bourgeois capitalism. This latter reference was made explicit by Hausmann in a photomontage from the same year, dedi-

Kurt Schwitters
Cover of *Die Kathedrale*, 1920
Lithograph with collage,
21.6 x 14.3 cm
New York, The Museum of Modern
Art, Gift of Edgar Kaufmann

Man Ray
Marcel Duchamp as Rrose Sélavy,
1920–21
Gelatin silver print with ink, 20 x 15 cm
Philadelphia, The Philadelphia Museum
of Art

Opposite
Max Ernst
*Two Children Are Threatened
by a Nightingale*, 1924
Oil on panel, with components made
of painted wood and frame,
69.8 x 57.1 x 11.4 cm
New York, The Museum of Modern Art

cated to the Russian Constructivist Tatlin. *Tatlin at Home* showed the artist in a sort of Metaphysical interior, surrounded by a map and strange mechanical gadgets, with an engine in place of his brain.

To return to assemblage, it should be noted that its birth from accumulation and its preference for waste and discarded items encouraged its monumental derive which, through the previously mentioned *Plasto-Dio-Dada-Drama* by Baader, took full and concrete form in the work of the German artist Kurt Schwitters. Born in Hanover, Schwitters trained in Dresden and then returned to his hometown in 1915. Despite his relative isolation, Schwitters entered into contact with the Dadaists of Zurich as early

as 1918; when Huelsenbeck, who saw him as being incorrigibly bourgeois, opposed his membership in the Club Dada, Schwitters invented a label for himself: from this point forward, his artworks, poetry, collages and assemblages, his entire activity and even his life would all become *Merz* (a nonsensical fragment of the word *Kommerz*). A degree of economic independence allowed him to carry on an array of undertakings: he opened a Merz store, he painted and sold traditional canvases, he composed traditional poems, like the renowned *To Anna Blume* (1919), or onomatopoetic poems, such as the colossal *Ur-Sonatas* (1924–25); he published the magazine *Merz*, and undertook, with friends such as Raul Hausmann and Theo van Doesburg,

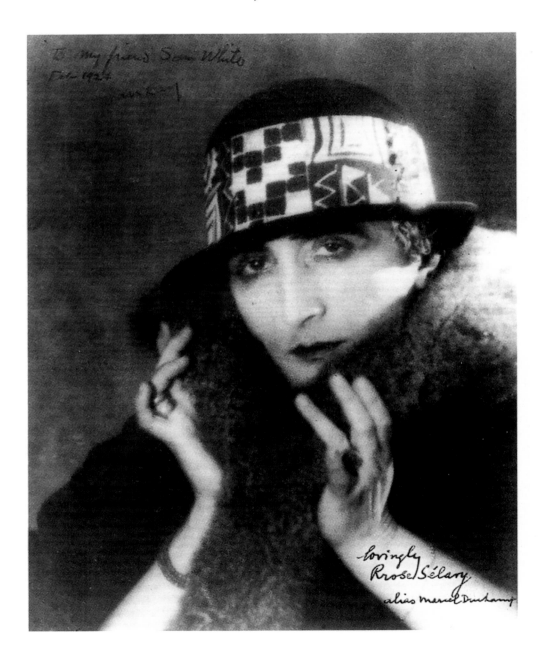

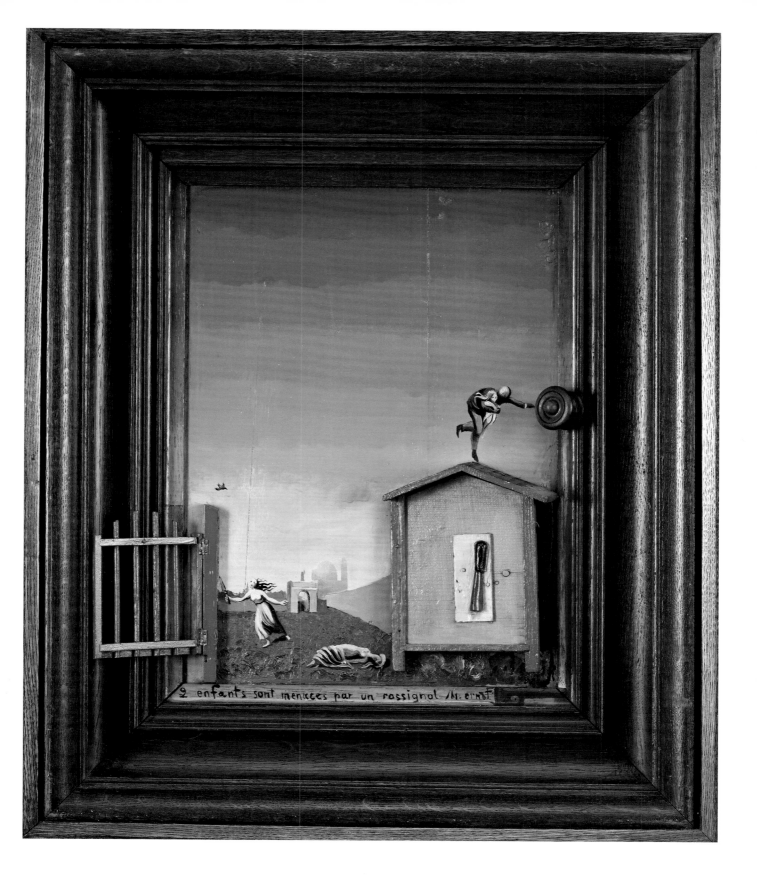

2 enfants sont menacés par un rossignol /M. ernst

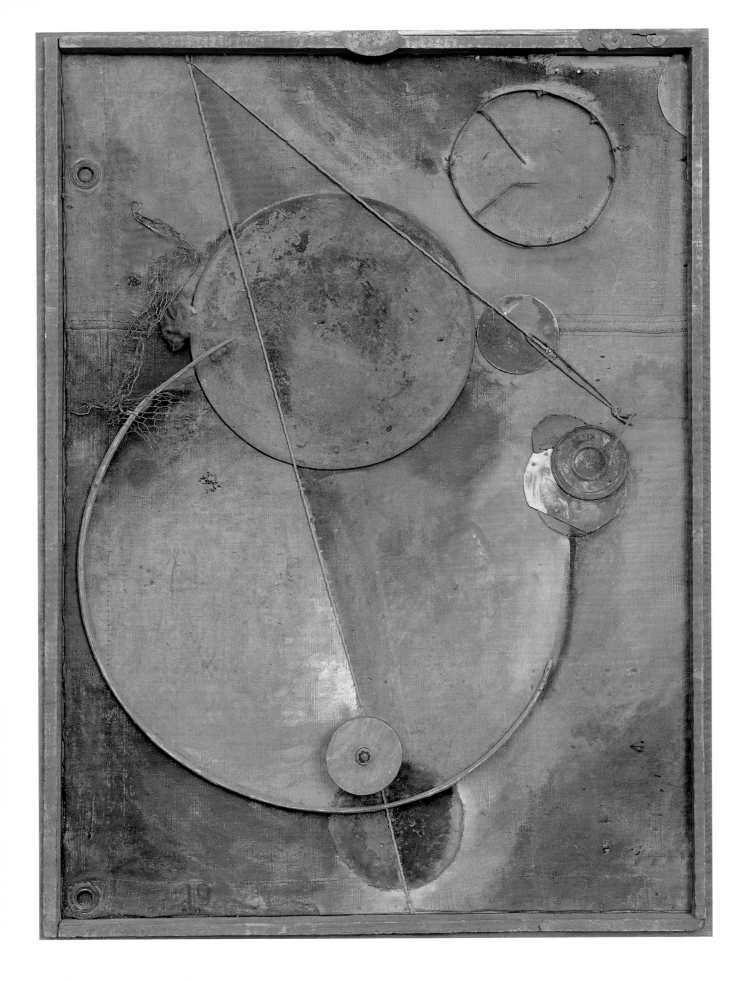

Marcel Duchamp
50 cc of Paris Air, 1919
Readymade: glass ampoule,
13 x 6.35 cm
The Philadelphia Museum of Art,
The Louise and Walter Arensberg
Collection

Opposite
Kurt Schwitters
Rotation, 1919
Oil on canvas and assemblage,
122.7 x 88.7 cm
New York, The Museum of Modern Art,
Advisory Committee Fund

Marcel Duchamp
Why Not Sneeze, Rrose Sélavy?, 1921
Readymade: 152 marble cubes in the
form of sugar cubes with thermometer
and cuttlefishbone in a birdcage,
11 x 22 x 16 cm
The Philadelphia Museum of Art,
The Louise and Walter Arensberg
Collection

Dada tours through the various countries of Europe, but above all he executed collages and assemblages. This Dadaism was joyful, vigorous and totalising; Schwitters' reuse of ordinary materials resulted not from a revolt against art, but from the belief that it is possible to make art out of anything. He stated, concerning the turbulent years that followed the war: 'I felt free and I had to cry out my joy to the whole world... It is possible to cry out even with garbage, and that is what I was doing, as I glued and nailed away. I called it MERZ, but it was my prayer of thanksgiving for the victorious end of the war, because once again peace had won'. Even when figurative fragments or pieces of text appeared in them, his assemblages remained abstract compositions: a ripped poster, a trolley ticket, a button or a chain always corresponded to a specific formal necessity. And yet they contained within themselves their own history and function, introducing new levels of meaning to the artwork. All this is clearly evident in the colossal *Merzbau*, also known as the *Schwitters Column*, which the artist considered to be his most successful creation. By 1918 he had begun to develop a complex agglomeration of heterogeneous objects around a plaster statue in his apartment, which he organised into a structure with many niches dedicated to the people and situations in his life. Soon the column grew until it had filled a whole room and it became necessary to cut a whole into the ceiling, to allow it to extend into the story above. In 1938, persecuted by the Nazis, Schwitters was obliged to abandon Hanover and seek refuge, first in Norway, then in England, where he tried to reconstruct the artwork that had been destroyed during the war. The *Schwitters Column* was both a Constructivist utopia and a Dadaist accumulation, an agglomeration and a piece of architecture, and a ceaseless battle between order and disorder, form and formlessness. It was an environment in continual metamorphosis, with which Schwitters had attempted to create not so much a total work of art, as much as an 'uninterrupted process of abolition of boundaries and interpenetration of all the arts' (Richter).

It was also the exponents of Berlin's Dada that developed the expressive potential of the collage on a polemical and political level. In the creation of the photomontage, whether it was an invention of Hausmann and Höch or Grosz and Heartfield, it is implicit that its original purpose was propagandistic. The targets were, variously, the militaristic ruling class that led Germany to war, the conservative and bigoted bourgeoisie, and the spirit of Weimar. Grosz and Heartfield, under the label 'Grosz–Heartfield mont.', executed a series of energy-filled montages, of which *Sunny Land* (1919) is one successful example. The collage combines fragments of newspaper concerning political news, typographical inserts like the word DADA, sentimental postcards and small devotional images as a denunciation of the hypocrisy of bourgeois society, and the warlike violence concealed behind the display of morality and fine feeling. In his Dada phase, Grosz made extensive use of collage, which he often completed with his violent, Expressionist graphics and a crude taste for caricature. Heartfield, who considered himself an authentic labourer of montage (to the point that he would appear in public wearing blue overalls), developed in the years that followed a special technique for mechanical montage, which made his work for posters and book covers increasingly effective in the juxtaposition of distant realities, which he combined with great illusory skill in the same image, making it one of the most incisive weapons of anti-Nazi propaganda.

Another great 'montagist' was Hannah Höch, Hausmann's companion and, with Sophie Tauber-Arp and Emmy Hennings, one of the great women of Dadaism. Long overshadowed by her companion's vehemence and thirst for the spotlight, her production was marked by an ironic and irreverent cri-

tique of bourgeois society and the position in which it confined women, who existed solely as angels of the hearth or as monsters of sensuality. The large collage, *Cut of the Dada Kitchen Knife in the Swollen Belly of the Last Cultural Epoch of Weimar Germany* (1920), is one of the most powerful critiques of an era of a profound moral crisis, made up of militarism and modernisation, mass movements and cults of personality, great wealth and great poverty. In this confused Babel of languages, the Dadaists seem to have been particularly skilful in their jugglers' freedom, seen also in the confused, cluttered composition, and independent of any compositional criterion other than that of accumulation and a *horror vacui*.

A different use of montage that was also provocative but almost never political was put into action in Cologne by Baargeld and Max Ernst, whose collages were filled with vivid analogies and a perverse sense of humour of early pre-Surrealist derivation. Ernst, who was familiar with the painting of De Chirico and his capacity for conferring mystery upon the most ordinary objects by deploying them out of their spatial and temporal context, used catalogues of industrial products, a mechanomorph realm of the imagination and popular illustration from the late nineteenth century. In his autobiographical notes, he wrote, speaking of himself in the third person: 'the catalogue of a supplier of school equipment attracted his attention. It featured announcements with little drawings referring to all sorts of disciplines... elements of such a diverse array of natures that the absurdity created by their accumulation disturbed his gaze and his senses; triggering hallucinations and giving the objects depicted new meanings...' And, concerning collage: 'It is a gesture of rebellion against the relationships, the functions, and the hierarchic scale between objects. A way to censure the world by overturning the conventional order of factors, and not merely an attempt to suppress the world nor to attain the marvellous'. This imaginative and cruel way of dismantling and reassembling reality, destroying its meaning and ignoring its morality, was as just as unacceptable to the established order and bourgeois society as the social critique of the Berliners, as was shown by the violent reactions produced by these works in Cologne.

But the collage was not the only medium employed by Ernst, who even in the early 1920s established himself as one of the greatest innovators of artistic techniques of the century, with the invention of *frottage*, *grattage*, decals, and later dripping, and with the exploitation of chance effects produced on the surface of the canvas by spots and patches of colour. *Frottage*, in particular, emerged from his irritation with wood grain, the warp of a fabric, or any imperfect surface, which he revealed simply by tracing and then elaborated to create great and fantastic effects.

But the Dadaist revolution did not necessarily need technical innovations in order to express itself in a radical manner. This was proven nicely by Francis Picabia, who between 1916 and 1922, made almost exclusive use of drawing and painting. By radicalising the mechanomorphic aesthetic that was already present in his Orphic phase, Picabia developed a style of high-energy painting, absolutely anti-artistic, in which the style was reduced to the minimum, as in technical drawings, to create useless machinery which he filled with references to eroticism and human life in general. These works had an affinity in both technique and inspiration with Duchamp's bachelor machines and the 'automatic' painting being explored in the same years by Man Ray, with the use of the air-brush.

The bachelor machine par excellence was indisputably Marcel Duchamp's *The Large Glass*, whose complete title was *The Bride Stripped Bare by Her Bachelors, Even*. Duchamp began it in New York in 1915 and continued to work on it off and on until 1918. Then, for about a year, he ignored it, allowing the city dust to gather on its horizontal surface. Then he asked Man Ray to photograph these layers of dust and then he cleaned it, but used a spray to fix the dust that had accumulated on the inside of the cones in the lower section. In 1923, he simply stopped working on it, and declared it unfinished. In 1926, while it was being transported, the grass cracked badly, but Duchamp did nothing more than to declare the contribution of chance to the artwork and refused to have it repaired. But the history of this authentic 'work in progress' is more extensive still because the thought processes that led to its creation are documented as having been underway as early as 1912, when Duchamp did his *Bride*; moreover, nearly all of the artworks executed in this period, including numerous readymades, are indebted to the artist's meditations on *The Large Glass*; and later, from the 1930s on, Duchamp published three boxfuls of notes and considerations, almost all of them concerning the development of

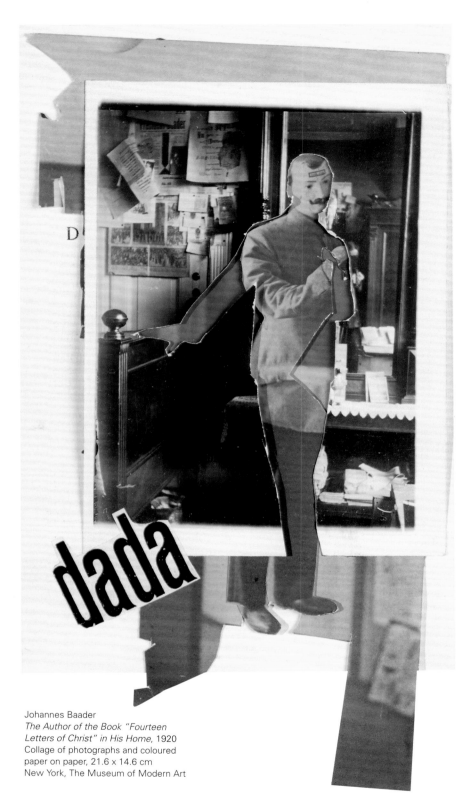

Johannes Baader
*The Author of the Book "Fourteen
Letters of Christ" in His Home*, 1920
Collage of photographs and coloured
paper on paper, 21.6 x 14.6 cm
New York, The Museum of Modern Art

the *Bride*. Despite these clarifications, the artwork as a whole remains an enigma, further complicated by the fact that Duchamp never denied any of the interpretations that were offered by critics, among which the suggestion of alchemy (developed by Arturo Schwarz) remains the most evocative and convincing. But this hermeticism, attributable only in part to the nonsense of Dada, is not the work's only point of strength, because *The Large Glass* remains the most radical affirmation of the death of art and painting, and the first example of the artwork-object and the installation-form in contemporary art.

The work, which is displayed at the Philadelphia Museum of Art, presents itself as an installation of two large sheets of glass separated halfway up, and a metal framework, on the surface of which Duchamp arranged slabs and threads of lead. These reproduce elements that he had already studied separately—the *Bride*, the *Sled*, the *Nine Malic Moulds* and the *Chocolate Grinder*—which converge to establish a complicated mechanism of love and suffering, regulated by laws that are as strict as they are absurd and arbitrary. Thus the artwork embraces a wide array of meanings, both from preliminary works, and from a vast corpus of notes that the artist assembled with the intention of publishing them to accompany the artwork. From a reading of the notes and the captions, created to identify the various components of the depiction, we learn that *La mariée mise à nu par ses célibataires, même* (The Bride Stripped Bare by Her Bachelors, Even) is an erotic, ironic and Metaphysical artwork, in which a perfect blend of form and language is achieved. The ethereal and female universe of the Bridge confronts that of the Bachelor Machine, but despite the presence of a complicated mechanism, nothing seems to happen, and the overall sensation is of a moment of suspense and immobility that is almost sacral. The ambiguous sense of the artwork is also increased by the title, in which *même* takes on different meanings: 'even' or 'loves me' (from the identical pronunciation of the words 'm'aime'), referring to the Bride, and 'the same', as if to say that Bachelors and Bride are two faces of the same reality. The alchemistic interpretation, suggested by Schwarz, identified the model in the theme of the Assumption of the Virgin (*La Mariée*) in the presence of the Apostles (*ses célibataires*) and of the Holy Trinity in the clouds (*mise à nu*) and in an alchemistic context, that is, Nature stripped bare by the

Otto Dix
Invalid Card Players, 1920 (detail)
Oil and collage on paper, 110 x 87 cm
Berlin, Neue Nationalgalerie,
Property of Association of Friends
of the Nationalgalerie

alchemists with the various levels of the process of transformation from the solid state (the chocolate grinder and the sled), to the liquid state (the malic moulds/containers), and to the gaseous state (the cloud).

Moving in the same direction was the invention of the ready-made, an existing sculpture that was proclaimed as such through an operation of choice, not execution. Here too, there is a vast array of explanations. Among them, the least acceptable is that which justifies the choice with the identification of an unsuspected aesthetic quality of the object chosen, from the pure line of the *Fountain* to the rhythmic flow of the *Bottle Rack* (1914). Even Duchamp debunked this, clarifying his real intentions only in part, making reference to an anaesthetic sensation, the indifference that he felt before these objects. In reality, this indifference was not total, because it was precisely that object which triggered the intuition that made it possible to rethink it, and which Duchamp made explicit through the title or a 'help' of some other sort ('assisted ready-made'). For instance, the urinal was redeemed by being turned upside down, making it useless as a urinal but interesting as an object, and by the title he gave it; likewise, Leonardo da Vinci's *Mona Lisa*, an artwork so widely worshipped that it leaves us indifferent, was redeemed by a fake moustache and by its new title, *L.H.O.O.Q.* (which, read in French, sounds like 'she has a hot ass'). Behind these instantaneous and desecrating operations there was actually a lengthy intellectual process, rich in connotation, so that the moustache on the Mona Lisa was both a violation of its value as a *monstre sacré* and an explicit reference to the figure's androgyny.

A close friend of Duchamp from 1915, the American artist Man Ray often collaborated with him, but also offered a notable contribution to the development of the ready-made with his 'interpreted found objects'. As Ray recalled, 'My attitude towards the object was different from that of Duchamp, who needed do nothing more than rename it. I needed more than one factor, at least two… The creative act was based for me on the pairing of these two different factors to produce something new… a visual poetry'. One emblematic example is *Cadeau* (1921): a steam iron that was redeemed by inserting a line of nails in the holes for the steam, an operation that transformed a banal domestic object into an instrument of offence or defence, but which at the same time aestheticised it.

Like Max Ernst, Man Ray was a great experimenter with new methods of creativity: this experimentalism was even more radical in him, because it was absolutely indifferent to any stylistic consistency. He trained as a painter, and after the revelation of the Armory Show (1913), he worked in all the other languages of the avant-garde, going on to extend them through the precocious experimentation with such forms as the assemblage (1916), *papier-collée* (in the *Revolving Doors* series, 1916–17), and airbrush painting. He also discovered photography, which he was the first to liberate from the constraints of representation, subverting both procedures and techniques: one emblematic case was that of Rayography, which he created in Paris in 1921 by setting objects on sensitive paper and exposing them to light (it had in fact already been pioneered, with more abstract and less intriguing results, by the German Dadaist Christian Schad, who called it Schadography). The result was fascinating, both for the phantom quality taken on by the shadows that the objects acquired and for the mysterious physicality that they revealed, which varied according to their opacity and resistance to the passage of light.

Man Ray arrived in Paris in July 1921, shortly after Duchamp, and remained until 1940, becoming the youngest member of the Dadaist group, and later of the Surrealists, even though this change did not reflect any real modification of his poetics. And this was not very different from the experiences of many other Dadaists, swept along, as they were, by the vehemence of André Breton into the coils of the new Surrealist movement which was, in many ways, an offspring of Dada.

[1] Ed. note: this is a pun with the two meanings '*Dada relieves everything*' and '*Dada incites everything to revolt*'.

Appendix

1900

History	• A xenophobic insurrection breaks out in Peking and in the Chinese Empire against the foreign presence (Boxer Rebellion). The Commonwealth of Australia is created. Bernhard von Bülow becomes the chancellor of the German Reich. • King Humbert I is assassinated in Monza by the anarchist Gaetano Bresci: he is succeeded by Victor Emmanuel III.
Science and Culture	• Max Planck develops quantum theory. Valdemar Poulsen builds the first telegraph machine. Karl Landsteiner discovers blood groups. Inaugural flight over Lake Constance of the first Zeppelin dirigible. • Sigmund Freud's *The Interpretation of Dreams* is published. Henri Bergson publishes *Laughter*. • Gabriele d'Annunzio's *Il fuoco*, Joseph Conrad's *Lord Jim* are published. • Giacomo Puccini presents *Tosca* in Rome. • Friedrich Nietzsche, Oscar Wilde and John Ruskin die.
Art	• In Paris, the Exposition Universelle is held, and is visited by over 50 million people: it is a triumph for Art Nouveau. In one of the pavilions, the large exhibition of Rodin's works marks the beginning of the sculptor's international success. Among the Italians present at the event are Umberto Boccioni and Giacomo Balla, while Monet exhibits his series of *Water Lilies*. The German Max Slevogt goes to Paris and is profoundly moved by the Impressionism that he sees there. At the Durand-Ruel gallery, the large solo exhibition opens of Sickert, the leading English Impressionist. • The magazine *Pan*, the chief forum for the diffusion of Jugendstil in Germany, closes. In Dresden, an exhibition of Henri de Toulouse-Lautrec's work opens. Henry Van de Velde moves to Hagen, where he reorganises the Folkwang Museum. • The eighth exhibition of the Vienna Secession is dedicated to European artistic artisanry, with pieces by Mackintosh, Ashbee and the Maison Moderne. The Glasgow Four decorate a music room for Waerndorfer. Klimt presents the first of his three canvases for the University of Vienna. In the Habsburg capital, the Hagenbund is founded under the leadership of Joseph Urban and directed toward an Art Nouveau aesthetic of English inspiration. • At St Petersburg, the second exhibition of The World of Art is held. In Moscow, Vasily Kandinsky presents his works with other artists at the exhibition of the Association of muscovite Artists. • In Tournai, Belgium, the Kortrijk Kunstgilde is founded, an association of artist-artisans emulating the Arts and Crafts movement. Horta completes the Solvay House in Brussels. • In Barcelona Gaudí begins work on the Parc Güell and builds the facade of the Sagrada Familia. Before taking his first trip to Paris, Picasso shows his famous exhibition of portraits at Els Quatre Gats.

1901

History

- The American president William McKinley is assassinated; Theodore Roosevelt takes his place.
Cuba becomes a United States protectorate. In England Queen Victoria dies, and her son is crowned Edward VII.
In Russia the Socialist Revolutionary Party is founded.
- In Italy Zanardelli is appointed Prime Minister, while Giolitti is Minister of the Interior.

Science and Culture

- Guglielmo Marconi makes the first trans-Atlantic radio transmission.
Edison designs the electric battery.
Röntgen is awarded the Nobel Prize for his discovery of X-rays.
The German Navy builds the first U-boats (submarines).
The first prototypes of the motorcycle are built.
In Russia, Ivan Petrovich Pavlov begins his studies on the conditioned reflexes of animals.
- Max Weber publishes his essay *The Protestant Ethic and the Spirit of Capitalism*.
Sigmund Freud publishes *The Psychopathology of Everyday Life*.
Adolfo Venturi begins to write his monumental *History of Italian Art*.
- *Buddenbrooks*, by Thomas Mann, is published.
Rudyard Kipling publishes his adventure novel *Kim*.
- Anton Chekhov's *Three Sisters* is performed in Russia.
- Arnold Böcklin, Toulouse-Lautrec, and Giuseppe Verdi die.

Art

- In Paris Alfons Mucha completes the decoration of the jewellers' shop Fouquet, one of the masterpieces of Art Nouveau (dismantled in the 1920s).
Le Douanier Rousseau exhibits at the Salon des Indépendants.
Picasso moves to Paris and begins his Blue Period.
- In Berlin, the Siegesallee is inaugurated, a triumphal boulevard in celebration of the Hohenzollerns.
In Darmstadt the first series of buildings by the art colony led by Olbrich is inaugurated.
In Munich, Kandinsky founds the Phalanx group.
Eric Heckel meets Karl Schmidt-Rottluff in Chemnitz.
- In St Petersburg, the third exhibition of the World of Art is held.
- In Brussels, Horta's Maison du Peuple is completed.
- Balla meets Severini and Boccioni.
Pellizza da Volpedo completes *The Fourth Estate*.

1902

History	• In South Africa, the Vereeniging Peace Treaty brings an end to the war between the Boers and the British with a British victory. In France, the elections bring a radical victory: the Combes cabinet initiates a strong anticlerical policy. In Russia the Minister of the Interior is assassinated.
Science and Culture	• In Milan, the 'Luigi Bocconi' University is founded. • Benedetto Croce's *Estetica* is published. In the United States, Louis Henri Sullivan publishes *Kindergarten Chats*, a fundamental theoretical text of modern architecture. • Gabriele d'Annunzio's *Le novelle della Pescara* is published. Gide publishes the novel *L'immoraliste*. Joseph Conrad writes *Heart of Darkness*. Rainer Maria Rilke composes the collection of poems, *The Book of Images*. • Francesco Cilea composes and stages in Milan the opera *Adriana Lecouvreur*. Claude Debussy composes the music for *Pelléas et Mélisande*. Gustav Mahler composes his *Fifth Symphony*. • Georges Méliès makes the fantastic film *A Trip to the Moon*. • Émile Zola dies.
Art	• Munch exhibits *The Frieze of Life* at the Berlin Secession. In Munich, Kandinsky meets Gabriele Münter, who will become his lover. Van de Velde moves to Weimar to direct the School of Applied Arts. • The Viennese Secession devotes a celebratory exhibition to Ludwig van Beethoven: among the other works shown is the famous sculpture by Max Klinger and a frieze by Gustav Klimt. • In Moscow, Mackintosh and Olbrich participate in an exhibition of architecture and the applied arts. • In Prague, the Mánes Secessionist association organises a retrospective dedicated to Rodin. • In Turin, the first Esposizione Internazionale d'Arte Decorativa Moderna is held: Mackintosh's group creates for the occasion the *Rose Boudoir*. In Venice, the Galleria d'Arte Moderna di Ca' Pesaro is inaugurated. • In New York, Stieglitz founds *Camera Work* and the Photo-Secession gallery.

1903

History	• Panama wins independence from Colombia. British troops invade Nigeria. Alexander I of Serbia is assassinated. At the congress in London there is a fracture inside the Russian Social Democratic Workers' Party: on one side are the Mensheviks and on the other are Lenin's Bolsheviks. • In Italy Giolitti becomes Prime Minister. Pius X is elected pope.
Science and Culture	• In the United States, the Wright brothers make the first flight with a motorised aeroplane, and the first coast-to-coast trip by automobile is made in 65 days. Louis Lumière invents the autochrome process for colour photography. Marie Curie and Henri Becquerel are awarded the Nobel Prize for their research on radium. • In Padua, the publishing house Cedam is founded. • Henri Bergson publishes the essay, *Introduction to Metaphysics*. In Naples, Benedetto Croce founds the magazine of philosophy, literature and history, *La critica*. • Jack London publishes *The Call of the Wild*. Giovanni Pascoli publishes the *Canti di Castelvecchio* and Gabriele d'Annunzio *Halcyon*. Thomas Mann publishes *Tonio Kröger*. • In Russia, Anton Chekhov stages his play *The Cherry Orchard*. • Arnold Schönberg composes the symphonic poem *Pelleas und Melisande*. • Paul Gauguin, Camille Pissarro and James McNeill Whistler die.
Art	• In Paris, the Salon d'Automne is founded, which in the years that followed would host the exhibitions of the Fauves and the Cubists. Munch exhibits in Paris at the Salon des Indépendants. • Koloman Moser, Josef Hoffmann and the industrialist Fritz Warndorfer found the Wiener Werkstätte in Vienna for the creation of furniture, utensils and household objects. The Secession organises the exhibition 'Evolution of Impressionism in Painting and Sculpture', with works by Manet, Monet, Cézanne, Van Gogh and the Nabis group. *Ver Sacrum*, the publication of the Viennese Secession, closes. • Mackintosh builds the Hill House, a masterpiece of Scottish Modernism. • In Moscow, the first exhibition of the Union of Painters is held. The Union of Russian Artists is also held, formed partly by artists from the World of Art. • Giuseppe Sommaruga builds Palazzo Castiglioni in Milan. Balla meets Sironi: a Divisionist 'group' is formed. • Pablo Picasso paints *Life*, the culmination of the social Symbolism that characterises his Blue Period.

1904

History	• The third edition of the Olympics is held at St. Louis in the United States with twelve countries taking part. The Japanese stage a surprise attack on the Russian fleet, starting a war for control of Manchuria. France and Great Britain sign the Entente Cordial, to regulate the colonial policy of the two nations. • The Italian Socialist Party calls for the first general strike in the history of Italy.
Science and Culture	• Ernest Rutherford and Frederick Soddy formulate the general theory of radioactivity. The first photoelectric is manufactured, as are the first ultraviolet bulbs. The first photographs are transmitted by telegraph. Excavation of the Panama Canal begins. • Max Weber publishes his essay *The Protestant Ethic and the Spirit of Capitalism*. • Luigi Pirandello writes *The Late Mattia Pascal*. In Scotland, James R. Barrie writes *Peter Pan*. • D'Annunzio stages *The Daughter of Jorio* at Milan's Teatro Lirico. Giacomo Puccini completes *Madame Butterfly*, which however opens to a 'disastrous' debut at Milan's La Scala. • At the Moscow Art Theatre, Chekhov's *The Cherry Orchard* is performed. • Anton Chekhov dies.
Art	• In Paris, the Salon d'Automne dedicates an entire room to Cézanne. Picasso travels once again to Paris and takes up residence in the Bateau-Lavoir. The Druet gallery actively supports the spread of Divisionism in those years. First solo exhibition by Matisse. • In Berlin, Munch joins the Secession and signs an advantageous contract with the gallery owner Paul Cassirer. In Munich, the Phalanx group dissolves. In Darmstadt, the Marienhalle, a major exhibition building with a famous panoramic tower, is completed. • In Vienna, the nineteenth exhibition of the Secession is dedicated to monumental art, with works by Hodler and Munch. • Robert Ashbee opens the School of Arts and Crafts in Chipping Campden. Rodin exhibits the large version of his *Thinker* in London (later at the Paris Salon). • In St Petersburg, the Soyuz Russkikh Khudozhnikov (Union of Russian Artists) begins to hold exhibitions. In Saratov, a provincial town, the Symbolist group Crimson Rose, a forerunner of the Blue Rose, holds exhibitions. • At the Universal Exposition of Saint Louis, Fattori is awarded a silver medal. Alfons Mucha moves to New York, where the *Daily News* devotes a supplement to him.

1905

History	• The war between Russia and Japan ends with a Japanese victory. In St Petersburg, troops fire upon a procession of people demonstrating against Czar Nicholas II, triggering a series of reactions throughout the country, including the mutiny of the battleship Potemkin and the outbreak of the First Russian Revolution: the workers' Soviets band together and proclaim a general strike; the Czar permits the establishment of a Parliament (Duma). The Norwegian parliament votes to secede from Sweden. • Giolitti resigns as prime minister of Italy and is replaced by Alessandro Fortis. With the encyclical *Il fermo proposito* Pius X allows Catholics to take part in political life for the higher considerations of the social good.
Science and Culture	• The physicist Albert Einstein develops the Special Theory of Relativity. • Edmondo De Amicis writes the long essay *L'idioma gentile*, inspired by the principles of Manzoni. • Georg Fuchs' book *Die Schaubühne der Zukunft* (*Revolution in the Theatre*) is published in Munich. Filippo Tommaso Marinetti founds the literary review *Poesia*. • Richard Strauss composes the opera *Salome*. Franz Lehar composes the operetta *The Merry Widow*.
Art	• In Paris, at the Salon des Indépendants, Matisse's *Luxe, Calme, et Volupté* is exhibited. The Salon d'Automne hosts retrospectives of Manet, Ingres, Seurat and Van Gogh; Kandinsky is also present. First exhibition of the Fauves (Matisse, Derain, de Vlaminck). Jawlensky meets Matisse. Picasso paints *Family of Saltimbanques* and begins his Pink Period. Cézanne completes his *Large Bathers*. • In Dresden, Die Brücke is founded, the first affirmation of Expressionism, bringing together such artists as Kirchner, Bleyl, Heckel and Schmidt-Rottluff. In the city there is also a show of works by Munch and Van Gogh. The Belgian Georges Minne creates the *Fountain of Five Youths* for the Folkwang Museum in Hagen. In Munich, at the Krause gallery, Kandinsky holds his first travelling solo exhibition. • In Vienna the group of artists led by Gustav Klimt (Klimtgruppe) splits off from the Secession. • In St Petersburg the exhibition of historic portraits organised by Diaghilev is held, while in Moscow, the magazine *Iskusstvo* ('Art') is published. • In Prague, a retrospective of Munch's work at the Mánes gallery meets with great success. • In Brussels, Hoffmann begins work on the Palais Stoclet, with the collaboration of the Wiener Werkstätten, completing it in 1914. • In New York, Stieglitz and Steichen open the 291 gallery.

1906

History

- The city of San Francisco is devastated by a powerful earthquake and by the many fires that break out (700 dead).
In France, on 1 May, a general strike is held to win an eight-hour workday.
Twelve years after the beginning of the trial of Captain Alfred Dreyfus, he is pardoned.
In Great Britain the Liberals win the elections and the Labour Party is born.
In Russia, the Czar reiterates his authority over the army and severely limits the powers of the Duma, which is dissolved.
- Giolitti's third term brings about major reforms in Italy, in the social sphere (social welfare, reductions in the workday).

Science and Culture

- Inauguration of the Sempione (Simplon) tunnel linking Switzerland and Italy.
In the United States the physicist Reginald A. Fessenden invents amplitude modulation (AM) radio and transmits the first voice message by radio.
The Norwegian explorer Roald Amundsen determines the location of the magnetic North Pole.
Dr Maria Montessori founds the Casa dei Bambini (Children's Home) in Rome.
- In Berlin, Cassirer publishes the first volume of *History of Modern Philosophy*.
In Turin, the *Principi scientifici del Divisionismo* is published, a late theoretical formulation by Previati.
Eugeni d'Ors, under the pseudonym of Xènius, publishes the *Gloses.*
- Giosuè Carducci is awarded the Nobel Prize for literature.
Robert Musil publishes *The Confusions of Young Törless*.
Jack London publishes *White Fang.*
Giovanni Papini publishes *Il tragico quotidiano.*
- Paul Cézanne dies.

Art

- Édouard Manet's *Luncheon on the Grass* (1863) is shown at the Louvre.
The Salon d'Automne hosts a retrospective of Gauguin. Diaghilev curates the Russian section of the Salon with the presence of works by Larionov and Goncharova.
The Fauves exhibit at the Salon des Indépendants, where works are also shown by Braque and *The Joy of Life* by Matisse. Rodin's large *Thinker*, donated to the French state, is installed before the Pantheon. First exhibition of African art.
Severini and Kandinsky move to Paris, and the latter discovers Matisse and Picasso. Also moving to the French capital are Modigliani, Gris and Boccioni; the latter later moves to Russia and finally to Venice.
- In Dresden, an exhibition of Munch's work is held.
Kirchner publishes the manifesto of Die Brücke, illustrated with his own woodcuts: Nolde and Pechstein also join the group.
- In St Petersburg the last World of Art exhibition is held. The first issue of *The Golden Fleece* is published in Moscow.
- In Prague, the Group of Eight is founded, close to Post-Impressionism and the Expressionist avant-gardes.
- Milan holds the Esposizione Internazionale del Sempione.
- Picasso returns to Gósol in Spain.
Gaudí begins to build the Milá House and goes to live in the Parc Güell.

1907

History	• In Russia the second and third Dumas are permitted. • With the encyclical *Pascendi dominici gregis*, Pius X condemns Modernism.
Science and Culture	• In Belgium, bakelite is invented. August Musger invents the slow-motion effect. • Henri Bergson writes *Creative Evolution*. • Arnoldo Mondadori founds in Italy the publishing house that bears his name.
Art	• In Paris, among those taking part in the Salon des Indépendants is Kandinsky, who visits the city, accompanied by Marc and Macke. The Salon d'Automne dedicates a retrospective to Cézanne. The Kahnweiler gallery opens. Picasso paints *Les Demoiselles d'Avignon*. Le Douanier Rousseau paints *The Snake Charmer*. Delaunay creates *Landscape by Night* or *The Fiacre*. • Die Brücke begins to exhibit at the Richter gallery in Dresden. In Munich, Langen is the director of the magazine *März*. Macke leaves Paris and goes to Berlin. • In Glasgow, Mackintosh begins work on the library of the local Art School, a paradigm for Scottish Art Nouveau. In London, the Guild of Handicraft closes. It had been founded by Ashbee in 1888 and produced refined Art Nouveau objects. • In Moscow, the Symbolist group Blue Rose organises its first exhibition. • In Prague, the first exhibition of the Group of Eight is held. • In Brussels, Maus founds La Libre Esthétique, with the participation of artists, writers, and musicians. • In Venice, the seventh edition of the Biennale features a significant presence of Russian artists. Boccioni moves to Milan. • In Barcelona, the Palau de la Música Catalana by Lluis Domènech i Montaner is inaugurated, and the Dalmau gallery opens.

1908

History

• In New York, on 8 March, 129 female factory workers are killed in a sweatshop fire.
In Portugal, following the assassination of King Don Carlos I and Crown Prince Don Luiz, Manuel II is made king.
Ferdinand I takes the title of Czar of the Kingdom of Bulgaria, now independent of the Ottoman empire.
Bosnia and Herzegovina are annexed by Austria.
• In Rome, the first national congress is held in favour of women's right to vote.
Messina and Reggio Calabria are hit by an earthquake and a flood that kill 150,000.

Science and Culture

• Henry Ford introduces the assembly line in his automobile factories and produces the first affordable automobile, the Model T.
In Ivrea, Olivetti is founded.
• The critic Louis Vauxcelles, commenting on one of the landscapes painted by Georges Braque, uses the term 'Cubism' for the first time.
• In Munich, Worringer's *Abstraction and Empathy: Essays in the Psychology of Style* (written in 1907) is published.
Loos publishes *Ornament and Crime*, a fundamental text of architectural functionalism.
David Burlyuk publishes the manifesto *The Voice of an Impressionist: in Defence of Painting*.
Giuseppe Prezzolini founds *La Voce* in Florence.
• Trilussa publishes his collection of poetry *Ommini e bestie*.
The children's publication *Il Corriere dei Piccoli* is founded.
• Isaac Albéniz composes his piano sonata *Iberia*.
Arturo Toscanini replaces Gustav Mahler as the conductor of the Metropolitan Opera in New York.

Art

• Georges Braque paints *Landscape at l'Estaque* and *Large Nude*, and is also the subject of a show at Kahnweiler in Paris.
In the French capital, the Matisse Academy opens. A celebration is held for Le Douanier Rousseau at the Bateau-Lavoir.
Delaunay and Metzinger abandon Divisionism and move toward Orphism.
Brancusi sculpts *The Kiss*.
• Kandinsky's first stay at Murnau.
Dufy and Friesz travel to Munich. Exhibition of Van Gogh at the Kunstsalon Zimmermann and at the Brackl gallery. Hans von Marées is present at the Munich Secession. Also in the Bavarian city, de Chirico paints *Siren and Triton*, *Prometheus* and *Sphinx*.
In Dresden, the Fauves and Die Brücke exhibit at the Richter gallery, with works by Van Gogh.
Nolde leaves Die Brücke.
• In Vienna, the Klimtgruppe organises an exhibition that marks the culmination of the development of Austrian Modernism.
• In Russia, the Blue Rose comes to an end.
In Moscow, *The Golden Fleece* organises the first exhibition in which Russian and French artists show their work, such as Van Gogh, Gauguin, Cézanne and the Nabis. Larionov becomes a co-editor of the publication's artistic section, which moves in new directions.
At St Petersburg, the exhibition Trends in Contemporary Art is held.
• In Prague, the *Artel* cooperative, inspired by the Wiener Werkstätte, is founded.
The Group of Eight organises its second show and then practically ceases all activity, though without breaking up.
• Mondrian stays in Domburg, in the art colony of the painter Jan Toorop.
• At the Esposizione Internazionale in Rome, Klimt receives the Gold Medal.
• At the Macbeth gallery in New York, an exhibition brings attention to the Group of Eight.

1909

History	• In Belgium, Albert I is crowned as successor to the dead king Leopold II. At the end of July in Barcelona, the anticlerical rioting breaks out that is known as the 'Semana trágica'. In Spain, an anarchistic revolt led by Francisco Ferrer is put down. In Germany, the chancellor Bernhard von Bülow resigns. A coup d'état in Turkey puts Sultan Mohammed V on the throne. In Sweden, universal suffrage is established. • In Italy, elections are held. Giolitti keeps his majority but soon resigns.
Science and Culture	• Louis Blériot makes the first air crossing by man of the English Channel. Marconi is awarded the Nobel Prize for 'wireless telegraphic communication'. Italian expedition to the Himalayas. • The publisher Angelo Rizzoli begins his printing activity. • Freud publishes *Five Lectures on Psycho-Analysis*. Filippo Tommaso Marinetti publishes the *Manifesto of Italian Futurism* in the newspaper *Le Figaro*. Maurice Denis publishes his theoretical essay *De Gauguin et de Van Gogh au classicisme*. • In Berlin, the association of poets, the Neue Club, is founded. • Richard Strauss composes *Elektra* to a libretto by Hugo von Hofmannsthal. • The American Winsor McCay makes the first animated cartoon. Robert Peary reaches the North Pole. George Claude creates the first neon tube light.
Art	• In Paris, inauguration of the first season of Diaghilev's Ballets Russes. Modigliani and Lipchitz move to Paris. Auguste Rodin inaugurates the monument to Victor Hugo. Balla and the Cubists exhibit at the Salon d'Automne. Severini paints *Spring in Montmartre*. Delaunay paints the *Saint Séverin* cycle. Fernand Léger begins *Nudes in the Forest*. • In Dusseldorf, the first exhibition of the Sonderbund Westdeutscher Kunstfreunde und Künstler is held. In Berlin, Behrens builds the AEG turbine factory. Also in Berlin, exhibition of the *Large Bathers* by Cézanne, whose works are also presented at the Munich Secession. In the Bavarian capital an exhibition is held of Japanese and Far Eastern art. Von Tschudi becomes the new director of the museums in Munich. The Brackl gallery exhibits works by Van Gogh and Toulouse-Lautrec. Kandinsky, Jawlensky, Gabriele Münter and Kubin found the Neue Künstlervereinigung München (NKVM), whose first exhibition is held at the Tannhauser gallery. Kandinsky creates his first *Improvisations* and writes his *Letters from Munich* for the magazine *Apollon* in St Petersburg. Kirchner and Pechstein execute their first wooden sculptures, under the directions of Heckel. • In Vienna, the Internationale Kunstschau is held with the works of 166 artists, including Gauguin, Van Gogh and Munch. In the same city, the Neukunstgruppe is also founded, largely clustering around Schiele. • In Russia, an exhibition of *The Golden Fleece* features the Nabis alongside the young Russians, including Goncharova and Larionov. • Klimt does the decorations for the Palais Stoclet in Brussels. • Arp meets Klee in Switzerland. • Galileo Chini executes cartoons for the dome of the Central Hall of the eleventh Venice Biennale. Heckel travels to Italy.

1910

History	• The South African Union is born. Japan annexes Korea. In Mexico, Francisco Madero leads the peasant rebellion against the dictatorship of Porfirio Díaz. In Great Britain, George V succeeds Edward VII. In Portugal the monarchy is replaced by the liberal republic. Nicholas II pays a visit to Germany.
Science and Culture	• In the United States the chromosome is identified as the factor for the transmission of hereditary characteristics. In New York the Brooklyn Bridge is inaugurated. The first Zeppelin dirigible for public use is built, and carries 20 passengers. The Geiger counter is invented for the measurement of radioactivity. Evans discover the archaeological site of Knossos. • Roger Fry, on the occasion of the inauguration of an exhibition, coins the term 'Post-Impressionism'. • Bertrand Russell begins his *Principia Mathematica*. The *Manifesto of Futurist Painters* and *The Technical Manifesto of Futurist Painting* are signed by Boccioni, Carrà, Russolo, Balla and Severini, and published in *Le Figaro*. • Aldo Palazzeschi publishes *L'incendiario*. In Great Britain, Edward Forster publishes *Howard's End*. Marinetti publishes the novel *Mafarka the Futurist* • Igor Stravinsky composes the music for the ballet, *The Firebird Suite*. • Leo Tolstoy, Charles van der Stappen and Henri Rousseau (Le Douanier) die.
Art	• In Paris, exhibitions of Picasso's work are held at the galleries belonging to Uhde and Vollard. Mondrian and Chagall are in the French capital. Picasso paints his *Portrait of Ambroise Vollard*, Matisse paints *Dance* and *Music* for Sergei Schukin. • At the Tannhauser gallery in Munich and at the Bernheim-Jeune gallery in Paris, a major exhibition is dedicated to Matisse. The Munich gallery also organises exhibitions of Manet, Gauguin and the NKVM, with the participation of Cubists and Fauves. Marc exhibits for the first time at the Brackl gallery and is invited to join the NKVM; Girieud and Le Fauconnier also join. In Munich a meeting takes place between Macke and Kandinsky. First abstract watercolour by Kandinsky and the first *Compositions*. Max Pechstein founds the New Secession in Berlin, and the artists of Die Brücke also join. Kokoschka publishes *Murderer, Hope of Women* (written in 1908), the first Expressionist play, and begins to contribute to the Berlin magazine *Der Sturm*. Gropius designs the Fagus factory at Alfeld-an-der-Leine. • In Vienna, Loos builds the Steiner House. • In London, the first Post-Impressionist exhibition opens at the Grafton galleries, curated by Fry and MacCarthy. • In St Petersburg, the Union of Youth is founded, while the World of Art resumes its activities. The magazine *The Golden Fleece* ceases publication: the last exhibition is dedicated entirely to Russia and features both folk art and contemporary art. In Moscow, the first exhibition of the Jack of Diamonds group and of Kulbin's *Triangle* is held. • In Amsterdam, Mondrian becomes an executive of the association, Moderne Kunstkring. • Boccioni exhibits *Mourning* at the Famiglia Artistica in Milan. • First solo exhibition of Klee's work at the Kunstmuseum in Bern. • Balla finishes his first Futurist painting, *Arc Lamp*, as well as *Villa Borghese*. • Umberto Boccioni works on *The City Rises*.

1911

History	• New constitution for Alsace-Lorraine, which wins greater independence. Proclamation of the Chinese Republic and the end of the Manchu dynasty. • Italy declares war on Turkey and quickly takes Tripolitania and Cyrenaica.
Science and Culture	• The Norwegian explorer Roald Amundsen reaches the South Pole. Ernest Rutherford codifies the first model of the atom. Frederick Taylor publishes his famous essay on the 'Taylorist system' and the productivity of machinery. • György Lukács publishes his essay *Soul and Form*. In Italy, Boccioni's *Technical Manifesto of Futurist Sculpture* is published. Schönberg publishes the *Manual of Harmony*. Pratella writes the *Manifesto of Futurist Musicians*. • Aldo Palazzeschi publishes *The Code of Perelà*.
Art	• In Paris, a major retrospective of Rousseau is organised. Severini invites the Futurists to move to the French city. De Chirico arrives in Paris, where he paints the series of the *Piazzas* and the *Towers*. Mondrian moves to Paris. • Marc, Kandinsky, Klee and Macke leave the NKVM and found the Blaue Reiter, whose first exhibition is held at the Tannhauser gallery in Munich. Taking inspiration from Schönberg, Kandinsky paints his canvas *Impression III – Concert and Composition V*. The painter also creates the first non-objective painting, entitled *Square with Circle*. Die Brücke moves to Berlin and exhibits with Pechstein's New Secession. Grosz's first caricature is published in the *Berliner Tagesblatt*. • Larionov and Goncharova break away from the Jack of Diamonds to found the Donkey's Tail group. Matisse is in Moscow to oversee the installation of the Schukin collection. At the second exhibition of the Union of Youth, Malevich and Tatlin also exhibit. • In Prague, the group of Plastic Artists, which has broken away from Mánes and is close to the positions of the Cubists, is founded. • The Moderne Kunstkring organises its first exhibition at the Stedelijk Museum in Amsterdam. • In the pages of *La Voce*, Boccioni quarrels with Soffici. Boccioni's *The Laugh* is damaged at the Esposizione d'arte libera in Milan. Also present at the exhibition are works by Carrà and Russolo. Carlo Carrà paints *The funeral of the Anarchist Galli*. • The theories of Noucentisme spread from Spain. • The 291 gallery in New York exhibits Picasso's Cubist works.

1912

History	• French protectorate for Morocco. The first war in the Balkans breaks out. In China, Sun Yat-sen founds the Kuomintang (Chinese Nationalist Party). In Basel, the congress of the Socialist International is held. • The ocean liner Titanic sinks during its maiden voyage. Italy occupies Rhodes and the islands of the Dodecanese. The government passes a law authorising universal male suffrage. Mussolini is appointed editor of the Socialist newspaper *Avanti!*
Science and Culture	In physics, the nature of X-rays is discovered. The first cellophane is manufactured. • Carl G. Jung publishes *Psychology of the Unconscious; A Study of the Transformation and Symbolisms of the Libido.* Vasily Kandinsky publishes *Concerning the Spiritual in Art* (begun in 1910) in Munich. Marinetti publishes the *Technical Manifesto of Futurist Literature.* Gleizes and Metzinger publish *Du Cubisme.* The first issue of *Pravda*, a daily founded by Lenin, is published. • Thomas Mann publishes *Death in Venice.* The Futurist poem, *A Game in Hell* by Khlebnikov and Kruchenykh, is published with illustrations by Larionov and Goncharova. • Schönberg composes the atonal masterpiece *Pierrot Lunaire.* Nijinsky directs the company of the Ballets Russes in Debussy's *The Afternoon of a Faun.* • Giovanni Pascoli dies.
Art	• Braque and Picasso create Cubist collages (Picasso, *Still Life With Chair Caning*). Picasso also creates *The Guitar*, his first Cubist sculpture. Marcel Duchamp paints *Nude Descending a Staircase* and takes part in the 'Section d'Or' exhibition at the La Boétie gallery. Raymond Duchamp-Villon's model of a Cubist house creates a scandal at the Salon des Indépendants. Delaunay founds the current of Cubism known as Orphism. Macke and Marc travel to Paris, where they visit Delaunay's atelier. At the Bernheim-Jeune gallery the first exhibition of Futurist painters is held, and later moves to London, Berlin, The Hague and Amsterdam. • Pechstein is expelled from Die Brücke for having exhibited at the Berlin Secession. Kandinsky and Marc publish the Blaue Reiter almanac. Second exhibition of the Blaue Reiter, with the participation of Klee (with 17 works) and Arp. First solo exhibition of Kandinsky at Der Sturm gallery in Berlin, opened by Walden. Also in Berlin, Marc meets Schönberg and visits an exhibition of Futurist painters. Klee moves to Munich, where he meets Delaunay. Kandinsky exhibits at the Goltz gallery. The Tannhauser gallery hosts a Futurist exhibition. Jawlensky meets Klee and Nolde, leaves with Werefkin the NKVM and moves to Switzerland. International exhibition organised by the Sonderbund in Cologne. Balla begins a series of studies for the *Iridescent Interpenetrations* and works on the decoration of the home of Margherita Löwenstein in Dusseldorf. • In Vienna, with the Scheu House, Loos builds the first instance of a flat roof in a private home. • The Grafton galleries in London hold two exhibitions, Manet and the Post-Impressionists and The Second Post-Impressionist Exhibition, with works by Picasso at the Stafford gallery. • Second exhibition in Moscow of the Jack of Diamonds and first exhibition of the Donkey's Tail, with the participation of Tatlin and Malevich. • Archipenko creates his first assemblages, dedicated to the Médrano Circus. • In Amsterdam, the second exhibition organised by the Moderne Kunstkring opens, with works by Gauguin and Le Fauconnier.

1913

History	• In Mexico, the revolutionary movement led by Pancho Villa and Emiliano Zapata is founded. The Treaty of Bucharest sanctions the new political and territorial status of the peninsula at the end of the Second Balkan War. Giolitti wins the support of Italian Catholics with the Gentiloni Pact.
Science and Culture	• In Great Britain, Harry Brearley produces the first 'rustless' (stainless) steel. • Freud publishes *Totem and Taboo*. Benedetto Croce publishes the essay *Breviario di Estetica* (*Guide to Aesthetics*). Giovanni Papini and Ardengo Soffici found the literary journal *Lacerba*. • Russolo publishes the manifesto *The Art of Noise*, Carrà publishes *The Painting of Sounds, Noises and Smells* and Severini publishes *Le analogie plastiche* ('The Plastic Analogies of Dynamism'). Marinetti writes *Destruction of Syntax – Imagination without strings – Words-in-Freedom* and *Manifesto of the Variety Theatre*. Larionov publishes the Manifesto of Rayism. Aleksandr Shevchenko writes the book, *Neo-primitivizm* (*Neoprimitivism: Its Theory, Its Potentials, Its. Achievement*). Guillaume Apollinaire publishes *Alcools* and *L'antitradition futuriste, Les peintres cubistes*. • Grazia Deledda publishes *Reeds in the Wind*. Marcel Proust writes *Swann's Way*, the first volume of the cycle *Remembrance of Things Past*. • Igor Stravinsky directs *Le sacre du Printemps* (*Rite of Spring*) in Paris. • Charlie Chaplin makes his first film. The films *Fantomas* by Louis Feuillade and *The Last Days of Pompeii* by Giovanni E. Vitali are released.
Art	• At the Salon des Indépendents Orphism explodes. Tatlin meets Picasso in Paris. Duchamp begins creating his first ready-mades. Brancusi works on the *Mademoiselle Pogany*. • In Berlin, Kirchner publishes the *Chronik der Brücke* ('Chronicle of the Brücke'), which unleashes discontent among his comrades and the group dissolves. Nolde, who has begun to write an essay on primitive art, leaves for New Guinea. Kirchner begins painting Berlin 'street scenes'. Delaunay exhibits in Cologne. Major exhibition on the Expressionists of the Rhineland in the art gallery of Friedrich Cohen in Bonn. The first Deutscher Erbstsalon (Autumn Salon) opens at Der Sturm gallery in Berlin; Ernst exhibits in the same gallery. Picasso is present with his own works at the Tannhauser gallery. Exhibition of Münter at the Neuer Kunstsalon. Exhibition of Schiele at the Goltz gallery in Munich. Macke exhibits at the Arnold gallery in Dresden. • Severini installs his first solo exhibition in London at the Marlborough gallery (later at Der Sturm gallery in Berlin). • Suprematism is established in Russia. In St Petersburg the third exhibition of the Jack of Diamonds and the last exhibition of the Soyuz Molodyozhi (Union of Youth) are held. At the Luna Park Theatre in St Petersburg, *Victory over the Sun* is staged, with sets and costumes by Malevich. Kasimir Malevich paints *Black Square on White Background*. • Third exhibition held by the Moderne Kunstkring in Amsterdam. • A dispute breaks out between Boccioni, Apollinaire and Delaunay over the concept of simultaneity. Balla paints the *Abstract Speed* series and exhibits for the first time with the Futurists at the Teatro Costanzi in Rome. In Rome, the Sprovieri gallery opens. • In New York, the Armory Show is held: among those exhibiting are Kandinsky and Kirchner.

1914

History	• In Sarajevo, on 28 June, the student Gavrilo Princip assassinates the Austrian archduke Franz Ferdinand: shortly thereafter World War I breaks out. The Panama Canal is inaugurated. St Petersburg changes its name to Petrograd. • In Italy, Giolitti resigns the premiership. Mussolini takes an interventionist position in World War I and founds the newspaper *Il Popolo d'Italia* in Milan. Pius X dies and is succeeded by Benedict XV.
Science and Culture	• Invention of the first compact camera using 35 mm film, made by Leica. In the United States, the first civilian, passenger-carrying airline begins operation. • Stalin writes *Marxism and the National Question*. Carl Einstein publishes *Negerplastik*, the first systematic study of African art, important to the Expressionist movement. Boccioni publishes *Futurist Painting and Sculpture*. Sant'Elia writes the *Manifesto of Futurist Architecture*. Carrà, Marinetti, Russolo, Piatti and Boccioni sign the manifesto *The Futurist Synthesis of War*. • Publication of André Gide's *Les Caves du Vatican*, James Joyce's *Dubliners* and George Bernard Shaw's *Pygmalion*. Kafka begins to compose *The Trial*. Alberto Savinio publishes the *Chants de la Mi-Mort*. • The films *Cabiria* (Giovanni Pastrone) and *Der Golem* (Paul Wegener) are released. • Berenguer and Macke die.
Art	• Larionov and Goncharova exhibit at the Paul Guillaume gallery in Paris. Raymond Duchamp-Villon executes *The Horse*. De Chirico paints *Song of Love* and the *Premonitory Portrait of Apollinaire*. • In Berlin, the last exhibition of the Blaue Reiter is held, along with an exhibition dedicated to Chagall. Van de Velde builds the theatre for the Exposition of Cologne, to which the architect, together with Behrens and Gropius, presents works in iron, glass and reinforced cement. Kokoschka paints *Bride of the Wind*. Kandinsky creates the *Improvisations* and the *Impressions*. • English Vorticism is founded. • Filippo Tommaso Marinetti delivers lectures in Moscow and Petrograd. In Moscow Tatlin exhibits his first *Synthetic-Static Compositions*. When war breaks out, Kandinsky leaves Gabriele Münter and returns to Russia. Chagall also returns to Russia, to Vitebsk, where he meets Bella Rosenfeld again; he marries her the following year. • In Milan, the Nuove Tendenze movement comes into being. In Rome, at the Sprovieri gallery, a Futurist exhibition is held. • Klee, Macke and Moilliet go to Tunisia. • In New York Gertrude Vanderbilt Whitney founds the nucleus of the Whitney Museum of American Art.

1915

History	• In Mexico the revolutionaries led by Villa and Zapata are defeated by the regular army. During the Second Battle of Ypres, the German army uses poison gas for the first time. A German U-boat sinks the ocean liner *Lusitania*. • On 24 May, in accordance with a pact signed in London, Italy declares war on the side of the Triple Entente, in exchange for territorial concessions.
Science and Culture	• The first telephone call is made between New York and San Francisco. The theory of continental drift is set forth in Alfred Wegener's book *The Origins of Continents and Oceans*. Wölfflin writes *Kunstgeschichtliche Grundbegriffe* (*Principles of Art History*). • Balla and Depero publish the *Manifesto of the Futurist Reconstruction of the Universe*. Marinetti, Carrà and Settimelli write *The Futurist Synthetic Theatre*. Malevich publishes the Manifesto of Suprematism. Pavel Filonov composes, in trans-mental *zaum* language, *A Sermon-Chant of Universal Flowering*. • The esoteric novel *The Golem* by Gustav Meyrink is published in Austria. Edgar Lee Masters publishes *The Spoon River Anthology*. Franz Marc writes *The Hundred Aphorisms*. • Chaplin's film *The Tramp* is released. David W. Griffith directs *Birth of a Nation*.
Art	• Modigliani paints the *Reclining Nude*. • The first abstract compositions by Hannah Höch in Berlin. • In Petrograd, the Tram V. First Futurist Exhibition opens: among those showing are Malevich and Tatlin. Larionov and Goncharova leave Russia. Also in Petrograd, the *0.10. Last Futurist Exhibition* opens. • In Zurich, first exhibition of Arp's abstract reliefs. • Carrà leaves the Futurist movement. De Chirico goes to Ferrara. • Miró shares his studio in Barcelona with Ricart. • In New York, the magazine *291* is founded; Stieglitz's gallery holds a solo exhibition of Picabia's work. Duchamp begins work on *The Large Glass* and publicises the ready-mades.

1916

History	• In Austria, Emperor Franz Josef dies and is succeeded by Karl I Habsburg. The Austrians execute Cesare Battisti and Fabio Filzi (for the crime of having enlisted in the Italian army). In Petrograd, Rasputin, adviser to the Czar, is murdered. • Italy declares war on Germany.
Science and Culture	• The British army uses tanks in battle for the first time. • Albert Einstein publishes the *General Theory of Relativity*. The students of Ferdinand De Saussure publish the *Course in General Linguistics*, which marks the beginning of structuralism. • Balla, Chiti, Corra, Ginna and Marinetti sign the *Manifesto of Futurist Cinema*. In Rome, the journal *L'Italia Futurista* is published. • Tristan Tzara publishes *La Première Aventure céleste de Monsieur Antipyrine*. James Joyce writes *A Portrait of the Artist as a Young Man*. Franz Kafka writes *Metamorphosis*. Ottorino Respighi composes *The Fountains of Rome*. • Odilon Redon, Umberto Boccioni, Antonio Sant'Elia, Franz Marc and the author Henry James die.
Art	• Severini paints *Maternity*. Commissioned by Diaghilev, Balla designs the multimedia set for Stravinsky's *Fireworks*. Severini breaks away from the Futurists. • Nolde retires permanently to Schleswig. The Berlin magazine *Die Aktion* devotes an entire supplement to Schiele. • Tatlin organises the exhibition Magazin. In Moscow, the fifth exhibition of the Jack of Diamonds is held, featuring no fewer than 45 works by Chagall. • Mondrian establishes contact with Van der Leck and Van Doesburg. • In Zurich, in February, Hugo Ball and Emmy Hennings found the Cabaret Voltaire. In May, the sole issue of *Cabaret Voltaire* is published. • Carlo Carrà paints *Anti-Graceful* or *Antigrazioso (Bambina)* and meets Giorgio de Chirico in Ferrara.

1917

History	• The February Revolution breaks out in Petrograd and the Soviets of workers and soldiers are founded. Lenin, having returned to Russia under German protection, issues *The April Theses*. The October Revolution begins with the attack on the Winter Palace. China declares war on the side of the Triple Entente. The United States enters the war as well. Lawrence of Arabia leads the revolt of the Arab tribes against the Turkish empire. The British occupy Jerusalem. • The Italian army is defeated at Caporetto; General Cadorna is replaced by Armando Diaz.
Science and Culture	• The physicist Paul Langevin builds the first Sonar system. First recording of a jazz concert. • In the United States, the Pulitzer Prize is established. In Russia, the The People's Commissariat of Education is founded by the Futurist Anatoly Lunacharsky. • Benedetto Croce publishes *Theory and History of Historiography*. In Italy, Marinetti writes the *Manifesto of Futurist Dance*. • The first performance of *Così è se vi pare* (*Right You Are [If You Think You Are]*), the *Berretto a sonagli* (*Cap and Bells*), and *Piacere dell'onestà* (*The Pleasure of Honesty*) by Luigi Pirandello. • Satie composes the ballet *Parade*. • Edgar Degas and Auguste Rodin die.
Art	• Picasso paints *Portrait of Olga in the Armchair*. • Kokoschka begins to teach at the Academy of Dresden, where he remains until 1924. He also composes *Sphinx und Strohmann* ('The Sphinx and the Scarecrow'), the most important Expressionist play. • In Russia, the Constructivist group is founded. In Moscow, Tatlin and Rodchenko decorate Yakulov's Café Pittoresque. Kandinsky marries Nina Andrevsky. • In Prague, the Group of Plastic Artists ceases activity. • Mondrian and Van Doesburg found the magazine *De Stijl* in Leyden. Mondrian paints *Composition in Blue*. • In Zurich, the first issue of the magazine *Dada* is published, and the Corray gallery is renamed the Dada gallery; Arp, Janco and Richter are exhibited. Kirchner moves to Frauenkirche, in Switzerland. • Picasso arrives in Rome with Cocteau to meet Diaghilev and the Italian Futurists. • In Barcelona, the young Miró meets Picabia. In the Catalan city, publication of the Dada magazine *391* begins under the direction of Picabia himself. At the Dalmau gallery, the Exposition d'art français is held. • First exhibition of the independent artists in New York; Duchamp's *Fountain* is shown. Arthur Cravan delivers his scandalous lecture on modern art.

1918

History	• The Italian army defeats the Austrians in the battle of Vittorio Veneto: the two nations sign an armistice. World War I ends. Facing abdication, Karl I Habsburg chooses exile: the Austro-Hungarian Empire comes to an end. Subsequently, Serbia, Czechoslovakia, Poland and Hungary declare themselves sovereign states. The German Republic is formed. In Great Britain, women exercise the right to vote. Europe is struck by an epidemic of Spanish flu. The Ukraine, Latvia, Lithuania and Finland win independence from the Russian Empire. In Russia, the Gregorian calendar is adopted, and the capital is transferred from Petrograd to Moscow.
Science and Culture	• Max Planck is awarded the Nobel Prize for quantum theory. • Oswald Spengler writes *The Decline of the West*. Klee writes the essay *Graphik*. The *Manifesto of the Italian Party Futurist* and, by Tristan Tzara, the *Dada Manifesto 1918*, are published. *Valori Plastici* is founded in Rome. • Alberto Savinio publishes *Hermafrodito*. Apollinaire creates *Calligrammes*. Vladimir Mayakovsky composes *Mystere Bouffe*. • Ettore Petrolini stages the satirical play *Nerone* (*Nero*). • The film *Shoulder Arms* (Charlie Chaplin) is released. • Koloman Moser, Egon Schiele, Gustav Klimt, Ferdinand Hodler, Otto Wagner and Guillaume Apollinaire die.
Art	• In Berlin, the Novembergruppe is founded, a stronghold of German Expressionism. Hausmann, Hartfield, Huelsenbeck, Grosz, Richter and Höch found the Club Dada. Schwitters begins work on the *Merzbau*. • With the deaths of Schiele and Klimt, the Viennese Secession comes to an end. • As a result of the October Revolution in 1917, Kandinsky becomes the director of the newly formed IZO (Department of Fine Arts): in that position, he organises the museum system of the new Russia. Also, the Svomas is founded (School of Free Art). Malevich paints *White Square on White Background*. Chagall is appointed director of the Academy of Vitebsk. The collections of Schukin and Morozov, dedicated chiefly to French contemporary painting, are nationalised. • Magritte moves to Brussels. • First manifesto of De Stijl. • First solo exhibition of Miró's work at the Dalmau gallery in Barcelona; Miró founds the Agrupació Courbet with other Catalan artists. • Giorgio de Chirico paints *The Disquieting Muses*.

1919

History	• In Paris, the peace conference at the end of World War I (Treaty of Versailles) establishes the creation of the League of Nations. With the signature of the Weimar Constitution, Germany becomes a Federal Republic. In Germany, during the repression of the revolt of the Spartacist Communists, Rosa Luxemburg and Karl Liebknecht are killed. • In Italy, Don Luigi Sturzo founds the Partito Popolare (Popular Party); Mussolini founds the movement of the Fasci Italiani di Combattimento (Fascists) in Milan. D'Annunzio occupies Fiume (Rijeka).
Science and Culture	• In Holland, the book *The Autumn of the Middle Ages* by Johan Huizinga is published. Carlo Carrà publishes *Pittura metafisica*. In Turin the newspaper *L'Ordine Nuovo* is published; among its founders is Antonio Gramsci. In Paris, the first issue of the magazine *Littérature* is published. Mayakovsky, Burlyuk and Kamensky publish the *Futurist Gazette*. • Giuseppe Ungaretti publishes *Allegria di naufragi*. Italo Svevo begins to write *The Conscience of Zeno*. Schwitters writes *To Anna Blume*. • Pierre-Auguste Renoir dies and Jacques Vaché commits suicide.
Art	• Miró goes to Paris, where he meets Picasso and Raynal. • In Berlin, Grosz and Heartfield found the magazine *Die Pleite* and, with Hausmann, the periodical *Der Dada*. In Cologne, Arp, Ernst, and Baargeld found Central W/3 and the first issue of the magazine *Der Ventilator* is published. Gropius founds the Bauhaus in Weimar. • In Moscow, the show opens titled *Tenth State Exhibition: Non-Objective Creativity and Suprematism*. Tatlin begins to design the *Monument to the Third International*. In Vitebsk, Malevich replaces Chagall as director of the Academy and founds the UNOVIS group. The Soviet state acquires twelve works by Chagall. • Mondrian paints his first diamond-shaped canvases and publishes in *De Stijl* the first part of his essay *Natural Reality and Abstract Reality*, which he continued in the subsequent eleven issues of the magazine. • First solo exhibition of Giorgio de Chirico at the Bragaglia gallery in Rome. The Grande Esposizione Nazionale Futurista travels to Milan, Florence and Naples.

Bibliography

Aesthetic Experimentation and Transformation of Artistic Language at the Dawn of the Twentieth Century

Symbolists and Nabis

Cogeval, G., *Vuillard: le temps détourne*, Paris 2003.

Cogeval, G., *Vuillard: Master of the Intimate Interior*, London 2002.

Delevoy, R. L., *Le Symbolisme*, Geneva 1982.

Dellanoy, A., Genty, G., de Bihan, R. (editors), *Da Pont Aven ai Nabis, le stagioni del simbolismo francese: Denis, Sérusier, Gauguin, Vallotton e gli altri*, Milan 1999.

Eckert Boyer, P., Prelinger, E., *The Nabis and the Parisian Avant-garde*, exhibition catalogue, London 1988.

Gamboni, D., *La plume et le pinceau, Odilon Redon et la littérature*, Paris 1989.

Gibson, M., *Odilon Redon (1840-1916): the prince of dreams*, Cologne 1999.

Jeancolas, C., *La peinture des Nabis*, Paris 2002.

Mazzocchi Doglio, M., *Teatro simbolista in Francia (1890-1896)*, Rome 1978.

Mathieu P.-L., *Gustave Moreau: monographie et nouveau catalogue de l'œuvre achevé*, Paris 1998.

Negri, R., *Bonnard e i Nabis*, Milan 1970.

Various Authors, *Artistes et théatres d'avantgarde: programmes de théatre illustrés, Paris 1890-1900*, Paris 1991–1992.

Various Authors, *Nabis: 1888-1900*, Munich 1993.

Various Authors, *Maurice Denis, 1870-1943*, Paris 1994.

Various Authors, *Il tempo dei Nabis*, Florence 1998.

Various Authors, *Puvis de Chavannes au Musée des Beaux Arts de Lyon*, RMN, Paris 1998.

Various Authors, *Symbolism in Danish and European Painting, 1870-1910*, Copenhagen 2000.

Various Authors, *E. Vuillard*, Montreal 2003.

Vialla, J., *Odilon Redon: sa vie, son œuvre*, Paris 2001.

Whitfield, S., Elderfiel, J., *Bonnard*, exhibition catalogue, edited by S. Whitfield, London 1998.

Munch's work is updated nicely in Italian with *Edvard Munch: dal realismo all'espressionismo*, exhibition catalogue, edited by M. Lange, S. Helliesen, Livorno 1999, and *Munch 1863-1944*, exhibition catalogue, edited by Ø. Storm Bjerke, A. Bonito Oliva, Milan 2005.

Post-Impressionists and Neo-Impressionists

Adler, K., *Pissarro in London*, London 2003.

Becks-Malorny, U., *Paul Cézanne, 1839-1906*, Taschen, Cologne 2002.

Benedetti, M.T., *Pissarro*, Florence 1998.

Bessonova, M. (editor), *Da Monet a Picasso: capolavori impressionisti e postimpressionisti dal Museo Puskin di Mosca*, Electa, Milan 1996.

Brettell, R.R., *Pissarro and Pontoise*, New Haven-London 1990.

Druick, D.W., Kort Zegers, P. (in collaboration with B. Salvesen, with contributions by K. Hoermann Lister and the assistance of M.C. Weaver), *Van Gogh and Gauguin: the Studio of the South*, The Art Institute of Chicago, Chicago 2001.

Franz, E. (editor), *Signac et la libération de la couleur: de Matisse à Mondrian*, Paris 1997.

Ishaghpour, Y., *Seurat: la pureté de l'élément spectral*, Paris 1991.

Ives, C., Stein, S.A., *The Lure of the Exotic: Gauguin in New York Collections*, The Metropolitan Museum of Art–Yale University Press, New York–New Haven 2002.

Leighton, J., Thomson, R., *Seurat and the Bathers*, exhibition catalogue, with contributions by D. Bomford, J. Kirby, A. Roy, London 1997.

McQuillan, M., *Van Gogh*, Geneva 2002.

Pickvance, R., *Van Gogh*, Martigny 2000.

Pissarro, J., Rachum, S., *Camille Pissaro: Impressionist Innovator*, Jerusalem 1994.

Rasponi, S., *Pissarro*, Milan 1990.

Shiff, R., *Cézanne et la fin de l'Impressionnisme: étude sur la théorie, la technique et l'évaluation critique de l'art moderne*, Paris 1995.

Smith, P., *Seurat and the avant-garde*, New Haven 1997.

Thomson, R., *Seurat*, Oxford–New York 1990.

Various Authors, *Camille Pissaro*, exhibition catalogue, Ferrara 1998.

Various Authors, *Cézanne: Finished, Unfinished*, Vienna 2000.

Various Authors, *Signac, 1863-1935*, exhibition catalogue, Paris 2001.

Various Authors, *Gauguin e la Bretagna*, Skira, Milan 2003.

Various Authors, *Paul Signac*, exhibition catalogue, Martigny 2003.

Walther, I.F., *Vincent Van Gogh, 1853-1890: visione e realtà*, Cologne 2001.

The Eccentric Vision of Modernism

Barcelona

Bohigas, O., *Architettura modernista: Gaudi e il movimento catalano*, Einaudi, Turin 1969.

Cirici, A., *Mirò Mirall*, Ediciones Poligrafa, Barcelona 1985.

Escudero, C., Montaner, T., *Joan Miró 1893-1993*, Leonardo Arte, Milan 1993.

Lahuerta, J.J., *Antoni Gaudi 1852-1926 architettura, ideologia e politica*, Electa, Milan 1992.

Rubin, W., *Picasso et le portrait*, Réunion des Musées Nationaux-Flammarion, Paris 1996.

Various Authors, *Homage to Barcelona: the City and Its Art 1888-1936*, Thames and Hudson, London 1986.

Various Authors, *Picasso, jeunesse et genese: dessin 1893-1905*, Réunion des Musées Nationaux-Flammarion, Paris 1991.

Various Authors, *Joan Miró catalogue raisonné: Paintings – Vol. I, 1908-1930*, Successio Miró, D. Lelong, Paris 1999.

Various Authors, *Picasso total: 1881-1973*, Ediciones Poligrafa, Barcelona 2000.

Various Authors, *Ramon Casas: el pintor del modernismo*, Museu Nacional d'Art de Catalunya and Fundacion Cultural Mapfre Vida, Barcelona, 2001.

Warncke, C.P., *Pablo Picasso: 1881-1973*, Taschen, Cologne 2000.

The Rigorous and Geometrical Line of Modernist Culture

Munich

Alexej von Jawlensky, exhibition catalogue, edited by R. Chiappini, A. Bianconi Jawlensky, L. Pieroni Jawlensky, Milan 1995.

Arnold Böcklin, exhibition catalogue, Heidelberg 2001.

Arnold Böcklin, 1827-1901, exhibition catalogue, edited by K. Schmidt, B. Lindemann, C. Lenz, Paris 2001.

De Chirico, G., *Memorie della mia vita*, (1962, Milan), Milan 2002.

Duchting, H., *Wassily Kandinsky, 1866-1944: la rivoluzione della pittura*, Cologne 2001.

Fäthke, B., *Marianne Werefkin: vita e opere: 1860-1938*, Ascona 1988.

Gustav, J., *August Macke*, Paris 1990.

Parmiggiani, S. (editor), *Marianne Werefkin: il fervore della visione*, Milan 2001.

Pellettier, N., Merlio, G., *Munich 1900 site de la modernité*, Bern 1998.

Pontiggia, E. (editor), *Franz Marc, la seconda vista*, Milan 1999.

Sembach, K.-J., *Jugendstil: l'utopia dell'armonia*, Cologne 1991.

Sternberger, D., *Jugendstil*, Bologna 1994.

Various Authors, *I Deutsch-Römer: il mito dell'Italia negli artisti tedeschi, 1850-1900*, Milan 1988.

Various Authors, *Marianne Werefkin*, Munich 1988.

Various Authors, *Franz von Stuck e l'Accademia di Monaco: da Kandinsky ad Albers*, Milan 1990.

Various Authors, *Arnold Böcklin, Giorgio de Chirico, Max Ernst: eine Reise ins Ungewisse*, exhibition catalogue, Bern 1997.

Various Authors, *Wassily Kandinsky: tra Monaco e Mosca, 1896-1921*, Milan 2000.

Various Authors, *Wassily Kandinsky (1866-1944)*, Milan 2001.

Various Authors, *The Spritual Landscape*, Venice 2003.

Various Authors, *Jawlensky: meine liebe Galka*, Wiesbaden 2004.

Von Holst, C. et al., *Franz Marc*, Ostfildern 2000.

Concerning the **Blue Reiter**

Il Cavaliere Azzurro, edited by L. Carluccio, Turin 1971; one interesting source is V. Kandinsky, *Il Cavaliere azzurro: Burliuk, Macke, Schönberg, Allard, von Hartmann, von Busse, Sabaneev, Kulbin*, Bari 1967; for more recent considerations in Italian, see *Kandinsky Vrubel' Jawlensky e gli artisti russi a Genova e nelle riviere: passaggio in Liguria*, exhibition catalogue (Genoa, 2001-2002) edited by Franco Ragazzi, Milan 2001; *Blaue Reiter und seine Künstler*, exhibition catalogue (Berlin-Tübingen, 1998–99), edited by M.M. Moeller, Munich 1998; *The Blaue Reiter in the Lenbachhaus of Munich*, edited by A. Zweite, Munich 1989.

Concerning **Kandinsky**: *Wassily Kandinsky: tradizione e astrazione in Russia 1896-1921*, exhibition catalogue (Milan, 2001), Milan 2001; *Kandinskij. Collection du Musée national d'art moderne*, edited by C. Derouet and J. Boissel, Paris 1984; M. Volpi Orlandini, *Kandinskij dall'Art Nouveau alla psicologia della forma*, Rome 1968.

Concerning **Kandinsky and other artists**: *Kandinsky, Chagall, Malevich e lo spiritualismo russo*, exhibition catalogue (Verona, 2000–2001) edited by G. Cortenova and Y. Petrova, Milan 1999; *Blue Four. Feininger, Jawlensky, Kandinsky, and Klee in the new world*, exhibition catalogue (Bern-Düsseldorf, 1998), Cologne 1997; *Franz Marc: dal pensiero alla forma*, edited by J. Nigro Covre, Turin 1971; *Alexej von Jawlensky*, exhibition catalogue (Milan, 1995), Milan 1989; among the works in German on **Münter** we should mention *Gabriele Münter: Eine Malerin des Blauen Reiters*, exhibition catalogue (Bietingheim-Bissingen, 1999), Ostfildern 1999; in Italian on **Kubin** we recommend highly A. Nigro, *Alfred Kubin, profeta del tramonto*, Rome 1983 and *Alfred Kubin, 1877-1959: 100 opere dall'Albertina di Vienna*, edited by E. Mitsch, Milan 1988.

For **Klee,** there is the recent and thorough *Paul Klee*, exhibition catalogue (Verona, 1992), Milan 1992, to be accompanied by M. Dantini, *La cameretta dei bambini: Paul Klee critico d'arte 1912-1913*, in *Prospettiva*, 81, 1996, pp. 56–63.

On **Prague**: Quattrocchi L., *La Secessione a Praga*, L'Editore, Trento 1990.

Concerning **Kupka**, readily available for the Italian reader is M. Rowell, *Kupka*, Modena 1969.

On **Austrian Expressionism**: *Klimt, Kokoschka, Schiele: dall'art nouveau all'espressionismo*, exhibition catalogue, edited by J. Kallir, Milan 2001; *Egon Schiele e l'Espressionismo in Austria (1908-1925)*, exhibition catalogue, Milan 2001; *Oskar Kokoshka*, exhibition catalogue, edited by K.A. Schröder, J. Winkler, Vienna 1991.

For the work of other members: *Kokoschka, Kollwitz, Kubin: tre aspetti dell'Espressionismo*, exhibition catalogue, Rome 2001; *Ludwig Meidner, Zeichner, Maler, Literat, 1884-1966*, exhibition catalogue, edited by G. Breuer, I. Wagemann, Darmstadt 1991.

Art Nouveau and the Parisian Crucible of the Avant-gardes

Brussels

M. Cohen, *Bruxelles: art nouveau*, Milan 1994; F. Borsi, H. Wieser, *Bruxelles capitale de l'Art Nouveau*, Brussels 1992; A.M. Damigella, *La natura, l'uomo, il mito nell'immaginario dei simbolisti*, Rome 2004. One interesting chapter is the one on Belgium in *Art Nouveau 1890-1914*, exhibition catalogue (London–Washington, 2000) edited by P. Greenhalgh, London 2000: *Belgium. The Golden Decades 1890-1914*, edited by J. Block, New York-Bern-Frankfurt am Main-Vienna-Paris 1997; F. Dierkens-Aubry, J. Vandenbreeden, *Art Nouveau en Belgique: architecture et intérieurs*, Brussels 1994 (English ed., Louvain-le-Neuve 1991); P. Loze, *Belgique et Art Nouveau: de Victor Horta à Antoine Pompe*, Brussels 1991; *Paris-Bruxelles, Bruxelles-Paris: réalisme, impressionisme, symbolisme, art nouveau: les relations artistiques entre la France et la Belgique, 1848-1914*, exhibition catalogue, edited by A. Pingeot, R. Hooze, Paris-Antwerp 1997.

Concerning **Horta**: *Victor Horta: architetto e designer; opere dal Musée Horta di Bruxelles*, edited by A.M. Fioravanti Baraldi, Ferrara 1991; *Horta: naissance et dépassement de l'Art Nouveau*, exhibition catalogue (Brussels, 1996–97) edited by F. Aubry and J. Vandenbreeden, Ghent 1996.

Concerning **Van de Velde**, the most recent contribution in Italian is F. Borsi, *Van de Velde e l'architettura*, in *Palladio*, 14, 1994, pp. 245–50. In other languages: *Henry van de Velde: ein europäischer Künstler in seiner Zeit*, exhibition catalogue (Hagen, 1992) edited by K. Sembach and B. Schulte, Cologne 1992; L. Ploegaerts, P. Puttemans, *L'oeuvre architectural de Henry van de Velde*, Paris 1990.

On the **other figures** we would also mention: *Splendeurs de l'idéal: Rops, Khnopff, Delville et leur temps*, exhibition catalogue (Lieges, 1996) edited by M. Draguet, Ghent 1996; *Fernand Khnopff*, exhibition catalogue (Brussels, 2004) edited by F. Leen, Brussels 2004; M.L. Frongia, *Il simbolismo di Jean Delville*, Bologna 1978; R. Watson, *Bing. Art Nouveau and Book in the Late Nineteenth Century*, in *Apollo*, 151, 2000, pp. 32–40; *Théo van Rysselberghe néo-impressioniste*, exhibition catalogue (Ghent, 1993), Antwerp 1993 (in English); *Dix ans d'Art Nouveau. Paul Hankar architecte*, Brussels 1992 (in French and in English); *George Minne en de kunst rond 1900*, exhibition catalogue (Ghent, 1982), Ghent 1982.

Paris 1900–1910

Lemoine, S. (editor), *Da Puvis de Chavannes a Matisse, a Picasso: verso l'arte moderna*, Venice 2002.

Concerning **Le Douanier Rousseau**, the catalogue raisonné of his works was published in 1970, in French, along with a rich array of documentation (D. Vallier, *Tout l'ouvre peint del Henri Rousseau. Documentation et catalogue raisonné*, Paris 1970). A readily available popularising instrument is certainly the handy monographic volume from Taschen, edited by Cornelia Stabenow (C. Stabenow, *Henri Rousseau 1844 – 1910*, Taschen, Cologne 1992). Concerning the historic monographs, we should at least mention the pioneering volumes by Uhde (W. Uhde, *Henri Rousseau*, Paris 1911), Vallier (D. Vallier, *Henri Rousseau*, Cologne 1961), and André Salmon (A. Salmon, *Henri Rousseau*, Paris 1962).

The Meteor of Fauvism

G. Duthuit, *Le Fauvisme*, Paris 1929–1931; G. Diehl, *Les Fauves*, Paris 1943; A. Salmon, *Le fauvisme*, Paris 1956. Of great historical importance was also the catalogue of the exhibition held at MoMA in New York in 1952: J. Rewald, *Les Fauves*, The Museum of Modern Art, New York 1952. As far as the writings of the artists are concerned, we should at least mention H. Matisse, 'Notes d'un peintre', in *La Grande Revue*, 25 December 1908 and A. Derain, *Lettres à Vlaminck*, Paris 1955. For the Italian reader, the best overall views still remain U. Apollonio, *Fauves e Cubisti*, Bergamo 1959 and J. Leymarie, *Secessioni, espressionismo, fauvismo*, Fabbri Editore, Milan 1967. We should also mention, also by Jean Leymarie, *Le fauvisme*, Geneva 1959 and J.P. Crespelle, *Fauves*, 1962.

Concerning **Matisse**, we would recommend a number of historic texts, such as M. Sembat, *Henri Matisse*, Paris 1920; G. Scheiwiller, *Henri Matisse*, Hoepli, Milan 1939; L. Aragon, *Matisse*, Geneva 1948; the monumental catalogue prepared by Barr for the exhibition at MoMA: A.H. Barr, *Matisse, His Art and His Public*, The Museum of Modern Art, New York, 1951. Among the more recent writings, we should cite R. Negri, *Matisse e i Fauves*, Milan 1967; E. Faure, J. Romains, C. Vidrac, L. Werth, *Henri Matisse*, Crés, Paris 1970; I.M. Fontaine, *Matisse. Œuvres de Henry Matisse (1869 – 1954)*, exhibition catalogue (Paris, 1980), Paris 1980; P. Schneider, *Matisse*, Milan 1985; J. Flam, *Matisse: the Man and His Art 1869 – 1918*, Thames and Hudson, London 1986. Finally, particularly useful for the lavish array of illustrations and for the tight comparison that it makes between the two great artists of the twentieth century, E. Cowling (editor), *Matisse Picasso*, exhibition catalogue (London, 2002), London 2002.

For **Derain**: D.H. Kahnweiler, *André Derain*, Leipzig 1920; A. Salmon, *André Derain*, Paris 1929; J. Leymarie, *Derain*, Geneva 1948; D. Sutton, *Derain*, London 1959; G. Diehl, *Derain*, Paris 1964.

Concerning **Dufy**, we recommend: C. Zervos, *Raoul Dufy*, Paris 1928; J. Cocteau, *Dufy*, Paris 1948; R. Cogniat, *Roul Dufy*, Milan 1962.

For **Friesz**, we should at least cite A. Salmon, *E. O. Friesz*, Paris 1920.

For **Van Dongen**, E. Des Courrières, *Van*

Dongen, Paris 1925 and L. Chaumeil, *Van Dongen*, Geneva 1967.

For **De Vlaminck**, D.H. Kahnweiler, *M. De Vlaminck*, Leipzig 1920 and J. Selz, *Vlaminck*, Vallardi, Milan 1963.

The Poetics of Cubism

A. Gleizes, J. Metzinger, *Du Cubisme*, Paris 1912, the theoretical manifesto of "minor" Cubism; G. Apollinaire, *Méditations esthétiques. Les peintres cubistes*, Paris 1913 (Italian trans. *I pittori cubisti. Meditazioni estetiche*, Il Balcone, Milan 1945), which collects that the great poet devoted to the artists of the movement; and R. Delaunay, *Du Cubisme a l'art abstrait, Documents inédits publiés par Pierre Francastel*, Paris 1957.

Concerning the historic monographs: G.C. Argan, *Il cubismo*, Rome 1948 and G. Habasque, *Le cubisme*, Skira, Geneva 1959. Sources that are even today unrivalled are the great studies of the Sixties: R. Rosenblum, *Cubism and Twentieth Century Art*, Stuttgart 1960 (Italian translation: *La storia del cubismo e l'arte del ventesimo secolo*, Il Saggiatore, Milan 1962); J. Golding, *Cubism: An History and an Analysis 1907 – 1914*, 1959 (Italian translation: *Storia del cubismo (1907 – 1914)*, Einaudi, Turin 1963; P. Cabanne, *L'epopee du cubisme*, Le Table Ronde, Paris 1963; E.F. Fry, *Cubism*, Verlag M. DuMont Schauberg, Cologne 1966 (Italian translation: *Cubismo*, Gabriele Mazzotta, Milan 1967 [also useful because of the rich anthology of texts from the Cubist era]); and, for the Italian reader, F. Mathey, *Le strutture del reale nella visione cubista*, in *L'arte moderna*, IV, Fabbri Editore, Milan 1967.

Recent texts: D. Cooper, *The Cubist Epoch*, Phaidon Press, London 1970; D. Cooper, *The Essential Cubism: Braque, Picasso & Their Friends 1907 – 1920*, Tate Gallery, London 1983; N. Barbier, *Il cubismo nella scultura*, exhibition catalogue (Lugano, 1988), Electa, Milan 1988; W. Rubin, *Picasso and Braque: The Invention of Cubism*, The Museum of Modern Art, New York 1989; D. Cottington, *Cubism in the Shadow of War: the Avant-Garde and Politics in Paris 1905 – 1914*, Yale University Press, New Haven-London 1998; and the recent N. Cox, *Cubism*, Phaidon Press, London 2000.

Concerning **Picasso**: C. Zervos, *Picasso, Cahiers d'Art*, Paris 1932–1978, 34 volumes; the writings of Gertrude Stein, in particular G. Stein, *Picasso*, Paris 1938; H. H. Barr, Jr, *Picasso, Fifty Years of His Art*, New York 1946. For further information: P. Daix, G. Boudaille, *The Blue and Rose Periods. A Catalogue Raisonné*, 1900–1906, London-New York 1966. Among the more recent texts, we should mention R. Penrose, *La Vie et l'œuvre de Picasso*, Paris 1961 (Italian translation: *Pablo Picasso: la vita e l'opera*, Turin 1969), J. Golding, R. Penrose, *Picasso 1881 – 1973*, London-New York 1973, and P. Daix, *Journal du Cubisme*, Geneva 1982; Various Authors, *The Ultimate Picasso*, Harry N. Abrams, New York 2000; Cowling, E. et al., *Matisse, Picasso*, Paris 2002. Readily available and useful for a first study of Picasso's work is

the recent book, I. F. Walther, *Pablo Picasso 1881-1973. Il genio del secolo*, Taschen, Cologne 1999.

Concerning **Braque**, we should first of all cite the *Diaries*, written later but capable of illuminating aspects of his Cubist phase. Among the historic monographs: R. Bissière, *Georges Braque*, Paris 1920; S. Fumet, *Braque*, Paris 1945; D. Cooper, *Braque, Paintings 1909 – 1947*, London 1948; J. Richardson, *Braque*, Milan 1960; J. Leymarie, *Braque*, Geneva 1961; and, for the Italian reader, U. Apollonio, *Georges Braque*, Paris 1966 and L. Vinca Masini, *Braque*, Florence 1969. Among the more recent texts: D. Cooper, *Braque, The Great Years*, Chicago 1972; the fundamental M. Carrà, P. Descargues, *Tout l'oeuvre peint de Braque: 1908 – 1929*, Paris 1973; J.L. Prat, *Georges Braque*, Martigny 1992; J. Nigro Covre, *Braque*, Giunti, Florence 1994.

From Secessions to Expressionismus

German Expressionism

In Italian, an excellent general source remains W.D. Dube, *L'espressionismo*, Milan 1979, with good biographies of the main artists. More up-to-date are the texts: *L'espressionismo: presenza della pittura in Germania 1900-2000*, Milan 2001; *Brücke, la nascita dell'espressionismo*, exhibition catalogue, Milan 1999; *Espressionismo tedesco: arte e società*, exhibition catalogue, edited by S. Barron and W.-D. Dube, Milan 1997; *Da Van Gogh a Schiele. L'Europa espressionista 1880-1918*, exhibition catalogue, Milan 1989.

For the **architecture** and the **cinema**: *1910 Halbzeit der Moderne: Van de Velde, Behrens, Hoffmann und die anderen*, exhibition catalogue, Stuttgart 1992; B. Zevi, *Mendelsohn. Opera completa*, Milan 1970; R. Kurz, *L'espressionismo e i film*, Milan 1981.

On **Kirchner**, in Italian: *Ernst Ludwig Kirchner*, exhibition catalogue, edited by M. Moeller, R. Scotti, Milan 2002; *Ernst Kirchner*, exhibition catalogue, edited by R. Chiappini, Milan 2000.

From Scapigliatura to Futurism

Calvesi, M., Coen, E., *Boccioni*, Milan 1983.
Cavallo, L., Squarotti, G.B. (editor), *Ardengo Soffici*, Milan 1992.
Coffin Hanson A., *Severini Futurista 1912 – 1917*, exhibition catalogue, New Haven 1995.
Crispolti, E. (editor), *Giacomo Balla*, Turin 1968.
Crispolti, E. (editor), *Casa Balla e il futurismo a Roma*, Rome 1989.
Crispolti, E., Sborgi, F. (editor), *Futurismo: i grandi temi, 1909-1944*, Milan 1997.
De Marchis, G., *Giacomo Balla, l'aura futurista*, Turin 1977.
De Maria, L., Dondi, L. (editor), *Marinetti e i futuristi*, Milan 1994.
Fagiolo dell'Arco, M. (editor), *Balla pre-futurista*, Rome 1968.
Fagone, V. (editor), *Carlo Carrà: la matita e il pennello*, Milan 1996.

Fonti D. (editor), *Gino Severini. Catalogo ragionato*, catalogue raisonné, Milan 1988.
Gian Ferrari, C. (editor), *Sironi 1885-1961*, Milan 1985.
Grisi F. (editor), *I futuristi: i manifesti, la poesia, le parole in libertà, i disegni e le fotografie di un movimento "rivoluzionario," che fu l'unica avanguardia italiana della cultura europea*, Rome 1990.
Hulten, P. (editor), *Futurismo & futurismi*, Milan 1986.
Maffina, G.F., *Luigi Russolo e l'arte dei rumori: con tutti gli scritti musicali*, Turin 1978.
Martin, M.W., *Futurist Art and Theory 1909-1915*, Oxford 1968.
Masoero, A., Miracco, R. (editor), *Futurismo 1909-1926: la bellezza della velocità*, Milan 2003.
Monferini, A. (editor), *Carlo Carrà (1881-1966)*, Milan 1994.
Salaris, C., *Dizionario del Futurismo: idee provocazioni e parole d'ordine di una grande avanguardia*, Rome 1996.
Santini P.C., Ragghianti C.L. (editor), *Ottone Rosai: opere dal 1911 al 1957*, Florence 1983.
Schiaffini, I., *Umberto Boccioni: stati d'animo teoria e pittura*, Cinisello Balsamo 2002.
Severini G., *La vita di un pittore*, Milan 1983.
Tisdall C., Bozzolla, A., *Futurismo*, Milan 1988.
Various Authors, *Nuove tendenze: Milano e l'altro Futurismo*, Milan 1980.
Various Authors, *Boccioni a Milano*, Milan 1982.
Various Authors, *Futurismo a Firenze 1910-1920*, Florence 1984.
Various Authors, *Mario Sironi 1885-1961*, Milan 1993.
Various Authors, *Futurismo: dall'avanguardia alla memoria*, Atti del convegno internazionale di studi sugli archivi futuristi, Milan 2004.
Verzotti, G., *Boccioni: catalogo completo dei dipinti*, Florence 1989.

Turin and Milan during Liberty, Milan and Rome in the Pre-Futurist Era

Bossaglia, R., *Il liberty in Italia*, Charta, Milan 1997.
Bossaglia, R., Terraroli, V., *Il liberty a Milano*, Skira, Milan 2003.
Fanelli, G., *Il disegno Liberty*, Laterza, Bari 1983.
Gordon, D.E., *Modern Art Exhibitions 1900-1916*, Prestel, Munich 1974.
Various Authors, *Torino 1902 – Esposizione Internazionale*, Fabbri Editore, Milan 1994.
Various Authors, *Da Segantini a Balla: un viaggio nella luce*, Elede, Turin 1999.
Various Authors, *Gaetano Previati 1852-1920: un protagonista del simbolismo europeo*, Electa, Milan 1999.

The Fusion of the New Languages

Russia 1910–1919

Arte russa e sovietica 1870-1930, exhibition catalogue (Milan, 1989) edited by G. Caradente, Milan 1989, to which we should add: *Arte russa e sovietica nelle raccolte italiane*, exhibition catalogue (Modena, 1993) edited by G. Di Milia, Bologna 1993;

L.P. Finizio, *L'astrattismo costruttivo: supre-matismo e costruttivismo*, Rome-Bari 1990; *Le avanguardie artistiche in Russia. Teorie e poetiche dal cubo-futurismo al costrut-tivismo*, edited by M. Böhming, Bari 1979. Available in French, the recent: P. Sers, *Totalitarisme et avant-gardes: au seuil de la transcendance*, Paris 2001.

For the main artists, the reader should turn to the recent *Kandinsky, Chagall, Malevich e lo spiritualismo russo*, exhibition cata-logue (Verona, 2000-2001) edited by G. Cortenova and Y. Petrova, Milan 1999, to which we may add more specific texts: L.S. Boersma, *0.10. The Last Futurist Ex-hibition of Paintings*, Rotterdam 1994; *Pavel Filonov*, exhibition catalogue (Leningrad, 1988) edited by E.F. Kovtun, 1988; S. Lisitskij-Küppers, *El Lisitskij. Pit-tore architetto tipografo fotografo*, Rome 1967; *Cari compagni posteri: Vladimir Ma-jakovskij 1893-1993*, exhibition catalogue (Bologna, 1993–1994) edited by E. Bal-lardini, A. Campagna, and D. Colombo, Bologna 1993.

Concerning **Malevich** and Suprematism, readily available in Italian are: *Kazimir Malevich e le sacre icone russe: avanguardia e tradizioni*, exhibition catalogue (Verona, 2000) edited by G. Cortenova, E. Petro-va, Milan 2000; *Kazimir Malevich. Una re-trospettiva*, exhibition catalogue (Florence, 1993), Florence 1993. A more detailed ex-ploration in A. Shatzkikh, *Malevich and Film*, in *The Burlington Magazine*, 1084, 1993, pp. 470–8.

Concerning **Tatlin**, **Larionov**, and **Gon-charova**: *Vladimir Tatlin. Retrospektive*, exhibition catalogue (Düsseldorf, 1993) edited by A. Strigalev and J. Harten, Cologne 1993; A. Kowaljow, *Larionow und Tatlin*, Cologne 1993, both in German; *Goncharova e Larionov*, exhibition cata-logue (Paris–Martigny–Milan, 1995–1996), 1995.

The Experiences of Abstraction

De Stijl

L.P. Finizio, *Dal neoplasticismo all'arte conc-reta: 1917-1937*, Rome 1993; *De Stijl. Nasci-ta di un movimento*, edited by C. Blotkamp, Milan 1989, with thorough treatments of the individual members of the movement; H.L.C. Jaffé, *Per un'arte nuova. De Stijl, 1917-1931*, Milan 1964. In other languages: P. Overy, *De Stijl*, London 1991; *De Stijl, 1917-1931: Visions of Utopia*, edited by H.L.C. Jaffé, Minneapolis 1983.

Concerning **neo-Plastic architecture**: B. Ze-vi, *Poetica dell'architettura neo-plastica*, Turin 1974; *De Stijl. Neo-Plasticism in ar-chitecture*, edited by C. Boekraad, Delft 1983; *Cornelis van Eesteren: Urbanismus zwischen "de Stijl" und C.I.A.M.*, edited by F. Bollerey, Braunschweig 1999.

On the origins of **Dutch Abstractism** and the members of the movement: *The Spir-itual in Art. Abstract Painting 1890-1985*, exhibition catalogue, New York 1986; *Ver-so l'astrattismo: Mondrian e la Scuola del-l'Aia*, exhibition catalogue, Florence 1981; *Line + movement: Mondrian, van Does-burg, van der Leck, Vantongerloo, Vordem-berge-Gildewart, Domela, and Moholy-Nagy*, exhibition catalogue, London 1979.

Concerning **Mondrian**'s work, the most re-cent contribution in Italian is *Mondrian e De Stijl*, exhibition catalogue, edited by G. Celant and M. Govan, Milan 1990. You may also want to consult: J. Nigro Covre, *Mondrian, composizione ovale con alberi*, Turin 1990; C.L. Ragghianti, *Mondrian e l'arte del XX secolo*, Milan 1962. In French, there is the very recent *Mondrian de 1892 à 1914: les chemins de l'abstraction*, exhi-bition catalogue, edited by H. Janssen and J.M. Joosten, Paris 2002.

Concerning Mondrian and his relationship with Cubism, we will cite only the mono-graphic work by Menna (F. Menna, *Mon-drian*, Rome 1962) and the text by Le Bot (M. Le Bot, *Mondrian et le cubisme*, in Various Authors, *Le Cubisme*, Saint-Eti-enne 1973).

For **Van Doesburg**: T. van Doesburg, *Scrit-ti di arte e di architettura*, edited by S. Polano, Rome 1979, important for his the-oretical work. *Theo van Doesburg. Peinture, architecture, théorie*, edited by S. Lemoine, Paris 1990; E. van Straaten, *Theo van Does-burg. Painter and architect*, The Hague 1988; A. Doig, *Theo Van Doesburg: Paint-ing into Architecture, Theory into Practice*, New York 1986.

**The Semantic Revolution
of the Avant-gardes**

Metaphysics

U. Apollonio, *Pittura metafisica*, Venice 1950 and M. Valsecchi, *La pittura metafisica moderna*, Venice 1958; M. Carrà, P. Wald-berg, E. Rathke, *Metafisica*, Milan 1968. Alongside a number of exhibition cata-logues focusing on Metaphysics taken as a whole, or a specific moment of it, such as M. Calvesi, E. Coen, G. dalla Chiesa (editor), *La metafisica. Museo documen-tario*, museum catalogue, Ferrara 1981; G. Briganti, E. Coen, A. Orsini Baroni (edi-tor), *La pittura metafisica*, exhibition cat-alogue, Venice 1979; R. Barilli, F. Solmi, *La metafisica. Gli anni Venti*, exhibition cat-alogue, Bologna 1980, and a number of critical studies such as P. Fossati, *Valori Plastici 1918-1922*, Turin 1981; M. Calvesi, *La metafisica schiarita*, Milan 1983; F. Poli, *La metafisica*, Rome-Bari 1989.

Concerning **De Chirico's writings** up to 1943 edited by Maurizio Fagiolo dell'Arco: G. de Chirico, *Il meccanismo del pensiero. Critica, polemica, autobiografia. 1911-1943*, edited by M. Fagiolo dell'Arco, Turin 1985 and G. de Chirico, *Memorie della mia vi-ta*, (1945, Milan), Milan 1998.

Concerning the **critical literature**, we should begin by mentioning, first of all, a number of foundations of the criticism on De Chiri-co: R. Vitrac, *Georges de Chirico et son oeuvre*, Paris 1927; J. Cocteau, *Le Mystère Laic*, Paris 1928 (which focuses on the lat-er de Chirico, so hated by the Surrealists, but also contains interesting observations on his earlier work); R. Carrieri, *Giorgio De Chirico*, Milan 1942; C. Ragghianti, *Il primo De Chirico*, Venice 1949; P. Fossati, *La pittura a programma. De Chirico metafisico*, Venice 1973. A number of pop-ularising works (M. Fagiolo dell'Arco, *L'-opera completa di de Chirico 1908-1924*, Milan 1984; P. Gimferrer, *De Chirico 1888-1978. Opere scelte*, Milan 1988), or works that are popularising as well as hagio-graphic, such as the fine monograph edit-ed by his wife, quite well informed even if set within the strategy of self-celebration that had already been instituted by the couple during his life: I. Far de Chirico, D. Porzio (editor), *Conoscere de Chirico. La vita e l'opera dell'inventore della pittura metafisica*, Milan 1979. We should also mention a number of the catalogues of the major exhibitions held in the years imme-diately following the artist's death: P. Vi-varelli (editor), *Giorgio de Chirico 1888-1978*, 2 volumes, Rome 1981; M. Fagiolo dell'Arco (editor), *Giorgio de Chirico. Il tempo di Apollinaire. Paris 1911-1915*, Rome 1981; M. Calvesi (editor), *De Chiri-co nel centenario della nascita*, Milan-Rome 1988.

Concerning **Carrà**, aside from the funda-mental reference to the general catalogue of his body of paintings, edited by his son Massimo (M. Carrà, *Carlo Carrà. Tutta l'-opera pittorica*, 3 volumes, Milan 1967–1968), we should at least mention: M. Carrà, G.A. dell'Acqua (editor), *Car-rà*, anthological exhibition catalogue, Mi-lan 1987; M. Carrà, P. Bigongiari, *Carrà 1910-1930*, in *Classici dell'Arte*, Milan 1970, readily available and accessible. C. Carrà, *La mia vita*, (1943, Rome) Milan 1981; C. Carrà, *Tutti gli scritti*, Milan 1978.

Concerning the Metaphysical work of **De Pisis**, we should at least mention C. Gian Ferrari (editor), *De Pisis*, exhibition cata-logue, Milan 1986; E. Pontiggia (editor), *De Pisis*, exhibition catalogue, Milan 1985.

Concerning **Morandi**, it can suffice in this context to cite the general catalogue, re-ferring the reader to the volume on the 1920s and 1930s for a more complete bib-liography: L. Vitali (*Morandi. Catalogo gen-erale*, Milan 1977, 2 volumes.

The same thing can be said for **Sironi** and **Casorati**, figures who were marginal to Metaphysics but who would prove to be fundamental in the context of the events of the decades that immediately followed: for the former, we shall cite only C. Gian Ferrari (editor), *Sironi 1885-1961. Mostra antologica*, exhibition catalogue, Milan 1985; F. Benzi (editor), *Mario Sironi*, ex-hibition catalogue, Milan 1993; as for the latter, we would mention the fundamen-tal monographic work of Luigi Carluccio (L. Carluccio, *Casorati*, Turin 1964) as well as the catalogue raisonné of the oeuvre, edited by Francesco Poli and Giorgina Bertolino: F. Poli, G. Bertolino, *Catalogo generale delle opere di Felice Casorati–i dip-inti 1904-1963*, Turin 1995.

Paris 1910–1919

Concerning the **Avant-garde** in general: B. Alshuser, *The Avant-garde in Exhibition: New Art in the 20th Century*, New York 1994, and J. Weiss, *The Popular Culture of Modern Art. Picasso, Duchamp and Avant-Gardism*, New Haven-London 1994. The issue of Primitivism is analysed thorough-ly by Colin Rhodes in: C. Rhodes, *Primi-*

tivism and Modern Art, London 1994, and by Charles Harrison in: C. Harrison et al., *Primitivism, Cubism, Abstraction: the Early Twentieth Century*, London 1993; from Linda Henderson instead we have an in-depth study of the theoretical background of Cubism and Orphism: L. Dalrymple Henderson, *The Fourth Dimension and Non-Euclidean Geometry in Modern Art*, Princeton 1983. For anyone who might be interested in exploring in greater depth the story of the Ruche, the large collective atelier of Montparnasse, we would cite J. Chapiro, *La Ruche*, Paris 1980 and J. Warnod, *La Ruche et Montparnasse*, Paris 1978. Finally, useful because of its informal character, is D. Valler, *L'interieur de l'Art: entretiens avec Braque, Léger, Villon, Miró, Brancusi (1954 – 1960)*, Paris 1982, in which the author has collected the results of her very useful conversations with the protagonists of the avante-garde.

Concerning **Cubism**, and its development as a movement, we should mention, alongside the texts cited above: D. Cooper, *The Cubist Epoch*, London 1970; D. Cooper, G. Tinterow, *The Essential Cubism: Braque, Picasso and Their Friends*, exhibition catalogue, Tate Gallery, London 1983; D. Cottington, *Cubism*, London 1998; L. Gamwell, *Cubist Criticism*, Ann Arbor 1980; Various Authors, *Cubism and La Section d'Or*, exhibition catalogue, Phillips Collection, Washington, D.C. 1991. The relationship between Cubism and architecture has been carefully studied by Eva Blau and Nancy Troy in E. Blau, N.J. Troy (editors), *Architecture and Cubism*, Cambridge (Mass.) 1997. Unfortunately there is no complete Italian translation of the text of Ozenfant and Jeanneret, a theoretical pillar of Purism: A. Ozenfant, P.É. Jeanneret, *Aprés le Cubisme*, Paris 1918.

Dating back to the 1970s is the catalogue raisonné, in French, of the work of **Juan Gris**: D. Cooper, M. Potter, *Juan Gris: catalogue raisonné de l'œuvre peint*, Paris 1977, 2 volumes. Among the numerous catalogues, we should at least mention J.T. Soby, *Juan Gris*, The Museum of Modern Art, New York 1958 and C. Green, *Juan Gris*, Whitechapel Art Gallery, London 1992; *Juan Gris*, exhibition catalogue (Madrid, Centro Reina Sofía de Arte Contemporanea), 2 volumes, Madrid 2001. Of fundamental importance, in part because of its documentary nature, is the monograph on him by his art dealer (and friend) Kahnweiler: D.-H. Kahnweiler, *Juan Gris*, Leipzig-Berlin 1929. A useful popularising tool was, instead, the monograph, translated into Italian, by Gaya Nuño: J.A. Gaya Nuño, *Juan Gris*, Barcelona 1985 (Italian translation: Milan 1987).

Concerning **Orphism**, we can certainly recommend the fundamental text by Virginia Spate for its interest and thoroughness: V. Spate, *Orphism. The Evolution of Non-Figurative Painting in Paris 1910 – 1914*, Clarendon Press, Oxford 1979. Of unfailing usefulness, and serious scholarship despite its popularising approach, remains for the Italian reader the part devoted to Orphism in the series on modern art published by the Fratelli Fabbri in 1967.

A very useful introduction to the work of **Francis Picabia** is certainly the rich anthology of texts edited by Elio Grazioli for the series *Riga*: E. Grazioli (editor), *Francis Picabia*, Marcos y Marcos, Milan 2003. Among the catalogues in Italian, we should mention M. Fagiolo dell'Arco, *Francis Picabia: mezzo secolo di avanguardia*, exhibition catalogue (Turin, 1974–1975), Turin 1974. Let us also mention the monographs by Camfield and Borras (W. Camfield, *Francis Picabia, His Art, Life and Times*, Princeton 1979 and M.L. Borras, *Picabia*, Barcelona 1985) and the exhibition catalogue edited by Jean Hubert Martin in 1976: J.H. Martin, H. Seckel, *Picabia*, exhibition catalogue (Paris, 1976), Paris 1976.

Concerning the **Delaunays**, unquestionably useful is the catalogue of the major exhibition devoted to Robert by the Centre Pompidou in 1999: Various Authors, *Robert Delaunay 1906 – 1914, de l'impressionisme a l'abstraction*, exhibition catalogue (Paris, 1999), Paris 1999. For Sonia, instead, we would mention S. Delaunay, *Libro Simultaneo*, Paris 1913 and S. Delaunay, *Rithmes-couleurs*, Paris 1966 (with a text by J. Damase).

Concerning **Léger**: C. Derouet (editor), *Fernand Léger*, exhibition catalogue (Paris, 1997), Paris 1997; C. Green, *Léger and the Avant-garde*, London 1976; P. De Francia, *Fernand Leger*, London 1983.

Concerning the **Duchamp brothers**: P. Cabanne, *The Brothers Duchamp – Jacques Villon, Raymond Duchamp-Villon, Marcel Duchamp*, Neuchâtel 1975-New York 1976; R. Cogniat, *Villon, Pitture*, Paris 1963-Milan 1964; Various Authors, *Duchamp-Villon*, exhibition catalogue (Rouen, 1999), Rouen 1999; J. Cassou, *Duchamp-Villon, Le Cheval Majeur*, exhibition catalogue (Paris 1966), Paris 1966.

Concerning the other members of the movement of **Cubist sculpture**, in the absence of a complete text on the phenomenon, we would at least cite a number of monographs: S. Kuthy, *Henri Laurens 1885 – 1954*, Fribourg 1985. Various Authors, *Henri Laurens, Retrospective*, exhibition catalogue (Lille, 1992), Lille 1992; Various Authors, *Henri Laurens: Le Cubisme: Constructions et papiers collés 1915 – 1919*, exhibition catalogue (Paris, 1985) Paris 1985; S. Lecombre, *Ossip Zadkine, l'œuvre sculpté*, Paris 1994; K.J. Michaelson, *Archipenko: A Study of the Early Works 1908 – 1920*, New York 1977. J. Lipchitz, *My Life in Sculpture*, London 1972; D. Stott, *Jacques Lipchitz and Cubism*, New York 1978; A. Wilkinson, *The Sculpture of Jacques Lipchitz: a Catalogue Raisonné*, vol. 1, *The Paris Years 1910 – 1940*, London 1996.

Concerning the two theorists of Cubism, **Gleizes** and **Metzinger**, we should mention, alongside the already mentioned *Du Cubisme*, the catalogue raisonné of the work of the former (D. Robbins, A. Varichon, *Albert Gleizes 1881 – 1955: Catalogue Raisonné*, Paris 1998, 2 volumes) and an extensive catalogue of the body of work of the latter: J. Moser (editor), *Jean Metzinger in Retrospect*, exhibition catalogue (Iowa City, 1985), Iowa City 1985.

Concerning **Brancusi** the Italian reader has the possibility of consulting a few key texts, such as the monograph written about him by Mario de Micheli (M. de Micheli, *Brancusi*, Milan 1966), the volume by Pontus Holten (P. Hulten, *Brancusi*, Milan 1986), and the critical studies by Paola Mola (P. Mola, *Studi su Brancusi*, in *Solchi*, IV, 1–3, April 2000), who was also the editor of the Italian edition of the artist's writings (C. Brancusi, *Aforismi*, edited by P. Mola, Milan 2001). Concerning the historic monographs, we should mention at least C. Zervos, *Constantin Brancusi. Sculptures, peintures, fresques, dessins*, Paris 1957 and C. Giedion-Welcker, *Constantin Brancusi 1876 – 1957*, Neuchâtel 1958. Extensive documentation is provided finally by the catalogue of the historic show at MoMA (S. Geist, *Constantin Brancusi 1876 – 1957. A Retrospective Exhibition*, exhibition catalogue, MoMA, New York 1969); while we should mention, especially given the lack of attention devoted till now to this aspect of the sculptor's work, the book by Tabart and Monod-Fontaine on Brancusi as photographer: M. Tabart, I. Monod-Fontaine, *Brancusi Photographe*, Paris 1977.

Concerning **Soutine**, one of the best-known figures of the School of Paris, we should mention as a useful starting point E.G. Güse (editor), *Chaïm Soutine 1893 – 1943*, exhibition catalogue, Arts Council of Great Britain, London 1982. For the Italian reader, the exhibition catalogue prepared in 1995 in Lugano may also prove useful: R. Chiappini (editor), *Chaïm Soutine*, exhibition catalogue (Lugano, 1995), Milan 1995. For further in-depth study, one cannot do without the catalogue raisonné (M. Tuchman, E. Dunow, K. Perls, *Chaïm Soutine (1893 – 1943). Catalogue Raisonné*, Taschen, Cologne 1993), the major exhibition held in 1950 by MoMA in New York (M. Wheeler, *Soutine*, exhibition catalogue, MoMA, New York 1950), as well as several, now historic, monographs: W. George, *Artistes juifs. Soutine*, Paris 1928; E. Faure, *Soutine*, Paris 1929; R. Cogniat, *Soutine*, Paris 1973; A. Werner, *Chaïm Soutine*, Harry N. Abrams, New York 1977.

Concerning **Rouault**, a first introduction is offered as well by the catalogue of the Lugano retrospective (R. Chiappini [editor], *Georges Rouault*, exhibition catalogue [Lugano, 1997], Skira, Milan 1997), as well as the essay by Carluccio in the historic series of the Fratelli Fabbri (L. Carluccio, *Georges Rouault*, in *L'arte moderna*, X, 84, Fabbri Editore, Milan 1967). In 1988, a catalogue raisonné of the body of paintings was published in French: B. Dorival, I. Rouault, *Rouault, catalogue raisonné de l'œuvre peint*, Montecarlo 1988. We should also mention: J.T. Soby, *Georges Rouault Paintings and Prints*, exhibition catalogue, MoMA, New York 1947; the monograph by Maritain, the Catholic thinker who was a close friend of the artist, and who radically influenced his work: J. Maritain, *Georges Rouault*, Harry N. Abrams, New York 1952; the historic exhibition catalogue of the centennial: M. Hoog, *Georges Rouault, exposition du cen-*

tenaire, exhibition catalogue (Paris, 1971), Paris 1971.

Concerning **Utrillo**, the Italian reader can turn to, aside from the recent catalogue of an exhibition held in Padua (J. Fabris [editor], *Maurice Utrillo*, exhibition catalogue [Padua, 1997], Marsilio, Venice 1997), the historic monographs by Francis Carco (F. Carco, *La légende et la vie d'Utrillo*, Paris 1928. Italian: *La leggenda e la vita di Utrillo*, Milan 1949), Franco Russoli (F. Russoli, *Maurice Utrillo*, Milan 1953), Waldemar George (W. George, *Utrillo*, Milan 1958), and Alfred Werner (A. Werner, *Utrillo*, New York 1981-Milan 1982). We should also mention, given its documentary value, the biography of the artist written by his wife and patron: L. Valore, *Maurice Utrillo, mon mari*, Paris 1956.

An initial orientation in the vast bibliography on **Modigliani** can be provided by a few good recent catalogues, such as M. Restellini (editor), *Modigliani, Soutine, Utrillo e i pittori di Zborowski*, exhibition catalogue (Florence, 1994), Marsilio, Venice 1994 and R. Chiappini (editor), *Amedeo Modigliani*, exhibition catalogue (Lugano, 1999), Skira, Milan 1999. Among the monographs available in Italian, we should at least mention the one written by his daughter Jeanne (J. Modigliani, *Modigliani senza leggenda*, Vallecchi, Florence 1958) and the one by Ceroni (A. Ceroni, *I dipinti di Modigliani*, Milan 1970). Among the critical texts of historic importance, A. Basler, *Modigliani*, Paris 1931; A. Werner, *Modigliani sculpteur*, Nagel, Geneva 1952; J. Lipchitz, *Amedeo Modigliani (1884 – 1920)*, Harry N. Abrams, New York 1952; A. Salmon, *La vie passionnée de Modigliani*, Paris 1957; A. Werner, *Amedeo Modigliani*, Harry N. Abrams, New York 1966-Milan 1967.

The End of Artistic Object

The Dada Revolution
Original documents: R. Motherwell, *Dada Painters and Poets*, (1951, New York), New York 1981; A. Schwarz (editor), *Almanacco Dada. Antologia letteraria-artistica. Cronologia. Repertorio delle riviste*, Milan 1976; F. Tedeschi, *Dadaismo*, Milan 1991, and M. de Micheli, *Idee e storie di artisti*, Milan 1981.

The manifestoes and the writings of **Tzara** are collected in T. Tzara, *Œuvres complètes*, edited by H. Behar, Paris 1975; T. Tzara, *Sept Manifestes Dada & Lampisteries*, Paris 1924 (Italian translation: *Manifesti del dadaismo e Lampisterie*, [1964, Turin] Turin 1990). Also fundamental for a study of Dadaism is A. Breton, *Anthologie de l'Humour Noir*, Paris 1939.

Among the **memoirs**, we should mention in particular: H. Richter, *DADA Kunst und Antikunst*, Cologne 1964 (Italian translation: *DADA Arte e Antiarte*, Milan 1966); G. Hugnet, *L'aventure Dada. 1916-1922*, Paris 1957 (Italian translation: *L'avventura Dada. 1916-1922*, Milan 1972); G. Ribemont-Dessaignes, *Storia del dadaismo*, Milan 1946; T. Tzara, *An Introduction to a Dada Anthology*, New York 1951; Max Ernst, *Écritures*, Paris 1970 (Italian translation:

Scritture, Milan 1972); H. Harp, *On My Way*, New York 1948; Man Ray, *Self Portrait*, Boston-Toronto 1963.

Among the popularising texts that are available in Italian: S. Danesi, *Il dadaismo*, Milan 1977; S. Lemoine, *Il dadaismo*, Milan 1986; F. Tedeschi, *Dadaismo*, Milan 1991; D. Elger, *Dadaismo*, Cologne 2004.

Among the countless exhibitions devoted to the movement, we should mention: A.H. Barr, Jr. (editor), *Fantastic Art, Dada, Surrealism*, New York 1947; K.H. Hering, E. Rathke, *Dada. Dokumente einer Bewegung*, Düsseldorf 1958; Various Authors, *Dada. Ausstellung zum 50-jährigen Jubiläum / Exposition Commémorative du Cinquantenaire*, Paris 1966–1967; Various Authors, *Dada 1916-1966. Documenti del movimento internazionale Dada*, Rome 1966; Various Authors, *Paris – New York*, Paris 1971; H. Szeemann (editor), *Le macchine celibi*, Venice 1975; Various Authors, *Dada in Zurich*, Zürich 1985; A. Schwarz (editor), *El Espiritu Dada. 1915 – 1925*, Caracas 1980; G. Cortenova (editor), *Dadaismo Dadaismi. Da Duchamp a Warhol*, Milan 1997.

For further study: M. Sanouillet, *Dada à Paris. Histoire générale du Mouvement Dada (1915-1923)*, Paris 1965, one of the best documented and most thorough works on the topic, with an extensive compendium of correspondence; W.S. Rubin, *Dada and Surrealist Art*, New York-London 1969; L.R. Lippard, *Dadas on Art*, Englewood Cliffs (New Jersey) 1971; W. Verkauf, *Dada. Monograph of a Movement*, London 1975; R. Sheppard (editor), *Dada. Studies of a Movement*, Buckinghamshire 1979; R. Sheppard (editor), *New Studies in Dada. Essays and Documents*, Hutton 1981; A. Schwarz, *New York Dada: Duchamp, Man Ray, Picabia*, Munich 1973.

Concerning the specific sectors of Dada activity, the **cinema**: G. Rondolino, *L'occhio tagliato: documenti del cinema dadaista e surrealista*, Turin 1972; photomontage is given one of the best treatments in: D. Ades, *Photomontage*, London 1976: M. Gordon (editor), *Dada Performance*, New York 1987; M. Dachy, *Journal du Mouvement Dada 1915-1923*, Geneva 1989.

For **Duchamp**, a good anthology of texts (by him or by figures close to him) is offered by E. Grazioli (editor), *Marcel Duchamp*, in *Riga*, 5, Milan 1993. Concerning his writings, the interviews he gave, and the critical literature, we should mention three collections published by Da Capo Press in New York: M. Duchamp, M. Sanouillet, E. Peterson, *The Writings of Marcel Duchamp*, 1989; P. Cabanne, *Dialogues With Marcel Duchamp*, 1987; J. Masheck (editor), and *Marcel Duchamp in Perspective*, 2002. Among the biographies, we should mention the historical biography by C. Tomkins, *Duchamp: A Biography*, (1996, New York), New York 1998, and the one by A. Bonito Oliva, *Vita di Marcel Duchamp*, Rome 1976. Concerning critical writings, we should at least mention A. Schwarz, *La sposa messa a nudo in Marcel Duchamp, anche*, Turin 1974; J. Clair, *Marcel Duchamp ou le Grand Fictif*, Paris 1975 (Italian translation: *Marcel Duchamp. Il*

grande illusionista, Milan 2003); D. Judovitz, *Unpacking Duchamp: Art in Transit*, Berkeley 1998; and, T. de Duve (editor), *The Definitively Unfinished Marcel Duchamp*, Cambridge (Mass.) 1991. Arturo Schwarz, a gallery owner and a friend of the artist, has edited among other things a catalogue of the complete oeuvre, to which we would refer the reader for any further study: A. Schwarz, *The Complete Works of Marcel Duchamp*, New York 2001.

Concerning **Picabia**: M. Fagiolo dell'Arco, *Francis Picabia*, Milan 1976; A. Jouffroy, *Picabia*, Paris 2002; P. de Massot, *Francis Picabia*, Paris 2002; and the very well documented M.L. Borràs, *Picabia*, Milan 1985.

Concerning **Ernst,** the monumental catalogue of the complete body of work and the catalogue of the travelling retrospective show of 1991–1992 edited by Werner Spies, perhaps the leading expert on the work of the artist, remain fundamental: W. Spies, *Max Ernst, Œuvre-Katalog*, Houston–Cologne 1975–1991 and W. Spies (editor), *Max Ernst. A Retrospective*, London–Stuttgart–Düsseldorf–Paris 1991–1992. Among the best-known monographs, we should especially mention P. Waldberg, *Max Ernst*, Paris 1958; J. Russell, *Max Ernst: Life and Work*, London 1967; U.M. Schneede, *The Essential Max Ernst*, London 1972; and, in Italian, G. Gatt, *Max Ernst*, Florence 1969.

Still an excellent point of departure for any study of the work of **Arp** is the MoMA exhibition catalogue edited by James T. Soby: J.T. Soby (editor), *Arp*, Salem (New Hampshire) 1986.

Concerning **Ray**, recent monographs: E. de l'Ecotais, K. Ware, *Man Ray 1890 – 1976*, Cologne 2001; A. Sayag, E. de l'Ecotais (editors), *Man Ray: Photography and Its Double*, Corte Madera 1998; I. Schaffner, *The Essential Man Ray*, New York 2003; and J.-H. Martin, *Man Ray*, London 2001.

The catalogue raisonné of **Schwitters** was recently published, and the first volume focuses specifically on the Dada work: K. Schwitters, *Kurt Schwitters: Catalogue Raisonne: Volume I 1905-1922*, Ostfildern 2001. Another book of interest for its documentary value is certainly K. Schwitters, J. Rothenberg, P. Joris (editor), *Poems Performance Pieces Proses Plays Poetics (The Border Lines)*, Philadelphia 1993, which assembles the artist's literary production; one might also examine such studies as E. Burns Gamard, *Kurt Schwitters' Merzbau: The Cathedral of Erotic Misery (Building Studies, 5)*, New York 2000; and Various Authors, *In the Beginning is MERZ: From Kurt Schwitters to the Present Day*, Ostfildern 2000.

Index of Names, Artists and Works of Art

Photography Credits

Photographic Agency Luisa Ricciarini, Milan:
pp. 14, 16–17, 19 bottom, 20, 35, 44 top, 45, 46, 47, 54, 57, 60 top, 60 bottom, 61, 62, 64, 65, 68 top, 68 bottom, 69 top, 69 bottom, 70 top, 70 bottom, 71, 72–73, 74–75, 76 top, 76 bottom, 77, 78 top, 78 bottom, 79, 80, 81, 82, 83, 84–85, 86, 87, 88, 106, 108–109, 113, 114, 116, 117, 121, 122 top, 122 bottom, 123 top, 123 bottom, 126, 127, 129, 132, 137, 138, 139, 140 top, 141 right, 143 top, 143 bottom, 145 left, 150 bottom, 151, 152, 153, 154, 155, 168, 171, 172–73, 174 top, 174 bottom, 176 left, 176 right, 177, 178, 179 top left, 179 top right, 181, 182, 183, 184 top, 184 bottom, 185, 186 bottom, 188, 189, 190 top, 190 bottom, 191, 192 top, 192 bottom, 193, 194, 195, 196–97, 198, 200, 201, 202, 203, 218, 219, 225, 228, 236, 237, 238 top, 240, 242, 243 left, 243 right, 244, 245, 246, 248 top, 250, 253, 254 top, 256 bottom, 258–59, 262, 263, 272, 275, 276, 277, 280, 281 bottom, 281 top, 282–83, 284, 285, 286, 288, 289, 290, 291, 292, 293, 306, 308, 310, 311 top, 312, 313, 314, 315, 316–17, 318, 320, 321, 323 bottom, 323 top, 332 right, 333 right, 334, 335, 338–39, 340, 341, 342, 343, 344, 345, 347, 350, 351, 352–53, 361.

© 2005, 2006 Scala Archives, Florence:
pp. 15, 19, 21, 23, 32, 34 bottom, 36, 37, 38, 39, 42, 43, 48, 49, 51, 53, 58, 112 top, 112 bottom, 115, 118, 119 left, 124, 130–31, 134 top, 134 bottom, 136, 140 bottom left, 141, 144, 145 right, 146–47, 147 right, 148–49, 150, 156, 157, 158, 159, 170, 175 bottom, 179 bottom, 180 top, 180 bottom, 186 top, 222 left, 224, 232, 233 top, 233 bottom, 238 left, 239, 248 bottom, 249 top, 256 top, 278, 296–97, 299, 311 left, 324, 325, 328–29, 346 top, 355, 362–63, 364, 366, 370 left, 370 right, 373, 374, 375, 376, 378–79, 380, 381, 383, 384, 385, 402 top, 403, 404 left, 410, 413.

© 2005, 2006 Digital image, The Museum of Modern Art, New York/Scala, Florence:
pp. 12, 18 top, 22, 110, 119 right, 128, 135, 140 bottom, 175 top, 187, 199, 216, 220–21, 226–27, 230–31, 235, 298, 322, 330, 332 left, 333 left, 337, 346 bottom, 348, 349, 354, 360, 365, 367, 368, 369, 371, 372, 382, 392 middle, 394, 395, 404 right, 405, 406 top, 407, 408, 411.

© Eric Lessing/Contrasto:
pp. 274 top, 274 bottom.

Foto Giuseppe Schiavinotto, Roma: 223.

© Photo CNAC/MNAM Dist. RMN/© Philippe Migeat:
pp. 50, 52, 279, 286, 331.

© Photo RMN/Gérard Blot: p. 125 top.

© The Solomon R. Guggenheim Foundation, New York:
pp. 44 bottom, 63, 66–7, 142.